DAVID BUSCH'S NIKON® D3200

GUIDE TO DIGITAL SLR PHOTOGRAPHY

David D. Busch

Course Technology PTRA part of Cengage Learning

David Busch's Nikon® D3200 Guide to Digital SLR Photography

David D. Busch

Publisher and General Manager, Course Technology PTR:

Stacy L. Hiquet

Associate Director of Marketing:

Sarah Panella

Manager of Editorial Services:

Heather Talbot

Senior Marketing Manager:

Mark Hughes

Executive Editor:

Kevin Harreld

Project Editor:

Jenny Davidson

Series Technical Editor:

Michael D. Sullivan

Interior Layout Tech:

Bill Hartman

Cover Designer:

Mike Tanamachi

Indexer:

Katherine Stimson

Proofreader:

Sara Gullion

© 2013 David D. Busch

ALL RIGHTS RESERVED. No part of this work covered by the copyright herein may be reproduced, transmitted, stored, or used in any form or by any means graphic, electronic, or mechanical, including but not limited to photocopying, recording, scanning, digitizing, taping, Web distribution, information networks, or information storage and retrieval systems, except as permitted under Section 107 or 108 of the 1976 United States Copyright Act, without the prior written permission of the publisher.

For product information and technology assistance, contact us at Cengage Learning Customer & Sales Support, 1-800-354-9706.

For permission to use material from this text or product, submit all requests online at **cengage.com/permissions**.

Further permissions questions can be emailed to **permissionrequest@cengage.com**.

Nikon is a registered trademark of Nikon Corporation in the United States and other countries.

All other trademarks are the property of their respective owners.

All images © David D. Busch unless otherwise noted.

Library of Congress Control Number: 2012940098

ISBN-13: 9-781-285-17130-2

ISBN-10: 1-285-17130-6

Course Technology, a part of Cengage Learning

20 Channel Center Street Boston, MA 02210 USA

Cengage Learning is a leading provider of customized learning solutions with office locations around the globe, including Singapore, the United Kingdom, Australia, Mexico, Brazil, and Japan. Locate your local office at: international.cengage.com/region.

Cengage Learning products are represented in Canada by Nelson Education, Ltd.

For your lifelong learning solutions, visit courseptr.com.

Visit our corporate website at cengage.com.

Printed in the United States of America 1 2 3 4 5 6 7 14 13 12

For Cathy

Acknowledgments

Once again thanks to the folks at Course Technology PTR, who recognized that a camera as popular as the Nikon D3200 deserves in-depth full-color coverage at a price anyone can afford. Special thanks to executive editor Kevin Harreld, who always gives me the freedom to let my imagination run free with a topic, as well as my veteran production team, including project editor Jenny Davidson and technical editor Mike Sullivan. Also thanks to Bill Hartman, layout; Katherine Stimson, indexing; Sara Gullion, proofreading; Mike Tanamachi, cover design; and my agent, Carole Jelen, who has the amazing ability to keep both publishers and authors happy.

About the Author

With more than a million books in print, **David D. Busch** is the world's #1 selling digital camera guide author, and the originator of popular digital photography series like *David Busch's Pro Secrets* and *David Busch's Quick Snap Guides*. He has written several dozen hugely successful guidebooks and compact guides for Nikon digital SLR models, many additional user guides for other camera models, as well as popular books devoted to dSLRs, including *Mastering Digital SLR Photography, Third Edition* and *Digital SLR Pro Secrets*. As a roving photojournalist for more than 20 years, he illustrated his books, magazine articles, and newspaper reports with award-winning images. He's operated his own commercial studio, suffocated in formal dress while shooting weddings-for-hire, and shot sports for a daily newspaper and upstate New York college. His photos have been published in magazines as diverse as *Scientific American* and *Petersen's PhotoGraphic*, and his articles have appeared in *Popular Photography & Imaging, Rangefinder, The Professional Photographer*, and hundreds of other publications. He's also reviewed dozens of digital cameras for CNet and *Computer Shopper*. His advice has been featured on National Public Radio's *All Tech Considered*.

When About.com named its top five books on Beginning Digital Photography, debuting at the #1 and #2 slots were Busch's *Digital Photography All-In-One Desk Reference for Dummies* and *Mastering Digital Photography*. During the past year, he's had as many as five of his books listed in the Top 20 of Amazon.com's Digital Photography Bestseller list—simultaneously! Busch's 100-plus other books published since 1983 include best-sellers like *David Busch's Quick Snap Guide to Using Digital SLR Lenses*.

Busch earned top category honors in the Computer Press Awards the first two years they were given (for *Sorry About The Explosion* and *Secrets of MacWrite, MacPaint and MacDraw*), and he later served as Master of Ceremonies for the awards. Visit his website at http://www.dslrguides.com/blog.

Contents

Preface	xiv
Introduction	xv
PART I: GETTING STARTED	
WITH YOUR NIKON D3200	
Chapter 1	
Thinking Outside the Box	5
In a Hurry?	
First Things First	7
Initial Setup	
Mastering the Multi Selector	
Setting the Clock	14
Battery Included	
Final Steps	16
Chapter 2	
Nikon D3200 Quick Start	23
Using the Information Edit Display	
Choosing a Release Mode	26
Selecting a Shooting Mode	28
Choosing a Scene Mode	
Choosing an Advanced Mode	
Choosing a Metering Mode	

Choosing Focus Modes	33
Choosing Autofocus-Area Mode	34
Choosing Focus Mode	
Adjusting White Balance and ISO	35
Reviewing the Images You've Taken	
Using the Built-in Flash	37
Transferring Photos to Your Computer	38
Using the Guide Mode	40
Guiding Light	40
Chapter 3	
Nikon D3200 Roadmap	43
NIKOII D3200: FIOIIL VIEW	44
The Nikon D3200's Business End	50
Playing Back Images	54
Zooming the Nikon D3200 Playback Display	55
Viewing Thumbnails	56
Working with Calendar View	58
Working with Photo Information	59
Shooting Information Display/Information Edit Screen	64
Going Topside	67
Lens Components	70
Underneath Your Nikon D3200	73
Looking Inside the Viewfinder	74
Chapter 4	
Playback and Shooting Menus	77
Anatomy of the Nikon D3200's Menus	78
Playback Menu Options	81
Delete	81
Playback Folder	82
Playback Display Options	83
Image Review	84
Rotate Tall	84
Slide Show	85
DPOF Print Order	87

vii

Beep
Rangefinder
File Number Sequence
Buttons
Slot Empty Release Lock
Print Date
Storage Folder
GPS
Eye-Fi Upload
Firmware Version
Retouch Menu Options
D-Lighting
Red-Eye Correction
Trim141
Filter Effects144
Color Balance
Image Overlay
NEF (RAW) Processing146
Resize148
Quick Retouch148
Straighten148
Distortion Control
Fisheye
Color Outline
Color Sketch
Perspective Control
Miniature Effect
Side-by-Side Comparison
Selective Color
Edit Movie
Using Recent Settings

PART II: BEYOND THE BASICS

Chapter 6	
Getting the Right Exposure	161
Getting a Handle on Exposure	162
How the D3200 Calculates Exposure	
Correctly Exposed	167
Overexposed	168
Underexposed	168
Choosing a Metering Method	170
Matrix Metering	170
Center-Weighted Metering	
Spot Metering	
Choosing an Exposure Method	
Aperture-Priority	
Shutter-Priority	176
Program Mode	
Manual Exposure	
Using Scene Modes	179
Adjusting Exposure with ISO Settings	
Dealing with Noise	
Fixing Exposures with Histograms	
Bracketing	
Bracketing and Merge to HDR	
Chapter 7	
Mastering the Mysteries of Autofocus	191
How Focus Works	191
Phase Detection	192
Contrast Detection	194
Locking in Focus	195
Focus Modes	196
Adding Circles of Confusion	
Using Autofocus with the Nikon D3200	199
Your Autofocus Mode Options	200
Autofocus Mode	201
Autofocus Area	

Focusing in Live View	.206
Focus Stacking	
1 ocus stacking	.210
Chapter 8	
	215
Working with Live View	
Fun with Live View	.216
Beginning Live View	
Shooting in Live View	.218
Shooting Movies with the D3200	
Viewing Your Movies	
Editing Your Movies	
Some Fundamentals	.221
Tips for Shooting Better Video	.222
Lens Craft	
Audio	
Keep Things Stable and on the Level	
Shooting Script	
Storyboards	.230
Storytelling in Video	.230
Composition	.231
Lighting for Video	.234
PART III: ENHANCING YOUR EXPERIENCE	
2222 M. EXTENIENCE	
Chapter 9	
Advanced Shooting Tips for Your	
3 T11 D 4 4 4 4	239
Continuous Shooting	
Exploring Ultra-Fast Exposures	241
Long Exposures	245
Three Ways to Take Long Exposures	245
Working with Long Exposures	.247

Geotagging with the Nikon GP-1	251
Wi-Fi	254
Tablets, Smart Phones, and the Nikon D3200	
What Else Can You Do with Them?	
Chapter 10	
Working with Lenses	261
Sensor Sensibilities	
Crop or Not?	
Your First Lens	264
Buy Now, Expand Later	
What Lenses Can You Use?	269
Ingredients of Nikon's Alphanumeric Soup	
What Lenses Can Do for You	
Zoom or Prime?	
Categories of Lenses	276
Using Wide-Angle and Wide-Zoom Lenses	277
Avoiding Potential Wide-Angle Problems	279
Using Telephoto and Tele-Zoom Lenses	280
Avoiding Telephoto Lens Problems	282
Telephotos and Bokeh	284
Add-ons and Special Features	286
Lens Hoods	286
Telephoto Converters	286
Macro Focusing	288
Vibration Reduction	290
Chapter 11	
Making Light Work for You	293
Continuous Illumination versus Electronic Flash	294
Continuous Lighting Basics	299
Continuous Lighting basics	300
Daylight	301
Fluorescent Light/Other Light Sources	302
Adjusting White Balance	303
Adjusting white balance	

Electronic Flash Basics)3
How Electronic Flash Works)4
Determining Exposure	
Guide Numbers	
Flash Control	
Flash Metering Mode31	
Choosing a Flash Sync Mode	
A Typical Electronic Flash Sequence31	4
Working with Nikon Flash Units	5
Nikon D3200 Built-in Flash31	5
Nikon SB-910	6
Nikon SB-700	7
Nikon SB-400	7
Nikon SB-R200	
Flash Techniques	8
Using the Zoom Head	9
Flash Modes31	9
Working with Wireless Commander Mode32	.0
Connecting External Flash	.1
More Advanced Lighting Techniques	.2
Diffusing and Softening the Light32	2
Using Multiple Light Sources	4
Other Lighting Accessories32	7
Chapter 12	
Useful Software for the Nikon D3200 33:	1
Nikon's Applications and Utilities	2
Nikon ViewNX 2	2
Nikon Transfer33	4
Nikon Capture NX 2	6
Other Software33	8
DxO Optics Pro33	9
Phase One Capture One Pro (C1 Pro)	9
BreezeBrowser Pro	0
Photoshop/Photoshop Elements	0

Chapter 13	
Nikon D3200: Troubleshooting	
and Prevention	345
Battery Powered	346
Updating Your Firmware	347
How It Works	
Why Two Firmware Modules?	
Getting Ready	
Updating from a Card Reader	
Updating with a USB Connection	
Starting the Update	
Protecting Your LCD	
Troubleshooting Memory Cards	
All Your Eggs in One Basket?	
What Can Go Wrong?	
What Can You Do?	
Preventive Measures	
Cleaning Your Sensor	
Dust the FAQs, Ma'am	
Identifying and Dealing with Dust	
Avoiding Dust	
Sensor Cleaning	
Sensor Cleaning	
Glossary	373
Index	385

Preface

You don't want good pictures from your new Nikon D3200—you demand *outstanding photos*. After all, the D3200 is the most advanced entry-level camera that Nikon has ever introduced. It boasts an amazing 24 megapixels of resolution and full high-definition movie-making capabilities. But your gateway to pixel proficiency is dragged down by the slim little pamphlets included in the box as a manual. Nikon doesn't even include a full printed manual for this camera—it's available only as a PDF file on a CD-ROM tucked away in the box!

You know everything you need to know is in there, somewhere, but you don't know where to start, and you probably don't like the idea of having to read your manual on a computer screen. In addition, the PDF camera manual doesn't offer much information on photography or digital photography. Nor are you interested in spending hours or days studying a comprehensive book on digital SLR photography that doesn't necessarily apply directly to your D3200.

What you need is a guide that explains the purpose and function of the D3200's basic controls, how you should use them, and *why*. Ideally, there should be information about file formats, resolution, exposure, and special autofocus modes, but you'd prefer to read about those topics only after you've had the chance to go out and take a few hundred great pictures with your new camera. Why isn't there a book that summarizes the most important information in its first two or three chapters, with lots of illustrations showing what your results will look like when you use this setting or that?

If you can't decide on what basic settings to use with your camera because you can't figure out how changing ISO or white balance or focus defaults will affect your pictures, you need this guide. I won't talk down to you, either; this book isn't padded with dozens of pages of checklists telling you how to take a travel picture, a sports photo, or how to take a snapshot of your kids in overly simplistic terms. There are no special sections devoted to "real world" recipes here. All of us do 100 percent of our shooting in the real world! So, I give you all the information you need to cook up great photos on your own!

Introduction

What part of "entry level" doesn't Nikon understand? This new, affordable beginner model is packed with advanced features, such as a class-leading 24 megapixels of resolution, and full high-definition 1920 × 1080 movie-making mode, and it includes a nifty Guide mode to lead the most neo of neophytes through the out-of-box basics. It's stuffed all those features into a compact body that elevates entry-level to a new high with the Nikon D3200.

But, despite its growing feature list, the D3200 retains the ease of use that smoothes the transition for those new to digital photography. For those just dipping their toes into the digital pond, the experience is warm and inviting. The Nikon D3200 isn't a snapshot camera—it's a point-and-shoot (if you want to use it in that mode) for the thinking photographer.

But once you've confirmed that you made a wise purchase decision, the question comes up, how do I use this thing? All those cool features can be mind numbing to learn, if all you have as a guide is the manual furnished with the camera. Help is on the way. I sincerely believe that this book is your best bet for learning how to use your new camera, and for learning how to use it well.

If you're a Nikon D3200 owner who's looking to learn more about how to use this great camera, you've probably already explored your options. There are DVDs and online tutorials—but who can learn how to use a camera by sitting in front of a television or computer screen? Do you want to watch a movie or click on HTML links, or do you want to go out and take photos with your camera? Videos are fun, but not the best answer.

There's always the manual furnished with the D3200. It's compact and filled with information, but comes only on a CD that's not very convenient to tote around, and there's really very little about *why* you should use particular settings or features. Its organization may make it difficult to find what you need. Multiple cross-references may send you searching back and forth between two or three sections of the book to find what you want to know. The basic manual is also hobbled by black-and-white line drawings and tiny monochrome pictures that aren't very good examples of what you can do.

Also available are third-party guides to the D3200, like this one. I haven't been happy with some of these guidebooks, which is why I wrote this one. The existing books range from skimpy and illustrated by black-and-white photos to lushly illustrated in full color but too generic to do much good. Photography instruction is useful, but it needs to be related directly to the Nikon D3200 as much as possible.

I've tried to make *David Busch's Nikon D3200 Guide to Digital SLR Photography* different from your other D3200 learn-up options. The roadmap sections use larger, color pictures to show you where all the buttons and dials are, and the explanations of what they do are longer and more comprehensive. I've tried to avoid overly general advice, including the two-page checklists on how to take a "sports picture" or a "portrait picture" or a "travel picture." Instead, you'll find tips and techniques for using all the features of your Nikon D3200 to take *any kind of picture* you want. If you want to know where you should stand to take a picture of a quarterback dropping back to unleash a pass, there are plenty of books that will tell you that. This one concentrates on teaching you how to select the best autofocus mode, shutter speed, f/stop, or flash capability to take, say, a great sports picture under any conditions.

This book is not a lame rewriting of the manual that came with the camera. Some folks spend five minutes with a book like this one, spot some information that also appears in the original manual, and decide "Rehash!" without really understanding the differences. Yes, you'll find information here that is also in the owner's manual, such as the parameters you can enter when changing your D3200's operation in the various menus. Basic descriptions—before I dig in and start providing in-depth tips and information—may also be vaguely similar. There are only so many ways you can say, for example, "Hold the shutter release down halfway to lock in exposure." But if you need advice on when and how to use the most important functions, you'll find the information here.

David Busch's Nikon D3200 Guide to Digital SLR Photography is aimed at both Nikon and dSLR veterans as well as newcomers to digital photography and digital SLRs. Both groups can be overwhelmed by the options the D3200 offers, while underwhelmed by the explanations they receive in their user's manual. The manuals are great if you already know what you don't know, and you can find an answer somewhere in a booklet arranged by menu listings and written by a camera vendor employee who last threw together instructions on how to operate a camcorder.

Once you've read this book and are ready to learn more, I hope you pick up one of my other guides to digital SLR photography. Five of them are offered by Course Technology PTR, each approaching the topic from a different perspective.

They include:

David Busch's Compact Field Guide for the Nikon D3200

Throw away your command cards and cheat sheets! This is a spiral-bound, lay-flat condensation of just my essential setup and controls guidelines for the Nikon D3200, in a bag-friendly size you can carry with you anywhere. When you can't take this book with you for study, you'll want my *Compact Field Guide* for your camera as a reference.

Quick Snap Guide to Digital SLR Photography

Consider this a prequel to the book you're holding in your hands. It might make a good gift for a spouse or friend who may be using your D3200, but who lacks even basic knowledge about digital photography, digital SLR photography, and Nikon photography. It serves as an introduction that summarizes the basic features of digital SLR cameras in general (not just the D3200), and what settings to use and when, such as continuous autofocus/single autofocus, aperture/shutter priority, EV settings, and so forth. The guide also includes recipes for shooting the most common kinds of pictures, with step-by-step instructions for capturing effective sports photos, portraits, land-scapes, and other types of images.

David Busch's Quick Snap Guide to Using Digital SLR Lenses

A bit overwhelmed by the features and controls of digital SLR lenses, and not quite sure when to use each type? This book explains lenses, their use, and lens technology in easy-to-access two- and four-page spreads, each devoted to a different topic, such as depth-of-field, lens aberrations, or using zoom lenses.

Mastering Digital SLR Photography, Third Edition

This book, completely revamped with six brand new chapters for this latest edition, is an introduction to digital SLR photography, with nuts-and-bolts explanations of the technology, more in-depth coverage of settings, and whole chapters on the most common types of photography. While not specific to the D3200, this book can show you how to get more from its capabilities.

Digital SLR Pro Secrets

This is my more advanced guide to dSLR photography with greater depth and detail about the topics you're most interested in. If you've already mastered the basics in *Mastering Digital SLR Photography*, this book will take you to the next level.

Family Resemblance

If you've owned previous models in the Nikon digital camera line, and copies of my books for those cameras, you're bound to notice a certain family resemblance. Nikon has been very crafty in introducing upgraded cameras that share the best features of the models they replace, while adding new capabilities and options. You benefit in two ways. If you used a Nikon D40/D40x, D60, D3100, or D3000 prior to switching to the latest D3200 model, you'll find that the D3200 has a certain familiarity for you, making it easy to make the transition. There are lots of features and menu choices of the D3200 that are exactly the same as those in the most recent models, or even "big siblings" like the D7000 and D300s. This family resemblance will help level the learning curve for you.

Similarly, when writing books for each new model, I try to retain the easy-to-understand explanations that worked for previous books dedicated to earlier camera models, and concentrate on expanded descriptions of things readers have told me they want to know more about, a solid helping of fresh sample photos, and lots of details about the latest and greatest new features. Rest assured, this book was written expressly for you, and tailored especially for the D3200.

Who Are You?

When preparing a guidebook for a specific camera, it's always wise to consider exactly who will be reading the book. Indeed, thinking about the potential audience for *David Busch's Nikon D3200 Guide to Digital SLR Photography* is what led me to taking the approach and format I use for this book. I realized that the needs of readers like you had to be addressed both from a functional level (what you will use the D3200 for) as well as from a skill level (how much experience you may have with digital photography, dSLRs, or Nikon cameras specifically).

From a functional level, you probably fall into one of these categories:

- Professional photographers who understand photography and digital SLRs, and simply want to learn how to use the Nikon D3200 as a backup camera, or as a camera for their personal "off-duty" use.
- Individuals who want to get better pictures, or perhaps transform their growing interest in photography into a full-fledged hobby or artistic outlet with a Nikon D3200 and advanced techniques.
- Those who want to produce more professional-looking images for their personal or business website, and feel that the Nikon D3200 will give them more control and capabilities.

- Small business owners with more advanced graphics capabilities who want to use the Nikon D3200 to document or promote their business.
- Corporate workers who may or may not have photographic skills in their job descriptions, but who work regularly with graphics and need to learn how to use digital images taken with a Nikon D3200 for reports, presentations, or other applications.
- Professional webmasters with strong skills in programming (including Java, JavaScript, HTML, Perl, etc.) but little background in photography, but who realize that the D3200 can be used for sophisticated photography.
- Graphic artists and others who already may be adept in image editing with Photoshop or another program, and who may already be using a digital camera (Nikon or otherwise), but who need to learn more about digital photography and the special capabilities of the D3200 dSLR.

Addressing your needs from a skills level can be a little trickier, because the D3200 is such a great camera that a full spectrum of photographers will be buying it, from absolute beginners who have never owned a digital camera before up to the occasional professional with years of shooting experience who will be using the Nikon D3200 as a backup body. (I have to admit I tend to carry my D3200 with me everywhere, even if I intend to take most of my photos with another camera.)

Before tackling this book, it would be helpful for you to understand the following:

- What a digital SLR is: It's a camera that shows an optical (not LCD) view of the picture that's being taken through the (interchangeable) lens that actually takes the photo, thanks to a mirror that reflects an image to a viewfinder, but flips up out of the way to allow the sensor to be exposed. Today, such cameras also offer an optional Live View feature if you want to preview your images on the LCD, especially when prepping to shoot movies.
- How digital photography differs from film: The image is stored not on film (which I call the *first* write-once optical media), but on a memory card as pixels that can be transferred to your computer, and then edited, corrected, and printed without the need for chemical processing.
- What the basic tools of correct exposure are: Don't worry if you don't understand these; I'll explain them later in this book. But if you already know something about shutter speed, aperture, and ISO sensitivity, you'll be ahead of the game. If not, you'll soon learn that shutter speed determines the amount of time the sensor is exposed to incoming light; the f/stop or aperture is like a valve that governs the quantity of light that can flow through the lens; the sensor's sensitivity (ISO setting) controls how easily the sensor responds to light. All three factors can be varied individually and proportionately to produce a picture that is properly exposed (neither too light nor too dark).

It's tough to provide something for everybody, but I am going to try to address the needs of each of the following groups and skill levels:

- Digital photography newbies: If you've used only point-and-shoot digital cameras, or have worked only with non-SLR film cameras, you're to be congratulated for selecting one of the very best entry-level digital SLRs available. This book can help you understand the controls and features of your D3200, and lead you down the path to better photography with your camera. I'll provide all the information you need, but if you want to do some additional reading for extra credit, you can also try one of the other books I mentioned earlier. They complement this book well.
- Advanced point-and-shooters moving on up: There are some quite sophisticated pocket-sized digital cameras available, including those with many user-definable options and settings, so it's possible you are already a knowledgeable photographer, even though you're new to the world of the digital SLR. You've recognized the limitations of the point-and-shoot camera: even the best of them have more noise at higher sensitivity (ISO) settings than a camera like the Nikon D3200; the speediest still have an unacceptable delay between the time you press the shutter and the photo is actually taken; even a non-interchangeable super-zoom camera with 12X to 20X magnification often won't focus close enough, include an aperture suitable for low-light photography, or take in the really wide view you must have. Interchangeable lenses and other accessories available for the Nikon D3200 are another one of the reasons you moved up. Because you're an avid photographer already, you should pick up the finer points of using the D3200 from this book with no trouble.
- Film SLR veterans new to the digital world: You understand photography, you know about f/stops and shutter speeds, and thrive on interchangeable lenses. If you have used a newer film SLR, it probably has lots of electronic features already, including autofocus and sophisticated exposure metering. Perhaps you've even been using a Nikon film SLR and understand many of the available accessories that work with both film and digital cameras. All you need is information on using digital-specific features, working with the D3200 itself, and how to match—and exceed—the capabilities of your film camera with your new Nikon D3200.
- Experienced dSLR users broadening their experience to include the D3200: Perhaps you started out with the Nikon D70 back in 2004, or a D100 before that. It's very likely that some of you used the 6-megapixel Nikon D40 before the bug to advance to more megapixels bit you. You may have used a digital SLR from Nikon or another vendor and are making the switch. You understand basic photography, and want to learn more. And, most of all, you want to transfer the skills you already have to the Nikon D3200, as quickly and seamlessly as possible.

■ Pro photographers and other advanced shooters: I expect my most discerning readers will be those who already have extensive experience with Nikon intermediate and pro-level cameras. I may not be able to teach you folks much about photography. But, even so, an amazing number of D3200 cameras have been purchased by those who feel it is a good complement to their favorite advanced dSLR. Others (like myself) own a camera like the Nikon D800 and find that the D3200 fills a specific niche incredibly well, and is useful as a backup camera, because the D3200's 24-megapixel images are often just as good as those produced by more "advanced" models. You pros and semi-pros, despite your depth of knowledge, should find this book useful for learning about the features the D3200 has that your previous cameras lack or implement in a different way.

Who Am I?

After spending years as the world's most successful unknown author, I've become slightly less obscure in the past few years, thanks to a horde of camera guidebooks and other photographically oriented tomes. You may have seen my photography articles in *Popular Photography & Imaging* magazine. I've also written about 2,000 articles for magazines like *Petersen's PhotoGraphic* (which is now defunct through no fault of my own), plus *Rangefinder, Professional Photographer*, and dozens of other photographic publications. But, first, and foremost, I'm a photojournalist and made my living in the field until I began devoting most of my time to writing books. Although I love writing, I'm happiest when I'm out taking pictures, which is why I spent a full two weeks in Salamanca, Spain, just before I began writing this book. Last year, my travels also took me to "exotic" locations that included Florida, San Diego, and Ireland. You'll find photos of some of these visual treasures within the pages of this book.

Like all my digital photography books, this one was written by a Nikon devotee with an incurable photography bug. My first Nikon SLR was a venerable Nikon F back in the 1960s, and I've owned most of the newer digital models since then.

Over the years, I've worked as a sports photographer for an Ohio newspaper and for an upstate New York college. I've operated my own commercial studio and photo lab, cranking out product shots on demand and then printing a few hundred glossy 8 × 10s on a tight deadline for a press kit. I've served as a photo-posing instructor for a modeling agency. People have actually paid me to shoot their weddings and immortalize them with portraits. I even prepared press kits and articles on photography as a PR consultant for a large Rochester, N.Y., company, which shall remain nameless. My trials and travails with imaging and computer technology have made their way into print in book form an alarming number of times, including a few dozen on scanners and photography.

Like you, I love photography for its own merits, and I view technology as just another tool to help me get the images I see in my mind's eye. But, also like you, I had to master this technology before I could apply it to my work. This book is the result of what I've learned, and I hope it will help you master your Nikon D3200 digital SLR, too.

As I write this, I'm currently in the throes of upgrading my website, which you can find at www.nikonguides.com, adding tutorials and information about my other books. There's a lot of information about several Nikon models right now, but I'll be adding tips and recommendations about the Nikon D3200 (including a list of equipment and accessories that I can't live without) in the next few months. I hope you'll stop by for a visit. I've also set up a wish list of Nikon cameras, lenses, and accessories on Amazon. com for those who want to begin shopping now. You'll find my equipment recommendations at http://astore.amazon.com/nikonphoto-20. I hope you'll stop by for a visit to my blog at http://www.dslrguides.com/blog, where you'll find a list of any typos sharpeyed readers have reported.

Part I

Getting Started with Your Nikon D3200

In digital photography, there is such a thing as *too* easy. If you bought a D3200, you certainly had no intention of using the camera as a point-and-shoot snapshooter. After all, the D3200 is a tool suitable for advanced photographic pursuits, with an extensive array of customization possibilities. As such, you don't want the camera's operation to be brainless; you want *access* to the advanced features to be easy.

You get that easy access with the Nikon D3200. However, you'll still need to take the time to learn how to use these features, and I'm going to provide everything you need to know in these first five chapters to begin shooting:

- Chapter 1: This is a "Meet Your D3200" introduction, where you'll find information about what came in the box with your camera and, more importantly, what didn't come with the camera that you seriously should consider adding to your arsenal. I'll also cover some things you might not have known about charging the D3200's battery, choosing a memory card, setting the time and date, and a few other pre-flight tasks. This is basic stuff, and if you're a Nikon veteran, you can skim over it quickly. A lot of this first chapter is intended for newbies, and even if you personally don't find it essential, you'll probably agree that there was some point during your photographic development (so to speak) that you wished this information was spelled out for you. There's no extra charge!
- Chapter 2: Here, you'll find a Quick Start aimed at those who may not be old hands with Nikon cameras having this level of sophistication. The D3200 has some interesting new features, but even with all the goodies to play with and learning curve still to climb, you'll find that Chapter 2 will get you shooting quickly with a minimum of fuss.
- Chapter 3: This is a Streetsmart Roadmap to the Nikon D3200. Confused by the tiny little diagrams and multiple cross-references for each and every control that send you scurrying around looking for information you know is buried somewhere in the small and inadequate manual stuffed in the box? This chapter uses multiple large full-color pictures that show every dial, knob, and button, and explain the basics of using each in clear, easy-to-understand language. I'll give you the basics up front, and, even if I have to send you deeper into the book for a full discussion of a complex topic, you'll have what you need to use a control right away.
- **Chapter 4:** You can customize how your D3200 displays and shoots images by mastering the tools available in the Playback and Shooting menus. The manual supplied with your camera tells you what each setting does—I'm going to explain why you should *or should not* use every option and setting, with plenty of tips on getting your best shots with each and every control.

■ Chapter 5: You may not use the Setup or Retouch menus every time you venture out with your camera, but learning how to make important settings in this chapter can be one of your keys to successful shooting. You'll also discover how to access your most used options with the Recent Settings menu.

Once you've finished (or skimmed through) these five chapters, you'll be ready for Part II, which explains how to use the most important basic features, such as the D3200's exposure controls and the related tools that put Live View and movie-making tools at your fingertips. Then, you can visit Part III, the advanced tools section, which explains all the dozens of setup options that can be used to modify the capabilities you've learned to use so far, how to choose and use lenses, and introduces the Nikon D3200's built-in flash and external flash capabilities. I'll wind up this book with Part IV, which covers image software, printing, and transfer options and includes some troubleshooting that may help you when good cameras (or memory cards) go bad.

	· ·	
`		

Thinking Outside the Box

With its 24-megapixel resolution, the Nikon D3200 is considerably more camera than any pocket-sized point-and-shoot model. Even so, Nikon has retained the "turn it on and shoot" ease of operation of its predecessor, so you can, with about 60 seconds' worth of instruction, go out and begin taking great pictures.

Try it. Insert a memory card and mount the lens (if you bought the D3200 at a store, they probably did that for you). Charge the battery and insert it into the camera. Remove the lens cap, turn the camera on (the switch is concentric with the shutter release button), and then set the big ol' dial on top to the green AUTO icon. Point the D3200 at something interesting and press the shutter release. Presto! A pretty good picture will pop up on the color LCD on the back of the camera. Wasn't that easy?

But if you purchased this book, you're probably not going to be satisfied with pretty good photos. You want to shoot *incredible* images. The D3200 can do that, too. All you need is this book and some practice. The first step is to familiarize yourself with your camera. The first three chapters of this book will take care of that. Then, as you gain experience and skills, you'll want to learn more about how to improve your exposures, fine-tune the color, or use the essential tools of photography, such as electronic flash and available light. You'll want to learn how to choose and use lenses, too. All that information can be found in the second part of this book. The Nikon D3200 is not only easy to use, it's easy to *learn* to use.

As I've done with my guidebooks for previous Nikon cameras, I'm going to divide my introduction to the Nikon D3200 into several parts. The first part will cover what you absolutely *need* to know just to get started using the camera (you'll find that in this chapter). The second part is a Quick Start that offers a more comprehensive look at what you *should* know about the camera and its controls to use its features effectively (that'll be found in Chapter 2). Finally, you'll learn how to use the D3200's controls in

Chapter 3, and then make key settings using the menu system, so you'll be able to fine-tune and tweak the D3200 to operate exactly the way you want, in Chapters 4 and 5. While you probably should master everything in the first three chapters right away, you can take more time to learn about the settings described in Chapters 4 and 5, because you won't need to use all those options right away. I've included everything about menus and settings in those two chapters so you'll find what you need, when you need it.

Some of you may have owned a Nikon digital SLR before. Perhaps you owned a Nikon D3000, enjoyed using it, and wanted more than the older camera's 10 megapixels and some of the added features the newer D3200 offers, such as full HD movie making. A few of you may even be someone like me, who often uses a more advanced Nikon dSLR, such as the D7000, as a "main" camera, but finds the super-compact D3200 an alluring walk-about camera and backup.

If you fall into any of those categories, you may be able to skim through this chapter quickly and move on to the two that follow. The next few pages are designed to get your camera fired up and ready for shooting as quickly as possible. If you're new to digital SLRs, Nikon dSLRs, or even digital photography, you'll want to read through this introduction more carefully. After all, the Nikon D3200 is not a point-and-shoot camera, although, as I said, you can easily set it up in fully automated Auto mode, or use the semi-automated Program exposure mode and a basic autofocus setting for easy capture of grab shots. But, if you want a little more control over your shooting, you'll need to know more. So I'm going to provide a basic pre-flight checklist that you need to complete before you really spread your wings and take off. You won't find a lot of detail in this chapter. Indeed, I'm going to tell you just what you absolutely *must* understand, accompanied by some interesting tidbits that will help you become acclimated to your D3200. I'll go into more depth and even repeat some of what I explain here in later chapters, so you don't have to memorize everything you see. Just relax, follow a few easy steps, and then go out and begin taking your best shots—ever.

In a Hurry?

Even a quick start like this one may be too much for those eager to begin using their cameras. Fortunately, Nikon has taken care of the most enthusiastic of the enthusiasts among you, with a great new feature called the Guide mode, which can lead you through basic picture taking and reviewing steps, and simple camera setup procedures, with little help from me. If you want to try it out immediately, and then come back to read this chapter, you have three choices:

■ Skim my two-minute introduction, then jump in. The very last section of this chapter has a short discussion explaining the Guide mode. Flip to it, glance through the intro, then grab your camera.

- Jump off the side of the boat now. Rotate the mode dial (located on the top-right surface of the camera, southwest of the shutter release button) to the GUIDE position, and then figure out what to do from the menus and prompts on the screen. Take some photos, then come back to learn more about what you just did!
- Go Live! If you're coming from a point-and-shoot camera and are used to composing and shooting your images using the LCD rather than a dSLR's cool throughthe-lens optical viewfinder, you can jump into Live View by reading the sidebar that's next.

LIVE VIEW CRASH COURSE

- 1. **Press the Live View button.** It's located to the upper right of the LCD on the back of the camera. You can exit Live View at any time by pressing the LV button again.
- 2. Zoom in/out. Check your view by pressing the Zoom In button (located at the lower-left corner next to the color LCD, third button from the bottom). A navigation box appears in the lower right of the LCD with a yellow box representing the portion of the image zoomed. Use the multi selector keys (that pad with the OK button in the center to the right of the LCD) to change the zoomed area within the full frame. Press the Zoom Out button (just below the Zoom In button) to zoom out again.
- 3. **Shoot.** Press the shutter release all the way down to take a still picture, or press the red-accented movie button (on top of the camera, just to the southwest of the shutter release) to start motion picture filming. Stop filming by pressing the movie button again.

First Things First

This section helps get you oriented with all the things that come in the box with your Nikon D3200, including what they do. I'll also describe some optional equipment you might want to have. If you want to get started immediately, skim through this section and jump ahead to "Initial Setup" later in the chapter.

The Nikon D3200 comes in an impressive gold box filled with stuff, booklets, a CD, and lots of paperwork. The most important components are the camera and lens (unlike some other Nikon models, the D3200 is most often sold in a kit with a lens), battery, battery charger, and, if you're the nervous type, the neck strap. You'll also need a Secure Digital memory card, as one is not included. If you purchased your D3200 from a camera shop, as I did, the store personnel probably attached the neck strap for you, ran through some basic operational advice that you've already forgotten, tried to sell you a Secure Digital card, and then, after they'd given you all the help you could absorb, sent you on your way with a handshake.

Perhaps you purchased your D3200 from one of those mass merchandisers that also sell washing machines and vacuum cleaners. In that case, you might have been sent on your way with only the handshake, or, maybe, not even that if you resisted the efforts to sell you an extended warranty. You save a few bucks at the big-box stores, but you don't get the personal service a professional photo retailer provides. It's your choice. There's a third alternative, of course. You might have purchased your camera from a mail order or Internet source, and your D3200 arrived in a big brown (or purple/red) truck. Your only interaction when you took possession of your camera was to scrawl your signature on an electronic clipboard.

In all three cases, the first thing to do is to carefully unpack the camera and double-check the contents with the checklist on one end of the box, helpfully designated under the [This Package Includes] heading. While this level of setup detail may seem as superfluous as the instructions on a bottle of shampoo, checking the contents *first* is always a good idea. No matter who sells a camera, it's common to open boxes, use a particular camera for a demonstration, and then repack the box without replacing all the pieces and parts afterwards. Someone might actually have helpfully checked out your camera on your behalf—and then mispacked the box. It's better to know *now* that something is missing so you can seek redress immediately, rather than discover two months from now that the eyepiece cap you thought you'd never use (but now *must* have) was never in the box. I once purchased a brand-new Nikon dSLR kit that was supposed to include a second focusing screen; it wasn't in the box, but because I discovered the deficiency right away, the dealer ordered a replacement for me post haste.

At a minimum, the box should hold the following:

- Nikon D3200 digital camera/lens. It almost goes without saying that you should check out the camera and its kit lens immediately, making sure the color LCD on the back isn't scratched or cracked, the Secure Digital and battery doors open properly, and, when a charged battery is inserted and lens mounted, the camera powers up and reports for duty. Out-of-the-box defects like these are rare, but they can happen. It's probably more common that your dealer played with the camera or, perhaps, it was a customer return. That's why it's best to buy your D3200 from a retailer you trust to supply a factory-fresh camera.
- Rechargeable Li-ion battery EN-EL14. You'll need to charge this 7.4V, 1030mAh (milliampere hour) battery before using it. I'll offer instructions later in this chapter.
- Quick charger MH-24. This charger is required to vitalize the EN-EL14 battery.
- Neck strap AN-DC3. Nikon provides you with a "steal me" neck strap emblazoned with the Nikon name, and while useful for showing off to your friends exactly which nifty new camera brand you bought, it's not very adjustable. I never attach the Nikon strap to my cameras, and instead opt for a more serviceable strap

Figure 1.1
Third-party
neck straps like
this UPstrap
model, are often
preferable to the
Nikon-supplied
strap.

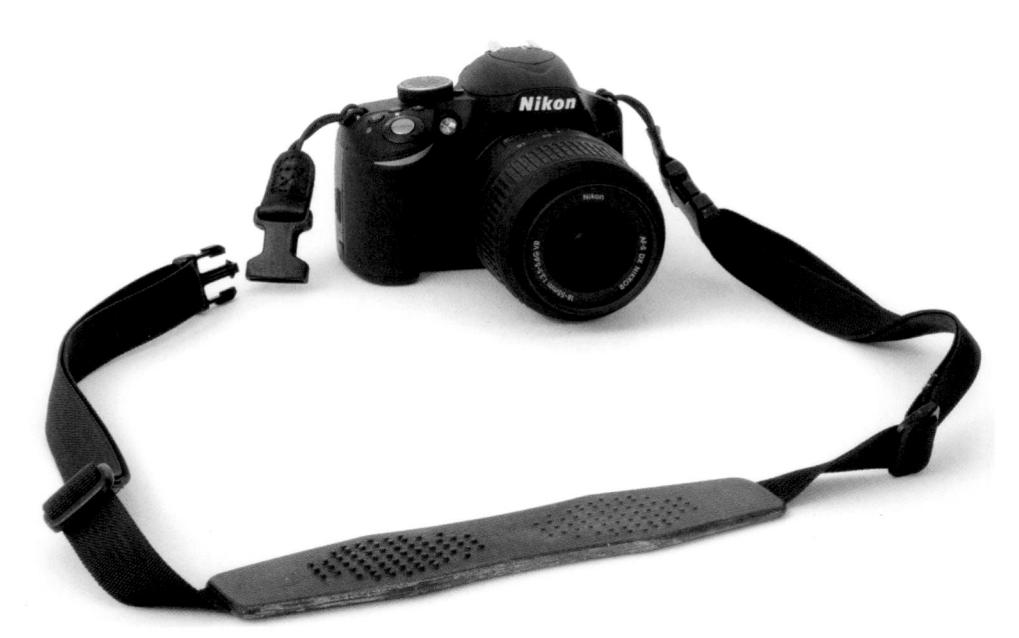

from UPstrap (www.upstrap-pro.com). If you carry your camera over one shoulder, as many do, I particularly recommend UPstrap (shown in Figure 1.1). It has a patented non-slip pad that offers reassuring traction and eliminates the contortions we sometimes go through to keep the camera from slipping off. I know several photographers who refuse to use anything else. If you do purchase an UPstrap, be sure to tell photographer-inventor Al Stegmeyer that I sent you hence.

- Video cable EG-CP14. Use this cable to connect your D3200 to a standard definition (analog) television through the set's yellow RCA video jack when you want to view the camera's output on a larger screen. In a welcome return to normalcy, Nikon is including this video cable with the D3200, after making it an optional accessory with some earlier entry-level cameras.
- USB cable UC-E17. You can use this supplied cable to transfer photos from the camera to your computer (I don't recommend that because direct transfer uses a lot of battery power), and to upload and download settings between the camera and your computer (highly recommended). This cable is a standard one that works with the majority of digital cameras—Nikon and otherwise—so if you have a spare one, you can use it with your D3200, too.
- BF-1B body cap/rear lens cap. The body cap keeps dust from infiltrating your camera when a lens is not mounted. Always carry a body cap (and rear lens cap, also supplied with the D3200) in your camera bag for those times when you need to have the camera bare of optics for more than a minute or two. (That usually

happens when repacking a bag efficiently for transport, or when you are carrying an extra body or two for backup.) The body cap/lens cap nest together for compact storage.

- **DK-20 rubber eyecup.** This is the square rubber eyecup that comes installed on the D3200. It slides on and off the viewfinder.
- **DK-5 eyepiece cap.** This small piece can be clipped over the viewfinder window to prevent strong light sources from entering the viewing system when your eye is not pressed up against it, potentially affecting exposure measurement. That can be a special problem when the camera is mounted on a tripod, because additional illumination from the rear can make its way to the 420-segment CCD that interprets light reaching the focusing screen. I pack this widget away to keep from losing it. As a practical matter, you'll never find it when you really need it, and covering the viewfinder with your hand (hover *near* the viewfinder window rather than touch it, to avoid shaking a tripod-mounted camera) works almost as well.
- **BS-1 accessory shoe cover.** This is a sliding plastic piece that fits into the accessory shoe on top of the camera, and protects its contents from damage. You can remove it (and probably lose it) when you attach an optional external electronic flash to the shoe. I always, without fail, tuck it into the same place each time (in my case, my right front pants pocket), and have yet to lose one.
- User manual/Quick Guide. In a significant departure for Nikon, the only printed "user manual" you receive with the Nikon D3200 is a terse booklet that includes only the basic setup and usage information, and an even smaller quick start guide pamphlet/poster. Many point-and-shoot cameras come with better printed materials. Both are decent for what they do, but they make a book like this one even more necessary.
- CD-ROM Reference Manual. The true "manual" for the D3200 is furnished as a PDF file on a CD-ROM packed in the box. If you have this book, you probably don't need the CD-ROM version of the manual, because I'm providing more complete descriptions of features and options. But, you might want to check the reference manual that Nikon provides, if only to confirm the actual nomenclature for some obscure accessory, or to double-check an error code. You can copy this PDF version to your laptop, netbook, a CD-ROM, or other media in case you want to access this reference when my book isn't handy. If you have an old Secure Digital card that's too small to be usable on a modern dSLR (I still have some 128MB and 256MB cards), you can store the PDF on that. But an even better choice is to put the manual on a low-capacity USB "thumb" drive, which you can buy for less than \$10. You'll then be able to access the reference anywhere you are, because you can always find someone with a computer that has a USB port and Adobe Acrobat Reader available. You might not be lucky enough to locate a computer with a Secure Digital reader.

- **Software CD-ROM.** Here you'll find Nikon ViewNX2 (a useful image management program). I'll cover the Nikon software offerings later in this book.
- Warranty and registration card. Don't lose these! You can register your Nikon D3200 by mail or online (in the USA, the URL is www.nikonusa.com/register) and may need the information in this paperwork (plus the purchase receipt/invoice from your retailer) should you require Nikon service support.

Don't bother rooting around in the box for anything beyond what I've listed previously. There are a few things Nikon classifies as optional accessories, even though you (and I) might consider some of them essential. Here's a list of what you *don't* get in the box, but might want to think about as an impending purchase. I'll list them roughly in the order of importance:

- Secure Digital card. First-time digital camera buyers are sometimes shocked that their new tool doesn't come with a memory card. Why should it? The manufacturer doesn't have the slightest idea of how much storage you require, or whether you want a slow/inexpensive card or one that's faster/more expensive, so why should they pack one in the box and charge you for it? Given the D3200's 24-megapixel resolution, you'll probably want an SD card with at least 8GB of capacity.
- Extra EN-EL14 battery. Even though you might get 500 to more than 1,000 shots from a single battery, it's easy to exceed that figure in a few hours of shooting sports at 4 fps. Batteries can unexpectedly fail, too, or simply lose their charge from sitting around unused for a week or two. Buy an extra (I own four, in total), keep it charged, and free your mind from worry.
- Add-on speedlight. Your built-in flash can function as the main illumination for your photo, or it can be softened and used to fill in shadows. But, you'll have to own one or more external flash units if you want to trigger multiple add-on flash units. If you do much flash photography at all, consider an add-on speedlight, such as the Nikon SB-700, as an important accessory.
- MC-DC2 remote cord or Wireless Remote Control ML-L3. Unlike the previous entry-level Nikon camera, the D3100, the D3200 *does* have an infrared sensor (one on the front and one on the back!) that can be used with the inexpensive Wireless Remote Control ML-L3. However, if you prefer a wired remote, you can opt for the MC-DC2 remote cord, which plugs into the remote/GPS socket on the left side of the camera. If you have neither optional accessory, you can use the D3200's self-timer to minimize vibration when triggering the camera. But when you want to take a photo at the exact moment you desire (and not when the self-timer happens to trip), or need to eliminate all possibility of human-induced camera shake, you need this remote cord. (See Figure 1.2.)

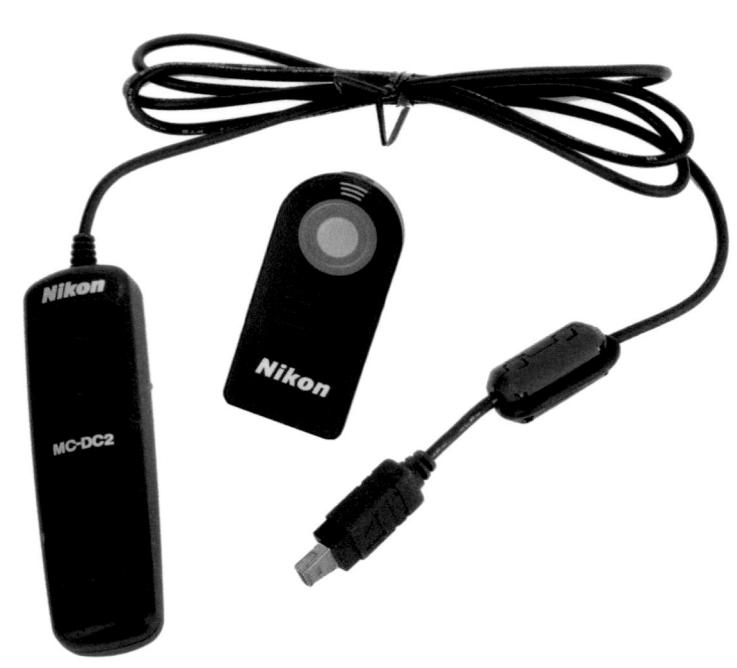

Figure 1.2
The Nikon
MC-DC2
remote cord and
ML-L3 IR
remote let you
trigger your
camera
remotely.

- AC Adapter EH-5b/Power Connector EP-5b. These two optional devices are used together to power the Nikon D3200 independently of the batteries. There are several typical situations where this capability can come in handy: when you're cleaning the sensor manually and want to totally eliminate the possibility that a lack of juice will cause the fragile shutter and mirror to spring to life during the process; when indoors shooting tabletop photos, portraits, class pictures, and so forth for hours on end; when using your D3200 for remote shooting as well as time-lapse photography; for extensive review of images on your television; or for file transfer to your computer. These all use prodigious amounts of power, which can be provided by this AC adapter. (Beware of power outages and blackouts when cleaning your sensor, however!)
- DR-6 right-angle viewer. Used with the Nikon Eyepiece Adapter DK-22, it fastens in place of the standard square rubber eyecup and provides a 90-degree view for framing and composing your image at right angles to the original viewfinder. It's useful for low-level (or high-level) shooting. (Or, maybe, shooting around corners!)
- DG-2 magnifier/Eyepiece Adapter DK-22. These replace the eyepiece to provide magnification of the center of the frame to ease focusing, particularly for close-up photography.
- SC-28 TTL flash cord. Allows using Nikon speedlights off-camera, while retaining all the automated features.

- SC-29 TTL flash cord. Similar to the SC-28, this unit has its own AF-assist lamp, which can provide extra illumination for the D3200's autofocus system in dim light (which, not coincidentally, is when you'll probably be using an electronic flash).
- WU-1a Wireless Mobile Transmitter. This compact, inexpensive (\$59) accessory plugs into the side of your Nikon D3200 and adds the capability of transmitting your pictures to a computer or mobile device (like your smartphone). I'll show you how to use this useful capability in Chapter 9.
- Nikon Capture NX2 software. Nikon's NEF (RAW) conversion and image tweaking software is an extra-cost option that most D3200 owners won't need until they progress into extensive image editing. I'll describe this utility's functions in Chapter 12.

Initial Setup

This section helps you become familiar with the controls most used to make adjustments: the multi selector and the command dial. You'll also find information on charging the battery, setting the clock, mounting a lens, and making diopter vision adjustments. If you're comfortable with all these things, skim through and skip ahead to "Choosing a Release Mode" in the next section.

Once you've unpacked and inspected your camera, the initial setup of your Nikon D3200 is fast and easy. Basically, you just need to charge the battery, attach a lens, and insert a Secure Digital card. I'll address each of these steps separately, but if you already are confident you can manage these setup tasks without further instructions, feel free to skip this section entirely. I realize that some readers are ambitious, if inexperienced, and should, at the minimum, skim the contents of the next section, because I'm going to list a few options that you might not be aware of.

Mastering the Multi Selector

I'll be saving descriptions of most of the controls used with the Nikon D3200 until Chapter 3, which provides a complete "roadmap" of the camera's buttons and dials and switches. However, you may need to perform a few tasks during this initial setup process, and most of them will require the MENU button and the multi selector pad. The MENU button is easy to find: it's located to the left of the LCD, the second button from the top. It requires almost no explanation; when you want to access a menu, press it. To exit most menus, press it again.

The multi selector pad may remind you of the similar control found on many pointand-shoot cameras, and other digital SLRs. It consists of a thumbpad-sized button with raised arrows at the North, South, East, and West positions, plus a button in the center marked "OK." (See Figure 1.3.)

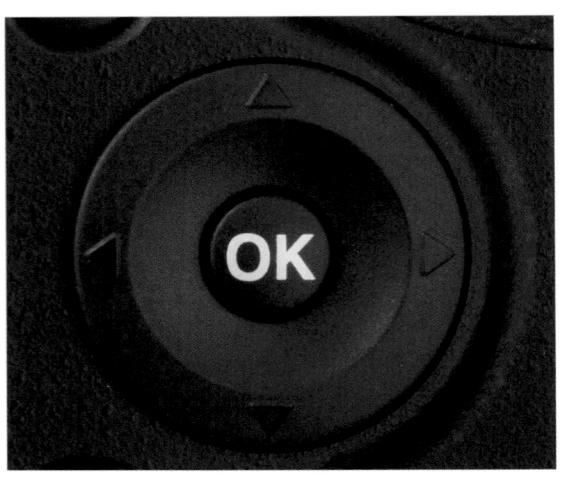

Figure 1.3
The multi selector pad has four directional buttons for navigating up/down/left/right, and an OK button to confirm your selection.

The multi selector on the D3200 functions slightly differently than its counterpart on some other cameras. For example, some point-and-shoot models assign a function, such as white balance or ISO setting, to one of the directional buttons (usually in conjunction with a function key of some sort). The use of the multi selector varies, even within the Nikon dSLR line up.

With the D3200, the multi selector is used exclusively for navigation; for example, to navigate among menus on the LCD or to choose one of the eleven focus points, to advance or reverse display of a series of images during picture review, or to change the kind of photo information displayed on the screen. The OK button is used to confirm your choices, or send the image currently being viewed to the Retouch menu for modification. So, from time to time in this chapter (and throughout this book) I'll be referring to the multi selector and its left/right/up/down buttons, and center OK button.

Setting the Clock

It's likely that your Nikon D3200's internal clock hasn't been set to your local time, so you may need to do that first. (The in-camera clock might have been set for you by someone checking out your camera prior to delivery.) If you do need to set the clock, the flashing CLOCK indicator on the LCD will be the giveaway. You'll find complete instructions for setting the four options for the date/time (time zone, actual date and time, the date format, and whether you want the D3200 to conform to Daylight Savings Time) in Chapter 5. However, if you think you can handle this step without instruction, press the MENU button to the left of the LCD, and then use the multi selector to scroll down to the Setup menu (it's marked with a wrench icon), press the multi selector button to the right, and then press the down button to scroll down to the Time Zone and Date entry, and press the right button again. The options will appear on the screen that appears next. Keep in mind that you'll need to reset your camera's internal
clock from time to time, as it is not 100 percent accurate. (If you use the Nikon GP-1 GPS device, you can tell the camera to use that accessory's satellite information to correct its internal clock.) Of course, your camera will not explode if the internal clock is inaccurate, but your images will have the wrong time stamped on them. You may also need to reset your camera's internal clock if you travel and you want the time stamp on your pictures to reflect the time where the images were shot, and not the time back home.

Battery Included

Your Nikon D3200 is a sophisticated hunk of machinery and electronics, but it needs a charged battery to function, so rejuvenating the EN-EL14 lithium-ion battery pack furnished with the camera should be your first step. A fully charged power source should be good for a minimum of 540 shots, based on standard tests defined by the Camera & Imaging Products Association (CIPA) document DC-002. In the real world, of course, the life of the battery will depend on how often you review the shots you've taken on the LCD screen, how many pictures you take with the built-in flash, and many other factors. You'll want to keep track of how many pictures *you* are able to take in your own typical circumstances, and use that figure as a guideline, instead.

All rechargeable batteries undergo some degree of self-discharge just sitting idle in the camera or in the original packaging. Lithium-ion power packs of this type typically lose a small amount of their charge every day, even when the camera isn't turned on. Li-ion cells lose their power through a chemical reaction that continues when the camera is switched off. It's very likely that the battery purchased with your camera is at least partially pooped out, so you'll want to revive it before going out for some serious shooting.

A BATTERY AND A SPARE

I always recommend purchasing Nikon brand batteries (for about \$40) over less expensive third-party packs, even though the \$30 substitute batteries may offer more capacity at a lower price (some top the 1,030 mAh offered by the Nikon battery). My reasoning is that it doesn't make sense to save \$10 on a component for a sophisticated camera, especially since batteries have been known to fail in potentially harmful ways. You need only look as far as Nikon's own 2012 recall of its EN-EL15 (used in the Nikon D7000, D800, and Nikon V1), which forced the company to ship out thousands of free replacement cells. You're unlikely to get the same support from a third-party battery supplier that sells under a half-dozen or more different brand names, and may not even have an easy way to get the word out that a recall has been issued.

If your pictures are important to you, always have at least one spare battery available, and make sure it is an authentic Nikon product.

Charging the Battery

When the battery is inserted into the MH-24 charger properly (it's impossible to insert it incorrectly), as you can see in Figure 1.4, the contacts on the battery line up and mate with matching contacts inside the charger. When properly connected, an orange charge light begins flashing, and remains flashing until the status lamp glows steadily, indicating that charging is finished. When the battery is charged, slide the latch on the bottom of the camera and ease the battery in, as shown in Figure 1.5.

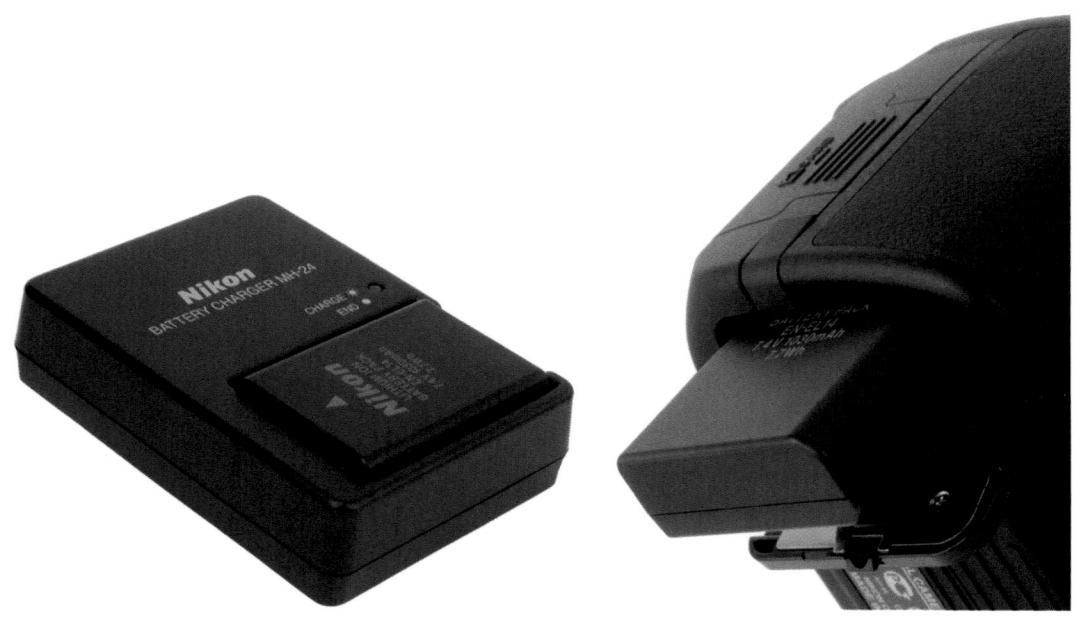

Figure 1.4 When the charger is plugged in, a flashing status light will illuminate while the battery is being charged.

Figure 1.5 Insert the battery in the camera; it only fits one way.

Final Steps

Your Nikon D3200 is almost ready to fire up and shoot. You'll need to select and mount a lens, adjust the viewfinder for your vision, and insert a Secure Digital card. Each of these steps is easy, and if you've used any Nikon before, you already know exactly what to do. I'm going to provide a little extra detail for those of you who are new to the Nikon or SLR worlds.

Mounting the Lens

As you'll see, my recommended lens mounting procedure emphasizes protecting your equipment from accidental damage and minimizing the intrusion of dust. If your D3200 has no lens attached, select the lens you want to use and loosen (but do not remove) the rear lens cap. I generally place the lens I am planning to mount vertically in a slot in my camera bag, where it's protected from mishaps, but ready to pick up quickly. By loosening the rear lens cap, you'll be able to lift it off the back of the lens at the last instant, so the rear element of the lens is covered until then.

After that, remove the body cap by rotating the cap away from the release button. You should always mount the body cap when there is no lens on the camera, because it helps keep dust out of the interior of the camera. (While the D3200's automatic sensor cleaning mechanism works fine, the less dust it has to contend with, the better.) The body cap also protects the camera's innards from damage caused by intruding objects (including your fingers, if you're not cautious).

Once the body cap has been removed, remove the rear lens cap from the lens, set it aside, and then mount the lens on the camera by matching the alignment indicator on the lens barrel with the white dot on the camera's lens mount. (See Figure 1.6.) Rotate the lens toward the shutter release until it seats securely. Some lenses are trickier to mount than others, especially telephoto lenses with special collars for attaching the lens itself to a tripod.

Figure 1.6
Match the indicator on the lens with the white dot on the camera mount to properly align the lens with the bayonet mount.

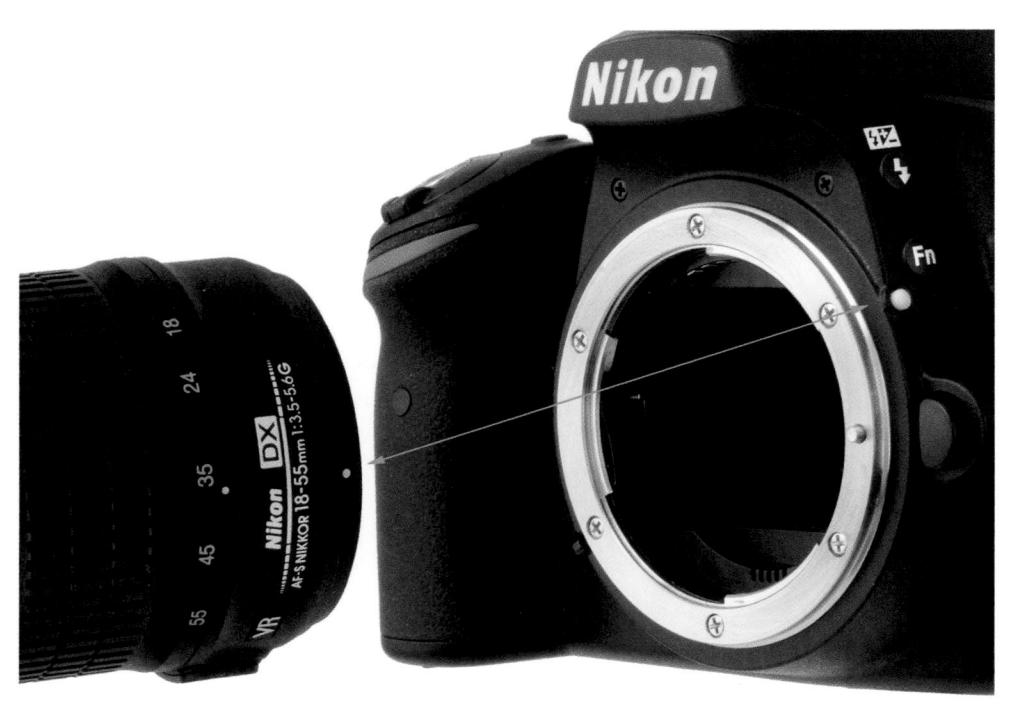

Set the focus mode switch on the lens to AF or M/A (Autofocus). If the lens hood is bayoneted on the lens in the reversed position (which makes the lens/hood combination more compact for transport), twist it off and remount with the "petals" (if present) facing outward. (See Figure 1.7.) A lens hood protects the front of the lens from accidental bumps, and reduces flare caused by extraneous light arriving at the front of the lens from outside the picture area.

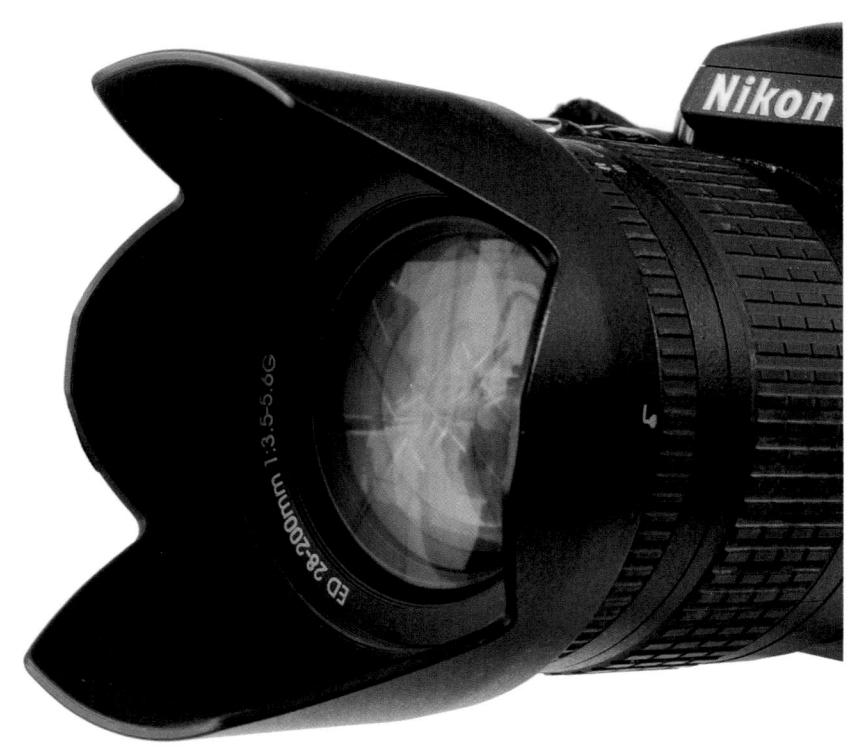

Figure 1.7
A lens hood protects the lens from extraneous light and accidental bumps.

Adjusting Diopter Correction

Those of us with less than perfect eyesight can often benefit from a little optical correction in the viewfinder. Your contact lenses or glasses may provide all the correction you need, but if you are a glasses wearer and want to use the D3200 without your glasses, you can take advantage of the camera's built-in diopter adjustment, which can be varied from -1.7 to +0.5 correction. Press the shutter release halfway to illuminate the indicators in the viewfinder, then rotate the diopter adjustment control next to the viewfinder (see Figure 1.8) while looking through the viewfinder until the indicators appear sharp. Should the available correction be insufficient, Nikon offers nine different DK-20C Diopter-Adjustment Viewfinder Correction lenses for the viewfinder window, ranging from -5 to +3, at a cost of \$15-\$20 each.

Diopter

control

adjustment

Figure 1.8
Viewfinder
diopter correction from –5
to +3 can be
dialed in.

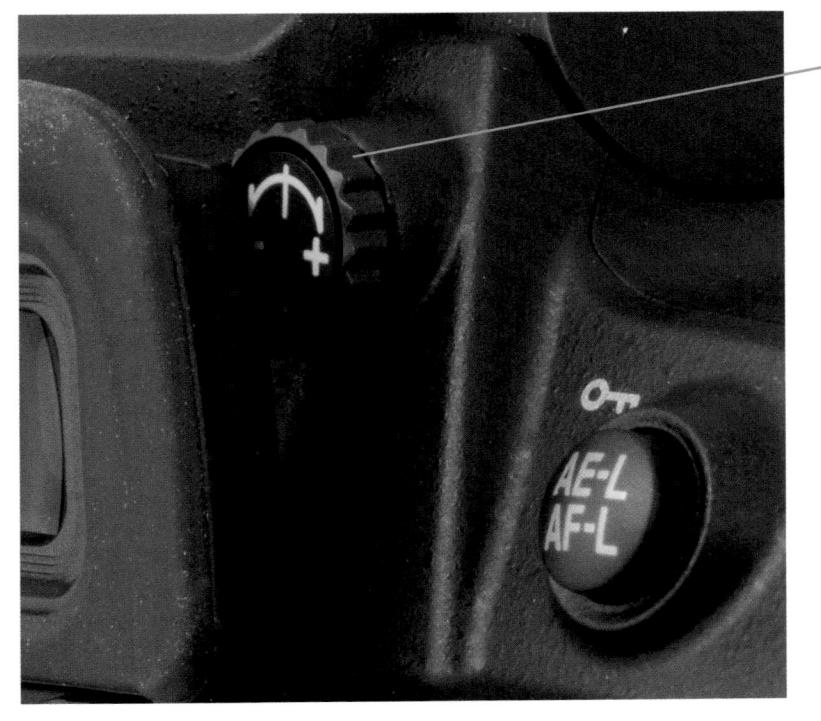

Inserting a Secure Digital Card

You've probably set up your D3200 so you can't take photos without a Secure Digital card inserted. (There is a Slot Empty Release Lock entry in the Setup menu that enables/disables shutter release functions when a memory card is absent—learn about that in Chapter 5.) So, your final step will be to insert a Secure Digital card. Slide the cover on the right side of the camera toward the back, and then open it. (You should only remove the memory card when the camera is switched off, or, at the very least, the yellow-green card access light [just to the northeast of the LCD and "trash can" icon on the back of the camera] that indicates the D3200 is writing to the card is not illuminated.)

Insert the memory card with the label facing the back of the camera oriented so the edge with the gold edge connectors goes into the slot first. Close the door, and, if this is your first use of the card, format it (described next). When you want to remove the memory card later, press the card inwards, and it will pop right out.

Formatting a Memory Card

There are three ways to create a blank Secure Digital card for your D3200, and two of them are at least partially wrong.

Here are your options, both correct and incorrect:

- Transfer (move) files to your computer. When you transfer (rather than copy) all the image files to your computer from the Secure Digital card (either using a direct cable transfer or with a card reader, as described later in this chapter), the old image files are erased from the card, leaving the card blank. Theoretically. Unfortunately, this method does *not* remove files that you've labeled as Protected (by pressing the Protect button to the right of the viewfinder window [it's marked with a key icon] while viewing the image on the LCD), nor does it identify and lock out parts of your SD card that have become corrupted or unusable since the last time you formatted the card. Therefore, I recommend always formatting the card, rather than simply moving the image files, each time you want to make a blank card. The only exception is when you *want* to leave the protected/unerased images on the card for awhile longer, say, to share with friends, family, and colleagues.
- (Don't) Format in your computer. With the SD card inserted in a card reader or card slot in your computer, you can use Windows or Mac OS to reformat the memory card. Don't! The operating system won't necessarily arrange the structure of the card the way the D3200 likes to see it (in computer terms, an incorrect *file system* may be installed). The only way to ensure that the card has been properly formatted for your camera is to perform the format in the camera itself. The only exception to this rule is when you have a seriously corrupted memory card that your camera refuses to format. Sometimes it is possible to revive such a corrupted card by allowing the operating system to reformat it first, then trying again in the camera.
- Setup menu format. To use the recommended methods to format a memory card, press the MENU button, use the up/down buttons of the multi selector (that thumb-pad-sized control to the right of the LCD) to choose the Setup menu (which is represented by that wrench icon), navigate to the Format Memory Card entry with the right button of the multi selector, and select Yes from the screen that appears. Press OK (in the center of the multi selector pad) to begin the format process.

Table 1.1 shows the typical number of shots you can expect using an 8GB SD memory card (which I expect will be a popular size card among D3200 users as prices continue to plummet during the life of this book). All figures are by actual count with my own 8GB SD card. Take those numbers and cut them in half if you're using a 4GB SD card; multiply by 25 percent if you're using a 2GB card, or by 12.5 percent if you're working with a 1GB SD card. (You can use the Shooting menu's Image Quality option to change the file/formats in column 1, and to change the image sizes in columns 2, 3, and, 4, or change either value using the information edit display, described in Chapters 2 and 3.)

HOW MANY SHOTS?

The D3200 provides a fairly accurate estimate of the number of shots remaining on the LCD, as well as at the lower-right edge of the viewfinder display when the display is active. (Tap the shutter release button to activate it.)

It is only an estimate, because the actual number will vary, depending on the capacity of your memory card, the file format(s) you've selected (more on those later), and the content of the image itself. (Some photos may contain large areas that can be more efficiently squeezed down to a smaller size.)

For example, an 8GB card can hold about 524 shots in the format known as JPEG Fine at the D3200's maximum resolution (Large) format; 1,100 shots using the Normal JPEG setting; or 2,000 shots with Basic JPEG setting. When numbers exceed 1,000, the D3200 displays a figure and decimal point, followed by a K superscript, so that 1,900 shots (or thereabouts) is represented by [1.9]^K on the LCD and viewfinder.

Table 1.1 Typical Shots with an 8GB Memory Card						
	Large	Medium	Small			
JPEG Fine	524	878	1700			
JPEG Normal	1100	1500	3300			
JPEG Basic	2000	3300	6500			
RAW	267	N/A	N/A			
RAW+JPEG Fine	176	N/A	N/A			

Nikon D3200 Quick Start

Now it's time to fire up your Nikon D3200 and take some photos. The easy part is turning on the power—the Off-On switch is on the right side, concentric with the shutter release button. Turn on the camera, and, if you mounted a lens and inserted a fresh battery and memory card—as I prompted you in the last chapter—you're ready to begin. You'll need to select a release mode, exposure mode, metering mode, focus mode, and, if need be, elevate the D3200's built-in flash.

But first, you need to learn how to use the screen that allows you to make most of the key adjustments and settings available with the D3200: the information edit display. Some of these choices can also be made using the menu system, as you'll learn in Chapters 4 and 5, but the information edit display is almost always faster.

Using the Information Edit Display

You can use the information edit display to change many of the D3200's basic settings. You shouldn't skip this section, because it provides basic information on how to change settings, including choosing exposure, metering, and autofocus modes.

There are *two* "information" buttons on the D3200, which can lead to confusion among new owners of this camera. The pair is shown in Figure 2.1. At right you can see the Info button; it's sole function is to turn the rear-panel LCD display on (if it's not visible) or off (if it is).

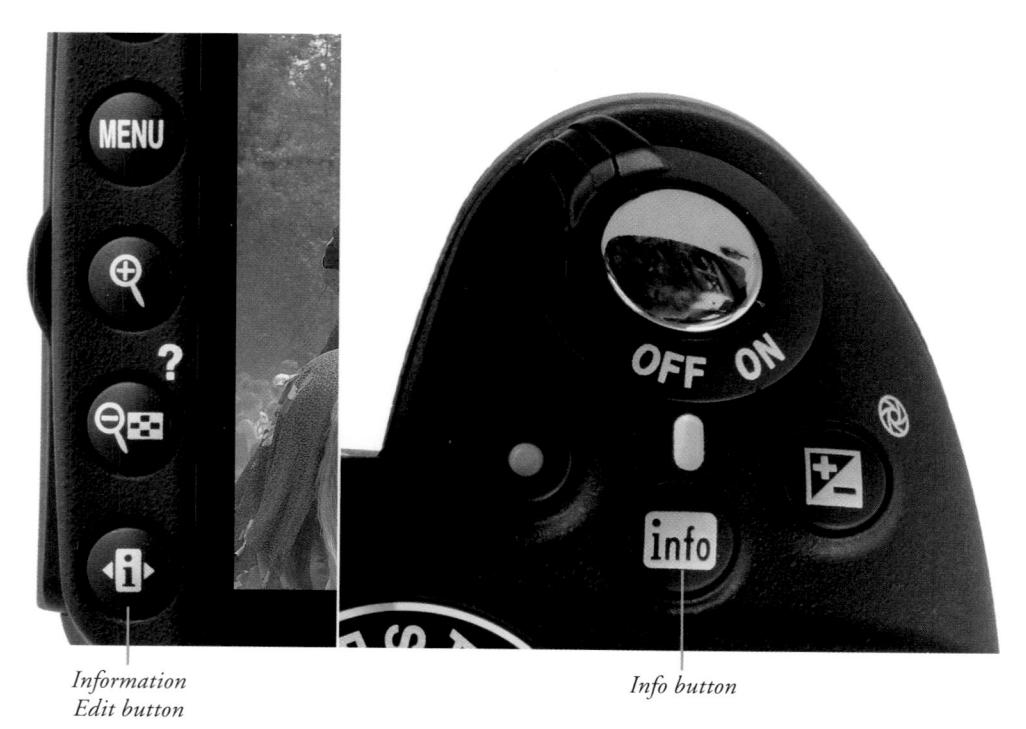

Figure 2.1
Information
Edit button
(left); Info
button (right).

At left in the figure is the Information Edit button, which is located in the lower-left corner of the back of the camera, next to the color LCD. The Information Edit button is pressed once to produce the shooting information display (see Figure 2.2) if it is not visible, and then a second time to activate the information edit display (see Figure 2.3), which is the screen you can use to make many adjustments.

The difference between the two is simple: the Info button just turns the shooting information screen on or off; the Information Edit button does the same thing, but a second press kicks the camera into information edit mode, which allows you to make those changes. Confusion solved!

The shooting information display is a useful status screen. (Shown in the figure is the "Classic" version. A "Graphic" version is also available; in Chapter 5, I'll show you how to select it using the Information Edit Display Format entry in the Setup menu.) For most of the changes described in this chapter, press the Information Edit button again to access the information edit screen, which allows you to modify the most frequently accessed options as I describe.

To change any settings, follow these steps:

1. **Overkill reminder.** If the LCD screen is blank, press the Information Edit button twice (it's the bottom button to the left of the LCD) to access the information edit screen.

Figure 2.2
Press the Information Edit button to view the information screen.

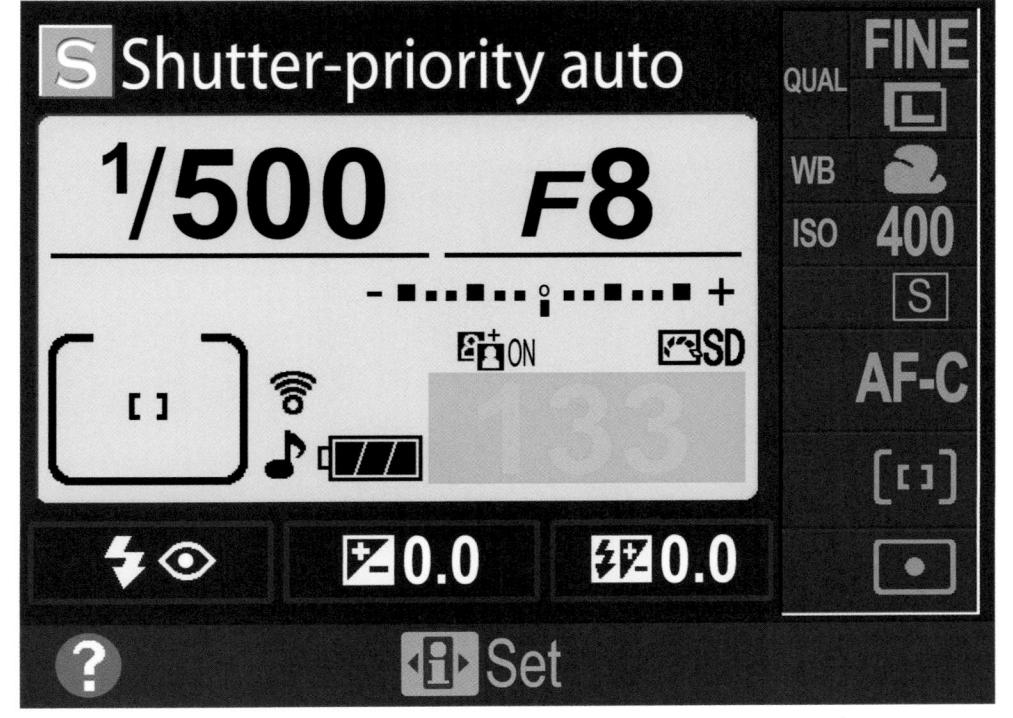

Figure 2.3

Press the Information Edit button a second time to use the information edit screen to modify your options.

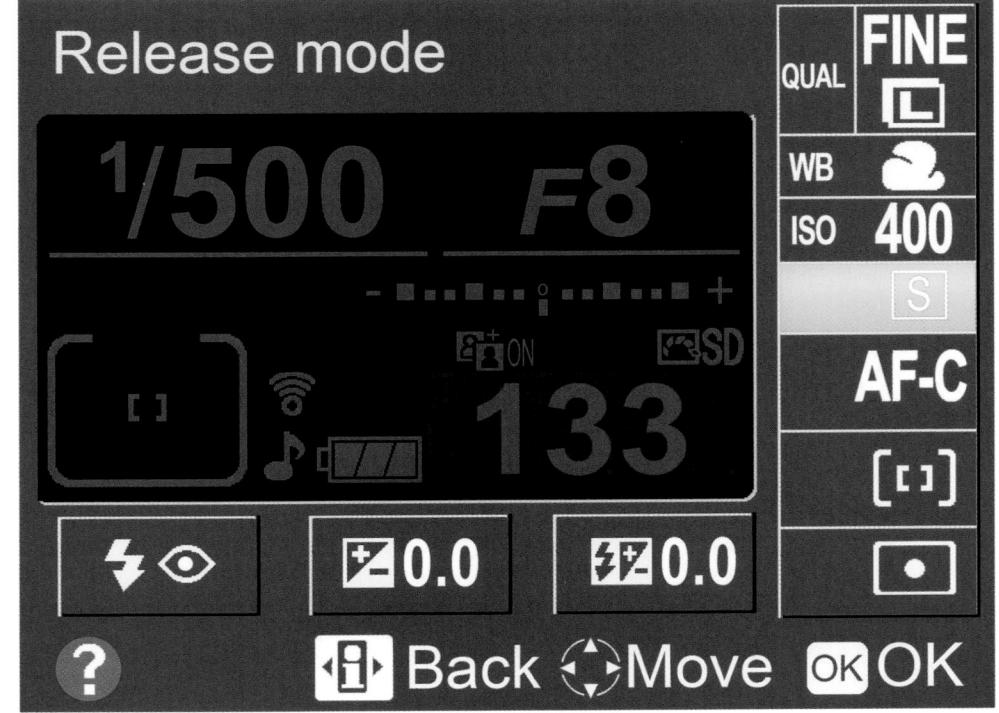

- 2. **Highlight the setting to be changed.** Use the multi selector pad's left/right/up/ down buttons to navigate to the settings at the bottom and side of the screen to the option you want to change.
- 3. Access settings screen. Press the OK button in the center of the multi selector pad to produce a screen where you can change options. These include image size, image quality, ISO, focus modes, and other settings.
- 4. **Select option.** Use the up/down buttons to highlight the desired option within the settings screen.
- 5. **Confirm.** Press the OK button to confirm your choice.
- 6. Exit. Press the Information Edit button to exit the screen.

Choosing a Release Mode

This section shows you how to choose from single-frame, continuous mode, self-timer mode, and remote control modes.

This shooting mode determines when (and how often) the D3200 makes an exposure. If you're coming to the dSLR world from a point-and-shoot camera, you might have used a model that labels these options as drive modes, dating back to the film era when cameras could be set for single-shot or "motor drive" (continuous) shooting modes. Your D3200 has six release (shooting/drive) modes: Single frame, Continuous (Burst), Self-timer, 2-Second Delayed Remote, Quick Response Remote, and Quiet Shutter Release. Set any of these using the information edit screen.

There are two ways to access the release mode screen, shown in Figure 2.4. You can press the Release Mode button, located on the back of the camera, just southwest of the multi selector pad. Or, you can use the information edit screen, as described previously. If you go that route, select Release mode (it's the fifth icon down from the top of the right-hand column, as seen in Figure 2.3), press OK, and then scroll down to select the exact release mode you want. A thumbnail appears at left, as shown in Figure 2.4, to provide a hint about what that release mode is used for. Press the Information Edit button to back out of the screen, or the OK button to confirm your highlighted choice and exit.

- **Single frame.** In this mode, a picture is taken each time the shutter release is pressed down all the way.
- Continuous. The camera records images at roughly a 4-frames-per-second rate as long as the shutter button is held down, or until an area of memory in the camera called a *buffer* fills, and the D3200 stops shooting until enough pictures are written to the memory card to allow more to be captured. Continuous shooting is useful

for grabbing action shots of sports, or for capturing fleeting expressions (especially of children). Since the D3200 has a 24MP sensor and its predecessor had just a 14MP sensor and a 3 fps continuous rate, this ability to capture larger images at a faster rate is quite impressive. Thanks, Nikon!

■ Self-timer. In this mode, press the shutter release down all the way, and the camera takes a picture 10 seconds later. You can also specify 2-, 5-, 10-, and 20-second delays in the Setup menu's Self-timer entry, as well as tell the camera to fire off from 1 to 9 shots when the timer has elapsed. (Chapter 5 will show you how to do this.) Multiple shots are a good way to thwart those accidental (or intentional) blinkers or yawners who might otherwise spoil a family portrait.

The self-timer is a good way to get into the picture yourself, or to allow the vibration induced in a tripod-mounted camera to settle down after you've "punched" the shutter release. A white lamp on the front of the camera will blink while the timer counts down, then remain on continuously for about two seconds just before the picture is taken. Any time you use the camera on a tripod (with the self-timer or otherwise) make sure there is no bright light shining on the viewfinder window; if so, cover it or replace the rubber eyecup with the DK-5 eyepiece cap and block the window.

Figure 2.4
Select a release mode from this scrolling screen of options.

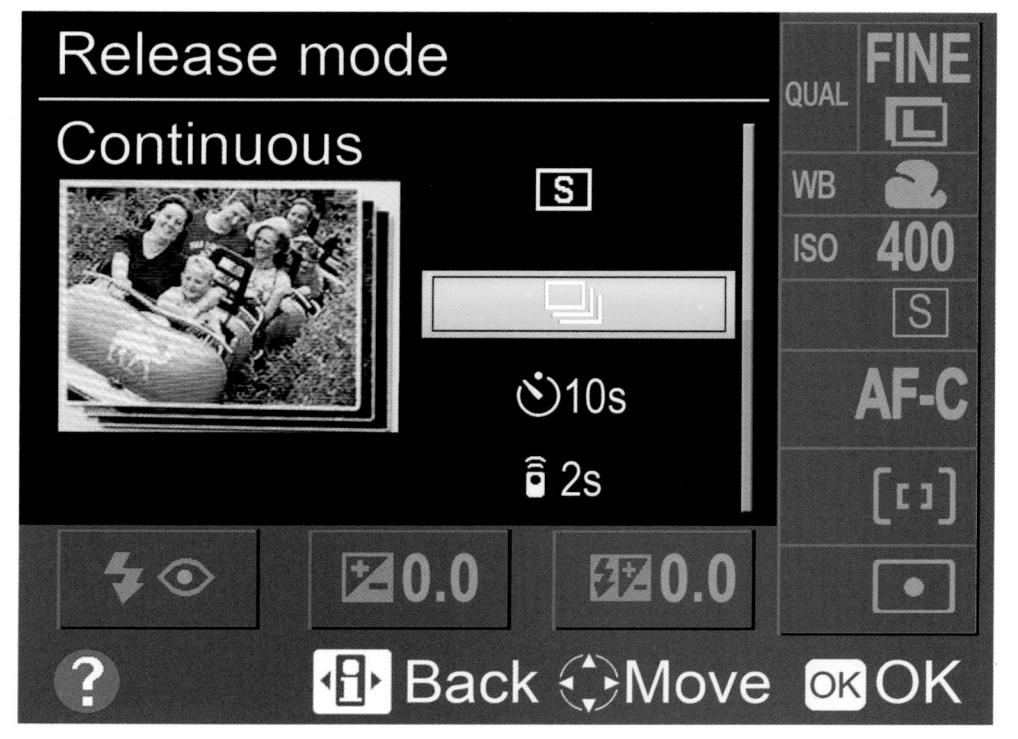

Note

If you plan to dash in front of the camera to join the scene, consider using manual focus so the D3200 won't refocus on your fleeing form and produce unintended results. (Nikon really needs to offer an option to autofocus at the *end* of the self-timer cycle.)

- Quiet Shutter Release. Think of this as a "quieter" shooting mode rather than a true "quiet" mode. In this mode, the camera takes a single picture when the shutter button is pressed all the way down, just as in Single frame mode. However, the camera's internal beeper won't chirp when autofocus is achieved, and after the shutter trips, capturing the image, the camera's viewing mirror doesn't flip back down until you release the shutter button. So, taking a picture in Quiet Shutter Release mode results in a single "clunk" sound as the mirror flips up and the shutter opens/ closes, eventually followed by a second "clunk" when you release pressure on the shutter button. Theoretically, that's quieter than the "beep-clunk-clunk" heard in Single frame mode.
- Delayed Remote/Quick Response Remote. No special setting of the release mode is necessary when you plug in the wired MC-DC2 remote into the side of the camera. However, if you want to use the ML-L3 infrared remote, you'll need to change the release mode to either of these two settings: 2s Delayed Remote (shutter releases two seconds after you press the button on the ML-L3 IR remote) or Quick Response Remote (the shutter trips immediately when the button is pressed). Once you've selected either of these two release modes, the camera then "looks" for the remote signal for a period of time you specify using the Remote On Duration setting in the Setup menu, where you can choose from 1, 5, 10, or 15 minutes. As with the self-timer, make sure there is no bright light shining on the viewfinder window; if so, cover it or locate that DK-5 eyepiece cap and block the window.

Selecting a Shooting Mode

This section shows you how to choose an exposure mode. If you'd rather have the D3200 make all of the decisions for you, just rotate the mode dial to the green Auto setting and jump to the section titled "Reviewing the Pictures You've Taken." If you'd rather choose one of the Scene modes, tailored to specific types of shooting situations, or try out the camera's semi-automatic modes, continue reading this section.

The Nikon D3200 has two types of shooting modes, advanced modes/exposure modes, and a second set, which Nikon labels Scene modes. The advanced modes include Programmed-auto (or Program mode), Aperture-priority auto, Shutter-priority auto, and Manual exposure mode. These are the modes you'll use most often after you've learned all your D3200's features, because they allow you to specify how the camera chooses its settings when making an exposure, for greater creative control.

The Scene modes take full control of the camera, make all the decisions for you, and don't allow you to override the D3200's settings. They are most useful while you're learning to use the camera, because you can select an appropriate mode (Auto, Auto/No Flash, Portrait, Landscape, Child, Sports, Close-up, or Night Portrait) and fire away. You'll end up with decent photos using appropriate settings, but your opportunities to use a little creativity (say, to overexpose an image to create a silhouette, or to deliberately use a slow shutter speed to add a little blur to an action shot) are minimal. The D3200 also has a Guide mode, with three simplified menus, Shoot, View/Delete, and Setup, that provides fast access only to the most frequently used settings. I'll explain Guide mode later in this chapter, after you've had an introduction to the three types of options that are available in its menus.

Choosing a Scene Mode

The eight Scene modes can be selected by rotating the mode dial on the top right of the Nikon D3200 to the appropriate icon (shown in Figure 2.5):

- Auto. In this mode, the D3200 makes all the exposure decisions for you, and will pop up the internal flash if necessary under low-light conditions. The camera automatically focuses on the subject closest to the camera (unless you've set the lens to manual focus), and the autofocus assist illuminator lamp on the front of the camera will light up to help the camera focus in low-light conditions.
- Auto (Flash Off). Identical to Auto mode, except that the flash will not pop up under any circumstances. You'd want to use this in a museum, during religious ceremonies, concerts, or any environment where flash is forbidden or distracting.
- **Portrait.** Use this mode when you're taking a portrait of a subject standing relatively close to the camera and want to de-emphasize the background, maximize sharpness, and produce flattering skin tones. The built-in flash will pop up if needed.
- Landscape. Select this mode when you want extra sharpness and rich colors of distant scenes. The built-in flash and AF-assist illuminator are disabled.
- Child. Use this mode to accentuate the vivid colors often found in children's clothing, and to render skin tones with a soft, natural-looking texture. The D3200 focuses on the closest subject to the camera. The built-in flash will pop up if needed.

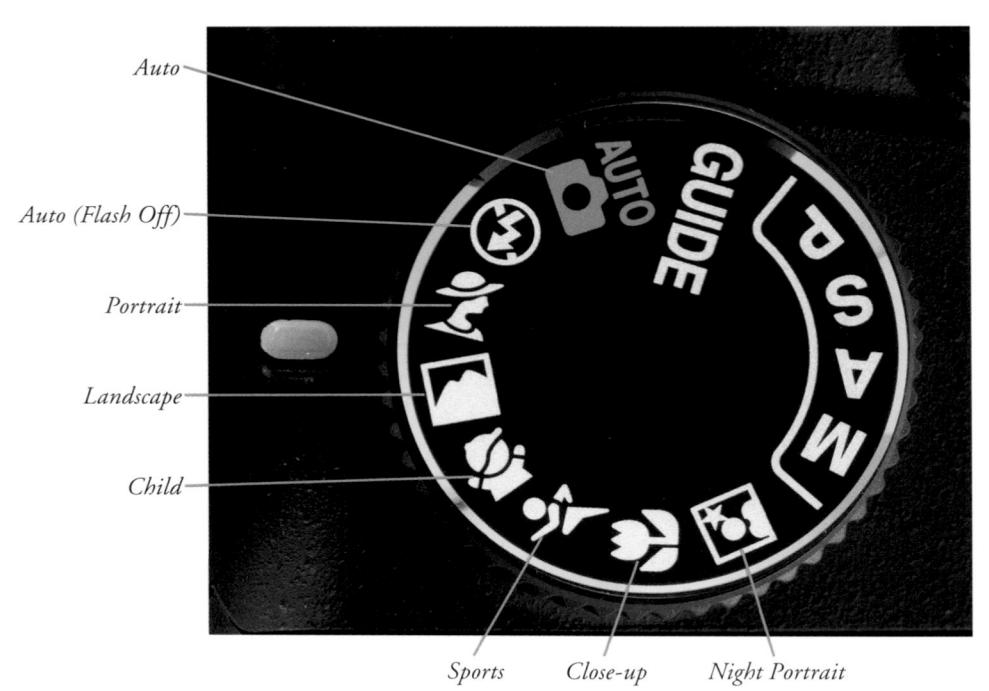

Figure 2.5
Rotate the mode dial to select an automated "Scene" mode.

- **Sports.** Use this mode to freeze fast-moving subjects. The D3200 selects a fast shutter speed to stop action, and focuses continuously on the center focus point while you have the shutter release button pressed halfway. However, you can select one of the other two focus points to the left or right of the center by pressing the multi selector left/right buttons. The built-in electronic flash and focus assist illuminator lamp are disabled.
- Close-up. This mode is helpful when you are shooting close-up pictures of a subject from about one foot away or less, such as flowers, bugs, and small items. The D3200 focuses on the closest subject in the center of the frame, but you can use the multi selector right and left buttons to focus on a different point. Use a tripod in this mode, as exposures may be long enough to cause blurring from camera movement. The built-in flash will pop up if needed.
- Night Portrait. Choose this mode when you want to illuminate a subject in the foreground with flash (it will pop up automatically, if needed), but still allow the background to be exposed properly by the available light. The camera focuses on the closest main subject. Be prepared to use a tripod or a vibration-resistant lens like the 18-55 VR kit lens to reduce the effects of camera shake. (You'll find more about VR and camera shake in Chapter 10.)

Choosing an Advanced Mode

If you're very new to digital photography, you might want to set the camera to P (Program mode) and start snapping away. That mode will make all the appropriate settings for you for many shooting situations. If you have more photographic experience, you might want to opt for one of the semi-automatic modes, or even Manual mode. These advanced modes all let you apply a little more creativity to your camera's settings. Figure 2.6 shows the position of the modes described next.

- M (Manual). Select when you want full control over the shutter speed and lens opening, either for creative effects or because you are using a studio flash or other flash unit not compatible with the D3200's automatic flash metering.
- A (Aperture-priority). Choose when you want to use a particular lens opening, especially to control sharpness or how much of your image is in focus. Specify the f/stop you want, and the D3200 will select the appropriate shutter speed for you.
- S (Shutter-priority). This mode is useful when you want to use a particular shutter speed to stop action or produce creative blur effects. Choose your preferred shutter speed, and the D3200 will select the appropriate f/stop for you.
- P (Program). This mode allows the D3200 to select the basic exposure settings, but you can still override the camera's choices to fine-tune your image, while maintaining metered exposure, as I'll describe in Chapter 6.

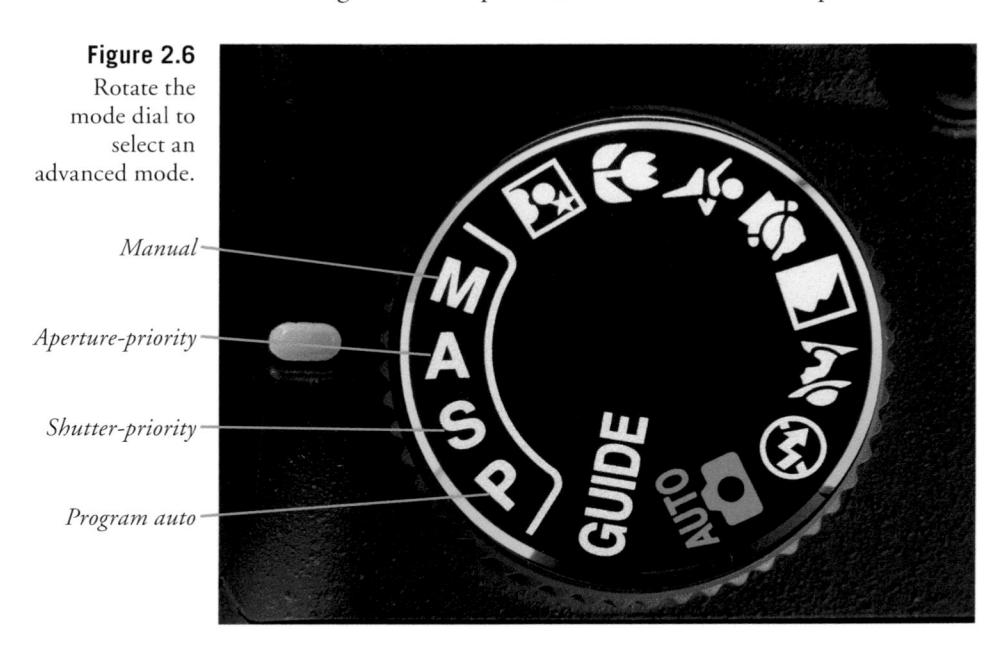

Choosing a Metering Mode

This section shows you how to choose the area the D3200 will use to measure exposure, giving emphasis to the center of the frame; evaluating many different areas of the frame; or measuring light from a small spot in the center of the frame.

The metering mode you select determines how the D3200 calculates exposure. You might want to select a particular metering mode for your first shots, although the default Matrix metering is probably the best choice as you get to know your camera. (It is used automatically in any of the D3200's Scene modes.) I'll explain when and how to use each of the three metering modes later. To change metering modes, use the information edit screen. (You can also specify metering mode using the Shooting menu, as I'll describe in Chapter 4.)

- 1. Access information edit screen. Press the Information Edit button twice and navigate to the metering selection (it's at the bottom of the right-hand column) using the multi selector buttons.
- 2. **View options.** Press OK to select the option.
- 3. **Select metering mode.** Use the multi selector up/down buttons to choose Matrix, Center-weighted, or Spot metering (described below and represented by the icons shown in Figure 2.7).
- 4. Confirm setting. Press OK to confirm your choice.
- 5. **Exit.** Press the Information Edit button to exit, or just tap the shutter release button.
- Matrix metering. The standard metering mode; the D3200 attempts to intelligently classify your image and choose the best exposure based on readings from a 420-segment color CCD sensor that interprets light reaching the viewfinder using a database of hundreds of thousands of patterns.
- Center-weighted metering. The D3200 meters the entire scene, but gives the most emphasis to the central area of the frame, measuring about 8mm.
- **Spot metering.** Exposure is calculated from a smaller 3.5 mm central spot, about 2.5 percent of the image area.

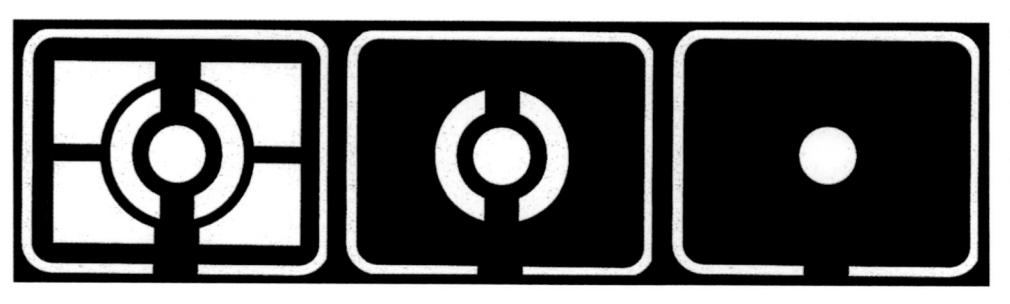

Figure 2.7 Metering mode icons are (left to right): Matrix, Centerweighted, Spot.

You'll find a detailed description of each of these modes in Chapter 6.

Choosing Focus Modes

This section shows how to select *when* the D3200 calculates focus: all the time (continuously), only once when you press a control like the shutter release button (single autofocus), or manually when you rotate a focus ring on the lens.

The Nikon D3200 can focus your pictures for you, or allow you to manually focus the image using the focus ring on the lens (I'll help you locate this ring in Chapter 3). Switching between automatic and manual focus is easy. You can move the AF/MF (autofocus/manual focus) or M/A-M (manual fine-tune autofocus/manual) switch on the lens mounted on your camera.

When using autofocus, you have additional choices. The D3200 has eleven autofocus zones that can be used to zero in on a particular subject area in your image. (See Figure 2.8.) In addition, you can select *when* the D3200 applies its focusing information to your image prior to exposure. I'll describe both in the next two sections.

Figure 2.8
The D3200
can select
which of eleven
focus zones to
use, or allow
you to make the
choice, depending on the autofocus area mode
you specify.

Choosing Autofocus-Area Mode

You can set the AF-area mode using the information edit screen.

- Press the Information Edit button twice and navigate to the AF-area mode selection (it's seventh from the top of the right-hand column) using the multi selector buttons.
- 2. Press OK to select the option.
- 3. Use the multi selector up/down buttons to choose Single-point AF, Dynamic-area AF, 3D-tracking (11 points), or Auto-area AF (described below).
- 4. Press OK to confirm your choice.
- 5. Press the Information Edit button to exit, or just tap the shutter release button.

The four modes, described in more detail in Chapter 7, are as follows:

- Single-point. You always choose which of the eleven points are used, and the Nikon D3200 sticks with that focus bracket, no matter what. This mode is best for non-moving subjects.
- Dynamic-area. You can choose which of the eleven focus zones to use, but the D3200 will switch to another focus mode when using AF-C or AF-A mode (described next) and the subject moves. This mode is great for sports or active children.
- **3D-tracking (11 points).** You can select the focus zone, but when not using AF-S mode, the camera refocuses on the subject if you reframe the image.
- Auto-area. This default mode chooses the focus point for you, and can use distance information when working with a lens that has a G or D suffix in its name. (See Chapter 10 for more on the difference between G/D lenses and other kinds of lenses.)

Choosing Focus Mode

When you are using Program, Aperture-priority, Shutter-priority, or Manual exposure mode, you can select the autofocus mode *when* the D3200 measures and locks in focus prior to pressing the shutter release down all the way and taking the picture. The focus mode is chosen using the information edit screen.

- 1. Press the Information Edit button twice and navigate to the focus mode selection (it's sixth from the top of the right-hand column) using the multi selector buttons.
- 2. Press OK to select the option.
- 3. Use the multi selector up/down buttons to choose AF-A, AF-C, AF-S, or M (described next).

- 4. Press OK to confirm your choice.
- 5. Press the Information Edit button to exit, or just tap the shutter release button.

The four focus modes when not using Live View are as follows (there are additional autofocus modes, including Face Priority, available when shooting in Live View mode):

- Auto-servo AF (AF-A). This default setting switches between AF-C and AF-S, as described below.
- Single-servo AF (AF-S). This mode, sometimes called *single autofocus*, locks in a focus point when the shutter button is pressed down halfway, and the focus confirmation light glows at bottom left in the viewfinder. The focus will remain locked until you release the button or take the picture. This mode is best when your subject is relatively motionless.
- Continuous-servo AF (AF-C). This mode, sometimes called *continuous autofocus*, sets focus when you partially depress the shutter button (or other autofocus activation button), but continues to monitor the frame and refocuses if the camera or subject is moved. This is a useful mode for photographing sports and moving subjects.
- Manual focus (M). When focus is set to manual, you always focus manually using the focus ring on the lens. The focus confirmation indicator in the viewfinder provides an indicator when correct focus is achieved.

Note

Note that the autofocus/manual focus switch on the lens and the setting made here in the camera body must agree; if either is set to manual focus, then the D3200 defaults to manual focus regardless of how the other is set.

Adjusting White Balance and ISO

This section describes some optional features you can select if you feel you need to choose the white balance or change the camera's sensitivity setting.

There are a few other settings you can make if you're feeling ambitious, but don't feel ashamed if you postpone using these features until you've racked up a little more experience with your D3200.

If you like, you can custom-tailor your white balance (color balance) and ISO (sensitivity) settings. I'll explain more about what these settings are, and why you might want to change them, in Chapter 4. To start out, it's best to set white balance (WB) to Auto, and ISO to ISO 200 for daylight photos, and ISO 400 for pictures in dimmer light.

(Don't be afraid of ISO 1600, however; the D3200 does a *much* better job of producing low-noise photos at higher ISOs than many other cameras.) You'll find complete recommendations for both these settings in Chapter 4. You can adjust either one now using the information edit screen, as described multiple times in this chapter. I won't repeat the instructions again. The WB (for white balance) and ISO settings are third and fourth from the top of the right-hand column in the information edit screen (respectively).

Reviewing the Images You've Taken

Here you'll discover how to review the images you've taken in a basic way. I'll provide more detailed options for image review in Chapter 4.

The Nikon D3200 has a broad range of playback and image review options, and I'll cover them in more detail in Chapter 4. For now, you'll want to learn just the basics. Here is all you really need to know at this time, as shown in Figure 2.9:

- **Display an image.** Press the Playback button (marked with a white right-pointing triangle) at the upper-left corner of the back of the camera to display the most recent image on the LCD.
- Scroll among images. Spin the command dial left or right to review additional images. You can also use the multi selector left/right buttons. Press right to advance to the next image, or left to go back to a previous image.
- Change image information display. Press the multi selector button up or down to change among overlays of basic image information or detailed shooting information.
- Magnify/reduce image on screen. Press the Zoom In button repeatedly to zoom in on the image displayed; the Zoom Out button reduces the image. A thumbnail representation of the whole image appears in the lower-right corner with a yellow rectangle showing the relative level of zoom. At intermediate zoom positions, the yellow rectangle can be moved around within the frame using the multi selector.
- Protect images. Press the Protect button to mark an image and shield it from accidental erasure (but not from reformatting of the memory card).
- **Delete current image.** Press the Trash button twice to remove the photo currently being displayed.
- Exit playback. Press the Playback button again, or just tap the shutter release button to exit playback view.

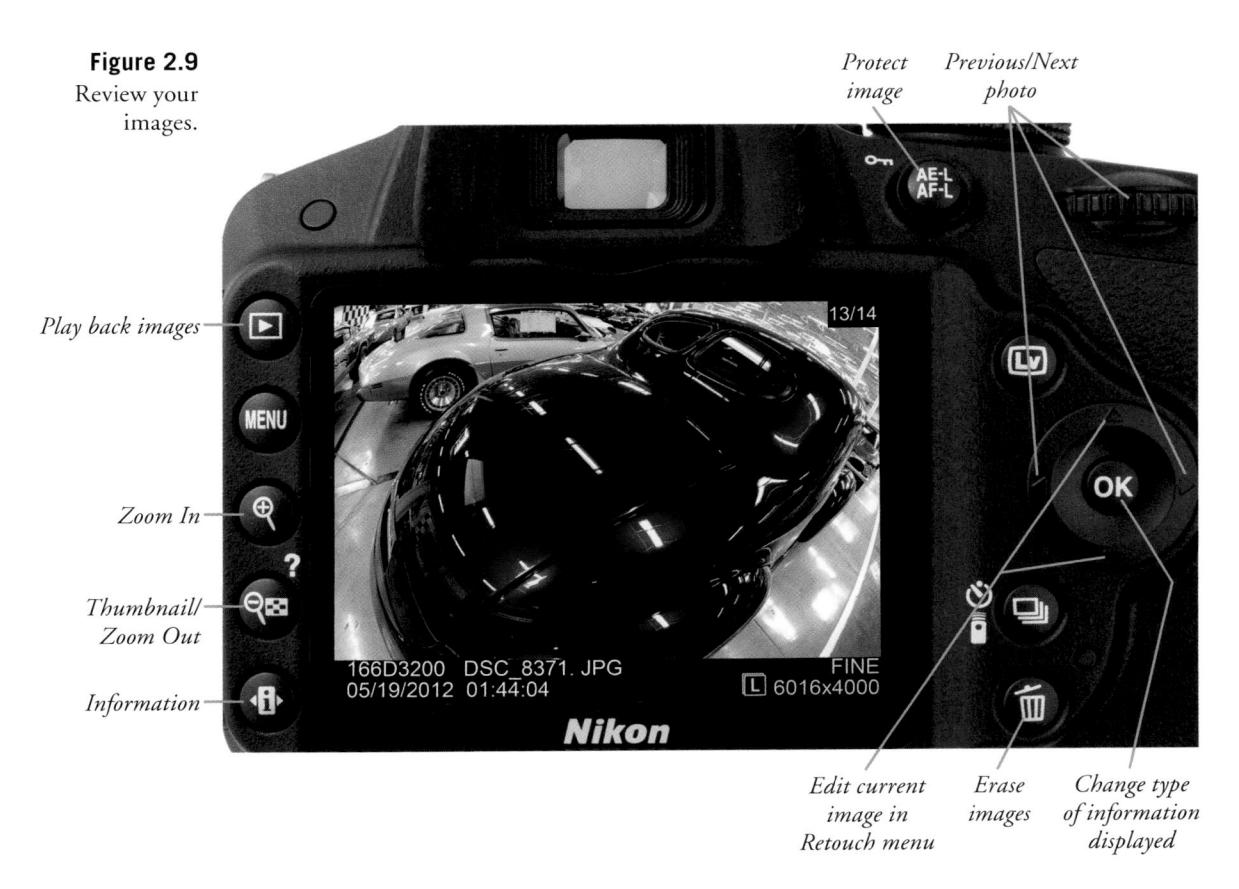

You'll find information on viewing thumbnail indexes of images, automated playback, and other options in Chapter 4.

Using the Built-in Flash

This section provides a quick introduction to your camera's built-in flash. You'll find more information on flash photography in Chapter 11.

Working with the D3200's built-in flash (as well as external flash units like the Nikon SB-400) deserves a chapter of its own, and I'm providing one (see Chapter 11). But the built-in flash is easy enough to work with that you can begin using it right away, either to provide the main lighting of a scene or as supplementary illumination to fill in the shadows.

The built-in flash will pop up automatically as required in Auto, Portrait, Child, Close-up, and Night Portrait Scene modes. To use the built-in flash in Manual, Aperture-priority, Shutter-priority, or Program modes, just press the flash pop-up

Figure 2.10
The pop-up electronic flash can be used as the main light source or for supplemental illumination.

button (shown in Figure 2.10). When the flash is fully charged, a lightning bolt symbol will appear at the right side of the viewfinder display. When using P (Program) and A (Aperture-priority) exposure modes, the D3200 will select a shutter speed for you automatically from the range of 1/250th to 1/60th seconds. In S (Shutter-priority) and M (Manual) modes, you select the shutter speed from 1/250th to 30 seconds.

Transferring Photos to Your Computer

When you're ready to transfer your photos to your computer, you'll find everything you need to know in this section.

The final step in your picture-taking session will be to transfer the photos you've taken to your computer for printing, further review, or image editing. Your D3200 allows you to print directly to PictBridge-compatible printers and to create print orders right in the camera, plus you can select which images to transfer to your computer. I'll outline those options in Chapter 4.

I always recommend using a card reader attached to your computer to transfer files, because that process is generally a lot faster and doesn't drain the D3200's battery. However, you can also use a cable for direct transfer (an extra-cost option because Nikon no longer includes a USB cable in the box), which may be your only option when you have the cable and a computer, but no card reader (perhaps you're using the computer of a friend or colleague, or at an Internet café).

To transfer images from the camera to a Mac or PC computer using the USB cable:

- 1. Turn off the camera.
- 2. Pry back the cover that protects the D3200's USB port, and plug the USB cable furnished with the camera into the USB port. (See Figure 2.11.)
- 3. Connect the other end of the USB cable to a USB port on your computer.
- 4. Turn on the camera. The operating system itself, or installed software such as Nikon Transfer or Adobe Photoshop Elements Transfer usually detects the camera and offers to copy or move the pictures. Or, the camera appears on your desktop as a mass storage device, enabling you to drag and drop the files to your computer.

To transfer images from a Secure Digital card to the computer using a card reader, as shown in Figure 2.12, do the following:

- 1. Turn off the camera.
- 2. Slide open the memory card door and remove the SD card.
- 3. Insert the Secure Digital card into your memory card reader. Your installed soft-ware detects the files on the card and offers to transfer them. The card can also appear as a mass storage device on your desktop, which you can open and then drag and drop the files to your computer.

Figure 2.11 Images can be transferred to your computer using a USB cable.

Figure 2.12 A card reader is the fastest way to transfer photos.

Using the Guide Mode

Here's the Guide mode overview.

The Nikon D3200 is one of the few Nikon digital SLRs to have a clever "mode" installed right on the mode dial in the form of the Guide mode, shown in Figure 2.13. This mode gives you fast access to some of the most-used commands, through an easy to navigate series of screens that lead you right through accessing the functions you need to shoot, view, or delete your photos, or set up the D3200 camera.

The Guide mode doesn't really need much in the way of instructions—once you rotate the mode dial to the GUIDE position you can easily figure out what you want to do by following through the menus and prompts. But that's the whole idea—the Guide mode is designed for absolute newbies to the Nikon D3200, who want to do simple tasks without the need to read even the abbreviated instructions provided in the manual. Of course, I'm going to provide instructions for using this menu, anyway, because the mere thought of going out and taking pictures with nothing but training wheels for support is frightening for some who've purchased the D3200 camera as their first digital camera or digital SLR.

Guiding Light

Rotate the mode dial to GUIDE and the LCD lights up with the screen, as shown in Figure 2.13. If it is not visible, press the MENU button located to the left of the LCD to make it appear. You can choose guides for shooting, viewing/deleting images, and setting up your camera. Use the left/right buttons on the multi selector pad to highlight Shoot, View/Delete, or Set up, and then press the OK button in the center of the pad.

Shoot Options

If you choose Shoot, you'll see a simple menu like the one shown in Figure 2.14. There are only two options. You can use the up/down buttons to highlight one, then press the multi selector right button to view that menu:

■ Easy operation. This lists functions like Auto, No Flash, Distant Subjects, Closeups, Moving subjects, Landscapes, Portraits, and Night Portraits. (If you haven't jumped directly to this section from the beginning of the chapter, you might recognize that these options correspond to the Scene modes that are also built into the mode dial.) The first page of the Easy Operation choices are shown in Figure 2.15. You can scroll with the multi selector's up/down buttons to view them all. Select one by highlighting it and pressing the right multi selector button, and you'll see a screen of instruction, and the choice of starting shooting, or viewing additional settings you might want to change.

Figure 2.13

Rotate the mode dial to GUIDE to use the ultra-easy Guide mode.

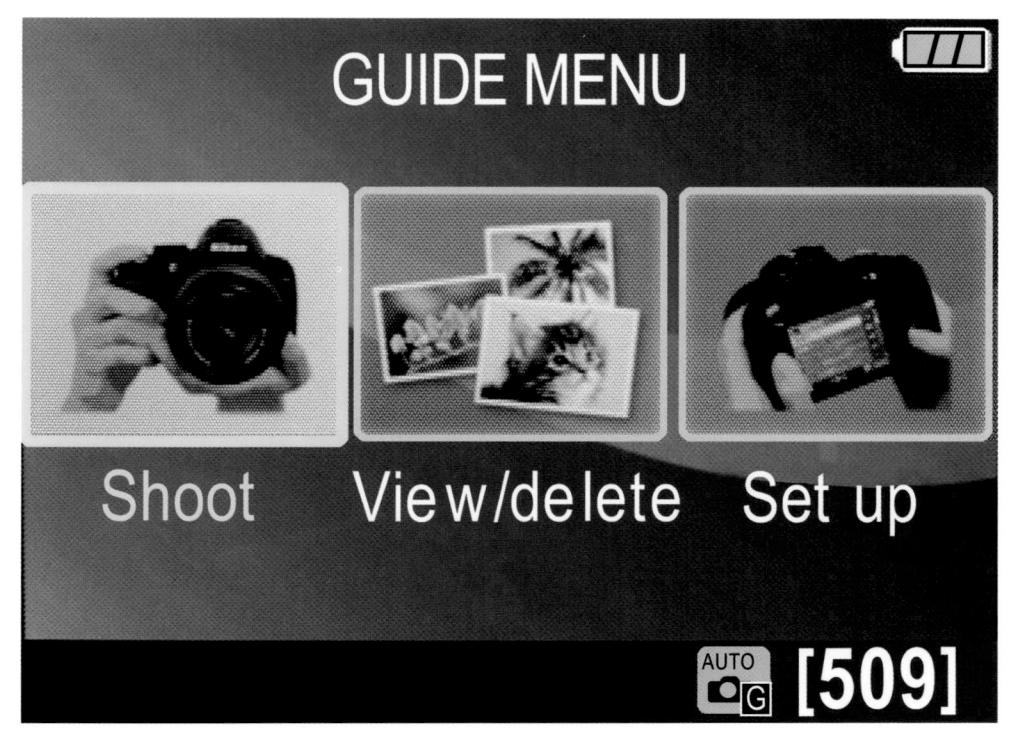

Figure 2.14
Easy Operation
corresponds to
the Scene
modes located
on the mode
dial.

Figure 2.15
Choose any of these available easy operations and you'll be shown a screen with instructions on how to take the picture.

■ Advanced operation. This choice has nine options: Soften Backgrounds, Bring More into Focus, Freeze Motion (People), Freeze Motion (Vehicles), Show Water Flowing, Capture Reds in Sunsets, Take Bright Photos, Take Dark (low key) Photos, and Reduce Blur. Selecting any of them sets up the camera for that type of picture, and provides you with a screen of information explaining how to take the picture.

View/Delete Options

This screen has five options you can select to activate functions (when not in Guide mode). These include View Single Photos, View Multiple Photos, Choose a Date (select images to view from a calendar of dates), View a Slide Show, and Delete Photos.

Set Up Options

This screen has 13 options that correspond to the choices available in the Shooting and Setup menus that I'll describe in detail in Chapter 3. The choices available include Image Quality, Image Size, Auto Off Timers, Print Date, Display and Sound Settings, Movie Settings, Output Settings, Playback Folder, Playback Display Options, DPOF Print Order, Clock and Language, Format Memory Card, and Slot Empty Release Lock. You can explore them in Guide mode if you like, or read how and why you might want to change these options in Chapters 3, 4, and 5.

Nikon D3200 Roadmap

With the D3200, Nikon has continued its emphasis on creating a super-compact entry-level digital SLR that retains the convenience and easy access to essential controls. Most of the Nikon D3200's key functions and settings that are changed frequently can be accessed directly using the array of dials, buttons, and knobs that populate the camera's surface, or through the information edit screen on the LCD. With so many quick-access controls available, you'll find that the bulk of your shooting won't be slowed down by a visit to the vast thicket of text options called Menuland.

However, if you want to operate your D3200 efficiently, you'll need to learn the location, function, and application of all these controls. You may have seen advice from well-meaning digital SLR veterans who tell you that a guide like this one isn't necessary because, "everything is in the user's manual." Sure it is! And a Road Atlas has every town, hamlet, and metropolitan area of the whole country. But planning the best route to your destination doesn't require a suffocating amount of information: what you need is expert advice (or a GPS!).

While the *basics* on each control is in the manual supplied with the camera, it's tucked away on a CD that you probably can't access when you need it most. Check out the "Getting to Know the Camera" pages in Nikon's manual, which compress views of the front, back, top, and bottom of the D3200 into two tiny black-and-white line drawings and a couple insets. There the tiny drawings with more than four dozen callouts point to various buttons and dials crammed into the pair of illustrations. If you can find the control you want within this cramped layout, you'll still need to flip back and forth among multiple pages (individual buttons can have several different cross-references!) to locate the information.

Most other third-party books follow this format, featuring black-and-white photos or line drawings of front, back, and top views, and many labels. I originated the

up-close-and-personal, full-color, street-level roadmap (rather than a satellite view) that I use in this book and my previous camera guidebooks. I provide you with an entire chapter filled with many different views, and lots of explanation accompanying each zone of the camera. By the time you finish this chapter, you'll have a basic understanding of every control and what it does. I'm not going to delve into menu functions here—you'll find a discussion of your setup, shooting, and playback menu options in Chapters 4 and 5. Everything here is devoted to the button pusher and dial twirler in you.

You'll also find this "roadmap" chapter a good guide to the rest of the book, as well. I'll try to provide as much detail here about the use of the main controls as I can, but some topics (such as autofocus and exposure) are too complex to address in depth right away. So, I'll point you to the relevant chapters that discuss things like setup options, exposure, use of electronic flash, and working with lenses with the occasional cross-reference.

I wish it were possible to explain all there is to know about every feature the first time a feature is introduced, but I know you'd rather not slog through an impenetrable 200-page chapter. Instead, I'm going to provide you with just enough information about each control to get you started, and go into more detail after you've had a chance to absorb the basics.

Nikon D3200: Front View

This is the side of the D3200 seen by your victims as you snap away. For the photographer, though, the front is the surface your fingers curl around as you hold the camera, and there are really only a few buttons to press, all within easy reach of the fingers of your left and right hands. There are additional controls on the lens itself. You'll need to look at several different views to see everything.

Figure 3.1 shows the front of the camera with the lens removed, so you can take a peek at some of your D3200's innards. The most important components you can see from this angle include:

- Red-eye reduction/self-timer/autofocus assist lamp. This LED provides a blip of light shortly before a flash exposure to cause the subjects' pupils to close down, reducing the effect of red-eye reflections off their retinas. When using the self-timer, this lamp also flashes to mark the countdown until the photo is taken, and serves to provide some extra illumination in dark environments to assist the autofocus system.
- **Aperture lever.** This mechanical lever pivots to physically move the diaphragm inside the lens to the f/stop that will be used to take the picture. The actual size of the aperture is determined by the setting calculated by the D3200's exposure system, or specified by you in manual exposure mode, and conveyed to the camera through the electrical contacts located at the top edge of the lens mount.

Figure 3.1

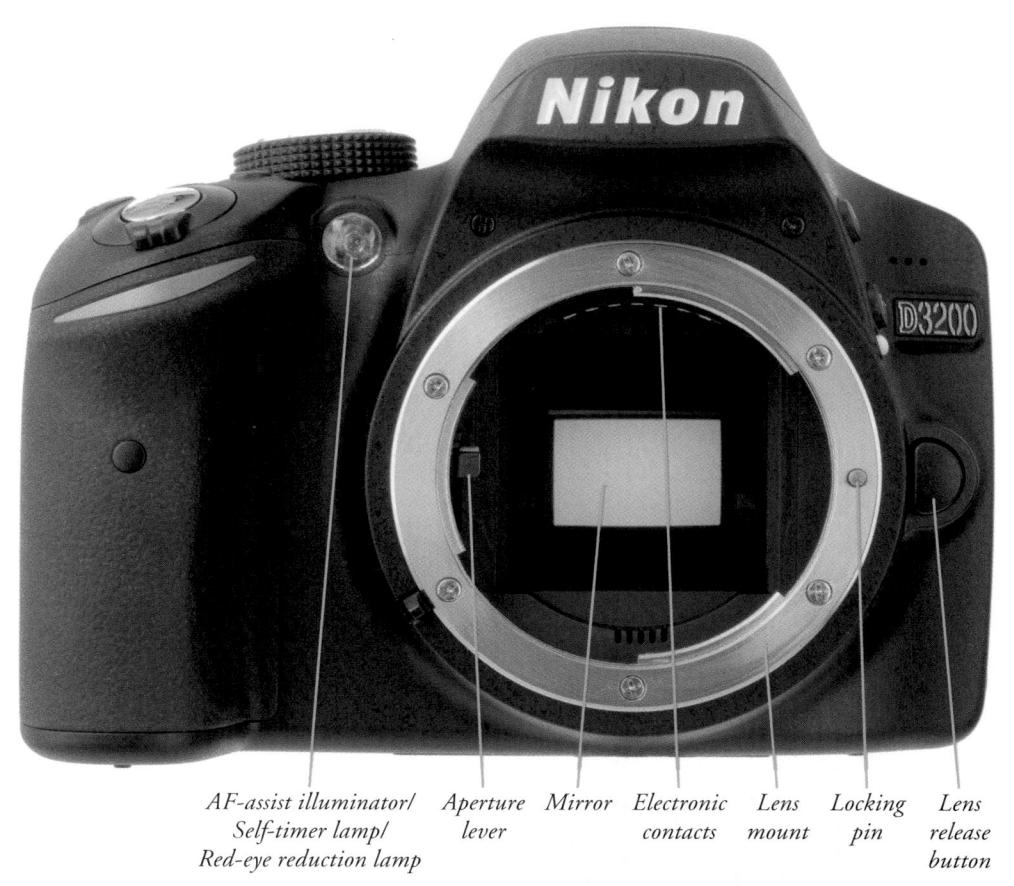

- Electronic contacts. These seven contact points mate with matching points on the bayonet mount of the lens itself, and allow two-way communication between the camera and lens for functions like aperture size and autofocus information.
- Mirror. This flip-up mirror directs the image seen by the lens upward to the viewing screen and exposure metering system, and thence onward to the eyepiece of the optical viewfinder. Semi-silvered locations on the mirror allow some illumination to be directed downward to the autofocus mechanism located on the floor of the compartment.
- Lens mount. This precision bayonet mount mates with the matching mount on the back of each compatible lens. The mount configuration is basically unchanged since the original Nikon F was introduced in 1959, with only a few changes. The D3200 version, for example, lacks something called a *lens indexing ring* that communicates the maximum aperture of older lenses (non-autofocus) to the camera, as well as an *autofocus motor/pin* that controls the focus of lenses with the AF (not AF-S) designation. As a result of these changes, the D3200 provides full

functionality only with lenses marked AF-S (or the equivalent with non-Nikkor optics). You'll find more information about lens compatibility in Chapter 10.

- Lens release button. Press this button to retract the locking pin on the lens mount so a lens can be rotated to remove it from the camera.
- Locking pin. This pin slides inside a matching hole in the lens to keep it from rotating until the lens release button is pressed.

Figure 3.2 shows a front view of the Nikon D3200 from a 45-degree angle. The main components you need to know about are as follows:

- Shutter release. Angled on top of the hand grip is the shutter release button, which has multiple functions. Press this button down halfway to lock exposure and focus. Press it down all the way to actually take a photo or sequence of photos if you're using the Continuous shooting mode. Tapping the shutter button when the D3200's exposure meters have turned themselves off reactivates them, and a tap can be used to remove the display of a menu or image from the rear color LCD.
- On/Off switch. Turns the D3200 on or off.
- Infrared sensor. Senses signals from the optional ML-L3 infrared remote control to trigger the camera. A second sensor is located on the back panel of the D3200.

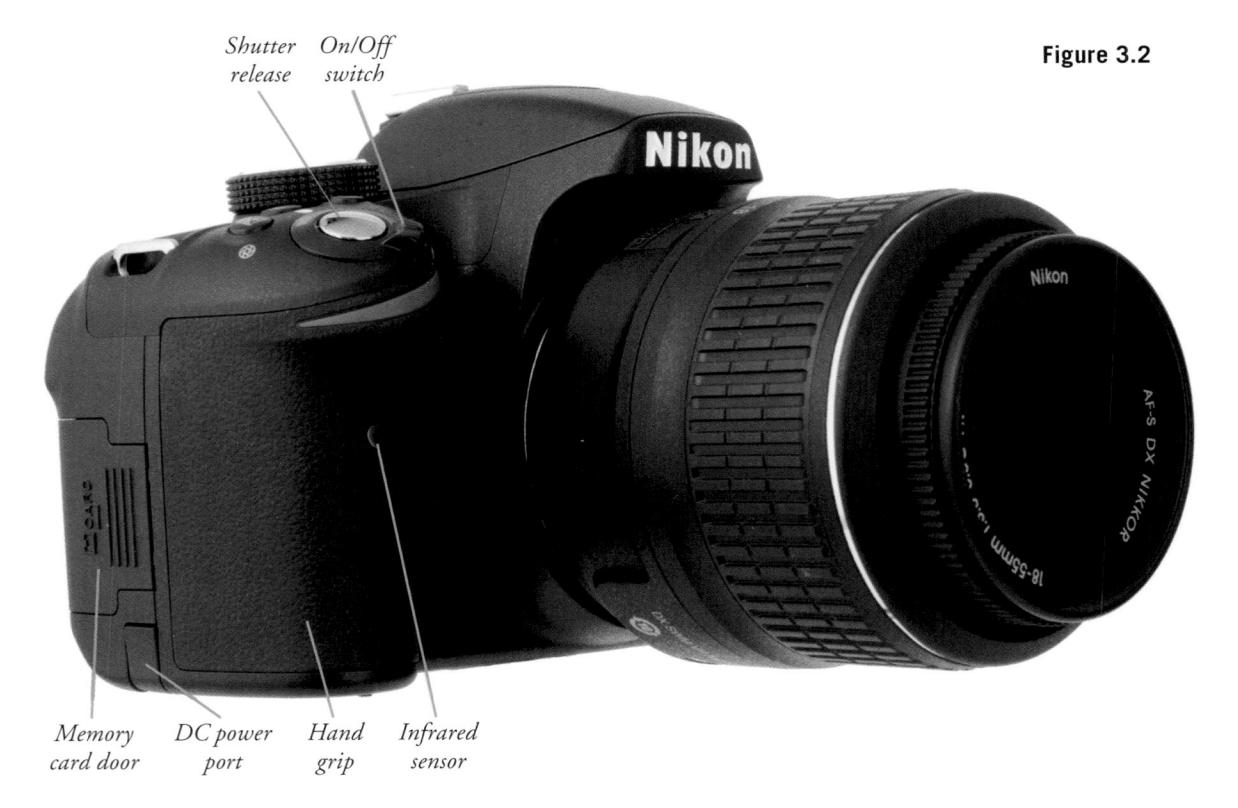

- **Hand grip.** This provides a comfortable hand-hold, and also contains the D3200's battery.
- **Memory card door.** Slide this door toward the back of the camera to provide access to the SD memory card slot.
- **DC power port.** Connect the optional EP-5a power cable from the EH-5b AC adapter through this port.

You'll find more controls on the other side of the D3200, shown in Figure 3.3. The main points of interest shown include:

■ Flash pop-up/Flash mode button. This button releases the built-in flash so it can flip up and start the charging process. If you decide you do not want to use the flash, you can turn it off by pressing the flash head back down. Hold down this button while spinning the command dial to choose a flash mode. Hold down this button while also pressing the exposure compensation button on the top panel of the D3200 to add/subtract flash exposure compensation. I'll explain how to use the various flash modes (red-eye reduction, front/rear curtain sync, and slow sync) in Chapter 11, along with some tips for adjusting flash exposure.

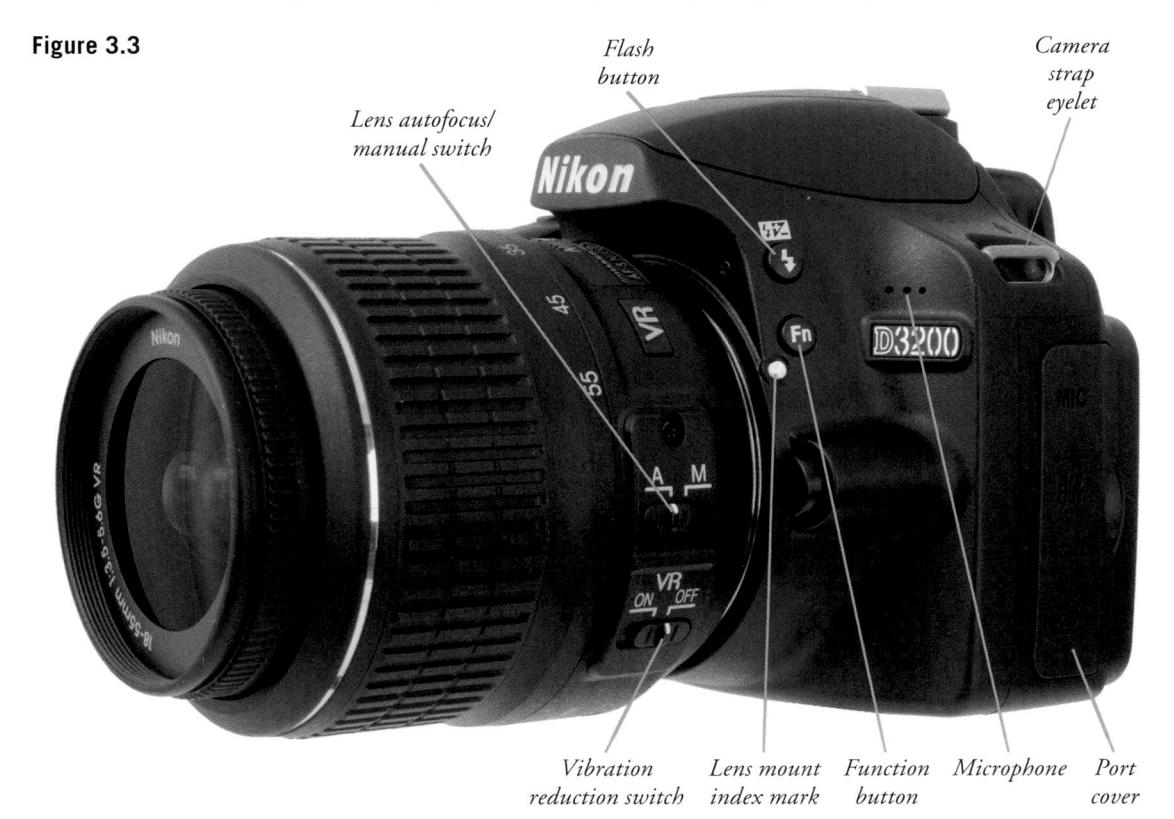

- Fn (Function button). This conveniently located button can be programmed to perform any one of several functions (including changing the image quality, setting ISO, Active D-Lighting, or specifying white balance), using the Buttons entry in the Setup menu. Its default behavior is to set the ISO sensitivity when you hold it while rotating the command dial. I recommend retaining this default behavior, because the D3200 doesn't have a dedicated button for this function, and ISO is a frequently adjusted setting.
- Pop-up flash. The flash elevates from the top of the camera (see Figure 3.4), theoretically reducing the chances of red-eye reflections, because the higher light source is less likely to reflect back from your subjects' eyes into the camera lens. In practice, the red-eye effect is still possible (and likely), and can be further minimized with the D3200's red-eye reduction lamp (which flashes before the exposure, causing the subjects' pupils to contract), and the after-shot red-eye elimination offered in the Retouch menu. (Your image editor may also have anti-red-eye tools.) Of course, the best strategy is to use an external speedlight that mounts on the accessory shoe on top of the camera (and thus is even higher) or a flash that is off-camera entirely.

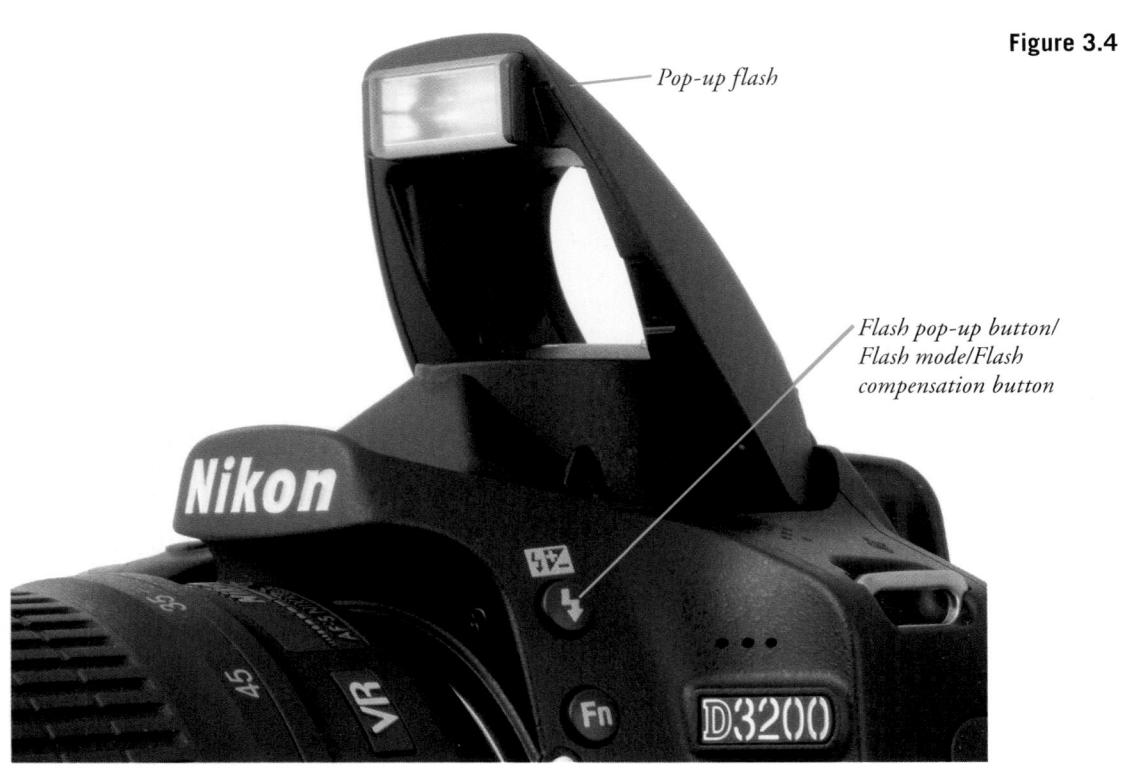

- **Microphone.** This monaural microphone records sound when shooting movies.
- Lens mount index mark. Align the dot on the base of the lens with this index to mount the lens, then rotate toward the shutter release.
- Lens autofocus/manual switch. Use to change from manual (M) to autofocus (A or A/M—the latter designation meaning that the lens can be manually adjusted even when using autofocus mode).
- **Vibration reduction switch.** Present only on lenses that offer the vibration reduction feature; it is used to turn VR on or off.
- **Port cover.** This panel protects the D3200's input/output connectors.
- Camera strap eyelet. Attach a camera strap here.

The main features on the side of the Nikon D3200 (under the cover that protects the four connectors from dust and moisture) are the ports themselves. In Figure 3.5 you can see:

- Microphone plug. Connect a stereo or monaural microphone here, such as the Nikon ME-1 mic.
- USB port. Plug in either of two cables, both included with the camera, or the optional WU-1a Wi-Fi adapter into this port. The USB cable UC-E6 can be connected to a USB port in your computer to transfer photos. The video cable EG-CP14 allows output to a standard definition television. Attach the yellow RCA plug from this cable to the yellow-coded RCA jack on your television, and the white RCA plug to the white audio RCA jack on your TV. (It's likely that your TV has both white and red coded RCA jacks for stereo sound; if your TV doesn't have a monaural setting, you can buy a y-connector to send audio from the camera to both jacks so sound will come from both speakers.)

The WU-1a Wireless Mobile adapter allows transmitting images directly from your D3200 to a smartphone or tablet. It also allows using the mobile device to trigger the camera's shutter release. When this book was written, the adapter supported only Android devices, but an app for iPhones will probably be available by the time you read this.

- HDMI port. Connect your camera to an HDTV television or monitor using this port. You'll have to buy a mini C HDMI cable for this option, as one is not furnished with the camera.
- Accessory terminal. Plug in the MC-DC2 wired remote control or the GP-1 global positioning system (GPS) accessory into this port.

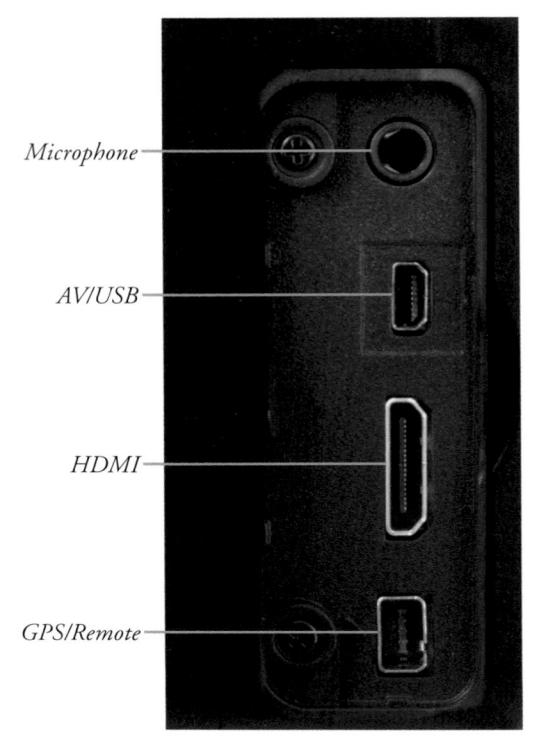

The Nikon D3200's Business End

The back panel of the Nikon D3200 bristles with almost a dozen different controls, buttons, and knobs. That might seem like a lot of controls to learn, but you'll find that it's a lot easier to press a dedicated button and spin a dial than to jump to a menu every time you want to access one of these features.

You can see the controls along the top edge of the back panel labeled in Figure 3.6. The key buttons and components and their functions are as follows:

- Infrared sensor. Detects signals from the optional ML-L3 infrared remote control to trigger the camera. A second sensor is located on the front panel of the D3200, and shown earlier.
- Viewfinder eyecup/eyepiece. You can frame your composition by peering into the viewfinder. It's surrounded by a soft rubber eyecup that seals out extraneous light when pressing your eye tightly up to the viewfinder, and it also protects your eyeglass lenses (if worn) from scratching. It can be removed and replaced by the DK-5 eyepiece cap when you use the camera on a tripod, to ensure that light coming from the back of the camera doesn't venture inside and possibly affect the exposure reading. Shielding the viewfinder with your hand may be more convenient (unless you're using the self-timer to get in the photo yourself).
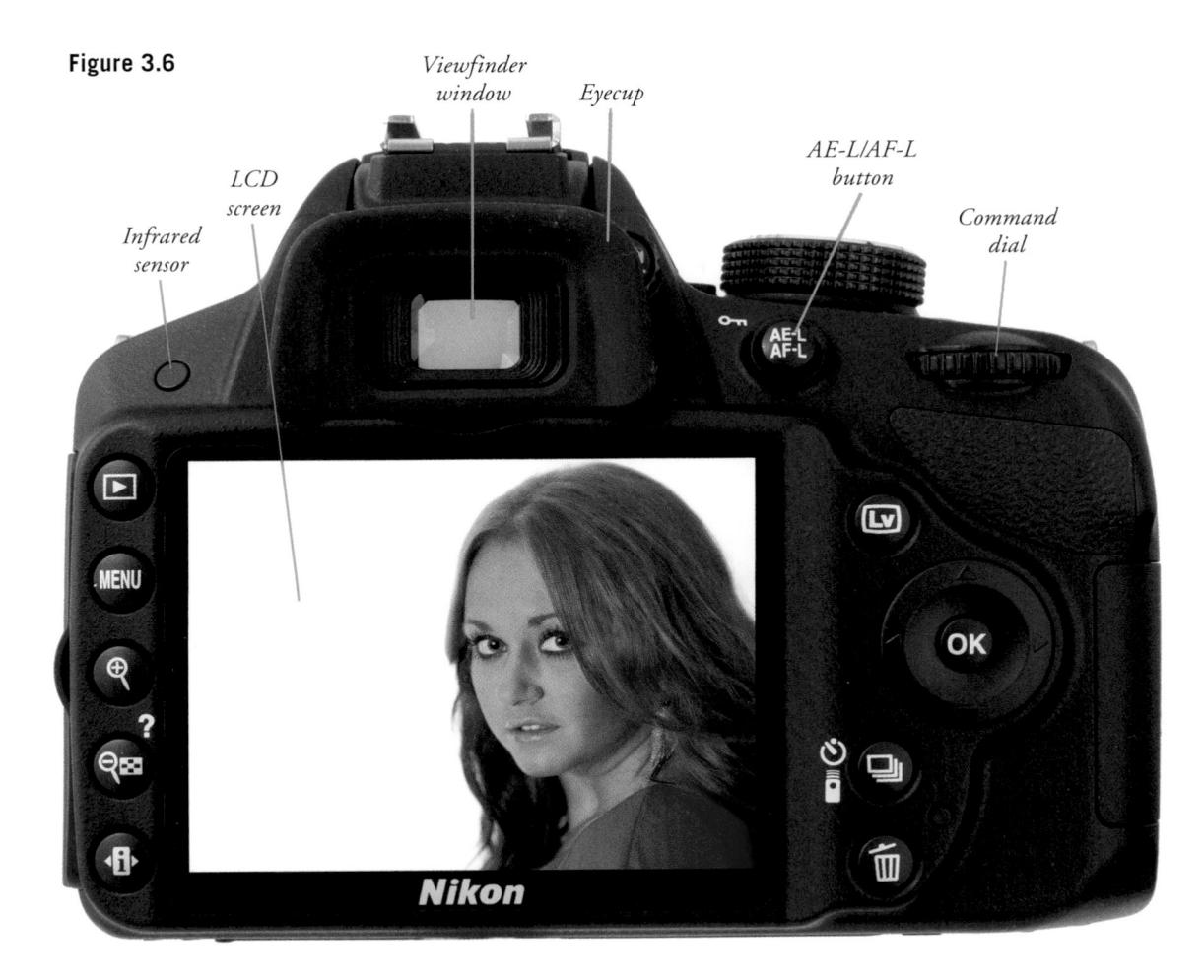

■ Protect image/AE-L/AF-L lock. This triple-duty button can be used to protect an image from accidental erasure. When reviewing a picture on the LCD, press once to protect the image, a second time to unprotect it. A key symbol appears when the image is displayed to show that it is protected. (This feature safeguards an image from erasure when deleting or transferring pictures only; when you format a card, protected images are removed along with all the others.) When shooting pictures, the button locks the exposure or focus that the camera sets when you partially depress the shutter button. The exposure lock indication (AE-L icon) appears in the viewfinder. If you want to recalculate exposure or autofocus with the shutter button still partially depressed, press the button again. The exposure/autofocus will be unlocked when you release the shutter button or take the picture. To retain the exposure/autofocus lock for subsequent photos even if you move the camera, keep the button pressed while shooting.

- **Command dial.** The command dial is used to set or adjust many functions, such as shutter speed, either alone or when another button is depressed simultaneously.
- LCD screen. This 3-inch display shows live view previews, images and thumbnails for review, menus, and informational screens.

You'll be using the five buttons to the left of the LCD monitor (shown in Figure 3.7) quite frequently, so learn their functions now.

- Playback button. Press this button to review images you've taken, using the controls and options I'll explain in the next section. To remove the displayed image, press the Playback button again, or simply tap the shutter release button.
- MENU button. Summons/exits the menu displayed on the rear LCD of the D3200. When you're working with submenus, this button also serves to exit a submenu and return to the main menu.
- Zoom In. In Playback mode, press to zoom in on an image.
- Thumbnail/Zoom Out/Help button. In Playback mode, use this button to change from full-screen view to 6, 9, or 72 thumbnails or calendar view, and to zoom out from a magnified image. I'll explain zooming and other playback options

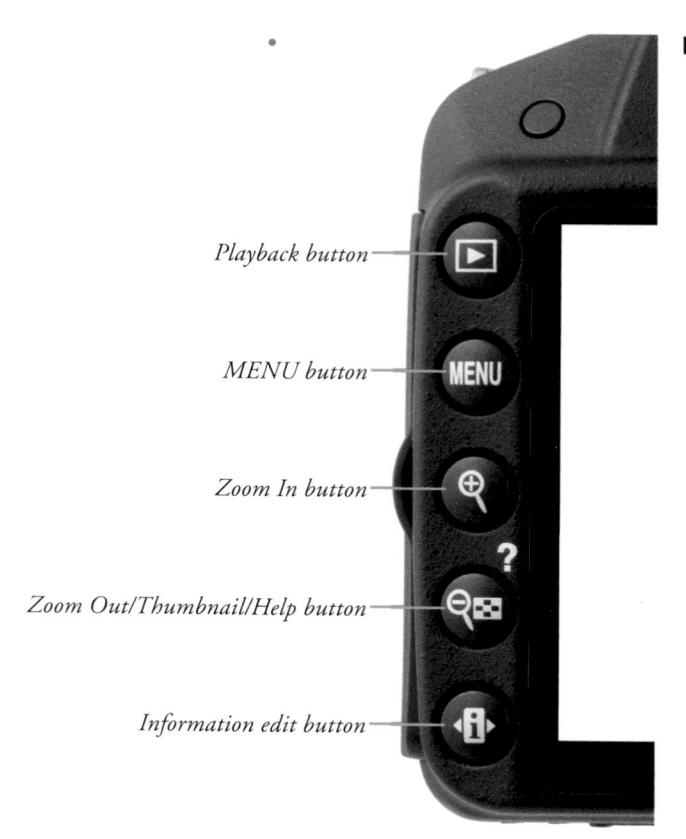

Figure 3.7

in the next section. When viewing most menu items on the LCD, pressing this button produces a concise Help screen with tips on how to make the relevant setting.

■ Information edit button. When shooting pictures, press this button to restore the shooting information display; press a second time to produce the information edit screen used to make many camera settings, such as metering mode, white balance, or ISO. Press this button to activate the shooting information display. Press again to remove the information display (or simply tap the shutter release button). The display will also clear after the period you've set for LCD display (the default value is 20 seconds). The information display can be set to alternate between modes that are best viewed under bright daylight, as well as in dimmer illumination.

More controls reside on the right side of the back panel, as shown in Figure 3.8. The key controls and their functions are as follows:

■ Live View button. This is a momentary contact switch that activates live view. Press again to turn live view off.

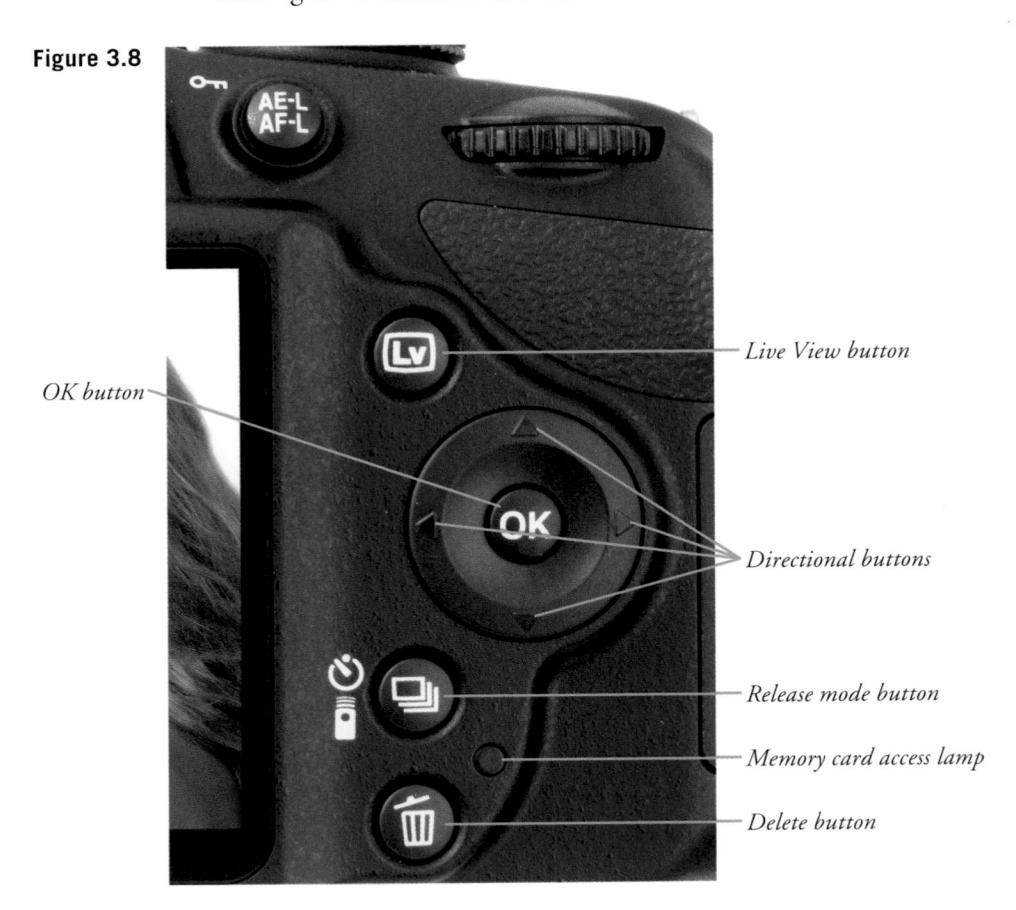

- Multi selector directional buttons. This joypad-like button can be shifted up/down and side to side to provide several functions, including AF point selection, scrolling around a magnified image, or trimming a photo. Within menus, pressing the up/down buttons moves the on-screen cursor up or down; pressing toward the right selects the highlighted item and displays its options; pressing left cancels and returns to the previous menu.
- **OK button.** Use this button to confirm a selection. When working with menus, press the MENU button instead to back out without making a selection.
- Memory card access lamp. When lit or blinking, this lamp indicates that the memory card is being accessed.
- **Delete button.** Press to erase the image shown on the LCD. A display will pop up on the LCD asking you to press the Trash button once more to delete the photo, or press the Playback button to cancel.
- Release mode button. Press to pop up the Release mode setting screen, shown in the Chapter 2, in Figure 2.4.

Playing Back Images

Reviewing images is a joy on the Nikon D3200's big 3-inch LCD. Here are the basics involved in reviewing images on the LCD screen (or on a television screen you have connected with a cable). You'll find more details about some of these functions later in this chapter, or, for more complex capabilities, in the chapters that I point you to. This section just lists the must-know information.

- Start review. To begin review, press the Playback button at the upper-left corner of the back of the D3200. The most recently viewed image or movie will appear on the LCD. (Movies are marked with an icon that has film sprocket holes.)
- Playback folder. Image review generally shows you the images in the currently selected folder on your memory card. A given card can contain several folders (a new one is created anytime you exceed 999 images in the current folder). You can use the Playback folder menu option in the Playback menu (as I'll explain in Chapter 4) to select a specific folder, or direct the D3200 to display images from all the folders on the memory card.
- View thumbnail images. To change the view from a single image to four, nine, or 72 thumbnails, or calendar view, follow the instructions in the "Viewing Thumbnails" section that follows.
- Zoom in and out. To zoom in or out, press the Zoom In button, following the instructions in the "Zooming the Nikon D3200 Playback Display" in the next section. (It also shows you how to move the zoomed area around using the multi selector pad.)

- Move back and forth. To advance to the next image, rotate the command dial to the right or press the right edge of the multi selector pad; to go back to a previous shot, rotate the command dial to the left or press the left edge of the multi selector. When you reach the beginning/end of the photos in your folder, the display "wraps around" to the end/beginning of the available shots.
- See different types of data. To change the type of information about the displayed image that is shown, press the up and down portions of the multi selector pad. To learn what data is available, read the "Working with Photo Information" section later in this chapter.
- Retouch image. Press the OK button while a single image is displayed on the screen to jump to the Retouch menu to modify that photograph. (I'll explain the workings of the Retouch menu in Chapter 5.)
- Remove images. To delete an image that's currently on the screen, press the Trash button once, and then press it again to confirm the deletion. To select and delete a group of images, use the Delete option in the Playback menu to specify particular photos to remove, as described in more detail in Chapter 4.
- Cancel playback. To cancel image review, press the Playback button again, or simply tap the shutter release button.

Zooming the Nikon D3200 Playback Display

Here's how to zoom in and out on your images during picture review:

- 1. **Zoom in.** When an image is displayed (use the Playback button to start), press the Zoom In button to fill the screen with a slightly magnified version of the image. You can keep pressing the Zoom In button to magnify a portion of the image up to 28X if you used the Large resolution setting when shooting the photo. An image at Medium resolution can be magnified up to 28X, while Small images can be zoomed in up to 19X. (See Figure 3.9.)
- 2. **Inset shows zoomed area highlighted in yellow.** A navigation window appears in the lower-right corner of the LCD showing the entire image. Keep pressing to continue zooming in. The yellow box in the navigation window shows the zoomed area within the full image. The entire navigation window vanishes from the screen after a few seconds, leaving you with a full-screen view of the zoomed portion of the image.
- 3. Faces marked in navigation window. If a face is detected in the scene, a white box appears around it within the navigation box, and icons show up at lower left (as seen in Figure 3.9) to remind you that if you press the information edit button and left/right multi selector buttons, you can switch among the detected faces. Up to 35 different faces may be detected and marked.

Figure 3.9
The D3200
incorporates a small thumbnail image with a yellow box showing the current zoom area, and one or more white boxes to mark any faces detected in the scene.

- 4. **Move zoomed view around within full image.** Use the multi selector buttons to move the zoomed area around within the image. The navigation window will reappear for reference when zooming or scrolling around within the display. Use the command dial to move to the same zoomed area of the next/previous image.
- 5. **Zoom Out.** Use the Zoom Out/Thumbnail button to zoom back out of the image. If you continue pressing the Zoom Out button from the full-screen view, you'll be shown four, nine, and 72 thumbnails, plus a calendar view. These are all described in the next section.
- 6. **Exit Zoom.** To exit Zoom In/Zoom Out display, keep pressing the Zoom Out button until the full-screen/full-image/information display appears again.

Viewing Thumbnails

The Nikon D3200 provides other options for reviewing images in addition to zooming in and out. You can switch between single image view and four, nine, or 72 reduced-size thumbnail images on a single LCD screen.

Pages of thumbnail images offer a quick way to scroll through a large number of pictures quickly to find the one you want to examine in more detail. The D3200 lets you

switch quickly from single- to four- to nine- to 72-image views, with a scroll bar displayed at the right side of the screen to show you the relative position of the displayed thumbnails within the full collection of images in the active folder on your memory card. Figure 3.10 offers a comparison between the three levels of thumbnail views. The Zoom In and Zoom Out/Thumbnail buttons are used.

- Add thumbnails. To increase the number of thumbnails on the screen, press the Zoom Out button. The D3200 will switch from single image to four thumbnails to nine thumbnails to 72 thumbnails, and then to calendar view (discussed next). Additional presses in calendar view toggles back and forth between highlighting calendar dates, or showing pictures taken on that date (see "Working with Calendar View," next). (The display doesn't cycle back to single image again.)
- Reduce number of thumbnails. To decrease the number of thumbnails on the screen, press the Zoom In button to change from calendar view to 72 to nine thumbnails to four thumbnails, or from four to single-image display. Continuing to press the Zoom In button once you've returned to single-image display starts the zoom process described in the previous section.
- Change highlighted thumbnail area. Use the multi selector to move the yellow highlight box around among the thumbnails.
- Protect and delete images. When viewing thumbnails or a single-page image, press the Protect button (on the upper right of the back of the D3200, marked with a key icon and AE-L/AF-L label) to preserve the image against accidental deletion (a key icon is overlaid over the full-page image) or the Trash button (twice) to erase it.
- Exit image review. Tap the shutter release button or press the Playback button to exit image review. You don't have to worry about missing a shot because you were reviewing images; a half-press of the shutter release automatically brings back the D3200's exposure meters, the autofocus system, and cancels image review.

Figure 3.10 Switch between four thumbnails (left), nine thumbnails (center), or 72 thumbnails (right), by pressing the Zoom Out and Zoom In buttons.

Working with Calendar View

Once in calendar view, you can sort through images arranged by the date they were taken. This feature is especially useful when you're traveling and want to see only the pictures you took in, say, a particular city on a certain day.

- Change dates. Use the multi selector keys or main dial and subcommand dial to move through the date list. If your memory card has pictures taken on a highlighted date, they will be arrayed in a scrolling list at the right side of the screen (see Figure 3.11).
- View a date's images. Press the Zoom In button to toggle between the date list to the scrolling thumbnail list of images taken on that date. When viewing the thumbnail list, you can use the multi selector up/down keys to scroll through the available images.
- Preview an image. In the thumbnail list, when you've highlighted an image you want to look at, press the Zoom In button to see an enlarged view of that image without leaving the calendar view mode. The zoomed image replaces the date list.
- **Delete images.** Pressing the Trash button deletes a highlighted image in the thumbnail list. In the date list view, pressing the Trash button removes all the images taken on that date (use with caution!).

Figure 3.11
Calendar view allows you to browse through all images on your memory card taken on a certain date.

■ Exit calendar view. In thumbnail view, if you highlight an image and press the OK button, you'll exit calendar view and the highlighted image will be shown on the LCD in the display mode you've chosen. (See "Working with Photo Information" to learn about the various display modes.) In date list view, pressing the Zoom In button exits calendar view and returns to 72 thumbnails view. You can also exit calendar view by tapping the shutter release (to turn off the LCD to ready the camera for shooting) or by pressing the MENU button.

Working with Photo Information

When reviewing an image on the screen, your D3200 can supplement the image itself with a variety of shooting data, ranging from basic information presented at the bottom of the LCD display, to three text overlays that detail virtually every shooting option you've selected. This section will show you the type of information available. Most of the data is self-explanatory, so the labels in the accompanying figures should tell you most of what you need to know. To change to any of these views while an image is on the screen in Playback mode, press the multi selector up/down buttons.

■ File information screen. The basic full-image review display is officially called the file information screen, and looks like Figure 3.12.

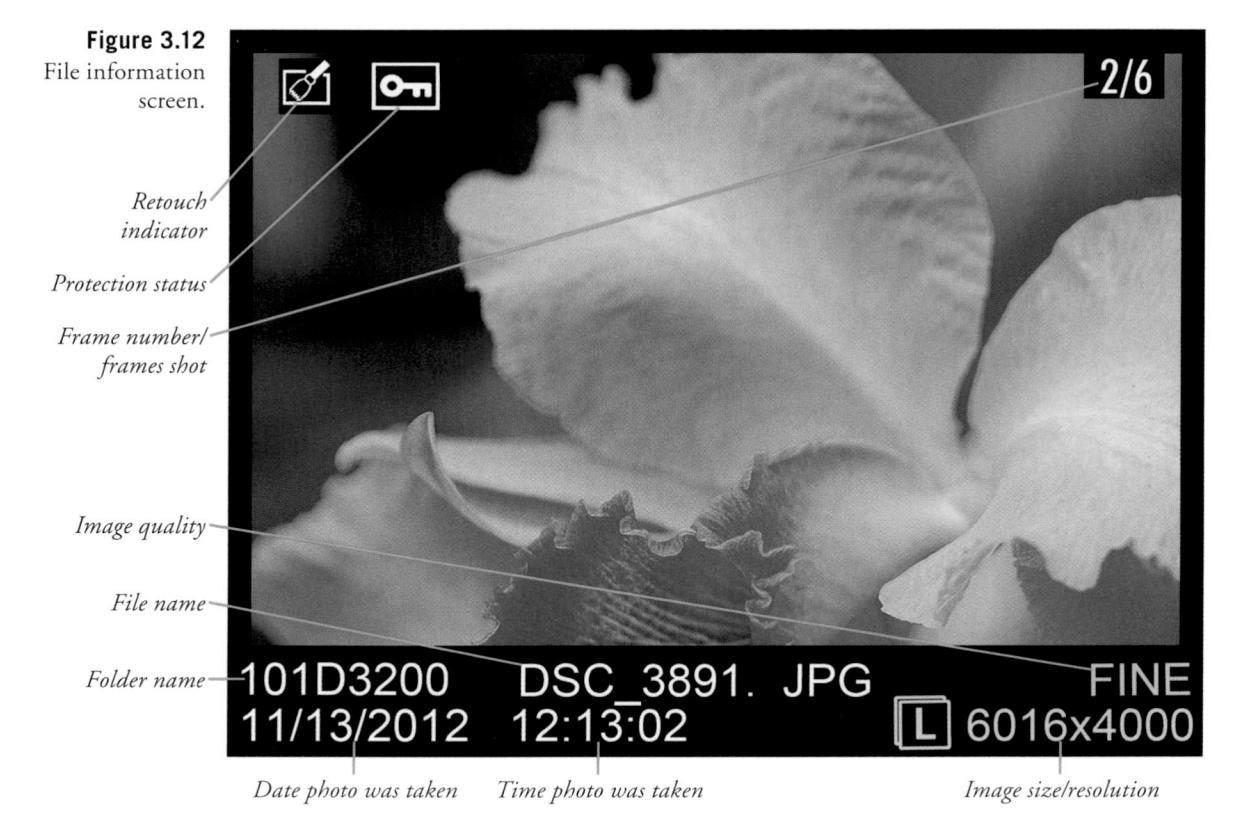

- No information. This screen displays your image only, with no data shown.
- Overview data. This screen adds more data, including metering mode, shutter speed, f/stop, and ISO setting, and looks like Figure 3.13.
- **GPS data.** This screen appears only if you have used a GPS device, such as the Nikon GP-1, to capture and record global positioning system information in the image file, as shown in Figure 3.14.
- **Shooting Data 1.** This screen shows noise reduction information, Active D-Lighting, retouching effects that have been applied, and your user comments, as shown in Figure 3.15.
- **Shooting Data 2.** This screen shows white balance data and adjustments, sharpness and saturation settings, and other parameters (see Figure 3.16).

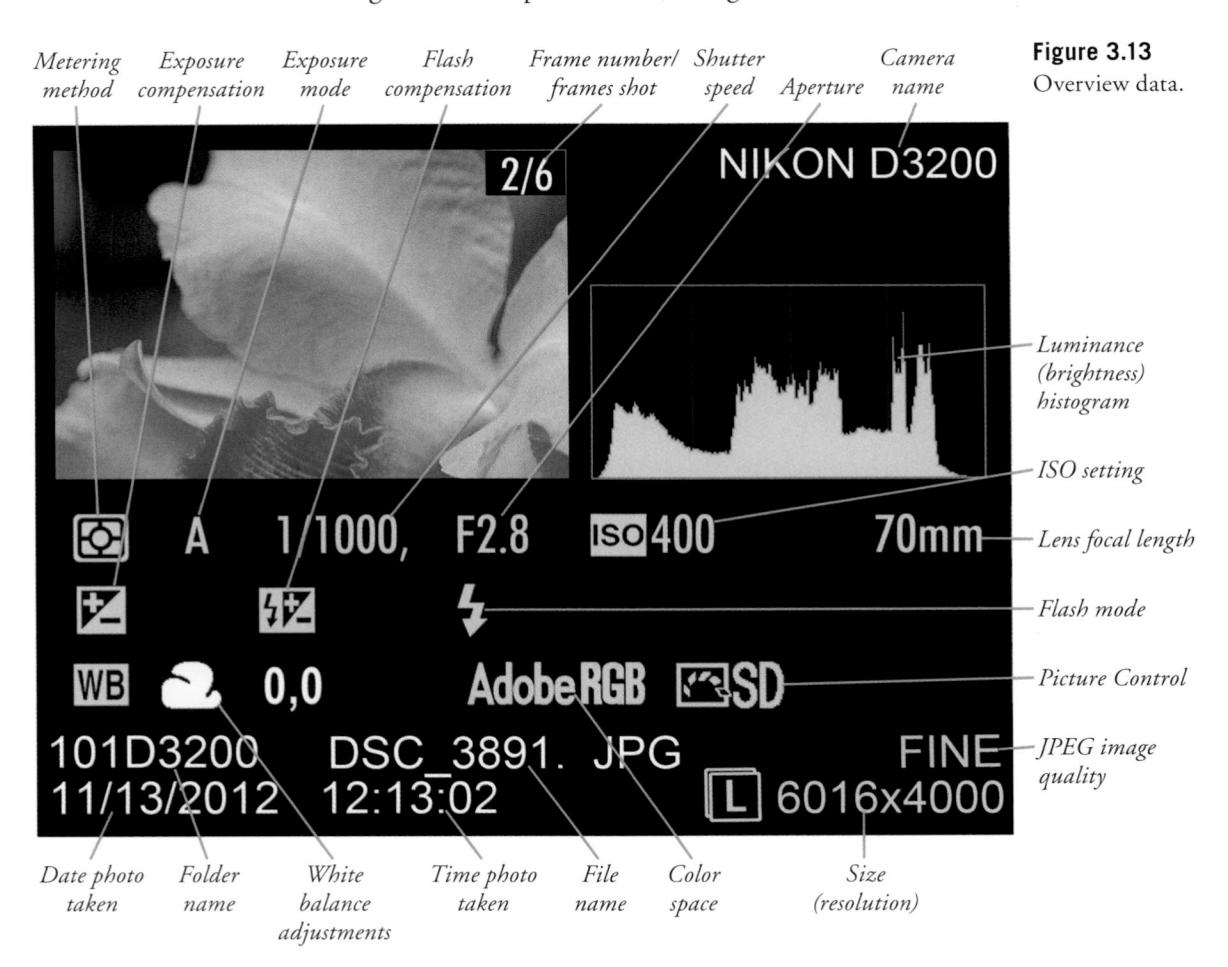

Figure 3.14 GPS data.

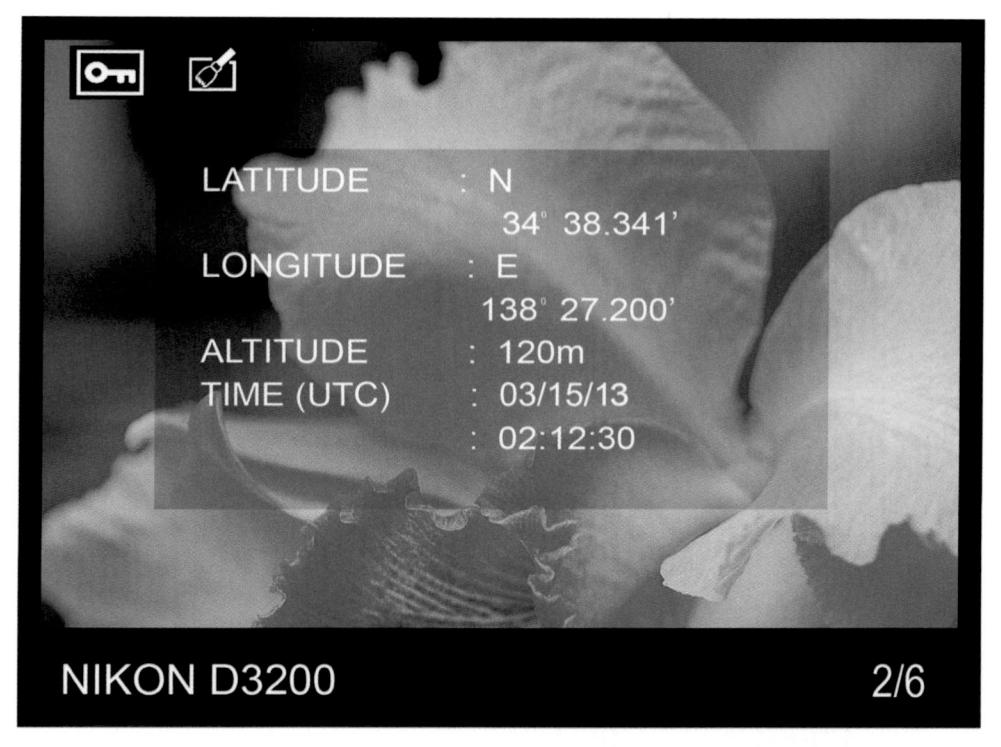

Figure 3.15 Shooting Data screen 1.

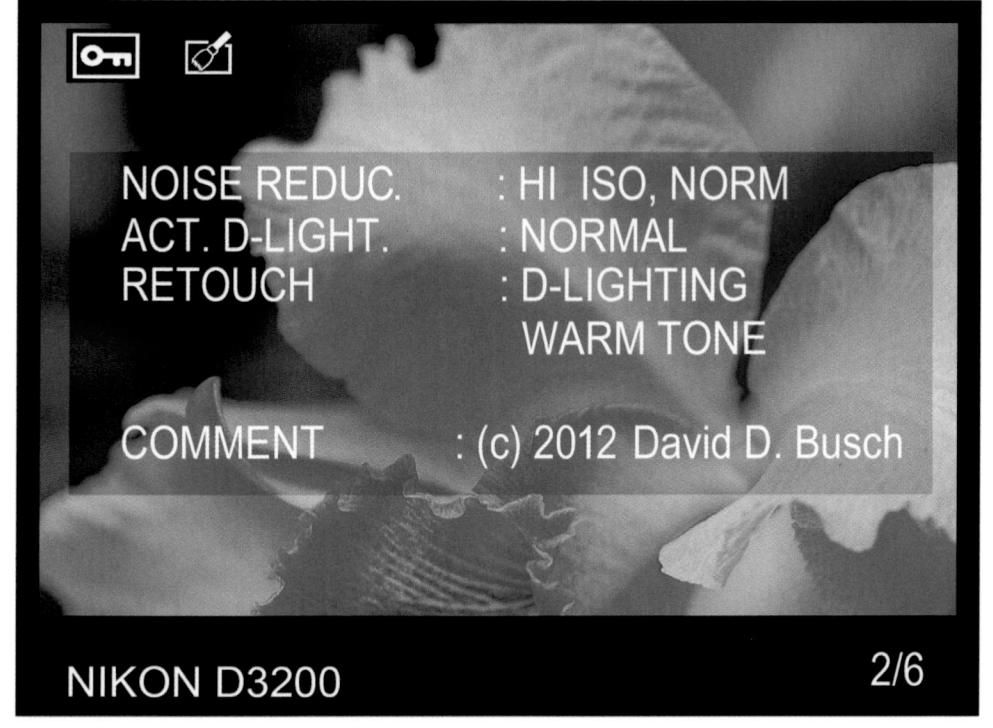

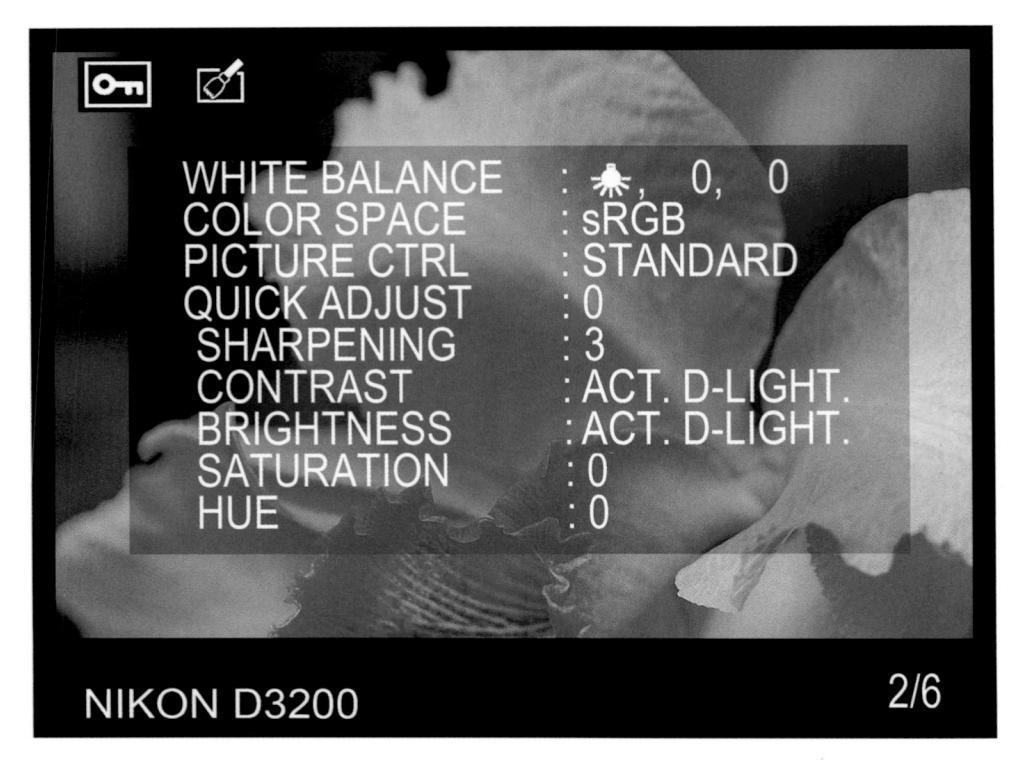

Figure 3.16 Shooting Data screen 2.

- Shooting Data 3. This screen tells you everything else you might want to know about a picture you've taken, including metering mode, exposure mode, exposure compensation, lens information, and all the details of any built-in or external dedicated flash units you might have used. See Figure 3.17.
- RGB histogram. This shows the image accompanied by a brightness histogram, as well as red, green, and blue histograms, which you can see in Figure 3.18. The histogram is a kind of chart that represents an image's exposure, and how the darkest areas, brightest areas, and middle tones have been captured. Histograms are easy to work with, and I'll show you how in Chapter 6.
- **Highlights.** When the Highlights display is active (see Figure 3.19), any overexposed areas will be indicated by a flashing black border. As I am unable to make the printed page flash, you'll have to check out this effect for yourself.

Figure 3.17 Shooting Data screen 3.

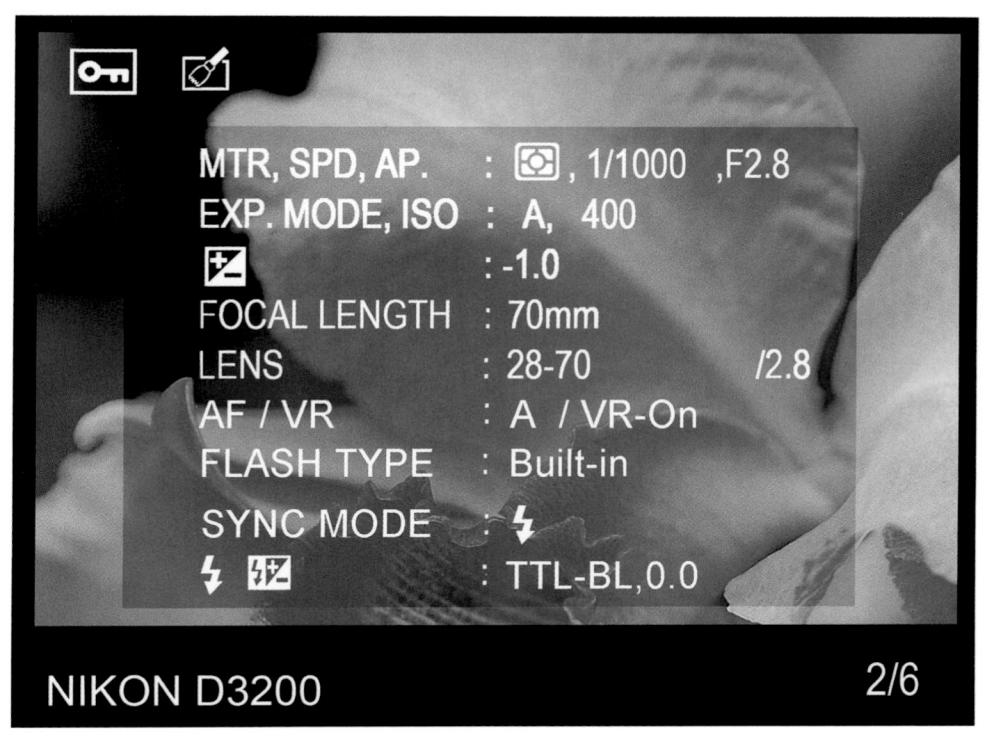

Figure 3.18 RGB histogram.

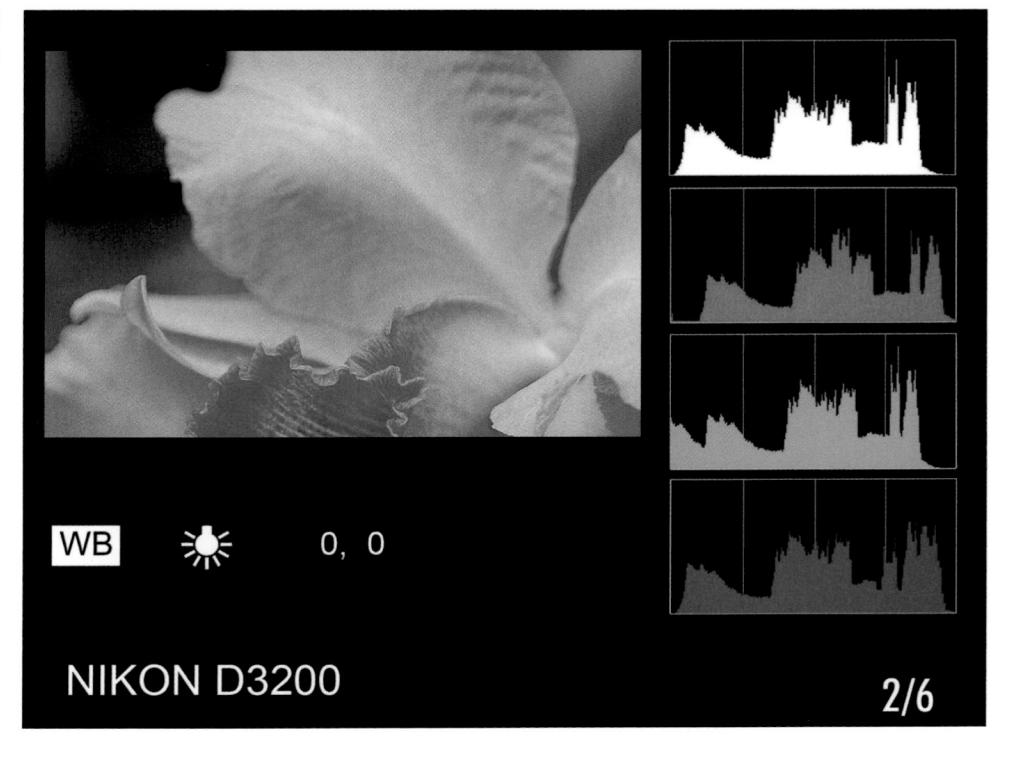

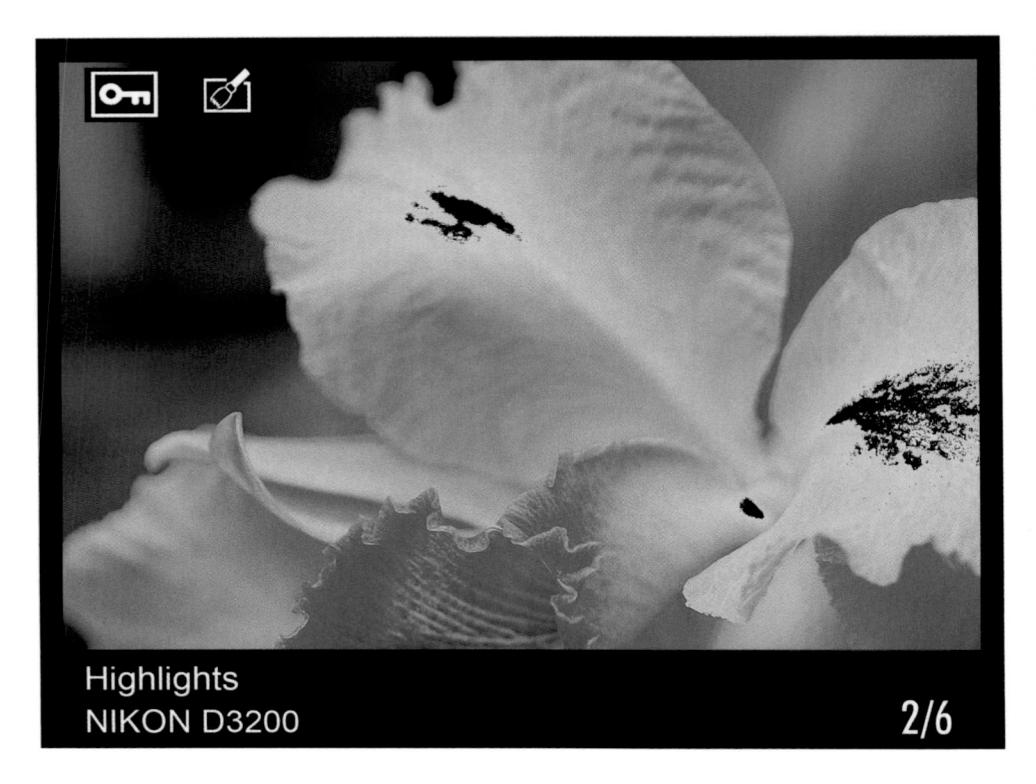

Figure 3.19 Highlights display.

Shooting Information Display/Information Edit Screen

As first described in Chapter 2, the back-panel color LCD can be used to provide a wealth of information (the shooting information display) and access to a number of settings (the information edit screen). The information edit screen can help you avoid some trips to Menuland, by making some basic adjustments available using the color LCD's speedy settings view.

To activate/deactivate the shooting information display, press the Info button on top of the camera (which just turns the display on or off), or press the information edit button on the back of the camera, near the bottom-left corner of the color LCD. (That button also allows you to *change* some of the settings.) When the screen is visible, you'll see settings like those shown at right in Figure 3.20. Two versions are available: the "Classic" version, which has a clean, text-based format, and the "Graphic" version, which includes a smattering of graphics—particularly in scene modes, when a representation of the mode dial appears briefly as you change modes. Use the Auto information display from the Setup menu to specify which of these two versions to use. You can choose the display type for Auto/scene modes and advanced modes separately, while choosing a blue,

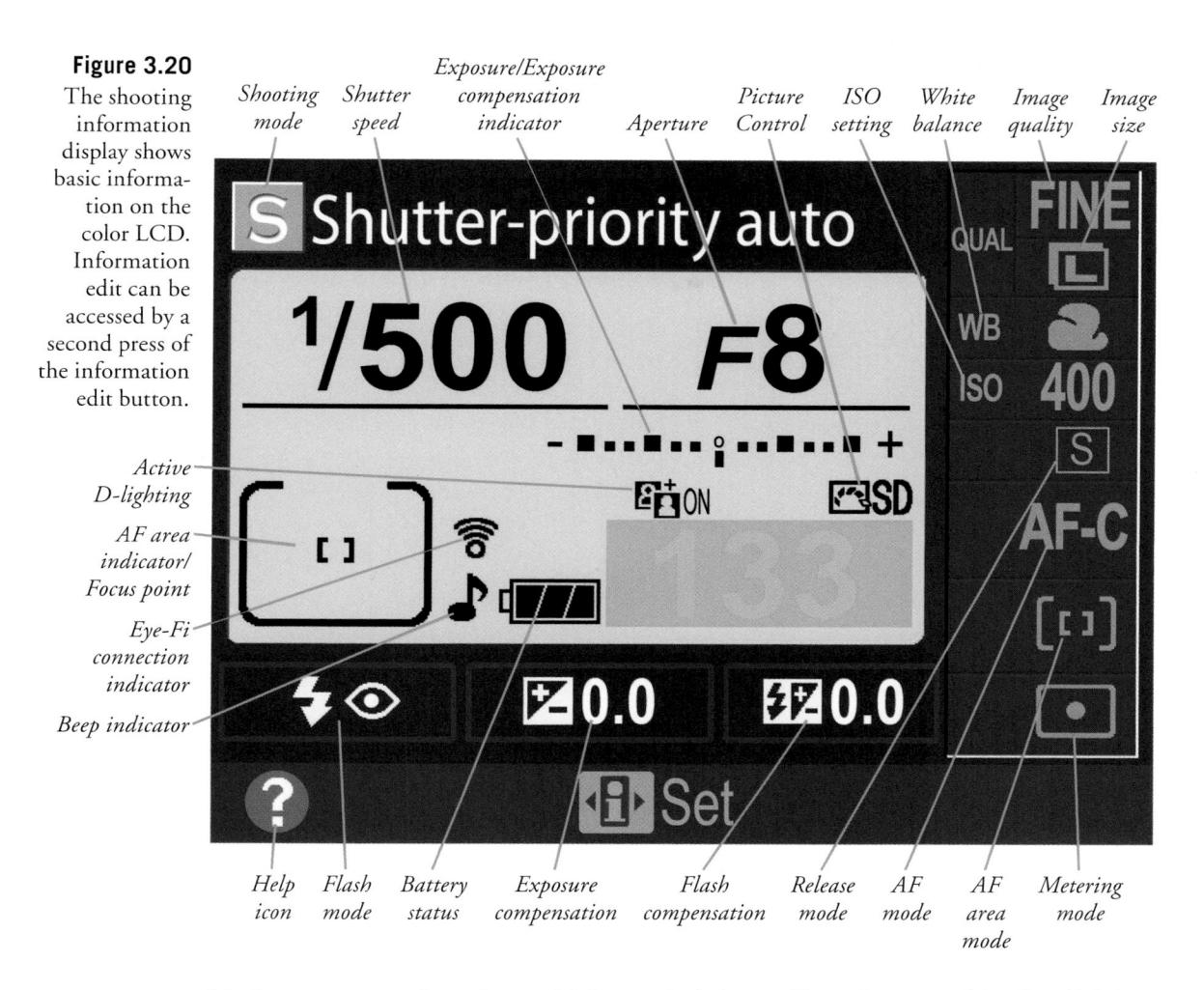

black, or orange color scheme. Light-on-dark is usually easier to read in dim lighting conditions, while the reverse scheme is better under bright lighting.

When the shooting information display is shown, press the information edit button a second time to activate the information edit menu. Use the multi selector left/right buttons to highlight one of the adjustments, then press the OK button to produce a screen of options for that setting. You'll find the information edit screen can be much faster to use for setting ISO Noise Reduction, adjusting Active D-Lighting, or accessing a Picture Control. You'll find full explanations of these features in Chapter 4.

The shooting information displayed on the LCD displays status information about most of the shooting settings. Some of the items on the status LCD also appear in the viewfinder, such as the shutter speed and aperture and the exposure level. This display remains active for about eight seconds, then shuts off if no operations are performed with the camera, or if the eye sensor detects that you're looking through the viewfinder.

The display also turns off when you press the shutter release halfway. You can re-activate the display by pressing the Zoom In/Info, Zoom Out, or Fn buttons (except when the behavior of the latter button has been set to white balance compensation). The display also appears when the exposure compensation/aperture button is pressed in P, S, or A exposure modes, or when the Flash button is pressed in any exposure mode other than Auto (Flash Off). In other words, the shooting information display appears whenever you're likely to need it, and can be summoned at other times by pressing the Zoom In/information edit button. (Remember, you can press the button a second time to access the information edit screen.)

- Exposure mode. This indicator tells you whether the D3200 is set for one of the scene modes, or for Program, Aperture-priority, Shutter-priority, or Manual exposure modes. An asterisk appears next to the P when you have used Flexible Program mode, which allows you to depart from the camera's programmed exposure setting to set a different combination of shutter speed/aperture that produces the same exposure. You'll find more about this feature in Chapter 4.
- Image size. Shows whether the D3200 is shooting Large, Medium, or Small sizes.
- Image quality. Shows current image quality, including JPEG, RAW, and RAW+JPEG Fine.
- White balance setting. One of the white balance settings will appear here, depending on the selection you've made.
- Release mode. Indicates whether the D3200 is set for Single frame, Continuous, or one of the Self-timer/Remote modes.
- Focus mode. Shows AF-C, AF-S, AF-A, and manual focus modes.
- Autofocus-area indicator. Displays the autofocus area status, from among Single-point, Dynamic-area, Auto-area, and 3D-tracking (11 points), all discussed earlier.
- Metering mode. Indicates whether Matrix, Center-weighted, or Spot metering has been selected.
- **ISO Auto indicator.** Displayed when you've set the D3200 to adjust ISO for you automatically.
- Electronic analog display. This is a continuous scale that shows that correct exposure is achieved when the indicator is in the center, and how many stops off exposure is when the indicator veers to the right (underexposure) or left (overexposure). This scale is also used to display other information, such as exposure compensation.

- Exposure compensation. Appears when you've dialed in exposure compensation. Monitor this indicator, as it's easy to forget that you've told the Nikon D3200 to use more or less exposure than what its (reasonably intelligent) metering system would otherwise select.
- Flash compensation. Reminds you that you've tweaked the D3200's electronic flash exposure system with more or less exposure.
- Number of exposures/additional functions. This indicator shows the number of exposures remaining on your memory card, as well as other functions, such as the number of shots remaining until your memory buffer fills.
- Battery status. Three segments show the approximate battery power remaining.
- Flash mode. The current mode for the D3200's built-in electronic flash unit is shown here.
- Active D-Lighting status. Shows whether this feature is active or turned off.
- Beep indicator. Indicates that a helpful beep will sound during the countdown in Self-timer or Delayed Remote Control mode, or just once in Quick Response Remote mode. The beep also chirps when the D3200 successfully focuses when using Sports scene mode, as well as in AF-S or AF-A Autofocus modes. No beep sounds in AF-C mode, or when the subject is moving while in AF-A mode (because the D3200 effectively switches to AF-C mode at that point).
- Aperture/additional functions. The selected f/stop appears here.
- Shutter speed/additional functions. Here you'll find the shutter speed, ISO setting, color temperature, and other useful data.
- **Help indicator.** Press the Help button (the third from the top to the left of the LCD) to receive more information about a setting.
- Eye-Fi Status. Appears when you have an Eye-Fi card installed in the D3200.

Going Topside

The top surface of the Nikon D3200 (see Figure 3.21) has its own set of frequently accessed controls. Those located on the right side of the camera are seen in close-up in Figure 3.22.

■ Accessory/flash shoe. Slide an electronic flash into this mount when you need a more powerful speedlight. A dedicated flash unit, like the Nikon SB-400, SB-600, SB-700, or SB-900/910, can use the multiple contact points shown to communicate exposure, zoom setting, white balance information, and other data between the flash and the camera. There's more on using electronic flash in Chapter 11.

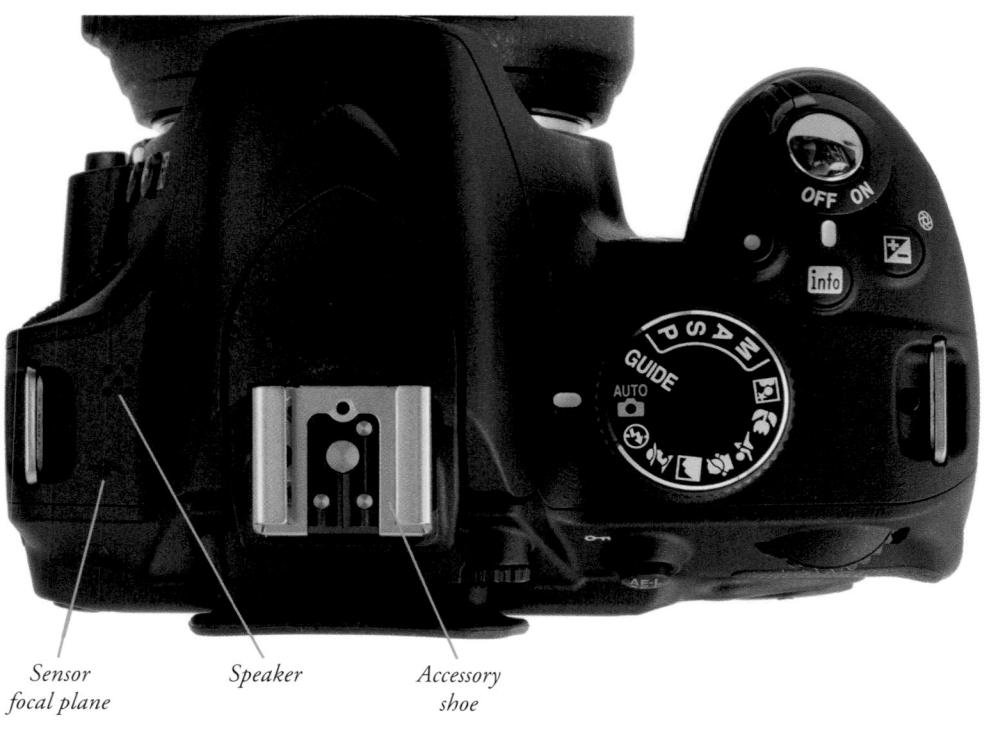

Figure 3.21

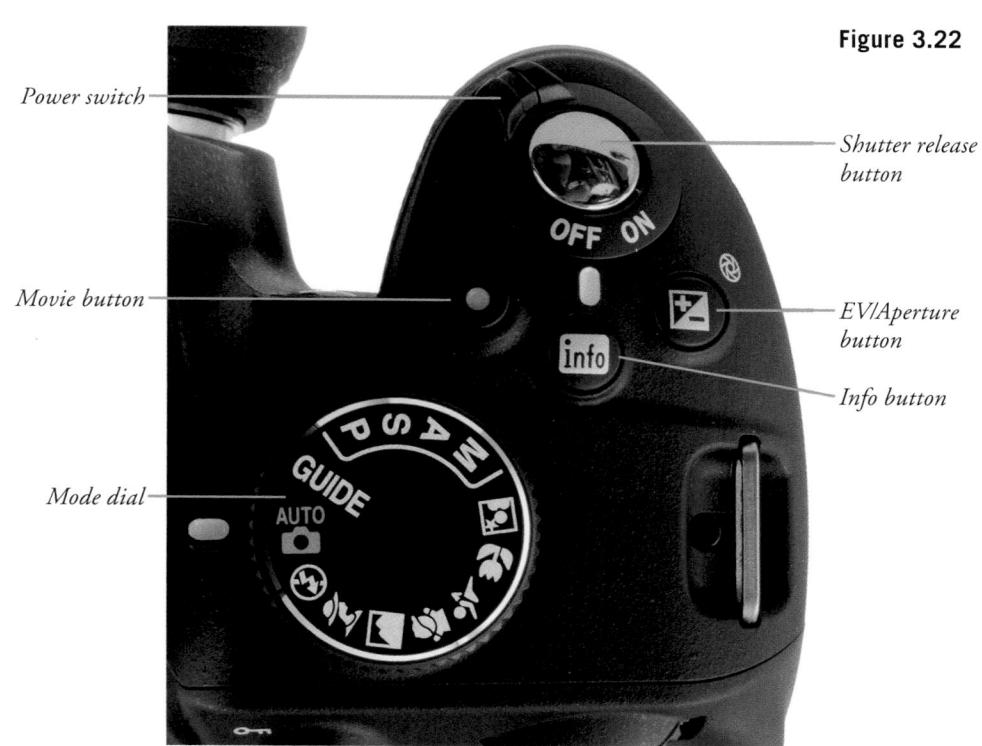

- Power switch. Rotate this switch clockwise to turn on the Nikon D3200 (and virtually all other Nikon dSLRs).
- **Info/Information button**. This button turns the shooting information display on or off.
- Shutter release button. Partially depress this button to lock in exposure and focus. Press all the way to take the picture. Tapping the shutter release when the camera has turned off the autoexposure and autofocus mechanisms reactivates both. When a review image is displayed on the back-panel color LCD, tapping this button removes the image from the display and reactivates the autoexposure and autofocus mechanisms.
- Exposure value/Aperture button. Press this button while spinning the command dial to change the aperture in Manual exposure mode (there is no need to press the button to change the aperture in Aperture-priority mode). Hold down this button and spin the command dial to add or subtract exposure when using Program, Aperture-priority, or Shutter-priority modes. This facility allows you to "override" the settings the camera has made and create a picture that is lighter or darker. This is called exposure compensation. You can "apply" exposure compensation in Manual mode, too, but in that case the exposure isn't really changed. The D3200 simply tells you how much extra or reduced exposure you are requesting, using a display in the viewfinder and LCD which I'll describe later in this chapter. Finally, the button can be used in conjunction with the flash button on the front of the camera to set flash exposure compensation. Hold down both buttons and spin the command dial to adjust the amount of flash exposure. (I'll explain this process in Chapter 11.)
- **Focal plane indicator.** This indicator shows the *plane* of the sensor, for use in applications where exact measurement of the distance from the focal plane to the subject are necessary. (These are mostly scientific/close-up applications.)
- Mode dial. Rotate the mode dial to choose between Program, Aperture-priority, Shutter-priority, and Manual exposure modes, as well as the scene modes Auto, Auto (No Flash), Portrait, Landscape, Child, Sports, Close-up, and Night Portrait. Your choice will be displayed on the LCD and in the viewfinder, both described in the next sections.
- **Movie button.** Press this button to start shooting video; press a second time to stop capture.
- **Speaker.** Sounds emitted by your D3200, including audio during video playback, are emitted from this speaker.

Lens Components

The lens shown at left in Figure 3.23 is a typical lens that might be mounted on the Nikon D3200. It is, in fact, the 18-55mm VR "kit" lens often sold with the camera body. Unfortunately, this particular lens doesn't include all the common features found on the various Nikon lenses available for your camera, so I am including a second lens (shown at right in the figure) that *does* have more features and components. It's not a typical lens that a D3200 user might work with, however. This 17-35mm zoom is a pricey "pro" lens that costs about twice as much as the entire D3200 camera. Nevertheless, it makes a good example. Components found on this pair of lenses include:

- Filter thread. Most lenses have a thread on the front for attaching filters and other add-ons. Some, like the 18-55 VR kit lens, also use this thread for attaching a lens hood (you screw on the filter first, and then attach the hood to the screw thread on the front of the filter). Some lenses, such as the AF-S Nikkor 14-24mm f/2.8G ED lens, have no front filter thread, either because their front elements are too curved to allow mounting a filter and/or because the front element is so large that huge filters would be prohibitively expensive. Some of these front-filter-hostile lenses allow using smaller filters that drop into a slot at the back of the lens.
- Lens hood bayonet. Lenses like the 17-35mm zoom shown in the figure use this bayonet to mount the lens hood. Such lenses generally will have a dot on the edge showing how to align the lens hood with the bayonet mount.
- Focus ring. This is the ring you turn when you manually focus the lens, or fine-tune autofocus adjustment. It's a narrow ring at the very front of the lens (on the 18-55mm kit lens), or a wider ring located somewhere else.
- Focus scale. This is a readout found on many lenses that rotates in unison with the lens's focus mechanism to show the distance at which the lens has been focused. It's a useful indicator for double-checking autofocus, roughly evaluating depth-of-field, and for setting manual focus guesstimates. Chapter 10 deals with the mysteries of lenses and their controls in more detail.
- Zoom setting. These markings on the lens show the current focal length selected.
- Zoom ring. Turn this ring to change the zoom setting.
- Autofocus/Manual switch. Allows you to change from automatic focus to manual focus.
- **Aperture ring.** Some lenses have a ring that allows you to set a specific f/stop manually, rather than use the camera's internal electronic aperture control. An aperture ring is useful when a lens is mounted on a non-automatic extension ring, bellows, or other accessory that doesn't couple electronically with the camera.

Aperture rings also allow using a lens on an older camera that lacks electronic control. In recent years, Nikon has been replacing lenses that have aperture rings with versions that only allow setting the aperture with camera controls.

- **Aperture lock.** If you want your D3200 (or other Nikon dSLR) to control the aperture electronically, you must set the lens to its smallest aperture (usually f/22 or f/32) and lock it with this control. (See Figure 3.23.)
- Focus limit switch. Some lenses have this switch (shown in Figure 3.25), which limits the focus range of the lens, thus potentially reducing focus seeking when shooting distant subjects. The limiter stops the lens from trying to focus at closer distances (in this case, closer than 2.5 meters).
- Vibration reduction switch. Lenses with Nikon's Vibration Reduction (VR) feature include a switch for turning the stabilization feature on and off (Figure 3.24), and, in some cases, for changing from normal vibration reduction to a more aggressive "active" VR mode useful for, say, shooting from moving vehicles. More on VR and other lens topics in Chapter 10.

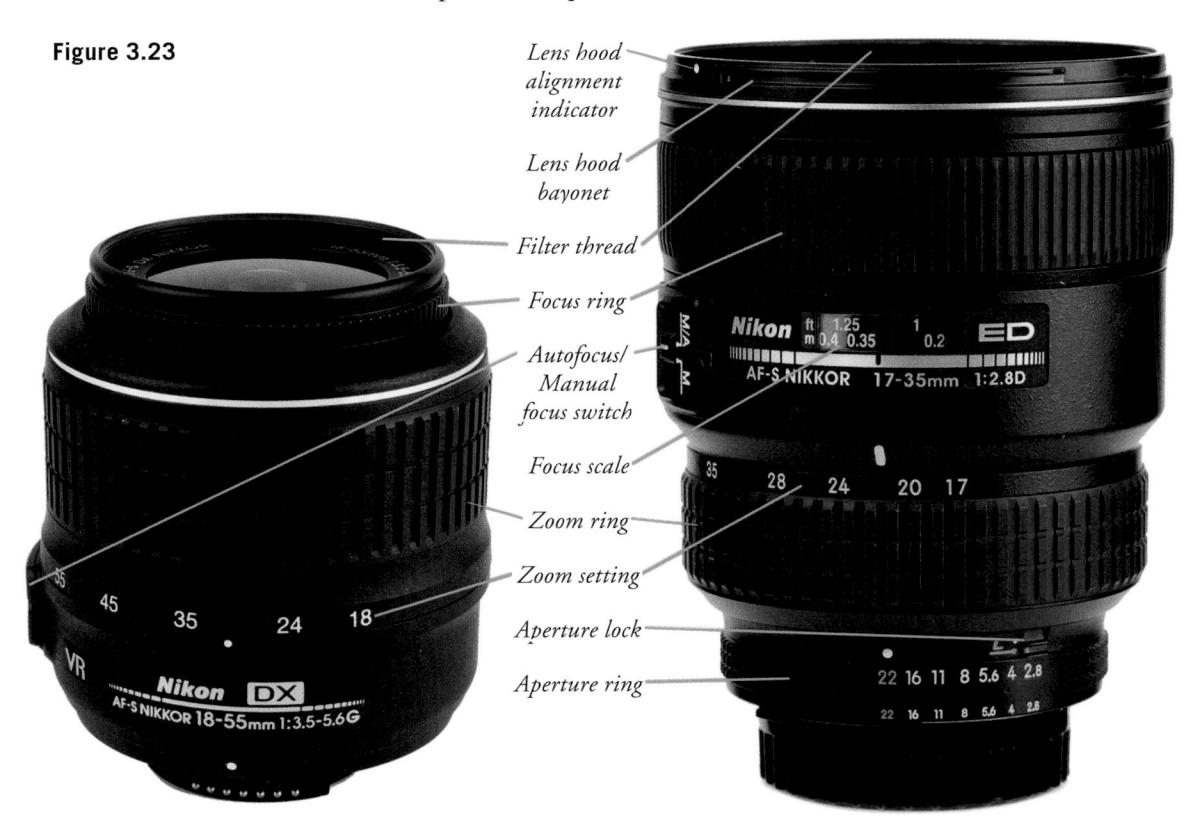

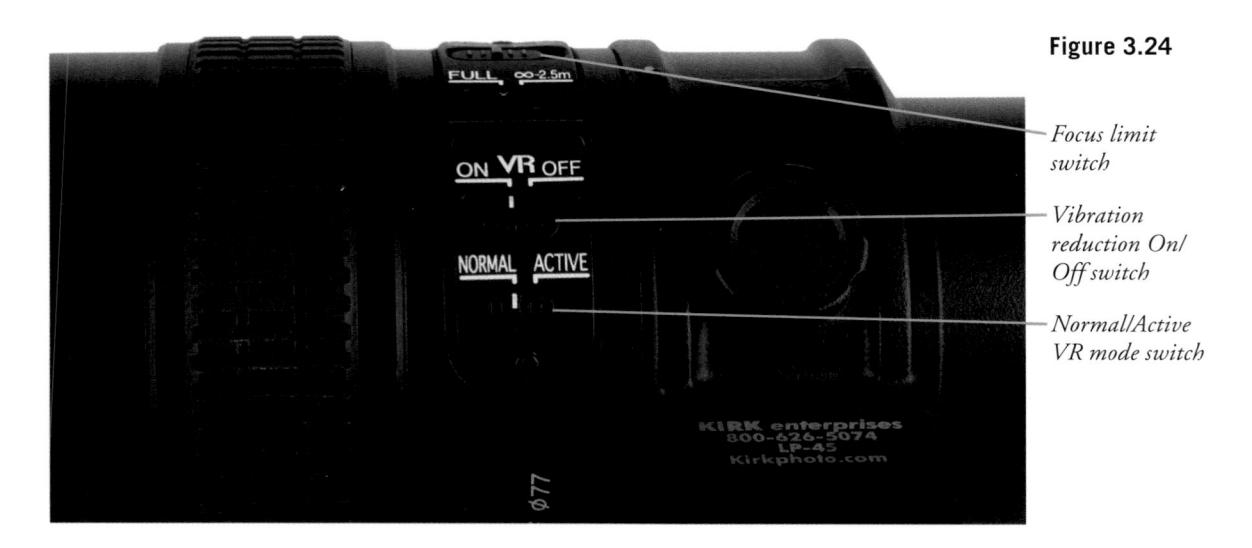

The back end of a lens intended for use on a Nikon camera has other components that you seldom see (except when you swap lenses), shown in Figure 3.25, but still should know about:

■ Lens bayonet mount. This is the mounting mechanism that attaches to a matching mount on the camera. Although the lens bayonet is usually metal, some lenses use a rugged plastic for this key component.

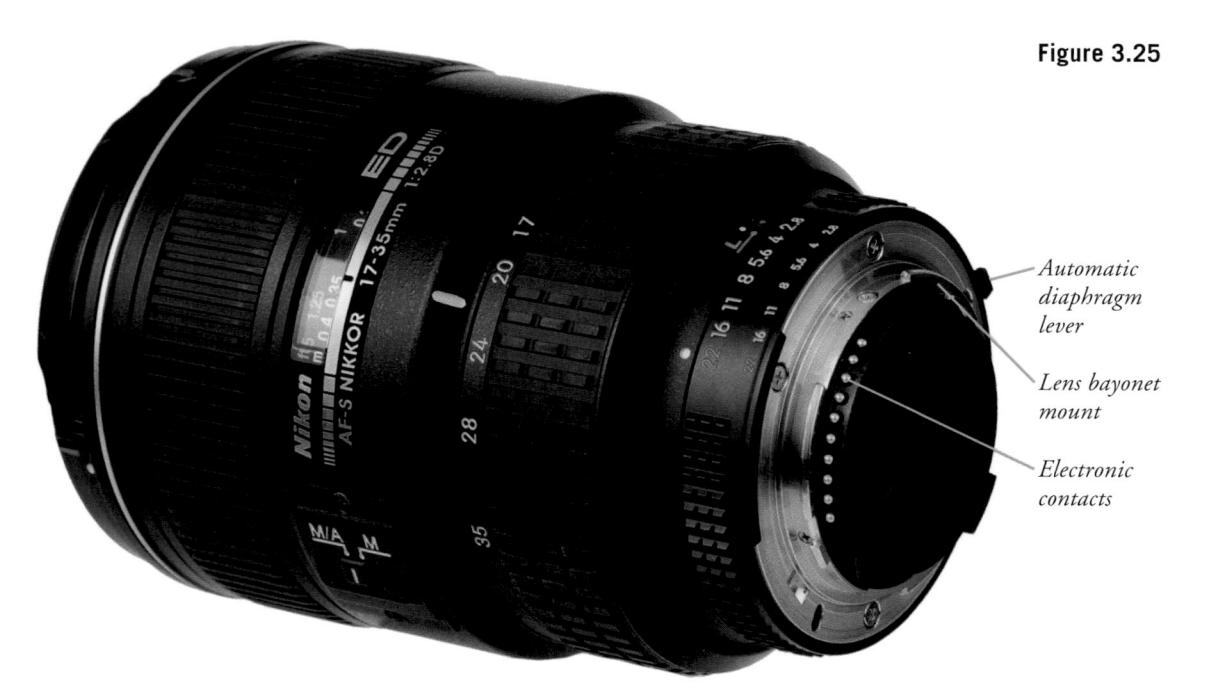

- Automatic diaphragm lever. This lever is moved by a matching lever in the camera to adjust the f/stop from wide open (which makes for the brightest view) to the taking aperture, which is the f/stop that will be used to take the picture. The actual taking aperture is determined by the camera's metering system (or by you when the D3200 is in Manual mode), and is communicated to the lens through the electronic contacts described next. (An exception is when the aperture ring on the lens itself is unlocked and used to specify the f/stop.) However, the spring-loaded physical levers are what actually push the aperture to the selected f/stop.
- Electronic contacts. These metal contacts pass information to matching contacts in the camera body allowing a firm electrical connection so that exposure, distance, and other information can be exchanged between the camera and lens.

Underneath Your Nikon D3200

There's not a lot going on with the bottom panel of your Nikon D3200. You'll find the battery compartment access door and a tripod socket, which secures the camera to a tripod. The socket accepts other accessories, such as flash brackets and quick release plates that allow rapid attaching and detaching of the D3200 from a matching platform affixed to your tripod.

Figure 3.26 shows the underside view of the camera.

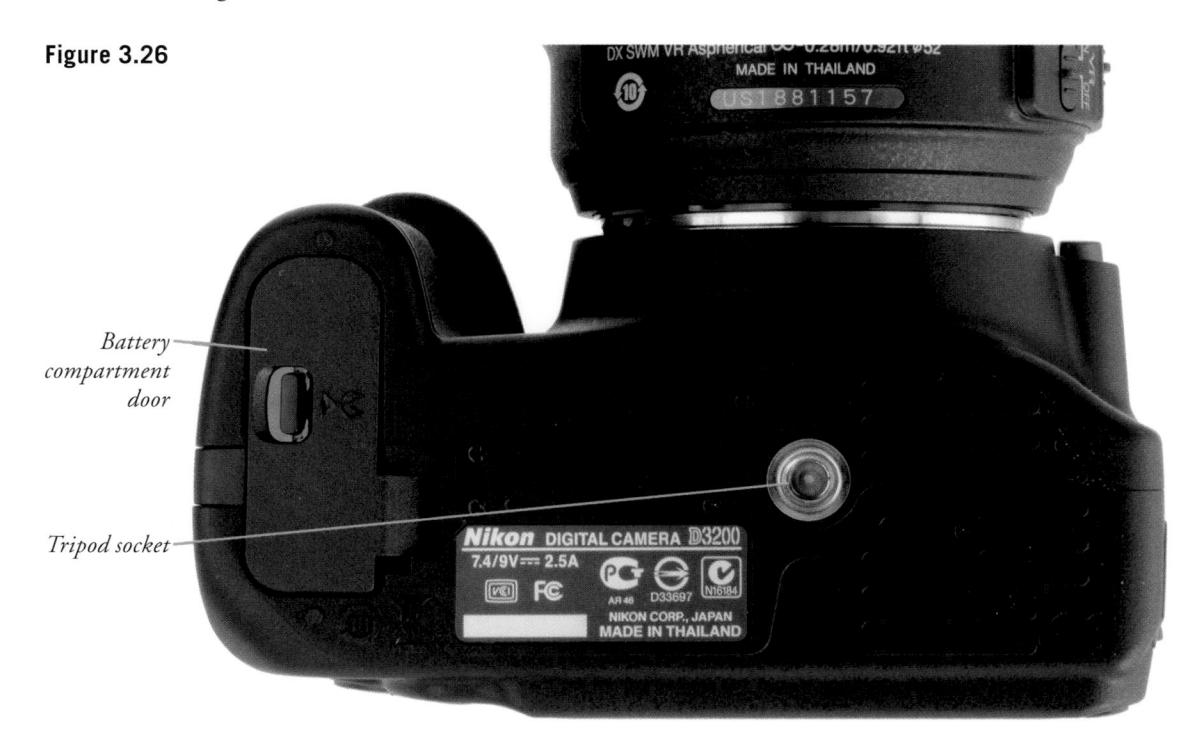

Looking Inside the Viewfinder

Much of the important shooting status information is shown inside the viewfinder of the Nikon D3200. Not all of this information will be shown at any one time. Figure 3.27 shows what you can expect to see. These readouts include:

- Focus points. Can display the 11 areas used by the D3200 to focus. The camera can select the appropriate focus zone for you, or you can manually select one or all of the zones, as described in Chapters 1 and 7.
- Active focus point. The currently selected focus point can be highlighted with red illumination, depending on focus mode.
- Battery indicator. Appears when the D3200's battery becomes depleted. (The current battery condition appears on the LCD, so you're not totally surprised.)

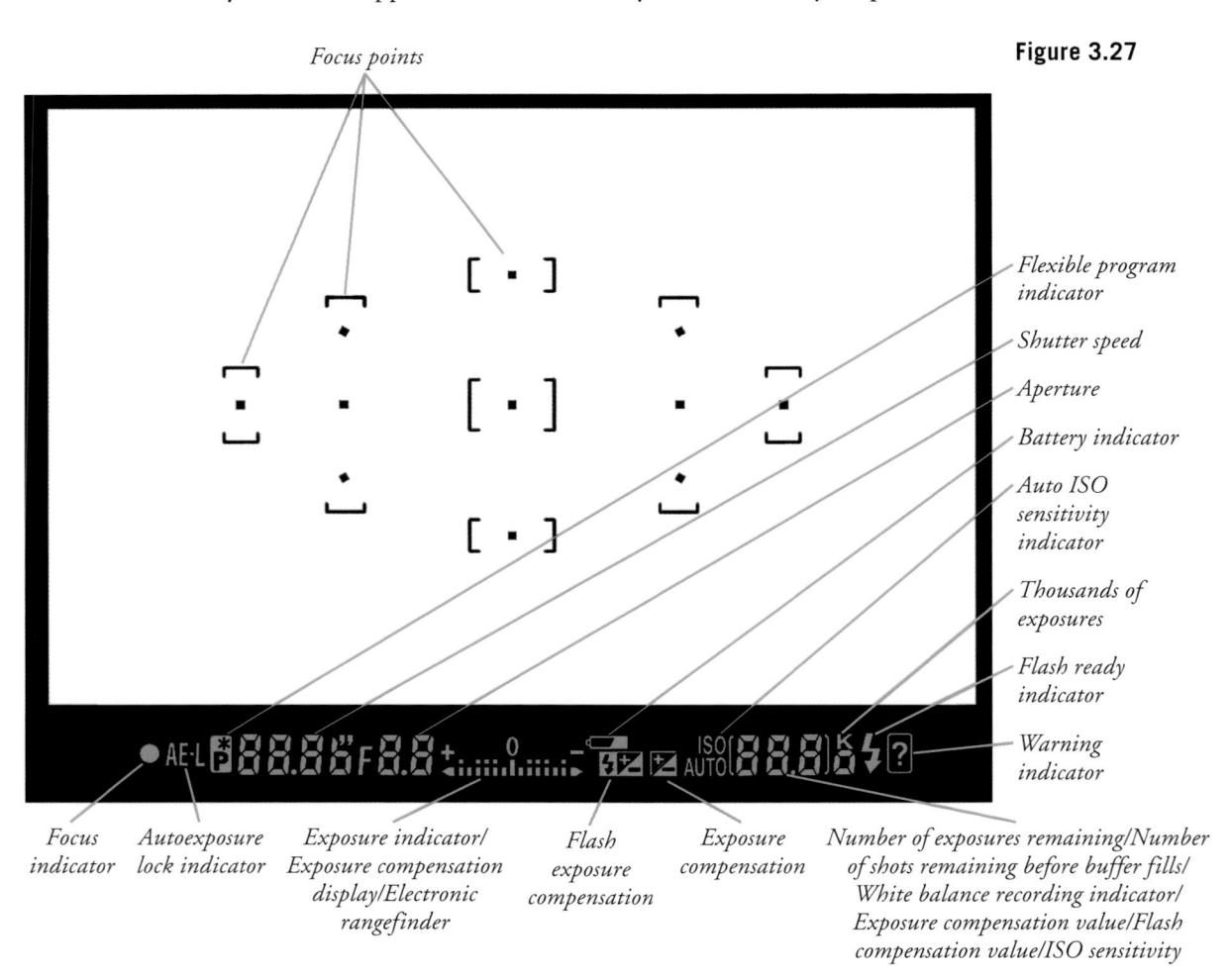

- Focus confirmation indicator. This green dot stops blinking when the subject covered by the active autofocus zone is in sharp focus, whether focus was achieved by the AF system, or by you using manual focusing.
- **Autoexposure lock.** Shows that exposure has been locked.
- **Shutter speed.** Displays the current shutter speed selected by the camera, or by you in Manual exposure mode.
- **Aperture.** Shows the current aperture chosen by the D3200's autoexposure system, or specified by you when using Manual exposure mode.
- Automatic ISO indicator. Shown as a reminder that the D3200 has been set to adjust ISO sensitivity automatically. It flashes when the exposure meters are active as a warning to you that the camera may be adjusting the ISO setting.
- Electronic analog exposure display. This scale shows the current exposure level, with the bottom indicator centered when the exposure is correct as metered. The indicator may also move to the left or right to indicate over- or underexposure (respectively). The scale is also used to show the amount of exposure compensation dialed in.
- Flash compensation indicator. Appears when flash EV changes have been made.
- Exposure compensation indicator. This is shown when exposure compensation (EV) changes have been made. It's easy to forget you've dialed in a little more or less exposure, and then shoot a whole series of pictures of a different scene that doesn't require such compensation. Beware!
- Flash ready indicator. This icon appears when the flash is fully charged.
- Exposures remaining/maximum burst available. Normally displays the number of exposures remaining on your memory card, but while shooting it changes to show a number that indicates the number of frames that can be taken in Continuous shooting mode using the current settings. This indicator also shows other information, such as exposure/flash compensation values, and whether the D3200 is connected to a PC through a USB cable. A question mark indicates an error condition of some sort, such as a full memory card or flash error.

•	

Playback and Shooting Menus

For an entry-level camera, the Nikon D3200 has a remarkable number of options and settings you can use to customize the way your camera operates. Not only can you change shooting settings used at the time the picture is taken, but you can adjust the way your camera behaves. Indeed, if your D3200 doesn't operate in exactly the way you'd like, chances are you can make a small change in the Playback, Shooting, and Setup menus that will tailor the D3200 to your needs.

This chapter will help you sort out the settings for two of the D3200's menus. These are the Playback and Shooting menus, which determine how the D3200 displays images on review, and how it uses many of its shooting features to take a photo. I'll cover the Setup and Retouch menus in Chapter 5.

As I've mentioned before, this book isn't intended to replace the manual you received with your D3200, nor have I any interest in rehashing its contents. You'll still find the original manual useful as a standby reference that lists every possible option in exhaustive (if mind numbing) detail—without really telling you how to use those options to take better pictures. There is, however, some unavoidable duplication between the Nikon manual and this chapter, because I'm going to explain all the key menu choices and the options you may have in using them. You should find, though, that I will give you the information you need in a much more helpful format, with plenty of detail on why you should make some settings that are particularly cryptic.

I'm not going to waste a lot of space on some of the more obvious menu choices in these chapters. For example, you can probably figure out, even without my help, that the

Beep option in the Setup menu with the solid-state beeper in your camera sounds off during various activities (such as the self-timer countdown). You can certainly decipher the import of the two options available for the Beep entry (On and Off). In this chapter, I'll devote no more than a sentence or two to the blatantly obvious settings and concentrate on the more confusing aspects of D3200 setup, such as autofocus. I'll start with an overview of using the D3200's menus themselves.

Anatomy of the Nikon D3200's Menus

For this entry-level camera, Nikon has tried to simplify the menu system, reducing four separate menu listings found in more upscale cameras in the Nikon line (Playback, Shooting, Custom Settings, and Setup) to three. (The Custom Settings menu has been banished, and its options distributed among the three remaining menus.) There are also two "bonus" menus: the Retouch menu, which contains functions you can apply to your images rather than operational options; and the Recent Settings menu, which simply displays the 20 most recent menu items you've accessed. If you've never used a Nikon digital SLR before, this chapter will help you learn how to access and apply all these choices and, most importantly, why you might want to use a particular option or feature. The Nikon D3200's menu lineup is quite sound, and easy to learn.

If you're switching from a previous Nikon dSLR, you *really* need this chapter. As always, in making its menu improvements, Nikon continues to confound long-time users by changing the names of many menu items, shuffling their order, and hiding old favorite options in places you might never think to look. (Entries for redefining Fn button options, the AE-L/AF-L control, and AE lock are now tucked away under a heading called "Buttons," for example.) Nikon must certainly love menu layouts, because it uses so many different versions of them in its various digital SLR cameras, with little consistency beyond family resemblance among them.

If you're lucky enough to be able to work with more than one Nikon camera, you also gain the opportunity to learn several different menu systems in the bargain. It's fortunate that so many menu options are duplicated in the information edit screen, because you can make many settings there and avoid the Lewis Carroll-like trip through Menuland entirely.

The MENU button and basic operation of the D3200's menus are simple. Press the MENU button, located second from the top at the left side of the LCD. The menus consist of a series of five separate screens with rows of entries, as shown in Figure 4.1. (Note that when the D3200 is set to the green Auto icon on the mode dial, or Scene modes, some menu choices are not available.)

There are three columns of information in each menu screen.

- The left-hand column includes an icon representing each of the top-level menu screens. From the top in Figure 4.1, they are Playback (right-pointing triangle icon), Shooting (camera icon), Setup (wrench), Retouch (a paintbrush), and Recent Settings (a tabbed page), with Help access represented by a question mark at the bottom of the column.
- The center column includes the name representing the function of each choice in the currently selected menu. For example, Delete represents the menu entry for removing individual photos or multiple images, while Print Set (DPOF) indicates the menu entry used for choosing photos for printing.
- The right-hand column has an icon or text that shows either the current setting for that menu item or text or an icon which represents the function of that menu entry. In Figure 4.1, a trash can icon shows that you can use the Delete entry for removing images, while the text OFF appears next to the Rotate Tall entry, indicating that the D3200 has been set to *not* rotate vertical images on the LCD.

Figure 4.1

The most recently accessed menu appears when you press the MENU button.

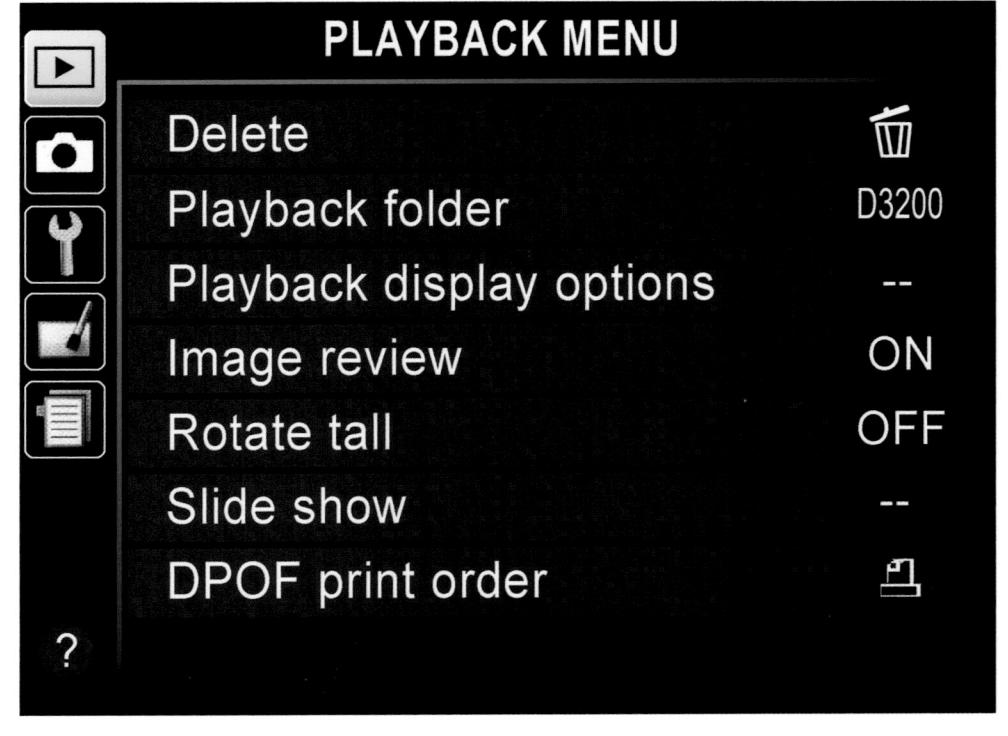

Navigating among the various menus is easy and follows a consistent set of rules.

- **Press MENU** to start. Press the MENU button to display the main menu screens.
- Navigate with the multi selector pad. The multi selector pad, located to the right of the LCD, has indents at the up/down/left/right positions. Press these "buttons" to navigate among the menu selections. Press the left button to move highlighting to the left column; then press the up/down buttons to scroll up or down among the five top-level menus.
- Highlighting indicates active choice. As each top-level menu is highlighted, its icon will first change from black-and-white to yellow/amber, white, and black. As you use the multi selector's right button to move into the column containing that menu's choices, you can then use the up/down buttons to scroll among the individual entries. If more than one screen full of choices is available, a scroll bar appears at the far right of the screen, with a position slider showing the relative position of the currently highlighted entry.
- Select a menu item. To work with a highlighted menu entry, press the OK button in the center of the multi selector on the back of the D3200 or just press the right button on the multi selector. Any additional screens of choices will appear, like the one you can see in Figure 4.2. You can move among them using the same multi selector movements.
- Choose your menu option. You can confirm a selection by pressing the OK button or, frequently, by pressing the right button on the multi selector once again. Some functions require scrolling to a Done menu choice, or include an instruction to set a choice using some other button.
- Leaving the menu system. Pressing the multi selector left button usually backs you out of the current screen, and pressing the MENU button again usually does the same thing. You can exit the menu system at any time by tapping the shutter release button. If you haven't confirmed your choice for a particular option, no changes will be made.
- Quick return. The Nikon D3200 "remembers" the top-level menu and specific menu entry you were using (but not any submenus) the last time the menu system was accessed (even if you have subsequently turned the camera off), so pressing the MENU button brings you back to where you left off.

The top-level menus are color coded, and a bar in that color is displayed underneath the menu title when one of those menus is highlighted. The colors are Playback menu (blue); Shooting menu (green); Setup menu (orange); Retouch menu (purple); and Recent Settings (gray).

Playback Menu Options

The blue-coded Playback menu has seven entries used to select options related to the display, review, and printing of the photos you've taken. The choices you'll find include:

- Delete
- Playback Folder
- Playback Display Options
- Image Review

- Rotate Tall
- Slide Show
- DPOF Print Order

Delete

Choose this menu entry and you'll be given three choices: Selected, Select Date, and All. If you choose Selected, you'll see an image selection screen like the one shown in Figure 4.2. Then, follow these instructions:

- 1. **Review thumbnails.** Use the multi selector up/down/left/right buttons to scroll among the available images.
- 2. **Examine image.** When you highlight an image you think you might want to delete, press the Zoom In button to temporarily enlarge that image so you can evaluate it further. When you release the button, the selection screen returns.

Figure 4.2 Images selected for deletion are marked with a trash can icon.

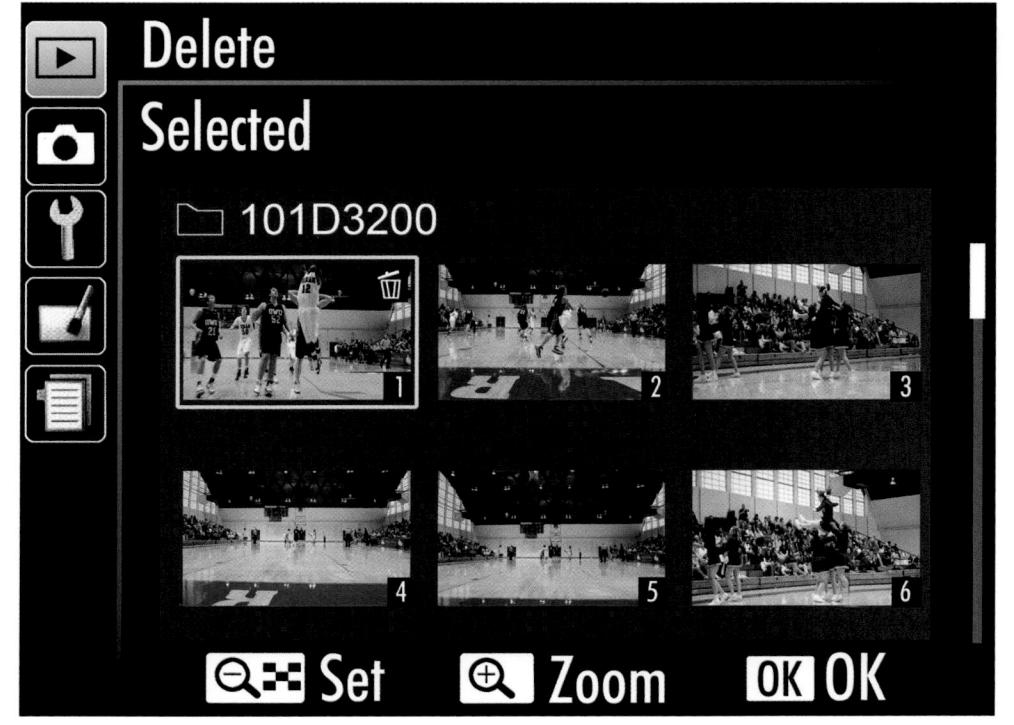

- 3. Mark/unmark images. To mark an image for deletion, press the Zoom Out/ Thumbnail button (not the Trash button). A trash can icon will appear overlaid on that image's thumbnail. To unmark an image, press the Zoom Out/Thumbnail button again.
- 4. **Remove images.** When you've finished marking images to delete, press OK. A final screen will appear asking you to confirm the removal of the image(s). Choose Yes to delete the image(s) or No to cancel deletion, and then press OK. If you selected Yes, then you'll return to the Playback menu; if you chose No, you'll be taken back to the selection screen to mark/unmark images.
- 5. To back out of the selection screen, press the MENU button.

Tip

Using the Delete menu option to remove images will have no effect on images that have been marked as protected with the Protect key.

Keep in mind that deleting images through the Delete process is slower than just wiping out the whole card with the Format command, so using Format is generally much faster than choosing Delete: All, and also is a safer way of returning your memory card to a fresh, blank state.

Playback Folder

Images created by your Nikon D3200 are deposited into folders on your memory card. These folders have names like 100D3200 or 101D3200, but you can change those default names to something else using the Folders option in the Setup menu, described later in Chapter 5.

With a freshly formatted memory card (formatting is covered under the Setup menu), the D3200 starts with a default name: 100D3200. When that folder fills with the maximum of 999 images, the camera automatically creates a new folder numbered one higher, such as 101D3200. If you use the same memory card in another camera, that camera will also create its own folder (say, 102NCD40 for a Nikon D40). Thus you can end up with several folders on the same memory card, at least one for each camera the card is used in, until you eventually reformat the card and folder creation starts anew. In Chapter 5, in the section on the Setup menu, I'll show you how to create folders with names you select yourself using the Storage Folder option.

This menu item allows you to choose which folders are accessed when displaying images using the D3200's Playback facility.

Your choices are as follows:

- Current. The D3200 will display only images in the current Active Folder, as specified in the Setup menu. For example, if you have been shooting heavily at an event and have already accumulated more than 999 shots and the D3200 has created a new folder for the overflow, you'd use this setting to view only the most recent photos, which reside in that new current folder. You can change the current folder to any other specific folder on your memory card using the Active Folder option in the Setup menu, described in Chapter 5.
- All. All folders containing images that the D3200 can read will be accessed, regardless of which camera created them. You might want to use this setting if you swap memory cards among several cameras and want to be able to review all the photos. You will be able to view images even if they were created by a non-Nikon camera if those images conform to a specification called the Design Rule for Camera File systems (DCF).

Playback Display Options

You'll recall from Chapter 2 that a great deal of information, available on multiple screens, can be displayed when reviewing images. This menu item helps you reduce/increase the clutter by specifying which information and screens will be available.

The submenu that appears has two options. The first is Additional Photo Info. The former presents you with a screen of possible display screens, which I showed you in the previous chapter. You can scroll among the options and select from None (image only); Highlights; RGB Histogram; Shooting Data (three different screens, plus GPS data if applicable); and Overview.

To activate or deactivate an info option, scroll to that option and press the right multi selector button to add a check mark to the box next to that item. Press the right button to unmark an item that has previously been checked. **Important:** when you're finished, you must scroll up to Done and press OK or the right multi selector button to confirm your choices. Exiting the Display mode menu any other way will cause any changes you may have made to be ignored.

The second option is Transitional Effects. It's pretty cool from a visual standpoint, but not essential to operating your camera. You can choose how the D3200 moves from one playback image to the next, selecting from Slide In, Zoom/Fade, and Off (which uses the boring old default method of simply replacing one image with another). The transitions look nifty and don't cost you anything, so you might want to try them out.

Image Review

There are certain shooting situations in which it's useful to have the picture you've just shot pop up on the LCD automatically for review. Perhaps you're fine-tuning exposure or autofocus and want to be able to see whether your most recent image is acceptable. Or, maybe you're the nervous type and just want confirmation that you actually took a picture. Instant review has saved my bacon a few times; for example, when I was shooting with studio flash in Manual mode and didn't notice that the shutter speed had been set to a (non-syncing) 1/320th second by mistake.

A lot of the time, however, it's a better idea to *not* automatically review your shots in order to conserve battery power (the LCD is one of the major juice drains in the camera) or to speed up or simplify operations. For example, if you've just fired off a burst of eight shots at 3 fps during a football game do you *really* need to have each and every frame displayed as the D3200 clears its buffer and stores the photos on your memory card? Or, when you're shooting at an acoustic concert, wouldn't it be smart to disable image review so the folks behind you aren't hit with a blast of light from that luminous 3-inch LCD every time you take a picture? This menu operation allows you to choose which mode to use:

- On. At this default setting, image review is automatic after every shot is taken.
- Off. Images are displayed only when you press the Playback button.

Rotate Tall

When you rotate the D3200 to photograph vertical subjects in portrait (tall), rather than landscape (wide) orientation, you probably don't want to view them tilted onto their sides later on, either on the camera LCD or within your image viewing/editing application on your computer. The D3200 is way ahead of you. It has a directional sensor built in that can detect whether the camera was rotated when the photo was taken and hide this information in the image file itself.

The orientation data is applied in two different ways. It can be used by the D3200 to automatically rotate images when they are displayed on the camera's LCD monitor, or you can ignore the data and let the images display in non-rotated fashion (so you have to rotate the camera to view them in their proper orientation). Your image-editing application, such as Adobe Photoshop Elements, can also use the embedded file data to automatically rotate images on your computer screen.

But either feature works only if you've told the D3200 to place orientation information in the image file so it can be retrieved when the image is displayed. You must set Auto Image Rotation to On in the Setup menu. (I'll show you how to do that later in this chapter.) Once you've done that, the D3200 will embed information about orientation in the image file, and both your D3200 and your image editor can rotate the images for you as the files are displayed.

This menu choice deals only with whether the image should be rotated when displayed on the *camera LCD monitor*. (If you de-activate this option, your image-editing software can still read the embedded rotation data and properly display your images.) When Rotate Tall is turned off, the Nikon D3200 does not rotate pictures taken in vertical orientation, displaying them as shown in Figure 4.3. The image is large on your LCD screen, but you must rotate the camera to view it upright.

When Rotate Tall is turned on, the D3200 rotates pictures taken in vertical orientation on the LCD screen so you don't have to turn the camera to view them comfortably. However, this orientation also means that the longest dimension of the image is shown using the shortest dimension of the LCD, so the picture is reduced in size, as you can see in Figure 4.3.

So, turn this feature On (as well as Auto Image Rotation in the Setup menu), if you'd rather not turn your camera to view vertical shots in their natural orientation, and don't mind the smaller image. Turn the feature Off if, as I do, you'd rather see a larger image and are willing to rotate the camera to do so.

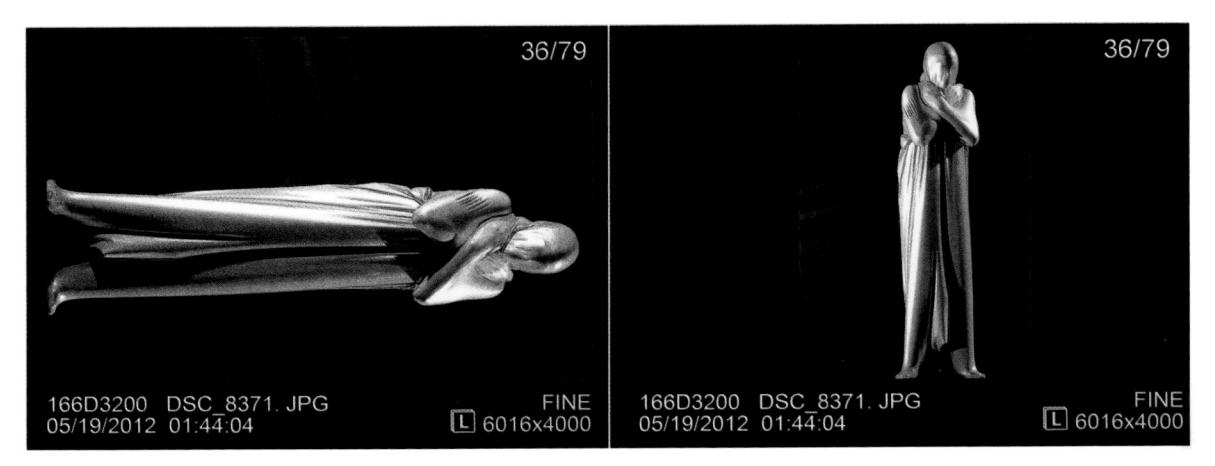

Figure 4.3 With Rotate Tall turned off (left), vertical images appear large on the LCD, but you must turn the camera to view them upright. With Rotate Tall turned on (right), vertical images are shown in a smaller size, but oriented for viewing without turning the camera.

Slide Show

The D3200's Slide Show feature is a convenient way to review images in the current playback folder one after another, without the need to manually switch between them. To activate, just choose Start from this entry in the Playback menu. If you like, you can choose Frame Interval before commencing the show in order to select an interval of either 2, 3, 5, or 10 seconds between "slides." A third choice, Transition Effects, allows you to specify what happens when the camera switches from one image to the next. You can select Zoom/fade, Cube, or None.

During playback, you can press the OK button to pause the "slide show" (in case you want to examine an image more closely). When the show is paused, a menu pops up, as shown in Figure 4.4, with choices to restart the show (by pressing the OK button again); change the interval between frames; modify the transition effects; or to exit the show entirely.

As the images are displayed, press the up/down multi selector buttons to change the amount of information presented on the screen with each image. For example, you might want to review a set of images and the settings used to shoot them. At any time during the show, press the up/down buttons until the informational screen you want is overlaid on the images.

As the slide show progresses, you can press the left/right multi selector buttons to move back to a previous frame or jump ahead to the next one. The slide show will then proceed as before. Press the MENU button to exit the slide show and return to the menu, or the Playback button to exit the menu system totally. As always, while reviewing images, you can tap the MENU button to exit the show and return to the menus, or tap the shutter release button if you want to remove everything from the screen and return to shooting mode.

Figure 4.4
Press the OK
button to pause
the slide show,
change the
interval
between slides,
modify transition effects, or
to exit the
presentation.
At the end of the slide show, as when you've paused it, you'll be offered the choice of restarting the sequence, changing the frame interval, or exiting the slide show feature completely.

DPOF Print Order

You can print directly from your camera to a printer compatible with a specification called *PictBridge* (most recent printers are, and have a connector for that mode). You can also move your memory card and give it to your retailer for printing in their lab or in-store printing machine, or insert the card into a stand alone picture kiosk and make prints yourself. In all these cases, you can easily specify exactly which photos you want printed, and how many copies you'd like of each picture. This menu item does all the work for you.

The Nikon D3200 supports the DPOF (Digital Print Order Format) that is now almost universally used by digital cameras to specify which images on your memory card should be printed, and the number of prints desired of each image. This information is recorded on the memory card and can be interpreted by a compatible printer when the camera is linked to the printer using the USB cable, or when the memory card is inserted into a card reader slot on the printer itself. Photo labs and stand alone kiosks are also equipped to read this data and make prints when you supply your memory card to them.

When you choose this menu item, you're presented with a set of screens that looks very much like the Delete Photos screens described earlier (I used the same set of example pictures for the illustration), only you're selecting pictures for printing rather than deleting. The first screen you see when you choose Print Set (DPOF) asks if you'd like to Select/Set pictures for printing, or Deselect All? images that have already been marked.

Choose Select/Set to choose photos and specify how many prints of each you'd like. Choose Deselect All? to cancel any existing print order and start over. If you want to select photos for printing, follow these steps when the screen shown in Figure 4.5 appears:

- 1. **View images on your card.** Use the multi selector left/right/up/down keys to scroll among the available images.
- 2. Evaluate specific photos. When you highlight an image you might want to print, press the Zoom In button to temporarily enlarge that image so you can evaluate it further. When you release the button, the selection screen returns.
- 3. Mark images for printing and specify number of copies. To mark a highlighted image for printing, hold down the Zoom Out/Thumbnail button and press the multi selector up/down buttons to choose the number of prints you want, up to 99 per image. The up button increases the number of prints; the down button decreases the amount. A printer icon and the number specified will appear overlaid on that image's thumbnail.

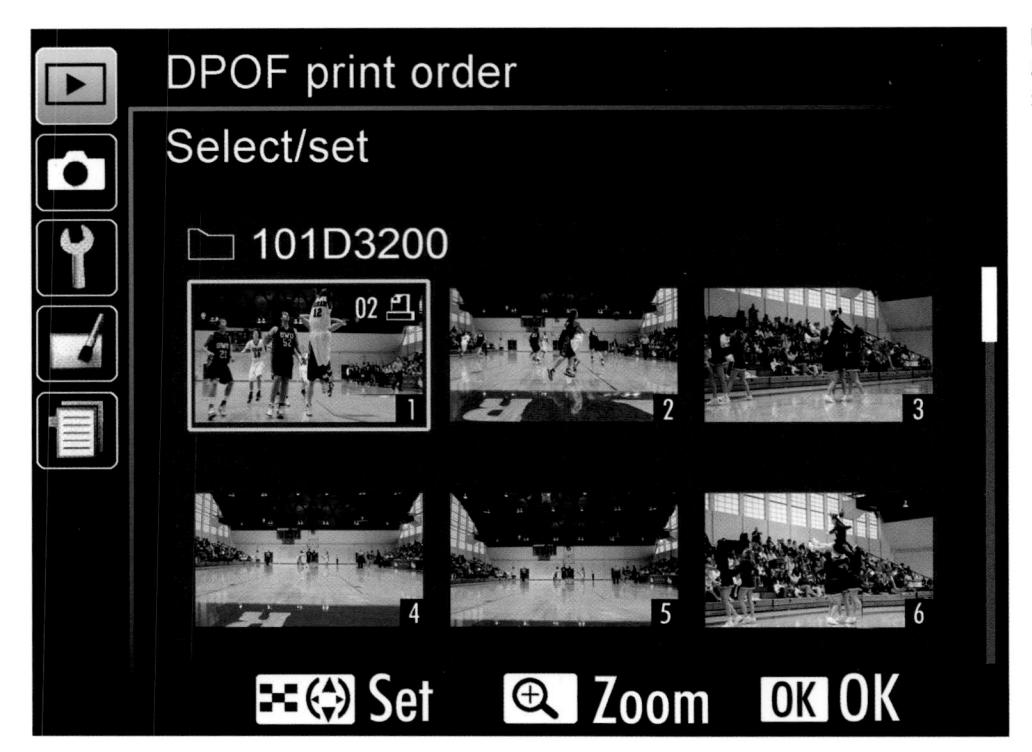

Figure 4.5Select images for printing.

- 4. **Unmark images if you change your mind.** To unmark an image for printing, highlight and hold the Zoom Out/Thumbnail button while pressing the down button until the number of prints reaches zero. The printer icon will vanish.
- 5. **Finish selecting and marking images.** When you've finished marking images to print, press OK.
- 6. **Specify date or shooting information on the print.** A final screen will appear in which you can request a data imprint (shutter speed and aperture) or imprint date (the date the photos were taken). Use the up/down buttons to select one or both of these options, if desired, and press the left/right buttons to mark or unmark the check boxes. When a box is marked, the imprint information for that option will be included on the face of *all* prints in the print order.
- 7. **Exit the Print Set screens.** Scroll up to Done when finished, and press OK or the right cursor button.

Shooting Menu Options

This concise menu has fifteen settings, and only three of them—Reset Shooting Options, Color Space, and AF-Assist—aren't duplicated on the information edit screen. These are likely to be the most frequently accessed settings changes you make, with

changes made to one or more of them during a particular session fairly common. You might make such adjustments as you begin a shooting session, or when you move from one type of subject to another. Nikon makes accessing these changes easiest through the information edit screen, and I recommend that method for making changes to the 12 entries duplicated there. You can readily see the current settings for any of these—and the other settings visible on the shooting information screen—and then press the information edit button, use the multi selector directional buttons to navigate to the entry you want to use, press OK, and make your change in a few seconds. Using the equivalent Shooting menu entries usually takes a little longer.

This section explains the options of the Shooting menu and how to use them. The options you'll find in these green-coded menus include:

- Reset Shooting Options
- Set Picture Control
- Image Quality
- Image Size
- White Balance

- ISO Sensitivity
- Active D-Lighting
- Auto Distortion Control
- Color Space
- Noise Reduction

- AF-Area Mode
- Built-in AF-Assist Illuminator
- Metering
- Movie Settings
- Flash Cntrl for Built-in Flash

Figure 4.6

Common shooting settings can be changed in this menu.

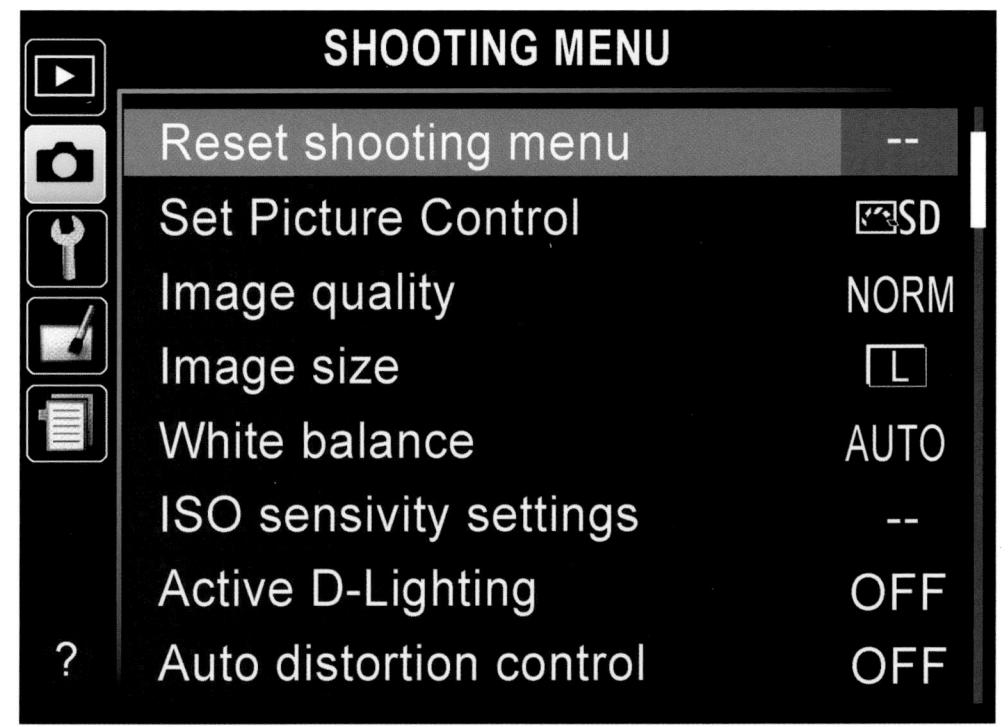

Reset Shooting Options

If you select Yes, the Shooting menu settings shown in Table 4.1 will be set to their default values. It has no effect on the settings in other menus, or any of the other camera settings.

You'd want to use this Reset option when you've made a bunch of changes (say, while playing around with them as you read this chapter), and now want to put them back to the factory defaults. Your choices are Yes and No.

Table 4.1 Values Reset	
Setting	Default Value
Picture Controls	Varies by Picture Control
Release Mode	Single Frame, all modes except Sports Continuous, Sports mode
Focus Point	Center
Flexible Program	Off
AE-L/AF-L Hold	Off
Focus Mode Viewfinder; Live View/Movie	Auto-servo AF; Single-servo AF
Flash Modes	Front Curtain Sync for Program, Aperture-priority, Shutter-priority, Manual modes; Auto Front Curtain Sync for Auto, Portrait, Child, Close-Up; Slow Sync for Night Portrait
Exposure Compensation	Off
Flash Compensation	Off

Set Picture Control

The pictures you take with your D3200 can be individually fine-tuned in an image editor, of course, but you can also choose certain kinds of adjustments that are made to every picture, as you shoot, using the camera's Picture Controls options. While there are only six predefined styles offered: (Standard, Neutral, Vivid, Monochrome, Portrait, and Landscape), you can *edit* the settings of any of those styles (but not rename them) so they better suit your taste.

In Set Picture Controls, available only in P, S, A, and M modes, choose from one of the predefined styles and follow these steps:

1. Choose Set Picture Control from the Shooting menu. The screen shown in Figure 4.7 appears. Note that Picture Controls that have been modified from their standard settings have an asterisk next to their name.

Figure 4.7 Set Picture Control You can choose from the six predefined SD Standard* Picture Controls. Neutral MC Monochrome Original Picture Controls T Portrait 🗠 LS Landscape Grid Indicates Press Zoom In Press multi selector custom to view grid right button to adjust setting highlighted style

- 2. Scroll down to the Picture Control you'd like to use.
- 3. Press OK to activate the highlighted style. (Although you can usually select a menu item by pressing the multi selector right button; in this case, that button activates editing instead.)
- 4. Press the MENU button or tap the shutter release to exit the menu system.

Editing a Picture Control Style

You can change the parameters of any of Nikon's predefined Picture Controls. You are given the choice of using the quick adjust/fine-tune facility to modify a Picture Control with a few sliders, or to view the relationship of your Picture Controls on a grid. To

make quick adjustments to any Picture Control except the Monochrome style, follow these steps:

- 1. Choose Set Picture Control from the Shooting menu.
- 2. Scroll down to the Picture Control you'd like to edit.
- 3. Press the multi selector right button to produce the adjustment screen shown in Figure 4.8.
- 4. Use the Quick Adjust slider to exaggerate the attributes of the Standard, Vivid, Portrait, or Landscape styles (Quick Adjustments are not available with other predefined styles).
- 5. Scroll down to the Sharpening, Contrast, Saturation, and Hue sliders with the multi selector up/down buttons, then use the left/right buttons to decrease or increase the effects. A line will appear under the original setting in the slider whenever you've made a change from the defaults.
- 6. Instead of making changes with the slider's scale, you can move the cursor to the far left and choose A (for auto) instead when working with the Sharpening, Contrast, and Saturation sliders. The D3200 will adjust these parameters automatically, depending on the type of scene it detects.

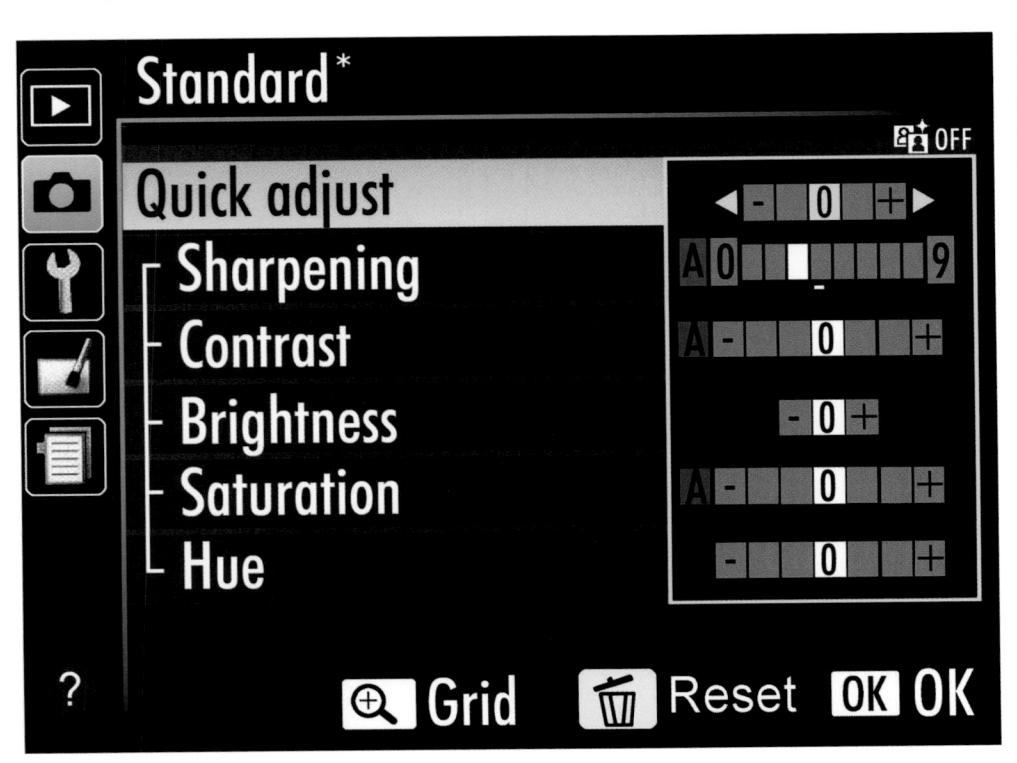

Figure 4.8 Sliders can be used to make quick adjustments to your Picture Control styles.

- 7. Press the Trash button to reset the values to their defaults.
- 8. Press the Zoom In button to view an adjustment grid (discussed next).
- 9. Press OK when you're finished making adjustments.

Editing the Monochrome style is similar, except that the parameters differ slightly. Sharpening and Contrast are available, but instead of Saturation and Hue, you can choose a filter effect (Yellow, Orange, Red, Green, or none) and choose a toning effect (black-and-white, plus seven levels of Sepia, Cyanotype, Red, Yellow, Green, Blue Green, Blue, Purple Blue, and Red Purple). (Keep in mind that once you've taken a JPEG photo using a Monochrome style, you can't convert the image back to full color. Shoot using RAW+JPEG, and you'll get a monochrome JPEG, plus the RAW file that retains all the color information.)

When you press the Zoom In button, a grid display, like the one shown in Figure 4.9, appears showing the relative contrast and saturation of each of the predefined Picture Controls. Because the values for autocontrast and autosaturation may vary, the icons for any Picture Control that uses the Auto feature will be shown on the grid in green, with lines extending up and down from the icon to tip you off that the position within the coordinates may vary from the one shown.

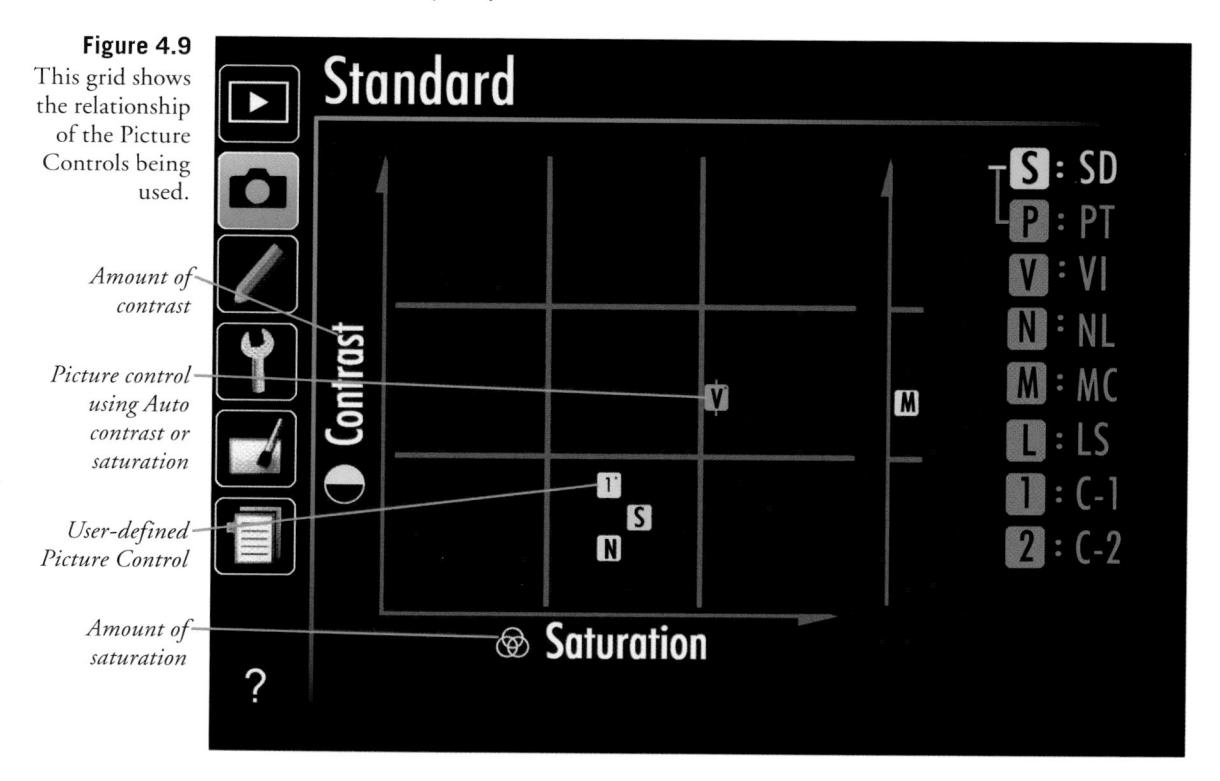

FILTERS VS. TONING

Although some of the color choices seem to overlap, you'll get very different looks when choosing between Filter Effects and Toning. Filter Effects add no color to the monochrome image. Instead, they reproduce the look of black-and-white film that has been shot through a color filter. That is, Yellow will make the sky darker and the clouds will stand out more, while Orange makes the sky even darker and sunsets more full of detail. The Red filter produces the darkest sky of all and darkens green objects, such as leaves. Human skin may appear lighter than normal. The Green filter has the opposite effect on

Figure 4.10
No filter (upper left); Yellow filter (upper right); Green filter (lower left); and Red filter (lower right).

leaves, making them appear lighter in tone. Figure 4.10 shows the same scene shot with no filter, then Yellow, Green, and Red filters.

The Sepia, Blue, Green, and other toning effects, on the other hand, all add a color cast to your monochrome image. Use these when you want an old-time look or a special effect, without bothering to recolor your shots in an image editor. You can see toning effects in Figure 4.11.

Figure 4.11

Sepia
(upper left);
Blue
(upper right);
Green
(lower right);
and Purple
(lower left).

Each of these provides varying amounts of five different attributes: sharpness, contrast, color mode, saturation, and hue. The individual parameters affect your images in various ways.

- **Sharpness.** This affects the contrast of the edges or outlines of your image, making a photo look more or less sharp.
- Contrast. This factor affects an attribute called *tone compensation*, which controls whether detail is visible or lost in the brightest areas and darkest areas of your image. An image with high contrast shows less detail in the highlights and shadows, but produces a more dramatic appearance. A lower contrast image has more detail in those areas, but, if contrast is too low, the image may appear to be flat and dull.
- **Saturation.** The richness of the colors is determined by the saturation setting. For example, a deep red rose is fully saturated, while one that appears more pinkish is still, technically, red, but the color is less saturated and more muted.
- **Hue.** Think of hue as rotating all the colors in an image around a color wheel. Positive hue adjustments bias reds toward the orange end of the spectrum, greens more towards the blue, and blues become purplish. Going the other way around the wheel, reds become more purple, blues more green, and greens more yellow.

Image Quality

You can choose the image quality settings used by the D3200 to store its files. The quickest way to do that is with the information edit screen. You can also use this menu option, if you prefer. There is no real advantage to using this menu instead of the information edit screen. You have two choices to make:

- Level of JPEG compression. To reduce the size of your image files and allow more photos to be stored on a given memory card, the D3200 uses JPEG compression to squeeze the images down to a smaller size. This compacting reduces the image quality a little, so you're offered your choice of Fine (a 1:4 reduction), Normal (1:8 reduction), and Basic (1:16) compression. You can see examples of the results of compression in Figure 4.12. I'll explain more about JPEG compression later in this section.
- JPEG, RAW, or both. You can elect to store only JPEG versions of the images you shoot, or you can save your photos as RAW images, which Nikon calls NEF, for Nikon Electronic Format files. RAW images consume more than twice as much space on your memory card. Or, you can store both RAW and a JPEG Basic file at once as you shoot. Many photographers elect to save *both* JPEG and a RAW, so they'll have a JPEG Basic version that might be usable as-is, as well as the original "digital negative" RAW file in case they want to do some processing of the image later. You'll end up with two different versions of the same file: one with a .jpg extension, and one with the .nef extension that signifies a Nikon RAW file.

Figure 4.12
JPEG compression yields little image quality loss (top); extreme compression produces visible loss of detail (bottom).

To choose the combination you want, access the Shooting menu, scroll to Image Quality, and select it by pressing OK or the multi selector right button. Scroll to highlight the setting you want, and either press OK or push the multi selector right button to confirm your selection.

In practice, you'll probably use the JPEG Fine or NEF (RAW)+JPEG Fine selections most often, although beginners concerned about squeezing many images onto a card, or who display them only online may prefer a more compact JPEG setting. Why so many choices, then? There are some advantages to using the JPEG Normal and JPEG Basic settings. Settings that are less than max allow stretching the capacity of your memory card so you can shoehorn quite a few more pictures onto a single memory card. That can come in useful when on vacation and you're running out of storage, or when you're shooting non-critical work that doesn't require 24 megapixels of resolution (such as photos taken for real estate listings, web page display, photo ID cards, or similar applications). Some photographers like to record RAW+JPEG Basic so they'll have a moderate quality JPEG file for review only and no intention of using for editing purposes, while retaining access to the original RAW file for serious editing.

For most work, using lower resolution and extra compression is false economy. You never know when you might actually need that extra bit of picture detail. Your best bet is to have enough memory cards to handle all the shooting you want to do until you have the chance to transfer your photos to your computer or a personal storage device.

However, reduced image quality can sometimes be beneficial if you're shooting sequences of photos rapidly, as the D3200 is able to hold more of them in its internal memory buffer before transferring to the memory card. Still, for most sports and other applications, you'd probably rather have better, sharper pictures than longer periods of continuous shooting. Do you really need 10 shots of a pass reception in a football game, or six slightly different versions of your local basketball star driving in for a lay-up?

JPEG vs. RAW

You'll sometimes be told that Nikon's NEF or RAW files are the "unprocessed" image information your camera produces, before it's been modified. That's nonsense. RAW files are no more unprocessed than camera film is after it's been through the chemicals to produce a negative or transparency. Your digital image undergoes a significant amount of processing before it is saved as a RAW file.

A RAW file is more similar to a film camera's processed negative. It contains all the information captured by the sensor, but with no sharpening and no application of any special filters or other settings you might have specified when you took the picture. Those settings are *stored* with the RAW file so they can be applied when the image is converted to a form compatible with your favorite image editor. However, using RAW conversion software such as Adobe Camera Raw or Nikon Capture NX, you can override those settings and apply settings of your own. You can select essentially the same changes there that you might have specified in your camera's picture-taking options.

RAW exists because sometimes we want to have access to all the information captured by the camera, before the camera's internal logic has processed it and converted the image to a standard file format. RAW doesn't save as much space as JPEG. What it does do is preserve all the information captured by your camera after it's been converted from analog to digital form.

So, why don't we always use RAW? Some photographers avoid using Nikon's RAW NEF files on the misguided conviction that they don't want to spend time in an image editor. But, if your basic settings are okay, such work is *optional*, and needs to be applied only when a particular image needs to be fine-tuned.

Although some photographers do save *only* in RAW format, it's common to use RAW+JPEG Fine, or, if you're confident about your settings, just shoot JPEG and eschew RAW altogether. In some situations, working with a RAW file can slow you down a little. RAW images take longer to store on the memory card, and must be converted from RAW to a format your image editor can handle, whether you elect to go

with the default settings in force when the picture was taken, or make minor adjustments to the settings you specified in the camera.

As a result, those who depend on speedy access to images or who shoot large numbers of photos at once may prefer JPEG over RAW. These photographers include wedding and sports shooters, who may take hundreds to more than a thousand pictures within a few hours.

JPEG was invented as a more compact file format that can store most of the information in a digital image, but in a much smaller size. JPEG predates most digital SLRs and was initially used to squeeze down files for transmission over slow dial-up connections. JPEG provides smaller files by compressing the information in a way that loses some image data. JPEG remains a viable alternative because it offers several different quality levels. At the highest-quality Fine level, you might not be able to tell the difference between the original RAW file and the JPEG version. If you don't mind losing some quality, you can use more aggressive Normal compression with JPEG to cut the size again.

Image Size

The next menu command in the Shooting menu lets you select the resolution, or number of pixels captured as you shoot with your Nikon D3200. Your choices range from Large (L—6,016 \times 4,000, 24 megapixels), Medium (M—4,512 \times 3,000, 13.5 megapixels), and Small (S—3,008 \times 2,000 pixels, 6 megapixels). There are no additional options available from the Image Size menu screen. Keep in mind that if you choose NEF (RAW) or NEF (RAW)+JPEG Fine, only the Large image size can be selected. The other size options are grayed out and unavailable. (See Figure 4.13.)

White Balance

The Shooting menu's White Balance settings are considerably more flexible than those available from the information edit screen, so you may want to use this menu entry instead. The information edit screen lets you choose one of six predefined settings, plus Auto and PRE (which is a user-definable white balance you can base on the lighting in a scene of your choice). The White Balance menu, on the other hand, has more choices of presets, and gives you the additional option of fine-tuning the white balance precisely.

Different light sources have difference "colors," at least as perceived by your D3200's sensor. Indoor illumination tends to be somewhat reddish, while daylight has, in comparison, a more bluish tinge. If the color balance the camera is using doesn't match the light source, you can end up with a color rendition that is off-kilter, as you can see in Figure 4.14.

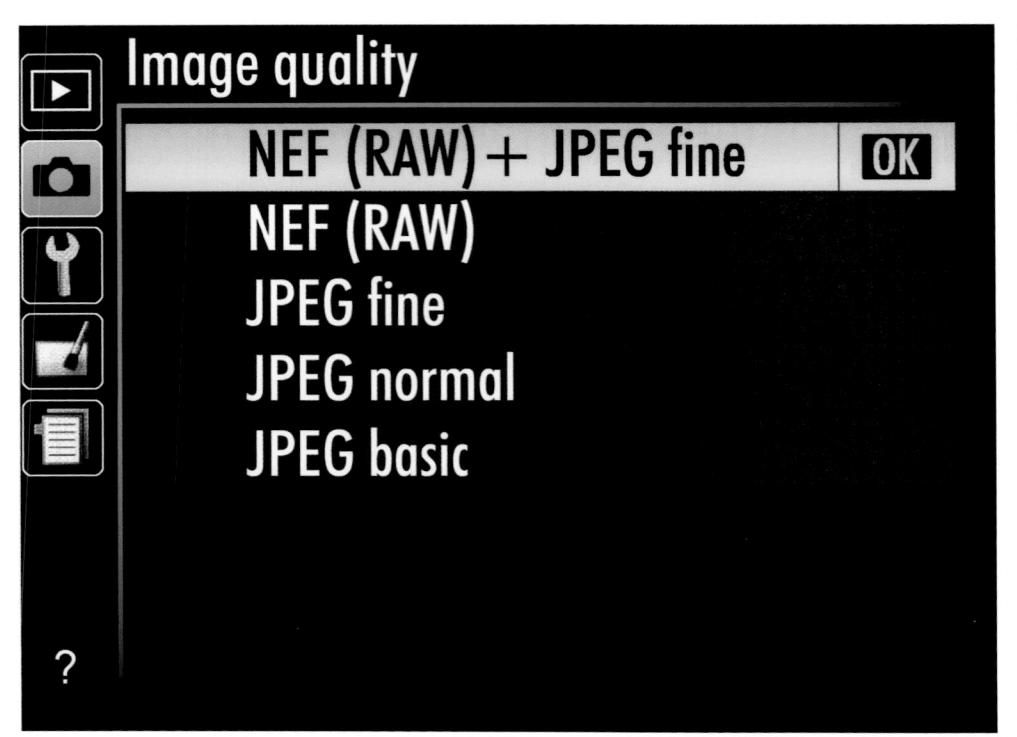

Figure 4.13 Choose image size options here.

Figure 4.14
Adjusting color temperature can provide different results of the same subject at settings of 3,400K (left), 5,000K (middle), and 2,800K (right).

This menu entry allows you to choose one of the white balance values from among Auto, incandescent, seven varieties of fluorescent illumination (the information edit screen only lets you switch to whichever fluorescent setting you define here), direct sunlight, flash, cloudy, shade, a specific color temperature of your choice, or a preset value taken from an existing photograph or a measurement you make.

In this section I'm going to describe only the menu commands at your disposal for setting white balance.

When you select the White Balance entry on the Shooting menu, you'll see an array of choices like those shown in Figure 4.15. (One additional choice, PRE Preset Manual is not visible until you scroll down to it.) Choose the predefined value you want by pressing the multi selector right button, or press OK.

If you choose Fluorescent, you'll be taken to another screen that presents seven different types of lamps, from sodium-vapor through warm-white fluorescent down to high temperature mercury-vapor. If you know the exact type of non-incandescent lighting being used, you can select it, or settle on a likely compromise. Press the multi selector right button again or press OK to select the fluorescent lamp variation you want to use.

Figure 4.15
The White
Balance menu
has predefined
values, plus the
option of setting a preset
you measure
yourself.

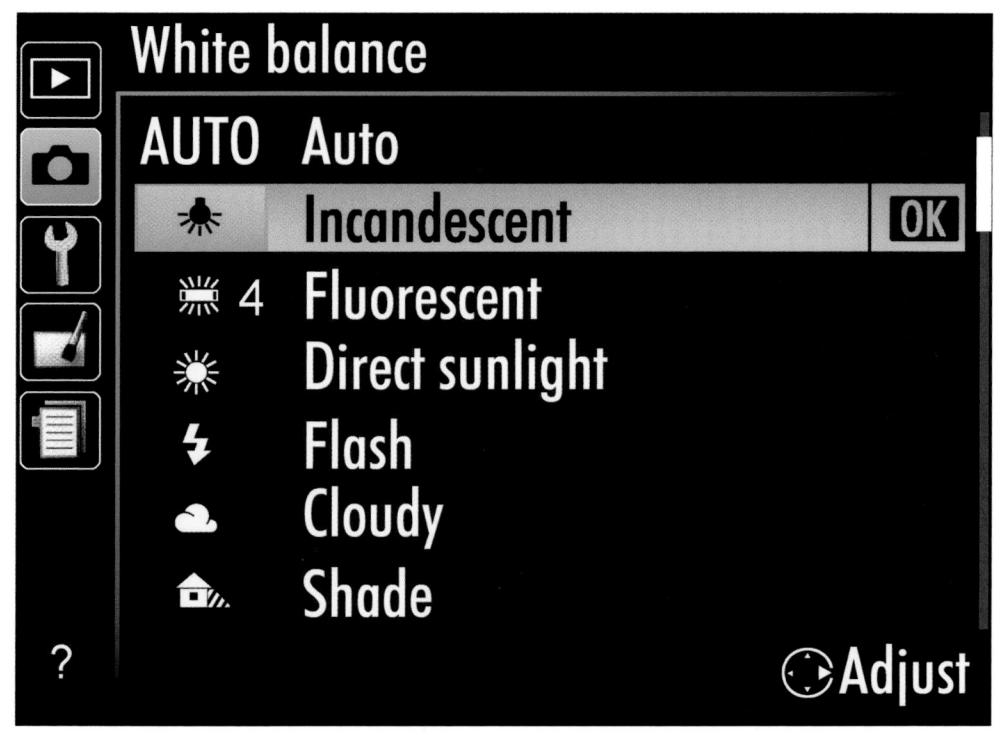

When you've finished choosing a fluorescent light source and for all other predefined values (Auto, Incandescent, Direct Sunlight, Flash, Cloudy, or Shade), you'll next be taken to the fine-tuning screen shown in Figure 4.16 (and which uses the incandescent setting as an example). The screen shows a grid with two axes, a blue/amber axis extending left/right, and a green/magenta axis extending up and down the grid. By default, the grid's cursor is positioned in the middle, and a readout to the right of the grid shows the cursor's coordinates on the A-B axis (yes, I know the display has the end points reversed) and G-M axis at 0,0.

You can use the multi selector's up/down and right/left buttons to move the cursor to any coordinate in the grid, thereby biasing the white balance in the direction(s) you choose. The amber-blue axis makes the image warmer or colder (but not actually yellow or blue). Similarly, the green/magenta axis preserves all the colors in the original image, but gives them a tinge biased toward green or magenta. Each increment equals about five mired units, but you should know that mired values aren't linear; five mireds at 2,500K produces a much stronger effect than five mireds at 6,000K. If you really want to fine-tune your color balance, you're better off experimenting and evaluating the results of a particular change.

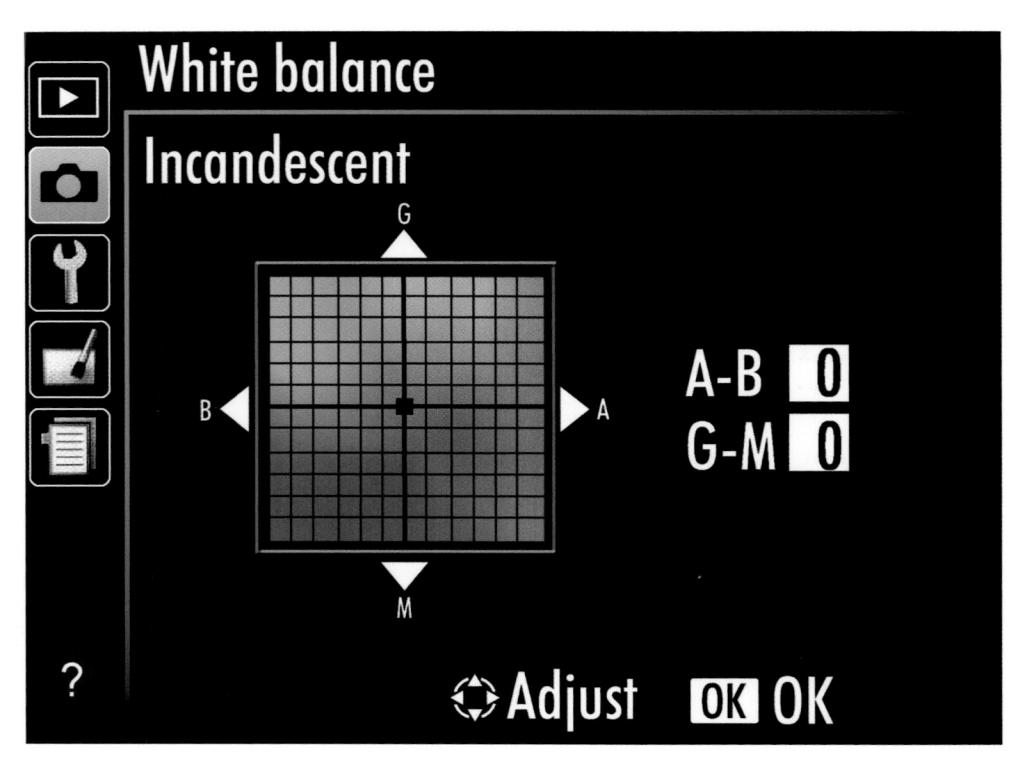

Figure 4.16
Specific white balance settings can be fine-tuned by changing their bias in the amber/blue, magenta/green directions—or along both axes simultaneously.

When you've fine-tuned white balance, an asterisk appears next to the white balance icon in both the Shooting menu and shooting information screen shown on the LCD, as a tip-off that this tweaking has taken place.

Using Preset Manual White Balance

If automatic white balance or one of the predefined settings available aren't suitable, you can set a custom white balance using the Preset Manual menu option. You can apply the white balance from a scene, either by shooting a new picture on the spot and using the resulting white balance (Measure), or using an image you have already shot (Use Photo). To perform direct measurement from your current scene using a reference object (preferably a neutral gray or white object), follow these steps:

- 1. Place the neutral reference under the lighting you want to measure.
- 2. Choose Preset Manual from the White Balance screen in the Shooting menu (you may need to scroll down to see it).
- 3. Select Measure from the screen that appears by scrolling to it and pressing the multi selector right button or pressing OK.
- 4. A warning message appears, Overwrite existing preset data? Choose Yes.
- 5. An instructional message appears for a few seconds telling you to take a photo of a white or gray object that fills the viewfinder under the lighting that will be used for shooting. Do that!
- 6. After you've taken the photo, if the D3200 was able to capture the white balance data, a message Data Acquired appears on the shooting information screen, and the PRE white balance setting is shown. If the D3200 was not able to capture white balance data, a pop-up message appears, and you should try again.

The preset value you've captured will remain in the D3200's memory until you replace that white balance with a new captured value. You can also use the white balance information from a picture you've already taken, using the Use Photo option, as described next:

- 1. Choose Preset Manual from the White Balance menu.
- 2. Select Use Photo.
- 3. The most recently shot picture will appear, with a menu offering to use This Image or Select Image.
- 4. Press OK to use the displayed image, or choose Select Image to specify another picture on your memory card.
- 5. If you want to select a different image, you can choose which folder on your memory card, then navigate through the selected images, using the standard D3200 image selection screen shown several times previously in this chapter. (See Figure 4.5 for a refresher.)

- 6. When the photo you'd like to use is highlighted, press OK to select it.
- 7. You'll be returned to the Shooting menu, where you can press the MENU button to exit, or just tap the shutter release.

A WHITE BALANCE LIBRARY

Consider dedicating a low-capacity memory card to stow a selection of images taken under a variety of lighting conditions. If you want to "recycle" one of the color temperatures you've stored, insert the card and select it with the Use Photo option.

ISO Sensitivity Settings

ISO governs how sensitive your Nikon D3200 is to light. Low ISO settings, such as ISO 100 or ISO 200 mean that you may have to use wider lens openings or slower shutter speeds. Faster ISO settings, on the other hand, let you take pictures in lower light levels, with faster shutter speeds (say, to freeze action) or with smaller lens openings (to produce a larger range in which objects are in sharp focus). I'll explain all these factors in more detail in Chapter 6.

This menu entry allows you to set an ISO sensitivity value, from ISO 100 (at the low end) through ISO 6400, plus H1, the equivalent of ISO 12800. You can also choose Auto, which allows the Nikon D3200 to change the ISO setting as you shoot if the setting you have made isn't high enough to produce the best combination of shutter speed and lens opening for a sharp picture. The Auto feature can be used when you're working in Auto, Scene, Program, Shutter-priority, Aperture-priority, or Manual exposure modes. This feature can be used both with available light shots, and those using electronic flash.

When Auto ISO is active, if the ISO rating that you've chosen doesn't provide enough sensitivity to take an optimal picture (that is one that is well-exposed, but also has a shutter speed that's fast enough to stop action, and an aperture that produces an acceptable range of sharpness), the camera can increase the ISO automatically.

This capability can be a convenience (and, at times, a life-saver), but is also fraught with pitfalls. For example, it is possible that the D3200 could, if not given some guidance, choose an ISO setting far higher than what you intended, producing pictures that might be unacceptably grainy for a given purpose. In such cases, you might have preferred to keep your original ISO setting and optimize exposure through some other means, such as supplementary flash or using a tripod with a longer shutter speed.

Fortunately, the D3200 does not easily lead you astray. Automatic ISO shifts are possible only if you've activated that feature in this menu, and, when implemented by the camera, you're given fair warning by an ISO-Auto indicator on the shooting

information screen and in the viewfinder. Better yet, you can lay down some rules that the D3200 will use before it meddles with the ISO setting you originally specified.

The lower half of the ISO sensitivity settings screen has three choices. One of them, On/Off, is self-explanatory; you can enable or disable the ISO Auto feature by choosing the appropriate option. The other two, available only when Auto is turned on, are Max. Sensitivity and Min. Shutter Speed. These lead you to separate screens you can use to lay down the ground-rules. Here's a quick explanation of how your options operate:

- Off. Set ISO Sensitivity Auto Control to Off, and the ISO setting will not budge from whatever value you have specified. Use this setting when you don't want any ISO surprises, or when ISO increases are not needed to counter slow shutter speeds. For example, if the D3200 is mounted on a tripod, you can safely use slower shutter speeds at a relatively low ISO setting, so there is no need for a speed bump.
- On. At other times, you may want to activate the feature. For example, if you're hand-holding the camera and the D3200 set for Program (P) or Aperture-priority (A) mode wants to use a shutter speed slower than, say, 1/30th second, it's probably a good idea to increase the ISO to avoid the effects of camera shake. If you're using a telephoto lens (which magnifies camera shake), a shutter speed of 1/125th second or higher might be the point where an ISO bump would be a good idea. In that case, you can turn on the ISO Sensitivity Auto Control, or remember to boost the ISO setting yourself.
- Maximum sensitivity. If the idea of unwanted noise bothers you, you can avoid using an ISO setting that's higher than you're comfortable with. This parameter sets the highest ISO setting the D3200 will use in ISO-Auto mode. You can choose from ISO 200, 400, 800, 1600, 3200, 6400, or H1 as the max ISO setting the camera will use. Use a low number if you'd rather not take any photos at a high ISO without manually setting that value yourself. Dial in a higher ISO number if getting the photo at any sensitivity setting is more important than worrying about noise.
- Minimum shutter speed. You can decide the shutter speed that's your personal "danger threshold" in terms of camera shake blurring. That is, if you feel you can't hand-hold the camera at a shutter speed slower than 1/30th second, you can tell the D3200 that when the metered exposure will end up with a speed slower than that, ISO-Auto should kick in and do its stuff. When the shutter speed is *faster* (shorter) than the speed you specify, ISO-Auto will not take effect and the ISO setting you've made yourself remains in force. The default value is 1/30th second, because in most situations, any shutter speed longer/slower than 1/30th is to be avoided, unless you're using a tripod, monopod, or looking for a special effect. If you're working with a telephoto lens and find even a relatively brief shutter speed "dangerous," you can set a minimum shutter speed threshold of 1/250th second. Of course, lenses with vibration reduction (VR) built in can raise your minimum shutter speed threshold preference.

Active D-Lighting

D-Lighting is a feature that improves the rendition of detail in highlights and shadows when you're photographing high contrast scenes (those which have dramatic differences between the brightest areas and the darkest areas that hold detail). It's been available as an internal retouching option that could be used *after* the picture has been taken, and has been found in Nikon's lower-end cameras (by that I mean the CoolPix point-and-shoot line) for some time, and has gradually worked its way up through the company's dSLR products. You'll find this post-shot feature in the Retouch menu, which I'll describe later in the chapter.

A new wrinkle, however, is the *Active D-Lighting* capability introduced with Nikon's recent cameras, which, unlike the Retouch menu post-processing feature, applies its improvements *while you are actually taking the photo.* That's good news and bad news. It means that, if you're taking photos in a contrasty environment, Active D-Lighting can automatically improve the apparent dynamic range of your image as you shoot, without additional effort on your part. However, you'll need to disable the feature once you leave the high contrast lighting behind, and the process does take some time to apply as you shoot. You wouldn't want to use Active D-Lighting for continuous shooting of sports subjects, for example. There are many situations in which the selective application of D-Lighting using the Retouch menu is a better choice.

For best results, use your D3200's Matrix metering mode, so the Active D-Lighting feature can work with a full range of exposure information from multiple points in the image. Active D-Lighting works its magic by subtly *underexposing* your image so that details in the highlights (which would normally be overexposed and become featureless white pixels) are not lost. At the same time, it adjusts the values of pixels located in midtone and shadow areas so they don't become too dark because of the underexposure. Highlight tones will be preserved, while shadows will eventually be allowed to go dark more readily. Bright beach or snow scenes, especially those with few shadows (think high noon, when the shadows are smaller) can benefit from using Active D-Lighting. Figure 4.17 shows a typical example.

You have just two choices: Off and On. You'll want to experiment to see which types of situations can benefit your shooting the most.

Auto Distortion Control

Wide-angle lenses can produce a bowing-in effect, called *barrel distortion*, that's most noticeable at the edges of images. Telephoto lenses can produce the opposite effect, an inward-bending effect called *pincushion distortion*. If you notice this problem in your pictures, you can partially nullify the effects by using Auto Distortion Control. If you have no distortion problems, leave it off, because the less manipulation of your images in the camera, the better. I'll explain these distortions in more detail in Chapter 10.

Figure 4.17 No D-Lighting (left); Active D-Lighting (right).

Color Space

The Nikon D3200's Color Space option, the first on the second page of the Shooting menu (see Figure 4.18) gives you the choice of two different color spaces (also called *color gamuts*), named Adobe RGB (because it was developed by Adobe Systems in 1998), and sRGB (supposedly because it is the *standard* RGB color space). These two color gamuts define a specific set of colors that can be applied to the images your D3200 captures.

You're probably surprised that the Nikon D3200 doesn't automatically capture *all* the colors we see. Unfortunately, that's impossible because of the limitations of the sensor and the filters used to capture the fundamental red, green, and blue colors, as well as that of the phosphors used to display those colors on your camera and computer monitors. Nor is it possible to *print* every color our eyes detect, because the inks or pigments used don't absorb and reflect colors perfectly.

Instead, the colors that can be reproduced by a given device are represented as a color space that exists within the full range of colors we can see. That full range is represented by the odd-shaped splotch of color shown in Figure 4.19, as defined by scientists at an international organization back in 1931. The colors possible with Adobe RGB are represented by the larger, black triangle in the figure, while the sRGB gamut is represented by the smaller white triangle.

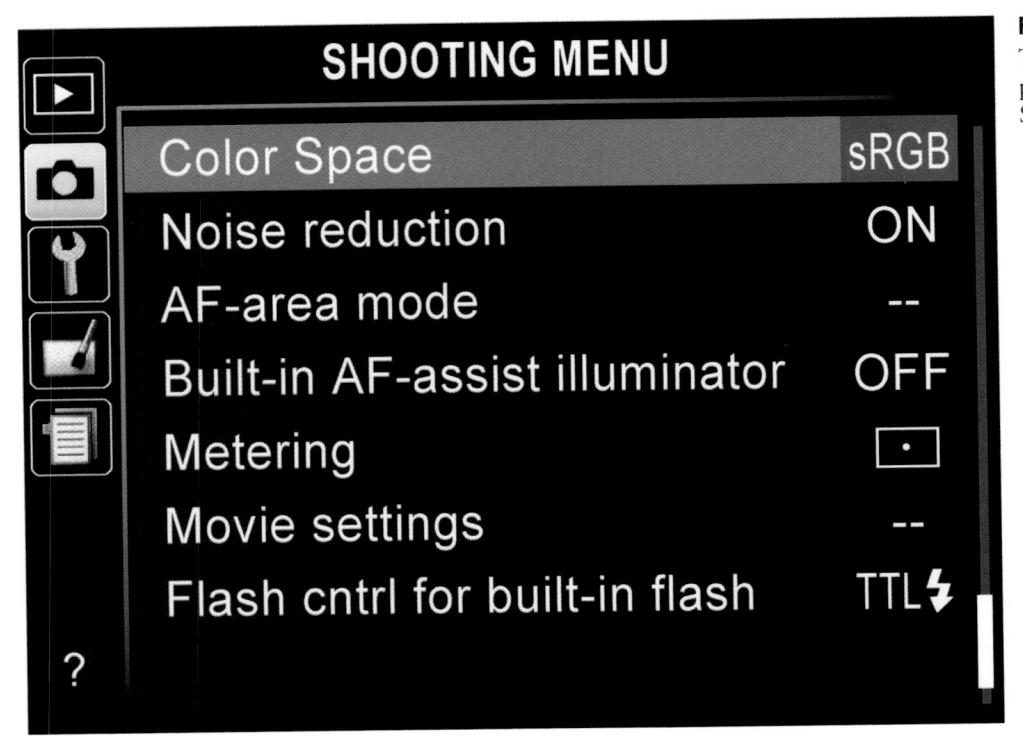

Figure 4.18
The second page of the Shooting menu.

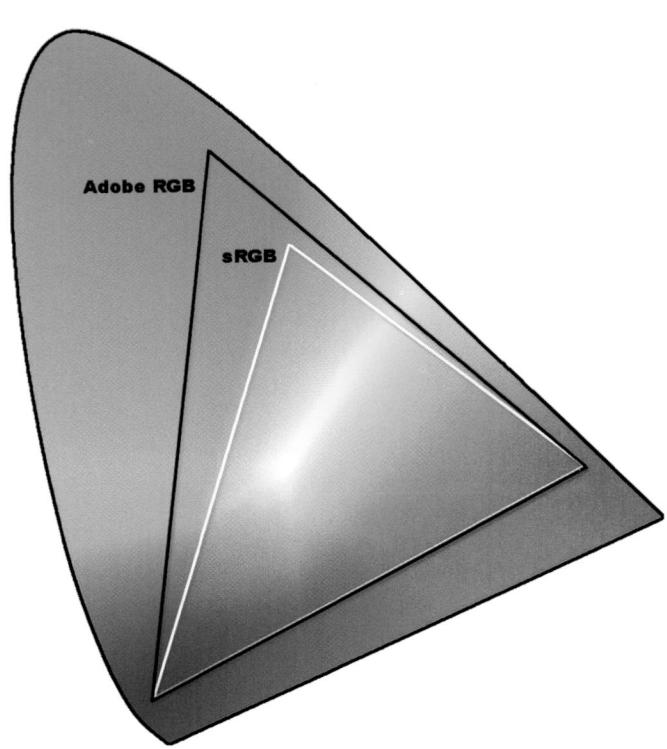

Figure 4.19

The outer figure shows all the colors we can see; the two inner outlines show the boundaries of Adobe RGB (black triangle) and sRGB (white triangle).

Regardless of which triangle—or color space—is used by the D3200, you end up with 16.8 million different colors that can be used in your photograph. (No one image will contain all 16.8 million!) But, as you can see from the figure, the colors available will be *different*.

Adobe RGB is what is often called an *expanded* color space, because it can reproduce a range of colors that is spread over a wider range of the visual spectrum. Adobe RGB is useful for commercial and professional printing. You don't need this range of colors if your images will be displayed primarily on your computer screen or output by your personal printer.

The other color space, sRGB, is recommended for images that will be output locally on the user's own printer, as this color space matches that of the typical inkjet printer fairly closely. While both Adobe RGB and sRGB can reproduce the exact same 16.8 million absolute colors, Adobe RGB spreads those colors over a larger portion of the visible spectrum, as you can see in the figure. Think of a box of crayons (the jumbo 16.8 million crayon variety). Some of the basic crayons from the original sRGB set have been removed and replaced with new hues not contained in the original box. Your "new" box contains colors that can't be reproduced by your computer monitor, but which work just fine with a commercial printing press.

Noise Reduction

Visual noise is that awful graininess caused by long exposures and high ISO settings, and which shows up as multicolored specks in images. This setting helps reduce noise, which is rarely desirable in a digital photograph. There are easier ways to add texture to your photos.

High ISO noise commonly appears when you raise your camera's sensitivity setting above ISO 800. This type of visual noise appears as a result of the amplification needed to increase the sensitivity of the sensor. While higher ISOs do pull details out of dark areas, they also amplify non-signal information randomly, creating noise.

A similar noisy phenomenon occurs during long time exposures, which allow more photons to reach the sensor, increasing your ability to capture a picture under low-light conditions. However, the longer exposures also increase the likelihood that some pixels will register random phantom photons, often because the longer an imager is "hot" the warmer it gets, and that heat can be mistaken for photons.

While high ISO settings are the usual culprit, some noise is created when you're using shutter speeds longer than eight seconds. Extended exposure times allow more photons to reach the sensor, but increase the likelihood that some photosites will react randomly even though not struck by a particle of light. Moreover, as the sensor remains switched on for the longer exposure, it heats, and this heat can be mistakenly recorded as if it were a barrage of photons.

While noise reduction does minimize the grainy effect, it can do so at the cost of some sharpness. This menu setting can be used to activate or deactivate the D3200's noise-canceling operation.

applies *some* noise reduction at all times, even when you select Off). Use it when you want the maximum amount of detail present in your photograph, even though higher noise levels will result. This setting also eliminates the delay caused by the more aggressive noise reduction process that occurs after the picture is taken (this delay is roughly the same amount of time that was required for the exposure). If you plan to use only lower ISO settings (thereby reducing the noise caused by high ISO values), the noise levels produced by longer exposures may be acceptable. For example, you might be shooting a waterfall at ISO 100 with the camera mounted on a tripod, using a neutral-density filter and a long exposure to cause the water to blur. (Try exposures of 2 to 16 seconds, depending on the intensity of the light and how much blur you want.) (See Figure 4.20.) To maximize detail in the non-moving portions of your photos for the exposures that are eight seconds or longer, you can switch off long exposure noise reduction.

Figure 4.20 A long exposure with the camera mounted on a tripod produces this traditional waterfall photo.

■ On. When exposures are eight seconds or longer, the Nikon D3200 takes a second, blank exposure to compare that to the first image. (While the second image is taken, the warning **Job nr** appears in the viewfinder.) Noise (pixels that are bright in a frame that *should* be completely black) in the "dark frame" image is subtracted from your original picture, and only the noise-corrected image is saved to your memory card. Because the noise-reduction process effectively doubles the time required to take a picture, you won't want to use this setting when you're rushed. Some noise can be removed later on, using tools in your image editor.

AF-Area Mode

This entry is a duplication of the autofocus area mode options in the information edit menu, as described in Chapter 1, but with the addition of options for choosing an autofocus zone when using Live View, too. You'll find more about autofocus and focus modes in Chapter 7. When you select this entry, you'll be given a choice of Viewfinder and Live View/Movie modes.

To recap, the four choices when using the viewfinder to compose your images are as follows:

- Single-point. You always choose which of the eleven points are used, and the Nikon D3200 sticks with that focus bracket, no matter what. This mode is best for non-moving subjects.
- **Dynamic-area.** You can choose which of the eleven focus zones to use, but the D3200 will switch to another focus mode when using AF-C or AF-A mode and the subject moves. This mode is great for sports or active children.
- **Auto-area.** This default mode chooses the focus point for you, and can use distance information when working with a lens that has a G or D suffix in its name. (See Chapter 10 for more on the difference between G/D lenses and other kinds of lenses.)
- **3D-tracking (11 points).** You can select the focus zone, but when not using AF-S mode, the camera refocuses on the subject if you reframe the image.

If you're using Live View to shoot stills or are shooting movies, you can specify four different AF-area selection modes:

- Face-priority AF. The D3200 detects faces and automatically chooses those faces to focus on.
- Wide-area AF. When shooting non-portrait subjects, such as landscapes, you can select the focus zone using the multi selector.

- Normal-area AF. Most useful when the camera is mounted on a tripod, you can select any area on the Live View frame to focus on.
- Subject-tracking AF. Autofocus will lock onto a subject and keep focus on that subject even if it moves throughout the frame.

I'll explain the mysteries of autofocus in detail in Chapter 7.

Built-in AF-Assist Illuminator

Use this setting to control the AF-assist lamp built into the Nikon D3200 when using the optical viewfinder.

■ On. This default value will cause the AF-assist illuminator lamp to fire when lighting is poor, but only if Single-servo autofocus (AF-S) or Automatic autofocus (AF-A) are active, or you have selected the center focus point manually and either Single-point or Dynamic-area autofocus (rather than Auto-area autofocus) has been chosen. It does not operate in Manual focus modes, in AF-C mode, or when AF-A has switched to its AF-C behavior, nor when Landscape or Sports scene modes are used.

Tip

With some lenses, the lens hood can block the AF-assist lamp's illumination; you may have to remove the hood in low-light situations.

■ Off. Use this to disable the AF-assist illuminator. You'd find that useful when the lamp might be distracting or discourteous (say, at a religious ceremony or acoustic music concert), or your subject is located closer than one foot, eight inches or farther than about 10 feet. One downside of turning AF-assist off is that the D3200 may be unable to focus accurately in situations where it really, really needs the extra light from the supplementary lamp. You may have to focus manually in such situations.

Metering

This is a duplicate of the settings you can make from the information edit screen. I'll explain each of the Nikon D3200's three metering modes in more detail in Chapter 6. As I explained in Chapter 1, the three modes are as follows:

■ Matrix metering. The standard metering mode; the D3200 attempts to intelligently classify your image and choose the best exposure based on readings from a 420-segment color CCD sensor that interprets light reaching the viewfinder using a database of hundreds of thousands of patterns.

- Center-weighted averaging metering. The D3200 meters the entire scene, but gives the most emphasis to the central area of the frame, measuring about 8mm in diameter.
- **Spot metering.** Exposure is calculated from a smaller 3.5 mm central spot, about 2.5 percent of the image area.

Movie Settings

The Movie Settings entry has two parts: Quality and Audio. You have the following choices:

- Frame Size/Frame Rate. Choose from 1920 × 1080 pixels/30 fps; 1920 × 1080 pixels/24 fps; 1280 × 720 pixels, 60 fps; or 640 × 424/30 fps. I'll explain why you'd select each of these in Chapter 8.
- Movie Quality. Select High or Normal quality compression.
- Microphone. Select from Auto sensitivity, Manual sensitivity (settings from 1 to 20), with a db meter shown to help you measure ambient sound levels, or Off. You'll find more about these options in Chapter 8, too.
- Manual movie settings. Select On if you want to adjust shutter speed and ISO sensitivity while shooting movies with the D3200 in Manual exposure mode. Note that, due to the interval required between frames, shutter speeds no slower than 1/30th second can be used. Speeds up to 1/8,000th second are possible, and ISO settings from ISO 100 to Hi 2 can be used. Exposure compensation cannot be used.

Flash Cntrl for Built-In Flash

This setting is used to adjust the features of the Nikon D3200's built-in pop-up electronic flash, or the optional Nikon SB-400 add-on flash unit, or other Nikon-compatible flash, which fits in the accessory shoe on top of the camera. Its settings are in force when you are using Program, Shutter-priority, Aperture-priority, or Manual exposure modes (but not when using any of the scene modes). You can read more about using the D3200's flash capabilities in Chapter 10.

You have two options with this setting:

■ TTL. When selected, the built-in flash or external flash operate in iTTL (intelligent through the lens) exposure mode to automatically choose an exposure based on measuring the light from a "preflash" (fired an instant before the picture is taken) as it reflects back to the camera. Use this setting under most circumstances. As you'll learn in Chapter 10, the D3200 can even balance the flash output with the daylight or other illumination to allow the flash to fill in dark shadows or provide supplementary light.

■ Manual. In this mode, the flash always fires using a preselected output level, which ranges from full power to 1/32 power. Use this mode when you want a certain exposure for every shot, say, to deliberately under- or overexpose an image for a special effect.

Setup, Retouching, and Recent Settings Menus

In this chapter, I'm going to introduce you to the final three tabs in the Nikon D3200 menu system: the Setup, Retouching, and Recent Settings menus. In the section on the Setup menu, you'll discover how to format a memory card, set the date/time and LCD brightness, and do other maintenance and configuration tasks. You'll learn how to use the Retouch menu to remove red-eye and fix up photos right in your camera. The Recent Settings menu displays a list of the last 20 menu items used—a sort of "favorites" display for quick access.

Setup Menu Options

The orange-coded Setup menu (see Figure 5.1 for its first page) has a long list of 28 entries (if you count the Eye-Fi Upload setting that appears *only* when an Eye-Fi card is installed). In this menu you can make additional adjustments on how your camera *behaves* before or during your shooting session, as differentiated from the Shooting menu, which adjusts how the pictures are actually taken.

Your choices include:

- Reset Setup Options
- Format Memory Card
- Monitor Brightness
- Info Display Format
- Auto Info Display
- Clean Image Sensor
- Lock Mirror Up for Cleaning
- Video Mode
- HDMI
- Flicker Reduction
- Time Zone and Date
- Language
- Image Comment
- Auto Image Rotation

- Image Dust Off Ref Photo
- Auto Off Timers
- Self-Timer
- Remote On Duration
- Beep
- Rangefinder
- File Number Sequence
- Buttons
- Slot Empty Release Lock
- Print Date
- Storage Folder
- GPS
- Eye-Fi Upload
- Firmware Version

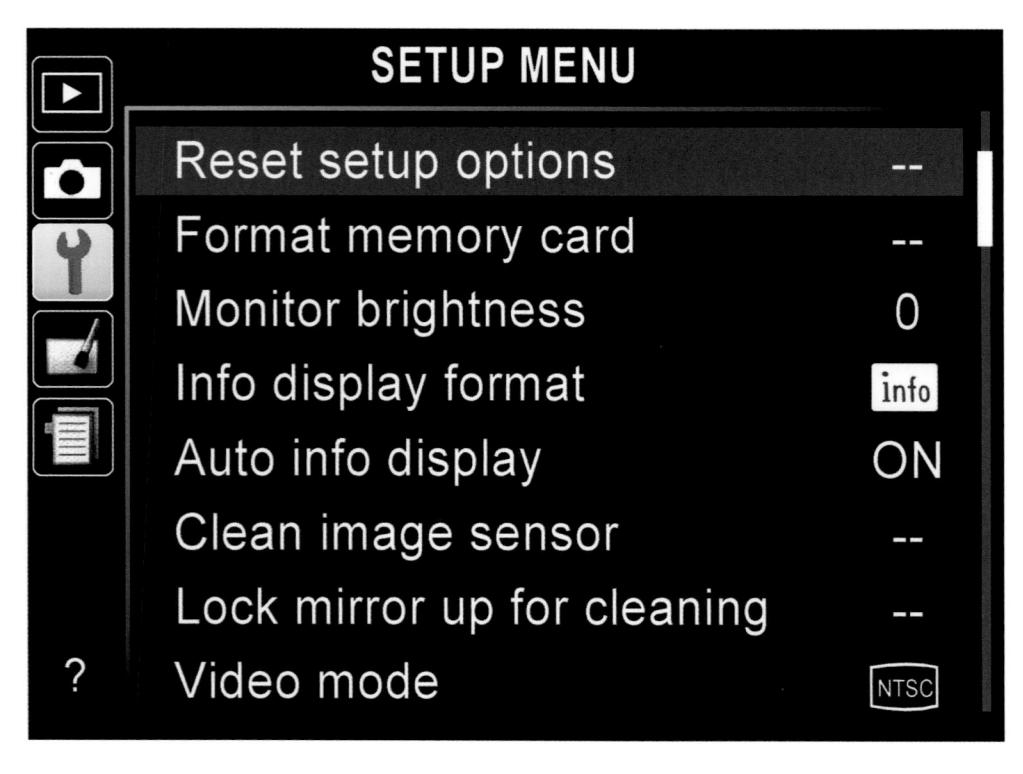

Figure 5.1
The first page of the Setup menu.

Reset Setup Options

If you select Yes, the Setup menu settings shown in Table 5.1 will be set to their default values. It has no effect on the settings in other menus, or any of the other camera settings. Note that there is also a Reset option in the Shooting menu to return your shooting settings to their defaults.

Table 5.1 Values Reset	
Setting	Default Value
Monitor Brightness	0
Info Display Format	Graphic; White background
Auto Info Display	On
Clean Image Sensor	Startup & Shutdown
HDMI Output resolution Device Control	Auto On
Time Zone and Date/ Daylight Saving Time	Off
Language	Varies by country of purchase
Auto Image Rotation	On
Auto Off Timers	Normal
Self-Timer Delay	10 seconds
Веер	On
Rangefinder	Off
File Number Sequence	Off
Buttons	Fn Button: ISO sensitivity AE-L/AF-L: AE/AF Lock AE Lock: Off
Slot Empty Release Lock	Release Locked
Print Date	Off
Eye-Fi Upload	On Enable
Flicker Reduction	Auto
GPS Timer	Enable
Use GPS to Set Clock	Yes

You'd want to use this Reset option when you've made a bunch of changes (say, while playing around with them as you read this chapter), and now want to put them back to the factory defaults. Your choices are Yes and No. Note that Video Mode, Time Zone and Date, Language, and Storage Folder are not reset.

Format Memory Card

I recommend using this menu entry to reformat your memory card after each shoot. While you can move files from the memory card to your computer, leaving behind a blank card, or delete files using the Playback menu's Delete feature, both of those options can leave behind stray files (such as those that have been marked as Protected). Format removes those files completely and beyond retrieval (unless you use a special utility program as described in Chapter 12) and establishes a spanking new fresh file system on the card, with all the file allocation table (FAT) pointers (which tell the camera and your computer's operating system where all the images reside) efficiently pointing where they are supposed to on a blank card.

To format a memory card, choose this entry from the Setup menu, highlight Yes on the screen that appears, and press OK.

Monitor Brightness

Choose this menu option to adjust the intensity of the display using the LCD Brightness option. A grayscale strip appears on the LCD, as shown in Figure 5.2. Use the multi selector up/down keys to adjust the brightness to a comfortable viewing level over a range of +3 to -3. Under the lighting conditions that exist when you make this adjustment, you should be able to see all 10 swatches from black to white. If the two end swatches blend together, the brightness has been set too low. If the two whitest swatches on the right end of the strip blend together, the brightness is too high. Brighter settings use more battery power, but can allow you to view an image on the LCD outdoors in bright sunlight. When you have the brightness you want, press OK to lock it in and return to the menu.

Info Display Format

You can choose the format the Nikon D3200 uses for its shooting information screen. Two formats are available as follows:

■ Classic. This is a mostly text-based format with a few icons. You'll find this format the fastest to use once you've grown accustomed to the D3200 and its features, as all the information is clustered in a no-nonsense way that is easy to read.

Figure 5.2
Adjust the LCD
brightness so
that all the
grayscale strips
are visible.

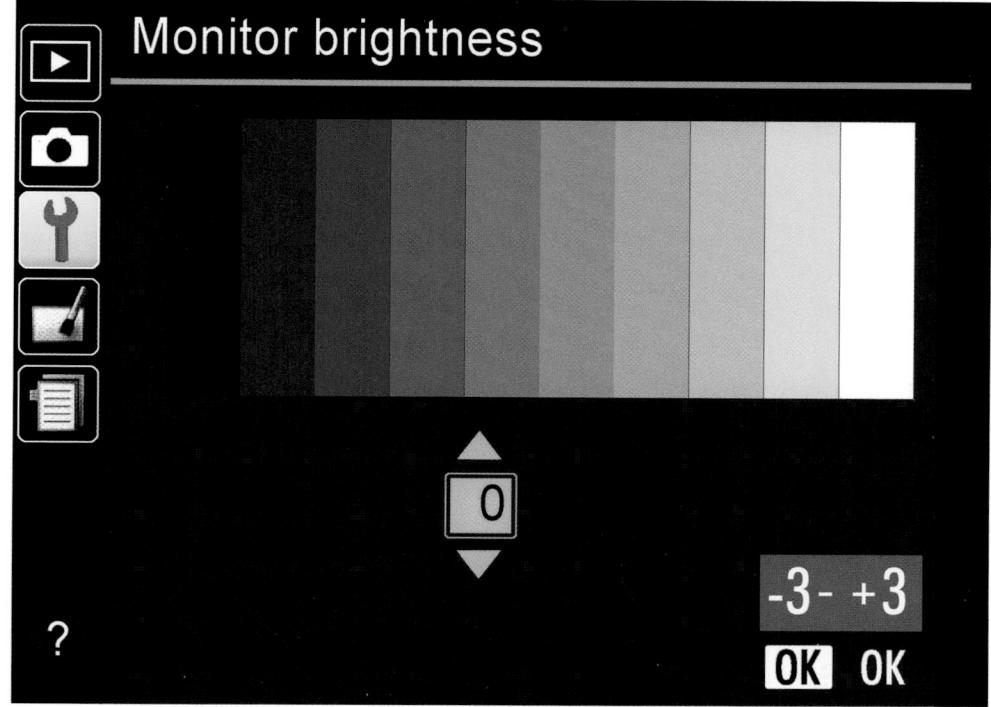

■ **Graphic.** This format mixes text and graphics, and includes a facsimile of the mode dial that appears briefly on the left side of the screen as you change from one exposure mode to the other. It's prettier to look at and adds a little flair to the display, because you can choose black, white, or orange backgrounds, but I find it distracting.

You can change the shooting information display to the format of your choice using three easy-to-understand screens:

- 1. Choose Info Display format from the Setup menu.
- 2. Choose either Classic or Graphic and press the multi selector right button.
- 3. Specify a background color and press OK:

Classic: Blue, Black, or Orange

Graphic: White, Black, or Brown

4. You'll be returned to the first screen you saw, where you can again choose from Classic or Graphic modes, or press the MENU button (or tap the shutter release) to exit.

Auto Info Display

This setting controls when the shooting information display is shown on the LCD. The display is a handy tool for checking your settings as you shoot. It does use up battery power, so you might want to turn off the automatic display if you don't need to review your settings frequently, or if you especially want to conserve battery power. The shooting information display can be viewed any time by pressing the Info button at the lower-left side of the back of the D3200. You can choose whether to display Auto/Scene modes or P, S, A, and M modes individually. Here's how this option works for both types of modes:

- On. The D3200 will display the shooting information screen if the shutter release button is pressed halfway and released. As always, the information display goes away when you press the shutter release halfway and hold it. If you've set Image Review to Off in the Playback menu, the shooting information screen also appears as soon as the photograph is taken. If Image Review is set to On, the shooting information screen appears only when the shutter release is pressed halfway and released, or if the Info button is pressed, but not immediately after the picture is taken. (Instead, the picture you just took is shown.)
- Off. The shooting information screen is not displayed when you press the shutter release button halfway and release it. You can activate the display by pressing the Info button.

Clean Image Sensor

This entry gives you some control over the Nikon D3200's automatic sensor cleaning feature, which removes dust through a vibration cycle that shakes the sensor until dust, presumably, falls off and is captured by a sticky surface at the bottom of the sensor area. If you happen to take a picture and notice an artifact in an area that contains little detail (such as the sky or a blank wall), you can access this menu choice, place the camera with its base downward, choose Clean Now, and press OK. A message Image Sensor Cleaning appears, and the dust you noticed has probably been shaken off.

You can also tell the D3200 when you'd like it to perform automatic cleaning without specific instructions from you. Chose Clean At and select from:

- **ON.** Clean at startup. This allows you to start off a particular shooting session with a clean sensor.
- **OFF.** Clean at shutdown. This removes any dust that may have accumulated since the camera has been turned on, say, from dust infiltration while changing lenses. Note that this choice does not turn off automatic cleaning; it simply moves the operation to the camera power-down sequence.

- **ON/OFF.** Clean at both startup and shutdown. Use this setting if you're paranoid about dust and don't mind the extra battery power consumed each time the camera is turned on or off. If you only turn off the D3200 when you're finished shooting, the power penalty is not large, but if you're the sort who turns off the camera every time you pause in shooting, the extra power consumed by the dust removal may exceed any savings you get from leaving the camera off.
- Cleaning Off. No automatic dust removal will be performed. Use this to preserve battery power, or if you prefer to use automatic dust removal only when you explicitly want to apply it.

Lock Mirror Up for Cleaning

You can also clean the sensor manually. Use this menu entry to raise the mirror and open the shutter so you'll have access to the sensor for cleaning with a blower, brush, or swab, as described in Chapter 13. You don't want power to fail while you're poking around inside the camera, so this option is available only when sufficient battery power (at least 60 percent) is available. Using a fully charged battery or connecting the D3200 to an EH-5a/EH5b AC adapter is an even better idea.

Video Mode

This setting controls the output of the Nikon D3200 when directed to a conventional video system through the video cable when you're displaying images on a monitor or connected to a VCR through the external device's yellow video input jack. You can select either NTSC, used in the United States, Canada, Mexico, many Central, South American, and Caribbean countries, much of Asia, and other countries; or PAL, which is used in the UK, much of Europe, Africa, India, China, and parts of the Middle East.

HDMI

This setting is the first option on the second "page" of the Setup menu (see Figure 5.3). Use it to control the HDMI format used to play back camera images and movies on a High Definition Television (HDTV) using a special cable not supplied by Nikon. Note that this setting controls *only* the output from your D3200 to the HDTV. It has no effect on the resolution of your images or your movie clips. Your choices:

■ Output resolution. You can choose Auto, in which case the camera selects the right format, or, to suit your particular HDTV, one of three progressive scan options: 480p—640 × 480 pixels; 576p—720 × 576 pixels; 720p—1280 × 720 pixels; and one interlaced scan option, 1080i—1920 × 1080 pixels.

Figure 5.3
The second "page" of the Setup menu.

■ Device control. You can select On or Off. This option applies when the D3200 is connected to a television that supports HDMI-CEC remote control operations. When you select On, if both the camera and HDTV are powered up, you will see a Play/Slideshow menu on the TV screen, and you can use the TV remote control as if they were the multi selector directional buttons and OK button during picture review and slide shows. An indicator reading CEC will appear in the camera view-finder in place of the exposures remaining indicator. Select Off, and the television remote control is disabled.

Flicker Reduction

This option reduces flicker and banding, which can occur when shooting in Live View mode and Movie mode under fluorescent and mercury vapor illumination, because the cycling of these light sources interacts with the frame rate of the camera's video system. In the United States, you'd choose the 60Hz frequency; in locations where 50Hz current is the norm, select that option instead.
Time Zone and Date

Use this menu entry to adjust the D3200's internal clock. Your options include:

- **Time zone.** A small map will pop up on the setting screen and you can choose your local time zone. I sometimes forget to change the time zone when I travel (especially when going to Europe), so my pictures are all time-stamped incorrectly. I like to use the time stamp to recall exactly when a photo was taken, so keeping this setting correct is important.
- Date. Use this setting to enter the exact year, month, day, hour, minute, and second.
- **Date format.** Choose from Year/month/day (Y/M/D), Month/day/year (M/D/Y), or Day/month/year (D/M/Y) formats.
- Daylight saving time. Use this to turn daylight saving time On or Off. Because the date on which DST takes effect has been changed from time to time, if you turn this feature on you may need to monitor your camera to make sure DST has been implemented correctly.

Language

Choose the language for menu display, from Arabic, Traditional Chinese, Simplified Chinese Czech, Danish, Dutch, English, Finnish, French German, Green, Hindi, Hungarian, Indonesian, Italian, Japanese, Korean, Norwegian, Polish, Portuguese, Romanian, Russian, Spanish, Swedish, Thai, Turkish, and Ukrainian.

Image Comment

The Image Comment is your opportunity to add a copyright notice, personal information about yourself (including contact info), or even a description of where the image was taken (e.g., Seville Photos 2012), although text entry with the Nikon D3200 is a bit too clumsy for doing a lot of individual annotation of your photos. (But you still might want to change the comment each time, say, you change cities during your travels.) The embedded comments can be read by many software programs, including Nikon ViewNX2 or Capture NX 2.

The standard text entry screen can be used to enter your comment, with up to 36 characters available. For the copyright symbol, embed a lowercase "c" within opening and closing parentheses: (c). You can enter text by choosing Input Comment, turn attachment of the comment On or Off using the Attach Comment entry, and select Done when you're finished working with comments. If you find typing with a cursor too tedious, you can enter your comment in Nikon Capture NX 2 and upload it to the camera through a USB cable.

Now is a good time to review text entry, because you can use it to enter comments, rename folders, and perform other functions.

- 1. Press MENU and select the Setup menu.
- 2. Scroll to Image Comment with the multi selector up/down buttons and press the multi selector right button.
- 3. Scroll down to Input Comment and press the multi selector right button to confirm your choice.
- 4. Use the multi selector navigational buttons to scroll around within the array of alphanumerics, as shown in Figure 5.4. There is a full array of uppercase, lowercase, and symbol characters. They can't be viewed all at once, so you may need to scroll up or down to locate the one you want. Then, enter your text:
 - Press the Zoom In button to insert the highlighted character. The cursor will move one place to the right to accept the next character.
 - Rotate the command dial button to move the cursor within the line of characters that have been input.
 - To remove a character you've already input, move the cursor with the command dial to highlight that character, and then press the Trash button.
 - When you're finished entering text, press the Zoom In button to confirm your entry and return to the Image Comment screen.
- 5. In the Image Comment screen, scroll down to Attach Comment and press the multi selector right button to activate the comment, or to disable it.
- 6. When finished, scroll up to Done and press OK.

Auto Image Rotation

Turning this setting On tells the Nikon D3200 to include camera orientation information in the image file. The orientation can be read by many software applications, including Adobe Photoshop, Nikon ViewNX2, and Capture NX 2, as well as the Rotate Tall setting in the Playback menu. Turn this feature Off, and none of the software applications or Playback's Rotate Tall will be able to determine the correct orientation for the image. Nikon notes that only the first image's orientation is used when shooting continuous bursts; subsequent photos will be assigned the same orientation, even if you rotate the camera during the sequence (which is something I have been known to do myself when shooting sports like basketball).

Image Dust Off Ref Photo

This menu choice lets you "take a picture" of any dust or other particles that may be adhering to your sensor. The D3200 will then append information about the location of this dust to your photos, so that the Image Dust Off option in Capture NX 2 can be used to mask the dust in the NEF image.

To use this feature, select Dust Off Ref Photo, choose either Start or Clean Sensor, Then Start, and then press OK. If directed to do so, the camera will first perform a self-cleaning operation by applying ultrasonic vibration to the low-pass filter that resides on top of the sensor. Then, a screen will appear asking you to take a photo of a bright featureless white object 10 cm from the lens. Nikon recommends using a lens with a focal length of at least 50mm. Point the D3200 at a solid white card and press the shutter release. An image with the extension .ndf will be created, and can be used by Nikon Capture NX 2 as a reference photo if the "dust off" picture is placed in the same folder as an image to be processed for dust removal.

Auto Off Timers

Use this setting to determine how long the D3200's LCD and viewfinder displays are shown, and how long exposure meters continue to function after the last operation, such as autofocusing, focus point selection, and so forth, was performed. You can choose a short timer to save power, or a longer value to keep the camera "alive" for a longer period of time. When the Nikon EH5a/EH-5b AC adapter is connected to the D3200, the exposure meters will remain on indefinitely, and when the D3200 is connected to a computer or PictBridge-compatible printer, the LCD and viewfinder displays do not turn off automatically.

Sports shooters and some others prefer longer delays, because they are able to keep their camera always "at the ready" with no delay to interfere with taking an action shot that unexpectedly presents itself. Extra battery consumption is just part of the price paid. For example, when I am shooting football, a meter-off delay of 16 seconds is plenty, because the players lining up for the snap is my signal to get ready to shoot. But for basketball or soccer, I typically set a longer limit, because action is virtually continuous.

Of course, if the meters have shut off, and if the power switch remains in the On position, you can bring the camera back to life by tapping the shutter button. You can select generic times such as Short, Norm, and Long as the auto-off delay, or specify custom times for playback/menus, image review, and exposure meters. Your delay options are as follows:

- Short. LCD Playback/Menus: 8 seconds; LCD Review: 4 seconds; Exposure Meters: 4 seconds.
- Norm. LCD Playback/Menus: 12 seconds; LCD Review: 4 seconds; Exposure Meters: 8 seconds.
- Long. LCD Playback/Menus: 20 seconds; LCD Review: 20 seconds; Exposure Meters: 60 seconds.
- Custom: Playback/Menus. Choose 8, 12, 20, 60 seconds, or 10 minutes.
- Custom: Image Review. Choose 4, 8, 20, 60 seconds, or 10 minutes.
- Custom: Live View: Choose 30 seconds, 1, 3, or 5 minutes.
- Custom: Standby timer. Choose 4, 8, 20, 60 seconds, or 30 minutes.

SAVING POWER WITH THE NIKON D3200

There are several settings techniques you can use to stretch the longevity of your D3200's battery. To get the most from each charge, consider these steps:

- Image Review. Turn off automatic image review after each shot. You can still review your images by pressing the Playback button. Or, leave image review on, but set the display for the minimum 4 seconds with this Auto Off Timers custom command.
- Auto meter-off-delay. Set to 4 seconds using Auto Off Timers if you can tolerate such a brief active time.
- Reduce LCD brightness. In the Setup menu's LCD Brightness option, select the lowest of the seven brightness settings that work for you under most conditions. If you're willing to shade the LCD with your hand, you can often get away with lower brightness settings outdoors, which will further increase the useful life of your battery.
- Turn off the shooting information display. You can always turn it on manually by pressing the Info button.
- Reduce internal flash use. No flash at all or fill flash use less power than a full blast.
- Cancel VR. Turn off vibration reduction if your lens (such as the 18-55mm VR kit lens) has that feature and you feel you don't need it.
- Use a card reader. When transferring pictures from your D3200 to your computer, use a card reader instead of the USB cable. Linking your camera to your computer and transferring images using the cable takes longer and uses a lot more power.

Self-Timer

This setting, the first in the third screen of the Setup menu (see Figure 5.5), lets you choose the length of the self-timer shutter release delay. The default value is 10 seconds. You can also choose 2, 5, 10, and 20 seconds, as well as multiple shots (2-9) at the end of the elapsed time. If I have the camera mounted on a tripod or other support and am too lazy to reach for my MC-DC2 remote cord, I can set a two-second delay that is sufficient to let the camera stop vibrating after I've pressed the shutter release.

Beep

The Nikon D3200's internal beeper provides a (usually) superfluous chirp to signify various functions, such as the countdown of your camera's self-timer or autofocus confirmation in AF-S mode or AF-A mode with a static subject. You can (and probably should) switch it off if you want to avoid the beep because it's annoying, impolite, or

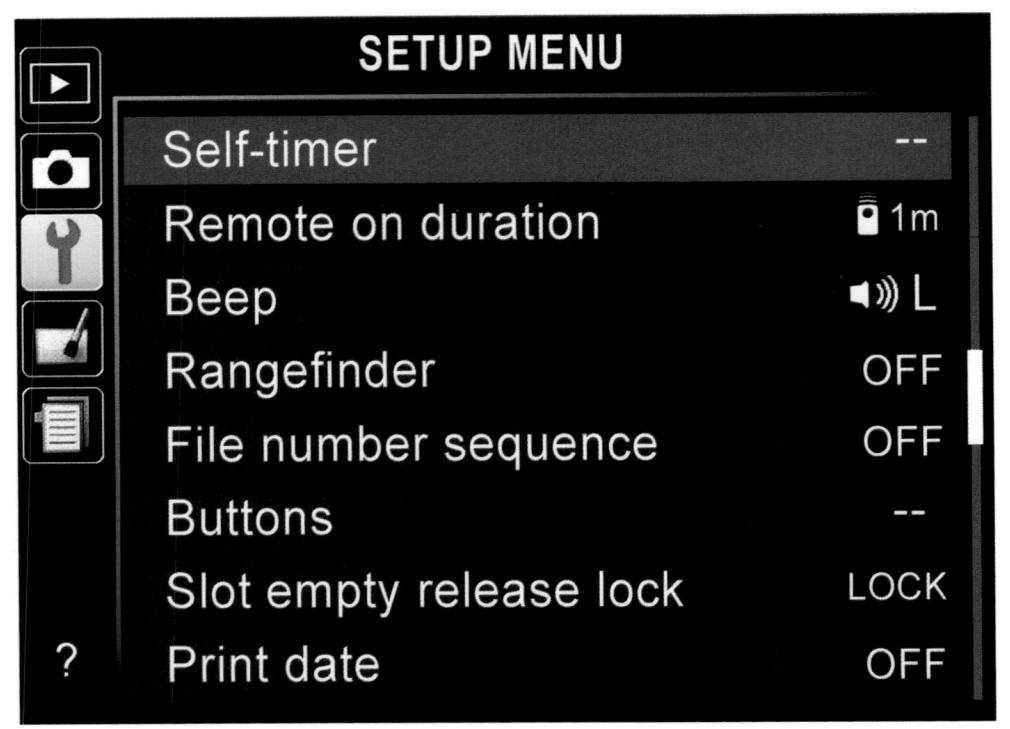

Figure 5.5
The third
screen of the
Setup menu.

distracting (at a concert or museum), or undesired for any other reason. It's one of the few ways to make the D3200 a bit quieter. (I've actually had new dSLR owners ask me how to turn off the "shutter sound" the camera makes; such an option was available in the point-and-shoot camera they'd used previously.) Your choices are High, Low, and Off. When the beeper is active, a musical note icon is shown in the shooting information display.

Rangefinder

The rangefinder is a clever feature, when activated, that supplements the green focus confirmation indicator at the left edge of the viewfinder by transforming the analog exposure indicator as an "in-focus/out-of-focus" scale to show that correct focus has been achieved when focusing manually.

Some lenses don't offer autofocus features with the Nikon D3200, because they lack the internal autofocus motor the D3200 requires. (They are able to autofocus on other Nikon cameras, except for the D3000-series, D5000-series, D60, and D40/D40x, because those other cameras include an autofocus motor in the body.) Many manual focus lenses that never had autofocus features can also be used with the D3200 in manual focus mode. You'll find more information about this limitation in Chapter 10, but all you need to know is that Nikon lenses with the AF-S designation in the lens name will autofocus on the D3200, while those with the AF, AI, or AI-S designation

will not. Specifications for lenses from other vendors will indicate whether the lens includes an autofocus motor or not.

When a non-autofocus lens is mounted on the Nikon D3200, and the camera has been set for any exposure mode except for Manual (M)—that is, any of the Scene modes, plus Program, Aperture-priority, or Shutter-priority, manual focus mode is automatically activated. You can manually focus by turning the focus ring on the lens (set the lens to manual focus if it is an AF-type lens) and watching the sharpness of the image on the focusing screen. The focus confirmation indicator at the lower-left corner of the viewfinder will illuminate when correct focus is achieved, if your lens has a maximum aperture of f/5.6 or larger (that is, a larger number, such as f/5.6, f/4.5, f/4, and so forth).

Tip

Note that this feature is not available when shooting in Manual *exposure* mode however. The D3200 shows whether exposure is under, over, or correct, instead. Use the focus confirmation lamp to monitor manual focus in this mode.

The readout in the viewfinder is not analog (that is, continuous). Only the six indicators shown in Figure 5.6 are displayed. Two centered rectangles indicate that correct focus has been achieved; when all 12 are shown, it means that correct focus cannot be indicated. Three and six rectangles show that slight or major focus corrections are needed, respectively.

Figure 5.6 Upper left: Correct focus; upper right: focus is grossly incorrect; center left: focus slightly in front of the subject; center right: focus slightly behind the subject; bottom left: focus significantly in front of the subject; bottom right: focus significantly behind the subject.

Turn the Rangefinder On with this setting option if you want an additional manual focusing aid. With a manual focus lens and the Rangefinder operating, the analog exposure display at bottom right in the viewfinder will be replaced by a rangefinder focusing scale. Indicators on the scale like those in Figure 5.6 show when the image is in sharp focus, as well as when you have focused somewhat in front of, or behind the subject. Follow these steps to use the Rangefinder:

- 1. Press the multi selector buttons to choose a focus point that coincides with the subject you'd like to be in focus.
- 2. Rotate the focusing ring, watching the rangefinder scale at the bottom of the view-finder. If the current sharp focus plane is *in front* of the point of desired focus, the rangefinder scale will point toward the left side of the viewfinder. The greater the difference, the more bars (either three or six bars) shown in the rangefinder.
- 3. When the current focus plane is *behind* the desired point of focus, the rangefinder indicator will point to the right.
- 4. When the subject you've selected with the focus zone bracket is in sharp focus, only two bars will appear, centered under the 0, and the focus confirmation indicator will stop blinking.

File Number Sequence

The Nikon D3200 will automatically apply a file number to each picture you take, using consecutive numbering for all your photos over a long period of time, spanning many different memory cards, starting over from scratch when you insert a new card, or when you manually reset the numbers. Numbers are applied from 0001 to 9999, at which time the D3200 "rolls over" to 0001 again.

The camera keeps track of the last number used in its internal memory and, if File Number Sequence is turned On, will apply a number that's one higher, or a number that's one higher than the largest number in the current folder on the memory card inserted in the camera. You can also start over each time a new folder has been created on the memory card, or reset the current counter back to 0001 at any time. Here's how it works:

- Off. At this default setting, if you're using a blank/reformatted memory card, or a new folder is created, the next photo taken will be numbered 0001. File number sequences will be reset every time you use or format a card, or a new folder is created (which happens when an existing folder on the card contains 999 shots).
- On. The Nikon D3200 will apply a number one higher than the last picture taken, even if a new folder is created, a new memory card inserted, or an existing memory card formatted.

■ **Reset.** The D3200 starts over with 0001, even if a folder containing images exists on the card. In that case, a new folder will be created. At this setting, new or reformatted memory cards will always have 0001 as the first file number.

HOW MANY SHOTS, REALLY?

The file numbers produced by the D3200 don't provide information about the actual number of times the camera's shutter has been tripped—called actuations. For that data, you'll need a third-party software solution, such as the free Opanda iExif (www.opanda.com) for Windows (see Figure 5.7) or the non-free (\$34.95) GraphicConverter for Macintosh (www.lemkesoft.com). These utilities can be used to extract the true number of actuations from the Exif information embedded in a JPEG file.

Figure 5.7

Opanda and other utilities can reveal the exact number of actuations your camera has racked up.

Buttons

You can define the action that the Fn button, AE-L/AF-L, and AE Lock buttons perform when pressed alone. Each of the buttons has its own set of actions that you can define.

Fn Button

There are four different actions you can define for the Fn button:

■ Image Size/Qual. With this setting, when the Fn button is pressed, the information edit screen pops up, and you can rotate the command dial to view and select image quality (RAW, JPEG Fine, JPEG Norm, JPEG Basic, or RAW+Fine) and image size (for JPEG images). When specifying JPEG quality and size, the information edit display cycles among the three quality settings, then moves to the next lower size, allowing you to set both with one (extended) rotation of the command

dial. For example, the Fine, Normal, and Basic Large settings are shown first, followed by Fine, Normal, and Basic Medium, and Fine, Normal, and Basic Small. I never use this function key definition; it's easier just to use the information edit menu, and I rarely change image size, anyway.

- ISO Sensitivity. Use this option if you want to adjust ISO setting using the Fn key. The information edit screen appears, and you can rotate the command dial to choose an ISO sensitivity.
- White Balance. When the Fn button is pressed, you can rotate the command dial to select one of the white balance settings when using Program, Shutter-priority, Aperture-priority, or Manual exposure modes.
- Active D-Lighting. This allows you to choose the Active D-Lighting mode using the Fn button and rotating the command dial.

AF-L/AF-L button

When the Nikon D3200 is set to its default values, a half-press of the shutter release locks in the current autofocus setting in AF-S mode, or in AF-A mode if your subject is not moving. (The camera will refocus if the subject moves and the D3200 is set for AF-C or AF-A mode.) That half-press also activates the exposure meter, but, ordinarily, the exposure changes as the lighting conditions in the frame change.

However, sometimes you want to lock in focus and/or exposure, and then reframe your photo. For that, and for other focus/exposure locking options, Nikon gives you the AE-L/AF-L button (located on the back of the camera to the right of the viewfinder window), and a variety of behavior combinations for it. This setting allows you to define whether the Nikon D3200 locks exposure, focus, or both when the button is pressed, so the AE-L/AF-L button can be used for these functions in addition to, or instead of a half-press of the shutter release. It can also be set so that autofocus starts only when the button is pressed; in that case, a half-press of the shutter release initiates autoexposure, but the AE-L/AF-L button must be pressed to start the autofocusing process. These options can be a little confusing, so I'll offer some clarification:

- AE/AF lock. Lock both focus and exposure while the AE-L/AF-L button is pressed and held down, even if the shutter release button has not been pressed. This is the default value, and is useful when you want to activate and lock in exposure and focus independently of the shutter release button. Perhaps your main subject is offcenter; place that subject in the middle of the frame, lock in exposure and focus, and then reframe the picture while holding the AE-L/AF-L button.
- AE lock only. Lock only the exposure while the AE-L/AF-L button is pressed. The exposure is fixed when you press and hold the button, but autofocus continues to operate (say, when you press the shutter release halfway) using the AF-A, AF-S, or AF-C mode you've chosen.

- **AF lock only.** Focus is locked in while the AE-L/AF-L button is held down, but exposure will continue to vary as you compose the photo and press the shutter release button.
- AE lock (Hold). Exposure is locked when the AE-L/AF-L button is pressed, and remains locked until the button is pressed again, or the exposure meter-off delay expires. Use this option when you want to lock exposure at some point, but don't want to keep your thumb on the AE-L/AF-L button.
- AF (AF-ON). The AE-L/AF-L button is used to initiate autofocus. A half-press of the shutter release button does not activate or change focus. This setting is useful when you want to frame your photo, press the shutter release halfway to lock in exposure, but don't want the D3200 to autofocus until you tell it to. I use this for sports photography when I am waiting for some action to move into the frame before starting autofocus. For example, I might press the AE-L/AF-L button just before a racehorse crosses the finish line.
- Shutter-release button AE-L. When you turn this option On, the exposure locks when the shutter release button is pressed halfway. When Off (the default), a shutter release half-press does not lock exposure; the camera will continue to adjust exposure until you press the shutter release all the way to take the picture, or take your finger off the button. Set this option to Off when you are shooting under lighting conditions that may change suddenly; use On when you want the exposure to remain constant even if the lighting changes. You might do this while recording a series of scenes illuminated by the setting sun, and want the scene to gradually get darker as the sun sinks behind the horizon. With the default Off setting, the D3200 would constantly compensate for the waning light, rendering each shot similar in appearance.

Slot Empty Release Lock

This entry gives you the ability to snap off "pictures" without a memory card installed—or, alternatively, to lock the camera shutter release if no card is present. It is sometimes informally called Play mode, because you can experiment with your camera's features or even hand your D3200 to a friend to let them fool around, without any danger of pictures actually being taken.

Back in our film days, we'd sometimes finish a roll, rewind the film back into its cassette surreptitiously, and then hand the camera to a child to take a few pictures—without actually wasting any film. It's hard to waste digital film, but "shoot without card" mode is still appreciated by some, especially camera vendors who want to be able to demo a camera at a store or trade show, but don't want to have to equip each and every demonstrator model with a memory card. Choose Enable Release to activate "play" mode or Release Locked to disable it. The pictures you actually "take" are displayed on the LCD with the legend "Demo" superimposed on the screen, and they are, of course, not saved.

Print Date

You can superimpose the date, time, or both on your photographs, or imprint a date counter that shows the number of days (or years and days, or months, years, and days) between when the picture was taken and a date (in the past or future) that you select. The good news is that this feature can be useful for certain types of photographs used for documentation. While the D3200's time/date stamp may not be admissible in a court of law, it makes a convincing (or convenient) in-picture indication of when the shot was made. This feature works only with JPEG images; you cannot use Date Imprint with pictures taken using the RAW or RAW+Fine settings.

The bad news, especially if you use the feature accidentally, is that the imprint is a permanent part of the photograph. You'll have to polish up your Photoshop skills if you want to remove it, or, at the very least, crop it out of the picture area. Date and time are set using the format you specify in the World Time setting of the Setup menu, described in the next section. Your options are as follows:

- **Off.** Deactivates the date/time imprint feature.
- **Date.** The date is overlaid on your image in the bottom-right corner of the frame, and appears in the shooting information display. If you've turned on Auto Image Rotation the date is overlaid at the bottom-right corner of vertically oriented frames.
- **Date/Time.** Both date and time are imprinted, in the same positions.
- **Date Counter.** This option imprints the current date on the image, but also adds the number of days that have elapsed since a particular date in the past that you specify, *or* the days remaining until an upcoming date in the future.

Using the Date Counter

If you're willing to have information indelibly embedded in your images, the Date Counter can be a versatile feature. You can specify several parameters in advance (or at the time you apply the Date Counter) and activate the overprinting *only* when you want it.

- Off. Select this from the main Date Imprint screen. Choosing Off disables the imprinting of date, date/time, and the Date Counter. When disabled, no date or counter information is shown, regardless of how you have set the other parameters.
- Choose date. When you enter the Date Counter screen, one option lets you enter up to three different dates for your countdown/countup. When you activate the Date Counter, you can choose from the three dates (or a new date you enter to replace one of the three) and use that for your date counting imprint.

- **Display options.** Also in the Date Counter screen, you can select Display Options, which allows you to specify Number of Days, Years and Days, or Years, Months, and Days for the Date Counter readout imprinted on your images.
- **Done.** When you've finished entering date and display options, choose Done to return to the Setup menu. (You *must* do this. If you press the MENU button or tap the shutter release button at this point, your changes will not be confirmed.)

Here are some applications for the Date Counter:

- Tracking a newborn. Enter the child's birthday as one of your three dates. Select Number of Days as your display option for a newborn. Then, as often as you like, activate the Date Counter and take a picture or two. The number of days since the baby's birth will be displayed right on the picture. (Remember to turn the feature off when shooting other pictures of the child, or of other subjects!)
- **Document construction projects.** Enter the start date of the project, activate the Date Counter, and take pictures of the construction progress. Each photo will show exactly how many days have elapsed since ground was broken (or the cornerstone laid, or that non-bearing wall demolished to begin remodeling).
- Long-term documentation. Perhaps you'd like to record the appearance of your favorite nature spot at different times of the year. Choose the first day of Spring as your start date, then shoot pictures at intervals for an entire year, activating the Date Counter as needed. The results will be interesting—and maybe a revelation. With the Years, Months, and Days selected as a display option, you can continue your documentation for years!
- **Countdown.** Something big scheduled for a particular day? Choose that date in the future as your counter, and any photo you take with imprinting activated will show the days remaining until the big day.

Storage Folder

This entry, the first on the last page of the Setup menu (see Figure 5.8), is useful if you want to store images in a folder other than the one created and selected by the Nikon D3200; you can switch among available folders on your memory card, or create your own folder. Remember that any folders you create will be deleted when you reformat your memory card.

The Nikon D3200 automatically creates a folder on a newly formatted memory card with a name like 100NCD3200, and when it fills with 999 images, it will automatically create a new folder with a number incremented by one (such as 101NCD3200).

Figure 5.8
The last page of the Setup menu.

The numeric portion of the folder name is always created by the D3200; your folder choice is based on the remaining five characters:

- If there are folders on your memory card named 100NCD3200 and 101NCD3200, you can choose the folder name NCD3200 from the folder screen. If you've specified a folder name such as SPAIN, the D3200 will create a folder named 100SPAIN, and when it fills up with 999 images, it will create a new folder numbered 101SPAIN, and so forth.
- The D3200 always uses the highest numbered folder with the specified name suffix when creating new images. For example, if you select NCD3200, all images will be created in folder 101NCD3200 until it fills up, and will then be deposited into a new folder 102NCD3200. If you chose SPAIN as your active folder name, all images would go into 100SPAIN until it fills and then 101SPAIN is created.

To change the currently active folder:

- 1. Choose Storage Folder in the Setup menu.
- 2. Scroll down to Select Folder and press the multi selector right button.

- 3. From among the available folders shown, scroll to the one that you want to become active for image storage and playback. (Handy when displaying slide shows.)
- 4. Press the OK button to confirm your choice, or press the multi selector right button to return to the Setup menu.
- 5. You can also choose Delete within the Folders menu to remove all empty folders on your memory card. This option is useful when you've created a bunch of folders and decided not to use them.

Why create your own folders? Perhaps you're traveling and have a high-capacity memory card and want to store the images for each day (or for each city that you visit) in a separate folder. Maybe you'd like to separate those wedding photos you snapped at the ceremony from those taken at the reception. To create your own folder, or to rename an existing folder:

- 1. Choose Storage Folder in the Setup menu.
- Scroll down to New and press the multi selector right button. You can also select Rename to apply a new name to an existing folder; you'll be asked to choose a folder before proceeding.
- 3. Use the text entry screen shown earlier to enter a name for your folder. Follow the instructions I outlined under Image Comment to enter text. The Folder text screen has only uppercase characters and the numbers 0-9, and just five letters can be entered.
- 4. Press the Zoom In button when finished to create and activate the new or renamed folder and return to the Setup menu.

GPS

This menu entry has options for using the Nikon GP-1 Global Positioning System (GPS) device, described in Chapter 5. It has two options, none of which turn GPS features on or off, despite the misleading Enable and Disable nomenclature (what you're enabling and disabling is the automatic exposure meter turn-off):

- Auto meter-off Enable. Reduces battery drain by allowing exposure meters to be turned off after the time specified while using the GP-1 device. The time specified in Auto meter-off delay (discussed earlier in this chapter) will be used. When the meters turn off, the GP-1 becomes inactive and must reacquire at least three satellite signals before it can begin recording GPS data once more.
- Auto meter-off Disable. Causes exposure meters to remain on while using the GP-1, so that GPS data can be recorded at any time, despite increased battery drain.

- **Position.** This is an information display, rather than a selectable option. It appears when the GP-1 is connected and receiving satellite positioning data. It shows the latitude, longitude, altitude, and Coordinated Universal Time (UTC) values.
- Use GPS to Set Camera Clock. If you choose Yes, the D3200 will set its internal clock to match the hyper-accurate setting supplied by the GP-1 device.

You'll find more on using GPS in Chapter 9.

Eye-Fi Upload

This option is displayed only when a compatible Eye-Fi memory card is being used in the D3200. The Eye-Fi card looks like an ordinary SDHC memory card, but has built-in Wi-Fi capabilities, so it can be used to transmit your photos as they are taken directly to a computer over a Wi-Fi network. You can select On or Off. There are times when you might want to disable the Eye-Fi card; for example, if you've set it to automatically upload your pictures to Facebook as you shoot, and you decide you don't want the current batch you're shooting to be transmitted. You'll find more about using Eye-Fi in Chapter 9.

Firmware Version

You can see the current firmware release in use in this menu listing, which you must scroll to view the menu entry that provides the information. You can learn how to update firmware in Chapter 13.

Retouch Menu Options

The Retouch menu has eight entries on its first screen (see Figure 5.9). This menu allows you to create a new copy of an existing image with trimmed or retouched characteristics. You can apply D-Lighting, remove red-eye, create a monochrome image, apply filter effects, rebalance color, overlay one image on another, and compare two images side-by-side. Just select a picture during Playback mode, and then scroll down to one of the retouching options. You can also go directly to the Retouch menu, select a retouching feature, and then choose a picture from the standard D3200 picture selection screen shown earlier.

The Retouch menu is most useful when you want to create a modified copy of an image on the spot, for immediate printing or e-mailing without first importing into your computer for more extensive editing. You can also use it to create a JPEG version of an image in the camera when you are shooting RAW-only photos.

While you can retouch images that have already been processed by the Retouch menu, you can apply up to 10 different effects, in total, but only once per effect (except for Image Overlay). You may notice some quality loss with repeated applications.

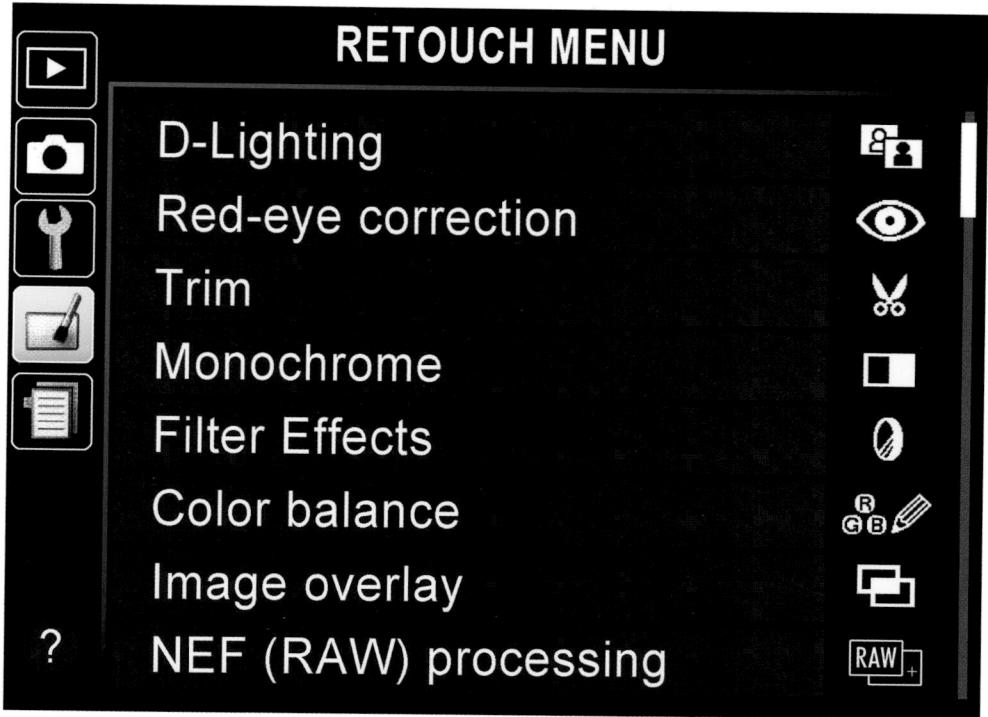

To create a retouched copy of an image:

- 1. While browsing among images in Playback mode, press OK when an image you want to retouch is displayed on the screen. The Retouch menu will pop up, and you can select a retouching option.
- 2. From the Retouch menu, select the option you want and press the multi selector right button. The Nikon D3200's standard image selection screen appears. Scroll among the images as usual with the left/right multi selector buttons, press the Zoom In button to examine a highlighted image more closely, and press OK to choose that image.
- 3. Work with the options available from that particular Retouch menu feature and press OK to create the modified copy, or Playback to cancel your changes.
- 4. The retouched image will bear a filename that reveals its origin. For example, if you make a Small Picture version of an image named DSC_0112.jpg, the reduced-size copy will be named SSC_0113.jpg. Copies incorporating other retouching features would be named CSC_0113.jpg instead.

- D-Lighting
- Red-Eye Correction
- Trim
- Monochrome
- Filter Effects
- Color Balance
- Image Overlay

- NEF (Raw processing)
- Resize
- Quick Retouch
- Straighten
- Distortion Control
- Fisheye
- Color Outline

- Color Sketch
- Perspective Control
- Miniature Effect
- Selective Color
- Edit Movie
- Side-by-Side Comparison

D-Lighting

This option brightens the shadows of pictures that have already been taken, similarly to the Active D-Lighting feature described in Chapter 4. It is a useful tool for backlit photographs or any image with deep shadows with important detail. Once you've selected your photo for modification, you'll be shown side-by-side images with the unaltered version on the left, and your adjusted version on the right. Press the multi selector's up/down buttons to choose from High, Normal, or Low corrections. Press the Zoom In button to magnify the image. When you're happy with the corrected image on the right, compared to the original on the left, press OK to save the copy to your memory card (see Figure 5.10).

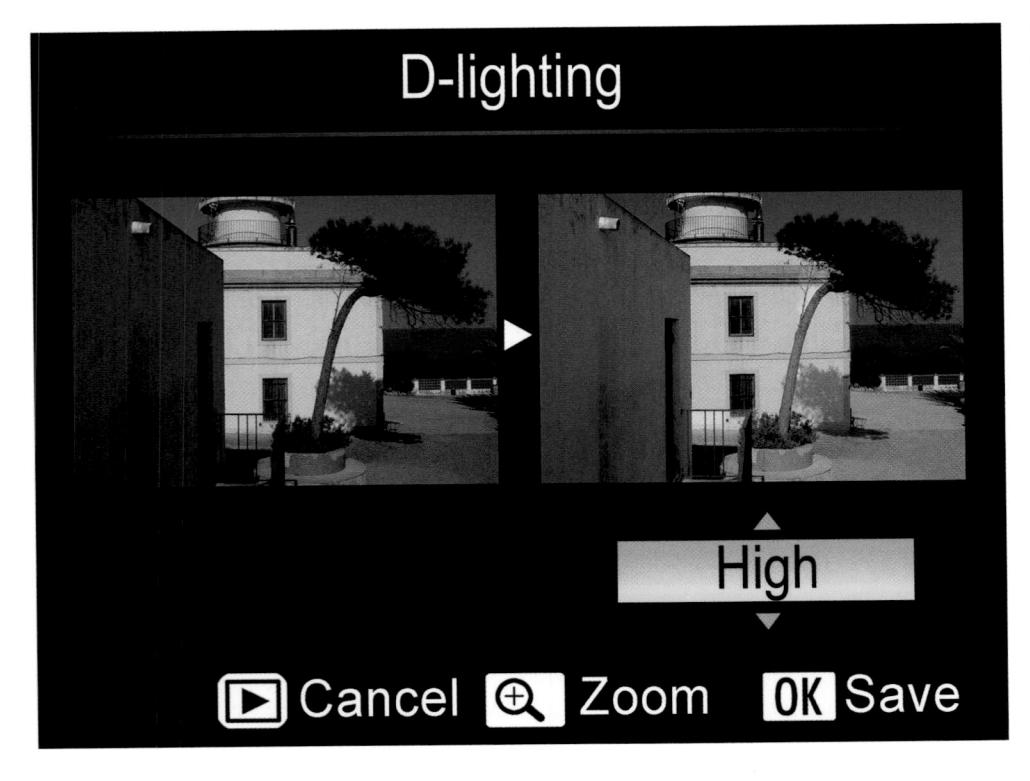

Figure 5.10
Use the
D-Lighting feature to brighten dark shadows while producing minimal changes in the highlights.

Red-Eye Correction

This Retouch menu tool can be used to remove the residual red-eye look that remains after applying the Nikon D3200's other remedies, such as the red-eye reduction lamp. (You can use the red-eye tools found in most image editors, as well.)

Your Nikon D3200 has a fairly effective red-eye reduction flash mode. Unfortunately, your camera is unable, on its own, to totally *eliminate* the red-eye effects that occur when an electronic flash (or, rarely, illumination from other sources) bounces off the retinas of the eye and into the camera lens. Animals seem to suffer from yellow or green glowing pupils, instead; the effect is equally undesirable. The effect is worst under low-light conditions (exactly when you might be using a flash) as the pupils expand to allow more light to reach the retinas. The best you can hope for is to *reduce* or minimize the red-eye effect.

The best way to truly eliminate red-eye is to raise the flash up off the camera so its illumination approaches the eye from an angle that won't reflect directly back to the retina and into the lens. The extra height of the built-in flash may not be sufficient, however. That alone is a good reason for using an external flash. If you're working with your D3200's built-in flash, your only recourse may be to switch on the red-eye reduction flash mode. That causes a lamp on the front of the camera to illuminate with a half-press of the shutter release button, which may result in your subjects' pupils contracting, decreasing the amount of the red-eye effect. (You may have to ask your subject to look at the lamp to gain maximum effect.)

If your image still displays red-eye effects, you can use the Retouch menu to make a copy with red-eye reduced further. First, select a picture that was taken with flash (non-flash pictures won't be available for selection). After you've selected the picture to process, press OK. The image will be displayed on the LCD. You can magnify the image with the Zoom In button, scroll around the zoomed image with the multi selector buttons, and zoom out with the Zoom Out button. While zoomed, you can cancel the zoom by pressing the OK button.

When you are finished examining the image, press OK again. The D3200 will look for red-eye, and, if detected, create a copy that has been processed to reduce the effect. If no red-eye is found, a copy is not created. Figure 5.11 shows an original image (left) and its processed copy (right).

Trim

This option creates copies in specific sizes based on the final size you select, chosen from among 3:2, 4:3, and 5:4 aspect rations (proportions). You can use this feature to create smaller versions of a picture for e-mailing without the need to first transfer the image to your own computer. If you're traveling, create your smaller copy here, insert the memory card in a card reader at an Internet café, your library's public computers, or some other computer, and e-mail the reduced-size version.

Figure 5.11
An image with red-eye (left) can be processed to produce a copy with no red-eye effects (right).

Just follow these steps:

- 1. **Select your photo.** Choose Trim from the Retouch menu. You'll be shown the standard Nikon D3200 image selection screen. Scroll among the photos using the multi selector left/right buttons, and press OK when the image you want to trim is highlighted. While selecting, you can temporarily enlarge the highlighted image by pressing the Zoom In button.
- 2. **Choose your aspect ratio.** Rotate the command dial to change from 3:2, 4:3, 5:4, 1:1, and 16:9 aspect ratios. These proportions happen to correspond to the proportions of common print sizes, plus HDTV, including the two most popular sizes: 4 × 6 inches (3:2) and 8 × 10 inches (5:4). (See Table 5.2.)
- 3. **Crop in on your photo.** Press the Zoom In button to crop your picture. The pixel dimensions of the cropped image at the selected proportions will be displayed in the upper-left corner (see Figure 5.12) as you zoom. The current framed size is outlined in yellow within an inset image in the lower-right corner.
- 4. **Move cropped area within the image.** Use the multi selector left/right and up/down buttons to relocate the yellow cropping border within the frame.
- 5. **Save the cropped image.** Press OK to save a copy of the image using the current crop and size, or press the Playback button to exit without creating a copy. Copies created from JPEG Fine, Normal, or Standard have the same Image Quality setting as the original; copies made from RAW files or any RAW+JPEG setting will use JPEG Fine compression.

Table 5.2 Trim Sizes	
Aspect Ratio	Sizes Available
3:2	5760 × 3850, 5120 × 3416, 4480 × 2984, 3840 × 2560; 3200 × 2128; 2560 × 1704; 1920 × 1280; 1280 × 856; 960 × 640; 640 × 424
4:3	5328 × 4000, 5120 × 3840, 4480 × 3360, 3840 × 2880; 3200 × 2400; 2560 × 1920; 1920 × 1440; 1280 × 960; 960 × 720; 640 × 480
5:4	5008 × 4000, 4800 × 3840, 4208 × 3360, 3600 × 2880; 2992 × 2400; 2400 × 1920; 1808 × 1440; 1200 × 960; 896 × 720; 608 × 480
1:1	3840 × 3840, 3360 × 3360, 2880 × 2880; 2400 × 2400; 1920 × 1920; 1440 × 1440; 960 × 960; 720 × 720; 480 × 480
16:9	6016 × 3384, 5760 × 3240, 5120 × 2880, 4480 × 2520, 3840 × 2160; 3200 × 1800; 2560 × 1440; 1920 × 1080; 1280 × 720; 960 × 536; 640 × 360

Figure 5.12
The Trim feature of the Retouch menu allows in-camera cropping.

Monochrome

This Retouch choice allows you to produce a copy of the selected photo as a black-and-white image, sepia-toned image, or cyanotype (blue-and-white). You can fine-tune the color saturation of the previewed Sepia or Cyanotype version by pressing the multi selector up button to increase color richness, and the down button to decrease saturation. When satisfied, press OK to create the monochrome duplicate.

Filter Effects

Add effects somewhat similar to photographic filters with this tool. You can choose from among six different choices:

- Skylight. This option makes the image slightly less blue.
- Warm. Use this filter to add a rich warm cast to the duplicate.
- Red, Green, Blue intensifiers. These three options make the red, green, and blue hues brighter, respectively. Use them to brighten a rose, intensify the greens of foliage, or deepen the blue of the sky.
- Cross screen. This option adds radiating star points to bright objects—such as the reflection of light sources on shiny surfaces. You can choose four different attributes of your stars:
 - **Number of points.** You can select from four, six, or eight points for each star added to your image.
 - **Filter amount.** Select from three different intensities, represented by two, three, and four stars in the menu (this doesn't reflect the actual number of stars in your image, which is determined by the number of bright areas in the photo).
 - **Filter angle.** Select from three different angles: steep, approximately 45 degrees, and a shallower angle.
 - **Length of points.** Three different lengths for the points can be chosen: short, medium, and long.
- **Soft.** Creates a dreamy, soft-focus version of your image. You can compare the "before" and "after" versions using a screen much like the one used for D-Lighting.

Color Balance

This option produces the screen shown in Figure 5.13, with a preview image of your photo. Use the multi selector up/down (green/pink) and left/right buttons (blue/red) to bias the color of your image in the direction of the hues shown on the color square below the preview.

Image Overlay

The Image Overlay tool, the first entry in the next page of the Setup menu options, allows you to combine two RAW photos (only NEF files can be used) in a composite image that Nikon claims is better than a "double exposure" created in an image-editing application because the overlays are made using RAW data. To produce this composite image, follow these steps:

- 1. Choose Image Overlay. The screen shown in Figure 5.14 will be displayed, with the Image 1 box highlighted.
- 2. Press OK and the Nikon D3200's image selection screen appears. Choose the first image for the overlay and press OK.
- 3. Press the multi selector right button to highlight the Image 2 box, and press OK to produce the image selection screen. Choose the second image for the overlay.
- 4. By highlighting either the Image 1 or Image 2 box and pressing the multi selector up/down buttons, you can adjust the "gain," or how much of the final image will be "exposed" from the selected picture. You can choose from X0.5 (half-exposure) to X2.0 (twice the exposure) for each image. The default value is 1.0 for each, so that each image will contribute equally to the final exposure.

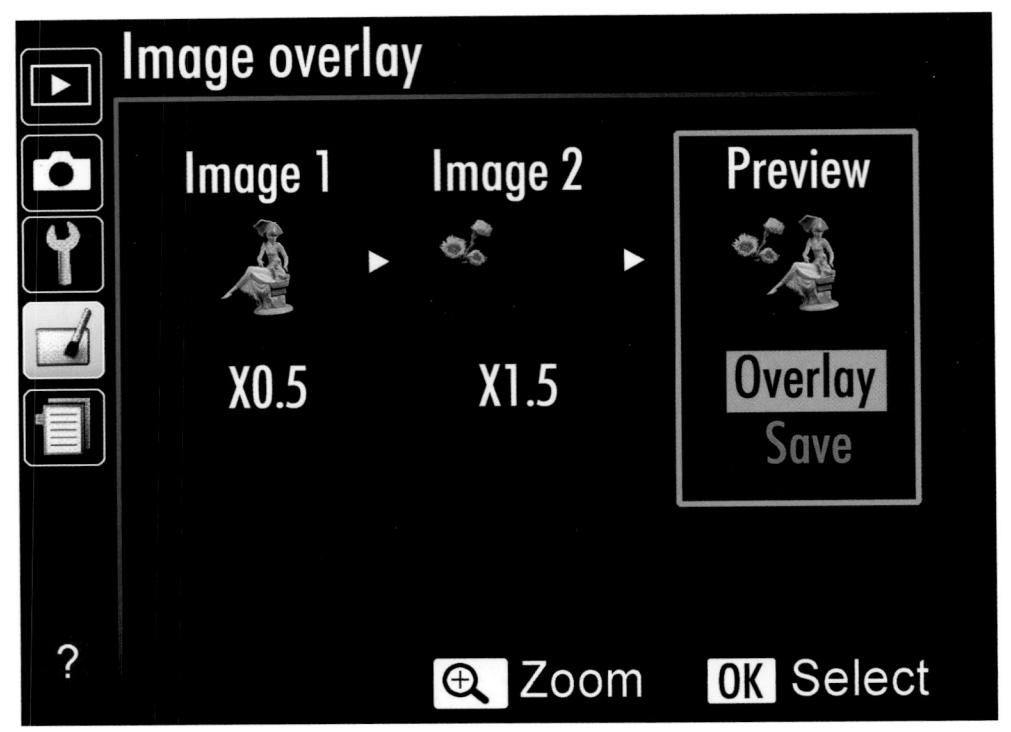

Figure 5.14
Overlay two
RAW images to
produce a "double exposure."

- 5. Use the multi selector right button to highlight the Preview box and view the combined picture. Press the Zoom In button to enlarge the view.
- 6. When you're ready to store your composite copy, press the multi selector down button when the Preview box is highlighted to select Save, and press OK. The combined image is stored on the memory card.

NEF (RAW) Processing

Use this tool to create a JPEG version of any image saved in either straight RAW (with no JPEG version) or RAW+Fine (with a Fine JPEG version). You can select from among several parameters to "process" your new JPEG copy right in the camera.

- Choose a RAW image. Select NEF (RAW) Processing from the Retouch menu. You'll be shown the standard Nikon D3200 image selection screen. Use the left/right buttons to navigate among the RAW images displayed. Press OK to select the highlighted image.
- 2. In the NEF (RAW) processing screen, shown in Figure 5.15, you can use the multi selector up/down keys to select from five different attributes of the RAW image information to apply to your JPEG copy. Choose Image Quality (Fine, Normal, or Basic), Image Size (Large, Medium, or Small), White Balance, Exposure Compensation, and Set Picture Control parameters.

Adjust five parameters and then save your JPEG copy from a RAW original file.

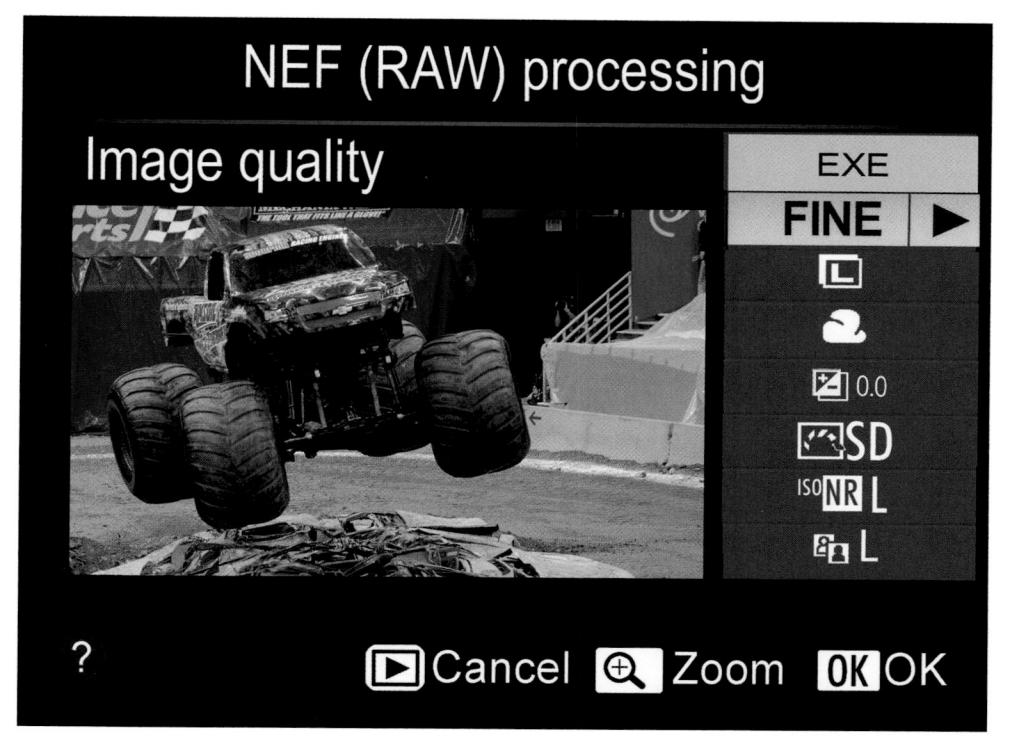

Tip

The White Balance parameter cannot be selected for images created with the Image Overlay tool, and the Preset manual white balance setting can be fine-tuned only with images that were originally shot using the Preset white balance setting. Exposure compensation cannot be adjusted for images taken using Active D-Lighting, and both white balance and optimize image settings cannot be applied to pictures taken using any of the Scene modes.

- 3. Press the Zoom In button to magnify the image temporarily while the button is held down.
- 4. Press the Playback button if you change your mind, to exit from the processing screen.
- 5. When all parameters are set, highlight EXE (for Execute) and press OK. The D3200 will create a JPEG file with the settings you've specified, and show an Image Saved message on the LCD when finished.

Resize

This option, the first in the next screen of the Retouch menu (see Figure 5.16), creates smaller copies of the selected images. It can be applied while viewing a single image in full-frame mode (just press the OK button while viewing a photo), or accessed from the Retouch menu (especially useful if you'd like to select and resize multiple images).

- Select images. If accessing from the Retouch menu, you can choose to select multiple images, or jump directly to the following two steps.
- Choose Size. Next, select the size for the finished copy, from 2.5M (1920 × 1280 pixels), 1.1M (1280 × 856 pixels), 0.6M (960 × 640 pixels), 0.3M (640 × 424 pixels), or 0.1M (320 × 216 pixels).
- Confirm. Press OK to create your copy.

Quick Retouch

This option brightens the shadows of pictures that have already been taken. Once you've selected your photo for processing, use the multi selector up/down keys in the screen that pops up (see Figure 5.17). The amount of correction that you select (High, Normal, or Low) will be applied to the version of the image shown at right. The left-hand version of the image shows the uncorrected version. While working on your image, you can press the Zoom In button to temporarily magnify the original photo.

Quick Retouch brightens shadows, enhances contrast, and adds color richness (saturation) to the image. Press OK to create a copy on your memory card with the retouching applied.

Straighten

Use this to create a corrected copy of a crooked image, rotated by up to five degrees, in increments of one-quarter of a degree. Use the right directional button to rotate clockwise, and the left directional button to rotate counterclockwise. Press OK to make a corrected copy, or the Playback button to exit without saving a copy.

Distortion Control

This option produces a copy with reduced barrel distortion (a bowing out effect) or pincushion distortion (an inward-bending effect), both most noticeable at the edges of a photo. You can select Auto to let the D3200 make this correction, or use Manual to make the fix yourself visually. Use the right directional button to reduce barrel distortion and the left directional button to reduce pincushion distortion. In both cases, some of the edges of the photo will be cropped out of your image. Press OK to make a corrected copy, or the Playback button to exit without saving a copy. Note that Auto cannot be used with images exposed using the Auto Distortion Control feature described

Figure 5.16
Resize is the first entry on the second page of the Retouch menu.

Figure 5.17
Quick Retouch
applies
D-Lighting,
enhanced contrast, and added
saturation to an
image.

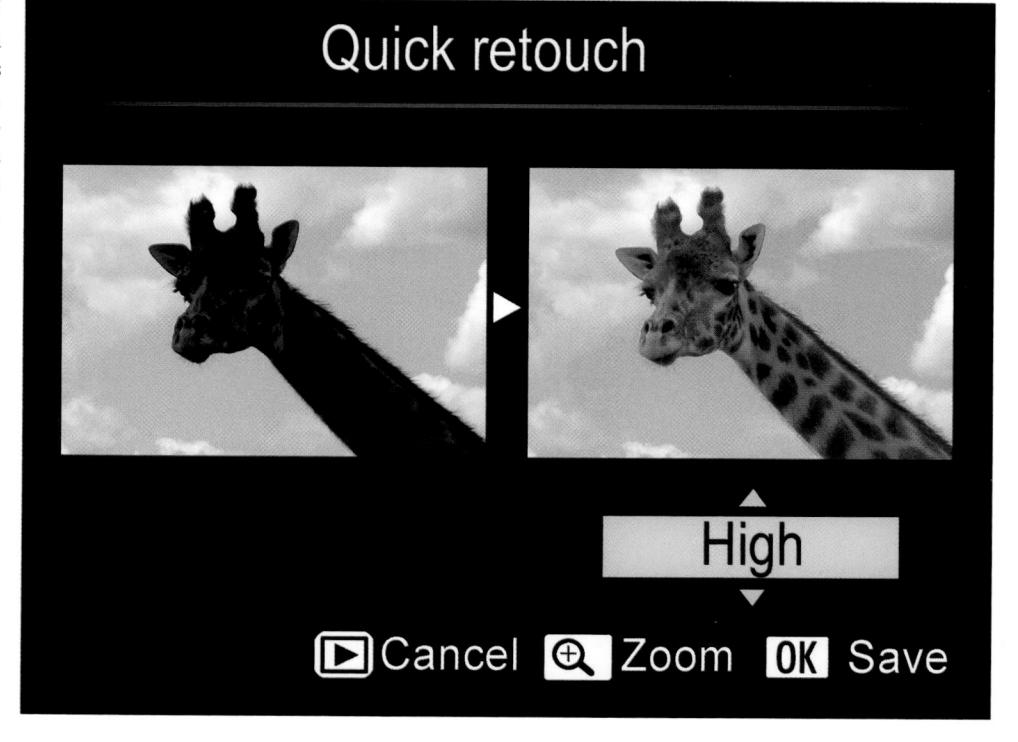

earlier in this chapter. Auto works only with type G and type D lenses (see Chapter 10 for a description of what these lenses are), and does not work well with certain lenses, such as fisheye lenses and perspective control lenses.

Fisheye

This feature emulates the extreme curving effect of a fisheye lens. Use the right directional button to increase the effect, and the left directional button to decrease it. Press OK to make a corrected copy, or the Playback button to exit without saving a copy. Figure 5.18 shows an example image.

Figure 5.18 You can apply a fisheye effect to an image.

Color Outline

This option creates a copy of your image in outline form (see Figure 5.19), which Nikon says you can use for "painting." You might like the effect on its own. It's a little like the Find Edges command in Photoshop and Photoshop Elements, but you can perform this magic in your camera!

Color Sketch

This option creates a copy of your image in outline form, too, but retains some of the colors of the original image.

Figure 5.19
The Color
Outline
retouching feature creates an
outline image
(right), but it's
not in color
(like the original, left).

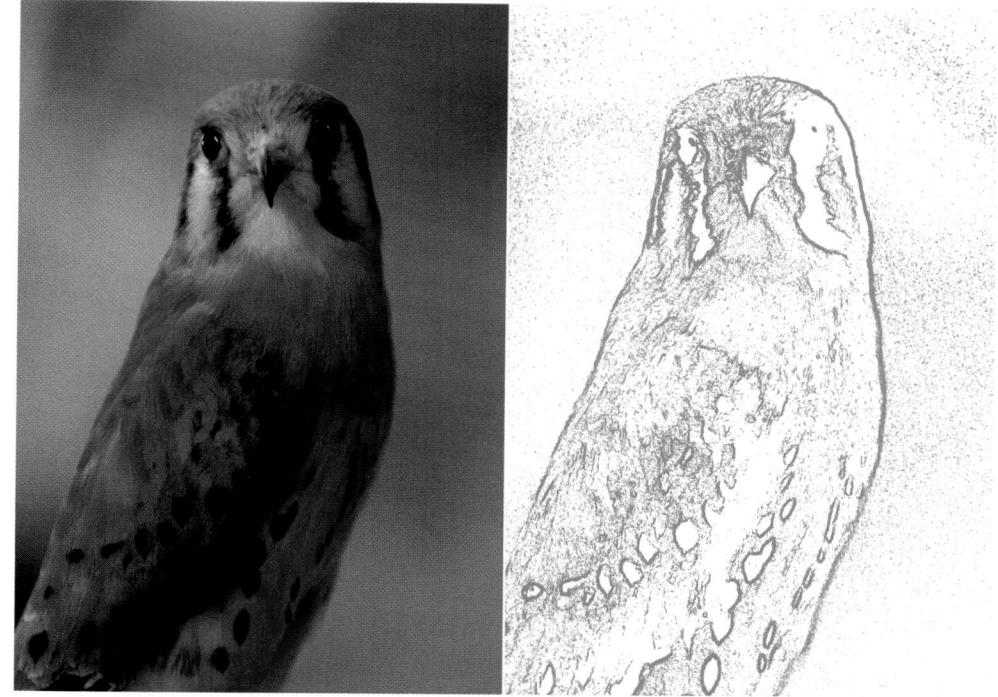

Perspective Control

This option lets you adjust the perspective of an image, reducing the falling back effect produced when the camera is tilted to take in the top of a tall subject, such as a building. Use the multi selector buttons to "tilt" the image in various directions and visually correct the distortion. (See Figure 5.20.)

Miniature Effect

This is a clever effect, and it's hampered by a misleading name and the fact that its properties are hard to visualize (which is not a great attribute for a visual effect). This tool doesn't create a "miniature" picture, as you might expect. What it does is mimic tilt/shift lens effects that angle the lens off the axis of the sensor plane to drastically change the plane of focus, producing the sort of look you get when viewing some photographs of a diorama, or miniature scene. Confused yet? It's the first entry on the last screen of the Retouch menu. (See Figure 5.21.)

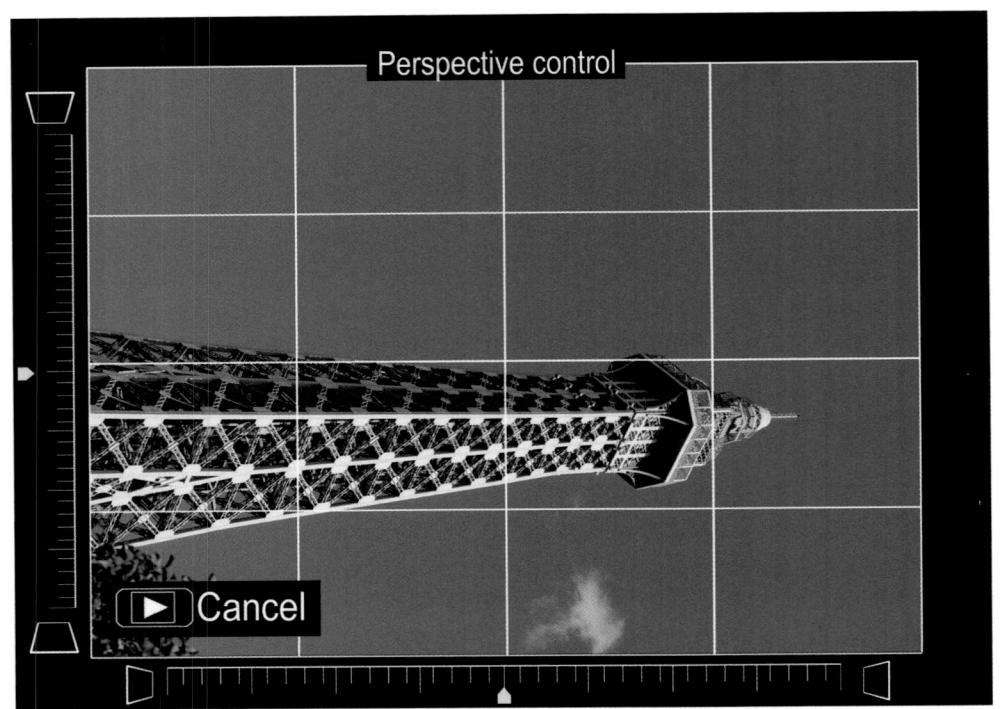

Figure 5.20 Perspective Control lets you fix "falling back" distortion when photographing tall subjects.

Figure 5.21
The last screen in the Retouch menu.

Perhaps the best way to understand this capability is to actually modify a picture using it. Just follow these steps:

- 1. **Take your best shot.** Capture an image of a distant landscape or other scene, preferably from a slightly elevated viewpoint.
- 2. Access Miniature Effect. When viewing the image during playback, press the multi selector center button to access the Retouch menu, and select Miniature Effect. A screen like the one shown in Figure 5.22 appears.
- 3. **Adjust selected area.** A wide yellow box (or a tall yellow box if the image is rotated to vertical perspective on playback) highlights a small section of the image. (No, we're not going to create a panorama from that slice; this Nikon super-tricky feature has fooled you yet again.) Use the up/down buttons (or left/right buttons if the image is displayed vertically) to move the yellow box, which represents the area of your image that will be rendered in (fairly) sharp focus. The rest of the image will be blurred.
- 4. **Preview area to be in sharp focus.** Press the Zoom In button to preview the area that will be rendered in sharp focus. Nikon labels this control Confirm, but that's just to mislead you. It's actually just a preview that lets you "confirm" that this is the area you want to emphasize.

Figure 5.22
Choose the area for sharp focus by moving the yellow box within the frame.

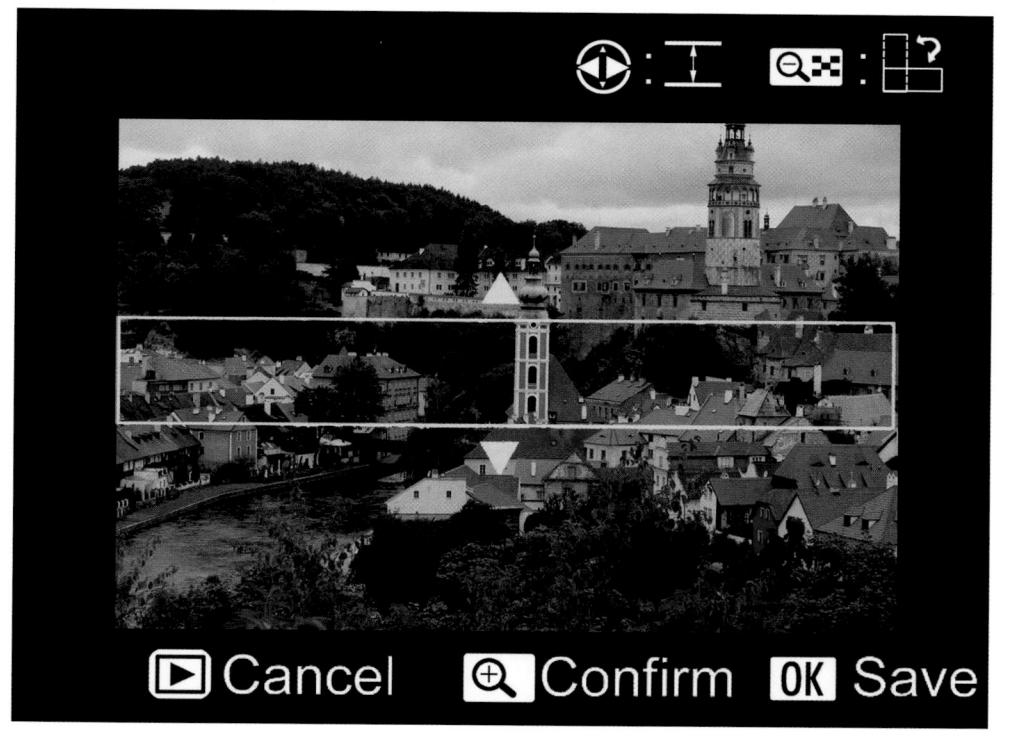

5. **Apply the effect.** Press the OK button to apply the effect (or the Playback button to cancel). Your finished image will be rendered in a weird altered-focus way, as shown at bottom in Figure 5.23.

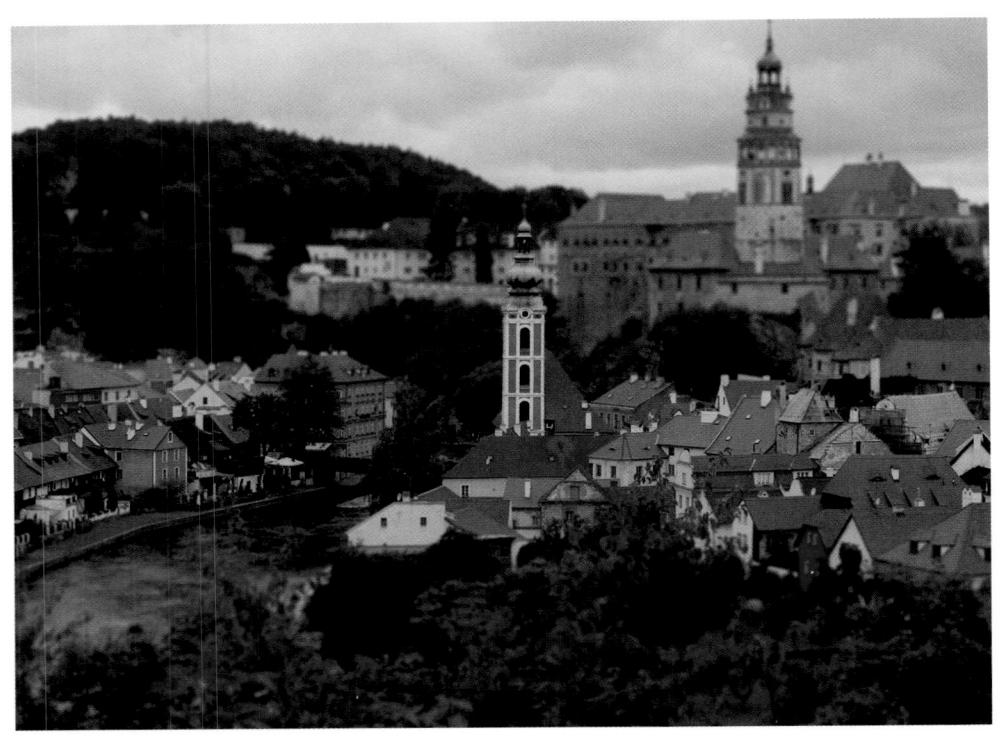

Figure 5.23
The photo with the diorama/ miniature effect applied.

Side-by-Side Comparison

Use this option to compare a retouched photo side-by-side with the original from which it was derived. This option is shown on the pop-up menu that appears when you are viewing an image (or copy) full screen and press the OK button.

To use Before and After comparisons:

- 1. Press the Playback button and review images in full-frame mode until you encounter a source image or retouched copy you want to compare. The retouched copy will have the retouching icon displayed in the upper-left corner. Press OK.
- The Retouch menu with Trim, Monochrome, Filter Effects, Small Picture, and Before and After appears. (These are the only options that can be applied to an image that has already been retouched.) Scroll down to Before and After and press OK.

- 3. The original and retouched image will appear next to each other, with the retouching options you've used shown as a label above the images.
- 4. Highlight the original or the copy with the multi selector left/right buttons, and press the Zoom In button to magnify the image to examine it more closely.
- 5. If you have created more than one copy of an original image, select the retouched version shown, and press the multi selector up/down buttons to view the other retouched copies. The up/down buttons will also let you view the other image used to create an Image Overlay copy.
- 6. When done comparing, press the Playback button to exit.

Selective Color

Use the multi selector to move the cursor over an object and press the AE-L/AF-L button to select that color, which will remain in the final retouched copy of the image, while the other colors are converted to black-and-white. You can press the Zoom In/Zoom Out buttons to choose a specific color more precisely. Rotate the command dial to expand/contract the color range of hues to match the selected color. (See Figures 5.24 and 5.25.)

Figure 5.24 Select the colors to be retained.

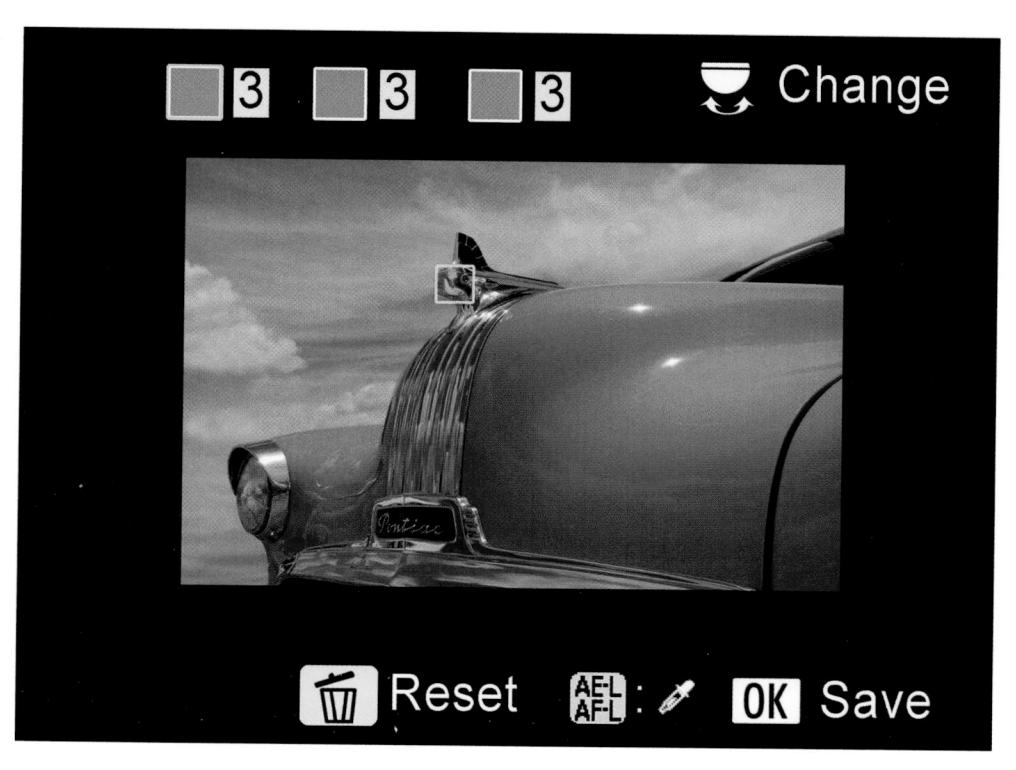

Figure 5.25 Non-selected colors will be converted to black-and-white.

Edit Movie

You can edit movies as you view them, pausing (using the down directional button) and clipping off portions from the beginning and/or end of the movie to create an edited version. Movie editing can be done from this menu entry, or accessed by pausing and pressing the AE-L/AF-L button to display a retouching menu.

I'll describe editing movies using this capability in detail in Chapter 8.

Using Recent Settings

The last menu in the D3200's main menu screen is Recent Settings (see Figure 5.26), which simply shows an ever-changing roster of the 20 menu items you used most recently. Press the up/down buttons to highlight an entry, and the right button to select it. To remove an entry from the Recent Settings listing, highlight it and press the Trash button.

Figure 5.26
The most recent menu items you've accessed appear in the Recent Settings menu.

Part II

Beyond the Basics

So, why do you need the three chapters in Part II: Beyond the Basics? I think you'll find that even if you've mastered the fundamentals and controls of the D3200 there is lots of room to learn more and use the features of the camera to their fullest. In this part you can explore some more advanced techniques:

- Chapter 6: Even if you're getting great exposures a high percentage of the time, you can fine-tune tonal values and use your shutter speed, aperture, and ISO controls creatively to zero in on the perfect exposure for that image you see in your mind.
- **Chapter 7:** Your camera's high performance autofocus system may do a great job in achieving sharp focus most of the time—but how do you nail automatic focus for each and every image you capture? Mastering the mysteries of autofocus will help you in your quest to tell the D3200 *what* to focus on, and *when*.
- **Chapter 8:** Your D3200 isn't simply a replacement for your old camcorder—it's a lot *better*. This chapter will show you how to plan and shoot movies and videos that will have your audience begging for more.

Getting the Right Exposure

When you bought your Nikon D3200, you probably thought your days of worrying about getting the correct exposure were over. To paraphrase an old Kodak tagline dating back to the 19th Century—the goal is, "you press the button, and the camera does the rest." For the most part, that's a realistic objective. The D3200 is one of the smartest cameras available when it comes to calculating the right exposure for most situations. You can generally choose one of the Scene modes, or press the mode button and spin the command dial to switch to Program (P), Aperture-priority (A), or Shutter-priority (S) and shoot away.

For example, when you shoot with the main light source behind the subject, you end up with *backlighting*, which can result in an overexposed background and/or an underexposed subject. The Nikon D3200 recognizes backlit situations nicely, and can properly base exposure on the main subject, producing a decent photo. Features like Active D-Lighting (discussed in Chapter 4) can fine-tune exposure as you take photos, to preserve detail in the highlights and shadows.

But what if you *want* to underexpose the subject, to produce a silhouette effect? Or, perhaps, you might want to flip up the D3200's built-in flash unit to fill in the shadows on your subject. The more you know about how to use your D3200, the more you'll run into situations where you want to creatively tweak the exposure to provide a different look than you'd get with a straight shot.

This chapter shows you the fundamentals of exposure, so you'll be better equipped to override the Nikon D3200's default settings when you want to, or need to. After all, correct exposure is one of the foundations of good photography, along with accurate focus and sharpness, appropriate color balance, freedom from unwanted noise and excessive contrast, as well as pleasing composition.

The Nikon D3200 gives you a great deal of control over all of these, although composition is entirely up to you. You must still frame the photograph to create an interesting arrangement of subject matter, but all the other parameters are basic functions of the camera. You can let your D3200 set them for you automatically, you can fine-tune how the camera applies its automatic settings, or you can make them yourself, manually. The amount of control you have over exposure, sensitivity (ISO settings), color balance, focus, and image parameters like sharpness and contrast make the D3200 a versatile tool for creating images.

In the next few pages, I'm going to give you a grounding in one of those foundations, and explain the basics of exposure, either as an introduction or as a refresher course, depending on your current level of expertise. When you finish this chapter, you'll understand most of what you need to know to take well-exposed photographs creatively in a broad range of situations.

Getting a Handle on Exposure

In the most basic sense, exposure is all about light. Exposure can make or break your photo. Correct exposure brings out the detail in the areas you want to picture, providing the range of tones and colors you need to create the desired image. Poor exposure can cloak important details in shadow, or wash them out in glare-filled featureless expanses of white. However, getting the perfect exposure requires some intelligence—either that built into the camera, or the smarts in your head—because digital sensors can't capture all the tones we are able to see. If the range of tones in an image is extensive, embracing both inky black shadows and bright highlights, we often must settle for an exposure that renders most of those tones—but not all—in a way that best suits the photo we want to produce. One solution is to use High Dynamic Range (HDR) photography—taking two (or more) exposures and combining them to create a single image with a full range of tones.

Look at two bracketed exposures presented in Figure 6.1. For the image at the top, the highlights (chiefly the clouds at upper left and the top left edge of the skyscraper) are well exposed, but everything else in the shot is seriously underexposed. The version at the bottom, taken an instant later with the tripod-mounted camera, shows detail in the shadow areas of the buildings, but the highlights are completely washed out. The camera's sensor simply can't capture detail in both dark areas and bright areas in a single shot. The final image is shown in Figure 6.2. I'll explain more about HDR photography later in this chapter. For now, though, I'm going to concentrate on showing you how to get the best exposures possible without resorting to such tools, using only the features of your Nikon D3200.

Figure 6.1
At left, the image is exposed for the highlights, losing shadow detail. At right, the exposure captures detail in the shadows, but the highlights are washed out.

Figure 6.2 Combining the two exposures produces the best compromise image.

To understand exposure, you need to understand the six aspects of light that combine to produce an image. Start with a light source—the sun, an interior lamp, or the glow from a campfire—and trace its path to your camera, through the lens, and finally to the sensor that captures the illumination. Here's a brief review of the things within our control that affect exposure, listed in "chronological" order (that is, as the light moves from the subject to the sensor):

■ **Light at its source.** Our eyes and our cameras—film or digital—are most sensitive to that portion of the electromagnetic spectrum we call *visible light*. That light has several important aspects that are relevant to photography, such as color and

harshness (which is determined primarily by the apparent size of the light source as it illuminates a subject). But, in terms of exposure, the important attribute of a light source is its *intensity*. We may have direct control over intensity, which might be the case with an interior light that can be brightened or dimmed. Or, we might have only indirect control over intensity, as with sunlight, which can be made to appear dimmer by introducing translucent light-absorbing or reflective materials in its path.

- Light's duration. We tend to think of most light sources as continuous. But, as you'll learn in Chapter 11, the duration of light can change quickly enough to modify the exposure, as when the main illumination in a photograph comes from an intermittent source, such as an electronic flash.
- Light reflected, transmitted, or emitted. Once light is produced by its source, either continuously or in a brief burst, we are able to see and photograph objects by the light that is reflected from our subjects toward the camera lens; transmitted (say, from translucent objects that are lit from behind); or emitted (by a candle or television screen). When more or less light reaches the lens from the subject, we need to adjust the exposure. This part of the equation is under our control to the extent we can increase the amount of light falling on or passing through the subject (by adding extra light sources or using reflectors), or by pumping up the light that's emitted (by increasing the brightness of the glowing object).
- **Light passed by the lens.** Not all the illumination that reaches the front of the lens makes it all the way through. Filters can remove some of the light before it enters the lens. Inside the lens barrel is a variable-sized diaphragm that produces an opening called an *aperture* that dilates and contracts to control the amount of light that enters the lens. You, or the D3200's autoexposure system, can control exposure by varying the size of the aperture. The relative size of the aperture is called the *f*/ *stop*. (See Figure 6.3.)
- Light passing through the shutter. Once light passes through the lens, the amount of time the sensor receives it is determined by the D3200's shutter, which can remain open for as long as 30 seconds (or even longer if you use the Bulb setting) or as briefly as 1/4,000th second.
- Light captured by the sensor. Not all the light falling onto the sensor is captured. If the number of photons reaching a particular photosite doesn't pass a set threshold, no information is recorded. Similarly, if too much light illuminates a pixel in the sensor, then the excess isn't recorded or, worse, spills over to contaminate adjacent pixels. We can modify the minimum and maximum number of pixels that contribute to image detail by adjusting the ISO setting. At higher ISOs, the incoming light is amplified to boost the effective sensitivity of the sensor.

These four factors—quantity of light, light passed by the lens, the amount of time the shutter is open, and the sensitivity of the sensor—all work proportionately and reciprocally to produce an exposure. That is, if you double the amount of light, increase the aperture by one stop, make the shutter speed twice as long, or boost the ISO setting 2X, you'll get twice as much exposure. Similarly, you can increase any of these factors while decreasing one of the others by a similar amount to keep the same exposure.

F/STOPS AND SHUTTER SPEEDS

If you're *really* new to more advanced cameras (and I realize that some ambitious amateurs do purchase the D3200 as their first digital SLR), you might need to know that the lens aperture, or f/stop, is a ratio, much like a fraction, which is why f/2 is larger than f/4, just as 1/2 is larger than 1/4. However, f/2 is actually *four times* as large as f/4. (If you remember your high-school geometry, you'll know that to double the area of a circle, you multiply its diameter by the square root of two: 1.4.)

Lenses are usually marked with intermediate f/stops that represent a size that's twice as much/half as much as the previous aperture. So, a lens might be marked: f/2, f/2.8, f/4, f/5.6, f/8, f/11, f/16, f/22, with each larger number representing an aperture that admits half as much light as the one before, as shown in Figure 6.3.

Shutter speeds are actual fractions (of a second), but the numerator is omitted, so that 60, 125, 250, 500, 1,000, and so forth represent 1/60th, 1/125th, 1/250th, 1/500th, and 1/1,000th second. To avoid confusion, Nikon uses quotation marks to signify longer exposures: 2", 2"5, 4", and so forth representing 2.0, 2.5, and 4.0-second exposures, respectively.

Figure 6.3

Top row
(left to right):
 f/2, f/2.8,
 f/4, f/5.6;
bottom row:
 f/8, f/11,
 f/16, f/22.

Most commonly, exposure settings are made using the aperture and shutter speed, followed by adjusting the ISO sensitivity, if it's not possible to get the preferred exposure (that is, the one that uses the "best" f/stop or shutter speed for the depth-of-field or action stopping we want). Table 6.1 shows equivalent exposure settings using various shutter speeds and f/stops.

Table 6.1 Equivalent Exposures			
Shutter speed	f/stop	Shutter speed	f/stop
1/30th second	f/22	1/500th second	f/5.6
1/60th second	f/16	1/1,000th second	f/4
1/125th second	f/11	1/2,000th second	f/2.8
1/250th second	f/8	1/4,000th second	f/2

When the D3200 is set for P mode, the metering system selects the correct exposure for you automatically, but you can change quickly to an equivalent exposure by spinning the command dial until the desired equivalent exposure combination is displayed. An asterisk next to the P on the displays indicate that you've adjusted the exposure combination. You can use this Flexible Program feature more easily if you remember that you need to rotate the command dial toward the left when you want to increase the amount of depth-of-field or use a slower shutter speed; rotate to the right when you want to reduce the depth-of-field or use a faster shutter speed. The need for more/less DOF and slower/faster shutter speed are the primary reasons you'd want to use Flexible Program. This program shift mode does not work when you're using flash.

F/STOPS VERSUS STOPS

In photography parlance, *f/stop* always means the aperture or lens opening. However, for lack of a current commonly used word for one exposure increment, the term *stop* is often used. (In the past, EV served this purpose, but Exposure Value and its abbreviation have since been inextricably intertwined with its use in describing Exposure Compensation.) In this book, when I say "stop" by itself (no *f/*), I mean one whole unit of exposure, and am not necessarily referring to an actual *f/stop* or lens aperture. So, adjusting the exposure by "one stop" can mean both changing to the next shutter speed increment (say, from 1/125th second to 1/250th second) or the next aperture (such as *f/*4 to *f/*5.6). Similarly, 1/3 stop or 1/2 stop increments can mean either shutter speed or aperture changes, depending on the context. Be forewarned.

In Aperture-priority (A) and Shutter-priority (S) modes, you can change to an equivalent exposure, but only by either adjusting the aperture (the camera chooses the shutter speed) or shutter speed (the camera selects the aperture). I'll cover all these exposure modes later in the chapter.

How the D3200 Calculates Exposure

Your D3200 calculates exposure by measuring the light that passes through the lens and is bounced up by the mirror to sensors located near the focusing surface, using a pattern you can select (more on that later) and based on the assumption that each area being measured reflects about the same amount of light as a neutral gray card that reflects a "middle" gray of about 12- to 18-percent reflectance. (The photographic "gray cards" you buy at a camera store have an 18-percent gray tone; your camera is calibrated to interpret a somewhat darker 12-percent gray; I'll explain more about this later.) That "average" 12- to 18-percent gray assumption is necessary, because different subjects reflect different amounts of light. In a photo containing, say, a white cat and a dark gray cat, the white cat might reflect five times as much light as the gray cat. An exposure based on the white cat will cause the gray cat to appear to be black, while an exposure based only on the gray cat will make the white cat washed out.

This is more easily understood if you look at some photos of subjects that are dark (they reflect little light), those that have predominantly middle tones, and subjects that are highly reflective. The next few figures show some images of actual cats (actually, the *same* cat rendered in black, gray, and white varieties through the magic of Photoshop), with each of the three strips exposed using a different cat for reference.

Correctly Exposed

The three pictures shown in Figure 6.4 represent how the black, gray, and white cats would appear if the exposure were calculated by measuring the light reflecting from the middle, gray cat, which, for the sake of illustration, we'll assume reflects approximately 12 to 18 percent of the light that strikes it. The exposure meter sees an object that it thinks is a middle gray, calculates an exposure based on that, and the feline in the center of the strip is rendered at its proper tonal value. Best of all, because the resulting exposure is correct, the black cat at left and white cat at right are rendered properly as well.

When you're shooting pictures with your D3200, and the meter happens to base its exposure on a subject that averages that "ideal" middle gray, then you'll end up with similar (accurate) results. The camera's exposure algorithms are concocted to ensure this kind of result as often as possible, barring any unusual subjects (that is, those that are backlit, or have uneven illumination). The D3200 has three different metering modes (described next), plus Scene modes, each of which is equipped to handle certain types of unusual subjects, as I'll outline.

Figure 6.4
When exposure is calculated based on the middle-gray cat in the center, the black and white cats are rendered accurately, too.

Overexposed

The strip of three images in Figure 6.5 show what would happen if the exposure were calculated based on metering the leftmost, black cat. The light meter sees less light reflecting from the black cat than it would see from a gray middle-tone subject, and so figures, "Aha! I need to add exposure to brighten this subject up to a middle gray!" That lightens the black cat, so it now appears to be gray.

But now the cat in the middle that was *originally* middle gray is overexposed and becomes light gray. And the white cat at right is now seriously overexposed, and loses detail in the highlights, which have become a featureless white.

Figure 6.5

When exposure is calculated based on the black cat at the left, the black cat looks gray, the gray cat appears to be a light gray, and the white cat is seriously overexposed.

Underexposed

The third possibility in this simplified scenario is that the light meter might measure the illumination bouncing off the white cat, and try to render that feline as a middle gray. A lot of light is reflected by the white kitty, so the exposure is *reduced*, bringing that cat closer to a middle gray tone. The cats that were originally gray and black are now rendered too dark. Clearly, measuring the gray cat—or a substitute that reflects about the same amount of light, is the only way to ensure that the exposure is precisely correct. (See Figure 6.6.)

As you can see, the ideal way to measure exposure is to meter from a subject that reflects 12 to 18 percent of the light that reaches it. If you want the most precise exposure calculations, if you don't have a gray cat handy, the solution is to use a stand-in, such as the evenly illuminated gray card I mentioned earlier. But, because the standard Kodak gray card reflects 18 percent of the light that reaches it and, as I said, your camera is

Figure 6.9 Center-weighted metering calculates exposure based on the full frame, but gives 75 percent of the weight to the center area shown; the remaining 25 percent of the exposure is determined by the rest of the image area.

Figure 6.10 Scenes with the main subject in the center, surrounded by areas that are significantly darker or lighter, are perfect for Center-weighted metering.

Spot Metering

Spot metering is favored by those of us who used a hand-held light meter to measure exposure at various points (such as metering highlights and shadows separately). However, you can use Spot metering in any situation where you want to individually measure the light reflecting from light, midtone, or dark areas of your subject—or any combination of areas.

This mode confines the reading to a limited 3.5mm area in the viewfinder, making up only 2.5 percent of the image, as shown in Figure 6.11. The circle is centered on the current focus point (which can be any of the focus points, not just the center one shown in Figure 6.11), but is larger than the focus point, so don't fall into the trap of believing that exposure is being measured only within the brackets that represent the active focus point. This is the only metering method you can use to tell the D3200 exactly where to measure exposure when using the optical viewfinder. However, if a non-CPU lens is mounted, or you have selected Auto-area AF, only the center focus point is used to spot meter.

You'll find Spot metering useful when you want to base exposure on a small area in the frame. If that area is in the center of the frame, so much the better. If not, you'll have to make your meter reading for an off-center subject using an appropriate focus point, and then lock exposure by pressing the shutter release halfway, or by pressing the AE-L/AF-L button. This mode is best for subjects where the background is significantly brighter or darker, as in Figure 6.12.

Figure 6.11 Spot metering calculates exposure based on a center spot that's only two 2.5 percent of the image area, centered around the current focus point.

Figure 6.12 Spot metering allowed measuring exposure from this performer's face.

Choosing an Exposure Method

You'll find four methods for choosing the appropriate shutter speed and aperture, when using the semi-automatic/manual modes. (Scene modes, which use their own exposure biases, are described next.) You can choose among Program, Aperture-priority, Shutter-priority, or Manual options by rotating the mode dial on top of the camera. Your choice of which is best for a given shooting situation will depend on things like your need for lots of (or less) depth-of-field, a desire to freeze action or allow motion blur, or how much noise you find acceptable in an image. Each of the D3200's exposure methods emphasizes one aspect of image capture or another. This section introduces you to all four.

Aperture-Priority

In A mode, you specify the lens opening used, and the D3200 selects the shutter speed. Aperture-priority is especially good when you want to use a particular lens opening to achieve a desired effect. Perhaps you'd like to use the smallest f/stop possible to maximize depth-of-field in a close-up picture. Or, you might want to use a large f/stop to throw everything except your main subject out of focus, as in Figure 6.13. Maybe you'd

Figure 6.13
Use Aperturepriority to "lock in" a large f/stop when you want to blur the background.

just like to "lock in" a particular f/stop because it's the sharpest available aperture with that lens. Or, you might prefer to use, say, f/2.8 on a lens with a maximum aperture of f/1.4, because you want the best compromise between speed and sharpness.

Aperture-priority can even be used to specify a *range* of shutter speeds you want to use under varying lighting conditions, which seems almost contradictory. But think about it. You're shooting a soccer game outdoors with a telephoto lens and want a relatively high shutter speed, but you don't care if the speed changes a little should the sun duck behind a cloud. Set your D3200 to A, and adjust the aperture until a shutter speed of, say, 1/1,000th second is selected at your current ISO setting. (In bright sunlight at ISO 400, that aperture is likely to be around f/11.) Then, go ahead and shoot, knowing that your D3200 will maintain that f/11 aperture (for sufficient depth-of-field as the soccer players move about the field), but will drop down to 1/750th or 1/500th second if necessary should the lighting change a little.

A flashing question mark in the viewfinder, accompanied by a Subject Is Too Dark or Subject Is Too Bright warning and flashing shutter speed or aperture on the LCD indicates that the D3200 is unable to select an appropriate shutter speed at the selected aperture and that over- and underexposure will occur at the current ISO setting. That's the major pitfall of using A: you might select an f/stop that is too small or too large to allow an optimal exposure with the available shutter speeds. For example, if you choose f/2.8 as your aperture and the illumination is quite bright (say, at the beach or in snow), even your camera's fastest shutter speed might not be able to cut down the amount of light reaching the sensor to provide the right exposure. Or, if you select f/8 in a dimly lit room, you might find yourself shooting with a very slow shutter speed that can cause blurring from subject movement or camera shake. Aperture-priority is best used by those with a bit of experience in choosing settings. Many seasoned photographers leave their D3200 set on A all the time.

Shutter-Priority

Shutter-priority (S) is the inverse of Aperture-priority: you choose the shutter speed you'd like to use, and the camera's metering system selects the appropriate f/stop. Perhaps you're shooting action photos and you want to use the absolute fastest shutter speed available with your camera; in other cases, you might want to use a slow shutter speed to add some blur to a sports photo that would be mundane if the action were completely frozen. (See the ends of the hockey sticks in Figure 6.14.) Shutter-priority mode gives you some control over how much action-freezing capability your digital camera brings to bear in a particular situation.

You'll also encounter the same problem as with Aperture-priority when you select a shutter speed that's too long or too short for correct exposure under some conditions. I've shot outdoor soccer games on sunny Fall evenings and used Shutter-priority mode

to lock in a 1/1,000th second shutter speed, and was unable to continue when the sun dipped behind some trees and there was no longer enough light to shoot at that speed, even with the lens wide open.

Like A mode, it's possible to choose an inappropriate shutter speed. If that's the case, the displays will flash.

Program Mode

Program mode (P) uses the D3200's built-in smarts to select the correct f/stop and shutter speed using a database of picture information that tells it which combination of shutter speed and aperture will work best for a particular photo. If the correct exposure cannot be achieved at the current ISO setting, the flashing question mark in the view-finder and flashing shutter speed/aperture on the LCD will appear. You can then boost or reduce the ISO to increase or decrease sensitivity.

The D3200's recommended exposure can be overridden if you want. Use the EV setting feature (described later, because it also applies to S and A modes) to add or subtract exposure from the metered value. And, as I mentioned earlier in this chapter, in Program mode you can rotate the command dial to change from the recommended setting to an equivalent setting (as shown in Table 6.1) that produces the same exposure, but using a different combination of f/stop and shutter speed.

This is called "Flexible Program" by Nikon. Rotate the command dial counterclockwise to reduce the size of the aperture (going from, say, f/4 to f/5.6), so that the D3200 will automatically use a slower shutter speed (going from, say, 1/250th second to 1/125th second). Rotate the command dial clockwise to use a larger f/stop, while automatically producing a shorter shutter speed that provides the same equivalent exposure as metered in P mode. An asterisk appears next to the P in the LCD and viewfinder so you'll know you've overridden the D3200's default program setting. Your adjustment remains in force until you rotate the command dial until the asterisk disappears, or you switch to a different exposure mode, or turn the D3200 off.

MAKING EV CHANGES

Sometimes you'll want more or less exposure than indicated by the D3200's metering system. Perhaps you want to underexpose to create a silhouette effect, or overexpose to produce a high-key look. It's easy to use the D3200's exposure compensation system to override the exposure recommendations. Press and hold the EV button on the top of the camera (just southeast of the shutter release). Then rotate the command dial right to add exposure, and left to subtract exposure. The EV change you've made remains for the exposures that follow, until you manually zero out the EV setting. The EV plus/minus icon appears in the viewfinder to warn you that an exposure compensation change has been entered. You can increase or decrease exposure over a range of plus or minus five stops.

Manual Exposure

Part of being an experienced photographer comes from knowing when to rely on your D3200's automation (with scene modes or P mode), when to go semi-automatic (with S or A), and when to set exposure manually (using M). Some photographers actually prefer to set their exposure manually, as the D3200 will be happy to provide an indication of when its metering system judges your manual settings provide the proper exposure, using the analog exposure scale at the bottom of the viewfinder and on the status LCD.

Manual exposure can come in handy in some situations. You might be taking a silhouette photo and find that none of the exposure modes or EV correction features give you exactly the effect you want. Set the exposure manually to use the exact shutter speed and f/stop you need. Or, you might be working in a studio environment using multiple flash units. The additional flash units are triggered by slave devices (gadgets that set off the flash when they sense the light from another flash, or, perhaps from a radio or infrared remote control). Your camera's exposure meter doesn't compensate for the extra illumination, so you need to set the aperture manually. Although, depending on your proclivities, you might not need to set exposure manually very often, you should still make sure you understand how it works. Fortunately, the D3200 makes setting exposure manually very easy. Just rotate the mode dial to change to Manual mode, and then turn the command dial to set the shutter speed, and hold down the Aperture/EV button (just southeast of the shutter release button) while rotating the command dial to adjust the aperture. Press the shutter release halfway or press the AE lock button, and the exposure scale in the viewfinder shows you how far your chosen setting diverges from the metered exposure.

Using Scene Modes

As described in Chapter 2, the D3200 retains the "quickie" exposure modes found in Nikon's earlier entry-level cameras, but absent from the company's "pro" and "semi-pro" models. Of course, anyone who uses a D3200 for more than a day will see that it is just as advanced as many cameras (from Nikon or other vendors) that cost hundreds of dollars more. But because the D3200 is a basic model, it includes Scene modes.

As an avid photographer, you probably won't use Scene modes much, except when you're in a hurry to capture a grab shot and don't have time to make any decisions about what advanced exposure mode to use. You're on a beach, so you rotate the mode dial on the top left of the camera to SCENE, then use the command dial to select Beach/Snow, and you're all set. Nothing could be easier and—surprise, surprise—you will probably end up with some nice snapshots. You don't have all the creative control you might need for a more studied image, but a grab shot that's not perfect trumps any photo you don't take because you're fiddling with settings.

Scene modes are also useful when you loan your camera to someone and don't want to explain to them how to use the D3200. Scene modes not only make decisions about basic exposure, but they select some focusing options, whether or not to use flash, and what shutter speeds/apertures are best for a particular type of subject. I'll recap the descriptions of these modes that I originally provided in Chapter 2:

- Auto. In this mode, the D3200 makes all the exposure decisions for you, and will pop up the internal flash if necessary under low-light conditions. The camera automatically focuses on the subject closest to the camera (unless you've set the lens to manual focus), and the autofocus assist illuminator lamp on the front of the camera will light up to help the camera focus in low-light conditions.
- Auto (Flash Off). Identical to Auto mode, except that the flash will not pop up under any circumstances. You'd want to use this in a museum, during religious ceremonies, concerts, or any environment where flash is forbidden or distracting.
- **Portrait.** Use this mode when you're taking a portrait of a subject standing relatively close to the camera and want to de-emphasize the background, maximize sharpness, and produce flattering skin tones. The built-in flash will pop up if needed.

- Landscape. Select this mode when you want extra sharpness and rich colors of distant scenes. The built-in flash and AF-assist illuminator are disabled.
- Child. Use this mode to accentuate the vivid colors often found in children's clothing, and to render skin tones with a soft, natural looking texture. The D3200 focuses on the closest subject to the camera. The built-in flash will pop up if needed.
- **Sports.** Use this mode to freeze fast moving subjects. The D3200 selects a fast shutter speed to stop action, and focuses continuously on the center focus point while you have the shutter release button pressed halfway. However, you can select one of the other two focus points to the left or right of the center by pressing the multi selector left/right buttons. The built-in electronic flash and focus assist illuminator lamp are disabled.
- Close-Up. This mode is helpful when you are shooting close-up pictures of a subject from about one foot away or less, such as flowers, bugs, and small items. The D3200 focuses on the closest subject in the center of the frame, but you can use the multi selector right and left buttons to focus on a different point. Use a tripod in this mode, as exposures may be long enough to cause blurring from camera movement. The built-in flash will pop up if needed.
- Night Portrait. Choose this mode when you want to illuminate a subject in the foreground with flash (it will pop up automatically, if needed), but still allow the background to be exposed properly by the available light. The camera focuses on the closest main subject. Be prepared to use a tripod or a vibration-resistant lens like the 18-55 VR kit lens to reduce the effects of camera shake. (You'll find more about VR and camera shake in Chapter 10.)

Adjusting Exposure with ISO Settings

Another way of adjusting exposures is by changing the ISO sensitivity setting. Sometimes photographers forget about this option, because the common practice is to set the ISO once for a particular shooting session (say, at ISO 200 for bright sunlight outdoors, or ISO 800 when shooting indoors) and then forget about ISO. ISOs higher than ISO 200 or 400 are seen as "bad" or "necessary evils." However, changing the ISO is a valid way of adjusting exposure settings, particularly with the Nikon D3200, which produces good results at ISO settings that create grainy, unusable pictures with some other camera models.

Indeed, I find myself using ISO adjustment as a convenient alternate way of adding or subtracting EV when shooting in Manual mode, and as a quick way of choosing equivalent exposures when in Program or Shutter-priority or Aperture-priority modes. For example, I've selected a Manual exposure with both f/stop and shutter speed suitable

for my image using, say, ISO 200. I can change the exposure in 1/3 stop increments by holding down the ISO button located on the left side of the camera next to the LCD, and spinning the command dial one click at a time. The difference in image quality/ noise at ISO 200 is negligible if I dial in ISO 160 or ISO 125 to reduce exposure a little, or change to ISO 250 or 320 to increase exposure. I keep my preferred f/stop and shutter speed, but still adjust the exposure.

Or, perhaps, I am using S mode and the metered exposure at ISO 200 is 1/500th second at f/11. If I decide on the spur of the moment I'd rather use 1/500th second at f/8, I can press the ISO button and spin the command dial three clicks counterclockwise to switch to ISO 100. Of course, it's a good idea to monitor your ISO changes, so you don't end up at ISO 6400 accidentally. An ISO indicator appears in the monochrome control panel and in the viewfinder to remind you what sensitivity setting has been dialed in.

ISO settings can, of course, also be used to boost or reduce sensitivity in particular shooting situations. The D3200 can use ISO settings from ISO 100 up to ISO 6400, plus H 1.0 (ISO 12800 equivalent). The camera can also adjust the ISO automatically as appropriate for various lighting conditions. When you choose the Auto ISO setting in the Shooting menu, as described in Chapter 4, the D3200 adjusts the sensitivity dynamically to suit the subject matter, based on minimum shutter speed and ISO limits you have prescribed. As I noted in Chapter 4, you should use Auto ISO cautiously if you don't want the D3200 to use an ISO higher than you might otherwise have selected.

Dealing with Noise

Visual image noise is that random grainy effect that some like to use as a special effect, but which, most of the time, is objectionable because it robs your image of detail even as it adds that "interesting" texture. Noise is caused by two different phenomena: high ISO settings and long exposures.

High ISO noise commonly appears when you raise your camera's sensitivity setting above ISO 400. With the Nikon D3200, noise may become visible at ISO 1600, and is often fairly noticeable at ISO 3200. At ISO 6400 and above, noise is usually quite bothersome. Nikon tips you off that ISO 12800 may be a tool used in special circumstances only by labeling it H1.0. You can expect noise and increase in contrast in any pictures taken at these lofty ratings. High ISO noise appears as a result of the amplification needed to increase the sensitivity of the sensor. While higher ISOs do pull details out of dark areas, they also amplify non-signal information randomly, creating noise. You'll find a High ISO NR choice in the Shooting menu, where you can specify Off or On. Because noise reduction tends to soften the grainy look while robbing an image of detail, you may want to disable the feature if you're willing to accept a little noise in exchange for more details.

A similar noisy phenomenon occurs during long time exposures, which allow more photons to reach the sensor, increasing your ability to capture a picture under low light conditions. However, the longer exposures also increase the likelihood that some pixels will register random phantom photons, often because the longer an imager is "hot," the warmer it gets, and that heat can be mistaken for photons. There's also a special kind of noise that CMOS sensors like the one used in the D3200 are potentially susceptible to. With a CCD, the entire signal is conveyed off the chip and funneled through a single amplifier and analog-to-digital conversion circuit. Any noise introduced there is, at least, consistent. CMOS imagers, on the other hand, contain millions of individual amplifiers and A/D converters, all working in unison. Because these circuits don't necessarily all process in precisely the same way all the time, they can introduce something called fixed-pattern noise into the image data.

You can also apply noise reduction to a lesser extent using Photoshop, and when converting RAW files to some other format, using your favorite RAW converter, or an industrial-strength product like Noise Ninja (www.picturecode.com) to wipe out noise after you've already taken the picture.

Fixing Exposures with Histograms

While you can often recover poorly exposed photos in your image editor, your best bet is to arrive at the correct exposure in the camera, minimizing the tweaks that you have to make in post-processing. However, you can't always judge exposure just by viewing the image on your D3200's LCD after the shot is made. Nor can you get a 100 percent accurately exposed picture by using the D3200's Live View feature. Ambient light may make the LCD difficult to see, and the brightness level you've set can affect the appearance of the playback image.

Instead, you can use a histogram, which is a chart displayed on the D3200's LCD that shows the number of tones being captured at each brightness level. You can use the information to provide correction for the next shot you take. The D3200 offers four histogram variations in three screens: three histograms that show overall brightness levels for an image and an alternate version that separates the red, green, and blue channels of your image into separate histograms.

DISPLAYING HISTOGRAMS

To view all the available histograms on your screen, you must have the D3200 set up properly. First, you'll need to mark Histograms using the Display Mode entry in the Playback menu, as described in Chapter 4. That will make the Histograms screen visible when you cycle among the informational screens while pressing the multi selector up/down buttons while an image is displayed.

The most basic histogram is displayed during playback when you press the multi selector up/down buttons to produce the Overview Data screen, as described briefly in Chapter 4. This screen provides a small histogram at the right side that displays the distribution of luminance or brightness. The most useful histogram screen is the one shown in Figure 6.15, which displays both a luminance chart and separate red, green, and blue charts.

Both luminance and RGB histograms are charts that include a representation of up to 256 vertical lines on a horizontal axis that show the number of pixels in the image at each brightness level, from 0 (black) on the left side to 255 (white) on the right. (The three-inch LCD doesn't have enough pixels to show each and every one of the 256 lines, but, instead provides a representation of the shape of the curve formed.) The more pixels at a given level, the taller the bar at that position. If no bar appears at a particular position on the scale from left to right, there are no pixels at that particular brightness level.

As you can see, a typical histogram produces a mountain-like shape, with most of the pixels bunched in the middle tones, with fewer pixels at the dark and light ends of the scale. Ideally, though, there will be at least some pixels at either extreme, so that your image has both a true black and a true white representing some details. Learn to spot histograms that represent over- and underexposure, and add or subtract exposure using an EV modification to compensate.

Figure 6.15
The D3200's most complete histogram screen shows both luminance and separate red, green, and blue histograms.

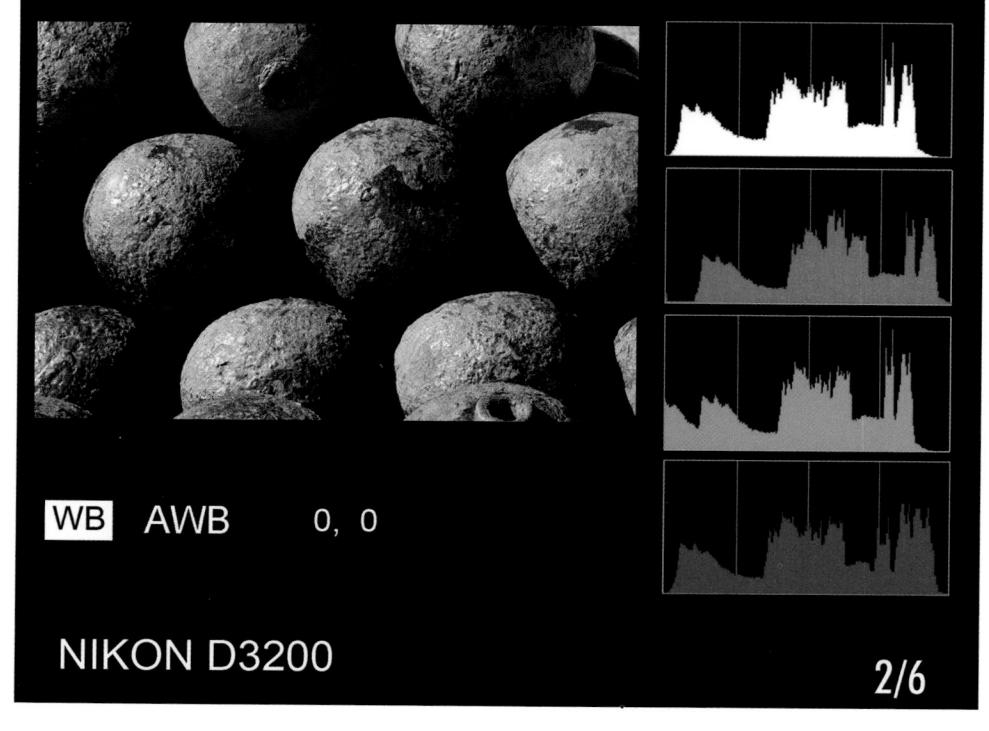

For example, Figure 6.16 shows the histogram (in the inset) for an image that is badly underexposed. You can guess from the shape of the histogram that many of the dark tones to the left of the graph have been clipped off. There's plenty of room on the right side for additional pixels to reside without having them become overexposed. Or, a histogram might look like the inset in Figure 6.17, which is overexposed. In either case, you can increase or decrease the exposure (either by changing the f/stop or shutter speed in Manual mode or by adding or subtracting an EV value in A or S modes) to produce the corrected histogram shown inset in Figure 6.18, in which the tones are more evenly distributed, reaching both left and right sides of the scale. See "Making EV Changes," above for information on dialing in exposure compensation.

The histogram can also be used to aid in fixing the contrast of an image, although gauging incorrect contrast is more difficult. For example, if the histogram shows all the tones bunched up in one place in the image, the photo will be low in contrast. If the tones are spread out more or less evenly, the image is probably high in contrast. In either case, your best bet may be to switch to RAW (if you're not already using that format) so you can adjust contrast in post processing. However, you can also change to a user-defined Picture Control with contrast set lower (–3 to -3) or higher (+1 to +3) as required. You'll find instructions for creating Picture Controls in Chapter 4.

One useful, but often overlooked tool in evaluating histograms is the Highlights display, which shows blown out highlights with a black blinking border for the selected active channel. Highlights can give you a better picture of what information is being lost to overexposure.

In working with histograms, your goal should be to have all the tones in an image spread out between the edges, with none clipped off at the left and right sides. Underexposing (to preserve highlights) should be done only as a last resort, because retrieving the underexposed shadows in your image editor will frequently increase the noise, even if you're working with RAW files. A better course of action is to expose for the highlights, but, when the subject matter makes it practical, fill in the shadows with additional light, using reflectors, fill flash, or other techniques rather than allowing them to be seriously underexposed.

The more you work with histograms, the more useful they become. One of the first things that histogram veterans notice is that it's possible to overexpose one channel even if the overall exposure appears to be correct. For example, flower photographers soon discover that it's really, really difficult to get a good picture of a rose, like the one shown in Figure 6.19. The exposure looks okay—but there's no detail in the rose's petals. Looking at the histogram (see Figure 6.20) shows why: the red channel is blown out. If you look at the red histogram, there's a peak at the right edge that indicates that highlight information has been lost. In fact, the green channel has been blown, too, and

Figure 6.16
This histogram shows an underexposed image.

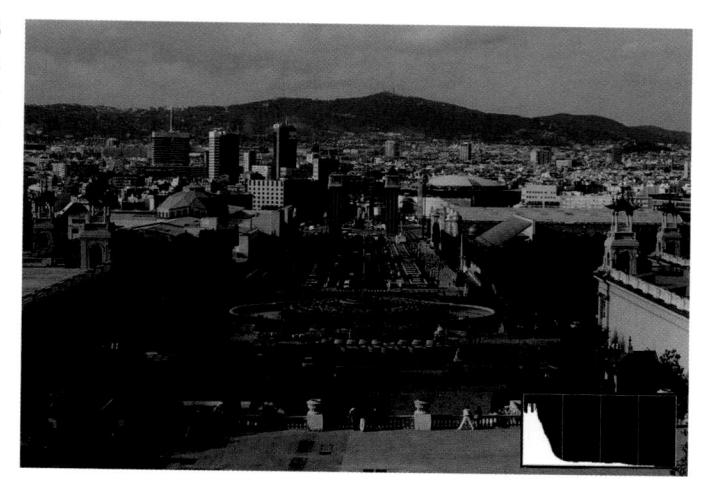

Figure 6.17 This histogram reveals that the image is overexposed.

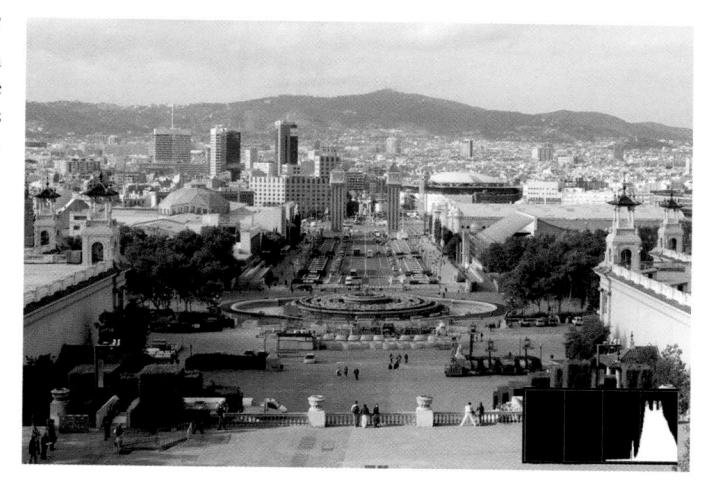

Figure 6.18
A histogram for a properly exposed image should look like this.

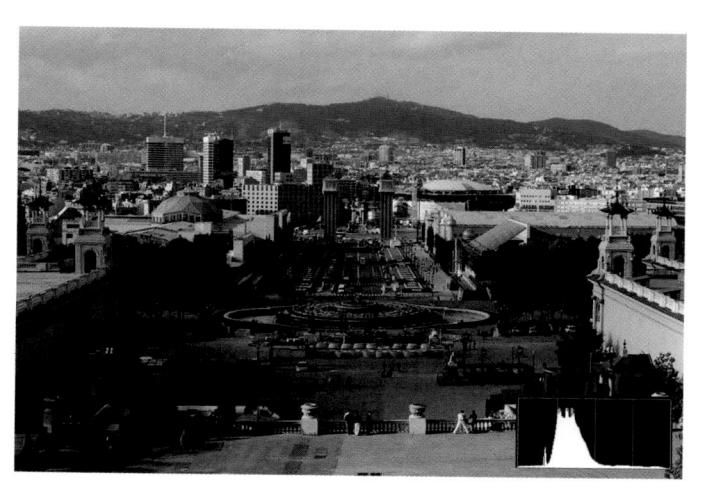

so the green parts of the flower also lack detail. Only the blue channel's histogram is entirely contained within the boundaries of the chart, and, on first glance, the white luminance histogram at top of the column of graphs seems fairly normal.

Any of the primary channels, red, green, or blue, can blow out all by themselves, although bright reds seem to be the most common problem area. More difficult to diagnose are overexposed tones in one of the "in-between" hues on the color wheel. Overexposed yellows (which are very common) will be shown by blowouts in *both* the red and green channels. Too-bright cyans will manifest as excessive blue and green highlights, while overexposure in the red and blue channels reduces detail in magenta colors. As you gain experience, you'll be able to see exactly how anomalies in the RGB channels translate into poor highlights and murky shadows.

The only way to correct for color channel blowouts is to reduce exposure. As I mentioned earlier, you might want to consider filling in the shadows with additional light to keep them from becoming too dark when you decrease exposure. In practice, you'll want to monitor the red channel most closely, followed by the blue channel, and slightly decrease exposure to see if that helps. Because of the way our eyes perceive color, we are more sensitive to variations in green, so green channel blowouts are less of a problem, unless your main subject is heavily colored in that hue. If you plan on photographing a frog hopping around on your front lawn, you'll want to be extra careful to preserve detail in the green channel, using bracketing or other exposure techniques outlined in this chapter.

Bracketing

Bracketing is a method for shooting several consecutive exposures using different settings, as a way of improving the odds that one will be exactly right. Before digital cameras took over the universe, it was common to bracket exposures, shooting, say, a series of three photos at 1/125th second, but varying the f/stop from f/8 to f/11 to f/16. In practice, smaller than whole-stop increments were used for greater precision, and lenses with apertures that were set manually commonly had half-stop detents on their aperture rings, or could easily be set to a mid-way position between whole f/stops. It was just as common to keep the same aperture and vary the shutter speed, although in the days before electronic shutters, film cameras often had only whole increment shutter speeds available.

Today, cameras like the D3200 can bracket exposures much more precisely, using "in between" settings. Unfortunately, the D3200 doesn't have automatic bracketing, like some of its more advanced siblings, but you can still bracket manually by adding and/or subtracting EV values, as described in the "Making EV Changes," sidebar earlier in the chapter, or by shooting in Manual mode.

Bracketing and Merge to HDR

One reason you might want to use manual bracketing is to create high dynamic range (HDR) photographs, which have become all the rage as a way to extend the number of tones that a digital camera like the D3200 can capture. While my goal in this book is to show you how to take great photos *in the camera* rather than how to fix your errors in Photoshop, the Merge to HDR Pro (high dynamic range) feature in Adobe's flagship image editor is too cool to ignore. The ability to have a bracketed set of exposures that are identical except for exposure, is key to getting good results with this Photoshop feature, which allows you to produce images with a full, rich dynamic range that includes a level of detail in the highlights and shadows that is almost impossible to achieve with digital cameras. In contrasty lighting situations, even the Nikon D3200 has a tendency to blow out highlights when you expose solely for the shadows or midtones.

Suppose you wanted to photograph a dimly lit room that had a bright window showing an outdoors scene. Proper exposure for the room might be on the order of 1/60th second at f/2.8 at ISO 200, while the outdoors scene probably would require f/11 at 1/400th second. That's almost a 7 EV step difference (approximately 7 f/stops) and well beyond the dynamic range of any digital camera, including the Nikon D3200.

When you're using Merge to HDR Pro, you'd take two to three pictures, one for the shadows, one for the highlights, and perhaps one for the midtones. Then, you'd use the Merge to HDR Pro command to combine all of the images into one HDR image that integrates the well-exposed sections of each version.

The images should be as identical as possible, except for exposure. So, it's a good idea to mount the D3200 on a tripod, use a remote release like MC-DC2 remote cord or ML-L3 infrared remote, and take all the exposures in one burst. Just follow these steps:

- 1. **Set up the camera.** Mount the D3200 on a tripod.
- Set the camera for Manual exposure. Use the mode dial to select Manual exposure.
- 3. **Choose an f/stop.** Select an aperture that will provide a correct exposure at your initial manual settings for the series of manually bracketed shots. *And then leave this adjustment alone!* You don't want the aperture to change for your series, as that would change the depth-of-field. You want to adjust exposure *only* with the shutter speed.
- 4. Choose a shutter speed for the initial exposure. For this exercise, we'll be shooting four different bracketed exposures, so set the shutter speed such that the image will be two stops underexposed. If necessary, take a test shot to find the "correct" exposure and adjust from there.

- 5. Choose manual focus. You don't want the focus to change between shots, so set the D3200 to manual focus, and carefully focus your shot.
- 6. **Choose RAW exposures.** Set the camera to take RAW files, which will give you the widest range of tones in your images.
- 7. **Take the first shot.** Press the button on the remote (or carefully press the shutter release) and take the first exposure, which will be two stops underexposed.
- 8. Adjust shutter speed to give one stop more exposure. For example, if your first shot was at 1/500th second at f/11, *gently* change to 1/250th second.
- 9. **Take the second shot.** Press the button on the remote or press the shutter release and take the second exposure, which will be one stop underexposed.
- 10. **Repeat steps 8 and 9 twice more.** Create exposures at the metered exposure and one stop overexposed. You'll end up with a set of photos like those shown in Figure 6.19.
- 11. Continue with the Merge to HDR Pro steps listed next. You can also use a different program, such as Photomatix, if you know how to use it. Note that these steps could also be carried out using Aperture-priority, and using EV adjustments to achieve the different exposures over the same range. I find manual bracketing to be just as fast.

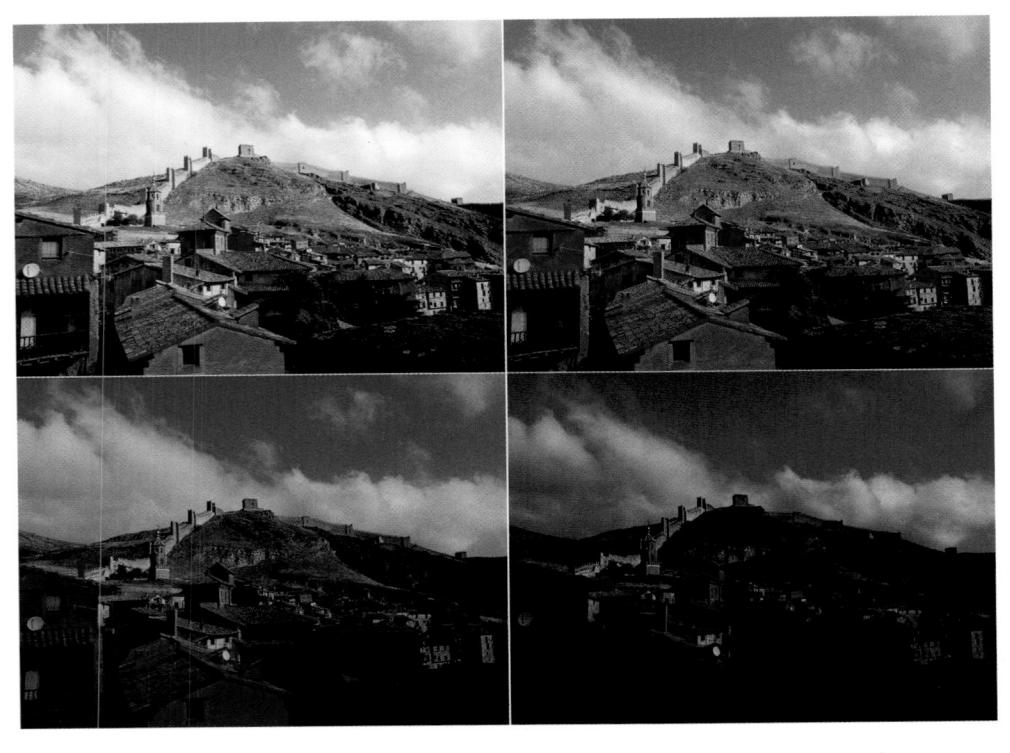

Figure 6.19 Your bracketed photos should look like this.

The next steps show you how to combine the separate exposures into one merged high dynamic range image.

- 1. **Copy your images to your computer.** If you use an application to transfer the files to your computer, make sure it does not make any adjustments to brightness, contrast, or exposure. You want the real raw information for Merge to HDR Pro to work with.
- 2. Activate Merge to HDR Pro. Choose File > Automate > Merge to HDR Pro.
- 3. **Select the photos to be merged.** Use the Browse feature to locate and select your photos to be merged. You'll note a checkbox that can be used to automatically align the images if they were not taken with the camera mounted on a rock-steady support. This will adjust for any slight movement of the camera that might have occurred when you changed exposure settings.
- 4. **Choose parameters (optional).** The first time you use Merge to HDR Pro, you can let the program work with its default parameters. Once you've played with the feature a few times, you can read the Adobe help files and learn more about the options than I can present in this non-software-oriented camera guide. (See Figure 6.20.)
- 5. Click OK. The merger begins.
- 6. Save. Once HDR merge has done its thing, save the file to your computer.

Figure 6.20
Use the Merge to HDR Pro command in Photoshop or Photoshop Elements to combine the four images.

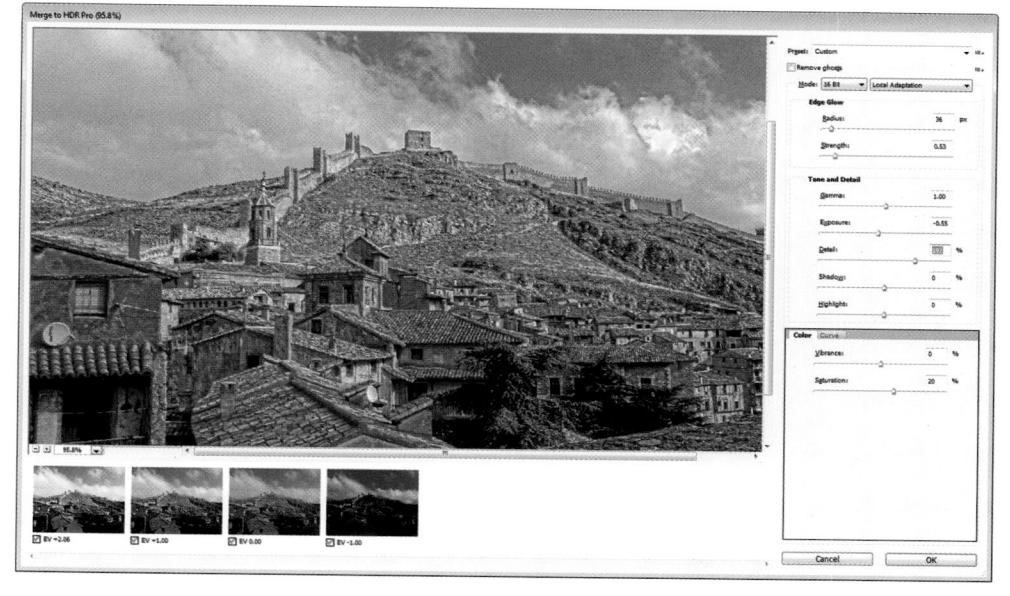

If you do everything correctly, you'll end up with a photo like the one shown in Figure 6.21, which has the properly exposed foreground of the first shot, and the well-exposed rocks of the second and third images. Note that, ideally, nothing should move between shots.

What if you don't have the opportunity, inclination, or skills to create several images at different exposures, as described? If you shoot in RAW format, you can still use Merge to HDR, working with a *single* original image file. What you do is import the image into Photoshop several times, using Adobe Camera Raw to create multiple copies of the file at different exposure levels.

For example, you'd create one copy that's too dark, so the shadows lose detail, but the highlights are preserved. Create another copy with the shadows intact and allow the highlights to wash out. Then, you can use Merge to HDR to combine the two and end up with a finished image that has the extended dynamic range you're looking for.

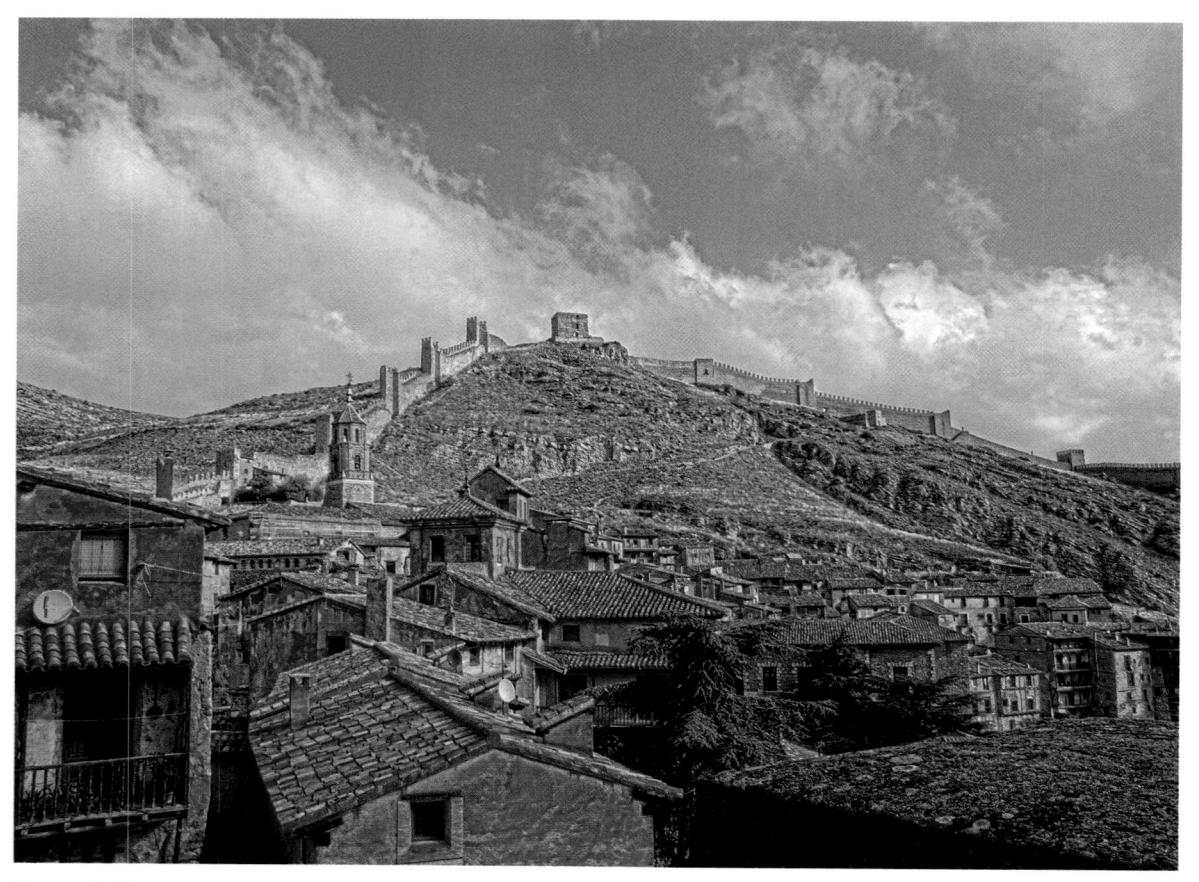

Figure 6.21 You'll end up with an extended dynamic range photo like this one.

Mastering the Mysteries of Autofocus

Getting the right exposure is one of the foundations of a great photograph, but a lot more goes into a compelling shot than good tonal values. A sharp image, proper white balance, good color, and other factors all can help elevate your image from good to exceptional. So, now that you've got a good understanding of exposure tucked away, you'll want to learn how to work with some additional exposure options, use the automatic and manual focusing controls available with the Nikon D3200, and master some of the many ways you can fine-tune your images.

In this chapter I'm including some specific advanced shooting techniques you can apply to your Nikon D3200. If you master these concepts, you can be confident that you're well on your way towards mastering your Nikon D3200. In fact, you'll be ready for the discussions of using lenses (Chapter 10) and working with light (Chapter 11).

How Focus Works

Although Nikon added autofocus capabilities to its cameras in the 1980s, back in the day of film, prior to that focusing was always done manually. Honest. Even though viewfinders were bigger and brighter than they are today, special focusing screens, magnifiers, and other gadgets were often used to help the photographer achieve correct focus. Imagine what it must have been like to focus manually under demanding, fastmoving conditions such as sports photography.

Focusing was problematic because our eyes and brains have poor memory for correct focus, which is why your eye doctor must shift back and forth between sets of lenses

and ask, "Does that look sharper—or was it sharper before?" in determining your correct prescription. Similarly, manual focusing involves jogging the focus ring back and forth as you go from almost in focus, to sharp focus, to almost focused again. The little clockwise and counterclockwise arcs decrease in size until you've zeroed in on the point of correct focus. What you're looking for is the image with the most contrast between the edges of elements in the image.

The camera also looks for these contrast differences among pixels to determine relative sharpness. There are two primary ways that sharp focus is determined: phase detection and contrast detection. As you'll see, these can be applied in several different ways, with options changing dramatically when you switch from composing through the optical viewfinder, and when you're using Live View to shoot stills or movies. First, let's get the primary focus methods out of the way. I'll cover the focus variations available in Live View/Movie modes in Chapter 8.

Phase Detection

This mode is used by the autofocus system when you're looking through the optical viewfinder. The autofocus sampling area is divided into two halves by a lens in the sensor. The two halves are compared, much like (actually, exactly like) a two-window rangefinder used in surveying weaponry—and non-SLR cameras like the venerable Leica M film models. The contrast between the two images changes as focus is moved in or out, until sharp focus is achieved when the images are "in phase," or lined up.

The eleven autofocus sensors of Nikon's Multi-CAM 1000 autofocus module are located in the "floor" of the mirror box, just under the flip-up mirror, which is partially silvered so that most of the light reaching it from the lens is bounced upwards to the viewfinder, while some light is directed downward toward the focus sensors. If you lock up the mirror of your camera (using the Lock Mirror Up for Cleaning option in the Setup menu), you can see where these sensors are located.

You can visualize how Phase Detection autofocus works if you look at Figures 7.1 and 7.2. (However, your camera's actual autofocus sensors don't look *anything* like this; I'm providing a greatly simplified view just for illustration.) In Figure 7.1, a typical horizontally oriented focus sensor is looking at a series of parallel vertical lines in a weathered piece of wood. The lines are broken into two halves by the sensor's rangefinder prism, and you can see that they don't line up exactly; the image is slightly out of focus.

Fortunately, the rangefinder approach of phase detection tells the D3200 exactly how out of focus the image is, and in which direction (focus is too near, or too far) thanks to the amount and direction of the displacement of the split image. The camera can quickly and precisely snap the image into sharp focus and line up the vertical lines, as shown in Figure 7.2. Of course, this scenario—vertical lines being interpreted by a horizontally oriented sensor—is ideal. When the same sensor is asked to measure focus for, say, horizontal lines that don't split up quite so conveniently, or, in the worst case,

Figure 7.1 When an image is out of focus, the split lines don't align precisely.

Figure 7.2 Using phase detection, the D3200 is able to align the features of the image and achieve sharp focus quickly.

subjects such as the sky (which may have neither vertical nor horizontal lines), focus can slow down drastically, or even become impossible.

Phase Detection is the normal mode used by the D3200. As with any rangefinder-like function, accuracy is better when the "base length" between the two images is larger. (Think back to your high school trigonometry; you could calculate a distance more accurately when the separation between the two points where the angles were measured was greater.) For that reason, Phase Detection autofocus is more accurate with larger (wider) lens openings—especially those with maximum f/stops of f/2.8 or better—than with smaller lens openings, and may not work at all when the f/stop is smaller than f/5.6. As I noted, the D3200 is able to perform these comparisons very quickly.

Improved Cross-Type Focus Point

One improvement that new Nikon D3200 owners sometimes overlook is the upgrade to a cross-type focus point at the center position. Why is this important? It helps to take a closer look at the Phase Detection system when presented with a non-ideal subject.

Figure 7.3 shows the same weathered wood pictured earlier, except in this case we've chosen to rotate the camera 90 degrees (say, because we want a vertically oriented composition). In the illustration, the image within the focus sensor's area is split in two and displaced slightly side to side, but the amount and direction of the misalignment is far from obvious. A horizontally oriented focus sensor will be forced to look for less obvious

Figure 7.3 A horizontal focus censor doesn't handle horizontal lines very well.

Figure 7.4 Cross-type sensors can evaluate contrast in both horizontal and vertical directions, as well as diagonally.

vertical lines to match up. Our best-case subject has been transformed into a *worst*-case subject for a horizontal focus sensor.

The value of the cross-type focus sensor, which can interpret contrast in both horizontal and vertical directions, can be seen in Figure 7.4. The horizontal lines are still giving the horizontal portion of the cross sensor fits, but the vertical bar can easily split and align the subject to achieve optimum focus. Cross-type sensors can handle horizontal and vertical lines with equal aplomb and, if you think about it, lines at any diagonal angle as well. In lower light levels, with subjects that were moving, or with subjects that have no pattern and less contrast to begin with, the cross-type sensor not only works faster but can focus subjects that a horizontal- or vertical-only sensor can't handle at all.

So, you can see that having a center cross-type focus sensor that is extra-sensitive with faster lenses is a definite advantage.

Contrast Detection

This is a slower mode, suitable for static subjects, and used by the D3200 in Live View mode. Your eye also uses contrast detection when you focus the camera manually.

Contrast detection is a bit easier to understand, and is illustrated by Figure 7.5. At top in the figure, the transitions between the edges found in the image are soft and blurred because of the low contrast between them. Although the illustration uses the same vertical lines used with the phase detection example, the orientation of the features doesn't matter. The focus system looks only for contrast between edges, and those edges can run in any direction.

Figure 7.5

Focus in

Contrast

Detection mode

evaluates the

increase in contrast in the

edges of subjects, starting

with a blurry

image (top) and

producing a

sharp, contrasty

image (bottom).

At the bottom of Figure 7.5, the image has been brought into sharp focus, and the edges have much more contrast; the transitions are sharp and clear. Although this example is a bit exaggerated so you can see the results on the printed page, it's easy to understand that when maximum contrast in a subject is achieved, it can be deemed to be in sharp focus.

Locking in Focus

The D3200's autofocus mechanism, like all such systems found in SLR cameras, evaluates the degree of focus, but, unlike the human eye, it is able to remember the progression perfectly, so that autofocus can lock in much more quickly and, with an image that has sufficient contrast, more precisely. Unfortunately, while the D3200's focus system finds it easy to measure degrees of apparent focus at each of the focus points in the viewfinder, it doesn't really know with any certainty which object should be in sharpest focus. Is it the closest object? The subject in the center? Something lurking behind the closest subject? A person standing over at the side of the picture? Many of the techniques for using autofocus effectively involve telling the Nikon D3200 exactly what it should be focusing on, by choosing a focus zone or by allowing the camera to choose a focus zone for you. I'll address that topic shortly.

As the camera collects focus information from the sensors, it then evaluates it to determine whether the desired sharp focus has been achieved. The calculations may include whether the subject is moving, and whether the camera needs to "predict" where the

subject will be when the shutter release button is fully depressed and the picture is taken. The speed with which the camera is able to evaluate focus and then move the lens elements into the proper position to achieve the sharpest focus determines how fast the autofocus mechanism is. Although your D3200 will almost always focus more quickly than a human, there are types of shooting situations where that's not fast enough. For example, if you're having problems shooting sports because the D3200's autofocus system manically follows each moving subject, a better choice might be to switch Autofocus modes or shift into Manual and prefocus on a spot where you anticipate the action will be, such as a goal line or soccer net. At night football games, for example, when I am shooting with a telephoto lens almost wide open, I sometimes focus manually on one of the referees who happens to be standing where I expect the action to be taking place (say, a halfback run or a pass reception).

Focus Modes

When you're using the optical viewfinder (and, therefore, Phase Detection autofocus), the D3200 has three AF modes: AF-S (also known as Single Autofocus or Single-servo autofocus), AF-C (Continuous Autofocus or Continuous-servo autofocus), and AF-A (which switches between the two as appropriate). I'll explain all of these in more detail later in this section. But first, some confusion...

MANUAL FOCUS

Manual focus is activated by sliding the switch on the lens to the M position. There are some advantages and disadvantages to focusing yourself. While your batteries will last longer in manual focus mode, it will take you longer to focus the camera for each photo, a process that can be difficult. Modern digital cameras, even dSLRs, depend so much on autofocus that the viewfinders of models that have less than full-frame-sized sensors are no longer designed for optimum manual focus. Pick up any film camera and you'll see a bigger, brighter viewfinder with a focusing screen that's a joy to focus on manually.

Adding Circles of Confusion

You know that increased depth-of-field brings more of your subject into focus. But more depth-of-field also makes autofocusing (or manual focusing) more difficult because the contrast is lower between objects at different distances. So, autofocus with a 200mm lens (or zoom setting) may be easier than at a 28mm focal length (or zoom setting) because the longer lens has less apparent depth-of-field. By the same token, a lens with a maximum aperture of f/1.8 will be easier to autofocus (or manually focus) than one of the same focal length with an f/4 maximum aperture, because the f/4 lens has more depth-of-field and a dimmer view. That's yet another reason why lenses with a maximum aperture smaller than f/5.6 can give your D3200's autofocus system

fits—increased depth-of-field joins forces with a dimmer image, and more difficulty in achieving phase detection.

To make things even more complicated, many subjects aren't polite enough to remain still. They move around in the frame, so that even if the D3200 is sharply focused on your main subject, it may change position and require refocusing. (This is where the Subject-tracking mode available in Live View is handy; once you've specified an area of focus, the D3200 is smart enough to follow your subject around the frame as your subject moves or you reframe the picture. I'll explain Subject-tracking in detail later in this chapter.)

In other cases, an intervening subject may pop into the frame and pass between you and the subject you meant to photograph. You (or the D3200) have to decide whether to lock focus on this new subject, or remain focused on the original subject. Finally, there are some kinds of subjects that are difficult to bring into sharp focus because they lack enough contrast to allow the D3200's AF system (or our eyes) to lock in. Blank walls, a clear blue sky, or other subject matter may make focusing difficult.

If you find all these focus factors confusing, you're on the right track. Focus is, in fact, measured using something called a *circle of confusion*. An ideal image consists of zillions of tiny little points, which, like all points, theoretically have no height or width. There is perfect contrast between the point and its surroundings. You can think of each point as a pinpoint of light in a darkened room. When a given point is out of focus, its edges decrease in contrast and it changes from a perfect point to a tiny disc with blurry edges (remember, blur is the lack of contrast between boundaries in an image). (See Figure 7.6.)

If this blurry disc—the circle of confusion—is small enough, our eye still perceives it as a point. It's only when the disc grows large enough that we can see it as a blur rather than a sharp point that a given point is viewed as out of focus. You can see, then, that enlarging an image, either by displaying it larger on your computer monitor or by making a large print, also enlarges the size of each circle of confusion. Moving closer to the

Figure 7.6
When a pinpoint of light
(left) goes out of
focus, its blurry
edges form a
circle of confusion (center and
right).

image does the same thing. So, parts of an image that may look perfectly sharp in a 5×7 -inch print viewed at arm's length, might appear blurry when blown up to 11×14 and examined at the same distance. Take a few steps back, however, and it may look sharp again.

To a lesser extent, the viewer also affects the apparent size of these circles of confusion. Some people see details better at a given distance and may perceive smaller circles of confusion than someone standing next to them. For the most part, however, such differences are small. Truly blurry images will look blurry to just about everyone under the same conditions.

Technically, there is just one plane within your picture area, parallel to the back of the camera (or sensor, in the case of a digital camera), that is in sharp focus. That's the plane in which the points of the image are rendered as precise points. At every other plane in front of or behind the focus plane, the points show up as discs that range from slightly blurry to extremely blurry until, as you can see in Figure 7.7, the out-of-focus areas become blurry and less distracting.

In practice, the discs in many of these planes will still be so small that we see them as points, and that's where we get depth-of-field. Depth-of-field is just the range of planes

Figure 7.7 With shallow depth-of-field, a distracting background becomes blurry.
that include discs that we perceive as points rather than blurred splotches. The size of this range increases as the aperture is reduced in size and is allocated roughly one-third in front of the plane of sharpest focus, and two-thirds behind it. The range of sharp focus is always greater behind your subject than in front of it.

Using Autofocus with the Nikon D3200

Autofocus can sometimes be frustrating for the new digital SLR photographer, especially those coming from the point-and-shoot world. That's because correct focus plays a greater role among your creative options with a dSLR, even when photographing the same subjects. Most non-dSLR digital cameras have sensors that are much tinier than the sensor in the D3200. Those smaller sensors require shorter focal lengths, which (as you'll learn in Chapter 10) have, effectively, more depth-of-field.

The bottom line is that with the average point-and-shoot camera, *everything* is in focus from about one foot to infinity and at virtually every f/stop. Unless you're shooting close-up photos a few inches from the camera, the depth-of-field is prodigious, and autofocus is almost a non-factor. The D3200, on the other hand, uses longer focal length lenses to achieve the same field of view with its larger sensor, so there is less depth-of-field. That's a *good* thing, creatively, because you have the choice to use selective focus to isolate subjects. But it does make the correct use of autofocus more critical. To maintain the most creative control, you have to choose three attributes:

- How much is in focus. Generally, by choosing the f/stop used, you'll determine the *range* of sharpness/amount of depth-of-field. The larger the DOF, the "easier" it is for the autofocus system's locked-in focus point to be appropriate (even though, strictly speaking, there is only one actual plane of sharp focus). With less depth-of-field, the accuracy of the focus point becomes more critical, because even a small error will result in an out-of-focus shot.
- What subject is in focus. The portion of your subject that is zeroed in for autofocus is determined by the autofocus zone that is active, and which is chosen either by you or by the Nikon D3200 (as described next). For example, when shooting portraits, it's actually okay for part of the subject—or even part of the subject's face—to be slightly out of focus as long as the eyes (or even just the *nearest* eye) appear sharp.
- When focus is applied. For static shots of objects that aren't moving, when focus is applied doesn't matter much. But when you're shooting sports, or birds in flight (see Figure 7.8), or children (traditionally three of the most difficult subjects to capture), the target may move within the viewfinder as you're framing the image. Whether that movement is across the frame or headed right toward you, timing the instant when autofocus is applied can be important.

Figure 7.8 When capturing moving subjects, such as birds in flight, timing the instant when autofocus is applied can be important.

Your Autofocus Mode Options

Choosing the right autofocus mode and the way in which focus points are selected is your key to success. Using the wrong mode for a particular type of photography can lead to a series of pictures that are all sharply focused—on the wrong subject. When I first started shooting sports with an autofocus SLR (back in the film camera days), I covered one game alternating between shots of base runners and outfielders with pictures of a promising young pitcher, all from a position next to the third base dugout. The base runner and outfielder photos were great, because their backgrounds didn't distract the autofocus mechanism. But all my photos of the pitcher had the focus tightly zeroed in on the fans in the stands behind him. Because I was shooting film instead of a digital camera, I didn't know about my gaffe until the film was developed. A simple change, such as locking in focus or focus zone manually, or even manually focusing, would have done the trick.

There are two main autofocus options you need to master to make sure you get the best possible automatic focus with your Nikon D3200: Autofocus mode and Autofocus Area. I'll explain each of them separately.

Autofocus Mode

This choice determines when your D3200 starts to autofocus, and what it does when focus is achieved. Automatic focus is not something that happens all the time when your camera is turned on. To save battery power, your D3200 generally doesn't start to focus the lens until you partially depress the shutter release. (You can also use the AE-L/AF-L button to start autofocus, as described in Chapter 3.) Autofocus isn't some mindless beast out there snapping your pictures in and out of focus with no feedback from you after you press that button. There are several settings you can modify that return at least a modicum of control to you.

Your first decision, if you'll be composing your image through the optical viewfinder, should be whether you set the D3200 to AF-S, AF-C, AF-A, or Manual. (Special issues for focusing in Live View mode are discussed in Chapter 8.) To change to any of the automatic focus modes, use the information edit menu and select the focus mode (AF is fifth from the bottom of the screen). With the camera set for one of the Scene modes, AF-S will be used automatically, except when using the Sports/Action scene mode. To switch to manual mode, slide the AF/M or M-A/M switch on the lens to M.

AF-S

In this mode, also called *Single Autofocus*, focus is set once and remains at that setting until the button is fully depressed, taking the picture, or until you release the shutter button without taking a shot. You can also use the AE-L/AF-L button, as described in Chapter 3, if you've set that button to lock focus when pressed. For non-action photography, this setting is usually your best choice, as it minimizes out-of-focus pictures (at the expense of spontaneity). The drawback here is that you might not be able to take a picture at all while the camera is seeking focus; you're locked out until the autofocus mechanism is happy with the current setting. AF-S/Single Autofocus is sometimes referred to as *focus priority* for that reason. Because of the small delay while the camera zeroes in on correct focus, you might experience slightly more shutter lag. This mode uses less battery power.

When sharp focus is achieved, the focus confirmation light at the lower left will remain green, without flashing. By keeping the shutter button depressed halfway, you'll find you can reframe the image while retaining the focus (and exposure) that's been set.

AF-C

This mode, also known as *Continuous Autofocus* is the one to use for sports and other fast-moving subjects. In this mode, once the shutter release is partially depressed, the camera sets the focus but continues to monitor the subject, so that if it moves or you move, the lens will be refocused to suit. Focus and exposure aren't really locked until you press the shutter release down all the way to take the picture. You'll often see

Continuous Autofocus referred to as *release priority*. If you press the shutter release down all the way while the system is refining focus, the camera will go ahead and take a picture, even if the image is slightly out of focus. You'll find that AF-C produces the least amount of shutter lag of any autofocus mode: press the button and the camera fires. It also uses the most battery power, because the autofocus system operates as long as the shutter release button is partially depressed.

AF-A

This setting is actually a combination of the first two. When selected, the camera focuses using AF-S AF and locks in the focus setting. But, if the subject begins moving, it will switch automatically to AF-C and change the focus to keep the subject sharp. AF-A is a good choice when you're shooting a mixture of action pictures and less dynamic shots and want to use AF-S when possible. The camera will default to that mode, yet switch automatically to AF-C when it would be useful for subjects that might begin moving unexpectedly. However, as with AF-S, the shutter can be released only when the subject at the selected focus point is in focus.

Manual Focus

In this mode, or when you've set the lens autofocus switch to Manual (or when you're using a non AF-S lens, which lacks an internal autofocus motor), the D3200 always focuses manually using the rotating focus ring on the lens barrel. However, if you are using a lens with a maximum aperture of at least f/5.6, the focus confirmation light in the viewfinder will glow a steady green when the image is correctly manually focused.

In manual focus mode, you can use the rangefinder feature to help you achieve sharp focus when you're shooting in Program, Aperture-priority, or Shutter-priority mode. You'll find an additional description and illustrations for using the rangefinder in Chapter 5. As I noted in Chapter 5, the rangefinder supplements the focus confirmation indicator at the left edge of the viewfinder by using the analog exposure indicator as a focusing "scale."

In Figure 7.9, at top you can see that the focus indicator has illuminated all the bars to the left and right of the "zero" point. That means that the current focus is grossly incorrect. In the middle illustration, the bars are illuminated to the left, indicating that current focus is significantly *behind the point* of focus for the current focus point. To focus on the piece in front, you'd need to focus more closely. At bottom, correct manual focus has been achieved, and the rangefinder indicator shows just a pair of bars, centered under the zero point.

To summarize the instructions in Chapter 5 for using the rangefinder:

Turn the rangefinder On with this option if you want an additional manual focusing aid. With a manual focus lens and the rangefinder operating, the analog exposure

Figure 7.9
The manual focus scale in the viewfinder shows (top) that the image is very out of focus; (middle) focus is behind the correct point; (bottom) correct focus has been achieved.

display at bottom center in the viewfinder will be replaced by a rangefinder focusing scale. Indicators on the scale like those in Figure 5.6 (back in Chapter 5) show when the image is in sharp focus, as well as when you have focused somewhat in front of, or behind the subject. Follow these steps to use the rangefinder:

- 1. **Activate.** Use the Setup menu's Rangefinder entry to turn on the rangefinder, as described in Chapter 5.
- 2. **Select a focus point.** Use the multi selector to move the highlighting around in the frame.
- 3. **Rotate the lens focus ring.** Zoom lenses will have *two* rings; there's no fixed convention as to whether the wider or narrower ring is the focus ring. Choose the one farthest from the zoom scale.
- 4. Watch the rangefinder. If the indicator is pointing toward the left, focus farther away. If the scale points toward the right, focus more closely.
- 5. **Achieve sharp focus.** When the subject you've selected with the focus zone bracket is in sharp focus, only two bars will appear, centered under the 0, and the focus confirmation indicator will stop blinking. If no 0 appears, the camera cannot determine focus.

Autofocus Area

Where autofocus mode chooses when to autofocus, the Autofocus Area parameter tells your Nikon D3200 how to choose which of the 11 focus points in the viewfinder should be used to evaluate and lock in focus. Ordinarily, your camera would like to be able to choose among the available AF points itself. In fact, that's the default behavior, and when AF-Area mode for Viewfinder is set to Auto-Area, the D3200 chooses the focus point automatically in Auto, No-Flash, Portrait, Landscape, Night Portrait, and PAS (Program, Aperture-priority, and Shutter-priority) exposure modes. Giving the D3200 free rein in selecting a focus point works well much of the time, and you can use this default mode with confidence.

If you want to choose a focus point yourself, you must do two things. When the focus point is unlocked, you can use the multi selector pad to shift the active point to any of the 11 focus points seen in the viewfinder. The available points are shown in Figure 7.10. The currently active focus point is highlighted in red.

The second thing to do is to switch the viewfinder Focus Area mode in the Shooting menu from Auto-area (which *always* chooses the focus point automatically) to Singlepoint, Dynamic-area, or 3D-tracking (11 Points). (Different focus area options are available for Live View mode, as described later.)

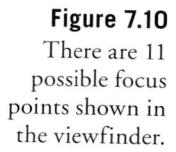

These viewfinder modes change the D3200's behavior as follows:

- Single-point. You choose which of the 11 points are used, and the Nikon D3200 sticks with that focus bracket, no matter what. This mode is best for stationary subjects, and is used automatically in Close-up scene mode. In this mode, you always select the focus point manually, using the multi selector button. The D3200 evaluates focus based solely on the point you select, making this a good choice for subjects that don't move much.
- Dynamic-area. You can select the focus point, but the D3200 can use other focus points as well. You'd want to use this mode when photographing subjects that are moving unpredictably, but want the flexibility of being able to choose one of the 11 focus zones yourself. Once you've specified the focus bracket you want using the multi selector's buttons, the D3200 will use that area exclusively in Single-servo autofocus mode (AF-S, described next). If you've chosen Continuous-autofocus mode (AF-C) or Automatic-autofocus mode (AF-A), if the subject begins moving after autofocus is activated, the D3200 will focus based on information from one of the other focus zones. Well suited for sports photography, this mode is applied automatically with the Sports scene setting, and can be used with other types of moving subjects, such as active children.

- 3D-tracking (11 points). In this mode, you select the focus point using the multi selector, but if you subsequently reframe the picture slightly, the D3200 uses distance information when in AF-C (Continuous Autofocus) or AF-A (Automatic Autofocus) modes to refocus on the original subject if necessary. When using AF-S (Single Autofocus), this mode functions the same as Single-point focus area mode. This mode is useful if you need to reframe a relatively static subject from time to time. If your subject leaves the frame entirely, you'll need to release the shutter button and refocus.
- **Auto-area.** This mode chooses the focus point for you, and can use distance information when working with a G or D lens that supplies that data to the camera. (See Chapter 10 for more on the difference between G/D lenses and other kinds of lenses.)

Focusing in Live View

When you're not using the optical viewfinder, and instead using the D3200's Live View mode on the back-panel color LCD, available modes differ slightly. Instead of using Phase Detection autofocus (or the human eye's contrast detection system when focusing manually), the D3200 puts contrast detection to work full-time. The camera evaluates the focus of the image as seen by the sensor, and makes adjustments from there.

This section will explain your Live View focus options.

Focus Mode

Activate Live View by pressing the LV button on the back of the D3200. Then press the Information Edit button to view the information edit screen. You can then adjust the focus mode. The available modes differ slightly from those possible when not shooting in Live View. The following three choices are possible when your lens is not set to the manual focus position:

- AF-S. This single autofocus mode, which Nikon calls single-servo AF, locks focus when the shutter release is pressed halfway. This mode uses *focus priority;* the shutter can be fully released to take a picture only if the D3200 is able to achieve sharp focus.
- AF-F. This new mode is roughly the equivalent of AF-C. Nikon calls it full-time servo AF. The D3200 focuses and refocuses continually as you shoot stills in Live View modes or record movies. Unlike AF-C, this mode also uses focus priority. You can't release the shutter unless the camera has achieved sharp focus.
- MF. Manual focus. You focus the image by rotating the focus ring on the camera.

Focus Area

Still in information edit mode, choose the D3200's AF-area mode for Live View. (You can also choose AF-area mode in the Shooting menu under the Live View/Movie entry, as described in Chapter 4.) Your choices are as follows:

- Face-priority AF. The camera automatically detects faces, and focuses on subjects facing the camera, as when you're shooting a portrait. You can't select the focus zone yourself. Instead, a double yellow border will be displayed on the LCD when the camera detects a face. You don't need to press the shutter release to activate this behavior. (Up to five faces may be detected; the D3200 focuses on the face that is closest to the camera.) When you press down the shutter release halfway, the camera attempts to focus the face. As sharp focus is achieved, the border turns green (see Figure 7.11). If the camera is unable to focus, the border blinks red. Focus may also be lost if the subject turns away from the camera and is no longer detectable by Face-priority.
- Wide-area AF. This is the mode to use for non-portrait subjects, such as land-scapes, as you can select the focus zone to be used manually. It's good for shooting hand-held, because the subjects may change as you reframe the image with a hand-held camera, and the wide-area zones are forgiving of these changes. The focus zone will be outlined in red. You can move the focus zone around the screen with the multi selector buttons. When sharp focus is achieved, the focus zone box will turn green. (See Figure 7.12.)
- Normal-area AF. This mode uses smaller focus zones, and so is best suited for tripod-mounted images where the camera is held fairly steady. As with Wide-area AF, the focus zone will be outlined in red. You can move the focus zone around the screen with the multi selector buttons. When sharp focus is achieved, the focus zone box will turn green. (See Figure 7.13.)
- Subject-tracking AF. This mode allows the camera to "grab" a subject, focus, and then follow the subject as it moves within the frame. You can use this mode for subjects that don't remain stationary, such as small children. When using Subject-tracking AF, a white border appears in the center of the frame, and turns yellow when focus is locked in (as described in the section that follows). To activate focus or refocus, press the multi selector up button. I'll explain Subject-tracking in more detail next. (See Figure 7.14.)
- Manual focus. In this non-automatic focus mode, you can select the focus zone to use with the multi selector buttons, press the shutter release halfway, and then adjust focus manually by rotating the focus ring on the lens. When sharp focus is achieved, the focus confirmation indicator at the lower left of the viewfinder will turn a steady green.

Figure 7.11
Face-priority
AF attempts to focus on the face that's closest to the camera.

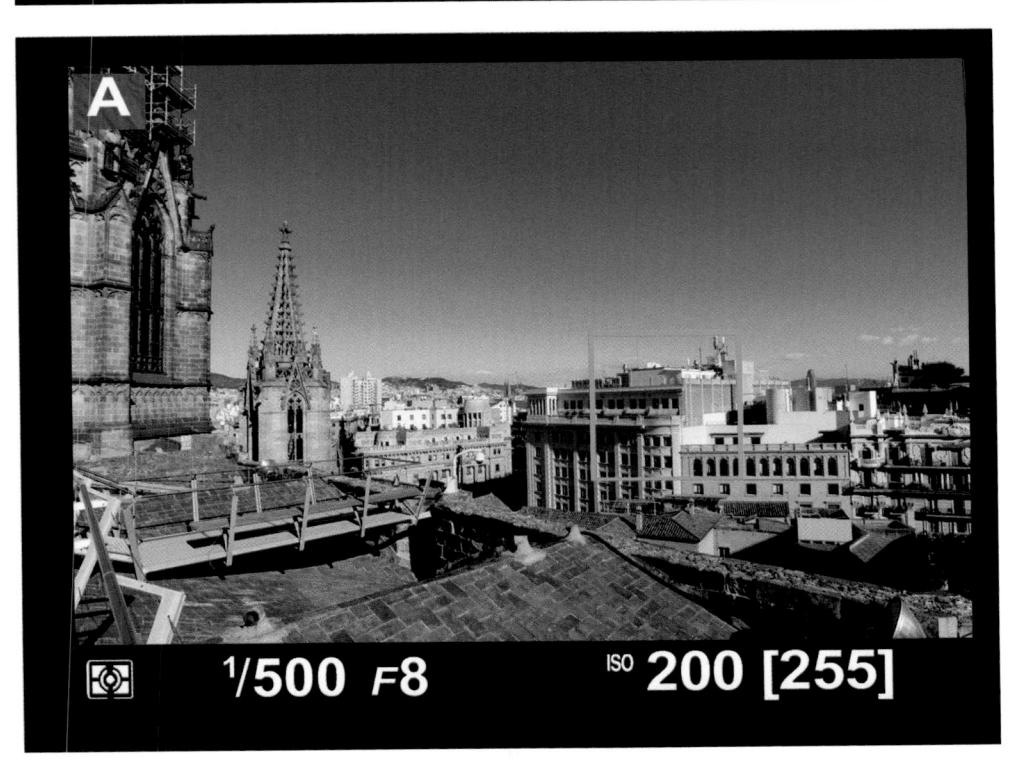

Figure 7.12 Wide-area AF is best for landscapes and other subjects with large elements.

Figure 7.13

Normal-area

AF allows you

to zero in on a
specific point of
focus.

Introducing Subject-Tracking

The useful Subject-tracking autofocus feature is one of those features that can be confusing at first, but once you get the hang of it, it's remarkably easy to use. Face-priority, in comparison, is almost intuitive to learn. Here's the quick introduction you need to Subject-tracking.

- Ready, aim... When you've activated Subject-tracking, a white border appears in the center of the frame. Use that border to "aim" the camera until the subject you want to focus on and track is located within the border.
- ...Focus. When you've pinpointed your subject, press the OK button to activate the D3200's Contrast Detection autofocus feature. The focus frame will turn yellow and the camera will emit a beep (unless you've disabled the beep with in the Setup menu) when locked in.
- Reframe as desired. Once the focus frame has turned yellow, it seemingly takes on a life of its own, and will "follow" your subject around on the LCD as you reframe your image. (See Figure 7.14.) (In other words, the subject being tracked doesn't have to be in the center of the frame for the actual photo.) Best of all, if your subject moves, the D3200 will follow it and keep focus as required.

Figure 7.14
Subject-tracking can keep focus as it follows your subject around in the frame.

- Tracking continues. The only glitches that may pop up might occur if your subject is small and difficult to track, or is too close in tonal value to its background, or if the subject approaches the camera or recedes sufficiently to change its relative size on the LCD significantly.
- **Grab a new subject.** If you want to refocus or grab a new subject, press the OK button again.

Focus Stacking

If you are doing macro (close-up) photography of flowers, or other small objects at short distances, the depth-of-field often will be extremely narrow. In some cases, it will be so narrow that it will be impossible to keep the entire subject in focus in one photograph. Although having part of the image out of focus can be a pleasing effect for a portrait of a person, it is likely to be a hindrance when you are trying to make an accurate photographic record of a flower, or small piece of precision equipment. One solution to this problem is focus stacking, a procedure that can be considered like HDR translated for the world of focus—taking multiple shots with different settings, and, using software as explained below, combining the best parts from each image in order to make a whole that is better than the sum of the parts. Focus stacking requires a non-moving object,

so some subjects, such as flowers, are best photographed in a breezeless environment, such as indoors.

For example, see Figures 7.15 through 7.17, in which I took photographs of three colorful crayons. As you can see from these images, the depth-of-field was extremely narrow, and only a small part of the subject was in focus for each shot.

Now look at Figure 7.18, in which the entire subject is in reasonably sharp focus. This image is a composite, made up of the three shots above, as well as 10 others, each one focused on the same scene, but at very gradually increasing distances from the camera's

Figures 7.15, 7.16, 7.17 These three shots were all focused on different distances within the same scene. No single shot could bring the entire subject into sharp focus.

Figure 7.18 Three partially out-of-focus shots have been merged, along with ten others, through a focus stacking procedure in Adobe Photoshop, to produce a single image with the entire subject in focus.

lens. All 13 images were then combined in Adobe Photoshop using the focus stacking procedure. Here are the steps you can take to combine shots for the purpose of achieving sharp focus in this sort of situation:

- 1. **Set the camera firmly on a solid tripod.** A tripod or other equally firm support is absolutely essential for this procedure.
- 2. **Set the Nikon D3200 for remote control.** Press the release mode button located southeast of multi selector and choose either of the two remote control settings.
- 3. **Set the camera to manual focus mode.** Use the procedure described in the previous section to activate manual focus.
- 4. **Set the exposure, ISO, and white balance manually.** Use test shots if necessary to determine the best values. This step in the Shooting menu will help prevent visible variations from arising among the multiple shots that you'll be taking. You don't want the D3200 to change the ISO setting or white balance between shots.
- 5. Set the quality of the images to NEF (RAW)+JPEG FINE. Use the Shooting menu to make this adjustment. Having both formats will give you flexibility when combining the images.
- 6. Focus manually on the very closest point of the subject to the lens. Rotate the multi selector dial to change the focus.
- 7. Trip the shutter. Use the ML-L3 infrared remote or wired remote.
- 8. **Carefully refocus.** Gently rotate the multi selector dial to focus on a point slightly farther away from the lens and trip the shutter again.
- 9. **Continue taking photographs** in this way until you have covered the entire subject with in-focus shots.

The next step is to process the images you've taken in Photoshop. Transfer the images to your computer, and then follow these steps:

- 1. In Photoshop, select File > Scripts > Load Files into Stack. In the dialog box that then appears, navigate on your computer to find the files for the photographs you have taken, and highlight them all.
- 2. At the bottom of the next dialog box that appears, check the box that says, "Attempt to Automatically Align Source Images," then click OK. The images will load; it may take several minutes for the program to load the images and attempt to arrange them into layers that are aligned based on their content.
- 3. Once the program has finished processing the images, go to the Layers panel and select all of the layers. You can do this by clicking on the top layer and then Shift-clicking on the bottom one.

- 4. While the layers are all selected, in Photoshop go to Edit > Auto-Blend Layers. In the dialog box that appears, select the two options, Stack Images and Seamless Tones and Colors, then click OK. The program will process the images, possibly for a considerable length of time.
- 5. If the procedure worked well, the result will be a single image made up of numerous layers that have been processed to produce a sharply focused rendering of your subject. If it did not work well, you may have to take additional images the next time, focusing very carefully on small slices of the subject as you move progressively farther away from the lens.

Although this procedure can work very well in Photoshop, you also may want to try it with programs that were developed more specifically for focus stacking and related procedures, such as Helicon Focus (www.heliconsoft.com), PhotoAcute (www.photo-acute.com), or CombineZM (www.hadleyweb.pwp.blueyonder.co.uk).

Movie Making with the Nikon D3200

As we've seen in our exploration of its features so far, the Nikon D3200 is superbly equipped for taking still photographs of very high quality in a wide variety of shooting environments. But this camera's superior level of performance is not limited to stills. The D3200 camera is unusually capable in the movie-making arena as well. So, even though you may have bought your camera primarily for shooting stationary scenes, you acquired a device that is equipped with a cutting-edge set of features for recording high-quality video clips. This camera can record high-definition (HD) video. Whether you're looking to record informal clips of the family on vacation, the latest viral video for YouTube, or a set of scenes that will be painstakingly crafted into a cinematic masterpiece using editing software, the D3200 will perform admirably.

Working with Live View

Live View is one of those features that experienced SLR users (especially those dating from the film era) originally thought they didn't need—until they tried it. While dSLR veterans didn't really miss what we've come to know as Live View, it was at least, in part, because, until the feature became universal, they couldn't miss what they never had. After all, why would you eschew a big, bright, magnified through-the-lens optical view that showed depth-of-field fairly well, and which was easily visible under virtually all ambient light conditions? LCD displays, after all, were small, tended to wash out in bright light, and didn't really provide you with an accurate view of what your picture was going to look like.

The Nikon D3200 has a versatile 3-inch LCD that can be viewed under a variety of lighting conditions and from wide-ranging angles, so you don't have to be exactly behind the display to see it clearly in Live View mode. It offers a 100-percent view of the sensor's capture area (the optical viewfinder shows just 95 percent of the sensor's field of view). It's large enough to allow manual focusing—but if you want to use automatic focus with contrast detection, the D3200 can do that, too. You still have to avoid pointing your D3200 at bright light sources (especially the sun) when using Live View, but the real-time preview can be used for fairly long periods without frying the sensor. (Image quality can degrade, but the camera issues a warning when the sensor starts to overheat.)

Fun with Live View

You may not have considered everything you can do with Live View. But once you've played with it, you'll discover dozens of applications for this capability, as well as a few things that you can't do. Here's a list of Live View considerations:

- Shoot stills and movies. You can take still pictures or movies using Live View, and alternate between the two.
- Preview your images on a TV. Connect your Nikon D3200 to a television using an optional video cable, and you can preview your image on a large standard definition television or HDTV screen.
- Preview remotely. Extend the cable between the camera and TV screen, and you can preview your images some distance away from the camera.
- Continuous shooting. You can shoot bursts of images using Live View, but all shots will use the focus and exposure setting established for the first picture in the series.
- Shoot from tripod or hand-held. Of course, holding the camera out at arm's length to preview an image is poor technique, and will introduce a lot of camera shake. If you want to use Live View for hand-held images, use an image-stabilized lens and/or a high shutter speed. A tripod is a better choice if you can use one.
- Watch your power. Live View uses a lot of juice and will deplete your battery rapidly. The optional AC adapter is a useful accessory.

Beginning Live View

Activate Live View by pressing the Lv button on the back of the camera (just to the right of the LCD) until the mirror flips up and the Live View preview is shown on the display. You can change the amount and type of information overlaid on the LCD by pressing the Info button (on top of the camera) repeatedly. This is one special case where the Info button does more than simply turn the information display on or off.

Not all of the information appears all the time. For example, the Time Remaining indicator shows only when there are 30 seconds or less remaining for Live View shooting. The indicators overlaid on the image can be displayed or suppressed by pressing the Info button, and the LCD cycles among these screen variations:

- Live view screen overlaid with shooting information.
- Live view screen overlaid with only minimal information.
- Live view screen overlaid with basic information, plus a 16-segment alignment grid.

The first thing to do when entering Live View is to double-check three settings that affect how your image or movie is taken. These settings include:

Metering Mode

While using Live View, you can press the Information Edit button (just one press is needed when Live View is active) to view the information edit screen. There, you can select the Metering option (it's the last selection in the right-hand column) and press OK. Then, choose Matrix, Center-weighted, or Spot metering.

Focus Mode

While the information edit screen is visible, adjust the focus mode. As mentioned in the last chapter, the available modes differ slightly from those possible when not shooting in Live View. You can select AF-S (single autofocus), AF-F (full-time servo AF), or MF (manual focus).

Focus Area

Also as described in the last chapter, you can choose the D3200's AF-area mode for Live View, either using the information edit screen or in the Shooting menu. A recap of your choices are as follows:

- Face-priority AF. The camera automatically detects faces, and focuses on subjects facing the camera, as when you're shooting a portrait, and you can't select the specific focus zone.
- Wide-area AF. You can select the focus zone with the directional buttons.
- Normal-area AF. Includes smaller focus zones for you to choose from with the multi selector directional buttons.
- Subject-tracking AF. Select a subject and let the D3200 track it to maintain focus.
- Manual focus. In this non-automatic focus mode, you can select the focus zone to use with the multi selector buttons, press the shutter release halfway, and then adjust focus manually by rotating the focus ring on the lens. When sharp focus is achieved, the focus confirmation indicator at the lower left of the viewfinder will glow steadily.

Shooting in Live View

Shooting stills and movies in Live View is easy. Just follow these steps:

- 1. **Press the Lv button.** Activate Live View by pressing the button. The D3200 can be hand-held or mounted on a tripod. (Using a tripod mode makes it easier to obtain and keep sharp focus.) You can exit Live View at any time by pressing the LV button again.
- 2. **Zoom in/out.** Check your view by pressing the Zoom In button (located at the lower-left corner next to the color LCD, second button from the bottom). A navigation box appears in the lower right of the LCD with a yellow box representing the portion of the image zoomed, just as when you're reviewing photos you've already taken using Playback mode. Use the multi selector keys to change the zoomed area within the full frame. Press the Zoom Out button to zoom out again.
- 3. **Make exposure adjustments.** While using an automatic exposure mode, you can add or subtract exposure using the EV settings, as described in Chapter 6. Hold down the EV button (just southeast of the shutter release) and rotate the command dial to add or subtract exposure when using P, S, and A modes. The back-panel color LCD will brighten or darken to represent the exposure change you make.
- 4. **Shoot.** Press the shutter release all the way down to take a still picture, or press the red movie button to start motion picture filming. Stop filming by pressing the movie button again. Movies up to 4GB in size can be taken (assuming there is sufficient room on your memory card), which limits you to 20 minutes for an HDTV clip.

Shooting Movies with the D3200

As you've probably gathered, movie making is an extension of the Live View concept. Once you've directed the output of the sensor to the LCD, capturing it as a video file—with audio—is relatively easy. All the focus modes and AF-area modes described for plain old Live View mode can be applied to movie making. Here are some considerations to think about:

- Stills, too. You can take a still photograph even while you're shooting a movie clip by pressing the shutter release all the way down.
- Exposure compensation. When shooting movies, exposure compensation is available in plus/minus 3EV steps in 1/3 EV increments.
- Size matters. Individual movie files can be up to 4GB in size (this will vary according to the resolution you select), and no more than 20 minutes in length. The speed and capacity of your memory card may provide additional restrictions on size/length.

- Choose your resolution. Use the Movie Settings entry in the Shooting menu. Or, when Live View is activated, and before you start shooting your video clip, you can select the resolution/frame rate of your movie. Press the Information Edit button once, navigate to the movie size choice at the bottom of the right-hand column, and press OK. Then, use the directional buttons to select. Press OK to confirm. Your choices are as follows:
 - 1920 × 1080 at 30 fps (for NTSC devices)
 - 1920 × 1080 at 24 fps (for NTSC devices)
 - 1920 × 1080 at 25 fps (for PAL devices)
 - 1280 × 720 at 60 fps (for NTSC devices)
 - 1280 × 720 at 50 fps (for PAL devices)
 - 640 × 424 at 30 fps (for NTSC devices)
- 640 × 424 at 25 fps (for PAL devices)
- Audio Settings. The Movie Settings entry in the Shooting menu, as described in Chapter 4, is the place to turn sound recording on or off and to adjust sound levels. A recording meter appears at the left side of the screen to show sound levels as you shoot.

NOT MUCH OF A LIMITATION

Unless you are shooting an entire performance from a fixed position, such as a stage play, the 20-minute limitation on HDTV movie duration won't put much of a crimp in your style. Good motion picture practice calls for each production to consist of a series of relatively *short* clips, with 10 to 20 seconds a good average. You can assemble and edit your D3200 movies into one long, finished production using one of the many moviediting software packages available. Andy Warhol might have been successful with his 1963 five-hour epic *Sleep*, but the rest of us will do better with short sequences of the type produced by the Nikon D3200.

Viewing Your Movies

Once you've finished recording your movies, they are available for review. Film clips show up during picture review, the same as still photos, but they are differentiated by a movie camera overlay. Press the OK button to start playback.

During playback, you can perform the following functions:

■ Pause. Press the multi selector down button to pause the clip during playback. Press the multi selector center button to resume playback.

- Rewind/Advance. Press the left/right multi selector buttons to rewind or advance (respectively). Press once for 2X speed, twice for 8X speed, or three times for 16X speed. Hold down the left/right buttons to move to the end or beginning of the clip.
- Single Frame Rewind/Advance. Press the multi selector down key to pause the clip, then use the left/right buttons to rewind or advance one frame at a time.
- Change volume. Press the Zoom In and Zoom Out buttons to increase/decrease volume.
- Trim movie. Press the AE-L/AF-L button while the movie is paused.
- Exit Playback. Press the multi selector up button to exit playback.
- View menus. Press the MENU button to interrupt playback to access menus.

Editing Your Movies

In-camera editing is limited to trimming the beginning or end from a clip, and the clip must be at least two seconds long. For more advanced editing, you'll need an application capable of editing AVI movie clips. Google "AVI Editor" to locate any of the hundreds of free video editors available, or use a commercial product like Corel Video Studio, Adobe Premiere Elements, or Pinnacle Studio. These will let you combine several clips into one movie, add titles, special effects, and transitions between scenes.

To do in-camera editing/trimming, follow these steps:

- 1. **Activate edit.** While viewing a movie clip, press the down button to pause, and then press the AE-L/AF-L button. The Edit Movie prompt will appear.
- Select start/end point. Select Choose Start Point/End Point and press OK. Then select Start Point or End Point and press OK again.
- 3. **Resume playback.** Press the center button of the multi selector to start or resume playback. You can use the Pause, Rewind, Advance, and Single Frame controls described previously to move around within your clip.
- 4. **Mark trim point.** When you reach the point where you want to trim, press the Pause button (if the movie is not already paused), and then press the multi selector up button. All frames prior to the pause will be deleted if you're in Choose Start Point mode; all frames *after* the pause will be deleted if you're in Choose End Point mode. Your trimmed movie must be at least two seconds long.
- 5. Confirm trim. A Proceed? prompt appears. Choose Yes or No, and press OK.
- 6. **Save movie.** You'll see a Saving Movie message and a green progress bar as the D3200 stores the trimmed clip to your memory card. Storage takes some time, and you don't want to interrupt it to avoid losing your saved clip. So, make sure your camera has a fully charged battery before you start to edit a clip.

Saving a Frame

You can store any frame from one of your movies as a JPEG still, using the resolution of the video format. Just follow these steps:

- 1. Pause your movie at the frame you want to save. Press the AE-L/AF-L button to access the Edit Movie screen.
- 2. Choose Save Selected Frame and press OK.
- 3. Choose Proceed to confirm.
- 4. Your frame will be stored on the memory card, and will be marked with a scissors icon.

Some Fundamentals

Recording a video with the Nikon D3200 is extraordinarily easy to accomplish—just press the LV button and then press the prominent red button at the upper right of the camera's back to start, and press it again to stop.

Before you press that button, though, there are some settings to prepare the camera to record the scene the way you want it to. Setting up the camera for recording video can be a bit tricky, because it's not immediately obvious, either from the camera's menus or from Nikon's manuals, which settings apply to video recording and which do not. I will unravel that mystery for you, and throw in a few other tips to help improve your movies.

I'll show you how to optimize your settings before you start shooting video, but here are some considerations to be aware of as you get started. Many of these points will be covered in more detail later in this chapter:

■ Use the right card. You'll want to use an SD or SDHC card with Class 6 or higher speed; if you use a slower card, like a Class 4 or especially Class 2, the recording may stop after a minute or two. Choose a memory card with at least 4GB capacity; 8GB or 16GB are even better. If you're going to be recording a lot of HD video, that could be a good reason to take advantage of the ability to use SDXC cards of 64GB capacity. Just make sure your memory card reader is SDXC compatible and your computer can read the files from that type of card. I've standardized on fast Class 6 or Class 10 16GB SDHC cards when I'm shooting movies; one of these cards will hold at least three hours of video. However, the camera cannot shoot a continuous movie scene for more than 20 minutes. You can start shooting the next clip right away, though, missing only about 30 seconds of the action. Of course that assumes there's enough space on your memory card and adequate battery power.

One aspect that doesn't always occur to new movie shooters is that the capacity of the card matters only with respect to the number and length of video clips you intend to shoot. Larger cards let you capture more and longer sequences. You don't need to upgrade the size of your card because you've upgraded the resolution of your camera. A 36-megapixel D800 and a 24-megapixel D3200 *both* record full HD movies using the exact same 1920 × 1080-pixel resolution. The upscale model may outperform your D3200 in other respects, but when it comes to HD movie making, the playing field is level.

- Add an external mic. For the best sound quality, and to avoid picking up the sound of the autofocus motor, get an external stereo mic. If you get a Nikon microphone, like the ME-1, it will slide right into the accessory shoe on top of the camera. Other brands will require an adapter. I'll have more advice about capturing sound later in this chapter.
- Minimize zooming. While it's great to be able to use the zoom for filling the frame with a distant subject, think twice before zooming during the shot. Unless you are using an external mic, the sound of the zoom ring being spun will be picked up and it will be audible when you play a movie. Any more than the occasional minor zoom will be very distracting to friends who watch your videos. And digital zoom will definitely degrade image quality. Don't use the digital zoom if quality is more important than recording a specific subject such as a famous movie star far from a distance.
- Use a fully charged battery. A fresh battery will allow about one hour of filming at normal (non-Winter) temperatures, but that can be shorter if there are many focus adjustments. Individual clips can be no longer than 20 minutes, however.
- **Keep it cool.** Video quality can suffer terribly when the imaging sensor gets hot so keep the camera in a cool place. When shooting on hot days especially, the sensor can get hot more quickly than usual; when there's a risk of overheating, the camera will stop recording and it will shut down about five seconds later. Give it time to cool down before using it again.
- Press the Movie button. You don't have to hold it down. Press it again when you're done to stop recording.

Tips for Shooting Better Video

Once upon a time, the ability to shoot video with a digital still camera was one of those "Gee whiz" gimmicks camera makers seemed to include just to have a reason to get you to buy a new camera. That hasn't been true for a couple of years now, as the video quality of many digital still cameras has gotten quite good. The D3200 is a stellar example.

It's capable of HD-quality video and is actually capable of outperforming typical modestly priced digital video camcorders, especially when you consider the range of lenses and other helpful accessories available for it.

Producing high-quality videos can be a real challenge for amateur photographers. After all, by comparison we're used to watching the best productions that television, video, and motion pictures can offer. Whether it's fair or not, our efforts are compared to what we're used to seeing produced by experts. While this book can't make you a professional videographer in half a chapter, there is some advice I can give you that will help you improve your results with the camera.

Lens Craft

I'll cover the use of lenses with the D3200 in more detail in Chapter 10, but a discussion of lens selection when shooting movies may be useful at this point. In the video world, not all lenses are created equal. The two most important considerations are depth-of-field, or the beneficial lack thereof, and zooming. I'll address each of these separately.

Depth-of-Field and Video

Have you wondered why professional videographers have gone nuts over still cameras that can also shoot video? The producers of *Saturday Night Live* could afford to have Alex Buono, their director of photography, use the niftiest, most expensive high-resolution video cameras to shoot the opening sequences of the program. Instead, Buono opted for a pair of digital SLR cameras. One thing that makes digital still cameras so attractive for video is that they have relatively large sensors, which provides improved low-light performance and results in the oddly attractive reduced depth-of-field, compared with most professional video cameras.

Figure 8.1 provides a comparison of the relative size of sensors. The typical size of a professional video camera sensor is shown at lower left. The APS-C (DX) sensor used in the D3200 is shown just northwest of it. You can see that it is much larger, especially when compared with the sensor found in the typical point-and-shoot camera shown at right. Compared with the sensors used in many pro video cameras and the even smaller sensors found in the typical computer camcorder, the D3200's image-grabber is much larger.

As you'll learn in Chapter 10, a larger sensor calls for the use of longer focal lengths to produce the same field of view, so, in effect, a larger sensor has reduced depth-of-field. And *that's* what makes cameras like the D3200 attractive from a creative standpoint. Less depth-of-field means greater control over the range of what's in focus. Your D3200, with its larger sensor, has a distinct advantage over consumer camcorders in this regard, and even does a better job than many professional video cameras.

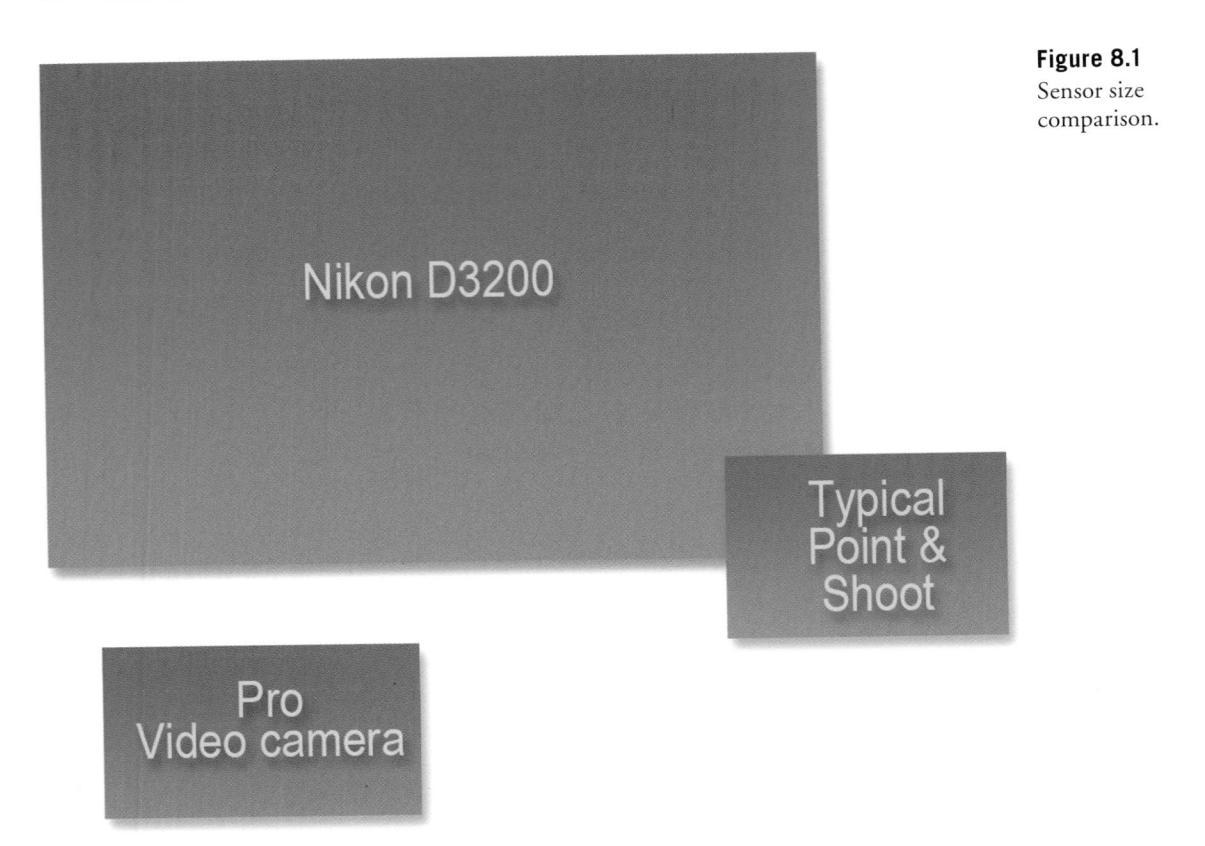

Zooming and Video

We're back to zooming (or not zooming) again! When shooting still photos, a zoom is a zoom is a zoom. The key considerations for a zoom lens used only for still photography are the maximum aperture available at each focal length ("How *fast* is this lens?"), the zoom range ("How far can I zoom in or out?"), and its sharpness at any given f/stop ("Do I lose sharpness when I shoot wide open?").

When shooting video, the priorities may change, and there are two additional parameters to consider. The first two I listed, lens speed and zoom range, have roughly the same importance in both still and video photography. Zoom range gains a bit of importance in videography, because you can always/usually move closer to shoot a still photograph, but when you're zooming during a shot most of us don't have that option (or the funds to buy/rent a dolly to smoothly move the camera during capture). But, oddly enough, overall sharpness may have slightly less importance under certain conditions when shooting video. That's because the image changes in some way many times per second, so any given frame doesn't hang around long enough for our eyes to pick out every single detail. You want a sharp image, of course, but your standards don't need to be quite as high when shooting video.

Here are the remaining considerations:

- Zoom lens maximum aperture. The speed of the lens matters in several ways. A zoom with a relatively large maximum aperture lets you shoot in lower light levels, and a big f/stop allows you to minimize depth-of-field for selective focus. Keep in mind that the maximum aperture may change during zooming. A lens that offers a f/3.5 maximum aperture at its widest focal length, may provide only f/5.6 worth of light at the telephoto position.
- Zoom range. Use of zoom during actual capture should not be an everyday thing, unless you're shooting a kung-fu movie. However, there are effective uses for a zoom shot, particularly if it's a "long" one from extreme wide angle to extreme close-up (or vice versa). We all can recall those memorable long shots of a building, seen from a distance, followed by a quick zoom in on Steve McGarrett poised outside that building with a steely glint in his eye.
 - But, most of the time, you'll use the zoom range to adjust the perspective of the camera *between* shots, and a longer zoom range can mean less trotting back and forth to adjust the field of view. Zoom range also comes into play when you're working with selective focus (longer focal lengths have less depth-of-field), or want to expand or compress the apparent distance between foreground and background subjects. A longer range gives you more flexibility.
- Linearity. Interchangeable lenses may have some drawbacks, as many photographers who have been using the video features of their digital SLRs have discovered. That's because, unless a lens is optimized for video shooting, zooming with a particular lens may not necessarily be linear. Rotating the zoom collar manually at a constant speed doesn't always produce a smooth zoom. There may be "jumps" as the elements of the lens shift around during the zoom. Keep that in mind if you plan to zoom during a shot, and are using a lens that has proved from experience to provide a non-linear zoom. (Unfortunately, there's no easy way to tell ahead of time whether you own a lens that is well-suited for zooming during a shot.)

Audio

When it comes to making a successful video, audio quality is one of those things that separates the professionals from the amateurs. We're used to watching top-quality productions on television and in the movies, yet the average person has no idea how much effort goes in to producing what seems to be "natural" sound. Much of the sound you hear in such productions is actually recorded on carefully controlled sound stages and "sweetened" with a variety of sound effects and other recordings of "natural" sound.

Tips for Better Audio

Since recording high-quality audio is such a challenge, it's a good idea to do everything possible to maximize recording quality. Here are some ideas for improving the quality of the audio your camera records:

- Get the camera and its microphone close to the speaker. The farther the microphone is from the audio source, the less effective it will be in picking up that sound. While having to position the camera and microphone closer to the subject affects your lens choices and lens perspective options, it will make the most of your audio source. Of course, if you're using a very wide-angle lens, getting too close to your subject can have unflattering results, so don't take this advice too far.
- Use an external microphone. The D3200's built-in microphone is monaural only. Plug a stereo mic into the jack on the side of the camera, and you'll immediately enjoy better sound, because you won't be recording noises including autofocus motors or your own breathing.
- Turn off any sound makers you can. Little things like fans and air handling units aren't obvious to the human ear, but will be picked up by the microphone. Turn off any machinery or devices that you can plus make sure cell phones are set to silent mode. Also, do what you can to minimize sounds such as wind, radio, television, or people talking in the background.
- Make sure to record some "natural" sound. If you're shooting video at an event of some kind, make sure you get some background sound that you can add to your audio as desired in postproduction.
- Consider recording audio separately. Lip-syncing is probably beyond most of the people you're going to be shooting, but there's nothing that says you can't record narration separately and add it later. It's relatively easy if you learn how to use simple software video-editing programs like iMovie (for the Macintosh) or Windows Movie Maker (for Windows PCs). Any time the speaker is off-camera, you can work with separately recorded narration rather than recording the speaker on-camera. This can produce much cleaner sound.

External Microphones

The single most important thing you can do to improve your audio quality is to use an external microphone. The D3200's internal microphone mounted on the front of the camera will do an acceptable job, but has some significant drawbacks, partially spelled out in the previous section:

■ Camera noise. The D3200's shutter may be relatively quiet, but there are plenty of other noise sources emanating from the camera, including your own breathing and rustling around as the camera shifts in your hand. Manual zooming is bound

to affect your sound, and your fingers will fall directly in front of the built-in mics as you change focal lengths. An external microphone isolates the sound recording from camera noise.

- **Distance.** Anytime your camera is located more than 6-8 feet from your subjects or sound source, the audio will suffer. An external unit allows you to place the mic right next to your subject.
- Improved quality. Obviously, Nikon isn't going to install a super high-quality microphone on an entry-level camera. Decent external microphones can cost a significant percentage of the price of the D3200. You might want to spend \$100-\$150 or more on your own if you're serious about good sound. I use the Nikon ME-1 microphone, shown in Figure 8.2.
- **Directionality.** The internal microphone generally records only sounds directly in front of it. An external microphone can be either of the directional type or omnidirectional, depending on whether you want to "shotgun" your sound or record more ambient sound.

Figure 8.2 The Nikon ME-1 microphone provides excellent sound quality.

You can choose from several different types of microphones, each of which has its own advantages and disadvantages. If you're avid about movie making with your D3200, you might want to own more than one. You can obtain a high-quality microphone made by a company such as Shure or Audio-Technica, and, if you are on a quest for really superior audio quality, you can even obtain a portable mixer that can plug into this jack, such as the affordable Rolls MX124 (around \$150) (www.rolls.com), letting you use multiple high-quality microphones (up to four) to record your soundtrack.

An exciting new option designed specifically for still cameras like the D3200 is the Beachtek DXA-SLR PRO HDSLR Audio Adapter. It's expensive, at around \$450, but has even more professional sound options and clips right onto the bottom of your camera using the tripod-mounting socket. (See Figure 8.3.)

Figure 8.3
The Beachtek
DXA-SLR PRO
HDSLR Audio
Adapter offers
professional
sound mixing
options.

One advantage that a sound mixing device like the DSX-SLR PRO offers over the stock D3200 is that it adds a headphone output jack to your camera, so you can monitor the sound being recorded (you can also listen to your soundtrack through the headphones during playback, which is *way* better than using the D3200's built-in speaker). The adapter has two balanced XLR microphone inputs and can also accept line input (from another audio source), and features cool features like AGC (automatic gain control), built-in limiting, and VU meters you can use to monitor sound input.

Common configurations of the microphones themselves include:

- Shotgun microphones. These can be mounted directly on your camera (with an adapter, if necessary). I prefer to use a bracket, originally intended for electronic flash units, which further isolates the microphone from any camera noise. Intended to pick up sound from the general direction in which it's pointed, such a microphone will provide decent pickup of ambient sound in its environment.
- Lapel microphones. Also called *lavalieres*, these microphones attach to the subject's clothing and picks up their voice with the best quality. You'll need a long

enough cord or a wireless mic (described later). These are especially good for video interviews, so whether you're producing a documentary or grilling relatives for a family history, you'll want one of these.

- Hand-held microphones. If you're capturing a singer crooning a tune, or want your subject to mimic famed faux newscaster Wally Ballou, a hand-held mic may be your best choice. They serve much the same purpose as a lapel microphone, and they're more intrusive—but that may be the point. A hand-held microphone can make a great prop for your fake newscast! The speaker can talk right into the microphone, point it at another person, or use it to record ambient sound. If your narrator is not going to appear on-camera, one of these can be an inexpensive way to improve sound.
- Wired and wireless external microphones. This option is the most expensive, but you get a receiver and a transmitter (both battery powered, so you'll need to make sure you have enough batteries). The transmitter is connected to the microphone, and the receiver is connected to your D3200. In addition to being less klutzy and enabling you to avoid having wires on view in your scene, wireless mics let you record sounds that are physically located some distance from your camera. Of course you need to keep in mind the range of your device, and be aware of possible signal interference from other electronic components in the vicinity.

WIND NOISE REDUCTION

Always use the wind screen provided with an external microphone to reduce the effect of noise produced by even light breezes blowing over the microphone. Both the camera and many mics include a low-cut filter to further reduce wind noise. However, these can also affect other sounds. You can disable the low-cut filters on the Nikon ME-1 microphone.

Keep Things Stable and on the Level

Camera shake's enough of a problem with still photography, but it becomes even more of a nuisance when you're shooting video. While the image-stabilization feature provided by some Nikon lenses can help minimize this, it can't work miracles. Placing your camera on a tripod will work much better than trying to hand-hold it while shooting.

Shooting Script

A shooting script is nothing more than a coordinated plan that covers both audio and video and provides order and structure for your video. A detailed script will cover what types of shots you're going after, what dialogue you're going to use, audio effects, transitions, and graphics.

Storyboards

A storyboard is a series of panels providing visuals of what each scene should look like. While the ones produced by Hollywood are generally of very high quality, there's nothing that says drawing skills are important for this step. Stick figures work just fine if that's the best you can do. The storyboard just helps you visualize locations; placement of actors/actresses, props, and furniture; and also helps everyone involved get an idea of what you're trying to show. It also helps show how you want to frame or compose a shot. You can even shoot a series of still photos and transform them into a "storyboard" if you want, such as in Figure 8.4.

Storytelling in Video

Today's audience is used to fast-paced, short-scene storytelling. In order to produce interesting video for such viewers, it's important to view video storytelling as a kind of shorthand code for the more leisurely efforts print media offers. Audio and video should always be advancing the story. While it's okay to let the camera linger from time to time, it should only be for a compelling reason and only briefly.

It only takes a second or two for an establishing shot to impart the necessary information. For example, many of the scenes for a video documenting a model being photographed in a Rock and Roll music setting might be close-ups and talking heads, but an establishing shot showing the studio where the video was captured helps set the scene.

Provide variety too. Change camera angles and perspectives often and never leave a static scene on the screen for a long period of time. (You can record a static scene for a reasonably long period and then edit in other shots that cut away and back to the longer scene with close-ups that show each person talking.)

Figure 8.4 A storyboard is a series of simple sketches or photos to help visualize a segment of video.

When editing, keep transitions basic! I can't stress this one enough. Watch a television program or movie. The action "jumps" from one scene or person to the next. Fancy transitions that involve exotic "wipes," dissolves, or cross fades take too long for the average viewer and make your video ponderous.

Composition

In movie shooting, several factors restrict your composition, and impose requirements you just don't always have in still photography (although other rules of good composition do apply). Here are some of the key differences to keep in mind when composing movie frames:

■ Horizontal compositions only. Some subjects, such as basketball players and tall buildings, just lend themselves to vertical compositions. But movies are shown in horizontal format only. So if you're interviewing a local basketball star, you can end up with a worst-case situation like the one shown in Figure 8.5. If you want to show how tall your subject is, it's often impractical to move back far enough to show him full-length. You really can't capture a vertical composition. Tricks like getting down on the floor and shooting up at your subject can exaggerate the perspective, but aren't a perfect solution.

Figure 8.5
Movie shooting requires you to fit all your subjects into a horizontally oriented frame.

- Wasted space at the sides. Moving in to frame the basketball player as outlined by the yellow box in Figure 8.5 means that you're still forced to leave a lot of empty space on either side. (Of course, you can fill that space with other people and/or interesting stuff, but that defeats your intent of concentrating on your main subject.) So when faced with some types of subjects in a horizontal frame, you can be creative, or move in *really* tight. For example, if I was willing to give up the "height" aspect of my composition, I could have framed the shot as shown by the green box in the figure, and wasted less of the image area at either side.
- Seamless (or seamed) transitions. Unless you're telling a picture story with a photo essay, still pictures often stand alone. But with movies, each of your compositions must relate to the shot that preceded it, and the one that follows. It can be jarring to jump from a long shot to a tight close-up unless the director—you—is very creative. Another common error is the "jump cut" in which successive shots vary only slightly in camera angle, making it appear that the main subject has "jumped" from one place to another. (Although everyone from French New Wave director Jean-Luc Goddard to Guy Ritchie—Madonna's ex—have used jump cuts effectively in their films.) The rule of thumb is to vary the camera angle by at least 30 degrees between shots to make it appear to be seamless. Unless you prefer that your images flaunt convention and appear to be "seamy."
- The time dimension. Unlike still photography, with motion pictures there's a lot more emphasis on using a series of images to build on each other to tell a story. Static shots where the camera is mounted on a tripod and everything is shot from the same distance are a recipe for dull videos. Watch a television program sometime and notice how often camera shots change distances and directions. Viewers are used to this variety and have come to expect it. Professional video productions are often done with multiple cameras shooting from different angles and positions. But many professional productions are shot with just one camera and careful planning, and you can do just fine with your D3200.

Here's a look at the different types of commonly used compositional tools:

■ Establishing shot. Much like it sounds, this type of composition, as shown in Figure 8.6, establishes the scene and tells the viewer where the action is taking place. Let's say you're shooting a video of your offspring's move to college; the establishing shot could be a wide shot of the campus with a sign welcoming you to the school in the foreground. Another example would be for a child's birthday party; the establishing shot could be the front of the house decorated with birthday signs and streamers or a shot of the dining room table decked out with party favors and a candle-covered birthday cake. Or, in Figure 8.6, I wanted to show the studio where the video was shot.

- **Medium shot.** This shot is composed from about waist to head room (some space above the subject's head). It's useful for providing variety from a series of close-ups and also makes for a useful first look at a speaker. (See Figure 8.7.)
- Close-up. The close-up, usually described as "from shirt pocket to head room," provides a good composition for someone talking directly to the camera. Although it's common to have your talking head centered in the shot, that's not a requirement. In Figure 8.8 the subject was offset to the right. This would allow other images, especially graphics or titles, to be superimposed in the frame in a "real" (professional) production. But the compositional technique can be used with D3200 videos, too, even if special effects are not going to be added.
- Extreme close-up. When I went through broadcast training back in the '70s, this shot was described as the "big talking face" shot and we were actively discouraged from employing it. Styles and tastes change over the years and now the big talking face is much more commonly used (maybe people are better looking these days?) and so this view may be appropriate. Just remember, the D3200 is capable of shooting in high-definition video and you may be playing the video on a high-def TV; be careful that you use this composition on a face that can stand up to high definition. (See Figure 8.9.)
- "Two" shot. A two shot shows a pair of subjects in one frame. (See Figure 8.10.) They can be side by side or one in the foreground and one in the background. This does not have to be a head to ground composition. Subjects can be standing or seated. A "three shot" is the same principle except that three people are in the frame.
- Over-the-shoulder shot. Long a composition of interview programs, the "over-the-shoulder shot" uses the rear of one person's head and shoulder to serve as a frame for the other person. This puts the viewer's perspective as that of the person facing away from the camera. (See Figure 8.11.)

Figure 8.6 An establishing shot sets the stage for your video scene.

Figure 8.7 A medium shot is used to bring the viewer into a scene without shocking them. It can be used to introduce a character and provide context via their surroundings.

Figure 8.8 A close-up generally shows the full face with a little head room at the top and down to the shoulders at the bottom of the frame.

Figure 8.9 An extreme close-up is a very tight shot that cuts off everything above the top of the head and below the chin (or even closer!). Be careful using this shot since many of us look better from a distance!

Figure 8.10 A "two shot" features two people in the frame. This version can be framed at various distances such as medium or close up.

Figure 8.11 An "over-the-shoulder" shot is a popular shot for interview programs. It helps make the viewers feel like they're the one asking the questions.

Lighting for Video

Much like in still photography, how you handle light pretty much can make or break your videography. Lighting for video can be more complicated than lighting for still photography, since both subject and camera movement is often part of the process.

Lighting for video presents several concerns. First off, you want enough illumination to create a useable video. Beyond that, you want to use light to help tell your story or increase drama. Let's take a closer look at both.

Illumination

You can significantly improve the quality of your video by increasing the light falling in the scene. This is true indoors or out, by the way. While it may seem like sunlight is more than enough, it depends on how much contrast you're dealing with. If your subject is in shadow (which can help them from squinting) or wearing a ball cap, a video light can help make them look a lot better.
Lighting choices for amateur videographers are a lot better these days than they were a decade or two ago. An inexpensive incandescent video light, which will easily fit in a camera bag, can be found for \$15 or \$20. You can even get a good-quality LED video light for less than \$100. Work lights sold at many home improvement stores can also serve as video lights since you can set the camera's white balance to correct for any color casts. You'll need to mount these lights on a tripod or other support, or, perhaps, to a bracket that fastens to the tripod socket on the bottom of the camera.

Much of the challenge depends upon whether you're just trying to add some fill light on your subject versus trying to boost the light on an entire scene. A small video light will do just fine for the former. It won't handle the latter. Fortunately, the versatility of the D3200 comes in quite handy here. Since the camera shoots video in Auto ISO mode, it can compensate for lower lighting levels and still produce a decent image. For best results though, better lighting is necessary.

Creative Lighting

While ramping up the light intensity will produce better technical quality in your video, it won't necessarily improve the artistic quality of it. Whether we're outdoors or indoors, we're used to seeing light come from above. Videographers need to consider how they position their lights to provide even illumination while up high enough to angle shadows down low and out of sight of the camera.

When considering lighting for video, there are several factors. One is the quality of the light. It can either be hard (direct) light or soft (diffused). Hard light is good for showing detail, but can also be very harsh and unforgiving. "Softening" the light, but diffusing it somehow, can reduce the intensity of the light but make for a kinder, gentler light as well.

While mixing light sources isn't always a good idea, one approach is to combine window light with supplemental lighting. Position your subject with the window to one side and bring in either a supplemental light or a reflector to the other side for reasonably even lighting.

Lighting Styles

Some lighting styles are more heavily used than others. Some forms are used for special effects, while others are designed to be invisible. At its most basic, lighting just illuminates the scene, but when used properly it can also create drama. Let's look at some types of lighting styles:

■ Three-point lighting. This is a basic lighting setup for one person. A main light illuminates the strong side of a person's face, while a fill light lights up the other side. A third light is then positioned above and behind the subject to light the back of the head and shoulders. (See Figure 8.12.)

- Flat lighting. Use this type of lighting to provide illumination and nothing more. It calls for a variety of lights and diffusers set to raise the light level in a space enough for good video reproduction, but not to create a particular mood or emphasize a particular scene or individual. With flat lighting, you're trying to create even lighting levels throughout the video space and minimize any shadows. Generally, the lights are placed up high and angled downward (or possibly pointed straight up to bounce off of a white ceiling). (See Figure 8.13.)
- "Ghoul lighting." This is the style of lighting used for old horror movies. The idea is to position the light down low, pointed upward. It's such an unnatural style of lighting that it makes its targets seem weird and ghoulish.
- Outdoor lighting. While shooting outdoors may seem easier because the sun provides more light, it also presents its own problems. As a general rule of thumb, keep the sun behind you when you're shooting video outdoors, except when shooting faces (anything from a medium shot and closer) since the viewer won't want to see a squinting subject. When shooting another human this way, put the sun behind her and use a video light to balance light levels between the foreground and background. If the sun is simply too bright, position the subject in the shade and use the video light for your main illumination. Using reflectors (white board panels or aluminum foil covered cardboard panels are cheap options) can also help balance light effectively.

Figure 8.12 With three-point lighting, two lights are placed in front and to the side of the subject (45-degree angles are ideal) and positioned about a foot higher than the subject's head. Another light is directed on the background in order to separate the subject and the background.

Figure 8.13 Flat lighting is another approach for creating even illumination. Here the lights can be bounced off of a white ceiling and walls to fill in shadows as much as possible. It is a flexible lighting approach since the subject can change positions without needing a change in light direction.

Part III Enhancing Your Experience

The next five chapters are devoted to helping you dig deeper into the capabilities of your Nikon D3200, so you can exploit all those cool features that your previous camera may have lacked. Here's what you can expect:

- Chapter 9: Learn some advanced shooting tools and techniques, including firing off continuous bursts, and working with GPS, tablets, and other tech.
- Chapter 10: Working with lenses is the goal of this chapter, where I'll show you how to select the best lenses for the kinds of photography you want to do, with my recommendations for starter lenses as well as more advanced optics for specialized applications.
- Chapter 11: This chapter is devoted to the magic of light—your fundamental tool in creating any photograph. There are entire books devoted to working with electronic flash, but I hope to get you started with plenty of coverage of the Nikon D3200's capabilities. I'll show you how to master your camera's built-in flash—and avoid that "built-in flash" look, and offer an introduction to the use of external flash units, including the Nikon SB-910.
- Chapter 12: The downloading and editing your images chapter will help you understand the software tools available to you.
- Chapter 13: Troubleshooting, updating your firmware, and cleaning your sensor are all covered in this chapter.

Advanced Shooting Tips for Your Nikon D3200

Getting the right exposure is one of the foundations of a great photograph, but a lot more goes into a compelling shot than good tonal values. A sharp image, proper white balance, good color, and other factors all can help elevate your image from good to exceptional. So, now that you've got a good understanding of exposure tucked away, you'll want to learn how to work with some additional exposure options, use the automatic and manual focusing controls available with the Nikon D3200, and master some of the many ways you can fine-tune your images.

In this chapter I'm including some specific advanced shooting techniques you can apply to your Nikon D3200. If you master these concepts, you can be confident that you're well on your way toward mastering your Nikon D3200. In fact, you'll be ready for the discussions of using lenses (Chapter 10) and working with light (Chapter 11).

Continuous Shooting

The Nikon D3200's 4 frames-per-second Continuous shooting release mode reminds me how far digital photography has brought us. The first accessory I purchased when I worked as a newspaper sports photographer some years ago was a motor drive for my film SLR. It enabled me to snap off a series of shots in rapid succession, which came in very handy when a fullback broke through the line and headed for the end zone. Even a seasoned action photographer can miss the decisive instant when a crucial block is made, or a baseball superstar's bat shatters and pieces of cork fly out. Continuous shooting simplifies taking a series of pictures, either to ensure that one has more or less the

exact moment you want to capture or to capture a sequence that is interesting as a collection of successive images.

The D3200's "motor drive" capabilities are, in many ways, much superior to what you get with a film camera. For one thing, a motor-driven film camera can eat up film at an incredible pace, which is why many of them were used with cassettes that held hundreds of feet of film stock. At three frames per second (typical of film cameras), a short burst of a few seconds can burn up as much as half of an ordinary 36 exposure roll of film. The Nikon D3200, which fires off bursts at a faster frame rate (up to 4 frames per second), has reusable "film," so if you waste a few dozen shots on non-decisive moments, you can erase them and shoot more.

The increased capacity of digital film cards gives you a prodigious number of frames to work with. At a basketball game I covered earlier this year, I took more than 1,000 images in a couple hours. Yet, even shooting JPEG Fine, I could fit nearly 500 images on a single memory card. Given an average burst of about six frames per sequence (nobody really takes 15-20 shots or more at one stretch in a basketball game), I was able to capture almost 100 different sequences before I needed to swap cards. Figure 9.1 shows the kind of results you can expect.

Figure 9.1 Continuous shooting allows you to capture an entire sequence of exciting moments as they unfold.

To use the D3200's Continuous shooting mode, press the Release mode button or use the information edit screen to set the camera for continuous shooting. When you partially depress the shutter button, the viewfinder will display at the right side a number representing the maximum number of shots you can take at the current quality settings. As a practical matter, the buffer in the Nikon D3200 will generally allow you to take up to a dozen JPEG shots in a single burst, but only a few RAW photos. It can also not be used when using the built-in flash.

To get the maximum number of shots, reduce the image-quality setting by switching to JPEG only (from RAW+Fine), to a lower JPEG quality setting, or by reducing the D3200's resolution from L to M or S. The reason the size of your bursts is limited is that continuous images are first shuttled into the D3200's internal memory buffer, then doled out to the memory card as quickly as they can be written to the card. Technically, the D3200 takes the RAW data received from the digital image processor and converts it to the output format you've selected—either JPG or NEF (RAW)—and deposits it in the buffer ready to store on the card.

This internal "smart" buffer can suck up photos much more quickly than the memory card and, indeed, some memory cards are significantly faster or slower than others. When the buffer fills, you can't take any more continuous shots until the D3200 has written some of them to the card, making more room in the buffer. (You should keep in mind that faster memory cards write images more quickly, freeing up buffer space faster.)

Exploring Ultra-Fast Exposures

Fast shutter speeds stop action because they capture only a tiny slice of time. Electronic flash also freezes motion by virtue of its extremely short duration—as brief as 1/50,000th second or less. The Nikon D3200 has a top shutter speed of 1/4,000th second and its built-in flash unit fires off brief bursts that can give you more of these ultra-quick glimpses of moving subjects. An external flash, such as one of the Nikon SB-series strobes, offers even more versatility. You can read more about using electronic flash to stop action in Chapter 11.

In this section, I'm going to emphasize the use of short exposures to capture a moment in time. The Nikon is fully capable of immobilizing all but the fastest movement using only its shutter speeds, which range all the way up to that impressive 1/4,000th second. Some cameras have speeds up to 1/8,000th second, but those ultra-fast shutters are generally overkill when it comes to stopping action, and are rarely needed for achieving the exposure you desire. For example, the image shown in Figure 9.2 required a shutter speed of just 1/2,000th second to freeze the high jumper clearing the bar.

When it comes to stopping action, most sports can be frozen at 1/2,000th second or slower, and for many sports a slower shutter speed is actually preferable—for example,

Figure 9.2 A shutter speed of 1/2,000th second will stop most action.

to allow the wheels of a racing automobile or motorcycle, or the propeller on a helicopter, to blur realistically.

In practice, shutter speeds faster than 1/4,000th second are rarely required. If you wanted to use an aperture of f/1.8 at ISO 200 outdoors in bright sunlight, say, to throw a background out of focus with a wide aperture's shallow depth-of-field, a shutter speed of 1/4,000th second would more than do the job. You'd need a faster shutter speed only if you moved the ISO setting to a higher sensitivity, and you probably wouldn't do that if your goal were to use the widest f/stop possible. Under *less* than full sunlight, 1/4,000th second is more than fast enough for any conditions you're likely to encounter. That's why electronic flash units work so well for high-speed photography when used as the only source of illumination: they provide both the effect of a very brief shutter speed and the high levels of light needed for an exposure.

Of course, as you'll see, the tiny slices of time extracted by the millisecond duration of an electronic flash exact a penalty. To use flash at its full power setting, you have to use a shutter speed equal to or slower than the *maximum sync speed* of your camera. With the D3200, the top speed usable for flash is 1/200th second (unless you're using the special High-speed sync mode I'll describe in Chapter 11). The sync speed is the fastest speed at which the camera's focal plane shutter is completely open. At shorter speeds,

the camera uses a "slit" passed in front of the sensor to make an exposure. The flash will illuminate only the portion of the slit exposed during the duration of the flash.

Indoors, that shutter speed limitation may cause problems: at 1/200th second, there may be enough existing ("ambient") light to cause ghost images. Outdoors, you may find it difficult to achieve a correct exposure. In bright sunlight at the lowest ISO settings available with the cameras, an exposure of 1/200th second at f/13 might be required. So, even if you want to use daylight as your main light source, and work with flash only as a fill for shadows, you can have problems. I'll explain the vagaries of electronic flash in more detail in Chapter 11.

You can have a lot of fun exploring the kinds of pictures you can take using very brief exposure times, whether you decide to take advantage of the action-stopping capabilities of your built-in or external electronic flash or work with the motion-freezing capabilities of the Nikon D3200's faster shutter speeds (between 1/1,000th and 1/4,000th second). Here are a few ideas to get you started:

- Take revealing images. Fast shutter speeds can help you reveal the real subject behind the façade, by freezing constant motion to capture an enlightening moment in time. Legendary fashion/portrait photographer Philippe Halsman used leaping photos of famous people, such as the Duke and Duchess of Windsor, Richard Nixon, and Salvador Dali, to illuminate their real selves. Halsman said, "When you ask a person to jump, his attention is mostly directed toward the act of jumping and the mask falls so that the real person appears." Try some high-speed portraits of people you know in motion to see how they appear when concentrating on something other than the portrait.
- Create unreal images. High-speed photography can also produce photographs that show your subjects in ways that are quite unreal. A helicopter in mid-air with its rotors frozen or a motocross cyclist leaping over a ramp, but with all motion stopped so that the rider and machine look as if they were frozen in mid-air, makes for an unusual picture. (See the frozen rotors at top in Figure 9.3.) When we're accustomed to seeing subjects in motion, seeing them stopped in time can verge on the surreal.
- Capture unseen perspectives. Some things are *never* seen in real life, except when viewed in a stop-action photograph. M.I.T. professor Dr. Harold Edgerton's famous balloon burst photographs were only a starting point for the inventor of the electronic flash unit. Freeze a hummingbird in flight for a view of wings that never seem to stop. Or, capture the splashes as liquid falls into a bowl, as shown in Figure 9.4. No electronic flash was required for this image (and wouldn't have illuminated the water in the bowl as evenly). Instead, a clutch of high-intensity lamps bounced off a green card and an ISO setting of 1600 allowed the Nikon to capture this image at 1/2,000th second.

Figure 9.3
Freezing a helicopter's rotors with a fast shutter speed makes for an image that doesn't look natural (top); a little blur helps convey a feeling of motion (bottom).

Figure 9.4
A large amount of artificial illumination and an ISO 1600 sensitivity setting allowed capturing this shot at 1/2,000th second without use of an electronic flash.

Long Exposures

Longer exposures are a doorway into another world, showing us how even familiar scenes can look much different when photographed over periods measured in seconds. At night, long exposures produce streaks of light from moving, illuminated subjects like automobiles or amusement park rides. Or, you can move the camera or zoom the lens to get interesting streaks from non-moving light sources, such as the holiday lights shown in Figure 9.5. Extra-long exposures of seemingly pitch-dark subjects can reveal interesting views using light levels barely bright enough to see by. At any time of day, including daytime (in which case you'll often need the help of neutral-density filters to make the long exposure practical), long exposures can cause moving objects to vanish entirely, because they don't remain stationary long enough to register in a photograph.

Three Ways to Take Long Exposures

There are actually three common types of lengthy exposures: timed exposures, bulb exposures, and time exposures. The Nikon D3200 offers only the first two, but once you understand all three, you'll see why Nikon made the choices it did. Because of the

Figure 9.5 Long exposures can produce interesting streaks of light, particularly if you zoom during the exposure.

length of the exposure, all of the following techniques should be used with a tripod to hold the camera steady.

- Timed exposures. These are long exposures from 1 second to 30 seconds, measured by the camera itself. To take a picture in this range, simply use Manual or Shutter priority mode and use the control dial to set the shutter speed to the length of time you want, choosing from several preset speeds ranging from 1.0 to 30.0 seconds. The advantage of timed exposures is that the camera does all the calculating for you. There's no need for a stopwatch. If you review your image on the EVF or LCD and decide to try again with the exposure doubled or halved, you can dial in the correct exposure with precision. The disadvantage of timed exposures is that you can't take a photo for longer than 30 seconds.
- Bulb exposures. This type of exposure is so-called because in the olden days the photographer squeezed and held an air bulb attached to a tube that provided the force necessary to keep the shutter open. Traditionally, a bulb exposure is one that lasts as long as the shutter release button is pressed; when you release the button, the exposure ends. To make a bulb exposure with the Nikon D3200, set the camera on Manual mode and use the control dial to select the shutter speed immediately after 30 seconds. BULB will be displayed on the LCD and in the viewfinder. (You can't set the shutter speed to BULB when using the Smile Shutter, Auto HDR, or Multi Frame Noise Reduction ISO settings.)

Then, press the shutter to start the exposure, and release it to close the shutter. If you'd like to minimize camera shake, you can use the self-timer or the Nikon wired or infrared remote control. With the wired remote MC-DC1 you can press and hold the release button to open the shutter and then release it to close the shutter. Or, you can lock the release button in place to open the shutter, and press it again later to end the exposure. With the infrared remote ML-L3 you press the remote's shutter release once to open the shutter, and press it one more time to close the shutter.

■ Time exposures. This is a setting found on some cameras to produce longer exposures. With cameras that implement this option, the shutter opens when you press the shutter release button, and remains open until you press the button again. Usually, you'll be able to close the shutter using a mechanical cable release or, more commonly, an electronic release cable. The advantage of this approach is that you can take an exposure of virtually any duration without the need for special equipment. You can press the shutter release button, go off for a few minutes, and come back to close the shutter (assuming your camera is still there). The disadvantages of this mode are exposures must be timed manually, and with shorter exposures it's possible for the vibration of manually opening and closing the shutter to register in the photo. For longer exposures, the period of vibration is relatively brief and not usually a problem—and there is always the release cable option to eliminate photographer-caused camera shake entirely. The ML-L3 remote will let you achieve time exposures with the D3200.

Working with Long Exposures

Because the Nikon produces such good images at longer exposures, and there are so many creative things you can do with long-exposure techniques, you'll want to do some experimenting. Get yourself a tripod or another firm support and take some test shots with long exposure noise reduction both enabled and disabled (to see whether you prefer low noise or high detail) and get started. Here are some things to try:

■ Make people invisible. One very cool thing about long exposures is that objects that move rapidly enough won't register at all in a photograph, while the subjects that remain stationary are portrayed in the normal way. That makes it easy to produce people-free landscape photos and architectural photos at night or, even, in full daylight if you use a neutral-density filter (or two or three) to allow an exposure of at least a few seconds. At ISO 100, f/22, and a pair of 8X (three-stop) neutral-density filters, you can use exposures of nearly two seconds; overcast days and/or even more neutral-density filtration would work even better if daylight people vanishing is your goal. They'll have to be walking *very* briskly and across the field of view (rather than directly toward the camera) for this to work. At night, it's much easier to achieve this effect with the 20- to 30-second exposures that are possible. (See Figure 9.6.)

Figure 9.6
This street was packed with tourists, but they are rendered invisible by the 30-second shutter speed.

■ Create streaks. If you aren't shooting for total invisibility, long exposures with the camera on a tripod can produce some interesting streaky effects. Even a single 8X ND filter will let you shoot at f/22 and 1/6th second in daylight. Indoors, you can achieve interesting streaks with slow shutter speeds, as shown in Figure 9.7. I shot the dancers using a 1/2-second exposure, triggering the shot at the beginning of a movement.

Tip

Neutral-density filters are gray (non-colored) filters that reduce the amount of light passing through the lens, without adding any color or effect of their own.

■ Produce light trails. At night, car headlights, taillights, and other moving sources of illumination can generate interesting light trails. Your camera doesn't even need to be mounted on a tripod; hand-holding the Nikon for longer exposures adds movement and patterns to your trails. If you're shooting fireworks, a longer exposure—with a tripod—may allow you to combine several bursts into one picture, as shown in Figure 9.8.

Figure 9.7
The shutter opened as the dancers began their movement from a standing position, and finished when they had bent over and paused.

Figure 9.8
I caught the fireworks after a baseball game from a half-mile away, using a four-second exposure to capture several bursts in one shot.

- Blur waterfalls, etc. You'll find that waterfalls and other sources of moving liquid produce a special type of long-exposure blur, because the water merges into a fantasy-like veil that looks different at different exposure times, and with different waterfalls. Cascades with turbulent flow produce a rougher look at a given longer exposure than falls that flow smoothly. Although blurred waterfalls have become almost a cliché, there are still plenty of variations for a creative photographer to explore, as you can see in Figure 9.9. For that shot, I incorporated the flowing stream in the background.
- Show total darkness in new ways. Even on the darkest, moonless nights, there is enough starlight or glow from distant illumination sources to see by, and, if you use a long exposure, there is enough light to take a picture, too. I was visiting a Great Lakes park hours after sunset, but found that a several-second exposure revealed the skyline scene shown in Figure 9.10, even though in real life, there was barely enough light to make out the boats in the distance. Although the photo appears as if it were taken at twilight or sunset, in fact the shot was made at 10 p.m.

Figure 9.9 Long exposures can transform a waterfall and stream into a display of flowing silk.

Figure 9.10 A long exposure transformed this night scene into a picture apparently taken at dusk.

Geotagging with the Nikon GP-1

The Nikon D3200 gained a lot of credibility as a tool for serious photographers (despite its entry-level status) when it debuted with the same GPS port found on its more expensive siblings. The port accepts the reasonably priced (about \$225) Nikon GP-1 Global Positioning System device. The unit makes it easy to tag your images with the same kind of longitude, latitude, altitude, and time stamp information that is supplied by the GPS unit you use in your car. (Don't have a GPS? Photographers who get lost in the boonies as easily as I do *must* have one of these!) The geotagging information is stored in the metadata space within your image files, and can be accessed by Nikon View NX, or by online photo services such as mypicturetown.com and Flickr. Having this information available makes it easier to track where your pictures are taken. That can be essential, as I learned from a trip out West, where I found the red rocks, canyons, and arroyos of Nevada, Utah, Arizona, and Colorado all pretty much look alike to my untrained eye.

For photographers, geotagging is most important as a way to associate the geographical location where the photographer was when a picture was taken, with the actual photograph itself. This is done using a GPS (global positioning system) device that calculates the latitude and longitude, and, optionally, the altitude, compass bearing, and other location information. Geotagging can be done automatically, through a device built into the camera (or your smartphone or other gadget) or manually, by attaching geographic information to the photo after it's already been taken.

Automatic geotagging, like that available with the D3200 and the Nikon GP-1, is the most convenient. GPS operates on a simple principle: using the network of GPS satellites to determine the position of the photographer. (Some mobile phones also use the location of the cell phone network towers to help collect location data.) The GPS data is automatically stored in the photo's EXIF information when the photo is taken. A connected GPS will generally remain switched on continuously, requiring power, and will then have location information available immediately when the camera is switched on.

Of course, you can still add geotags to your D3200 images even if you don't spring for the GP-1. You can take the picture normally, without GPS data, and then special software can match up the time stamps on the images with timestamps recorded by some other vendor's external GPS device, and then add the coordinates to the EXIF information for that photo. (Obviously, your camera's date/time settings must be synchronized with that of the GPS for this to work.) This method is time consuming, because the GPS data is added to the photograph through post processing.

You can also add location information to your photographs manually. This is often done with online sharing services, such as Flickr, which allow you to associate your uploaded photographs with a map, city, street address, or postal code. When properly

geotagged and uploaded to sites like Flickr, users can browse through your photos using a map, finding pictures you've taken in a given area, or even searching through photos taken at the same location by other users.

The GP-1 (see Figure 9.11) slips onto the accessory shoe on top of the Nikon D3200. It connects to the GPS port on the camera using a supplied cable, which plugs into the connector marked CAMERA on the GP-1. (If you want to use the unit with one of the other supported cameras, you'll need to buy the GP1-CA10 cable as well—it attaches to the 10-pin port on the front of some of Nikon's other cameras. The device also has a port labeled with a remote control icon, so you can plug in the Nikon MC-DC2 remote cable release, which would otherwise attach to the GPS port when you're not using the geotagging unit.

A third connector connects the GP-1 to your computer using a USB cable. Once attached, the device is very easy to use. You need to activate the Nikon D3200's GPS capabilities in the GPS choice within the Setup menu.

The first step is to allow the GP-1 to acquire signals from at least three satellites. If you've used a GPS in your car, you'll know that satellite acquisition works best outdoors under a clear sky and out of the "shadow" of tall buildings, and the Nikon unit is no exception. It takes about 40-60 seconds for the GP-1 to "connect." A red blinking LED means that GPS data is not being recorded; a green blinking LED signifies that the unit has acquired three satellites and is recording data. When the LED is solid green, the unit has connected to four or more satellites, and is recording data with optimum accuracy.

Next, set up the camera by selecting the GPS option found under the Setup menu on the Nikon D3200. Then, select Auto Meter Off to disable automatic shutoff of the D3200's exposure meters. That will assure that the camera doesn't go to sleep while you're using the GPS unit. Of course, in this mode the camera will use more power (the

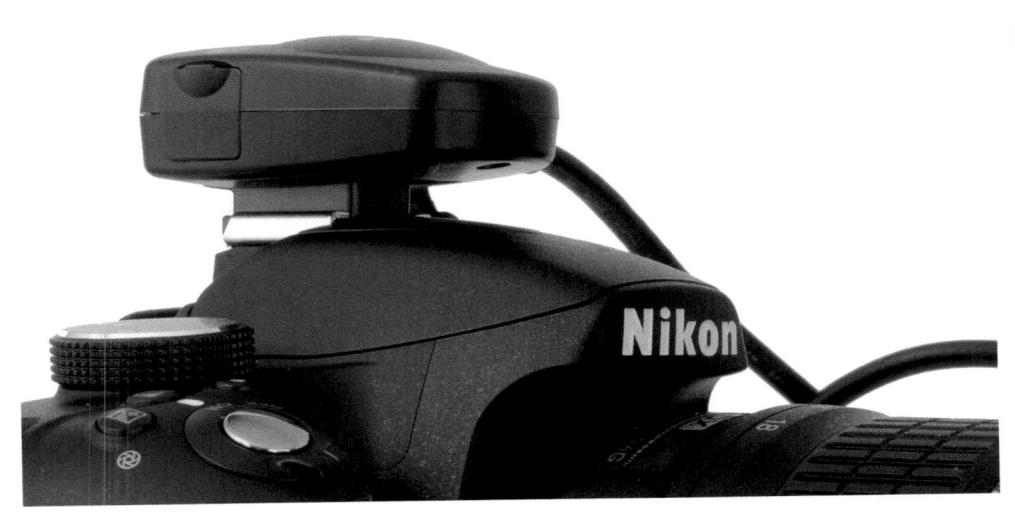

Figure 9.11 Nikon GP-1 geotagging unit.

meters never go off, and the GPS draws power constantly), but you don't want to go through the 40-60-second satellite acquisition step each time you take a picture. There is also a Position option in the Setup menu's GPS entry, which doesn't really do anything other than show you your current GPS information on the D3200's LCD screen.

You're all set. Once the unit is up and running, you can view GPS information using photo information screens available on the color LCD. The GPS screen, which appears only when a photo has been taken using the GPS unit, looks something like Figure 9.12. The shooting information screen provides a constant update of your GPS status, with an indicator in the upper-right corner of the screen.

- Non-flashing (static). You're in business. The GP-1 has acquired the satellites it needs to function, and any pictures you take will have location data embedded in the Exif information attached to your image file.
- Flashing. The GP-1 is searching for satellites. No GPS data will be recorded when you take pictures. You'll probably see this flashing indicator when you shoot indoors in a location that doesn't have a clear view of the sky through some open windows.
- No icon. The GP-1 is not receiving location data from the satellites for a period of at least two seconds. No GPS data will be attached to your images while the icon is not visible.

Figure 9.12
Captured GPS
information can
be displayed
when you
review the
image.

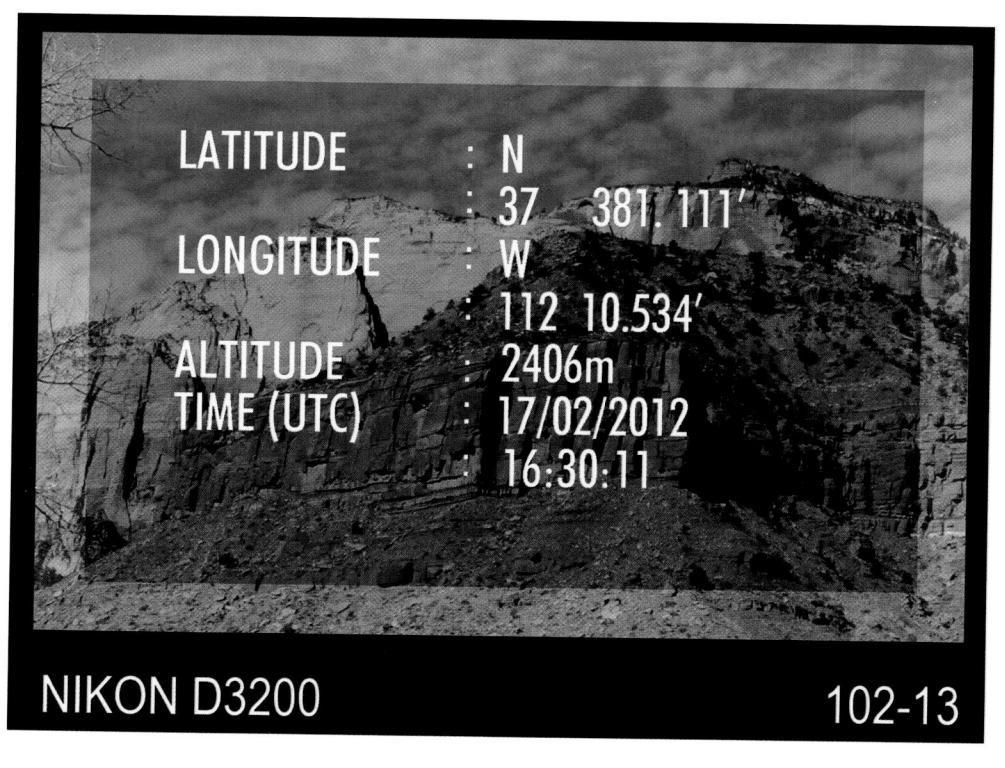

Unless you only take pictures, and then immediately print them directly to a PictBridge-compatible printer, somewhere along the line you're going to need to make use of the broad array of software available for the Nikon D3200. The picture-fixing options in the Retouch menu let you make only modest modifications to your carefully crafted photos. If your needs involve more than fixing red-eye, cropping and trimming, and maybe adjusting tonal values with D-Lighting, you're definitely going to want to use a utility or editor of some sort to perfect your images. After you've captured some great images and have them safely stored on your Nikon D3200's memory card, you'll need to transfer them from your camera and memory card to your computer, where they can be organized, fine-tuned in an image editor, and prepared for web display, printing, or some other final destination.

Wi-Fi

These days, GPS and Wi-Fi capabilities work together with your D3200 in interesting new ways. Wireless capabilities allow you to upload photos directly from your D3200 to your computer at home or in your studio, or, through a hotspot at your hotel or coffee shop back to your home computer or to a photo sharing service like Facebook or Flickr. Your D3200 has two viable Wi-Fi options.

One of these is the \$59 WU-1a Wi-Fi adapter (shown in Figure 9.13), which slips into the USB port on the side of the camera, and transmits your photos directly to your Android smartphone or tablet, using a custom app. This gadget is a great idea, and has only two defects that bother me. First, it sticks out of the camera and precludes closing the port door, making it a bit clumsy to use. Second, it isn't actually shipping to customers as I write this (so I haven't had a chance to try it), and currently is supported only by Android devices (so it wouldn't work with my iPhone, in any case). The app is expected to be available for iOS late in 2012, and I'm looking forward to trying this device out for myself.

Fortunately, a more flexible and universal solution is also available, in the form of the long-established Eye-Fi SDHC cards. These are special Wi-Fi-enabled memory cards that you slip in the SD slot of your camera. They have been on the market long enough that most digital cameras—including those from Nikon—have an Eye-Fi Upload entry right in their menu system. In addition to Wi-Fi, cards like the Eye-Fi Pro X2 (shown in Figure 9.14) also has a type of GPS capability that allow you to mark your photographs with location information, so you don't have to guess where a picture was taken.

Both features are very cool. Wi-Fi uploads can provide instant backup of important shots and sharing. And, as noted in the previous section, geotagging is most important as a way to associate the geographical location where the photographer was when a picture was taken, with the actual photograph itself. It can be done with the location-mapping capabilities of the Wi-Fi card, or through add-on devices that third parties make available for your D3200.

Figure 9.14 The Eye-Fi card is an SD card with built-in Wi-Fi features.

The Eye-Fi card (www.eye.fi) is an SDHC memory card with a wireless transmitter built in. You insert it in your camera just as with any ordinary card, and then specify which networks to use. You can add as many as 32 different networks. The next time your camera is on within range of a specified network, your photos and videos can be uploaded to your computer and/or to your favorite sharing site. During setup, you can customize where you want your images uploaded. The Eye-Fi card will only send them to the computer and to the sharing site you choose. Upload to any of 25 popular sharing websites, including Flickr, Facebook, MobileMe, Costco, Adorama, Smugmug, YouTube, Shutterfly, or Walmart. Online Sharing is included as a lifetime, unlimited service with all X2 cards.

When uploading to online sites, you can specify not just where your images are sent, but how they are organized, by specifying preset album names, tags, descriptions, and even privacy preferences on certain sharing sites. Some Eye-Fi cards also include geotagging service, which help you view uploaded photos on a map, and sort them by location. Eye-Fi's geotagging uses Wi-Fi Positioning System (WPS) technology. Using built-in Wi-Fi, the Eye-Fi card senses surrounding Wi-Fi networks as you take pictures. When photos are uploaded, the Eye-Fi service then adds the geotags to your photos. You don't need to have the password or a subscription for the Wi-Fi networks the card accesses; it can grab the location information directly without the need to "log in." You don't need to set up or control the Eye-Fi card from your camera. Software on your computer manages all the parameters. (See Figure 9.15.)

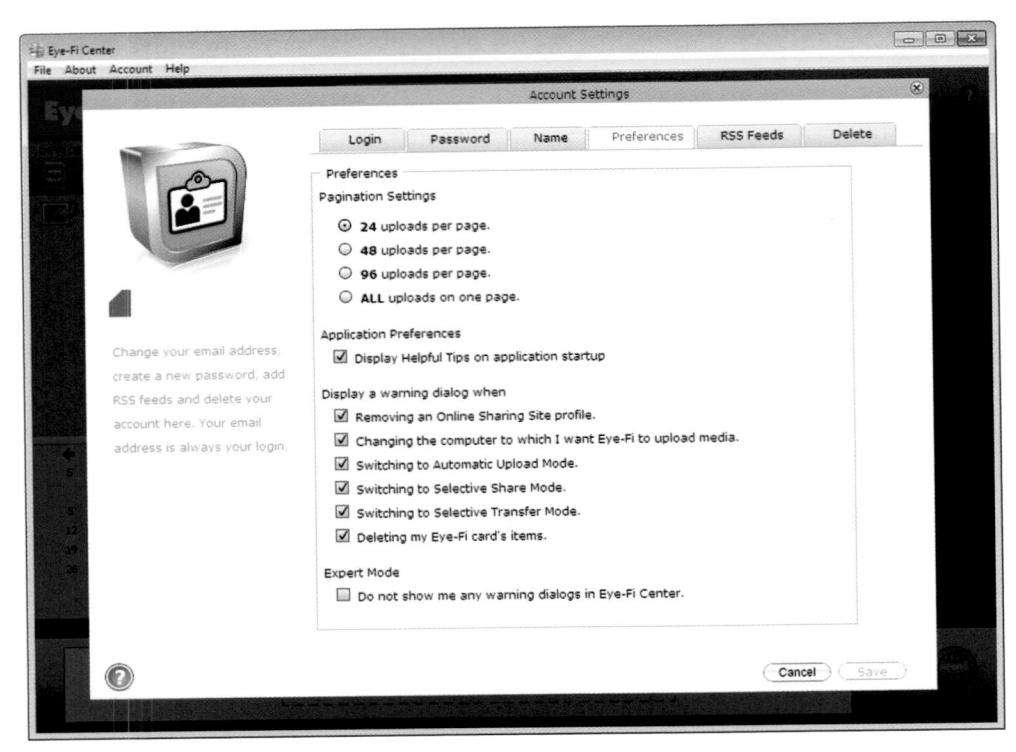

Figure 9.15
Functions of the Eye-Fi card can be controlled from your computer.

Your D3200 has an Eye-Fi Upload entry in the Setup menu that appears when an Eye-Fi card is inserted in the camera, that allows you to enable or disable this capability. You'll want to turn off Eye-Fi when traveling on an airplane (just as you disable your cell phone, tablet, or laptop's wireless capabilities when required to do so). In addition, use of Wi-Fi cards may be restricted or banned outside the United States, because the telecommunications laws differ in other countries.

If you frequently travel outside the range of your home (or business) Wi-Fi network, an optional service called Hotspot Access is available, allowing you to connect to any AT&T Wi-Fi hotspot in the USA. In addition, you can use your own Wi-Fi accounts from commercial network providers, your city, even organizations you belong to such as your university.

The card has another interesting feature called Endless Memory. When pictures have been safely uploaded to an external site, the card can be set to automatically erase the oldest images to free up space for new pictures. You choose the threshold where the card starts zapping your old pictures to make room.

Tablets, Smart Phones, and the Nikon D3200

Although tablets and smart phones are still in their infancies, in the future, your iPhone, iPad/tablet computer, iPod Touch/MP3 player, smart phone, or Google Android portable device will be one of the most important accessories you can have for your digital camera. We're only now seeing the beginnings of the trend. The relevant platforms are these:

- Old-style smart phones. I include in this category all smart phones that are *not* iPhones or phones based on Google's Android operating system. You can buy lots of interesting apps for these phones, although not many applications specifically for photography. This type of phone should be on its way out, too, with iPhone and Android smart phones dominating, simply because it's easier to write applications for the iPhone's iOS and Android than to create them for multiple "old" smart phone platforms.
- Android smart phones. There are already more Android-based smart phones on the market than for all other types, including iOS. Although Apple had a head start, the number of Android applications is rapidly catching up.
- iPhones. Apple's iOS leads in number of applications, especially for photography apps. When my first app was developed, it appeared for the iOS platform first. It doesn't hurt that virtually all iOS apps run on iPhones, later-generation iPods, and iPads, too.
- iPod Touch. Basically, the latest iPod Touch is an iPhone that can't make phone calls. (Although there are some hacks around that limitation.) Virtually all of the apps that run on the iPhone under iOS also run on the iPod Touch. You need a Wi-Fi connection to access features that use network capabilities, but, these days, Wi-Fi hot spots aren't that difficult to find. Tethering and Mi-Fi (which allow another device to serve as a hot spot for non-connected gadgets like the Touch), and *automobiles* that include built-in Wi-Fi (!) make connectivity almost universal. In my travels through Europe in the last year, I found free Wi-Fi connections in the smallest towns. (Indeed, the only time I was asked to pay for it was when staying in an upscale hotel.) So, for many who are tied to a non-iPhone cell phone, the iPod Touch is a viable alternative.
- **Tablet computers.** I've been welded to my iPad (shown alongside my iPhone in Figure 9.16) since I bought it the first day they became available. I use it to access e-mail, useful apps, and as a portable portfolio. Today, there are alternative tablet computers running Android. I recently picked up an Amazon Kindle Fire, which also does e-mail and a limited number of apps, and which has a Gallery feature (see Figure 9.17) that transforms it into a compact portfolio almost as useful for that purpose as an iPad. (However, only 6 of the Kindle Fire's 8GB of storage are available to the user, so you'll have to limit the size of your portfolio.)

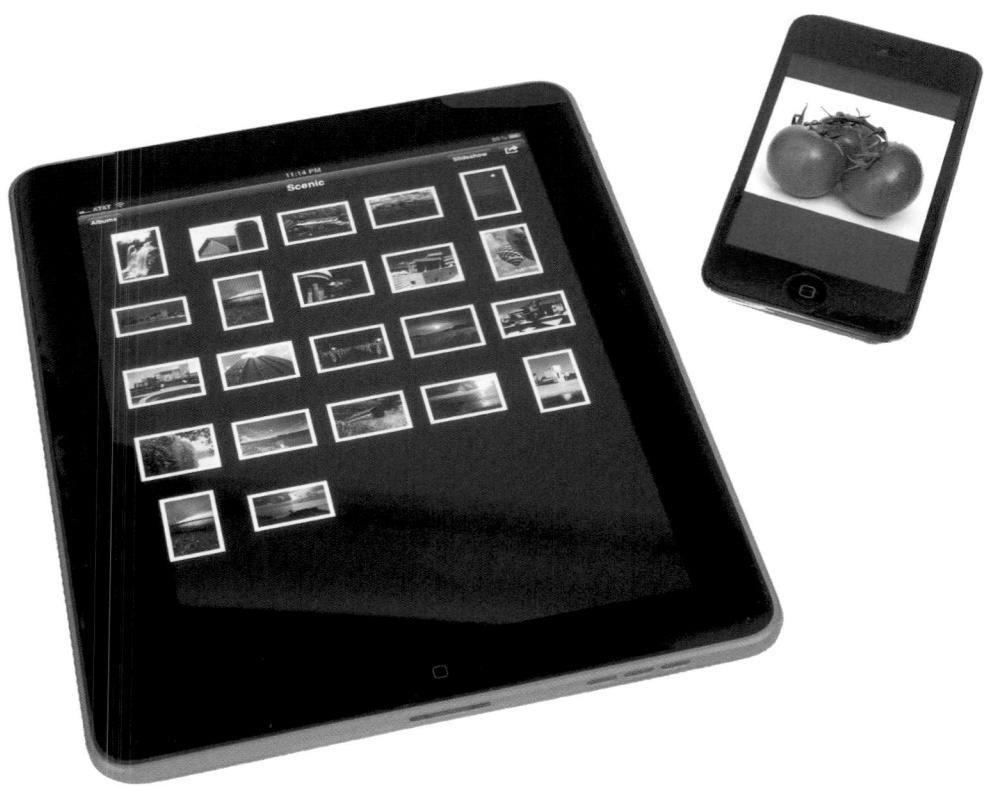

Figure 9.16
The iPad, iPod, and other devices open a whole world of useful apps to the photographer.

Figure 9.17
The Kindle Fire is a smaller, more affordable alternative to the iPad.

I use the Kindle Fire and both an iPhone and iPad. (If I'm traveling overseas where my iPhone can't be used, I usually take along the iPod Touch instead.) The iPhone/iPod slips in a pocket and can be used anywhere. I don't even have to think about taking it with me, because I always have one or the other. I have to remember to tote along the iPad or Kindle Fire, and, I do, to an extent you'd probably find surprising. (After the movie finally starts, I fold them into their cases and use them as a tray for my popcorn bucket.) Tablet computers can do everything a pocket-sized device can do, and are easier to read/view/type on. When I am out shooting, I prefer to have all my apps in a smaller device that I can slip in the camera bag, but if there's room, the iPad goes along instead. Because my iPad (unlike the Kindle Fire) has 3G connectivity, I don't need a Wi-Fi connection to use it almost anywhere. I do have a Wi-Fi hot spot built into my iPhone that I can use to connect the Kindle Fire to the net if I need to.

What Else Can You Do with Them?

Many of these devices can serve as a backup for your Nikon D3200's memory cards. I've got Apple's camera connection kit, and can offload my pictures to my iPad's 64GB of memory, then upload them to Flickr or Facebook, or send to anyone through e-mail. My iPad also makes a perfect portable portfolio, too. I have hundreds of photos stored on mine, arranged into albums ready for instant display, either individually, or in slide shows. I have the same photo library on my iPhone and iPod Touch, and more than a few pictures available for showing on my Kindle Fire.

But the real potential for using these devices comes from specialized apps written specifically to serve photographic needs. Here are some of the kinds of apps you can expect in the future. (I'm working on more than a few of them myself.)

- Camera guides. Even the inadequate manual that came with your camera is too large to carry around in your camera bag all day. I'm converting many of my own camera-specific guides to app form, while adding interactive elements, including hyperlinks and videos. You can already put a PDF version of your camera manual on your portable device and read it, if you like. In the future, you should be able to read any of the more useful third-party guides anywhere, anytime.
- Lens selector. Wonder what's the best lens to use in a specific situation? Enter information about your scene, and your app will advise you.
- Exposure estimator. Choose a situation and the estimated exposure will be provided. Useful as a reality check and in difficult situations, such as fireworks, where the camera's meters may falter.
- Shutter speed advisor. The correct shutter speed for a scene varies depending on whether you want to freeze action, or add a little blur to express motion. Other variables include whether the subject is crossing the frame, moving diagonally, or headed toward you. The photographer also needs to consider the focal length of the

lens, and presence/absence of image stabilization features, tripod, monopod, etc. This app will allow you to tap in all the factors and receive advice about what shutter speed to use.

- Hyperfocal length calculator. In any given situation, set the focus point at the distance specified for your lens's current focal length setting, and everything from half that distance to infinity will be in focus. But the right setting differs at various focal lengths. This app tells you, and is a great tool for grab shots.
- Accessory selector. Confused about what flash, remote control, battery grip, lens hood, filter, or other accessory to use with your camera or lens? This selector lists the key gadgets, which ones fit which cameras, and explains how to use them.
- **Before and after.** Images showing before/after versions of dozens of situations with and without corrective/in-camera special effects applied.
- Fill light. Pesky shadows on faces from overhead lighting indoors? This turns your iPod/iPhone or (best of all) iPad into a bright, diffuse fill light panel. Choose from white fill light, or *colors* for special effects. Makes good illumination for viewing your camera's buttons and dials in dark locations, too.
- Level. Set your device on top of your camera and use it to level the camera, with or without a tripod.
- **Gray card.** Turn your i-device into an 18-percent gray card for metering and color balance.
- **Super links.** If you don't find your answer in the Toolkit, you can link to websites, including mine, with more information.
- **How It's Made.** A collection of inspiring photos, with details on how they were taken in camera—or manipulated in Photoshop (if that's your thing).
- Quickie guides. Small apps that lead you, step-by-step, through everything you need to photograph lots of different types of scenes. Typical subjects would be sports, landscape photography, macro work, portraits, concerts/performances, flowers, wildlife, and nature.

As you can see, the potential for apps is virtually unlimited. You can expect your smart phone, tablet computer, or other device to be a mainstay in your camera bag within a very short time.

Working with Lenses

There's no disputing the fact that there is a key reason why many digital SLR buyers choose Nikon cameras: Nikon lenses. Some favor Nikon cameras because of the broad selection of quality lenses. Others already possess a large collection of Nikon optics (perhaps dating from the owner's photography during the film era), and the ability to use those lenses on the latest digital cameras is a big plus. A few may be attracted to the Nikon brand because there are many inexpensive lenses (including a few in the \$100-\$200 price range) that make it possible to assemble a basic kit for cameras like the D3200 without spending a lot of cash.

It's true that there is a mind-bending assortment of high-quality lenses available to enhance the capabilities of Nikon cameras. You can use thousands of current and older lenses introduced by Nikon and third-party vendors since 1959, although lenses made before 1977 may need an inexpensive modification for use with cameras *other* than the Nikon D5100, D5000, D3200, D3100, D3000, D60, D40, and D40x. (More on this later.) These lenses can give you a wider view, bring distant subjects closer, let you focus closer, shoot under lower light conditions, or provide a more detailed, sharper image for critical work. Other than the sensor itself, the lens you choose for your dSLR is the most important component in determining image quality and perspective of your images.

This chapter explains how to select the best lenses for the kinds of photography you want to do.

Sensor Sensibilities

From time to time, you've heard the term *crop factor*, and you've probably also heard the term *lens multiplier factor*. Both are misleading and inaccurate terms used to describe the same phenomenon: the fact that cameras like the D3200 (and most other affordable

digital SLRs) provide a field of view that's smaller and narrower than that produced by certain other (usually much more expensive) cameras, when fitted with exactly the same lens.

Figure 10.1 quite clearly shows the phenomenon at work. The outer rectangle, marked 1X, shows the field of view you might expect with a 28mm lens mounted on one of Nikon's "full-frame" (non-cropped) cameras, like the Nikon D700, D3, or D3x. The area marked 1.5X shows the field of view you'd get with that 28mm lens installed on a D3200. It's easy to see from the illustration that the 1X rendition provides a wider, more expansive view, while the inner field of view is, in comparison, *cropped*.

The cropping effect is produced because the sensors of DX cameras like the Nikon D3200 are smaller than the sensors of the D700/D800, D3/D3s/D3x, or D4. The "full-frame" camera has a sensor that's the size of the standard 35mm film frame, $24\text{mm} \times 36\text{mm}$. Your D3200's sensor does *not* measure $24\text{mm} \times 36\text{mm}$; instead, it specs out at 23.2×15.4 mm, or about 66.7 percent of the area of a full-frame sensor, as shown by the red boxes in the figure. You can calculate the relative field of view by dividing the focal length of the lens by .667. Thus, a 100mm lens mounted on a D3200 has the same field of view as a 150mm lens on the Nikon D800. We humans tend to perform multiplication operations in our heads more easily than division, so such field of view comparisons are usually calculated using the reciprocal of .667—1.5—so we can multiply instead. ($100 \times .667$ =150; 100×1.5 =150.)

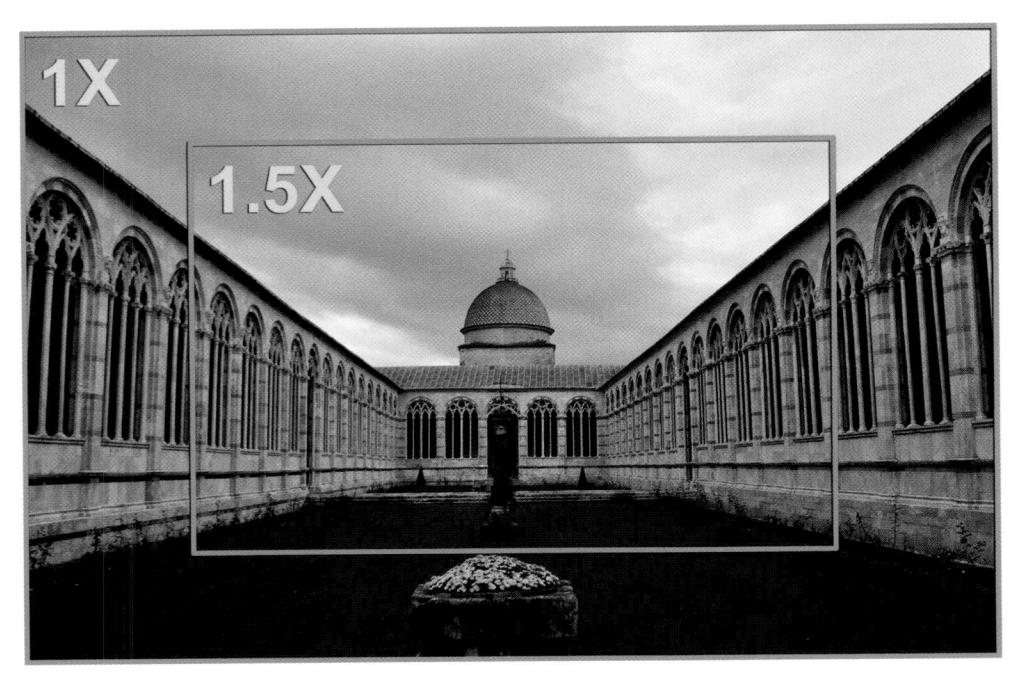

Figure 10.1 Nikon offers digital SLRs with full-frame (1X) crops, as well as 1.5X crops.

This translation is generally useful only if you're accustomed to using full-frame cameras (usually of the film variety) and want to know how a familiar lens will perform on a digital camera. I strongly prefer *crop factor* over *lens multiplier*, because nothing is being multiplied; a 100mm lens doesn't "become" a 150mm lens—the depth-of-field and lens aperture remain the same. (I'll explain more about these later in this chapter.) Only the field of view is cropped. But *crop factor* isn't much better, as it implies that the 24 × 36mm frame is "full" and anything else is "less." I get e-mails all the time from photographers who point out that they own full-frame cameras with 36mm × 48mm sensors (like the Mamiya 645ZD or Hasselblad H3D-39 medium-format digitals). By their reckoning, the "half-size" sensors found in cameras like the Nikon D800 and D4 are "cropped."

If you're accustomed to using full-frame film cameras, you might find it helpful to use the crop factor "multiplier" to translate a lens's real focal length into the full-frame equivalent, even though, as I said, nothing is actually being multiplied. Throughout most of this book, I've been using actual focal lengths and not equivalents, except when referring to specific wide-angle or telephoto focal length ranges and their fields of view.

Crop or Not?

There's a lot of debate over the "advantages" and "disadvantages" of using a camera with a "cropped" sensor, versus one with a "full-frame" sensor. The arguments go like these:

- **"Free" 1.5X teleconverter.** The Nikon D3200 (and other cameras with the 1.5X crop factor) magically transforms any telephoto lens you have into a longer lens, which can be useful for sports, wildlife photography, and other endeavors that benefit from more reach. Yet, your f/stop remains the same (that is, a 300mm f/4 becomes a very fast 450mm f/4 lens). Some discount this advantage, pointing out that the exact same field of view can be had by taking a full-frame image, and trimming it to the 1.5X equivalent. While that is strictly true, it doesn't take into account a factor called *pixel density*.
- Dense pixels=more noise. The other side of the pixel density coin is that the denser packing of pixels to achieve 24 megapixels in the D3200 sensor means that each pixel must be smaller, and will have less light-gathering capabilities. Larger pixels capture light more efficiently, reducing the need to amplify the signal when boosting ISO sensitivity, and, therefore, producing less noise. In an absolute sense, this is true, and cameras like the D4 do have sensational high ISO performance. However, the D3200's sensor is improved over earlier cameras (for one thing, it is a high-sensitivity CMOS sensor, rather than a noisier CCD sensor like that found in some earlier Nikon entry-level cameras), so you'll find it performs very well at higher ISOs.

- Lack of wide-angle perspective. Of course, the 1.5X "crop" factor applies to wide-angle lenses, too, so your 20mm ultrawide lens becomes a hum-drum 30mm near-wide-angle, and a 35mm focal length is transformed into what photographers call a "normal" lens. Zoom lenses, like the 18-105mm lens that is often purchased with the Nikon cameras in a kit, have less wide-angle perspective at their minimum focal length. The 18-105mm optic, for example, is the equivalent of a 27mm moderate wide angle when zoomed to its widest setting. Nikon has "fixed" this problem by providing several different extra-wide zooms specifically for the DX format, including the (relatively) affordable 12-24mm and 10-24mm DX Nikkors. You'll never really lack for wide-angle lenses, but some of us will need to buy wider optics to regain the expansive view we're looking for.
- Mixed body mix-up. The relatively small number of Nikon D3200 owners who also have a Nikon full-frame camera like the D700 or D800 can't ignore the focallength mix-up factor. If you own both FX and DX-format cameras (some D3200 owners use them as a backup to a D700, for example), it's vexing to have to adjust to the different fields of view that the cameras provide. If you remove a given lens from one camera and put it on the other, the effective focal length/field of view changes. That 17-35mm f/2.8 zoom works as an ultrawide to wide angle on a D700, but functions more as a moderate wide-angle to normal lens on a D3200. To get the "look" on both cameras, you'd need to use a 12-24mm zoom on the D3200, and the 17-35mm zoom on the D700. It's possible to become accustomed to this field of view shake-up and, indeed, some photographers put it to work by mounting their longest telephoto lens on the D3200 and their wide-angle lenses on their full-frame camera. Even if you've never owned both an FX and DX camera, you should be aware of the possible confusion.

Your First Lens

Some Nikon dSLRs are almost always purchased with a lens. The entry- and mid-level Nikon dSLRs, including the Nikon D3200, are often bought by those new to digital photography, frequently by first-time SLR or dSLR owners who find the AF-S DX Nikkor 18-105mm f/3.5-5.6G ED VR or AF-S DX Zoom-Nikkor 18-55mm f/3.5-5.6G ED II, both with vibration reduction, irresistible bargains. Other Nikon models, including the Nikon D300, D700, and D3/D3x, are generally purchased without a lens by veteran Nikon photographers who already have a complement of optics to use with their cameras.

I bought my D3200 with the 18-55mm VR lens, even though I already had a (large) collection of lenses, because the VR was an attractive feature, and the lens is perfect to mount on the camera when I loan it to family members who have little photographic

experience. Depending on which category of photographer you fall into, you'll need to make a decision about what kit lens to buy, or decide what other kind of lenses you need to fill out your complement of Nikon optics. This section will cover "first lens" concerns, while later in the chapter we'll look at "add-on lens" considerations.

When deciding on a first lens, there are several factors you'll want to consider:

- Cost. You might have stretched your budget a bit to purchase your Nikon D3200, so the 18-55mm VR kit lens helps you keep the cost of your first lens fairly low. In addition, there are excellent moderately priced lenses available that will add from \$100 to \$300 to the price of your camera if purchased at the same time.
- Zoom range. If you have only one lens, you'll want a fairly long zoom range to provide as much flexibility as possible. Fortunately, several popular basic lenses for the D3200 have 3X to 5.8X zoom ranges (I'll list some of them next), extending from moderate wide-angle/normal out to medium telephoto. Either is fine for everyday shooting, portraits, and some types of sports.
- Adequate maximum aperture. You'll want an f/stop of at least f/3.5 to f/4 for shooting under fairly low light conditions. The thing to watch for is the maximum aperture when the lens is zoomed to its telephoto end. You may end up with no better than an f/5.6 maximum aperture. That's not great, but you can often live with it, particularly with a lens having vibration reduction (VR) capabilities, because you can often shoot at lower shutter speeds to compensate for the limited maximum aperture.
- Image quality. Your starter lens should have good image quality, because that's one of the primary factors that will be used to judge your photos. Even at a low price, several of the different lenses that can be used with the D3200 kit include extra-low dispersion glass and aspherical elements that minimize distortion and chromatic aberration; they are sharp enough for most applications. If you read the user evaluations in the online photography forums, you know that owners of the kit lenses have been very pleased with its image quality.
- Size matters. A good walking-around lens is compact in size and light in weight.
- Fast/close focusing. Your first lens should have a speedy autofocus system (which is where the Silent Wave motor found in all but the bargain basement lenses [older, non-AF-S models] is an advantage). Close focusing (to 12 inches or closer) will let you use your basic lens for some types of macro photography.

You can find comparisons of the lenses discussed in the next section, as well as evaluations of lenses I don't describe, third-party optics from Sigma, Tokina, Tamron, and other vendors, in online groups and websites.

Buy Now, Expand Later

When the Nikon D3200 was introduced, it was available only in kit form with the 18-55mm VR lens. By the time this book is published, I expect to see it offered packaged with other lenses, including the terrific 18-105mm VR lens. These are all good, basic lenses that can serve you well as a "walk-around" lens (one you keep on the camera most of the time, especially when you're out and about without your camera bag). The number of options available to you is actually quite amazing, even if your budget is limited to about \$100-\$350 for your first lens. One other vendor, for example, offers only 18mm-70mm and 18mm-55mm kit lenses in that price range, plus a 24mm-85mm zoom. Here's a list of Nikon's best-bet "first" lenses. Don't worry about sorting out the alphabet soup right now; I provide a complete list of Nikon lens "codes" later in the chapter.

- AF-S DX Nikkor 18-105mm f/3.5-5.6G ED VR. This lens is one of my choices as a "walking-around" lens for this camera. I much prefer it over the 18-200mm VR (described later), even though it has a more limited zoom range. Its focal length range is quite sufficient for most general photography, and at around \$400 with the camera, it's a real bargain (see Figure 10.2).
- AF-S DX Nikkor 18-55mm f/3.5-5.6G VR. This new VR version of the 18-55 (see Figure 10.3) is a better choice than the basic 18-55 optic, which remains available from many stores. That's because the vibration reduction ("anti-shake") feature of this lens partially offsets the relatively slow maximum aperture of the lens at the telephoto position. It can be mated with Nikon's AF-S DX VR Zoom-Nikkor 55-200mm f/4-5.6G IF-ED to give you a two-lens VR pair that will handle everything from 18mm to 200mm, at a relatively low price of around \$120.
- AF-S DX Nikkor 16-85mm f/3.5-5.6G ED VR. The 16-85mm VR lens is the zoom that would make a lot of sense as a kit lens for the D3200 if price were no object. It costs a significant fraction of the price of the D3200 itself! If you really want to use just a single lens with your camera, this one provides an excellent combination of focal lengths, image quality, and features. Its zoom range extends from a true wide angle (equivalent to a 24mm lens on a full-frame camera) to useful medium telephoto (about 128mm equivalent), and so can be used for everything from architecture to portraiture to sports. If you think vibration reduction is useful only with longer telephoto lenses, you may be surprised at how much it helps you hand-hold your D3200 even at the widest focal lengths. The only disadvantage to this lens is its relatively slow speed (f/5.6) when you crank it out to the telephoto end
- AF-S DX Zoom-Nikkor 18-70mm f/3.5-4.5G IF-ED. If you don't plan on getting a longer zoom-range basic lens and can't afford the 16-85 zoom, I highly recommend this aging, but impressive lens, if you can find one in stock. Originally

Figure 10.2 AF-S DX Nikkor 18-105mm f/3.5-5.6G ED VR can be purchased as the basic kit lens for the D3200 from some retailers.

Figure 10.3 The AF-S DX Nikkor 18-55mm f/3.5-5.6G VR is a low-cost basic lens option for the Nikon D3200.

introduced as the kit lens for the venerable Nikon D70, the 18-70mm zoom quickly gained a reputation as a very sharp lens at a bargain price. It doesn't provide a view that's as long or as wide as the 16-85, but it's a half-stop faster at its maximum zoom position. You may have to hunt around to find one of these, but they are available for \$250-\$300 and well worth it. I own one to this day, and use it regularly, although it spends most of its time installed on my D70, which has been converted to infrared-only photography.

■ AF-S DX Zoom-Nikkor 18-135mm f/3.5-5.6G IF-ED. This lens has been sold as a kit lens for cameras aimed at intermediate amateur-level shooters, and some retailers with stock on hand are packaging it with the D3200 body as well. While decent, it's really best suited for the crowd who buy one do-everything lens and then never purchase another. Available for less than \$300, you won't tie up a lot of money in this lens. There's no VR, so, for most, the 18-105mm VR lens is a better choice.

- AF-S DX VR Zoom-Nikkor 18-200mm f/3.5-5.6G IF-ED. I owned this lens for about three months, and decided it really didn't meet my needs. It was introduced as an ideal "kit" lens for the Nikon D200 a few years back, and, at the time had almost everything you might want. It's a holdover, more upscale kit lens for the D3200. Its stunning 11X zoom range covers everything from the equivalent of 27mm to 300mm when the 1.5X crop factor is figured in, and its VR capabilities plus light weight let you use it without a tripod most of the time. However, I found the image quality to be good, but not outstanding, and the slow maximum aperture at 200mm to be limiting when a fast shutter speed is required to stop action. The "zoom creep" (a tendency for the lens to zoom when the camera is tilted up or down) found in many examples will drive you nuts after awhile (see Figure 10.4).
- AF-S VR II Zoom-Nikkor 24-120mm f/3.5-5.6G IF-ED. This one is a relatively new full-frame lens, but it works fine on a cropped sensor model like the D3200. It has a useful zoom range, and, as a bonus, if you ever decide to upgrade to a full-frame camera, you can take this lens along with you. There's also a newer f/4 version that has improved image quality, but it's more expensive and will cost you a bit more than \$1,000.

Figure 10.4
The AF-S DX
VR ZoomNikkor
18-200mm
f/3.5-5.6G
IF-ED is a
lightweight
"walkingaround" lens.

What Lenses Can You Use?

The previous section helped you sort out what basic lens you need to buy with your Nikon D3200. Now, you're probably wondering what lenses can be added to your growing collection (trust me, it will grow). You need to know which lenses are suitable and, most importantly, which lenses are fully compatible with your Nikon D3200.

With the Nikon D3200, the compatibility issue is a simple one: It can use any modernera Nikon lens with the AF-S designation, with full availability of all autofocus, auto aperture, autoexposure, and image stabilization features (if present). Older lenses with the AF designation won't autofocus on the D3200, but can still be used for automatic exposure. You can also use any Nikon AI, AI-S, or AI-P lens, which are manual focus lenses that were produced starting in 1977 and continue in production effectively through the present day, because Nikon continues to offer a limited number of manual focus lenses for those who need them. Just remember: AF-S—all features available; non-AF-S (including AF)—no autofocusing possible.

The Nikon D3200, as well as previous entry-level models D5100, D5000, D3100, D3000, D60, D40, and D40x don't have an autofocusing motor built into the camera body itself. The motor, present in all other Nikon digital SLRs, allows the camera to adjust the lens focus mechanically. Without that motor in the body, cameras like the D3200 must communicate focus information to the lens, so that the lens's own built-in AF motor can take care of the autofocus process. Because virtually all newer Nikonbrand lenses are of the AF-S type, this means your D3200 will have problems only with older Nikon optics.

That's not true with third-party (non-Nikon) lenses. While your D3200 will accept virtually all modern lenses produced by Tokina, Tamron, Sigma, and other vendors, they will autofocus only with those lenses that contain an internal focusing motor, similar to Nikon's AF-S offerings. Vendors have different designators to indicate these lenses, such as HSM (for hypersonic motor). You'll have to check with the manufacturer of non-Nikon lenses to see if they are compatible with the D3200, particularly since some vendors have been gradually introducing revamped versions of their existing lenses with the addition of an internal motor.

There's some good news for those using one of Nikon's focus-motorless entry-level models. These cameras, *unlike* Nikon models that have the camera body focus motor, can safely use lenses offered prior to 1977 (although I expect that, while numerous, most of these aren't used much by those who have modern digital cameras). That's because cameras other than Nikon's entry-level quartet have a pin on the lens mount that can be damaged by an older, unmodified lens. John White at www.aiconversions. com will do the work for about \$35 to allow these older lenses to be safely used on any Nikon digital camera. If you own or may someday purchase one of those other cameras, you'll want to consider having the lens conversion done, even though your D3200 doesn't require it to use the lens safely.

Today, in addition to its traditional full-frame lenses, Nikon offers lenses with the DX designation, which is intended for use only on DX-format cameras, like your D3200. While the lens mounting system is the same, DX lenses have a coverage area that fills only the smaller frame, allowing the design of more compact, less-expensive lenses especially for non-full-frame cameras. The AF-S DX Nikkor 35mm f/1.8G, a fixed focal length (non-zoom) lens with a fast f/1.8 maximum aperture, is an example of such a lens.

Ingredients of Nikon's Alphanumeric Soup

Nikon has always been fond of appending cryptic letters and descriptors onto the names of its lenses. Here's an alphabetical list of lens terms you're likely to encounter, either as part of the lens name or in reference to the lens's capabilities. Not all of these are used as parts of a lens's name, but you may come across some of these terms in discussions of particular Nikon optics:

- AF, AF-D, AF-I, AF-S. In all cases, AF stands for *autofocus* when appended to the name of a Nikon lens. An extra letter is added to provide additional information. A plain-old AF lens is an autofocus lens that uses a slot-drive motor in the camera body to provide autofocus functions (and so cannot be used in AF mode on the entry-level models noted earlier). The D means that it's a D-type lens (described later in this listing); the I indicates that focus is through a motor inside the lens; and the S means that a super-special (Silent Wave) motor in the lens provides focusing. (Don't confuse a Nikon AF-S lens with the AF-S [Single-Servo Autofocus mode].) Nikon is currently upgrading its older AF lenses with AF-S versions, but it's not safe to assume that all newer Nikkors are AF-S, or even offer autofocus. For example, the PC-E Nikkor 24mm f/3.5D ED perspective control lens must be focused manually, and Nikon offers a surprising collection of other manual focus lenses to meet specialized needs.
- AI, AI-S. All Nikkor lenses produced after 1977 have either automatic aperture indexing (AI) or automatic indexing-shutter (AI-S) features that eliminate the previous requirement to manually align the aperture ring on the camera when mounting a lens. Within a few years, all Nikkors had this automatic aperture indexing feature (except for G-type lenses, which have no aperture ring at all), including Nikon's budget-priced Series E lenses, so the designation was dropped at the time the first autofocus (AF) lenses were introduced.
- E. The E designation was used for Nikon's budget-priced E Series optics, five prime and three zoom manual focus lenses built using aluminum or plastic parts rather than the preferred brass parts of that era, so they were considered less rugged. All are effectively AI-S lenses. They do have good image quality, which makes them a bargain for those who treat their lenses gently and don't need the latest autofocus features. They were available in 28mm f/2.8, 35mm f/2.5, 50mm f/1.8, 100mm
- f/2.8, and 135mm f/2.8 focal lengths, plus 36-72mm f/3.5, 75mm-150mm f/3.5, and 70-210mm f/4 zooms. (All these would be considered fairly "fast" today.)
- **D.** Appended to the maximum f/stop of the lens (as in f/2.8D), a D-Series lens is able to send focus distance data to the camera, which uses the information for flash exposure calculation and 3D Color Matrix II metering.
- **DC.** The DC stands for defocus control, which allows managing the out-of-focus parts of an image to produce better-looking portraits and close-ups.
- DX. The DX lenses are designed for use with digital cameras using the APS-C—sized sensor having the 1.5X crop factor. The image circle they produce isn't large enough to fill up a full 35mm frame at all focal lengths, but they can be used on Nikon's full-frame models using the automatic/manual DX crop mode.
- ED (or LD/UD). The ED (extra-low dispersion) designation indicates that some lens elements are made of a special hard and scratch-resistant glass that minimizes the divergence of the different colors of light as they pass through, thus reducing chromatic aberration (color "fringing") and other image defects. A gold band around the front of the lens indicates an optic with ED elements. You sometimes find LD (low dispersion) or UD (ultra-low dispersion) designations.
- FX. When Nikon introduced the Nikon D3 as its first full-frame camera, it coined the term "FX," representing the 23.9 × 36mm sensor format as a counterpart to "DX," which was used for its 15.8 × 23.6mm APS-C-sized sensors. Although FX hasn't been officially applied to any Nikon lenses so far, expect to see the designation used more often to differentiate between lenses that are compatible with any Nikon digital SLR (FX) and those that operate only on DX-format cameras, or in DX mode when used on an FX camera like the D700, D800, D3, D3s, D3x, and D4.
- **G.** G-type lenses have no aperture ring, and you can use them at other than the maximum aperture only with electronic cameras like the D3200 that set the aperture automatically. Fortunately, this includes all Nikon digital dSLRs.
- IF. Nikon's *internal focusing* lenses change focus by shifting only small internal lens groups with no change required in the lens's physical length, unlike conventional double helicoid focusing systems that move all lens groups toward the front or rear during focusing. IF lenses are more compact and lighter in weight, provide better balance, focus more closely, and can be focused more quickly.
- IX. These lenses were produced for Nikon's long-discontinued Pronea 6i and S APS film cameras. While the Pronea could use many standard Nikon lenses, IX lenses cannot be mounted on any Nikon digital SLR.
- **Micro.** Nikon uses the term *micro* to designate its close-up lenses. Most other vendors use *macro* instead.

- PC (Perspective Control). A PC lens is capable of shifting the lens from side to side (and up/down) to provide a more realistic perspective when photographing architecture and other subjects that otherwise require tilting the camera so that the sensor plane is not parallel to the subject. Older Nikkor PC lenses offered shifting only, but more modern models, such as the PC-E Nikkor 24mm f/3.5D ED lens introduced early in 2008 allow both shifting and tilting.
- UV. This term is applied to special (and expensive) lenses designed to pass ultraviolet light.
- UW. Lenses with this designation are designed for underwater photography with Nikonos camera bodies, and cannot be used with Nikon digital SLRs.
- VR. Nikon has an expanding line of vibration reduction (VR) lenses, including several very affordable models and the AF-S DX Nikkor 16-85mm f/3.5-5.6G ED VR lens, which shifts lens elements internally to counteract camera shake. The VR feature allows using a shutter speed up to four stops slower than would be possible without vibration reduction.

What Lenses Can Do for You

No one can afford to buy even a percentage of the lenses available. The sanest approach to expanding your lens collection is to consider what each of your options can do for you and then choose the type of lens and specific model that will really boost your creative opportunities. So, in the sections that follow, I'm going to provide a general guide to the sort of capabilities you can gain for your D3200 by adding a lens to your repertoire.

- Wider perspective. Your 18-105mm f/3.5-5.6, 18-55mm f/3.5-5.6, or 16-85mm f/4-5.6 lens has served you well for moderate wide-angle shots. Now you find your back is up against a wall and you *can't* take a step backwards to take in more subject matter. Perhaps you're standing on the rim of the Grand Canyon, and you want to take in as much of the breathtaking view as you can. You might find yourself just behind the baseline at a high school basketball game and want an interesting shot with a little perspective distortion tossed in the mix.
- Bring objects closer. A long lens brings distant subjects closer to you, offers better control over depth-of-field, and avoids the perspective distortion that wide-angle lenses provide. They compress the apparent distance between objects in your frame. Don't forget that the Nikon D3200's crop factor narrows the field of view of all these lenses, so your 70-300mm lens looks more like a 105mm-450mm zoom through the viewfinder. The image shown in Figure 10.5 was taken using a wide 24mm lens, while Figures 10.6 and 10.7 were taken from the same position as Figure 10.5, but with focal lengths of 75mm and 200mm, respectively.

Figure 10.5
A wide-angle lens provided this view of Castle Rock in Sedona, Arizona.

Figure 10.6
This photo, taken from the same distance shows the view using a short telephoto lens.

Figure 10.7
A long telephoto lens captured this close-up view of the formation, from the same shooting position.

- Bring your camera closer. Macro lenses allow you to focus to within an inch or two of your subject. Nikon's best close-up lenses are all fixed focal length optics in the 60mm to 200mm range, but you'll find good macro zooms available from Sigma and others. They don't tend to focus quite as close, but they provide a bit of flexibility when you want to vary your subject distance (say, to avoid spooking a skittish creature).
- Look sharp. Many lenses are prized for their sharpness and overall image quality. While your run-of-the-mill lens is likely to be plenty sharp for most applications, the very best optics are even better over their entire field of view (which means no fuzzy corners), are sharper at a wider range of focal lengths (in the case of zooms), and have better correction for various types of distortion. Of course, these lenses cost a great deal more (sometimes \$1,000 or more each).
- More speed. Your Nikon 70-300mm f/4.5-5.6 telephoto zoom lens might have the perfect focal length and sharpness for sports photography, but the maximum aperture won't cut it for night baseball or football games, or, even, any sports shooting in daylight if the weather is cloudy or you need to use some ungodly fast shutter speed, such as 1/4,000th second. You might be happier to gain a full f/stop with an AF-S Nikkor 300mm f/4D IF-ED for a little more than \$1,500, mated to a 1.4x teleconverter (giving you a 420mm f/5.6 lens). Or, maybe you just need the speed and can benefit from an f/1.8 or f/1.4 prime lens. They're all available in Nikon mounts (there's even an 85mm f/1.4 and 50mm f/1.4 for the real speed demons). With any of these lenses you can continue photographing under the dimmest of lighting conditions without the need for a tripod or flash.
- Special features. Accessory lenses give you special features, such as tilt/shift capabilities to correct for perspective distortion in architectural shots. You'll also find macro lenses, including the AF-S Micro-Nikkor 60mm f/2.8G ED. Fisheye lenses like the AF DX Fisheye-Nikkor 10.5mm f/2.8G ED, and all other VR (vibration reduction) lenses also count as special-feature optics.

Zoom or Prime?

Zoom lenses have changed the way serious photographers take pictures. One of the reasons that I still own 12 (almost worthless) SLR film bodies dating back to the prezoom days is that in ancient times it was common to mount a different fixed focal length prime lens on various cameras and take pictures with two or three cameras around your neck (or tucked in a camera case) so you'd be ready to take a long shot or an intimate close-up or wide-angle view on a moment's notice, without the need to switch lenses. It made sense (at the time) to have a half-dozen or so bodies (two to use, one in the shop, one in transit, and a couple backups). Zoom lenses of the time had a limited zoom range, were heavy, and not very sharp (especially when you tried to wield

one of those monsters hand-held). That's all changed today. Smaller, longer, sharper zoom lenses, many with VR features, are available.

When selecting between zoom and prime lenses, there are several considerations to ponder. Here's a checklist of the most important factors. I already mentioned image quality and maximum aperture earlier, but those aspects take on additional meaning when comparing zooms and primes.

- Logistics. As prime lenses offer just a single focal length, you'll need more of them to encompass the full range offered by a single zoom. More lenses mean additional slots in your camera bag, and extra weight to carry. Just within Nikon's line alone you can choose from a good selection of general purpose (if you can count AF lenses that won't autofocus with the D3200 as "general purpose") prime lenses in 28mm, 35mm, 50mm, 85mm, 100mm, 135mm, and 200mm focal lengths, all of which are overlapped by the 18-200mm zoom I mentioned earlier. Even so, you might be willing to carry an extra prime lens or two in order to gain the speed or image quality that lens offers.
- Image quality. Prime lenses usually produce better image quality at their focal length than even the most sophisticated zoom lenses at the same magnification. Zoom lenses, with their shifting elements and f/stops that can vary from zoom position to zoom position, are in general more complex to design than fixed focal length lenses. That's not to say that the very best prime lenses can't be complicated as well. However, the exotic designs, aspheric elements, and low-dispersion glass can be applied to improving the quality of the lens, rather than wasting a lot of it on compensating for problems caused by the zoom process itself.
- Maximum aperture. Because of the same design constraints, zoom lenses usually have smaller maximum apertures than prime lenses, and the most affordable zooms have a lens opening that grows effectively smaller as you zoom in. The difference in lens speed verges on the ridiculous at some focal lengths. For example, the 18mm-55mm basic zoom gives you a 55mm f/5.6 lens when zoomed all the way out, while prime lenses in that focal length commonly have f/1.8 or faster maximum apertures. Indeed, the fastest f/2, f/1.8, f/1.4, and f/1.2 lenses are all manual focus primes (at least on the D3200, because they are AF models), and if you require speed, a fixed focal length lens is what you should rely on. Figure 10.8 shows an image taken with a Nikon 85mm f/1.4 lens.
- Speed. Using prime lenses takes time and slows you down. It takes a few seconds to remove your current lens and mount a new one, and the more often you need to do that, the more time is wasted. If you choose not to swap lenses, when using a fixed focal length lens you'll still have to move closer or farther away from your subject to get the field of view you want. A zoom lens allows you to change magnifications and focal lengths with the twist of a ring and generally saves a great deal of time.

Figure 10.8
An 85mm f/1.4
lens was perfect
for this handheld photo at a
concert featuring British
Invasion singer
Peter Asher.

Categories of Lenses

Lenses can be categorized by their intended purpose—general photography, macro photography, and so forth—or by their focal length. The range of available focal lengths is usually divided into three main groups: wide angle, normal, and telephoto. Prime lenses fall neatly into one of these classifications. Zooms can overlap designations, with a significant number falling into the catch-all, wide-to-telephoto zoom range. This section provides more information about focal length ranges, and how they are used.

When the 1.5X crop factor (mentioned at the beginning of this chapter) is figured in, any lens with an equivalent focal length of 10mm to 16mm is said to be an *ultrawide-angle lens*; from about 16mm to 30mm is said to be a *wide-angle lens*. Normal lenses have a focal length roughly equivalent to the diagonal of the film or sensor, in millimeters, and so fall into the range of about 30mm to 40mm on a D3200. Short telephoto lenses start at about 40mm to 70mm, with anything from 70mm to 250mm qualifying as a conventional telephoto. For the Nikon D3200, anything from about 300mm to 400mm or longer can be considered a *super-telephoto*.

Using Wide-Angle and Wide-Zoom Lenses

To use wide-angle prime lenses and wide zooms, you need to understand how they affect your photography. Here's a quick summary of the things you need to know.

- More depth-of-field. Practically speaking, wide-angle lenses offer more depth-of-field at a particular subject distance and aperture. (But, see the sidebar below for an important note.) You'll find that helpful when you want to maximize sharpness of a large zone, but not very useful when you'd rather isolate your subject using selective focus (telephoto lenses are better for that).
- Stepping back. Wide-angle lenses have the effect of making it seem that you are standing farther from your subject than you really are. They're helpful when you don't want to back up, or can't because there are impediments in your way.
- Wider field of view. While making your subject seem farther away, as implied above, a wide-angle lens also provides a larger field of view, including more of the subject in your photos.
- More foreground. As background objects retreat, more of the foreground is brought into view by a wide-angle lens. That gives you extra emphasis on the area that's closest to the camera. Photograph your home with a normal lens/normal zoom setting, and the front yard probably looks fairly conventional in your photo (that's why they're called "normal" lenses). Switch to a wider lens and you'll discover that your lawn now makes up much more of the photo. So, wide-angle lenses are great when you want to emphasize that lake in the foreground, but problematic when your intended subject is located farther in the distance.
- Super-sized subjects. The tendency of a wide-angle lens to emphasize objects in the foreground, while de-emphasizing objects in the background can lead to a kind of size distortion that may be more objectionable for some types of subjects than others. Shoot a bed of flowers up close with a wide angle, and you might like the distorted effect of the larger blossoms nearer the lens. Take a photo of a family member with the same lens from the same distance, and you're likely to get some complaints about that gigantic nose in the foreground.
- Perspective distortion. When you tilt the camera so the plane of the sensor is no longer perpendicular to the vertical plane of your subject, some parts of the subject are now closer to the sensor than they were before, while other parts are farther away. So, buildings, flagpoles, or NBA players appear to be falling backwards, as you can see in Figure 10.9. While this kind of apparent distortion (it's not caused by a defect in the lens) can happen with any lens, it's most apparent when a wide angle is used.

Figure 10.9
Tilting the camera back produces this "falling back" look in architectural photos.

- Steady cam. You'll find that you can hand-hold a wide-angle lens at slower shutter speeds, without need for vibration reduction, than you can with a telephoto lens. The reduced magnification of the wide-lens or wide-zoom setting doesn't emphasize camera shake like a telephoto lens does.
- Interesting angles. Many of the factors already listed combine to produce more interesting angles when shooting with wide-angle lenses. Raising or lowering a telephoto lens a few feet probably will have little effect on the appearance of the distant subjects you're shooting. The same change in elevation can produce a dramatic effect for the much-closer subjects typically captured with a wide-angle lens or wide-zoom setting.

DOF IN DEPTH

The DOF advantage of wide-angle lenses is diminished when you enlarge your picture; believe it or not, a wide-angle image enlarged and cropped to provide the same subject size as a telephoto shot would have the *same* depth-of-field. Try it: take a wide-angle photo of a friend from a fair distance, and then zoom in to duplicate the picture in a telephoto image. Then, enlarge the wide shot so your friend is the same size in both. The wide photo will have the same depth-of-field (and will have much less detail, too).

Avoiding Potential Wide-Angle Problems

Wide-angle lenses have a few quirks that you'll want to keep in mind when shooting so you can avoid falling into some common traps. Here's a checklist of tips for avoiding common problems:

- Symptom: converging lines. Unless you want to use wildly diverging lines as a creative effect, it's a good idea to keep horizontal and vertical lines in landscapes, architecture, and other subjects carefully aligned with the sides, top, and bottom of the frame. That will help you avoid undesired perspective distortion. Sometimes it helps to shoot from a slightly elevated position so you don't have to tilt the camera up or down.
- Symptom: color fringes around objects. Lenses are often plagued with fringes of color around backlit objects, produced by *chromatic aberration*, which is produced when all the colors of light don't focus in the same plane or same lateral position (that is, the colors are offset to one side). This phenomenon is more common in wide-angle lenses and in photos of subjects with contrasty edges. Some kinds of chromatic aberration can be reduced by stopping down the lens, while all sorts can be reduced by using lenses with low diffraction index glass (or ED elements, in Nikon nomenclature) and by incorporating elements that cancel the chromatic aberration of other glass in the lens.
- Symptom: lines that bow outward. Some wide-angle lenses cause straight lines to bow outwards, with the strongest effect at the edges. In fisheye (or *curvilinear*) lenses, this defect is a feature, as you can see in Figure 10.10. When distortion is not desired, you'll need to use a lens that has corrected barrel distortion. Manufacturers like Nikon do their best to minimize or eliminate it (producing a *rectilinear* lens), often using *aspherical* lens elements (which are not cross-sections of a sphere). You can also minimize barrel distortion simply by framing your photo with some extra space all around, so the edges where the defect is most obvious can be cropped out of the picture. Some image editors, including Photoshop and Photoshop Elements and Nikon Capture NX, have a lens distortion correction feature.
- Symptom: dark corners and shadows in flash photos. The Nikon D3200's built-in electronic flash is designed to provide even coverage for lenses as wide as 17mm. If you use a wider lens, you can expect darkening, or *vignetting*, in the corners of the frame. At wider focal lengths, the lens hood of some lenses (my 18mm-70mm lens is a prime offender) can cast a semi-circular shadow in the lower portion of the frame when using the built-in flash. Sometimes removing the lens hood or zooming in a bit can eliminate the shadow. Mounting an external flash unit, such as the mighty Nikon SB-910 can solve both problems, as this high-end flash unit (it costs almost half as much as the D3200 camera) has zoomable coverage up to as wide as the field of view of a 14mm lens when used with the included adapter. Its higher vantage point eliminates the problem of lens hood shadow, too.

Figure 10.10
Many wideangle lenses
cause lines to
bow outward
toward the
edges of the
image; with a
fisheye lens,
this tendency is
considered an
interesting
feature.

Using Telephoto and Tele-Zoom Lenses

Telephoto lenses also can have a dramatic effect on your photography, and Nikon is especially strong in the long-lens arena, with lots of choices in many focal lengths and zoom ranges. You should be able to find an affordable telephoto or tele-zoom to enhance your photography in several different ways. Here are the most important things you need to know. In the next section, I'll concentrate on telephoto considerations that can be problematic—and how to avoid those problems.

■ Selective focus. Long lenses have reduced depth-of-field within the frame, allowing you to use selective focus to isolate your subject. You can open the lens up wide to create shallow depth-of-field, or close it down a bit to allow more to be in focus. The flip side of the coin is that when you *want* to make a range of objects sharp, you'll need to use a smaller f/stop to get the depth-of-field you need. Like fire, the depth-of-field of a telephoto lens can be friend or foe. Figure 10.11 shows a photo of a statue shot with a 200mm lens and a wider f/2.8 f/stop to de-emphasize the distracting background.

Figure 10.11
A wide f/stop
helped isolate
the statue while
allowing the
background to
go out of focus.

- **Getting closer.** Telephoto lenses bring you closer to wildlife, sports action, and candid subjects. No one wants to get a reputation as a surreptitious or "sneaky" photographer (except for paparazzi), but when applied to candids in an open and honest way, a long lens can help you capture memorable moments while retaining enough distance to stay out of the way of events as they transpire.
- Reduced foreground/increased compression. Telephoto lenses have the opposite effect of wide angles: they reduce the importance of things in the foreground by squeezing everything together. This compression even makes distant objects appear to be closer to subjects in the foreground and middle ranges. You can use this effect as a creative tool to squeeze subjects together.
- Accentuates camera shakiness. Telephoto focal lengths hit you with a double whammy in terms of camera/photographer shake. The lenses themselves are bulkier, more difficult to hold steady, and may even produce a barely perceptible see-saw rocking effect when you support them with one hand halfway down the lens barrel. Telephotos also magnify any camera shake. It's no wonder that vibration reduction is popular in longer lenses.
- Interesting angles require creativity. Telephoto lenses require more imagination in selecting interesting angles, because the "angle" you do get on your subjects is so narrow. Moving from side to side or a bit higher or lower can make a dramatic difference in a wide-angle shot, but raising or lowering a telephoto lens a few feet probably will have little effect on the appearance of the distant subjects you're shooting.

Avoiding Telephoto Lens Problems

Many of the "problems" that telephoto lenses pose are really just challenges and are not that difficult to overcome. Here is a list of the seven most common picture maladies and suggested solutions.

- Symptom: flat faces in portraits. Head-and-shoulders portraits of humans tend to be more flattering when a focal length of 50mm to 85mm is used. Longer focal lengths compress the distance between features like noses and ears, making the face look wider and flat. A wide angle might make noses look huge and ears tiny when you fill the frame with a face. So stick with 50mm to 85mm focal lengths, going longer only when you're forced to shoot from a greater distance, and wider only when shooting three-quarters/full-length portraits, or group shots.
- Symptom: blur due to camera shake. Use a higher shutter speed (boosting ISO if necessary), consider an image-stabilized lens, or mount your camera on a tripod, monopod, or brace it with some other support. Of those three solutions, only the first will reduce blur caused by *subject* motion; a VR lens or tripod won't help you freeze a race car in mid-lap.

- Symptom: color fringes. Chromatic aberration is the most pernicious optical problem found in telephoto lenses. There are others, including spherical aberration, astigmatism, coma, curvature of field, and similarly scary-sounding phenomena. The best solution for any of these is to use a better lens that offers the proper degree of correction, or stop down the lens to minimize the problem. But that's not always possible. Your second-best choice may be to correct the fringing in your favorite RAW conversion tool or image editor. Photoshop's Lens Correction filter (found in the Filter menu's Distort submenu) offers sliders that minimize both red/cyan and blue/yellow fringing.
- Symptom: lines that curve inwards. Pincushion distortion is found in many telephoto lenses. You might find after a bit of testing that it is worse at certain focal lengths with your particular zoom lens. Like chromatic aberration, it can be partially corrected using tools like the correction tools built into Photoshop and Photoshop Elements. You can see an exaggerated example in Figure 10.12, especially at the right edge where the walls of the tower bend noticeably; pincushion distortion isn't always this obvious.

Figure 10.12
Pincushion distortion in telephoto lenses causes lines to bow inwards from the edges.

- Symptom: low contrast from haze or fog. When you're photographing distant objects, a long lens shoots through a lot more atmosphere, which generally is muddied up with extra haze and fog. That dirt or moisture in the atmosphere can reduce contrast and mute colors. Some feel that a skylight or UV filter can help, but this practice is mostly a holdover from the film days. Digital sensors are not sensitive enough to UV light for a UV filter to have much effect. So you should be prepared to boost contrast and color saturation in your Picture Controls menu or image editor if necessary.
- Symptom: low contrast from flare. Lenses are furnished with lens hoods for a good reason: to reduce flare from bright light sources at the periphery of the picture area, or completely outside it. Because telephoto lenses often create images that are lower in contrast in the first place, you'll want to be especially careful to use a lens hood to prevent further effects on your image (or shade the front of the lens with your hand).
- Symptom: dark flash photos. Edge-to-edge flash coverage isn't a problem with telephoto lenses as it is with wide angles. The shooting distance is. A long lens might make a subject that's 50 feet away look as if it's right next to you, but your camera's flash isn't fooled. You'll need extra power for distant flash shots, and probably more power than your D3200's built-in flash provides. The Nikon SB-900 Speedlight, for example, can automatically zoom its coverage to illuminate the area captured by a 200mm telephoto lens, with three light distribution patterns (Standard, Center-weighted, and Even). (Try that with the built-in flash!)

Telephotos and Bokeh

Bokeh describes the aesthetic qualities of the out-of-focus parts of an image and whether out-of-focus points of light—circles of confusion—are rendered as distracting fuzzy discs or smoothly fade into the background. Boke is a Japanese word for "blur," and the h was added to keep English speakers from rendering it monosyllabically to rhyme with broke. Although bokeh is visible in blurry portions of any image, it's of particular concern with telephoto lenses, which, thanks to the magic of reduced depth-of-field, produce more obviously out-of-focus areas.

Bokeh can vary from lens to lens, or even within a given lens depending on the f/stop in use. Bokeh becomes objectionable when the circles of confusion are evenly illuminated, making them stand out as distinct discs, or, worse, when these circles are darker in the center, producing an ugly "doughnut" effect. A lens defect called spherical aberration may produce out-of-focus discs that are brighter on the edges and darker in the center, because the lens doesn't focus light passing through the edges of the lens exactly as it does light going through the center. (Mirror or *catadioptric* lenses also produce this effect.)

Other kinds of spherical aberration generate circles of confusion that are brightest in the center and fade out at the edges, producing a smooth blending effect, as you can see at bottom in Figure 10.13. Ironically, when no spherical aberration is present at all, the discs are a uniform shade, which, while better than the doughnut effect, is not as pleasing as the bright center/dark edge rendition. The shape of the disc also comes into play, with round smooth circles considered the best, and nonagonal or some other polygon (determined by the shape of the lens diaphragm) considered less desirable.

Figure 10.13

Bokeh is less pleasing when the discs are prominent (top), and less obtrusive when they blend into the background (bottom).

If you plan to use selective focus a lot, you should investigate the bokeh characteristics of a particular lens before you buy. Nikon user groups and forums will usually be full of comments and questions about bokeh, so the research is fairly easy.

Add-ons and Special Features

Once you've purchased your telephoto lens, you'll want to think about some appropriate accessories for it. There are some handy add-ons available that can be valuable. Here are a couple of them to think about.

Lens Hoods

Lens hoods are an important accessory for all lenses, but they're especially valuable with telephotos. As I mentioned earlier, lens hoods do a good job of preserving image contrast by keeping bright light sources outside the field of view from striking the lens and, potentially, bouncing around inside that long tube to generate flare that, when coupled with atmospheric haze, can rob your image of detail and snap. In addition, lens hoods serve as valuable protection for that large, vulnerable, front lens element. It's easy to forget that you've got that long tube sticking out in front of your camera and accidentally whack the front of your lens into something. It's cheaper to replace a lens hood than it is to have a lens repaired, so you might find that a good hood is valuable protection for your prized optics.

When choosing a lens hood, it's important to have the right hood for the lens, usually the one offered for that lens by Nikon or the third-party manufacturer. You want a hood that blocks precisely the right amount of light: neither too much light nor too little. A hood with a front diameter that is too small can show up in your pictures as vignetting. A hood that has a front diameter that's too large isn't stopping all the light it should. Generic lens hoods may not do the job.

When your telephoto is a zoom lens, it's even more important to get the right hood, because you need one that does what it is supposed to at both the wide-angle and telephoto ends of the zoom range. Lens hoods may be cylindrical, rectangular (shaped like the image frame), or petal shaped (that is, cylindrical, but with cut-out areas at the corners that correspond to the actual image area). Lens hoods should be mounted in the correct orientation (a bayonet mount for the hood usually takes care of this).

Telephoto Converters

Teleconverters (often called telephoto extenders outside the Nikon world) multiply the actual focal length of your lens, giving you a longer telephoto for much less than the price of a lens with that actual focal length. These converters fit between the lens and your camera and contain optical elements that magnify the image produced by the lens.

Available in 1.4X, 1.7X, and 2.0X configurations from Nikon, a teleconverter transforms, say, a 200mm lens into a 280mm, 340mm, or 400mm optic, respectively. Given the D3200's crop factor, your 200mm lens now has the same field of view as a 420mm, 510mm, or 600mm lens on a full-frame camera. At around \$500 each, converters are quite a bargain, aren't they? You can also find less expensive telephoto extenders, like the one shown in Figure 10.14, from third-party suppliers.

Figure 10.14
Teleconverters
multiply the
true focal
length of your
lenses—but at a
cost of some
sharpness and
aperture speed.

The only drawback is that Nikon's own TC II and TC III teleconverters can be used only with a limited number of Nikkor AF-S lenses. The compatible models include the 200mm f/2G ED-IF AF-S VR Nikkor, 300mm f/2.8G ED-IF AF-S VR Nikkor, 400mm f/2.8D ED-IF AF-S II Nikkor, 80-200mm f/2.8D ED-IF AF-S, 70-200mm f/2.8G ED-IF AF-S VR Zoom-Nikkor, 200-400mm f/4G ED-IF AF-S VR Zoom-Nikkor, 300mm f/4D ED-IF AF-S Nikkor, 500mm f/4D ED-IF AF-S II Nikkor, and 600mm f/4D ED-IF AF-S II Nikkor. These tend to be pricey (or ultra-pricey) lenses. Teleconverters from Sigma, Kenko, Tamron, and others cost less, and may be compatible with a broader range of lenses. (They work especially well with lenses from the same vendor that produces the teleconverter.)

There are other downsides. While extenders retain the closest focusing distance of your original lens, autofocus is maintained only if the lens's original maximum aperture is f/4 or larger (for the 1.4X extender) or f/2.8 or larger (for the 2X extender). The components reduce the effective aperture of any lens they are used with, by one f/stop with the 1.4X converter, 1.5 f/stops with the 1.7X converter, and two f/stops with the 2X extender. So, your 200mm f/2.8 lens becomes a 280mm f/4 or 400mm f/5.6 lens.

Although Nikon converters are precision optical devices, they do cost you a little sharpness, but that improves when you reduce the aperture by a stop or two. Each of the converters is compatible only with a particular set of lenses greater, so you'll want to check Nikon's compatibility chart to see if the component can be used with the lens you want to attach to it.

If your lenses are compatible and you're shooting under bright lighting conditions, the Nikon extenders make handy accessories. I recommend the 1.4X version because it robs you of very little sharpness and only one f/stop. The 1.7X version also works well, too, but I've found the 2X teleconverter to exact too much of a sharpness and speed penalty to be of much use.

Macro Focusing

Some telephotos and telephoto zooms available for the Nikon D3200 have particularly close focusing capabilities, making them *macro* lenses. Of course, the object is not necessarily to get close (get too close and you'll find it difficult to light your subject). What you're really looking for in a macro lens is to magnify the apparent size of the subject in the final image. Camera-to-subject distance is most important when you want to back up farther from your subject (say, to avoid spooking skittish insects or small animals). In that case, you'll want a macro lens with a longer focal length to allow that distance while retaining the desired magnification.

Nikon makes five lenses that are officially designated as macro lenses. They include:

- AF-S Micro-Nikkor 60mm f/2.8G ED. This type-G lens supposedly replaces the type-D lens listed next, adding an internal Silent Wave autofocus motor that should operate faster, and which is also compatible with cameras lacking a body motor, such as the Nikon D40/D40x and D3200. It also has ED lens elements for improved image quality. However, because it lacks an aperture ring, you can control the f/stop only when the lens is mounted directly on the camera or used with automatic extension tubes. Should you want to reverse a macro lens using a special adapter (the Nikon BR2-A ring) to improve image quality or mount it on a bellows, you're better off with a lens having an aperture ring.
- AF Micro-Nikkor 60mm f/2.8D. This non-AF-S lens won't autofocus on the Nikon D3200, but, then, you might be manually focusing most of the time when shooting close-ups, and may appreciate the lower cost of an "obsolete" lens.
- AF-S Micro-Nikkor 40mm f/2.8 DX. The latest macro lens in the lineup, this one is an inexpensive (roughly \$275) non-full-frame lens produced especially for DX-format cameras like the D3200. It's sharp and affordable.

- AF-S VR Micro-Nikkor 105mm f/2.8G IF-ED. This G-series lens did replace a similar D-type, non-AF-S version that also lacked VR. I own the older lens, too, and am keeping it because I find VR a rather specialized tool for macro work. Some 99 percent of the time, I shoot close-ups with my D3200 mounted on a tripod or, at the very least, on a monopod, so camera vibration is not much of a concern. Indeed, *subject* movement is a more serious problem, especially when shooting plant life outdoors on days plagued with even slight breezes. Because my outdoor subjects are likely to move while I am composing my photo, I find both VR and autofocus not very useful. I end up focusing manually most of the time, too. This lens provides a little extra camera-to-subject distance, so you'll find it very useful, but consider the older non-G, non-VR version, too, if you're in the market and don't mind losing autofocus features.
- AF Micro-Nikkor 200mm f/4D IF-ED. With a price tag of about \$1,800, you'd probably want this lens only if you planned a great deal of close-up shooting at greater distances. It focuses down to 1.6 feet, and is manual focus only with the D3200, but provides enough magnification to allow interesting close-ups of subjects that are farther away. A specialized tool for specialized shooting.
- AF-S DX Micro 85mm f/3.5 ED VR. This lens was designed especially for cropped sensor (DX) models like the D3200. It autofocuses on the D3200, it has vibration reduction, and it's relatively fast at f/3.5, making it an excellent choice for hand-held close-up photography.
- PC Micro-Nikkor 85mm f/2.8D. Priced about the same as the 200mm Micro-Nikkor, this is a manual focus lens (on *any* camera; it doesn't offer autofocus features) that has both tilt and shift capabilities, so you can adjust the perspective of the subject as you shoot. The tilt feature lets you "tilt" the plane of focus, providing the illusion of greater depth-of-field, while the shift capabilities make it possible to shoot down on a subject from an angle and still maintain its correct proportions. If you need one of these for perspective control, you already know it; if you're still wondering how you'd use one, you probably have no need for these specialized capabilities. However, I have recently watched some very creative fashion and wedding photographers use this lens for portraits, applying the tilting features to throw parts of the image wildly out of focus to concentrate interest on faces, and so forth. None of these are likely pursuits of the average Nikon D3200 photographer, but I couldn't resist mentioning this interesting lens.

You'll also find macro lenses, macro zooms, and other close-focusing lenses available from Sigma, Tamron, and Tokina. If you want to focus closer with a macro lens, or any other lens, you can add an accessory called an *extension tube*, like the one shown in Figure 10.15, or a *bellows extension*. These add-ons move the lens farther from the focal plane, allowing it to focus more closely. Nikon also sells add-on close-up lenses, which look like filters, and allow lenses to focus more closely.

Figure 10.15
Extension tubes enable any lens to focus more closely to the subject.

Vibration Reduction

Nikon has a burgeoning line of more than 16 lenses with built-in vibration reduction (VR) capabilities. I probably shouldn't have mentioned a specific number, because I expect another half dozen or so new VR lenses to be introduced rather early in the life of this book.

The VR feature uses lens elements that are shifted internally in response to vertical or horizontal motion of the lens, which compensates for any camera shake in those directions. Vibration reduction is particularly effective when used with telephoto lenses, which magnify the effects of camera and photographer motion. However, VR can be useful for lenses of shorter focal lengths, such as Nikon's 16-85mm, 18-105mm, and 18-55mm VR lenses. Other Nikon VR lenses provide stabilization with zooms that are as wide as 24mm.

Vibration reduction offers two to three shutter speed increments' worth of shake reduction. (Nikon claims a four-stop gain, which I feel may be optimistic.) This extra margin can be invaluable when you're shooting under dim lighting conditions or hand-holding a lens for, say, wildlife photography. Perhaps that shot of a foraging deer would require a shutter speed of 1/2,000th second at f/5.6 with your AF-S VR Zoom-Nikkor 200-400mm f/4G IF-ED lens. Relax. You can shoot at 1/250th second at f/11 and get a photo that is just as sharp, as long as the deer doesn't decide to bound off. Or, perhaps you're shooting indoors and would prefer to shoot at 1/15th second at f/4. Your 16mm-85mm VR lens can grab the shot for you at its wide-angle position.

However, consider these facts:

- **VR doesn't freeze subject motion.** Vibration reduction won't freeze moving subjects in their tracks, because it is effective only at compensating for *camera* motion. It's best used in reduced illumination, to steady the up-down swaying of telephoto lenses, and to improve close-up photography. If your subject is in motion, you'll still need a shutter speed that's fast enough to stop the action.
- VR adds to shutter lag. The process of adjusting the lens elements, like autofocus, takes time, so vibration reduction may contribute to a slight increase in shutter lag. If you're shooting sports, that delay may be annoying, but I still use my VR lenses for sports all the time!
- Use when appropriate. You may find that your results are worse when using VR while panning, although newer Nikon VR lenses work fine when the camera is deliberately moved from side to side during exposure. Older lenses can confuse the panning motion with camera wobble and provide too much compensation. You might want to switch off VR when panning or when your camera is mounted on a tripod.
- **Do you need VR at all?** Remember that an inexpensive monopod might be able to provide the same additional steadiness as a VR lens, at a much lower cost. If you're out in the field shooting wild animals or flowers and think a tripod isn't practical, try a monopod first.

VIBRATION REDUCTION: IN THE CAMERA OR IN THE LENS?

The adoption of image stabilization/anti-shake technology into the camera bodies of models from Sony, Olympus, Pentax, and Samsung has revived an old debate about whether VR belongs in the camera or in the lens. Perhaps it's my Nikon bias showing, but I am quite happy not to have vibration reduction available in the body itself. Here are some reasons:

- Should in-camera VR fail, you have to send the whole camera in for repair, and camera repairs are generally more expensive than lens repairs. I like being able to simply switch to another lens if I have a VR problem.
- VR in the camera doesn't steady your view in the viewfinder, whereas a VR lens shows you a steadied image as you shoot.
- You're stuck with the VR system built in to your camera. If an improved system is incorporated into a lens and the improvements are important to you, just trade in your old lens for the new one.
- When building VR in the camera, a compromise system that works with all lenses must be designed. VR in the lens, however, can be custom-tailored to each specific lens's needs.

The AF-S VR Zoom-Nikkor 70-200mm f/2.8G IF-ED, though atypical for the average D3200 owner, is typical of the VR lenses Nikon offers, so I'll use it as an example. It has the basic controls shown in Figure 10.16, to adjust focus range (full, or limited to infinity down to 2.5 meters); VR On/Off; and Normal VR/Active VR (the latter an aggressive mode used in extreme situations, such as a moving car). Not visible (it's over the horizon, so to speak) is the M/A-M focus mode switch, which allows changing from autofocus (with manual override) to manual focus.

Figure 10.16
On the Nikon
70-200mm VR
zoom you'll
find (top to bottom): the focus
limit switch,
VR on/off
switch, and
Normal/Active
VR adjustment.

Making Light Work for You

Successful photographers and artists have an intimate understanding of the importance of light in shaping an image. Rembrandt was a master of using light to create moods and reveal the character of his subjects. Late artist Thomas Kinkade's official tagline was "Painter of Light." Dean Collins, co-founder of Finelight Studios, revolutionized how a whole generation of photographers learned and used lighting. It's impossible to underestimate how the use of light adds to—and how misuse can detract from—your photographs.

All forms of visual art use light to shape the finished product. Sculptors don't have control over the light used to illuminate their finished work, so they must create shapes using planes and curved surfaces so that the form envisioned by the artist comes to life from a variety of viewing and lighting angles. Painters, in contrast, have absolute control over both shape and light in their work, as well as the viewing angle, so they can use both the contours of their two-dimensional subjects and the qualities of the "light" they use to illuminate those subjects to evoke the image they want to produce.

Photography is a third form of art. The photographer may have little or no control over the subject (other than posing human subjects) but can often adjust both viewing angle and the nature of the light source to create a particular compelling image. The direction and intensity of the light sources create the shapes and textures that we see. The distribution and proportions determine the contrast and tonal values: whether the image is stark or high key, or muted and low in contrast. The colors of the light (because even "white" light has a color balance that the sensor can detect), and how much of those colors the subject reflects or absorbs, paint the hues visible in the image.

As a Nikon D3200 photographer, you must learn to be a painter and sculptor of light if you want to move from *taking* a picture to *making* a photograph. This chapter provides an introduction to using the two main types of illumination: *continuous* lighting

(such as daylight, incandescent, or fluorescent sources) and the brief, but brilliant snippets of light we call *electronic flash*.

Continuous Illumination versus Electronic Flash

Continuous lighting is exactly what you might think: uninterrupted illumination that is available all the time during a shooting session. Daylight, moonlight, and the artificial lighting encountered both indoors and outdoors count as continuous light sources (although all of them can be "interrupted" by passing clouds, solar eclipses, a blown fuse, or simply by switching off a lamp). Indoor continuous illumination includes both the lights that are there already (such as incandescent lamps or overhead fluorescent lights indoors) and fixtures you supply yourself, including photoflood lamps or reflectors used to bounce existing light onto your subject.

The surge of light we call electronic flash is produced by a burst of photons generated by an electrical charge that is accumulated in a component called a *capacitor* and then directed through a glass tube containing xenon gas, which absorbs the energy and emits the brief flash. Electronic flash is notable because it can be much more intense than continuous lighting, lasts only a brief moment, and can be much more portable than supplementary incandescent sources. It's a light source you can carry with you and use anywhere.

Indeed, your D3200 has a flip-up electronic flash unit built in, as shown in Figure 11.1. But you can also use an external flash, either mounted on the D3200's accessory shoe

Figure 11.1 One form of light that's always available is the flip-up flash on your D3200.

or used off-camera and linked with a cable or triggered by a slave light (which sets off a flash when it senses the firing of another unit). Studio flash units are electronic flash, too, and aren't limited to "professional" shooters, as there are economical "monolight" (one-piece flash/power supply) units available in the \$200 price range. Serious photographers with some spare cash can buy a couple to store in a closet and use to set up a home studio, or use as supplementary lighting when traveling away from home. You'll need a remote trigger mounted on the D3200's accessory/hot shoe, or an accessory/hot shoe-to-PC connector adapter to use studio flash with your camera.

There are advantages and disadvantages to each type of illumination. Here's a quick checklist of pros and cons:

■ Lighting preview—Pro: continuous lighting. With continuous lighting, you always know exactly what kind of lighting effect you're going to get and, if multiple lights are used, how they will interact with each other, as shown in Figure 11.2. With electronic flash, the general effect you're going to see may be a mystery until you've built some experience, and you may need to review a shot on the LCD, make some adjustments, and then reshoot to get the look you want. (In this sense, a digital camera's review capabilities replace the Polaroid test shots pro photographers relied on in decades past.)

Figure 11.2
You always
know how the
lighting will
look when using
continuous
illumination.

- Lighting preview—Con: electronic flash. With flash, the general effect you're going to see may be a mystery until you've built some experience, and you may need to review a shot on the LCD, make some adjustments, and then reshoot to get the look you want. (In this sense, a digital camera's review capabilities replace the Polaroid test shots pro photographers relied on in decades past.)
- Exposure calculation—Pro: continuous lighting. Your D3200 has no problem calculating exposure for continuous lighting, because it remains constant and can be measured through a sensor that interprets the light reaching the viewfinder. The amount of light available just before the exposure will, in almost all cases, be the same amount of light present when the shutter is released. The D3200's Spot metering mode can be used to measure and compare the proportions of light in the highlights and shadows, so you can make an adjustment (such as using more or less fill light) if necessary. You can even use a hand-held light meter to measure the light yourself and transfer the settings to the camera in Manual exposure mode.
- Exposure calculation—Con: electronic flash. Electronic flash illumination doesn't exist until the flash fires, and so it can't be measured by the D3200's exposure sensor when the mirror is flipped up during the exposure. Instead, the light must be measured by metering the intensity of a pre-flash that is triggered an instant before the main flash, as it is reflected back to the camera and through the lens. An alternative is to use a sensor built into an external flash itself and measure reflected light that has not traveled through the lens. If you have a do-it-yourself bent, there are the hand-held flash meters I already mentioned, which include models that measure both flash and continuous light.
- Evenness of illumination—Pro/con: continuous lighting. Of continuous light sources, daylight, in particular, provides illumination that tends to fill an image completely, lighting up the foreground, background, and your subject almost equally. Shadows do come into play, of course, so you might need to use reflectors or fill-in light sources to even out the illumination further, but barring objects that block large sections of your image from daylight, the light is spread fairly evenly. Indoors, however, continuous lighting is commonly less evenly distributed. The average living room, for example, has hot spots and dark corners. But on the plus side, you can see this uneven illumination and compensate with additional lamps.
- Evenness of illumination—Con: electronic flash. Electronic flash units (like continuous light sources such as lamps that don't have the advantage of being located 93 million miles from the subject) suffer from the effects of their proximity. The *inverse square law*, first applied to both gravity and light by Sir Isaac Newton, dictates that as a light source's distance increases from the subject, the amount of light reaching the subject falls off proportionately to the square of the distance. In plain English, that means that a flash or lamp that's six feet away from a subject

Figure 11.3
A light source that is twice as far away provides only one-quarter as much illumination.

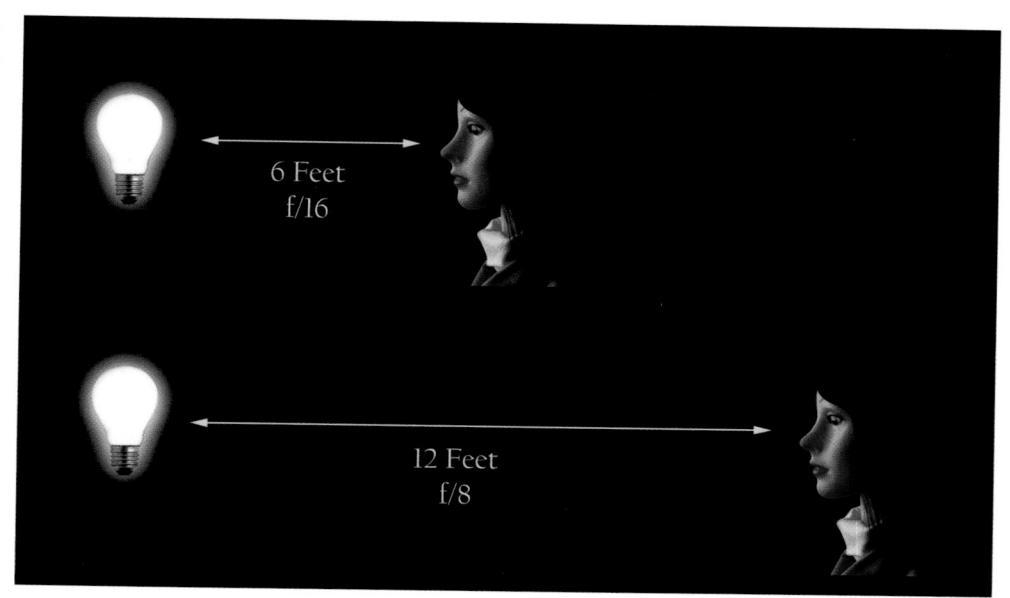

provides only one-quarter as much illumination as a source that's 12 feet away (rather than half as much). (See Figure 11.3.) This translates into relatively shallow "depth-of-light."

- Action stopping—Con: continuous lighting. Action stopping with continuous light sources is completely dependent on the shutter speed you've dialed in on the camera. And the speeds available are dependent on the amount of light available and your ISO sensitivity setting. Outdoors in daylight, there will probably be enough sunlight to let you shoot at 1/2,000th second and f/6.3 with a non-grainy sensitivity setting of ISO 400. That's a fairly useful combination of settings if you're not using a super-telephoto with a small maximum aperture. But inside, the reduced illumination quickly has you pushing your D3200 to its limits. For example, if you're shooting indoor sports, there probably won't be enough available light to allow you to use a 1/2,000th second shutter speed (although I routinely shoot indoor basketball with my D3200 at ISO 1600 and 1/500th second at f/4). In many indoor sports situations, you may find yourself limited to 1/500th second or slower.
- Action stopping—Pro: electronic flash. When it comes to the ability to freeze moving objects in their tracks, the advantage goes to electronic flash. The brief duration of electronic flash serves as a very high "shutter speed" when the flash is the main or only source of illumination for the photo. Your D3200's shutter speed may be set for 1/200th second during a flash exposure, but if the flash illumination predominates, the *effective* exposure time will be the 1/1,000th to 1/50,000th second or less duration of the flash, as you can see in Figure 11.4, because the flash

unit reduces the amount of light released by cutting short the duration of the flash. The only fly in the ointment is that, if the ambient light is strong enough, it may produce a secondary "ghost" exposure, as I'll explain later in this chapter.

■ Cost—Pro: continuous lighting. Fluorescent lamps or incandescent lamps (the use of which will be limited by new efficiency standards that go into effect between 2012 and 2014) are generally much less expensive than electronic flash units, which can easily cost several hundred dollars. I've used everything from desktop high-intensity lamps to reflector flood lights for continuous illumination at very little cost. There are lamps made especially for photographic purposes, too, priced up to \$50 or so. Maintenance is economical, too; many incandescent or fluorescents use bulbs that cost only a few dollars.

Figure 11.4
Electronic flash can freeze almost any action.

- Cost—Con: electronic flash. Electronic flash units aren't particularly cheap. The lowest-cost dedicated flash designed specifically for the Nikon dSLRs is about \$120. Such units are limited in features, however, and intended for those with entry-level cameras. Plan on spending some money to get the features that a sophisticated electronic flash offers.
- Flexibility—Con: continuous lighting. Because incandescent and fluorescent lamps are not as bright as electronic flash, the slower shutter speeds required (see "Action stopping," above) mean that you may have to use a tripod more often, especially when shooting portraits. The incandescent variety of continuous lighting gets hot, especially in the studio, and the side effects range from discomfort (for your human models) to disintegration (if you happen to be shooting perishable foods like ice cream). The heat also makes it more difficult to add filtration to incandescent sources.
- Flexibility—Pro: electronic flash. Electronic flash's action-freezing power allows you to work without a tripod in the studio (and elsewhere), adding flexibility and speed when choosing angles and positions. Flash units can be easily filtered, and, because the filtration is placed over the light source rather than the lens, you don't need to use high-quality filter material. For example, Roscoe or Lee lighting gels, which may be too flimsy to use in front of the lens, can be mounted or taped in front of your flash with ease.

Continuous Lighting Basics

While continuous lighting and its effects are generally much easier to visualize and use than electronic flash, there are some factors you need to take into account, particularly the color temperature of the light. (Color temperature concerns aren't exclusive to continuous light sources, of course, but the variations tend to be more extreme and less predictable than those of electronic flash, which output relatively consistent daylight-like illumination.)

Color temperature, in practical terms, is how "bluish" or how "reddish" the light appears to be to the digital camera's sensor. Indoor illumination is quite warm, comparatively, and appears reddish to the sensor. Daylight, in contrast, seems much bluer to the sensor. Our eyes (our brains, actually) are quite adaptable to these variations, so white objects don't appear to have an orange tinge when viewed indoors, nor do they seem excessively blue outdoors in full daylight. Yet, these color temperature variations are real and the sensor is not fooled. To capture the most accurate colors, we need to take the color temperature into account in setting the color balance (or *white balance*) of the D3200—either automatically using the camera's smarts or manually using our own knowledge and experience.

When using the Nikon D3200, you don't need to think in terms of actual color temperature (although you can measure existing color temperature using the Preset feature described later), because the camera won't let you set white balance using color temperature values, which are measured in *degrees Kelvin*. But it is useful to know that warmer (more reddish) color temperatures (measured in degrees Kelvin) are the *lower* numbers, while cooler (bluer) color temperatures are *higher* numbers. It might not make sense to say that 3,400K is warmer than 6,000K, but that's the way it is. If it helps, think of a glowing red ember contrasted with a white-hot welder's torch, rather than fire and ice.

You can set white balance by type of illumination, and then fine-tune it in the D3200 using the Shooting menu's White Balance option, as described in Chapter 4. The Nikon D3200 will usually do an acceptable job of calculating white balance for you, so Auto can be used most of the time. Use the preset values or set a custom white balance that matches the current shooting conditions.

Remember that if you shoot RAW, you can specify the white balance of your image when you import it into Photoshop, Photoshop Elements, or another image editor using Nikon Capture NX, Adobe Camera Raw, or your preferred RAW converter. While color-balancing filters that fit on the front of the lens exist, they are primarily useful for film cameras, because film's color balance can't be tweaked as extensively as that of a sensor.

Daylight

Daylight is produced by the sun, and so is moonlight (which is just reflected sunlight). Daylight is present, of course, even when you can't see the sun. When sunlight is direct, it can be bright and harsh. If daylight is diffused by clouds, softened by bouncing off objects such as walls or your photo reflectors, or filtered by shade, it can be much dimmer and less contrasty.

Daylight's color temperature can vary quite widely. It is highest in temperature (most blue) at noon when the sun is directly overhead, because the light is traveling through a minimum amount of the filtering layer we call the atmosphere. The color temperature at high noon may be 6,000K. At other times of day, the sun is lower in the sky and the particles in the air provide a filtering effect that warms the illumination to about 5,500K for most of the day. Starting an hour before dusk and for an hour after sunrise, the warm appearance of the sunlight is even visible to our eyes when the color temperature may dip to 5,000-4,500K, as shown in Figure 11.5.

Figure 11.5 At dawn and dusk, the color temperature of daylight may dip as low as 4,500K, and at sunset can go even lower.

Incandescent/Tungsten Light

The term incandescent or tungsten illumination is usually applied to the direct descendents of Thomas Edison's original electric lamp. Such lights consist of a glass bulb that contains a vacuum, or is filled with a halogen gas, and contains a tungsten filament that is heated by an electrical current, producing photons and heat. Tungsten-halogen lamps are a variation on the basic light bulb, using a more rugged (and longer-lasting) filament that can be heated to a higher temperature, housed in a thicker glass or quartz envelope, and filled with iodine or bromine ("halogen") gases. The higher temperature allows tungsten-halogen (or quartz-halogen/quartz-iodine, depending on their construction) lamps to burn "hotter" and whiter. Although popular for automobile headlamps today, they've also been used for photographic illumination.

The other qualities of this type of lighting, such as contrast, are dependent on the distance of the lamp from the subject, type of reflectors used, and other factors that I'll explain later in this chapter.

Fluorescent Light/Other Light Sources

Fluorescent light has some advantages in terms of illumination, but some disadvantages from a photographic standpoint. This type of lamp generates light through an electrochemical reaction that emits most of its energy as visible light, rather than heat, which is why the bulbs don't get as hot. The type of light produced varies depending on the phosphor coatings and type of gas in the tube. So, the illumination fluorescent bulbs produce can vary widely in its characteristics.

That's not great news for photographers. Different types of lamps have different "color temperatures" that can't be precisely measured in degrees Kelvin, because the light isn't produced by heating. Worse, fluorescent lamps have a discontinuous spectrum of light that can have some colors missing entirely. A particular type of tube can lack certain shades of red or other colors (see Figure 11.6), which is why fluorescent lamps and other alternative technologies such as sodium-vapor illumination can produce ghastly looking

Figure 11.6
The uncorrected fluorescent lighting in the gym added a distinct greenish cast to this image when exposed with a daylight white balance setting.

human skin tones if the white balance isn't set correctly. Their spectra can lack the reddish tones we associate with healthy skin and emphasize the blues and greens popular in horror movies.

There is good news, however. There are special fluorescent and LED lamps compatible with the Spiderlite lighting fixtures sold through dealers affiliated with the F. J. Westcott Company (www.fjwestcott.com), designed especially for photography, with the color balance and other properties required. They can be used for direct light, placed in soft boxes (described later), and used in other ways.

Adjusting White Balance

I showed you how to adjust white balance in Chapter 4, using the D3200's built-in presets and white balance shift capabilities.

In most cases, however, the D3200 will do a good job of calculating white balance for you, so Auto can be used as your choice most of the time. Use the preset values or set a custom white balance that matches the current shooting conditions when you need to. The only really problematic light sources are likely to be fluorescents. Vendors, such as GE and Sylvania, may actually provide a figure known as the *color rendering index* (or CRI), which is a measure of how accurately a particular light source represents standard colors, using a scale of 0 (some sodium-vapor lamps) to 100 (daylight and most incandescent lamps). Daylight fluorescents and deluxe cool white fluorescents might have a CRI of about 79 to 95, which is perfectly acceptable for most photographic applications. Warm white fluorescents might have a CRI of 55. White deluxe mercury vapor lights are less suitable with a CRI of 45, while low-pressure sodium lamps can vary from CRI 0-18.

Electronic Flash Basics

Until you delve into the situation deeply enough, it might appear that serious photographers have a love/hate relationship with electronic flash. You'll often hear that flash photography is less natural looking, and that the built-in flash in most cameras should never be used as the primary source of illumination because it provides a harsh, garish look. Indeed, most "pro" cameras like the Nikon D3/D3x don't have a built-in flash at all. Available ("continuous") lighting is praised, and built-in flash photography seems to be roundly denounced.

In truth, however, the bias is against *bad* flash photography. Indeed, flash has become the studio light source of choice for pro photographers, because it's more intense (and its intensity can be varied to order by the photographer), freezes action, frees you from using a tripod (unless you want to use one to lock down a composition), and has a snappy, consistent light quality that matches daylight. (While color balance changes as

the flash duration shortens, some Nikon flash units can communicate to the camera the exact white balance provided for that shot.) And even pros will cede that the built-in flash of the Nikon D3200 has some important uses as an adjunct to existing light, particularly to illuminate dark shadows using a technique called *fill flash*.

But electronic flash isn't as inherently easy to use as continuous lighting. As I noted earlier, electronic flash units are more expensive, don't show you exactly what the lighting effect will be (unless you use a second source called a *modeling light* for a preview), and the exposure of electronic flash units is more difficult to calculate accurately.

How Electronic Flash Works

The bursts of light we call electronic flash are produced by a flash of photons generated by an electrical charge that is accumulated in a component called a *capacitor* and then directed through a glass tube containing xenon gas, which absorbs the energy and emits the brief flash. For the pop-up flash built into the D3200, the full burst of light lasts about 1/1,000th second and provides enough illumination to shoot a subject 10 feet away at f/4 using the ISO 100 setting. In a more typical situation, you'd use ISO 200, f/5.6 to f/8 and photograph something 8 to 10 feet away. As you can see, the built-in flash is somewhat limited in range; you'll see why external flash units are often a good idea later in this chapter.

An electronic flash (whether built in or connected to the D3200 through a cable plugged into a hot shoe adapter) is triggered at the instant of exposure, during a period when the sensor is fully exposed by the shutter. As I mentioned earlier in this book, the D3200 has a vertically traveling shutter that consists of two curtains. The first curtain opens and moves to the opposite side of the frame, at which point the shutter is completely open. The flash can be triggered at this point (so-called *first-curtain sync*), making the flash exposure. Then, after a delay that can vary from 30 seconds to 1/200th second (with the D3200; other cameras may sync at a faster or slower speed), a second curtain begins moving across the sensor plane, covering up the sensor again. If the flash is triggered just before the second curtain starts to close, then *rear-curtain sync* (also called *second-curtain sync*) is used. In both cases, though, a shutter speed of 1/200th second is the maximum that can be used to take a photo.

Figure 11.7 illustrates how this works, with a fanciful illustration of a generic shutter (your D3200's shutter does *not* look like this, and some vertically traveling shutters move bottom to top rather than the top-to-bottom motion shown). Both curtains are tightly closed at upper left. At upper right, the first curtain begins to move downward, starting to expose a narrow slit that reveals the sensor behind the shutter. At lower left, the first curtain moves downward farther until, as you can see at lower right in the figure, the sensor is fully exposed.

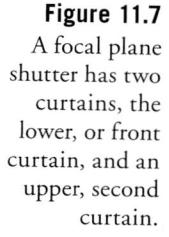

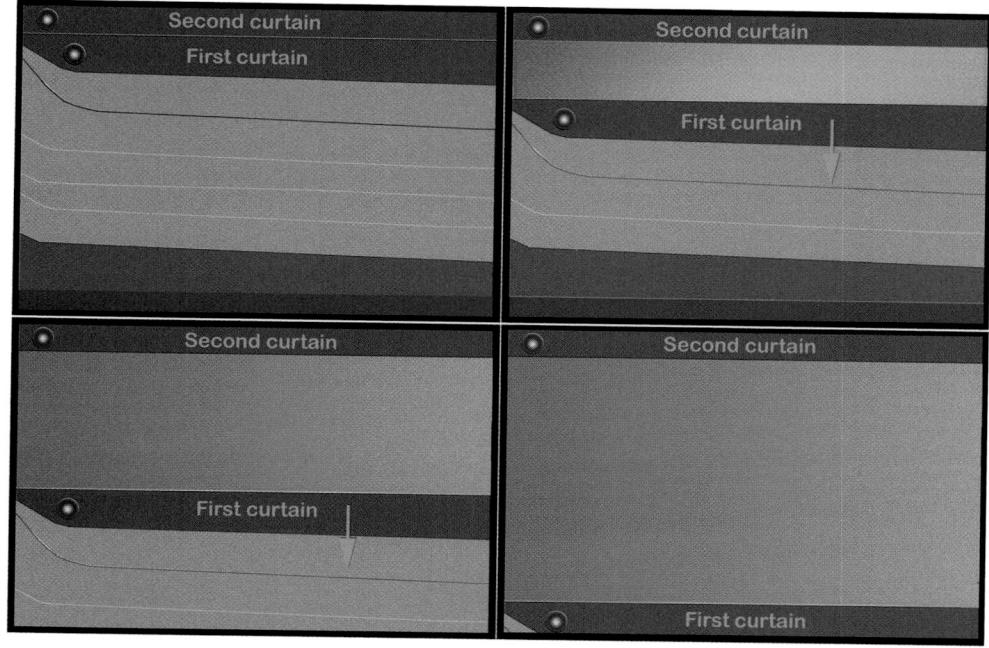

When first-curtain sync is used, the flash is triggered at the instant that the sensor is completely exposed. The shutter then remains open for an additional length of time (from 30 seconds to 1/200th second), and the second curtain begins to move downward, covering the sensor once more. When second-curtain sync is activated, the flash is triggered *after* the main exposure is over, just before the second curtain begins to move downward.

Ghost Images

The difference between triggering the flash when the shutter just opens, or just when it begins to close might not seem like much. But whether you use first-curtain sync (the default setting) or second-curtain sync (an optional setting) can make a significant difference to your photograph *if the ambient light in your scene also contributes to the image.*

At faster shutter speeds, particularly 1/200th second, there isn't much time for the ambient light to register, unless it is very bright. It's likely that the electronic flash will provide almost all the illumination, so first-curtain sync or second-curtain sync isn't very important. However, at slower shutter speeds, or with very bright ambient light levels, there is a significant difference, particularly if your subject is moving, or the camera isn't steady.

In any of those situations, the ambient light will register as a second image accompanying the flash exposure, and if there is movement (camera or subject), that additional image will not be in the same place as the flash exposure. It will show as a ghost image and, if the movement is significant enough, as a blurred ghost image trailing in front of or behind your subject in the direction of the movement.

As I noted, when you're using first-curtain sync, the flash's main burst goes off the instant the shutter opens fully (a pre-flash used to measure exposure in auto flash modes fires *before* the shutter opens). This produces an image of the subject on the sensor. Then, the shutter remains open for an additional period (30 seconds to 1/200th second, as I said). If your subject is moving, say, towards the right side of the frame, the ghost image produced by the ambient light will produce a blur on the right side of the original subject image, making it look as if your sharp (flash-produced) image is chasing the ghost. For those of us who grew up with lightning-fast superheroes who always left a ghost trail *behind them*, that looks unnatural (see Figure 11.8).

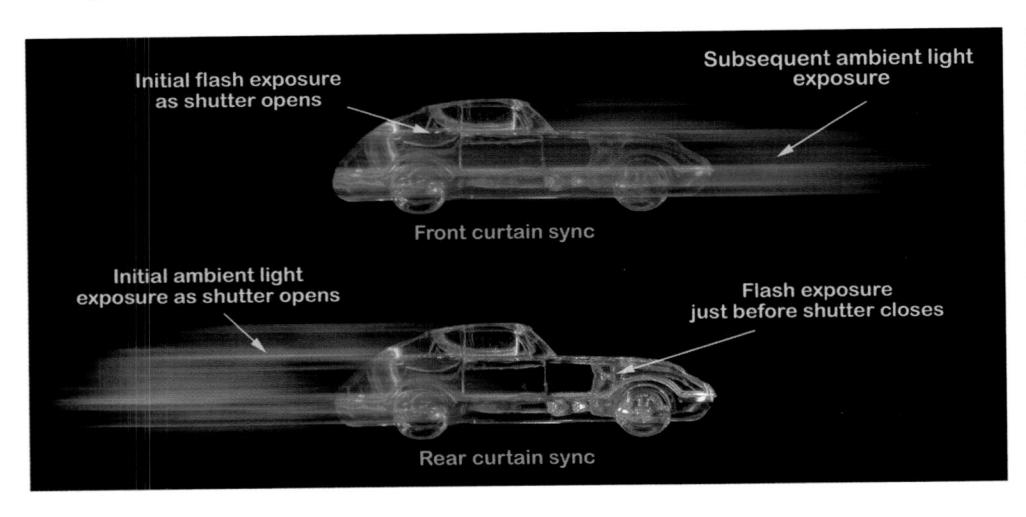

Figure 11.8
First-curtain sync produces an image that trails in front of the flash exposure (top), while second-curtain sync creates a more "natural looking" trail behind the flash image.

So, Nikon uses second-curtain sync to remedy the situation. In that mode, the shutter opens, as before. The shutter remains open for its designated duration, and the ghost image forms. If your subject moves from the left side of the frame to the right side, the ghost will move from left to right, too. *Then*, about 1.5 milliseconds before the second shutter curtain closes, the flash is triggered, producing a nice, sharp flash image *ahead* of the ghost image. Voilà! We have monsieur *Speed Racer* outdriving his own trailing image.
Avoiding Sync Speed Problems

Using a shutter speed faster than 1/200th second can cause problems. Triggering the electronic flash only when the shutter is completely open makes a lot of sense if you think about what's going on. To obtain shutter speeds faster than 1/200th second, the D3200 exposes only part of the sensor at one time, by starting the second curtain on its journey before the first curtain has completely opened, as shown in Figure 11.9. That effectively provides a briefer exposure as a slit that's narrower than the full height of the sensor passes over the surface of the sensor. If the flash were to fire during the time when the first and second curtains partially obscured the sensor, only the slit that was actually open would be exposed.

You'd end up with only a narrow band, representing the portion of the sensor that was exposed when the picture is taken. For shutter speeds *faster* than 1/200th second, the second curtain begins moving *before* the first curtain reaches the top of the frame. As a result, a moving slit, the distance between the first and second curtains, exposes one portion of the sensor at a time as it moves from the bottom to the top. Figure 11.9 shows three views of our typical (but imaginary) focal plane shutter. At left is pictured the closed shutter; in the middle version you can see the first curtain has moved up about 1/4 of the distance to the top; and in the right-hand version, the second curtain has started to "chase" the first curtain across the frame toward the top.

If the flash is triggered while this slit is moving, only the exposed portion of the sensor will receive any illumination. You end up with a photo like the one shown in Figure 11.10. Note that a band across the bottom of the image is black. That's a shadow of the second shutter curtain, which had started to move when the flash was triggered. Sharpeyed readers will wonder why the black band is at the *bottom* of the frame rather than at the top, where the second curtain begins its journey. The answer is simple: your lens flips the image upside down and forms it on the sensor in a reversed position. You never notice that, because the camera is smart enough to show you the pixels that make up your photo in their proper orientation during picture review. But this image flip is why, if your sensor gets dirty and you detect a spot of dust in the upper half of a test photo, if cleaning manually, you need to look for the speck in the *bottom* half of the sensor.

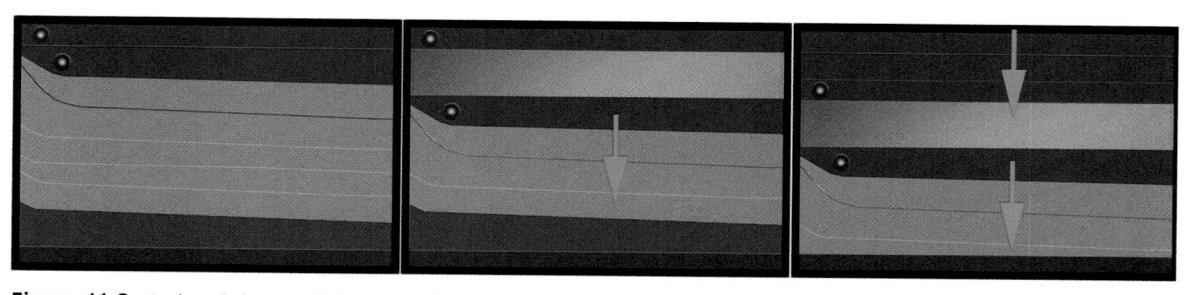

Figure 11.9 A closed shutter (left); partially open shutter as the first curtain begins to move downward (middle); only part of the sensor is exposed as the slit moves (right).

Figure 11.10 If a shutter speed faster than 1/200th second is used, you can end up photographing only a portion of the image.

I generally end up with sync speed problems only when shooting in the studio, using studio flash units rather than my D3200's built-in flash or a Nikon dedicated speed-light. That's because if you're using either type of "smart" flash, the camera knows that a strobe is attached, and remedies any unintentional goof in shutter speed settings. If you happen to set the D3200's shutter to a faster speed in S or M mode, the camera will automatically adjust the shutter speed down to 1/200th second. In A, P, or any of the scene modes, where the D3200 selects the shutter speed, it will never choose a shutter speed higher than 1/200th second when using flash. In P mode, shutter speed is automatically set between 1/60th to 1/200th second when using flash. But when using a non-dedicated flash, such as a studio unit plugged into the D3200's hot shoe connector, the camera has no way of knowing that a flash is connected, so shutter speeds faster than 1/200th second can be set inadvertently.

Determining Exposure

Calculating the proper exposure for an electronic flash photograph is a bit more complicated than determining the settings for continuous light. The right exposure isn't simply a function of how far away your subject is (which the D3200 can figure out based on the autofocus distance that's locked in just prior to taking the picture). Various objects reflect more or less light at the same distance so, obviously, the camera needs to

measure the amount of light reflected back and through the lens. Yet, as the flash itself isn't available for measuring until it's triggered, the D3200 has nothing to measure.

The solution is to fire the flash twice. The initial shot is a *monitor pre-flash* that can be analyzed, then followed virtually instantaneously by a main flash (to the eye the bursts appear to be a single flash) that's given exactly the calculated intensity needed to provide a correct exposure. As a result, the primary flash may be longer in duration for distant objects and shorter in duration for closer subjects, depending on the required intensity for exposure. This through-the-lens evaluative flash exposure system is called i-TTL (intelligent Through-The-Lens), and it operates whenever the pop-up internal flash is used, or you have attached a Nikon dedicated flash unit to the D3200.

Guide Numbers

Guide numbers, usually abbreviated GN, are a way of specifying the power of an electronic flash in a way that can be used to determine the right f/stop to use at a particular shooting distance and ISO setting. In fact, before automatic flash units became prevalent, the GN was actually used to do just that. A GN is usually given as a pair of numbers for both feet and meters that represent the range at ISO 100. For example, the Nikon D3200's built-in flash has a GN in i-TTL mode of 12/39 (meters/feet) at ISO 100. In Manual mode, the true guide number is a fraction higher: 13/43 meters/feet. To calculate the right exposure at that ISO setting, you'd divide the guide number by the distance to arrive at the appropriate f/stop.

Using the D3200's built-in flash as an example, at ISO 100 with its GN of 43 in Manual mode, if you wanted to shoot a subject at a distance of 10 feet, you'd use f/4.3 (43 divided by 10), or, in practice, f/4.0. At 5 feet, an f/stop of f/8 would be used. Some quick mental calculations with the GN will give you any particular electronic flash's range. You can easily see that the built-in flash would begin to peter out at about 13 feet if you stuck to the lowest ISO of 100, because you'd need an aperture of f/2.8. Of course, in the real world you'd probably bump the sensitivity up to a setting of ISO 800 so you could use a more practical f/8 at 13 feet, and the flash would be effective all the way out to 20 feet or more at wider f/stops.

Today, guide numbers are most useful for comparing the power of various flash units, rather than actually calculating what exposure to use. You don't need to be a math genius to see that an electronic flash with a GN in feet of, say, 111.5 at ISO 100 (like the SB-910) would be *a lot* more powerful than your built-in flash. At ISO 100, you could use f/5.6 to shoot as far as 20 feet.

Flash Control

The Nikon D3200's built-in flash has two modes, TTL (in two variations) and Manual. It does not have a repeating flash option, nor can it be used to trigger other Nikon flashes in Commander mode, unlike its siblings the Nikon D90 and above. You can choose between TTL and Manual modes using the Built-In Flash entry in the Shooting menu, as first described in Chapter 4. Note that the label on this menu listing changes to Optional Flash when an external flash is mounted on the D3200 and powered up. You can then make the same flash mode changes for the SB-400 as you can for the built-in flash. Other Nikon external flash units, such as the Nikon SB-910, have additional exposure modes, which I'll discuss later in this chapter. Your Flash Control options are as follows:

- TTL. When the built-in flash is triggered, the D3200 first fires a pre-flash and measures the light reflected back and through the lens to calculate the proper exposure when the full flash is emitted a fraction of a second later. Either i-TTL Balanced Fill-Flash or Standard i-TTL Fill-Flash exposure calculation modes are used. I'll explain these modes next.
- Manual. You can set the level of the built-in flash from full power to 1/32 power. A flash icon blinks in the viewfinder and on the shooting information display when you're using Manual mode, and the built-in flash has been flipped up.

Flash Metering Mode

You don't select the way your flash meters the exposure directly; the two modes, i-TTL Balanced Fill-Flash and Standard i-TTL Fill-Flash, are determined by the camera metering mode—Matrix, Center-weighted, or Spot—that you select. Indeed, the built-in flash in the Nikon D3200, as well as external flash units attached to the camera, use the same three metering modes that are available for continuous light sources: Matrix, Center-weighted, and Spot. So, you can choose the flash's metering mode based on the same subject factors as those explained in reference to non-flash exposure techniques in Chapter 4 (for example, use Spot metering to measure exposure from an isolated subject within the frame). Choice of a metering mode determines how the flash reacts to balance the existing light with the light from the electronic unit:

■ i-TTL Balanced Fill-Flash. This flash mode is used automatically when you choose Matrix or Center-weighted exposure metering. The Nikon D3200 measures the available light and then adjusts the flash output to produce a natural balance between main subject and background. This setting is useful for most photographic situations.

■ Standard i-TTL Fill-Flash. This mode is activated when you use Spot metering or choose the standard mode with an external flash unit's controls. The flash output adjusted only for the main subject of your photograph, and the brightness of the background is not factored in. Use this mode when you want to emphasize the main subject at the expense of proper exposure for the background.

Choosing a Flash Sync Mode

The Nikon D3200 has five flash sync modes that determine when and how the flash is fired (as I'll explain shortly). They are selected from the information edit screen, or by holding down the Flash button on the front of the camera lens housing while rotating the command dial. In both cases, the mode chosen appears in the information edit screen as the selection is made.

Not all sync modes are available with all exposure modes. Depending on whether you're using scene modes, or Program, Aperture-priority, Shutter-priority, or Manual exposure modes, one or more of the following sync modes may not be available. I'm going to list the sync options available for each exposure mode separately, although that produces a little duplication among the options that are available with several exposure modes. However, this approach should reduce the confusion over which sync method is available with which exposure mode.

In Program and Aperture-priority modes you can select these flash modes:

- Front-curtain sync/fill flash. In this mode, represented by a lightning bolt symbol, the flash fires as soon as the front curtain opens completely. The shutter then remains open for the duration of the exposure, until the rear curtain closes. If the subject is moving and ambient light levels are high enough, the movement will cause a secondary "ghost" exposure that appears to be a stream of light advancing ahead of the flash exposure of the same subject. You'll find more on "ghost" exposures next.
- Rear-curtain sync. With this setting, the front curtain opens completely and remains open for the duration of the exposure. Then, the flash is fired and the rear curtain closes. If the subject is moving and ambient light levels are high enough, the movement will cause a secondary "ghost" exposure that appears to stream behind the flash exposure. In Program and Aperture-priority modes, the D3200 will combine rear-curtain sync with slow shutter speeds (just like slow sync, discussed below) to balance ambient light with flash illumination. (It's best to use a tripod to avoid blur at these slow shutter speeds.)
- Red-eye reduction. In this mode, there is a one-second lag after pressing the shutter release before the picture is actually taken, during which the D3200's red-eye reduction lamp lights, causing the subject's pupils to contract (assuming they are looking at the camera), and thus reducing potential red-eye effects. Don't use with moving subjects or when you can't abide the delay.

- Slow sync. This setting allows the D3200 in Program and Aperture-priority modes to use shutter speeds as slow as 30 seconds with the flash to help balance a background illuminated with ambient light with your main subject, which will be lit by the electronic flash. You'll want to use a tripod at slower shutter speeds, of course. As shown in Figure 11.11, it's common that the ambient light will be much warmer than the electronic flash's "daylight" balance, so, if you want the two sources to match, you may want to use a warming filter on the flash. That can be done with a gel if you're using an external flash like the SB-910, or by taping an appropriate warm filter over the D3200's built-in flash. (That's not a convenient approach, and many find the warm/cool mismatch not objectionable and don't bother with filtration.)
- Red-eye reduction with slow sync. This mode combines slow sync with the D3200's red-eye reduction behavior when using Program or Aperture-priority modes.

Figure 11.11 I deliberately used flash and slow sync with a scene otherwise illuminated by tungsten light to create this unconventional mixed-lighting image.

In Shutter-priority and Manual exposure modes, you can select the following three flash synchronization settings:

- Front-curtain sync/fill flash. This setting should be your default setting. This mode is also available in Program and Aperture-priority mode, as described above, and, with high ambient light levels, can produce ghost images, discussed below.
- Red-eye reduction. This mode, with its one-second lag and red-eye lamp flash, is described above.
- Rear-curtain sync. As noted previously, in this sync mode, the front curtain opens completely and remains open for the duration of the exposure. Then, the flash is fired and the rear curtain closes. If the subject is moving and ambient light levels are high enough, the movement will cause that "ghost" exposure that appears to be trailing the flash exposure.

In Auto, Portrait, Child, and Close-Up, scene modes, the following flash sync options are available:

- **Auto.** This setting is the same as front-curtain sync, but the flash pops up automatically in dim lighting conditions.
- Red-eye reduction auto. In this mode, there is a one-second lag after pressing the shutter release before the picture is actually taken, during which the D3200's redeye reduction lamp lights, causing the subject's pupils to contract (assuming they are looking at the camera), and thus reducing potential red-eye effects. Don't use with moving subjects or when you can't abide the delay.
- Flash off. This is not really a sync setting, although it is available from the same selection screen. It disables the flash for those situations in which you absolutely do not want it to pop up and fire.

In Night Portrait mode, only slow synchronization flash and flash off modes are available:

- Auto Slow sync. This setting allows the D3200 to select shutter speeds as slow as 30 seconds with the flash to help balance a background illuminated with ambient light with your main subject, which will be lit by the electronic flash. Best for shooting pictures at night when the subjects in the foreground are important, and you want to avoid a pitch-black background. I recommend using a tripod in this mode.
- Auto Red-eye reduction with slow sync. Another mode that calls for a tripod, this sync setting mode combines slow sync with the D3200's red-eye reduction pre-flash. This is the one to use when your subjects are people who will be facing the camera.
- Flash off. Disables the flash in museums, concerts, religious ceremonies, and other situations in which you absolutely do not want it to pop up and fire.

A Typical Electronic Flash Sequence

Here's what happens when you take a photo using electronic flash, either the unit built into the Nikon D3200 or an external flash like the Nikon SB-700:

- Sync mode. Choose the flash sync mode by holding down the Flash button and rotating the command dial to choose the sync mode, as described above.
- 2. **Metering method.** When working in P, S, A, or M exposure modes, choose the metering method you want, from Matrix, Center-weighted, or Spot metering, using the information edit screen.
- 3. **Activate flash.** Press the flash pop-up button to flip up the built-in flash, or mount (or connect with a cable) an external flash and turn it on. A ready light appears in the viewfinder or on the back of the flash when the unit is ready to take a picture.
- 4. **Check exposure.** Select a shutter speed when using Manual, Program, or Shutter-priority modes; select an aperture when using Aperture-priority and Manual exposure modes. The D3200 will set both shutter speed and aperture if you're using a scene mode.
- 5. Take photo. Press the shutter release down all the way.
- D3200 receives distance data. A D- or G-series lens now supplies focus distance to the D3200.
- 7. **Pre-flash emitted.** The internal flash, if used, or external flash sends out one pre-flash burst used to determine exposure.
- 8. Exposure calculated. The pre-flash bounces back and is measured by the 420-pixel RGB sensor in the viewfinder. It measures brightness and contrast of the image to calculate exposure. If you're using Matrix metering, the D3200 evaluates the scene to determine whether the subject may be backlit (for fill flash), or a subject that requires extra ambient light exposure to balance the scene with the flash exposure, or classifies the scene in some other way. The camera to subject information as well as the degree of sharp focus of the subject matter is used to locate the subject within the frame. If you've selected Spot metering, only standard i-TTL (without balanced fill-flash) is used.
- 9. Mirror up. The mirror flips up. At this point exposure and focus are locked in.
- 10. **Flash fired.** At the correct triggering moment (depending on whether front or rear sync is used), the camera sends a signal to one or more flashes to start flash discharge. The flash is quenched as soon as the correct exposure has been achieved.
- 11. **Shutter closes.** The shutter closes and mirror flips down. You're ready to take another picture.

12. **Exposure confirmed.** Ordinarily, the full charge in the flash may not be required. If the flash indicator in the viewfinder blinks for about three seconds after the exposure, that means that the entire flash charge was required, and it *could* mean that the full charge wasn't enough for a proper exposure. Be sure to review your image on the LCD to make sure it's not underexposed, and, if it is, make adjustments (such as increasing the ISO setting of the D3200) to remedy the situation.

Working with Nikon Flash Units

If you want to work with dedicated Nikon flash units, at this time you have five choices: the D3200's built-in flash, the Nikon SB-910, SB-700, SB-400 on-camera flash units, and the SB-R200 wireless remote flash. These share certain features, which I'll discuss while pointing out differences among them. Nikon may introduce additional flash units during the life of this book, but the current batch and the Nikon Creative Lighting System ushered in with them were significant steps forward.

Nikon D3200 Built-in Flash

In automatic mode, the built-in flash has a guide number of 12/39 (meters/feet) at ISO 100, and must be activated by manually flipping it up when not using one of the scene modes that feature automatic pop-up. This flash is powerful enough to provide primary direct flash illumination when required, but can't be angled up for diffuse bounce flash off the ceiling. It's useful for balanced fill flash. You can use Manual flash mode and the Built-in Flash settings in the Shooting menu to dial down the intensity of the built-in flash to 1/32 power.

Changing settings is easy:

- Elevate the built-in flash. Press the Flash button on the front left side of the viewfinder housing to pop up the flash.
- Choose sync mode. If you want to change the flash sync mode, after the flash is elevated, hold down the Flash button and rotate the main dial. The sync mode you've selected will appear on the shooting information screen.
- **Apply flash exposure compensation.** If your pictures in a session are consistently overexposed or underexposed, you can dial in flash compensation by holding down the compensation button (just southeast of the shutter release) and the Flash button at the same time, and rotating the main dial. The amount of compensation from +1.0 to -3.0EV is displayed on the shooting information screen.
- Use the information edit screen. You can also choose sync mode and flash compensation using the information edit screen. Press the Info button twice, navigate to the function you want to adjust, press OK, and use the up/down buttons to enter the value.

■ Set color temperature. The D3200's Auto color temperature setting will adjust for the built-in flash nicely. But there might be times when you want to set the color temperature manually. For example, you might be shooting under incandescent illumination and have put an orange gel over your internal or external flash so both light sources match. You'd want to set the color temperature manually to incandescent. Or, you might want to use an odd-ball setting as a special effect. Use the information edit screen to adjust the color temperature to Flash, Incandescent, or any of the other choices, as described in Chapter 4.

Because the built-in flash draws its power from the D3200's battery, extensive use will reduce the power available to take pictures. For that reason alone, use of an external flash unit can be a good idea when you plan to take a lot of flash pictures.

Nikon SB-910

The Nikon SB-910 and its predecessor the SB-900 (see Figure 11.12, which shows the SB-900 mounted off camera with a connecting cable) are currently the flagships of the Nikon flash line up, and have a guide number of 34/111.5 (meters/feet) when the "zooming" flash head (which can be set to adjust the coverage angle of the lens) is set to the 35mm position. They have all the features of the D3200's flash unit, plus Commander mode (which allows them to trigger other flash units wirelessly), repeating flash, modeling light, and selectable power output, along with some extra capabilities.

For example, you can angle the flash and rotate it to provide bounce flash. It includes additional, non-through-the-lens exposure modes, thanks to its built-in light sensor,

Figure 11.12 The Nikon SB-910 and SB-900 (shown in the figure) are currently the flagships of the Nikon electronic flash line up.

and can "zoom" and diffuse its coverage angle to illuminate the field of view of lenses from 8mm (with the wide angle/diffusion dome attached) to 120mm on a D3200. The SB-910 also has its own powerful focus assist lamp to aid autofocus in dim lighting, and has reduced red-eye effects simply because the unit, when attached to the D3200, is mounted in a higher position that tends to eliminate reflections from the eye back to the camera lens.

Nikon SB-700

This lower-cost unit (see Figure 11.13) has a guide number of 28/92 (meters/feet) at ISO 100 when set to the 35mm zoom position. It has many of the SB-910's features, including zoomable flash coverage equal to the field of view of a 16-56mm lens on the D3200 (24-120mm settings with a full-frame camera), and 14mm with a built-in diffuser panel. It has a built-in modeling flash feature, but lacks repeating flash, accessory filters, and an included flash diffuser dome, which can be purchased separately.

Nikon SB-400

The entry-level SB-400 (see Figure 11.14) is a good choice for most Nikon D3200 applications. It's built specifically for entry-level Nikon cameras like the D40 or D3200,

Figure 11.13 The Nikon SB-700 is a popular medium-priced electronic flash with most of the features of the SB-900.

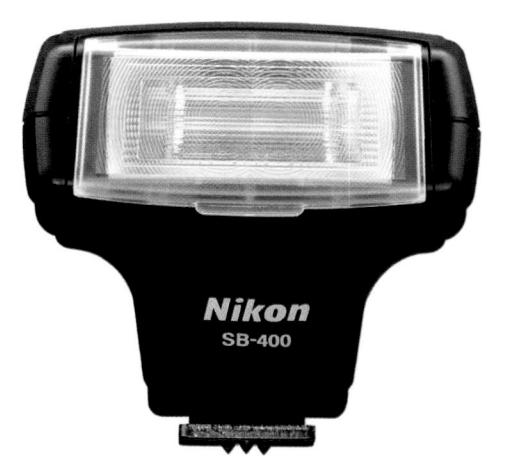

Figure 11.14 The Nikon SB-400 is an entry-level flash best suited for Nikon's entry-level dSLRs.

and has a limited, easy-to-use feature set. It has a limited ISO 100 guide number of 21/68 at the 18mm zoom-head position. It tilts up for bounce flash to 90 degrees, with click detents at the 0, 60, 75, and 90 degree marks. Unless you feel the need for an emergency flash or fill-flash unit that's only slightly more powerful than the D3200's built-in flash, for the most flexibility, you might want to consider the SB-700.

Nikon SB-R200

This is a specialized wireless-only flash (see Figure 11.15) that's especially useful for close-up photography, and is often purchased in pairs for use with the Nikon R1 and R1C1 Wireless Close-Up Speedlight systems. Its output power is low at 10/33 (meters/feet) for ISO 100 as you might expect for a unit used to photograph subjects that are often inches from the camera. It has a fixed coverage angle of 78 degrees horizontal and 60 degrees vertical, but the flash head tilts down to 60 degrees and up to 45 degrees (with detents every 15 degrees in both directions). In this case, "up" and "down" has a different meaning, because the SB-R200 can be mounted on the SX-1 Attachment Ring mounted around the lens, so the pair of flash units are on the sides and titled toward or away from the optical axis. It supports i-TTL, D-TTL, TTL (for film cameras), and Manual modes.

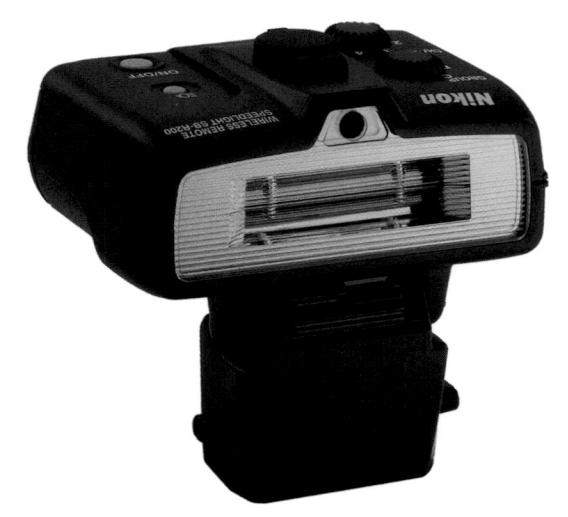

Figure 11.15
The Nikon
SB-R200 is a
wireless macroonly flash supplied with the
Nikon R1 and
R1C1 Wireless
Close-Up
Speedlight
systems.

Flash Techniques

This next section will discuss using specific features of the Nikon D3200's built-in flash, as well as those of the Nikon dedicated external flash units. It's not possible to discuss every feature and setting of the external flash units in this chapter (entire books have been written to do that), so I'll simply provide an overview here.

Using the Zoom Head

External flash zoom heads can adjust themselves automatically to match lens focal lengths in use reported by the D3200 to the flash unit, or you can adjust the zoom head position manually. With flash units prior to the SB-910 and SB-700, automatic zoom adjustment wasted some of your flash's power, because the flash unit assumed that the focal length reported comes from a full-frame camera. Because of the 1.5X crop factor, the flash coverage when the flash is set to a particular focal length was wider than is required by the D3200's cropped image. The SB-900, on the other hand, automatically determines whether your camera is an FX-format, full-frame model, or is a DX "cropped sensor" model like the Nikon D3200, and adjusts coverage angle to suit.

You can manually adjust the zoom position yourself, if you want the flash coverage to correspond to something other than the focal length in use. Just press the Zoom button on the SB-910, and turn the selector dial clockwise to increase the zoom value, or counterclockwise to decrease the zoom value. You can also adjust the zoom position by repeatedly pressing the Zoom button.

Flash Modes

The external flash units have various flash modes included, which are available or not available with different camera models (both film and digital types, dating back many years). They are categorized by Nikon into nine different groups, which may be confusing to new digital camera owners who probably haven't heard of most of these cameras. While a table showing most of the groups is included in the manuals for the external flash units, the table is irrelevant for D3200 users (unless you happen to own an older digital or film SLR, as well). For digital cameras, there are only two main groups: digital cameras *not* compatible with the Nikon Creative Lighting System (Nikon D1-series cameras, and the Nikon D100), and digital cameras that *are* compatible with CLS (including the D3200). Groups I through VII, which support various combinations of features, consist of various film SLRs. You can ignore those options, unless you're using your external flash with an older film camera.

The TTL automatic flash modes available for the SB-910 are as follows:

- AA. Auto Aperture flash. The SB-910 uses a built-in light sensor to measure the amount of flash illumination reflected back from the subject, and adjusts the output to produce an appropriate exposure based on the ISO, aperture, focal length, and flash compensation values set on the D3200. This setting on the flash can be used with the D3200 in Program or Aperture-priority modes.
- A. Non-TTL Auto flash. The SB-910's sensor measures the flash illumination reflected back from the subject, and adjusts the output to provide an appropriate exposure. This setting on the flash can be used when the D3200 is set to Aperture-priority or Manual modes. You can use this setting to manually "bracket"

exposures, as adjusting the aperture value of the lens will produce more or less exposure.

- **GN.** Distance priority manual. You enter a distance value, and the SB-910 adjusts light output based on distance, ISO, and aperture to produce the right exposure in either Aperture-priority or Manual exposure modes. Press the Mode button on the flash until the GN indicator appears, then press the SEL button to highlight the distance display, using the plus and minus buttons to enter the distance value you want (from 1 to 65.6 feet, or 0.3 to 20 meters). The SB-800 will indicate a recommended aperture, which you then set on the lens mounted on the D3200.
- M. Manual flash. The flash fires at a fixed output level. Press the MODE button until M appears on the SB-910's LCD panel. Press the SEL button and the plus or minus buttons to increase or decrease the output value of the flash. Use the table in the flash manual to determine a suggested aperture setting for a given distance. Then, set that aperture on the D3200 in either Aperture-priority or Manual exposure modes.
- RPT. Repeating flash. The flash fires repeatedly to produce a multiple flash strobing effect. To use this mode, set the D3200's exposure mode to Manual. Then set up the number of repeating flashes per frame, frequency, and flash output level on the SB-910.

BURN OUT

When using repeating flash with the SB-910/900, or *any* large number of consecutive flashes in any mode (more than about 15 shots at full power), allow the flash to cool off (Nikon recommends a 10-minute time out) to avoid overheating the flash. The SB-900 will signal you with a warning chime that rings twice when it's time for a cooling-off period. The flash will actually disable itself, if necessary, to prevent damage. The newer SB-910 has circuitry that lengthens recycle time as the flash heats up, postponing the overheating phase long enough that you may be able to complete your shooting session.

Working with Wireless Commander Mode

The D3200's built-in flash cannot be set to Commander mode and used to control other compatible flash units. However, if you mount one of several compatible external dedicated flash units, such as the Nikon SB-910, it can serve as a flash "Commander" to communicate with and trigger other flash units. Nikon offers a unit called the SU-800, which is a commander unit that has no built-in visible flash, and which controls other units using infrared signals.

The SU-800 has several advantages. It's useful for cameras like the D3200, which lacks a Commander mode, and several "pro" cameras, like the D4, D3x, D3, D3s, and D2xs, which have no built-in flash to function in Commander mode. The real advantage the SU-800 has is its "reach." Because it uses IR illumination rather than visible light to communicate with remote flashes, the infrared burst can be much stronger, doubling its effective control range to 66 feet.

Once you have set the flash as the Master/Commander, you can specify a shooting mode, either Manual with a power output setting you determine from 1/1 to 1/128 or for TTL automatic exposure. When using TTL, you can dial in from –1.0 to +3.0 flash exposure compensation for the master flash. You can also specify a channel (1, 2, 3, or 4) that all flashes will use to communicate among themselves. (If other Nikon photographers are present, choosing a different channel prevents your flash from triggering their remotes, and vice versa.)

Each remote flash unit can also be set to one of three groups (A, B, or C), so you can set the exposure compensation and exposure mode of each group separately. For example, one or more flashes in one group can be reduced in output compared to the flashes in the other group, to produce a particular lighting ratio of effect. You'll find instructions for setting exposure mode, channel, and compensation next (for the built-in flash).

Connecting External Flash

You have three basic choices for linking an external flash unit to your Nikon D3200. They are as follows:

- Mount on the accessory shoe. Sliding a compatible flash unit into the Nikon D3200's accessory shoe provides a direct connection. With a Nikon dedicated flash, all functions of the flash are supported.
- (shown back in Figure 11.12) and SC-29 TTL coiled remote cords have an accessory shoe on one end of a nine-foot cable to accept a flash, and a foot that slides into the camera accessory shoe on the other end, providing a link that is the same as when the flash is mounted directly on the camera. The SC-29 version also includes a focus assist lamp, like that on the camera and SB-910. You can also use an adapter in the accessory shoe that accepts a standard flash cable. In all cases, you should make sure that the external flash doesn't use a triggering voltage high enough to "fry" your camera's circuitry. You'll find more information on this, and recommendations for a voltage isolator to prevent problems, later in this chapter.
- Wireless link. An external Nikon electronic flash can be triggered by another Master flash such as the Nikon SB-910 in Commander mode or by the SU-800 infrared unit. You can also use a wireless controller like the radio unit shown in Figure 11.16.

Figure 11.16
Wireless flash
control.

More Advanced Lighting Techniques

As you advance in your Nikon D3200 photography, you'll want to learn more sophisticated lighting techniques, using more than just straight-on flash, or using just a single flash unit. Entire books have been written on lighting techniques (check out *David Busch's Quick Snap Guide to Lighting*). I'm going to provide a quick introduction to some of the techniques you should be considering.

Diffusing and Softening the Light

Direct light can be harsh and glaring, especially if you're using the flash built in to your camera, or an auxiliary flash mounted in the hot shoe and pointed directly at your subject. The first thing you should do is stop using direct light (unless you're looking for a stark, contrasty appearance as a creative effect). There are a number of simple things you can do with both continuous and flash illumination.

■ Use window light. Light coming in a window can be soft and flattering, and a good choice for human subjects. Move your subject close enough to the window that its light provides the primary source of illumination. You might want to turn off other lights in the room, particularly to avoid mixing daylight and incandescent light.

- Use fill light. Your D3200's built-in flash makes a perfect fill-in light for the shadows, brightening inky depths with a kicker of illumination (see Figure 11.17).
- **Bounce the light.** External electronic flash units mounted on the D3200 usually have a swivel that allows them to be pointed up at a ceiling for a bounce light effect. You can also bounce the light off a wall. You'll want the ceiling or wall to be white or have a neutral gray color to avoid a color cast.

Figure 11.17
Fill flash illuminated the shadows for this candid portrait.

- Use reflectors. Another way to bounce the light is to use reflectors or umbrellas that you can position yourself to provide a greater degree of control over the quantity and direction of the bounced light. Good reflectors can be pieces of foamboard, Mylar, or a reflective disk held in place by a clamp and stand. Although some expensive umbrellas and reflectors are available, spending a lot isn't necessary. A simple piece of white foamboard does the job beautifully. Umbrellas have the advantage of being compact and foldable, while providing a soft, even kind of light. They're relatively cheap, too, with a good 40-inch umbrella available for as little as \$20.
- Use diffusers. Nikon supplies a Sto-Fen-style diffuser dome with the SB-910 flash. You can purchase a similar diffuser for the SB-700 from Nikon, Sto-Fen, and some other vendors that offer clip-on diffusers. The two examples shown in Figures 11.18 and 11.19 fit over your electronic flash head and provide a soft, flattering light. These add-ons are more portable than umbrellas and other reflectors, yet provide a nice diffuse lighting effect.

Figure 11.18 This diffuser dome is provided by Nikon with the SB-910, and softens the light of an external flash unit.

Figure 11.19 Soft boxes use Velcro strips to attach them to just about any shoe-mount flash unit.

Using Multiple Light Sources

Once you gain control over the qualities and effects you get with a single light source, you'll want to graduate to using multiple light sources. Using several lights allows you to shape and mold the illumination of your subjects to provide a variety of effects, from backlighting to side lighting to more formal portrait lighting. You can start simply with several incandescent light sources, bounced off umbrellas or reflectors that you construct. Or you can use more flexible multiple electronic flash setups.

Effective lighting is the one element that differentiates great photography from candid or snapshot shooting. Lighting can make a mundane subject look a little more glamorous. Make subjects appear to be soft when you want a soft look, or bright and sparkly when you want a vivid look, or strong and dramatic if that's what you desire. As you might guess, having control over your lighting means that you probably can't use the lights that are already in the room. You'll need separate, discrete lighting fixtures that can be moved, aimed, brightened, and dimmed on command.

Selecting your lighting gear will depend on the type of photography you do, and the budget you have to support it. It's entirely possible for a beginning D3200 photographer to create a basic, inexpensive lighting system capable of delivering high-quality results for a few hundred dollars, just as you can spend megabucks (\$1,000 and up) for a sophisticated lighting system.

Basic Flash Setups

If you want to use multiple electronic flash units, the Nikon speedlights described earlier will serve admirably. The higher-end models can be used with Nikon's wireless i-TTL features, which allow you to set up to three separate groups of flash units (several flashes can be included in each group) and trigger them using a master flash and the camera. Just set up one master unit, and arrange the compatible slave units around your subject. You can set the relative power of each unit separately, thereby controlling how much of the scene's illumination comes from the main flash, and how much from the auxiliary flash units, which can be used as fill flash, background lights, or, if you're careful, to illuminate the hair of portrait subjects.

Studio Flash

If you're serious about using multiple flash units, a studio flash setup might be more practical. The traditional studio flash is a multi-part unit, consisting of a flash head that mounts on your light stand, and is tethered to an AC (or sometimes battery) power supply. A single power supply can feed two or more flash heads at a time, with separate control over the output of each head.

When they are operating off AC power, studio flash don't have to be frugal with the juice, and are often powerful enough to illuminate very large subjects or to supply lots and lots of light to smaller subjects. The output of such units is measured in watt seconds (ws), so you could purchase a 200ws, 400ws, or 800ws unit, and a power pack to match.

Their advantages include greater power output, much faster recycling, built-in modeling lamps, multiple power levels, and ruggedness that can stand up to transport, because many photographers pack up these kits and tote them around as location lighting rigs. Studio lighting kits can range in price from a few hundred dollars for a set of lights, stands, and reflectors, to thousands for a high-end lighting system complete with all the necessary accessories.

Figure 11.20 All-in-one "monolights" contain flash, power supply, and a modeling light in one compact package (umbrella not included).

A more practical choice these days is *monolights* (see Figure 11.20), which are "all-inone" studio lights that sell for about \$200-\$400. They have the flash tube, modeling light, and power supply built into a single unit that can be mounted on a light stand. Monolights are available in AC-only and battery-pack versions, although an external battery eliminates some of the advantages of having a flash with everything in one unit. They are very portable, because all you need is a case for the monolight itself, plus the stands and other accessories you want to carry along. Because these units are so popular with photographers who are not full-time professionals, the lower-cost monolights are often designed more for lighter duty than professional studio flash. That doesn't mean they aren't rugged; you'll just need to handle them with a little more care, and, perhaps, not expect them to be used eight hours a day for weeks on end. In most other respects, however, monolights are the equal of traditional studio flash units in terms of fast recycling, built-in modeling lamps, adjustable power, and so forth.

Connecting Multiple Non-Dedicated Units to Your Nikon D3200

Non-dedicated electronic flash units can't use the automated i-TTL features of your Nikon D3200; you'll need to calculate exposure manually, through test shots evaluated on your camera's LCD, or by using an electronic flash meter. Moreover, you don't have to connect them to the accessory shoe on top of the camera. Instead, you can remove them from the camera and plug in an adaptor like the Nikon AS-15 onto the accessory shoe to provide a PC/X connector for use with an old-style camera sync cord.

You should be aware that older electronic flash units sometimes use a triggering voltage that is too much for your D3200 to handle. You can actually damage the camera's electronics if the voltage is too high. You won't need to worry about this if you purchase brand-new units from Alien Bees, Adorama, or other vendors. But if you must connect an external flash with an unknown triggering voltage, I recommend using a Wein Safe Sync (see Figure 11.21), which isolates the flash's voltage from the camera triggering circuit.

Finally, some flash units have an optical slave trigger built in, or can be fitted with one, so that they fire automatically when another flash, including your camera's built-in unit, fires. Or, you can use radio control devices like the ones shown in Figure 11.22. Your slave flash should have a "digital" setting that allows it to be triggered by the full burst of the main flash, and not fooled by the pre-flash.

Figure 11.21 A voltage isolator can prevent frying your D3200's flash circuits if you use an older electronic flash.

Figure 11.22 A radio-control device frees you from a sync cord tether between your flash and camera.

Other Lighting Accessories

Once you start working with light, you'll find there are plenty of useful accessories that can help you. Here are some of the most popular that you might want to consider.

Soft Boxes

Soft boxes are large square or rectangular devices that may resemble a square umbrella with a front cover, and produce a similar lighting effect. They can extend from a few feet square to massive boxes that stand five or six feet tall—virtually a wall of light. With a flash unit or two inside a soft box, you have a very large, semi-directional light source that's very diffuse and very flattering for portraiture and other people photography.

Soft boxes are also handy for photographing shiny objects. They not only provide a soft light, but if the box itself happens to reflect in the subject (say you're photographing a chromium toaster), the box will provide an interesting highlight that's indistinct and not distracting.

You can buy soft boxes (like the one shown in Figure 11.23) or make your own. Some lengths of friction-fit plastic pipe and a lot of muslin cut and sewed just so may be all that you need.

Light Stands

Both electronic flash and incandescent lamps can benefit from light stands. These are lightweight, tripod-like devices (but without a swiveling or tilting head) that can be set on the floor, tabletops, or other elevated surfaces and positioned as needed. Light stands should be strong enough to support an external lighting unit, up to and including a relatively heavy flash with a soft box or umbrella reflectors. You want the supports to be capable of raising the lights high enough to be effective. Look for light stands capable of extending six to seven feet high. The nine-foot units usually have larger, steadier bases, and extend high enough that you can use them as background supports. You'll be using these stands for a lifetime, so invest in good ones. I bought the light stand shown in Figure 11.24 when I was in college, and I have been using it for decades.

Figure 11.23 Soft boxes provide an even, diffuse light source.

Figure 11.24 Light stands can hold lights, umbrellas, backdrops, and other equipment.

Backgrounds

Backgrounds can be backdrops of cloth, sheets of muslin you've painted yourself using a sponge dipped in paint, rolls of seamless paper, or any other suitable surface your mind can dream up. Backgrounds provide a complementary and non-distracting area behind subjects (especially portraits) and can be lit separately to provide contrast and separation that outlines the subject, or which helps set a mood.

I like to use plain-colored backgrounds for portraits, and white seamless backgrounds for product photography. You can usually construct these yourself from cheap materials and tape them up on the wall behind your subject, or mount them on a pole stretched between a pair of light stands.

Snoots and Barn Doors

These fit over the flash unit and direct the light at your subject. Snoots are excellent for converting a flash unit into a hair light, while barn doors give you enough control over the illumination by opening and closing their flaps that you can use another flash as a background light, with the capability of feathering the light exactly where you want it on the background. A barn door unit is shown in Figure 11.25.

Figure 11.25
Snoots and barn doors allow you to modulate the light from a flash or lamp, and they are especially useful for hair lights and background lights.

Useful Software for the Nikon D3200

Unless you only take pictures and then immediately print them directly to a PictBridge-compatible printer, somewhere along the line you're going to need to make use of the broad array of software available for the Nikon D3200. The picture-fixing options in the Retouch menu let you make only modest modifications to your carefully crafted photos. If your needs involve more than fixing red-eye, cropping and trimming, and maybe adjusting tonal values with D-Lighting, you're definitely going to want to use a utility or editor of some sort to perfect your images. After you've captured some great images and have them safely stored on your Nikon D3200's memory card, you'll need to transfer them from your camera and Secure Digital card to your computer, where they can be organized, fine-tuned in an image editor, and prepared for web display, printing, or some other final destination.

Fortunately, there are lots of software utilities and applications to help you do all these things. This chapter will introduce you to a few of them. Please note that this is *not* a "how-to-do-it" software chapter. I'm going to use every available page in this book to offer advice on how to get the most from your D3200. There's no space to explain how to use all the features of Nikon Capture NX 2, nor how to tweak RAW file settings in Adobe Camera Raw. Entire books have been written about both products. This chapter is intended solely to help you get your bearings among the large number of utilities and applications available, to help you better understand what each does, and how you might want to use them. At the very end of the chapter, however, I'm going to make an exception and provide some simple instructions for using Adobe Camera Raw, to help those who have been using Nikon's software exclusively get a feel for what you can do with the Adobe product.

The basic functions found in most of the programs discussed in this chapter include image transfer and management, camera control, and image editing. You'll find that many of the programs overlap several of these capabilities, so it's not always possible to categorize the discussions that follow by function. In fact, I'm going to start off by describing a few of the offerings available from Nikon.

Nikon's Applications and Utilities

If nothing else, Nikon has made sorting through the software for its digital cameras an interesting pursuit. Through the years, we've had various incarnations of programs with names like PictureProject, NikonView, and Nikon Capture. Some have been compatible with both the Nikon dSLR and amateur Coolpix product lines. Many of them have been furnished on disk with the cameras. Others, most notoriously Nikon Capture NX 2, have been an extra-cost option, which particularly infuriated those of us who had paid a lot for a Nikon dSLR, and found that we'd need to pay even more to get the software needed for the camera.

Nikon has split their software offerings into separate programs that are sort of standalone products, but which integrate with the others. For example, if you bought Nikon Capture NX you found that the program didn't really capture anything, as the previous Nikon Capture 4 did. If you wanted to operate the camera remotely, you needed to buy the off-shoot program, Nikon Camera Control Pro, which costs even *more* money (which doesn't work with the D3200 at this writing).

If Nikon software wasn't interesting enough already, some years back Nikon began *encrypting* the white balance information in image files, so that third-party utility programmers needed to use Nikon's software development kit or reverse-engineer the encryption to make their utilities work with Nikon NEF files. Even today, each time a new Nikon dSLR is introduced, you must upgrade your copy of most Nikon software products, as well as third-party products like Adobe Camera Raw, to ensure compatibility with the new camera's files. The fact that these upgrades often are not available until months after the camera is introduced is nothing short of frustrating.

The next few sections provide some descriptions of the Nikon software you'll want to use with your D3200.

Nikon ViewNX 2

This latest incarnation of Nikon's basic file viewer is better than ever, making it easy to browse through images, convert RAW files to JPEG or TIFF, and make corrections to white balance and exposure, either on individual files or on batches of files. It works in tandem with Nikon Transfer and Nikon Capture NX 2, as you can open files inspected in ViewNX 2 in one of the other programs—or within a third-party application you

"register" (add to the utility's list of programs it can access automatically). Also included with this product is Nikon Movie Editor and Nikon Transfer 2.

First and foremost, Nikon ViewNX 2 is a great file viewer. There are three modes for looking at images: a Thumbnail Grid mode for checking out small previews of your images; an Image Viewer mode (see Figure 12.1) that shows a group of thumbnails along with an enlarged version of a selected image; and Full Screen mode, which allows you to examine an image in maximum detail.

If you like to shoot RAW+JPEG Fine, you can review image pairs as if they were a single image (rather than view the RAW and JPEG versions separately), and work with whichever version you need. The active focus area can be displayed in the image, and there are histogram, highlight, and shadow displays to help you evaluate an image.

Should you want to organize your images, there are 10 labels available to classify images by criteria such as images printed, images copied, or images sent as e-mail, and you can mark your best shots for easier retrieval with a rating system of one to five stars. (See Figure 12.2.) ViewNX 2 also allows you to edit embedded XMP/IPTC Information in fields such as Creator, Origin, Image Title, and suitable keywords. The utility can be downloaded from the support/download pages of the Nikon website at www.nikonusa.com.

Figure 12.1Nikon ViewNX
2 is a great file viewer.

Figure 12.2 You can edit images with quick adjustments.

Nikon Transfer

It seems like everyone offers some sort of image transfer system that automatically recognizes when a memory card is inserted in a reader, or a digital camera like the Nikon D3200 is attached to a computer using a USB cable. The most popular operating systems, from Mac OS X to Windows XP and Vista have their own built-in transfer programs, and Adobe Photoshop Elements includes one in its suite of utilities.

Nikon Transfer is particularly well-suited for D3200 owners, because it integrates easily with other Nikon software products, including ViewNX and Nikon Capture NX. You can download photos to your computer, and then continue to work on them in the Nikon application (or third-party utility) of your choice.

When a memory card is inserted into a card reader, or when the D3200 is connected to your computer through the USB cable, Nikon Transfer recognizes the device, searches it for thumbnails, and provides a display like the one shown in Figure 12.3. You can preview the images and mark the ones you want to transfer with checks to create a Transfer Queue.

Then, click on the Primary Destination tab (see Figure 12.4) and choose a location for the photos that will be transferred. Nikon Transfer can create a new folder for each transfer based on a naming convention you set up (click the Edit button next to the box

Figure 12.3 After Nikon Transfer displays thumbnails of the images on your memory card or camera, mark the ones you want to transfer.

Figure 12.4 Copy files to a

destination you specify using an optional filename template you can define.

at top center in the figure), or copy to a folder named after the current folder in the D3200's memory card. You can keep the current filename as the files are transferred, or assign a new name with a prefix you designate, such as Spain11_. The program will add a number from 001 to 999 to the filename prefix you specify.

One neat feature is the ability to name a Backup Destination location, so that all transferred pictures can also be copied to a second folder, which can be located on a different hard disk drive or other media. You can embed information such as copyright data, star ratings, and labels in the images as they are transferred. When the file transfer is complete, Nikon Transfer can launch an application of your choice, set with a few clicks in the Preferences tab (see Figure 12.5).

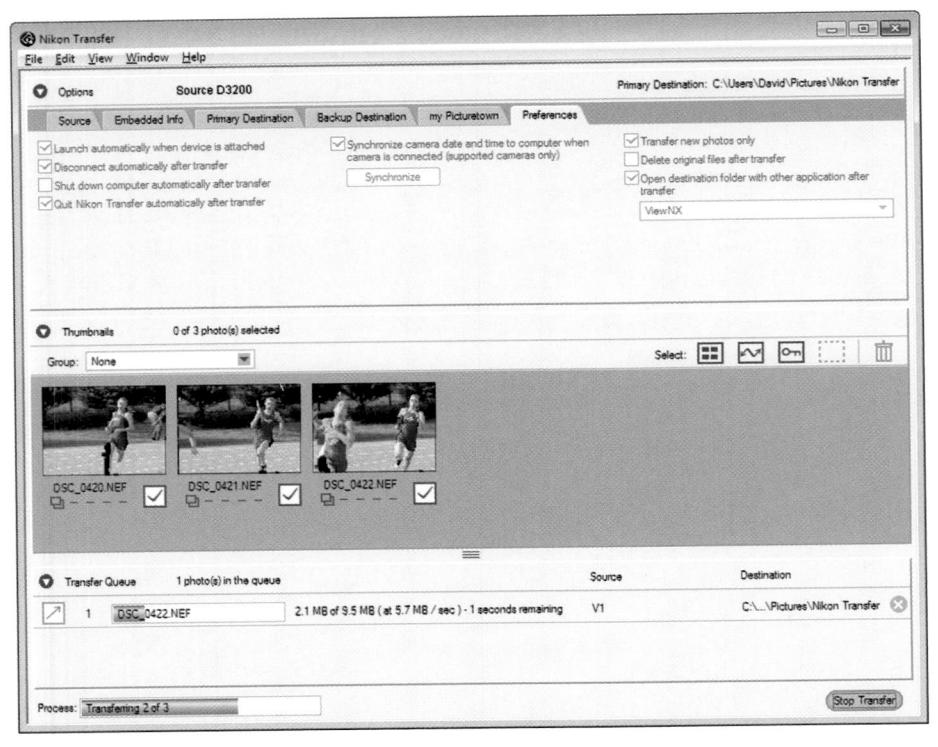

Figure 12.5
You can tell
Nikon Transfer
what to do after
images are
transferred in
the Preferences

tab.

Nikon Capture NX 2

Capture NX 2 is a pretty hefty chunk of software for the typical entry-level Nikon D3200 owner to tackle (and somewhat expensive at about \$180), but if you're ambitious and willing to plant your pitons for a steep climb up the learning curve, the program is indeed a powerful image-editing utility. It's designed specifically to process Nikon's NEF-format RAW files (although this new edition has added the ability to manipulate JPEG and TIFF images as well). It includes an image browser (with labeling, sorting,

and editing) that can be used to make many adjustments directly through the thumbnails. It also has advanced color management tools, impressive noise reduction capabilities, and batch processing features that allow you to apply sets of changes to collections of images. All the tools are arranged in dockable/expandable/collapsible palettes (see Figure 12.6) that tell you everything you need to know about an image, and provide the capabilities to push every pixel in interesting ways.

Photographers tend to love Capture NX or hate it, and it's easy to separate the fans from the furious. Those who are enamored of the program have invested a great deal of time in learning its quirky paradigm and now appreciate just how powerful Capture NX is. The detractors are usually those who are comfortable with another program, such as Photoshop or even Capture 4, this program's predecessor, and are upset that even the simplest functions can be confoundingly difficult for a new user to figure out. Capture NX's murky Help system isn't a lot of help; there's room for a huge book (or two) to explain how to use this program.

For example, instead of masks, Capture NX uses Nik Software's U Point technology, which applies Control Points to select and isolate parts of an image for manipulation. There are Color Control Points, with up to nine different sliders for each selected area (see Figure 12.7). There are also Black-and-White Control Points for setting dynamic range, Neutral Control Points for correcting color casts, and a Red-Eye Reduction Control Point that removes crimson glows from pupils.

Figure 12.6
Capture NX's
tools are
arranged in
dockable
palettes.

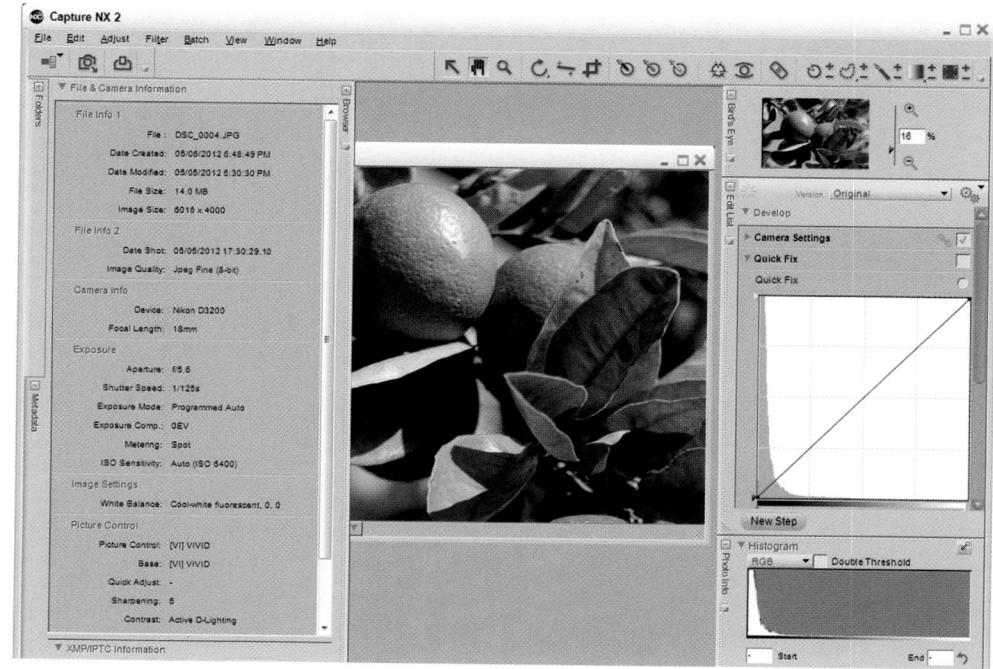

Figure 12.7 Control Points are used to make common adjustments.

The workflow revolves around an Edit List, which contains a list of enhancements, including Camera Adjustments, RAW Adjustments, Light & Color Adjustments, Detail Adjustments, and Lens Adjustments, which can each be controlled separately. You can add steps of your own, cancel adjustments individually, and store steps in the Edit List as Settings that can be applied to individual images or batches.

There are also Color Aberration Controls, D-Lighting, Image Dust Off, Vignette Control, Fisheye-to-Rectilinear Image Transformation ("de-fishing"), and a Distortion Control to reduce pincushion and barrel distortion.

Other Software

Other useful software for your Nikon D3200 falls into several categories. You might want to fine-tune your images, retouch them, change color balance, composite several images together, and perform other tasks we know as image editing, with a program like Adobe Photoshop, Photoshop Elements, or Corel Photo Paint.

You might want to play with the settings in RAW files, too, as you import them into an image editor. There are specialized tools expressly for tweaking RAW files, ranging from Adobe Camera Raw to Phase One's Capture One Pro (C1 Pro). A third type of manipulation is the specialized task of noise reduction, which can be performed within Photoshop, or Adobe Camera Raw. There are also specialized tools just for noise

reduction, such as Noise Ninja and Neat Image. Some programs, like the incomparable DxO Optics Pro perform magical transformations that you can't achieve any other way.

Each of these utilities and applications deserves a chapter of its own, so I'm simply going to enumerate some of the most popular applications and utilities and tell you a little about what they do.

DxO Optics Pro

DxO Labs (www.DxO.com) offers an incredibly useful program called Optics Pro for both Windows and Mac OS (\$170-\$300) that is unique in the range of functions it provides. Ostensibly an image quality enhancement utility that "cures" some of the ails that plague even the best lenses, the latest v6.x.x release also features single shot HDR processing, an improved RAW conversion engine that uses a new demosaicing algorithm to translate your NEF files into images with more detail, less noise, and fewer artifacts. These features meld well with the program's original mission: fixing the optical "geometry" of images, using settings custom-tailored for each individual lens. (I'm not kidding: when you "assemble" the program, you specify each and every camera body you want to use with Optics Pro, and designate exactly which lenses are included in your repertoire.)

Once an image has been imported into Optics Pro, it can be manipulated within one of four main sections: Light, Color, Geometry, and Details. It's especially useful for correcting optical flaws, color, exposure, and dynamic range, while adjusting perspective, distortion, and tilting. If you own a fisheye lens, Optics Pro will "de-fish" your images to produce a passable rectilinear photo from your curved image. A new Dust/Blemish Removal tool operates something like a manual version of the D3200's Dust Off Reference Photo. The user creates a dust/blemish template, and the program removes dust from the marked area in multiple images.

Phase One Capture One Pro (C1 Pro)

If there is a Cadillac of RAW converters for Nikon and Canon digital SLR cameras, C1 Pro has to be it. This premium-priced program from Phase One (www.phaseone.com) does everything, does it well, and does it quickly. If you can't justify the price tag of this professional-level software (as much as \$300 for the top-of-the-line edition), there are "lite" versions for serious amateurs and cash-challenged professionals for as little as \$100. You can try out either version for a limited period at no cost.

Aimed at photographers with high-volume needs (that would include school and portrait photographers, as well as busy commercial photographers), C1 Pro is available for both Windows and Mac OS X, and supports a broad range of digital cameras. Phase One is a leading supplier of megabucks digital camera backs for medium and larger format cameras, so they really understand the needs of photographers.

The latest features include individual noise reduction controls for each image, automatic levels adjustment, a "quick develop" option that allows speedy conversion from RAW to TIFF or JPEG formats, dual-image side-by-side views for comparison purposes, and helpful grids and guides that can be superimposed over an image. Photographers concerned about copyright protection will appreciate the ability to add watermarks to the output images.

BreezeBrowser Pro

A versatile program you want to consider is BreezeBrowser Pro (Windows only), from Breeze Systems (www.breezesys.com), which performs several useful functions in addition to RAW file conversion and image browsing. It can produce contact sheets and proof images, generate nifty web pages with only a little input on your part, and, importantly in this GPS-crazy age, link geo-tagged images with Google Earth and online maps. Now that the Nikon D3200 provides the compact Nikon GP-1 geo-tagging unit, which clips onto the camera's accessory shoe, software like BreezeBrowser provides an actual real-world application for this kind of data.

A real bargain at \$69.95, BreezeBrowser Pro offers all the basic conversion, sharpening, resizing, and adjustments for your RAW images. You can create captioned web pages from within the program, and, if you want to sell your pictures, it will protect them with watermarking and provide a system for online ordering of images/prints. Batch rename features let you change the filename applied in the camera to something more useful, and edit the date/time stamps of your files. The Windows-only program is shown in Figure 12.8.

Photoshop/Photoshop Elements

Photoshop is the high-end choice for image editing, and Photoshop Elements is a great alternative for those who need some of the features of Photoshop, but can do without the most sophisticated capabilities, including editing CMYK files. Both editors use the latest version of Adobe's Camera Raw plug-in, which makes it easy to adjust things like image resolution, white balance, exposure, shadows, brightness, sharpness, luminance, and noise reduction. One plus with the Adobe products is that they are available in identical versions for both Windows and Macs.

The latest version of Photoshop includes a built-in RAW plug-in that is compatible with the proprietary formats of a growing number of digital cameras, both new and old, and which can perform a limited number of manipulations on JPEG and TIFF files, too. This plug-in also works with Photoshop Elements, but with fewer features.

Here's how easy it is to manipulate a RAW file using the Adobe converter:

- 1. Transfer the RAW images from your camera to your computer's hard drive.
- 2. In Photoshop, choose Open from the File menu, or use Bridge.
- 3. Select a RAW image file. The Adobe Camera Raw plug-in will pop up, showing a preview of the image, like the one shown in Figure 12.8.
- 4. If you like, use one of the tools found in the toolbar at the top left of the dialog box. From left to right, they are as follows:
 - **Zoom.** Operates just like the Zoom tool in Photoshop.
 - **Hand.** Use like the Hand tool in Photoshop.
 - White Balance. Click an area in the image that should be neutral gray or white to set the white balance quickly.
 - Color Sampler. Use to determine the RGB values of areas you click with this eyedropper.
 - **Crop.** Pre-crops the image so that only the portion you specify is imported into Photoshop. This option saves time when you want to work on a section of a large image, and you don't need the entire file.
 - Straighten. Drag in the preview image to define what should be a horizontal or vertical line, and ACR will realign the image to straighten it.
 - **Retouch.** Use to heal or clone areas you define.
 - Red-Eye Removal. Quickly zap red pupils in your human subjects.
 - ACR Preferences. Produces a dialog box of Adobe Camera Raw preferences.
 - Rotate Counterclockwise. Rotates counterclockwise in 90-degree increments with a click.
 - Rotate Clockwise. Rotates clockwise in 90-degree increments with a click.
- 5. Using the Basic tab, you can have ACR show you red and blue highlights in the preview that indicate shadow areas that are clipped (too dark to show detail) and light areas that are blown out (too bright). Click the triangles in the upper-left corner of the histogram display (shadow clipping) and upper-right corner (highlight clipping) to toggle these indicators on or off.
- 6. Also in the Basic tab you can choose white balance, either from the drop-down list or by setting a color temperature and green/magenta color bias (tint) using the sliders.

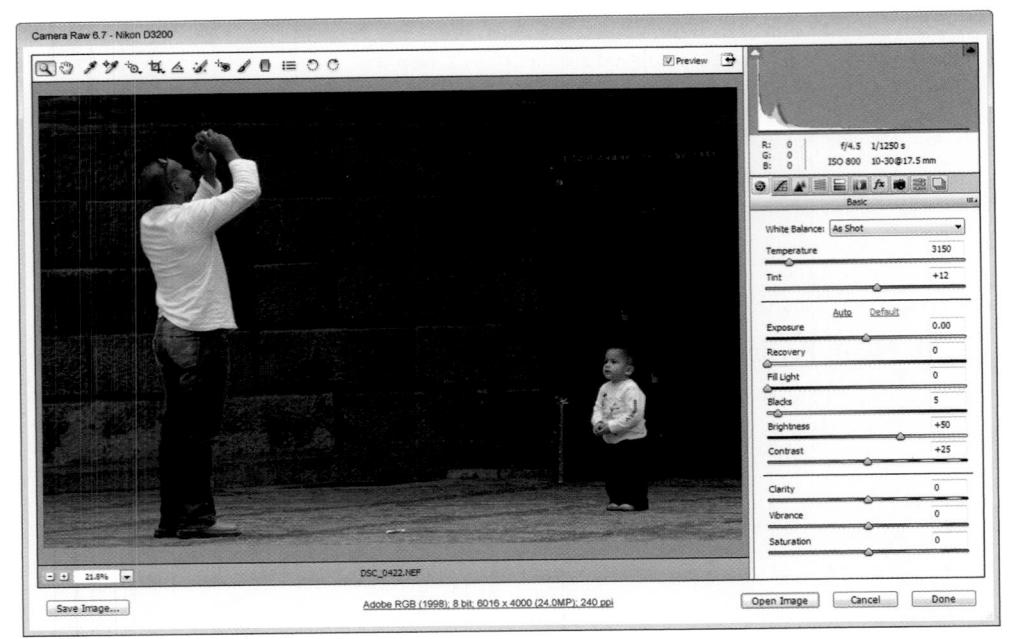

Figure 12.8
The basic ACR dialog box looks like this when processing a single image.

- 7. Other sliders are available to control exposure, recovery, fill light, blacks, brightness, contrast, vibrance, and saturation. A check box can be marked to convert the image to grayscale.
- 8. Make other adjustments (described in more detail below).
- 9. ACR makes automatic adjustments for you. You can click Default and make the changes for yourself, or click the Auto link (located just above the Exposure slider) to reapply the automatic adjustments after you've made your own modifications.
- 10. If you've marked more than one image to be opened, the additional images appear in a "filmstrip" at the left side of the screen. You can click on each thumbnail in the filmstrip in turn and apply different settings to each.
- 11. Click Open Image/Open Image(s) into Photoshop using the settings you've made.
The Basic tab is displayed by default when the ACR dialog box opens, and it includes most of the sliders and controls you'll need to fine-tune your image as you import it into Photoshop. These include:

- White Balance. Leave it As Shot or change to a value such as Daylight, Cloudy, Shade, Tungsten, Fluorescent, or Flash. If you like, you can set a custom white balance using the Temperature and Tint sliders.
- Exposure. This slider adjusts the overall brightness and darkness of the image.
- **Recovery.** Restores detail in the red, green, and blue color channels.
- Fill Light. Reconstructs detail in shadows.
- Blacks. Increases the number of tones represented as black in the final image, emphasizing tones in the shadow areas of the image.
- Brightness. This slider adjusts the brightness and darkness of an image.
- Contrast. Manipulates the contrast of the midtones of your image.
- Clarity. Use this slider to apply a hybrid type of contrast enhancement to boost midtone contrast.
- Vibrance. Prevents over-saturation when enriching the colors of an image.
- **Saturation.** Manipulates the richness of all colors equally, from zero saturation (gray/black, no color) at the −100 setting to double the usual saturation at the +100 setting.

Additional controls are available on the Tone Curve, Detail, HSL/Grayscale, Split Toning, Lens Corrections, Camera Calibration, Presets, and Snapshots tabs (all but Presets and Shapshots are shown in Figure 12.9). The Tone Curve tab can change the tonal values of your image. The Detail tab lets you adjust sharpness, luminance smoothing, and apply color noise reduction. The HSL/Grayscale tab offers controls for adjusting hue, saturation, and lightness and converting an image to black-and-white. Split Toning helps you colorize an image with sepia or cyanotype (blue) shades. The Lens Corrections tab has sliders to adjust for chromatic aberrations and vignetting. The Camera Calibration tab provides a way for calibrating the color corrections made in the Camera Raw plug-in. The Presets tab (not shown) is used to load settings you've stored for reuse.

Figure 12.9 More controls are available within the additional tabbed dialog boxes in Adobe Camera Raw.

Nikon D3200: Troubleshooting and Prevention

You won't expend a lot of effort keeping your Nikon D3200 humming and operating smoothly. There's not a lot that can go wrong. An electronically controlled camera like the Nikon D3200 has fewer mechanical moving parts to fail, so they are less likely to "wear out." There is no film transport mechanism, no wind lever or motor drive, and, when using lenses with the AF-S designation (as described in Chapter 10), no complicated mechanical linkages from camera to lens to adjust the automatic focus. Instead, tiny, reliable motors are built into each lens (and you lose the use of only that lens should something fail), and one of the few major moving parts in the camera itself is a lightweight mirror (its small size is one of the advantages of the D3200's 1.5X crop factor) that flips up and down with each shot.

Of course, the camera also has a moving shutter that can fail, but the shutter is built rugged enough that, even though Nikon doesn't provide an official toughness "rating," many users of previous Nikon entry-level cameras have reported 100,000 trouble-free shutter cycles or more. Unless you're shooting sports in Continuous mode day in and day out, the shutter on your D3200 is likely to last as long as you expect to use the camera.

The only other things on the camera that move are switches, dials, buttons, the flip-up electronic flash, and the door that slides open to allow you to remove and insert the

Secure Digital card. Unless you're extraordinarily clumsy or unlucky and manage to give your built-in flash a good whack while it is in use, there's not a lot that can go wrong mechanically with your Nikon D3200.

There are numerous electrical and electronic connections in the camera (many connected to those mechanical switches and dials), and components like the color LCD that can potentially fail or suffer damage. You must contend with dust lodging itself on your sensor, and, from time to time, perhaps the need to periodically update your camera's internal software, called *firmware*. This chapter will show you how to diagnose problems, fix some common ills, and, importantly, learn how to avoid them in the future.

Battery Powered

One of the chief liabilities of modern electronic cameras is that they are modern *electronic* cameras. Your D3200 is fully dependent on two different batteries. Without them, the camera can't be used. Photographers from both the film and digital eras have grown used to this limitation, and I've grown to live with the need for batteries even though I shot for years using all-mechanical Nikon cameras that had no batteries (or even a built-in light meter!). The need for electrical power is the price we pay for modern conveniences like autofocus, autoexposure, LCD image display, backlit menus, and, of course, digital images.

One of the batteries you rely on is the EN-EL14 battery installed in the grip. It's rechargeable, can last for as long as 540 shots, and is user-replaceable if you have a spare. The second power cell in your camera is a so-called *clock battery*, which is also rechargeable, but is tucked away within the innards of the camera and can't be replaced by the user. The clock battery retains the settings of the camera when it's powered down, and, even, when the main battery is removed for charging. If you remove the EN-EL14 for long periods, the clock battery may discharge, but it will be quickly rejuvenated when you replace the main battery. (It's recharged by juice supplied by the EN-EL14.) Although you can't replace this battery yourself, you can expect it to last for the useful life of the camera.

So, your main concern will be to provide a continuous, reliable source of power for your D3200. As I noted in Chapter 1, you should always have a spare battery or two so you won't need to stop shooting when your internal battery dies. I recommend buying Nikon-brand batteries: saving \$20 or so for an after-market battery may seem like a good deal, but it can cost you much more than that if the battery malfunctions and damages your camera.

KEEPING TRACK OF YOUR BATTERIES AND MEMORY CARDS

Here's a trick I use to keep track of which batteries are fresh/discharged, and which memory cards are blank/exposed. I cut up some small slips of paper and fold them in half, forming a tiny "booklet." Then I write EXPOSED in red on the "inside" pages of the booklet and UNEXPOSED in green on the outside pages. Folded one way, the slips read EXPOSED on both sides; folded the other way, the slips read UNEXPOSED. I slip them inside the plastic battery cover, which you should *always* use when the batteries are not in the camera (to avoid shorting out the contacts), folded so the appropriate "state" of the batteries is visible. The same slips are used in the translucent plastic cases I use for my memory cards (see Figure 13.1). For my purposes, EXPOSED means the same as DISCHARGED, and UNEXPOSED is the equivalent of CHARGED. The color-coding is an additional clue as to which batteries/memory cards are good to go, or not ready for use.

Figure 13.1

Mark your batteries—
or memory cards—so you'll know which are ready for use.

Updating Your Firmware

The camera relies on its "operating system," or *firmware*, which should be updated in a reasonable fashion as new releases become available. The firmware in your Nikon D3200 handles everything from menu display (including fonts, colors, and the actual entries themselves), what languages are available, and even support for specific devices and features. Upgrading the firmware to a new version makes it possible to add or fine-tune features while fixing some of the bugs that sneak in.

Firmware upgrades are used most frequently to fix bugs in the software, and much less frequently to add or enhance features. The exact changes made to the firmware are generally spelled out in the firmware release announcement. You can examine the remedies provided and decide if a given firmware patch is important to you. If not, you can usually safely wait a while before going through the bother of upgrading your firmware—at least long enough for the early adopters (such as those who haunt the Digital

Photography Review forums at www.dpreview.com) to report whether the bug fixes have introduced new bugs of their own. Each new firmware release incorporates the changes from previous releases, so if you skip a minor upgrade you should have no problems.

WHEN TO UPGRADE YOUR FIRMWARE

I *always* recommend waiting at least two weeks after a firmware upgrade is announced before changing the software in your camera. This is often in direct contradiction to the online Nikon "gurus" who breathlessly announce each new firmware release on their web pages, usually with links to where you can download the latest software. *Don't do it!* Yet. Nikon has, in the past, introduced firmware upgrades that were buggy and added problems of their own. If you own a camera affected by a new round of firmware upgrades, I urge you to wait and let a few million over-eager fellow users "beta test" this upgrade for you. Within a few weeks, any problems (although I don't expect there will be any) will surface and you'll know whether the update is safe. Your camera is working fine right now, so why take the chance?

How It Works

If you're computer savvy, you might wonder how your Nikon D3200 is able to overwrite its own operating system—that is, how can the existing firmware be used to load the new version on top of itself? It's a little like lifting yourself by reaching down and pulling up on your bootstraps. Not ironically, that's almost exactly what happens: At your command (when you start the upgrade process), the D3200 shifts into a special mode in which it is no longer operating from its firmware but, rather, from a small piece of software called a *bootstrap loader*, a separate, protected software program that functions only at startup or when upgrading firmware. The loader's function is to look for firmware to launch or, when directed, to copy new firmware from a Secure Digital card to the internal memory space where the old firmware is located.

The loader software isn't set up to go hunting through your Secure Digital card for the firmware file. It looks only in the top or root directory of your card, so that's where you must copy the firmware you download. Once you've determined that a new firmware update is available for your camera and that you want to install it, just follow these steps. (If you chicken out, any Nikon Service Center can install the firmware upgrade for you.)

Why Two Firmware Modules?

Your Nikon D3200's firmware is divided into two parts, Firmware C (for camera) and Firmware L (for lens). The firmware number can be found in the Firmware Version entry in the Setup menu. There's a good reason why the firmware was previously divided in twain. Each of the two modules was "in charge" of particular parts of the camera's operating system. So, when a bug was found, or a new feature added, it was possible, in many cases, to offer only an upgrade for either Firmware C or Firmware L, depending on which module was affected. Although mistakes in upgrading firmware are rare, you cut the opportunities for user errors in half when only one of the modules needs to be replaced.

WARNING

Use a fully charged EN-EL14 charged battery or a Nikon AC adapter to ensure that you'll have enough power to operate the camera for the entire upgrade. Moreover, you should not turn off the camera while your old firmware is being overwritten. Don't open the Secure Digital card door or do anything else that might disrupt operation of the D3200 while the firmware is being installed.

Getting Ready

The first thing to do is determine whether you need the current firmware update. First, confirm the version number of your Nikon D3200's current firmware:

- 1. Turn on the D3200.
- 2. Press the MENU button and select Firmware Version from the Setup menu. The camera's firmware version will be displayed, as in Figure 13.2.
- 3. Write down the version number for Parts C and L.
- 4. Turn off the D3200.

Next, go to the Nikon support site, locate, and download the firmware update. In the USA, the place to go is http://support.nikontech.com/, and search for firmware from there. Click that link, then click the DSLR link on the page displayed next. Scroll down to the D3200 row in the table, and review the version number for the current update.

If the version is later than the one you noted in your camera, click the firmware link in either the Windows or Macintosh columns (depending on your computer) to download the file. It will have a name like D3200Update.zip (Windows) or D3200update.sitx (Macintosh). Extract the file to a folder on your computer using the unzipping or unstuffing software of your choice.

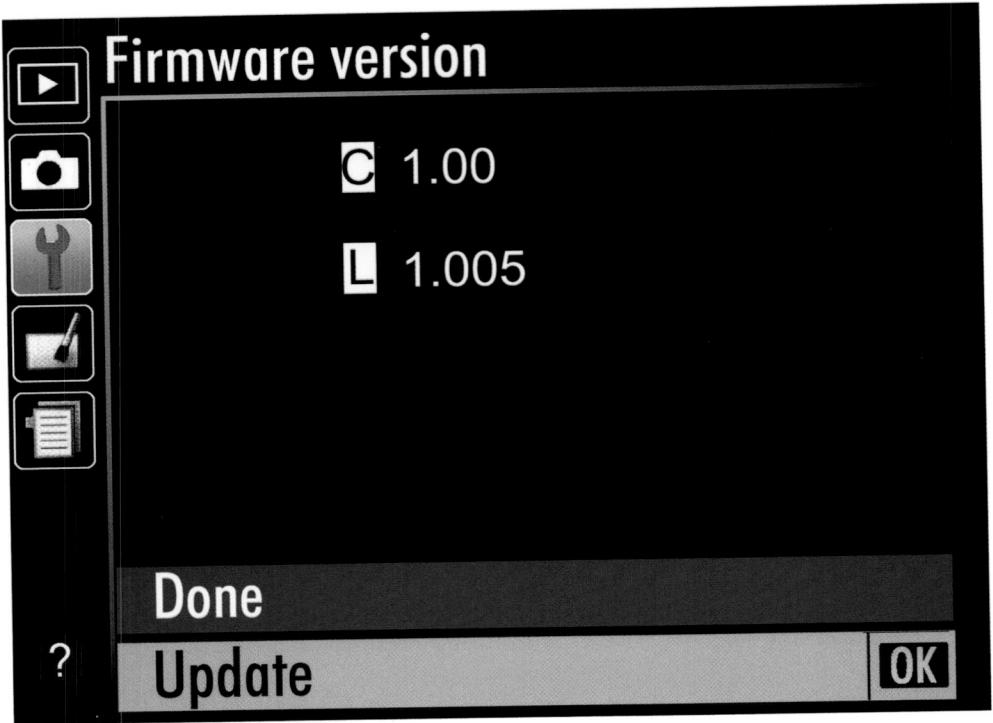

Figure 13.2 View your current firmware versions before upgrading.

The D3200's firmware comes in two parts, C and L, which can be updated individually. The actual update files will be named something like:

C32000101.bin

L32000101.bin

The final preparation you need to make is to decide whether you'd like to upgrade your firmware using a memory card reader, or by transferring the software to the D3200 using the USB cable. In either case, you'll need to format a memory card in the D3200. Then, perform one of the sets of steps in the sections that follow.

Updating from a Card Reader

To update from a card reader, use a reader connected to your computer with a USB cable. Then, follow these steps:

1. Insert a freshly formatted SD memory card clean of images into the card reader. If you have been using Nikon Transfer or the "autoplay" features of your operating system to transfer images from your memory card to the computer, the automated transfer dialog box may appear. Close it.

- 2. The memory card will appear on your Macintosh desktop, or in the Computer/My Computer folders under Windows 7/Windows Vista/Windows XP.
- 3. Drag one of the firmware files to the memory card. You can install "C," or "L" first (if more than one is provided). If your particular upgrade consists of only one of the two files, drag that to the memory card. Remember to copy the firmware to the *root* (top) directory of the memory card. The D3200 will be unable to find it if you place it in a folder.

Updating with a USB Connection

You can also copy the firmware to the D3200's memory card using a USB connection. Just follow these steps:

- 1. With the camera turned off, insert the clean, newly formatted memory card. Then, turn the camera back on.
- 2. Turn off the D3200 and connect it to your computer using the USB cable, or another similar cable.
- 3. Turn the camera back on. If you have been using Nikon Transfer or the "autoplay" features of your operating system to transfer images from your memory card to the computer, the automated transfer dialog box may appear. Close it.
- 4. The camera will appear on the Macintosh desktop, or in the Computer/My Computer folders under Windows 7/Windows Vista/Windows XP.
- 5. Drag one of the firmware files to the memory card. It doesn't matter whether you install "C" or "L" first. If your particular upgrade consists of only one .bin file, drag that to the memory card. Remember to copy the firmware to the *root* (top) directory of the memory card. The D3200 will be unable to find it if you place it in a folder.
- 6. Disconnect the camera from the computer.

Starting the Update

To perform the actual update, follow these steps:

- 1. With the memory card containing the firmware update software in the camera, turn the camera on.
- 2. Press the MENU button and select Firmware version in the Setup menu.
- 3. Select Update and press the multi selector button to the right.
- 4. When the firmware update screen appears, highlight Yes and press OK to begin the update.

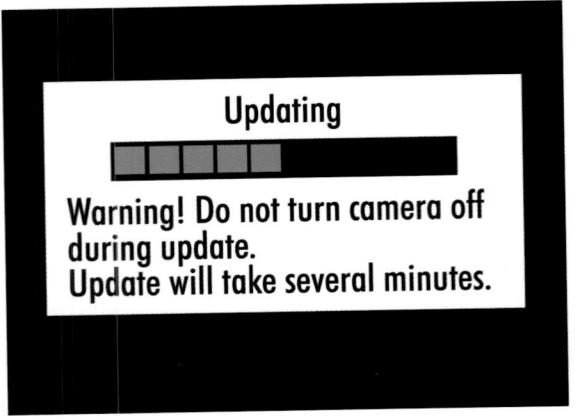

Figure 13.3 Don't turn the camera off while updating is underway.

Figure 13.4 Turn the camera off when update is

- 5. The actual process may take a few minutes (from two to five). Be sure not to turn off the camera or perform any other operations while it is underway. (See Figure 13.3.)
- 6. When the update is completed, the warning message will no longer be displayed on the screen. You can turn off the camera when the message disappears. (See Figure 13.4.)
- 7. Remove the memory card.
- 8. Turn the D3200 back on to load the updated firmware.
- 9. Press the MENU button and select Firmware version in the Setup menu to view the current firmware number. If it matches the update, you've successfully upgraded that portion of the firmware.
- 10. Reformat the memory card.
- 11. If there is a second part to your firmware upgrade ("C" or "L"), then repeat all the steps for the additional firmware software.
- 12. Reformat the memory card to return it to a "clean" condition.

Protecting Your LCD

The large 3-inch color LCD on the back of your Nikon D3200 almost seems like a target for banging, scratching, and other abuse. The LCD itself is quite rugged, and a few errant knocks are unlikely to shatter the protective cover over the LCD, and scratches won't easily mar its surface. However, if you want to be on the safe side, there are a number of protective products you can purchase to keep your LCD safe—and, in

some cases, make it a little easier to view. Here's a quick overview of your other options, some of which are likely to add enough thickness to your LCD to prevent you from reversing the LCD when you need to. That's a choice you'll have to make.

- Plastic overlays. The simplest solution (although not always the cheapest), is to apply a plastic overlay sheet or "skin" cut to fit your LCD. These adhere either by static electricity or through a light adhesive coating that's even less clingy than stick-it notes. You can cut down overlays made for PDAs (although these can be pricey at up to \$19.95 for a set of several sheets), or purchase overlays sold specifically for digital cameras. Vendors such as Hoodman (www.hoodmanusa.com) offer overlays of this type. These products will do a good job of shielding your D3200's LCD screen from scratches and minor impacts, but will not offer much protection from a good whack.
- Acrylic/glass shields. These scratch-resistant acrylic panels, laser cut to fit your camera perfectly, are my choice as the best protection solution, and what I use on my own D3200. At about \$6 each, they also happen to be the least expensive option as well. I get mine from a company called 'da Products (www.daproducts. com). They attach using strips of sticky adhesive that hold the panel flush and tight, but which allow the acrylic to be pried off and the adhesive removed easily if you want to remove or replace the shield. They don't attenuate your view of the LCD and are non-reflective enough for use under a variety of lighting conditions. I also like the glass covers from GGS, available from a variety of sources, and shown in Figure 13.5.

Figure 13.5
A tough glass shield can protect your LCD from scratches.

- Flip-up hoods. These protectors slip on using the flanges around your D3200's eyepiece, and provide a cover that completely shields the LCD, but unfolds to provide a three-sided hood that allows viewing the LCD while minimizing the extraneous light falling on it and reducing contrast. They're sold for about \$40 by Delkin and Hoodman. If you want to completely protect your LCD from hard knocks and need to view the screen outdoors in bright sunlight, there is nothing better. However, I have a couple problems with these devices. First, with the cover closed, you can't peek down after taking a shot to see what your image looks like during picture review. You must open the cap each time you want to look at the LCD. Moreover, with the hood unfolded, it's difficult to look through the view-finder: Don't count on being able to use the viewfinder and the LCD at the same time with one of these hoods in place.
- Magnifiers. If you look hard enough, you should be able to find an LCD magnifier that fits over the monitor panel and provides a 2X magnification. These often strap on clumsily, and serve better as a way to get an enlarged view of the LCD than as protection. Hoodman and other suppliers offer these specialized devices.

Troubleshooting Memory Cards

Sometimes good memory cards go bad. Sometimes good photographers can treat their memory cards badly. It's possible that a memory card that works fine in one camera won't be recognized when inserted into another. In the worst case, you can have a card full of important photos and find that the card seems to be corrupted and you can't access any of them. Don't panic! If these scenarios sound horrific to you, there are lots of things you can do to prevent them from happening, and a variety of remedies available if they do occur. You'll want to take some time—before disaster strikes—to consider your options.

All Your Eggs in One Basket?

The debate about whether it's better to use one large memory card or several smaller ones has been going on since even before there were memory cards. I can remember when computer users wondered whether it was smarter to install a pair of 200MB (not *gigabyte*) hard drives in their computer, or if they should go for one of those new-fangled 500MB models. By the same token, a few years ago the user groups were full of proponents who insisted that you ought to use 128MB memory cards rather than the huge 512MB versions. Today, most of the arguments involve 8GB cards versus 16GB cards, and I expect that as prices for 32GB SD cards continue to drop, they'll find their way into the debate as well.

Why all the fuss? Are 16GB memory cards more likely to fail than 8GB cards? Are you risking all your photos if you trust your images to a larger card? Isn't it better to use

several smaller cards, so that if one fails you lose only half as many photos? Or, isn't it wiser to put all your photos onto one larger card, because the more cards you use, the better your odds of misplacing or damaging one and losing at least some pictures?

In the end, the "eggs in one basket" argument boils down to statistics, and how you happen to use your D3200. The rationales can go both ways. If you have multiple smaller cards, you do increase your chances of something happening to one of them, so, arguably, you might be boosting the odds of losing some pictures. If all your images are important, the fact that you've lost 100 rather than 200 pictures isn't very comforting.

Also, consider that the eggs/basket scenario assumes that the cards that are lost or damaged are always full. It's actually likely that your 16GB card might suffer a mishap when it's less than half full (indeed, it's more likely that a large card won't be completely filled before it's offloaded to a computer), so you really might not lose any more shots with a single 16GB card than with multiple 4GB or 8GB cards.

If you shoot photojournalist-type pictures, you probably change memory cards when they're less than completely full in order to avoid the need to do so at a crucial moment. (When I shoot sports, my cards rarely reach 80 to 90 percent of capacity before I change them.) Using multiple smaller cards means you have to change them that more often, which can be a real pain when you're taking a lot of photos. As an example, if you use 1GB memory cards with a Nikon D3200 and shoot RAW+JPEG Fine, you may get only a few dozen pictures on the card. That's not even twice the capacity of a 36-exposure roll of film (remember those?). In my book, I prefer keeping all my eggs in one basket, and then making very sure that nothing happens to that basket.

The other reason comes into play when every single picture is precious to you and the loss of any of them would be a disaster. If you were a wedding photographer, for example, and unlikely to be able to restage the nuptials if a memory card goes bad, you'll probably want to shoot no more pictures than you can afford to lose on a single card, and have an assistant ready to copy each card removed from the camera onto a backup hard drive or DVD onsite.

What Can Go Wrong?

There are lots of things that can go wrong with your memory card, but the ones that aren't caused by human stupidity are statistically very rare. Yes, a Secure Digital card's internal bit bin or controller can suddenly fail due to a manufacturing error or some inexplicable event caused by old age. However, if your SD card works for the first week or two that you own it, it should work forever. There's really not a lot that can wear out.

The typical Secure Digital card is rated for a Mean Time Between Failures of 1,000,000 hours of use. That's constant use 24/7 for more than 100 years! According to the manufacturers, they are good for 10,000 insertions in your camera, and should be able to

retain their data (and that's without an external power source) for something on the order of 11 years. Of course, with the millions of SD cards in use, there are bound to be a few lemons here or there.

Given the reliability of solid-state memory compared to magnetic memory, though, it's more likely that your Secure Digital problems will stem from something that you do. SD cards are small and easy to misplace if you're not careful. For that reason, it's a good idea to keep them in their original cases or a "card safe" offered by Gepe (www.gepe-cardsafe.com), Pelican (www.pelican.com), and others. Always placing your memory card in a case can provide protection from the second-most common mishap that befalls Secure Digital cards: the common household laundry. If you slip a memory card in a pocket, rather than a case or your camera bag often enough, sooner or later it's going to end up in the washing machine and probably the clothes dryer, too. There are plenty of reports of relieved digital camera owners who've laundered their memory cards and found they still worked fine, but it's not uncommon for such mistreatment to do some damage.

Memory cards can also be stomped on, accidentally bent, dropped into the ocean, chewed by pets, and otherwise rendered unusable in myriad ways. Or, if the card is formatted in your computer with a memory card reader, your D3200 may fail to recognize it. Occasionally, I've found that a memory card used in one camera would fail if used in a different camera (until I reformatted it in Windows, and then again in the camera). Every once in awhile, a card goes completely bad and—seemingly—can't be salvaged.

Another way to lose images is to do commonplace things with your SD card at an inopportune time. If you remove the card from the D3200 while the camera is writing images to the card, you'll lose any photos in the buffer and may damage the file structure of the card, making it difficult or impossible to retrieve the other pictures you've taken. The same thing can happen if you remove the SD card from your computer's card reader while the computer is writing to the card (say, to erase files you've already moved to your computer). You can avoid this by *not* using your computer to erase files on a Secure Digital card but, instead, always reformatting the card in your D3200 before you use it again.

What Can You Do?

Pay attention: If you're having problems, the *first* thing you should do is *stop* using that memory card. Don't take any more pictures. Don't do anything with the card until you've figured out what's wrong. Your second line of defense (your first line is to be sufficiently careful with your cards that you avoid problems in the first place) is to *do no harm* that hasn't already been done. Read the rest of this section and then, if necessary, decide on a course of action (such as using a data recovery service or software, described later) before you risk damaging the data on your card further.

Now that you've calmed down, the first thing to check is whether you've actually inserted a card in the camera. If you've set the camera so that the No Memory Card? option has been set to allow taking pictures without a card, it's entirely possible (although not particularly plausible) that you've been snapping away with no memory card to store the pictures to, which can lead to massive disappointment later on. You can avoid all this by setting the Slot Empty Release Lock in the Setup menu to Release Locked, and leaving it there.

Things get more exciting when the card itself is put in jeopardy. If you lose a card, there's not a lot you can do other than take a picture of a similar card and print up some "Have You Seen This Lost Flash Memory?" flyers to post on utility poles all around town.

If all you care about is reusing the card, and have resigned yourself to losing the pictures, try reformatting the card in your camera. You may find that reformatting removes the corrupted data and restores your card to health. Sometimes I've had success reformatting a card in my computer using a memory card reader (this is normally a no-no because your operating system doesn't understand the needs of your D3200), and *then* reformatting again in the camera.

If your Secure Digital card is not behaving properly, and you *do* want to recover your images, things get a little more complicated. If your pictures are very valuable, either to you or to others (for example, a wedding), you can always turn to professional data recovery firms. Be prepared to pay hundreds of dollars to get your pictures back, but these pros often do an amazing job. You wouldn't want them working on your memory card on behalf of the police if you'd tried to erase some incriminating pictures. There are many firms of this type, and I've never used them myself, so I can't offer a recommendation. Use a Google search to turn up a ton of them.

THE ULTIMATE IRONY

I recently purchased an 8GB Kingston memory card that was furnished with some nifty OnTrack data recovery software. The first thing I did was format the card to make sure it was OK. Then I hunted around for the free software, only to discover it was preloaded onto the memory card. I was supposed to copy the software to my computer before using the memory card for the first time.

Fortunately, I had the OnTrack software that would reverse my dumb move, so I could retrieve the software. No, wait. I *didn't* have the software I needed to recover the software I erased. I'd reformatted it to oblivion. Chalk this one up as either the ultimate irony or Stupid Photographer Trick #523.

A more reasonable approach is to try special data recovery software you can install on your computer and use to attempt to resurrect your "lost" images yourself. They may not actually be gone completely. Perhaps your SD card's "table of contents" is jumbled, or only a few pictures are damaged in such a way that your camera and computer can't read some or any of the pictures on the card. Some of the available software was written specifically to reconstruct lost pictures, while other utilities are more general-purpose applications that can be used with any media, including floppy disks and hard disk drives. They have names like OnTrack, Photo Rescue 2, Digital Image Recovery, MediaRecover, Image Recall, and the aptly named Recover My Photos. You'll find a comprehensive list and links, as well as some picture-recovery tips at www.ultimateslr. com/memory-card-recovery.php. I like the RescuePRO software that SanDisk supplies (see Figure 13.6), especially since it came on a mini-CD that was impossible to erase by mistake.

DIMINISHING RETURNS

Usually, once you've recovered any images on a Secure Digital card, reformatted it, and returned it to service, it will function reliably for the rest of its useful life. However, if you find a particular card going bad more than once, you'll almost certainly want to stop using it forever. See if you can get it replaced by the manufacturer if you can, but, in the case of SD card failures, the third time is never the charm.

Figure 13.6 SanDisk supplies RescuePRO recovery software with some of its memory cards.

Preventive Measures

Here are some options for preventing loss of valuable images:

- Interleaving. One option is to *interleave* your shots. Say you don't shoot weddings, but you do go on vacation from time to time. Take 50 or so pictures on one card, or whatever number of images might fill about 25 percent of its capacity. Then, replace it with a different card and shoot about 25 percent of that card's available space. Repeat these steps with diligence (you'd have to be determined to go through this inconvenience), and, if you use four or more memory cards you'll find your pictures from each location scattered among the different memory cards. If you lose or damage one, you'll still have *some* pictures from all the various stops on your trip on the other cards. That's more work than I like to do (I usually tote around a portable hard disk and copy the files to the drive as I go), but it's an option.
- Transmit your images. Another option is to transmit your images, as they are shot, over a network to your laptop, assuming a network and a laptop are available. A company called Eye-Fi (www.eye.fi) markets a clever Secure Digital card with wireless capabilities built-in. They currently offer several models, from about \$50 to less than \$100, which can be used to transmit your photos from the D3200 to a computer on your home network (or any other network you set up somewhere, say, at a family reunion). You can also upload your images from your camera through your computer network directly to websites such as Flickr, Facebook, Shutterfly, Nikon's own My Picturetown, and digital printing services that include Walmart Digital Photo Center. The most sophisticated option is Eye-Fi Explore, which I use, an 8GB SDHC card that adds geographic location labels to your photo (so you'll know where you took it), and frees you from your own computer network by allowing uploads from more than 10,000 Wi-Fi hotspots around the USA. Very cool, and the ultimate in picture backup.
- External backup. You can purchase external hard disk gadgets called Personal Storage Devices (see Figure 13.7), which can copy files from your memory cards automatically. More expensive models have color LCD screens so you can review your images. I tend to prefer using a netbook, like the one shown in Figure 13.8. I can store images on the netbook's internal hard disk, and make an extra backup copy to an external drive as well. Plus, I can access the Internet from Wi-Fi hotspots, all using a very compact device. Lately, I've been backing up many images on my iPad, which has 64GB of storage—enough for short trips.

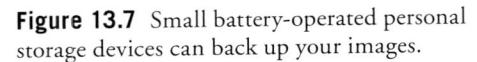

Figure 13.8 A small netbook, with or without an external hard drive, is another backup option.

Cleaning Your Sensor

Yes, the Nikon D3200 has a two-pronged sensor dust prevention scheme: an innovative air control system that keeps dust away from the sensor in the first place, and a sensor-shaking cleaning mechanism. But no dust-busting technology is 100-percent effective.

Indeed, there's no avoiding dust. No matter how careful you are, some of it is going to settle on your camera and on the mounts of your lenses, eventually making its way inside your camera to settle in the mirror chamber. As you take photos, the mirror flipping up and down causes the dust to become airborne and eventually make its way past the shutter curtain to come to rest on the anti-aliasing filter atop your sensor. There, dust and particles can show up in every single picture you take at a small enough aperture to bring the foreign matter into sharp focus. No matter how careful you are and how cleanly you work, eventually you will get some of this dust on your camera's sensor.

But as I mentioned, one of the Nikon D3200's most useful features is the automatic sensor cleaning system that reduces or eliminates the need to clean your camera's sensor manually. The sensor vibrates ultrasonically each time the D3200 is powered either on or off (or both, at your option), shaking loose any dust. Although the automatic sensor cleaning feature operates when you power the camera up, you can activate it manually at any time. Choose Clean Image Sensor from the Setup menu, and select Clean Now.

If some dust does collect on your sensor, you can often map it out of your images (making it invisible) using software techniques with the Image Dust Off Ref feature in the Setup menu. Operation of this feature is described in Chapter 4.

Of course, even with the Nikon D3200's automatic sensor cleaning/dust resistance features, you may still be required to manually clean your sensor from time to time.

This section explains the phenomenon and provides some tips on minimizing dust and eliminating it when it begins to affect your shots. I also cover this subject in my book, *Digital SLR Pro Secrets*, with complete instructions for constructing your own sensor cleaning tools. However, I'll provide a condensed version here of some of the information in that book, because sensor dust and sensor cleaning are two of the most contentious subjects Nikon D3200 owners have to deal with.

Dust the FAQs, Ma'am

Here are some of the most frequently asked questions about sensor dust issues.

Q. I see tiny specks in my viewfinder. Do I have dust on my sensor?

A. If you see sharp, well-defined specks, they are clinging to the underside of your focus screen and not on your sensor. They have absolutely no effect on your photographs, and are merely annoying or distracting.

Q. I can see dust on my mirror. How can I remove it?

A. Like focus-screen dust, any artifacts that have settled on your mirror won't affect your photos. You can often remove dust on the mirror or focus screen with a bulb air blower, which will loosen it and whisk it away. Stubborn dust on the focus screen can sometimes be gently flicked away with a soft brush designed for cleaning lenses. I don't recommend brushing the mirror or touching it in any way. The mirror is a special front-surface-silvered optical device (unlike conventional mirrors, which are silvered on the back side of a piece of glass or plastic) and can be easily scratched. If you can't blow mirror dust off, it's best to just forget about it. You can't see it in the viewfinder, anyway.

Q. I see a bright spot in the same place in all of my photos. Is that sensor dust?

A. You've probably got either a "hot" pixel or one that is permanently "stuck" due to a defect in the sensor. A hot pixel is one that shows up as a bright spot only during long exposures as the sensor warms. A pixel stuck in the "on" position always appears in the image. Both show up as bright red, green, or blue pixels, usually surrounded by a small cluster of other improperly illuminated pixels, caused by the camera's interpolating the hot or stuck pixel into its surroundings, as shown in Figure 13.9. A stuck pixel can also be permanently dark. Either kind is likely to show up when they contrast with plain, evenly colored areas of your image.

Finding one or two hot or stuck pixels in your sensor is unfortunately fairly common. They can be "removed" by telling the D3200 to ignore them through a simple process called *pixel mapping*. If the bad pixels become bothersome, Nikon can remap your sensor's pixels with a quick trip to a service center.

Bad pixels can also show up on your camera's color LCD panel, but, unless they are abundant, the wisest course is to just ignore them.

Figure 13.9
A stuck pixel is surrounded by improperly interpolated pixels created by the D3200's demosaicing algorithm.

Q. I see an irregular out-of-focus blob in the same place in my photos. Is that sensor dust?

A. Yes. Sensor contaminants can take the form of tiny spots, larger blobs, or even curvy lines if they are caused by minuscule fibers that have settled on the sensor. They'll appear out of focus because they aren't actually on the sensor surface but, rather, a fraction of a millimeter above it on the filter that covers the sensor. The smaller the f/stop used, the more in-focus the dust becomes. At large apertures, it may not be visible at all.

Q. I never see any dust on my sensor. What's all the fuss about?

A. Those who never have dust problems with their Nikon D3200 fall into one of four categories: those for whom the camera's automatic dust removal features are working well; those who seldom change their lenses and have clean working habits that minimize the amount of dust that invades their cameras in the first place; those who simply don't notice the dust (often because they don't shoot many macro photos or other pictures using the small f/stops that makes dust evident in their images); and those who are very, very lucky.

Identifying and Dealing with Dust

Sensor dust is less of a problem than it might be because it shows up only under certain circumstances. Indeed, you might have dust on your sensor right now and not be aware of it. The dust doesn't actually settle on the sensor itself, but, rather, on a protective filter a very tiny distance above the sensor, subjecting it to the phenomenon of *depth-of-focus*. Depth-of-focus is the distance the focal plane can be moved and still render an object in sharp focus. At f/2.8 to f/5.6 or even smaller, sensor dust, particularly if small, is likely to be outside the range of depth-of-focus and blur into an unnoticeable dot.

However, if you're shooting at f/16 to f/22 or smaller, those dust motes suddenly pop into focus. Forget about trying to spot them by peering directly at your sensor with the shutter open and the lens removed. The period at the end of this sentence, about .33mm in diameter, could block a group of pixels measuring 40×40 pixels (160 pixels in all!). Dust spots that are even smaller than that can easily show up in your images if you're shooting large, empty areas that are light colored. Dust motes are most likely to show up in the sky, as in Figure 13.10, or in white backgrounds of your seamless product shots and are less likely to be a problem in images that contain lots of dark areas and detail.

Figure 13.10
Only the dust spots in the sky are apparent in this shot.

To see if you have dust on your sensor, take a few test shots of a plain, blank surface (such as a piece of paper or a cloudless sky) at small f/stops, such as f/22, and a few wide open. Open Photoshop or another image editor, copy several shots into a single document in separate layers, then flip back and forth between layers to see if any spots you see are present in all layers. You may have to boost contrast and sharpness to make the dust easier to spot.

Avoiding Dust

Of course, the easiest way to protect your sensor from dust is to prevent it from settling on the sensor in the first place. Here are my stock tips for eliminating the problem before it begins.

- Clean environment. Avoid working in dusty areas if you can do so. Hah! Serious photographers will take this one with a grain of salt, because it usually makes sense to go where the pictures are. Only a few of us are so paranoid about sensor dust (considering that it is so easily removed) that we'll avoid moderately grimy locations just to protect something that is, when you get down to it, just a tool. If you find a great picture opportunity at a raging fire, during a sandstorm, or while surrounded by dust clouds, you might hesitate to take the picture, but, with a little caution (don't remove your lens in these situations, and clean the camera afterwards!) you can still shoot. However, it still makes sense to store your camera in a clean environment. One place cameras and lenses pick up a lot of dust is inside a camera bag. Clean your bag from time to time, and you can avoid problems.
- Clean lenses. There are a few paranoid types that avoid swapping lenses in order to minimize the chance of dust getting inside their cameras. It makes more sense just to use a blower or brush to dust off the rear lens mount of the replacement lens first, so you won't be introducing dust into your camera simply by attaching a new, dusty lens. Do this before you remove the current lens from your camera, and then avoid stirring up dust before making the exchange.
- Work fast. Minimize the time your camera is lens-less and exposed to dust. That means having your replacement lens ready and dusted off, and a place to set down the old lens as soon as it is removed, so you can quickly attach the new lens.
- Let gravity help you. Face the camera downward when the lens is detached so any dust in the mirror box will tend to fall away from the sensor. Turn your back to any breezes, indoor forced air vents, fans, or other sources of dust to minimize infiltration.
- Protect the lens you just removed. Once you've attached the new lens, quickly put the end cap on the one you just removed to reduce the dust that might fall on it.
- Clean out the vestibule. From time to time, remove the lens while in a relatively dust-free environment and use a blower bulb like the one shown in Figure 13.11 (not compressed air or a vacuum hose) to clean out the mirror box area. A blower bulb is generally safer than a can of compressed air, or a strong positive/negative airflow, which can tend to drive dust further into nooks and crannies.

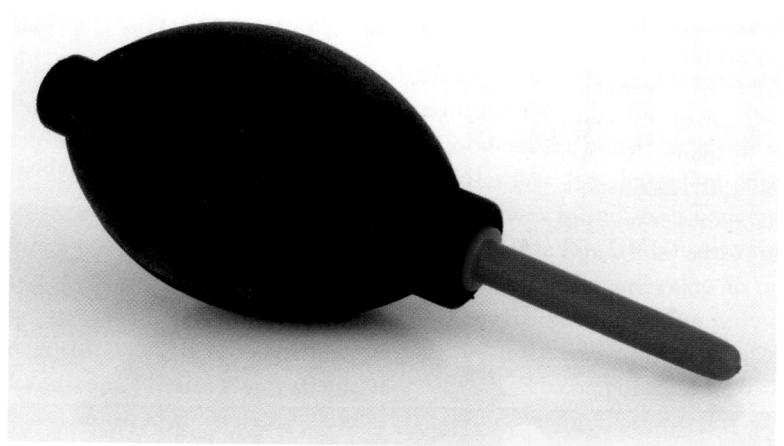

- Be prepared. If you're embarking on an important shooting session, it's a good idea to clean your sensor *now*, rather than come home with hundreds or thousands of images with dust spots caused by flecks that were sitting on your sensor before you even started. Before I left on my most recent trip to Spain, I put both cameras I was taking through a rigid cleaning regimen, figuring they could remain dust-free for a measly 10 days. I even left my bulky blower bulb at home, and took along a new, smaller version for emergencies.
- Clone out existing spots in your image editor. Photoshop and other editors have a clone tool or healing brush you can use to copy pixels from surrounding areas over the dust spot or dead pixel. This process can be tedious, especially if you have lots of dust spots and/or lots of images to be corrected. The advantage is that this sort of manual fix-it probably will do the least damage to the rest of your photo. Only the damaged pixels will be affected.
- Use filtration in your image editor. A semi-smart filter like Photoshop's Dust & Scratches filter can remove dust and other artifacts by selectively blurring areas that the plug-in decides represent dust spots. This method can work well if you have many dust spots, because you won't need to patch them manually. However, any automated method like this has the possibility of blurring areas of your image that you didn't intend to soften.

Sensor Cleaning

Those new to the concept of sensor dust actually hesitate before deciding to clean their camera themselves. Isn't it a better idea to pack up your D3200 and send it to a Nikon service center so their crack technical staff can do the job for you? Or, at the very least, shouldn't you let the friendly folks at your local camera store do it?

Of course, if you choose to let someone else clean your sensor, they will be using methods that are more or less identical to the techniques you would use yourself. None of these techniques are difficult, and the only difference between their cleaning and your cleaning is that they might have done it dozens or hundreds of times. If you're careful, you can do just as good a job.

Of course vendors like Nikon won't tell you this, but it's not because they don't trust you. It's not that difficult for a real goofball to mess up their camera by hurrying or taking a shortcut. Perhaps the person uses the "Bulb" method of holding the shutter open and a finger slips, allowing the shutter curtain to close on top of a sensor cleaning brush. Or, someone tries to clean the sensor using masking tape, and ends up with goo all over its surface. If Nikon recommended *any* method that's mildly risky, someone would do it wrong, and then the company would face lawsuits from those who'd contend they did it exactly in the way the vendor suggested, so the ruined camera is not their fault.

You can see that vendors like Nikon tend to be conservative in their recommendations, and, in doing so, make it seem as if sensor cleaning is more daunting and dangerous than it really is. Some vendors recommend only dust-off cleaning, through the use of reasonably gentle blasts of air, while condemning more serious scrubbing with swabs and cleaning fluids. However, these cleaning kits for the exact types of cleaning they recommended against are for sale in Japan only, where, apparently, your average photographer is more dexterous than those of us in the rest of the world. These kits are similar to those used by official repair staff to clean your sensor if you decide to send your camera in for a dust-up.

As I noted, sensors can be affected by dust particles that are much smaller than you might be able to spot visually on the surface of your lens. The filters that cover sensors tend to be fairly hard compared to optical glass. Cleaning the 23.2mm × 15.4mm sensor in your Nikon D5100 within the tight confines of the mirror box can call for a steady hand and careful touch. If your sensor's filter becomes scratched through inept cleaning, you can't simply remove it yourself and replace it with a new one.

There are four basic kinds of cleaning processes that can be used to remove dusty and sticky stuff that settles on your dSLR's sensor. All of these must be performed with the shutter locked open. I'll describe these methods and provide instructions for locking the shutter later in this section.

- Air cleaning. This process involves squirting blasts of air inside your camera with the shutter locked open. This works well for dust that's not clinging stubbornly to your sensor.
- **Brushing.** A soft, very fine brush is passed across the surface of the sensor's filter, dislodging mildly persistent dust particles and sweeping them off the imager.

- Liquid cleaning. A soft swab dipped in a cleaning solution such as ethanol is used to wipe the sensor filter, removing more obstinate particles.
- Tape cleaning. There are some who get good results by applying a special form of tape to the surface of their sensor. When the tape is peeled off, all the dust goes with it. Supposedly. I'd be remiss if I didn't point out right now that this form of cleaning is somewhat controversial; the other three methods are much more widely accepted.

Placing the Mirror/Shutter in the Locked and Fully Upright Position for Landing

Make sure you're using a fully charged battery or an AC adapter. Fortunately, the Nikon D3200 is smart enough that it won't let you try to clean the sensor manually unless the battery has a sufficient charge.

- 1. Remove the lens from the camera and then turn on the camera.
- 2. You'll find the Lock Mirror Up for Cleaning menu choice in the Setup menu. Select it.
- 3. Choose Start. The mirror will flip up and the shutter will open.
- 4. Use one of the methods described below to remove dust and grime from your sensor. Be careful not to accidentally switch the power off or open the Secure Digital card or battery compartment doors as you work. If that happens, the shutter may be damaged if it closes onto your cleaning tool.
- 5. When you're finished, turn off the power, replace your lens, and switch your camera back on.

Air Cleaning

Your first attempts at cleaning your sensor should always involve gentle blasts of air. Many times, you'll be able to dislodge dust spots, which will fall off the sensor and, with luck, out of the mirror box. Attempt one of the other methods only when you've already tried air cleaning and it didn't remove all the dust.

Here are some tips for doing air cleaning:

- Use a clean, powerful air bulb. Your best bet is bulb cleaners designed for the job, like the Giottos Rocket. Smaller bulbs, like those air bulbs with a brush attached sometimes sold for lens cleaning or weak nasal aspirators may not provide sufficient air or a strong enough blast to do much good.
- Hold the camera upside down. Then look up into the mirror box as you squirt your air blasts, increasing the odds that gravity will help pull the expelled dust downward, away from the sensor. You may have to use some imagination in positioning yourself. (See Figure 13.12, which illustrates how I clean my Nikon D3200.)

Figure 13.12 Hold the camera upside down and blow the dust off the sensor.

- Never use air canisters. The propellant inside these cans can permanently coat your sensor if you tilt the can while spraying. It's not worth taking a chance.
- Avoid air compressors. Super-strong blasts of air are likely to force dust under the sensor filter.

Brush Cleaning

If your dust is a little more stubborn and can't be dislodged by air alone, you may want to try a brush, charged with static electricity, which can pick off dust spots by electrical attraction. One good, but expensive, option is the Sensor Brush sold at www.visible-dust.com. A cheaper version can be purchased at www.copperhillimages.com. You need a 16mm version, like the one in Figure 13.13. It can be stroked across the short dimension of your D3200's sensor.

Ordinary artist's brushes are much too coarse and stiff and have fibers that are tangled or can come loose and settle on your sensor. A good sensor brush's fibers are resilient and described as "thinner than a human hair." Moreover, the brush has a wooden handle that reduces the risk of static sparks.

Brush cleaning is done with a dry brush by gently swiping the surface of the sensor filter with the tip. The dust particles are attracted to the brush particles and cling to them. You should clean the brush with compressed air before and after each use, and store it in an appropriate air-tight container between applications to keep it clean and dust-free. Although these special brushes are expensive, one should last you a long time.

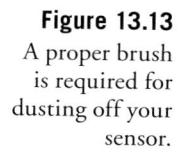

Liquid Cleaning

Unfortunately, you'll often encounter really stubborn dust spots that can't be removed with a blast of air or flick of a brush. These spots may be combined with some grease or a liquid that causes them to stick to the sensor filter's surface. In such cases, liquid cleaning with a swab may be necessary. During my first clumsy attempts to clean my own sensor, I accidentally got my blower bulb tip too close to the sensor, and some sort of deposit from the tip of the bulb ended up on the sensor. I panicked until I discovered that liquid cleaning did a good job of removing whatever it was that took up residence on my sensor.

You want a sturdy swab that won't bend or break so you can apply gentle pressure to the swab as you wipe the sensor surface. Use the swab with methanol (as pure as you can get it, particularly medical grade; other ingredients can leave a residue), or the Eclipse solution also sold by Photographic Solutions. Eclipse is actually quite a bit purer than even medical-grade methanol. A couple drops of solution should be enough, unless you have a spot that's extremely difficult to remove. In that case, you may need to use extra solution on the swab to help "soak" the dirt off.

You can make your own swabs out of pieces of plastic (some use fast food restaurant knives, with the tip cut at an angle to the proper size) covered with a soft cloth or Pec-Pad, as shown in Figure 13.14. However, if you've got the bucks to spend, you can't go wrong with good-quality commercial sensor cleaning swabs, such as those sold by Photographic Solutions, Inc. (www.photosol.com/swabproduct.htm).

Once you overcome your nervousness at touching your D3200's sensor, the process is easy. You'll wipe continuously with the swab in one direction, then flip it over and wipe in the other direction. You need to completely wipe the entire surface; otherwise, you may end up depositing the dust you collect at the far end of your stroke. Wipe; don't rub.

Figure 13.14
Carefully wrap
a Pec-Pad
around a plastic
knife that
you've
truncated.

Tape Cleaning

There are people who absolutely swear by the tape method of sensor cleaning. The concept seems totally wacky, and I have never tried it personally, so I can't say with certainty that it either does or does not work. In the interest of completeness, I'm including it here. I can't give you a positive recommendation, so if you have problems, please don't blame me. The Nikon D3200 is still too new to have generated any reports of users accidentally damaging the anti-dust coating on the sensor filter using this method.

Tape cleaning works by applying a layer of Scotch Brand Magic Tape to the sensor. This is a minimally sticky tape that some of the tape cleaning proponents claim contains no adhesive. I did check this out with 3M, and can say that Magic Tape certainly *does* contain an adhesive. The question is whether the adhesive comes off when you peel back the tape, taking any dust spots on your sensor with it. The folks who love this method claim there is no residue. There have been reports from those who don't like the method that residue is left behind. This is all anecdotal evidence, so you're pretty much on your own in making the decision whether to try out the tape cleaning method.

Magnifier Assisted Cleaning

Using a magnifier to view your sensor as you clean it is a good idea. I rely on two types. I have four Carson MiniBrite PO-25 magnifiers (see Figure 13.15), and keep one in each camera bag. So, no matter where I am shooting, I have one of these \$8.95 gadgets with me. You can read more about this great tool at my blog (http://dslrguides.com/blog/).

When I'm not traveling, I use a SensorKlear loupe. It's a magnifier with a built-in LED illuminator. There's an opening on one side that allows you to insert a SensorKlear cleaning wand, a lens pen-like stylus with a surface treated to capture dust particles. (See Figure 13.16.) Both the SensorKlear loupe and the SensorKlear wand are available from www.lenspen.com.

Figure 13.15
The Carson
MiniBrite is a
good value sensor magnifier.

Figure 13.16
The
SensorKlear
Loupe and
wand allow
quickly removing multiple
dust particles.

When I'm using the MiniBrite, I locate the dust on the sensor with the magnifier, remembering that the position of the dust will be *reversed* from what I might have seen on an image on the camera's LCD (because the camera lens flips the image when making the exposure). Then, I use the SensorKlear wand or the blower brush to remove the artifact.

The SensorKlear loupe actually allows you to keep your eye on the prize as you do the cleaning. You can peer through the viewer, rotate the opening to the side opposite the position of the dust, then insert the hinged wand to tap the dust while you're watching. This method allows removing a bunch of dust particles quickly, so it's my preferred procedure when I have the loupe with me.

Glossary

It's always handy to have a single resource where you can look up various terms you'll encounter while working with your digital camera. Here is the latest update of a glossary I've compiled over the years, with some new additions specifically for the Nikon D3200.

AE-L/AF-L A button on the D3200 that allows locking exposure and/or focus point prior to taking a photo.

ambient lighting Diffuse, non-directional lighting that doesn't appear to come from a specific source but, rather, bounces off walls, ceilings, and other objects in the scene when a picture is taken.

analog/digital converter The EXPEED module in the camera that electronically converts the analog information captured by the D3200's sensor into digital bits that can be stored as an image.

angle of view The area of a scene that a lens can capture, determined by the focal length of the lens. Lenses with a shorter focal length have a wider angle of view than lenses with a longer focal length.

anti-alias A process that smoothes the look of rough edges in images (called *jaggies* or *staircasing*) by adding partially transparent pixels along the boundaries of diagonal lines that are merged into a smoother line by our eyes. *See also* jaggies.

aperture The size of the opening in the iris or diaphragm of a lens, relative to the lens's focal length. Also called an *f/stop*. For example, with a lens having a focal length of 100mm, an f/stop with a diameter of 12.5mm would produce an aperture value of f/8.

Aperture-priority A camera setting that allows you to specify the lens opening or f/stop that you want to use, with the camera selecting the required shutter speed automatically based on its light meter reading. *See also* Shutter-priority.

artifact A type of noise in an image, or an unintentional image component produced in error by a digital camera during processing, usually caused by the JPEG compression process in digital cameras, or, in some cases, by dust settling on the sensor.

aspect ratio The proportions of an image as printed, displayed on a monitor, or captured by a digital camera.

Autofocus A camera setting that allows the Nikon D3200 to choose the correct focus distance for you, based on the contrast of an image (the image will be at maximum contrast when in sharp focus). The camera can be set for *Single Servo Autofocus (AF-S)*, in which the lens is not focused until the shutter release is partially depressed, *Continuous Servo Autofocus (AF-C)*, in which the lens refocuses constantly as you frame and reframe the image, and *Automatic Autofocus (AF-A)*, in which the D3200 focuses using AF-S mode, but switches to AF-C mode if the subject starts to move. The D3200 can also be set for *Manual* focus.

backlighting A lighting effect produced when the main light source is located behind the subject. Backlighting can be used to create a silhouette effect, or to illuminate translucent objects. *See also* front lighting and side lighting.

barrel distortion A lens defect that causes straight lines at the top or side edges of an image to bow outward into a barrel shape. *See also* pincushion distortion.

blooming An image distortion caused when a photosite in an image sensor has absorbed all the photons it can handle so that additional photons reaching that pixel overflow to affect surrounding pixels, producing unwanted brightness and overexposure around the edges of objects.

blur To soften an image or part of an image by throwing it out of focus, or by allowing it to become soft due to subject or camera motion. Blur can also be applied creatively in an image-editing program.

bokeh A term derived from the Japanese word for blur, which describes the aesthetic qualities of the out-of-focus parts of an image. Some lenses produce "good" bokeh and others offer "bad" bokeh. Some lenses produce uniformly illuminated out-of-focus discs. Others produce a disc that has a bright edge and a dark center, producing a "doughnut" effect, which is the worst from a bokeh standpoint. Lenses that generate a bright center that fades to a darker edge are favored, because their bokeh allows the circle of confusion to blend more smoothly with the surroundings. The bokeh characteristics of a lens are most important when you're using selective focus (say, when shooting a portrait) to deemphasize the background, or when shallow depth-of-field is a given because you're working with a macro lens, with a long telephoto, or with a wide-open aperture. *See also* circle of confusion.

bounce lighting Light bounced off a reflector, including ceiling and walls, to provide a soft, natural-looking light.

buffer The digital camera's internal memory where an image is stored immediately after it is taken until it can be written to the camera's non-volatile (semi-permanent) memory card.

burst mode The digital camera's equivalent of the film camera's motor drive, used to take multiple shots within a short period of time, each stored in a memory buffer temporarily before writing them to the media.

calibration A process used to correct for the differences in the output of a printer or monitor when compared to the original image. Once you've calibrated your scanner, monitor, and/or your image editor, the images you see on the screen more closely represent what you'll get from your printer, even though calibration is never perfect.

Camera Raw A plug-in included with Photoshop and Photoshop Elements that can manipulate the unprocessed images captured by digital cameras, such as the Nikon D3200's NEF files. The latest versions of this module can also work with JPEG and TIFF images.

camera shake Movement of the camera, aggravated by slower shutter speeds, which produces a blurred image.

Center-weighted metering A light-measuring system that emphasizes the area in the middle of the frame when calculating the correct exposure for an image. *See also* Matrix metering and Spot metering.

channel In an electronic flash, a channel is a protocol used to communicate between a master flash unit and the remote units slaved to that main flash. The ability to change channels allows several master flash units to operate in the same environment without interfering with each other.

chromatic aberration An image defect, often seen as green or purple fringing around the edges of an object, caused by a lens failing to focus all colors of a light source at the same point. *See also* fringing.

circle of confusion A term applied to the fuzzy discs produced when a point of light is out of focus. The circle of confusion is not a fixed size. The viewing distance and amount of enlargement of the image determine whether we see a particular spot on the image as a point or as a disc. *See also* bokeh.

close-up lens A lens add-on that allows you to take pictures at a distance that is less than the closest-focusing distance of the lens alone.

color correction Changing the relative amounts of color in an image to produce a desired effect, typically a more accurate representation of those colors. Color correction can fix faulty color balance in the original image, or compensate for the deficiencies of the inks used to reproduce the image.

compression Reducing the size of a file by encoding using fewer bits of information to represent the original. Some compression schemes, such as JPEG, operate by discarding some image information, while others have options that preserve all the detail in the original, discarding only redundant data.

Continuous Servo Autofocus An automatic focusing setting (AF-C) in which the camera constantly refocuses the image as you frame the picture. This setting is often the best choice for moving subjects. *See also* Single Servo Autofocus.

contrast The range between the lightest and darkest tones in an image. A high-contrast image is one in which the shades fall at the extremes of the range between white and black. In a low-contrast image, the tones are closer together.

Creative Lighting System (CLS) Nikon's electronic flash system used to coordinate exposure, camera information, and timing between a camera's built-in flash (if present) and external flash units, which can be linked through direct electrical connections or wirelessly. Some external flash units can act as a "master" to command other external units.

dedicated flash An electronic flash unit, such as the Nikon SB-400 Speedlight, designed to work with the automatic exposure features of a specific camera.

depth-of-field A distance range in a photograph in which all included portions of an image are at least acceptably sharp.

diaphragm An adjustable component, similar to the iris in the human eye, which can open and close to provide specific-sized lens openings, or f/stops, and thus control the amount of light reaching the sensor or film.

diffuse lighting Soft, low-contrast lighting.

digital processing chip A solid-state device found in digital cameras that's in charge of applying the image algorithms to the raw picture data prior to storage on the memory card.

diopter A value used to represent the magnification power of a lens, calculated as the reciprocal of a lens's focal length (in meters). Diopters are most often used to represent the optical correction used in a viewfinder to adjust for limitations of the photographer's eyesight, and to describe the magnification of a close-up lens attachment.

equivalent focal length A digital camera's focal length translated into the corresponding values for a 35mm film camera. This value can be calculated for lenses used with the Nikon D3200 by multiplying by 1.5.

exchangeable image file format (Exif) Developed to standardize the exchange of image data between hardware devices and software. A variation on JPEG, Exif is used by most digital cameras, and includes information such as the date and time a photo was taken, the camera settings, resolution, amount of compression, and other data.

Exif See exchangeable image file format (Exif).

exposure The amount of light allowed to reach the film or sensor, determined by the intensity of the light, the amount admitted by the iris of the lens, the length of time determined by the shutter speed, and the sensitivity of the sensor or film to light.

exposure compensation Exposure compensation, which uses exposure value (EV) settings, is a way of adding or decreasing exposure without the need to reference f/stops or shutter speeds. For example, if you tell your camera to add +1EV, it will provide twice as much exposure by using a larger f/stop, slower shutter speed, or both. The D3200 offers both conventional exposure compensation and flash exposure compensation.

fill lighting In photography, lighting used to illuminate shadows. Reflectors or additional incandescent lighting or electronic flash can be used to brighten shadows. One common technique outdoors is to use the camera's flash as a fill in sunlit situations.

filter In photography, a device that fits over the lens, changing the light in some way. In image editing, a feature that changes the pixels in an image to produce blurring, sharpening, and other special effects. Photoshop includes several interesting filter effects, including Lens Blur and Photo Filters.

flash sync The timing mechanism that ensures that an internal or external electronic flash fires at the correct time during the exposure cycle. A digital SLR's flash sync speed is the highest shutter speed that can be used with flash, ordinarily 1/200th of a second with the Nikon D3200. *See also* front-curtain sync and rear-curtain sync.

focal length The distance between the film and the optical center of the lens when the lens is focused on infinity, usually measured in millimeters.

focal plane A line, perpendicular to the optical axis, which passes through the focal point forming a plane of sharp focus when the lens is set at infinity. A focal plane indicator is etched into the Nikon D3200 on the top panel.

focus tracking The ability of the automatic focus feature of a camera to change focus as the distance between the subject and the camera changes. One type of focus tracking is *predictive*, in which the mechanism anticipates the motion of the object being focused on, and adjusts the focus to suit.

format To erase a memory card and prepare it to accept files.

fringing A chromatic aberration that produces fringes of color around the edges of subjects, caused by a lens's inability to focus the various wavelengths of light onto the same spot. Purple fringing is especially troublesome with backlit images.

front-curtain sync (first-curtain sync) The default kind of electronic flash synchronization technique, originally associated with focal plane shutters, which consists of a traveling set of curtains, including a *front curtain*, which opens to reveal the film or sensor, and a *rear curtain*, which follows at a distance determined by shutter speed to conceal the film or sensor at the conclusion of the exposure. For a flash picture to be taken, the entire sensor must be exposed at one time to the brief flash exposure, so the image is exposed after the front curtain has reached the other side of the focal plane, but before the rear curtain begins to move. Front-curtain sync causes the flash to fire at the beginning of this period when the shutter is completely open, in the instant that

378

the first curtain of the focal plane shutter finishes its movement across the film or sensor plane. With slow shutter speeds, this feature can create a blur effect from the ambient light, showing as patterns that follow a moving subject with the subject shown sharply frozen at the beginning of the blur trail. *See also* rear-curtain sync.

front lighting Illumination that comes from the direction of the camera. *See also* backlighting and side lighting.

f/stop The relative size of the lens aperture, which helps determine both exposure and depth-of-field. The larger the f/stop number, the smaller the f/stop itself.

graduated filter A lens attachment with variable density or color from one edge to another. A graduated neutral-density filter, for example, can be oriented so the neutral-density portion is concentrated at the top of the lens's view with the less dense or clear portion at the bottom, thus reducing the amount of light from a very bright sky while not interfering with the exposure of the landscape in the foreground. Graduated filters can also be split into several color sections to provide a color gradient between portions of the image.

gray card A piece of cardboard or other material with a standardized 18-percent reflectance. Gray cards can be used as a reference for determining correct exposure or for setting white balance.

group A way of bundling more than one wireless flash unit into a single cluster that shares the same flash output setting, as controlled by the master flash unit.

Guide mode An option on the D3200 that simplifies choosing Scene and exposure settings for various types of photography, through multiple levels of choices and helpful descriptions.

HDMI (**High-Definition Multimedia Interface**) An audio/video interface for transferring uncompressed digital audio/video data from a source device like the Nikon D3200 to a compatible digital output device, such as a computer monitor, video projector, or high definition television.

high contrast A wide range of density in a print, negative, or other image.

highlights The brightest parts of an image containing detail.

histogram A kind of chart showing the relationship of tones in an image using a series of 256 vertical bars, one for each brightness level. A histogram chart, such as the one the Nikon D3200 can display during picture review, typically looks like a curve with one or more slopes and peaks, depending on how many highlight, midtone, and shadow tones are present in the image.

hot shoe A mount on top of a camera used to hold an electronic flash, while providing an electrical connection between the flash and the camera. Also called an accessory shoe.
hyperfocal distance A point of focus where everything from half that distance to infinity appears to be acceptably sharp. For example, if your lens has a hyperfocal distance of four feet, everything from two feet to infinity would be sharp. The hyperfocal distance varies by the lens and the aperture in use. If you know you'll be making a grab shot without warning, sometimes it is useful to turn off your camera's automatic focus, and set the lens to infinity, or, better yet, the hyperfocal distance. Then, you can snap off a quick picture without having to wait for the lag that occurs with most digital cameras as their autofocus locks in.

image rotation A feature that senses whether a picture was taken in horizontal or vertical orientation. That information is embedded in the picture file so that the camera and compatible software applications can automatically display the image in the correct orientation.

image stabilization A technology that compensates for camera shake, usually by adjusting the position of the camera sensor or (with the implementation used by Nikon) by rearranging the position of certain lens elements in response to movements of the camera.

incident light Light falling on a surface.

International Organization for Standardization (ISO) A governing body that provides standards used to represent film speed, or the equivalent sensitivity of a digital camera's sensor. Digital camera sensitivity is expressed in ISO settings.

interpolation A technique digital cameras, scanners, and image editors use to create new pixels required whenever you resize or change the resolution of an image based on the values of surrounding pixels. Devices such as scanners and digital cameras can also use interpolation to create pixels in addition to those actually captured, thereby increasing the apparent resolution or color information in an image.

ISO See International Organization for Standardization (ISO).

i-TTL Nikon's intelligent through-the-lens flash metering system, which uses preflashes to calculate exposure and to communicate between flash units, using the camera's 420-segment RGB sensor viewfinder exposure meter.

jaggies Staircasing effect of lines that are not perfectly horizontal or vertical, caused by pixels that are too large to represent the line accurately. *See also* anti-alias.

JPEG A file "lossy" format (short for Joint Photographic Experts Group) that supports 24-bit color and reduces file sizes by selectively discarding image data. Digital cameras generally use JPEG compression to pack more images onto memory cards. You can select how much compression is used (and, therefore, how much information is thrown away) by selecting from among the Standard, Fine, Super Fine, or other quality settings offered by your camera. *See also* RAW.

Kelvin (**K**) A unit of measure based on the absolute temperature scale in which absolute zero is zero; it's used to describe the color of continuous-spectrum light sources and applied when setting white balance. For example, daylight has a color temperature of about 5,500K, and a tungsten lamp has a temperature of about 3,400K.

lag time The interval between when the shutter is pressed and when the picture is actually taken. During that span, the camera may be automatically focusing and calculating exposure. With digital SLRs like the Nikon D3200, lag time is generally very short; with non-dSLRs, the elapsed time easily can be one second or more under certain conditions.

latitude The degree by which exposure can be varied and still produce an acceptable photo.

lens flare A feature of conventional photography that is both a bane and a creative outlet. It is an effect produced by the reflection of light internally among elements of an optical lens. Bright light sources within or just outside the field of view cause lens flare. Flare can be reduced by the use of coatings on the lens elements or with the use of lens hoods. Photographers sometimes use the effect as a creative technique, and Photoshop includes a filter that lets you add lens flare at your whim.

lighting ratio The proportional relationship between the amount of light falling on the subject from the main light and other lights, expressed in a ratio, such as 3:1.

lossless compression An image-compression scheme, such as TIFF, that preserves all image detail. When the image is decompressed, it is identical to the original version.

lossy compression An image-compression scheme, such as JPEG, that creates smaller files by discarding image information, which can affect image quality.

macro lens A lens that provides continuous focusing from infinity to extreme close-ups, often to a reproduction ratio of 1:2 (half life-size) or 1:1 (life-size).

Matrix metering A system of exposure calculation that looks at many different segments of an image to determine the brightest and darkest portions, and base f/stop and shutter speed on settings derived from a database of images. *See also* Center-weighted metering and Spot metering.

maximum burst The number of frames that can be exposed at the current settings until the buffer fills.

midtones Parts of an image with tones of an intermediate value, usually in the 25 to 75 percent brightness range. Many image-editing features allow you to manipulate midtones independently from the highlights and shadows.

mirror lock-up The ability of the D3200 to retract its mirror out of the light path to allow access to the sensor for cleaning.

neutral color A color in which red, green, and blue are present in equal amounts, producing a gray.

neutral-density filter A gray camera filter reducing the amount of light entering the camera without affecting the colors.

noise In an image, pixels with randomly distributed color values. Noise in digital photographs tends to be the product of low-light conditions and long exposures, particularly when you've set your camera to a higher ISO rating.

noise reduction A technology used to cut down on the amount of random information in a digital picture, usually caused by long exposures or increased ISO sensitivity ratings.

normal lens A lens that makes the image in a photograph appear in a perspective that is like that of the original scene, typically with a field of view of roughly 45 degrees.

overexposure A condition in which too much light reaches the film or sensor, producing a dense negative or a very bright/light print, slide, or digital image.

pincushion distortion A type of lens distortion in which lines at the top and side edges of an image are bent inward, producing an effect that looks like a pincushion. *See also* barrel distortion.

Playback menu The D3200's list of settings and options that deal with reviewing and printing images that you've shot.

polarizing filter A filter that forces light, which normally vibrates in all directions, to vibrate only in a single plane, reducing or removing the specular reflections from the surface of objects and darkening blue skies.

RAW An image file format, such as the NEF format in the Nikon D3200, which includes all the unprocessed information captured by the camera after conversion to digital form. RAW files are very large compared to JPEG files and must be processed by a special program such as Nikon Capture NX or Adobe's Camera Raw filter after being downloaded from the camera.

rear-curtain sync (second-curtain sync) An optional kind of electronic flash synchronization technique, originally associated with focal plane shutters, which consists of a traveling set of curtains, including a front (first) curtain (which opens to reveal the film or sensor) and a rear (second) curtain (which follows at a distance determined by shutter speed to conceal the film or sensor at the conclusion of the exposure). For a flash picture to be taken, the entire sensor must be exposed at one time to the brief flash exposure, so the image is exposed after the front curtain has reached the other side of the focal plane, but before the rear curtain begins to move. Rear-curtain sync causes the flash to fire at the end of the exposure, an instant before the second or rear curtain

of the focal plane shutter begins to move. With slow shutter speeds, this feature can create a blur effect from the ambient light, showing as patterns that follow a moving subject with the subject shown sharply frozen at the end of the blur trail. If you were shooting a photo of The Flash, the superhero would appear sharp, with a ghostly trail behind him. *See also* front-curtain sync (first-curtain sync).

red-eye An effect from flash photography that appears to make a person's eyes glow red, or an animal's yellow or green. It's caused by light bouncing from the retina of the eye and is most pronounced in dim illumination (when the irises are wide open) and when the electronic flash is close to the lens and, therefore, prone to reflect directly back. Image editors can fix red-eye through cloning other pixels over the offending red or orange ones.

RGB color A color model that represents the three colors—red, green, and blue—used by devices such as scanners or monitors to reproduce color. Photoshop works in RGB mode by default, and even displays CMYK images by converting them to RGB.

Retouch menu The D3200's list of special effects and editing changes you can make to images you've already taken. Choices in this menu allow you to trim/crop photos, and add effects such as fisheye looks.

saturation The purity of color; the amount by which a pure color is diluted with white or gray.

selective focus Choosing a lens opening that produces a shallow depth-of-field. Usually this is used to isolate a subject in portraits, close-ups, and other types of images, by causing most other elements in the scene to be blurred.

self-timer A mechanism that delays the opening of the shutter for some seconds after the release has been operated.

sensitivity A measure of the degree of response of a film or sensor to light, measured using the ISO setting.

Setup menu The D3200's list of settings and options that deal with overall changes to the camera's operation, such as Date/Time, LCD brightness, sensor cleaning, self-timer delay, and so forth.

shadow The darkest part of an image, represented on a digital image by pixels with low numeric values.

sharpening Increasing the apparent sharpness of an image by boosting the contrast between adjacent pixels that form an edge.

Shooting menu The D3200's list of settings and options that deal with how the camera behaves as you take pictures, such as image size and quality, white balance, autofocus settings, ISO sensitivity, or movie shooting options.

shutter In a conventional film camera, the shutter is a mechanism consisting of blades, a curtain, a plate, or some other movable cover that controls the time during which light reaches the film. Digital cameras can use both a mechanical shutter and an electronic shutter for higher effective speeds.

Shutter-priority An exposure mode in which you set the shutter speed and the camera determines the appropriate f/stop. *See also* Aperture-priority.

side lighting Applying illumination from the left or right sides of the camera. *See also* backlighting and front lighting.

Single Servo Autofocus An automatic focusing setting (AF-S) in which the camera focuses once when the shutter release is pressed down halfway. *See also* Continuous Servo Autofocus.

slave unit An accessory flash unit that supplements the main flash, usually triggered electronically when the slave senses the light output by the main unit, or through radio waves.

slow sync An electronic flash synchronizing method that uses a slow shutter speed so that ambient light is recorded by the camera in addition to the electronic flash illumination. This allows the background to receive more exposure for a more realistic effect.

specular highlight Bright spots in an image caused by reflection of light sources.

Spot metering An exposure system that concentrates on a small area in the image. *See also* Center-weighted metering and Matrix metering.

time exposure A picture taken by leaving the shutter open for a long period, usually more than one second. The camera is generally locked down with a tripod to prevent blur during the long exposure. The D3200 can automatically shoot time exposures up to 30 seconds, as well as much longer exposures with the camera set to Bulb and the shutter opened/closed manually.

through-the-lens (TTL) A system of providing viewing and exposure calculation through the actual lens taking the picture.

tungsten light Light from ordinary room lamps and ceiling fixtures, as opposed to fluorescent illumination.

underexposure A condition in which too little light reaches the film or sensor, producing a thin negative, a dark slide, a muddy-looking print, or a dark digital image.

unsharp masking The process for increasing the contrast between adjacent pixels in an image, increasing sharpness, especially around edges.

vignetting Dark corners of an image, often produced by using a lens hood that is too small for the field of view, a lens that does not completely fill the image frame, or generated artificially using image-editing techniques.

VR (vibration reduction) A system for stabilizing an image during exposures using shutter speeds that aren't fast enough to counter camera motion. Nikon's system uses a group of optical elements that shift to compensate for camera motion, found in lenses that offer VR.

white balance The adjustment of a digital camera to the color temperature of the light source. Interior illumination is relatively red; outdoor light is relatively blue. Digital cameras like the Nikon D3200 set correct white balance automatically or let you do it through menus. Image editors can often do some color correction of images that were exposed using the wrong white balance setting, especially when working with RAW files that contain the information originally captured by the camera before white balance was applied.

zoom head The capability of an electronic flash to change the area of its coverage to more closely match the focal length setting of a prime or zoom lens.

Index

A (Non-TTL Auto Flash) for Nikon	Adobe Camera Raw, 98, 331, 338,
SB-910 flash unit, 319-320	340-344
A (Aperture-priority) mode, 31	Basic tab, 341–343
built-in flash in, 38	Merge to HDR with, 190
equivalent exposures and, 166	Adobe Photoshop/Photoshop Elements,
red-eye reduction in, 311	338, 340-344. See also Adobe
slow sync in, 312	Camera Raw
sync speeds in, 311–312	Auto Image Rotation and, 124
working with, 175–176	dust
AA (Auto Aperture) flash for Nikon	cloning out, 365
SB-910 flash unit, 319	Dust & Scratches filter, 365
AC adapters, 12	identifying, 363
Auto Off Timers option with, 126	focus stacking with, 212–213
for Live View, 216	Lens Distortion Correction feature, 279,
accessories, apps for selecting, 260	283
accessory/hot shoe, 67–68	Merge to HDR, 187–190
cover for, 10	noise reduction with, 182
external flash, connecting, 321,	pincushion distortion, correcting, 283
326–327	rotating images with, 84
GPS device, connecting, 252	Adobe Premiere Elements, 220
multiple non-dedicated flash units,	Adobe RGB, 107–109
connecting, 326–327	Adorama
remote triggers on, 295	Eye-Fi cards for uploading to, 255
accessory lenses, 274	flash units, 327
accessory terminal, 49–50	AE-L/AF-L lock, 51
acrylic shields for LCD, 353	Setup menu options for, 132–133
action-stopping. See freezing action	viewfinder information display for, 74–75
Active D-Lighting	AF (autofocus). See also AF-area; focus
Fn (Function) button and, 132	modes; focus points; rangefinder
overlaying images and, 147	AE-L/AF-L lock and, 133
shooting information display for, 65, 67	circles of confusion, 196-199
Shooting menu options, 106–107	contrast detection, 194-195
oncoming menta options, 100–10/	cross-type focus points, 193-194

actuations, 131

A

Live View, focusing in, 206–210 locking in focus, 195–196 morphing, 45 phase detection, 192–194 shooting information display for, 65 working with, 199–200

AF-A (auto-servo AF), 35

working with, 202

AF-area. See also auto-area AF; dynamic-area AF; single-point AF; 3D-tracking mode

with Live View, 111–112, 207–210, 217 selecting, 34 shooting information display for, 65–66 Shooting menu options, 111–112 working with, 204–206

AF-assist lamp, 44-45

Shooting menu options, 112

AF-C (continuous-servo AF), 35 working with, 201–202

AF-D lenses, 270

AF DX Fisheye-Nikkor 10.5mm f/2.8G ED lens, 274

AF-F (full-time AF) with Live View, 206, 217

AF-I lenses, 270

AF lenses, 270

AF/MF switch, 18, 33, 47, 49, 70-71

AF Micro-Nikkor 60mm f/2.8D lens, 288

AF Micro-Nikkor 200mm f/4D IF-Ed lens, 289

AF-S (single-servo AF), 35

with Live View, 206, 217 working with, 201

AF-S lenses, 270

AF-S DX Micro 85mm f/3.5 ED VR lens, 289

AF-S DX Nikkor 16-85mm f/3.5-5.6G ED VR lens, 266

AF-S DX Nikkor 18-55mm f/3.5-5.6G VR lens, 266

AF-S DX Nikkor 18-105mm f/3.5-5.6G ED VR lens, 264, 266 AF-S DX Nikkor 35mm f/1.8G lens, 270

AF-S DX VR Zoom-Nikkor 18-200mm f/3.5-5.6G IF-ED lens, 268

AF-S DX Zoom-Nikkor 18-55mm f/3.5-5.6G ED II lens, 264

AF-S DX Zoom-Nikkor 18-70mm f/3.5-4.5G IF-ED lens, 266–267

AF-S DX Zoom-Nikkor 18-135mm f/3.5-5.6G IF-ED lens, 267

AF-S Micro-Nikkor 40mm f/2.8 DX lens, 288

AF-S Micro-Nikkor 60mm f/2.8G ED lens, 274, 288

AF-S Nikkor 14-24mm f/2.8G ED lens, 70

AF-S Nikkor 300mm f/4D IF-ED lens, 274

AF-S VR Micro-Nikkor 105mm f/2.8G IF-ED lens, 289

AF-S VR II Zoom Nikkor 24-120mm f/3.5-5.6G IF-ED lens, 268

AF-S VR Zoom-Nikkor 70-200mm f/2.8G IF-ED lens, 292

AGC (automatic gain control), 228

AI lenses, 269-270

AI-S lenses, 269-270

air blowers. See blower bulbs

air cleaning sensors, 366-368

Alien Bees

flash units, 367-327

Amazon Kindle Fire, 257-259

Android phones, 257

Wireless Mobile adapter for, 49 WU-la Wi-Fi adapter with, 254

angles

right-angle viewer, 12 with telephoto lenses, 282 with wide-angle lenses, 278

aperture, 164–165. See also f/stops; maximum aperture

shooting information display for, 65 taking aperture, 73 viewfinder information display for, 74–75

black-and-white. See also Monochrome Picture Control Retouch menu's Monochrome options, Selective Color options, Retouch menu, 155-156 toning effects, 93-95 black tones with Adobe Camera Raw, 343 blower bulbs for air cleaning sensors, 367–368 for vestibule cleaning, 364-365 Blue filter effects, 144 C Blue Green toning effects, 93-95 Blue toning effects, 93-95 blurring circles of confusion, 196-199 with long exposures, 249–250 Reduce Blur options, 42 with telephoto lenses, 282-286 body cap, 9-10 removing, 17 bokeh, 284-286 bouncing light, 323 bowing-outward lines. See barrel distortion box, contents of, 7-11 card readers bracketing, 186-190 and Merge to HDR, 187-190 BreezeBrowser Pro, 340 brightness. See also LCD with Active D-Lighting, 106 Adobe Camera Raw, adjusting with, 343 center-weighted metering for, 172 Picture Controls, editing for, 92-96 Take Bright Photos option, 42

brightness histograms, 182-186 Bring More into Focus option, 42 brush cleaning sensors, 366, 368-369 buffer for continuous shooting, 26-27, 241 RAW formats and, 98

built-in flash, 47-48, 294-295

changing settings for, 315 color temperature, setting, 316 guide numbers (GN) and, 309 red-eye reduction with, 141 Shooting menu options, 113–114 techniques with, 318–320 working with, 37–38, 315–316

bulb blowers. See blower bulbs bulb exposures, 245-246 Buono, Alex, 223-224

cables. See also USB cables; video cables external flash, connecting, 321 calendar view, working with, 58-59 Camera Calibration control, Adobe Camera Raw, 343-344 camera guide apps, 259 camera shake. See also VR (vibration reduction) with telephoto lenses, 282 with wide-angle lenses, 278 capacitors, 294, 304 Capture One Pro (C1 Pro), 338-340 Capture Reds in Sunsets option, 42

firmware updates with, 350-351 saving power with, 127 transferring images to computer with,

38 - 39card safes, 356 Carson MiniBrite magnifiers, 370-372 cascades, blurring, 249-250 catadioptric lenses, 284 CCD sensors, 182 CD-ROM

reference manual, 10 software CD-ROM, 11 cell phones. See smart phones

center-weighted metering, 32	color temperature. See also WB (white
flash metering and, 310-311	balance)
with Live View, 217	for built-in flash, 316
Shooting menu options, 113	of continuous light, 299–303
working with, 172-173	of daylight, 299-301
Child mode, 29, 180	colors
sync options in, 313	Color Balance options, Retouch menu,
children. See also Child mode	144–145
Date Counter for tracking, 135	Color Outline options, Retouch menu,
chromatic aberration	150–151
ED lenses and, 271	Color Sketch options, Retouch menu,
with telephoto lenses, 283	150
with wide-angle lenses, 279	menus, color-coding for, 80
CIPA (Camera & Imaging Products	Selective Color options, Retouch menu,
Association), 15	155–156
circles of confusion, 196-199	3D Color Matrix metering II, 171
bokeh and, 284–286	coma with telephoto lenses, 283
clarity adjustments with Adobe Camera	CombineZM, 213
Raw, 343	command dial, 51–52
classic information display, 24-26, 64	Commander mode for external flash,
Setup menu option, 118	320–321
cleaning. See also sensor cleaning	comments
lenses, 364	Setup menu options for, 123–124
vestibule, 364–365	text entry for, 124–125
clock, setting, 14–15	composition for movies, 231-234
clock battery, 346	computers. See also tablet computers;
cloning out dust spots, 365	transferring images to computer
Close-Up mode, 30, 180	formatting memory cards in, 20
sync options in, 313	netbooks, backing up images to,
close-ups	359–360
with lenses, 272	Wireless Mobile Transmitter for
in movies, 233–234	transferring to, 13
with telephoto lenses, 282	construction projects, Date Counter for
Cloudy WB (white balance), 101-102	tracking, 135
CMOS sensors, 182	contact lenses, diopter correction for,
Collins, Dean, 293	18–19
color fringes. See chromatic aberration	contents of box, 7–11
Color Matrix metering II, 171-172	continuous light
color rendering index (CRI), 300, 303	basics of, 299–303
Color Sampler, Adobe Camera Raw, 341	cost of, 298
color space options, Shooting menu,	evenness of illumination with, 296
107–109	exposure calculation with, 296
	flash compared, 294–299

freezing action with, 297 previewing with, 295 WB (white balance), adjusting, 303 continuous-servo AF (AF-C). See AF-C (continuous-servo AF) continuous shooting, 26, 239–241 with Live View, 216 contrast Adobe Camera Raw, adjusting with, 343 histograms for fixing, 184	D-Lighting, 106. See also Active D-Lighting Retouch menu options, 140 D-Series lenses, 271 'da Products acrylic shields, 353 Dali, Salvador, 243 dark corners with wide-angle lenses, 279 dark flash photos with telephoto lenses, 284
with incandescent/tungsten light, 301	dark frame images, 111
Picture Controls, editing for, 92–96	darkness. See Night/darkness
telephoto lenses, problems with, 284	Date Counter, using, 134–135 dates and times
contrast detection, 194–195	calendar view, working with, 58–59
with subject-tracking AF, 209	clock, setting, 14–15
converging lines with wide-angle lenses, 279	Date Counter, using, 134–135
copperhillimages.com, 368–369	Print Date options, Setup menu,
Corel Photo Paint, 338	134–135
Corel Video Studio, 220	Setup menu options, 123
cost	David Busch's Digital SLR Pro Secrets,
of continuous light, 298	361
of first lens, 265	David Busch's Quick Snap Guide to Lighting, 322
of flash, 299	dawn, color temperature at, 301
Costco, Eye-Fi cards for uploading to,	daylight
255	color temperature of, 299–301
crop factor, 261-264, 276	for movies, 234, 236
cropping/trimming images	short exposures in, 242
with Adobe Camera Raw, 341	window light, working with, 322
crop factor, 261–264, 276	Daylight Savings Time
Retouch menu options, 141–143 size for, 143	setting for, 14
steps for, 142	Setup menu options, 123
cross fades in movies, 231	DC lenses, 271
Cross Screen filter effect, 144	DC power port, 46–47
cross-type focus points, 193–194	defaults
Cube Slide Show option, 85–86	Reset Setup options, Setup menu,
curvature of field with telephoto lenses,	117–118
283	Reset Shooting options, Shooting menu,
curving-inward lines. See pincushion	90 degrees Kelvin 300
distortion	degrees Kelvin, 300 of fluorescent light, 302
Cyanotype toning effects, 93-95	Delayed Remote mode, 28

Delete button, 53–54	dust. See also Adobe Photoshop/
deleting	Photoshop Elements; sensor
in calendar view, 58	cleaning
Guide mode options, 42	avoiding, 364–365
Playback menu options, 81–82	FAQs about, 361–362
on reviewing images, 36, 55	identifying/dealing with, 362-363
thumbnails, 57, 81	Image Dust Off Ref Photo options,
depth-of-field (DOF). See DOF	Setup menu, 125
(depth-of-field)	DX lenses, 271. See also specific types
depth-of-focus and dust, 362	DxO Optics Pro, 339
Detail control, Adobe Camera Raw,	dynamic-area AF, 34, 111
343-344	working with, 205
diffusers, 324	
diffusing light, 322-324	E
Digital Image Recovery, 358	e-mail trimming images for 1/1 1/2
diopter correction, adjusting, 18-19	e-mail, trimming images for, 141–143 E-Series lenses, 270–271
Direct Sunlight WB (white balance),	
101–102	Eclipse solution, Photographic Solutions, 369
directionality of microphones, 227-228	ED lenses, 271
dissolves in movies, 231	
distortion. See also barrel distortion;	Edgerton, Harold, 243 Edison, Thomas, 301
pincushion distortion	
Auto Distortion Control options,	editing. See also movies
Shooting menu, 106	Picture Controls, 90, 91–96
lenses correcting, 274	RAW formats and, 97
Retouch menu's control options,	18% gray cards, 167–170
148–150	electronic analog display, 66
with wide-angle lenses, 277–278	viewfinder information on, 74–75
documentation, Date Counter for	electronic contacts for lenses, 45, 72–73
tracking, 135	emitted light, 164
DOF (depth-of-field)	Endless Memory feature, Eye-Fi cards,
AF (autofocus) and, 199	256
bokeh and, 284–286	equivalent exposures, 166–167
circles of confusion, 196-199	establishing shots in movies, 232-233
movies and, 223-224	EV (exposure compensation), 166. See
shutter speed and, 166	also FEV (flash exposure
with telephoto lenses, 280	compensation)
with wide-angle lenses, 277-278	changing, 178
doughnut effect, 284	ISO sensitivity adjustments and,
DPOF Print Order options, Playback	180–181
menu, 87–88	in Live View, 218
drive modes. See shooting modes	for movies, 218
duration of light, 164	shooting information display for, 65, 67
dusk, color temperature at, 301	viewfinder information display for, 74–75

EV (exposure compensation) button, 68–69

evenness of illumination

with continuous light, 296 with flash, 296–297

Exif information, 131

exposure, 161–190. See also bracketing; EV (exposure compensation); histograms; ISO sensitivity; long exposures; metering modes; overexposure; underexposure

Adobe Camera Raw, adjusting with, 343

apps for estimating, 259
calculation of, 167–170, 296
continuous light, calculating with, 296
correct exposure, example of, 167–168
equivalent exposures, 166–167
flash, calculating with, 296, 308–309
for focus stacking, 212
shooting information display for, 65–66
short exposures, 241–244
viewfinder information display for,
74–75

exposure modes. See also A (Aperturepriority) mode; P (Program) mode; S (Shutter-priority) mode

defined, 169 selecting, 174–179

extension tubes, 289-290

external flash, 11, 294–295. See also specific units

color temperature, setting, 316 Commander mode for, 320–321 connecting, 321–322 flash modes for, 319–320 guide numbers (GN) and, 309 red-eye reduction with, 141 slave triggers with, 327 techniques with, 318–320 zoom head, adjusting, 319

external microphones. *See* microphones extra batteries, 11, 15

extreme close-ups in movies, 233–234 Eye-Fi cards, 254–256

Endless Memory feature, 256 Setup menu's Upload options, 138, 256 shooting information display for, 65, 67 transmitting images as taken with, 358

Eye-Fi Explore cards, 358

eyecup/eyepiece, 50-51

cap, 10 magnifier for, 12

eyeglasses, diopter correction for, 18-19 eyelet for attaching neck/shoulder straps, 47, 49

F

F. J. Westcott Company, 303 f/stops, 164–165

equivalent exposures, 166 stops and, 166

face-priority AF, 111

with Live View, 207-208, 217

Facebook, 254

Eye-Fi cards for uploading to, 255 transmitting images as taken to, 358

faces. See also face-priority AF

flat faces in portraits with telephoto lenses, 282 reviewing images, zooming in/out on, 55–56

falling backward effect

Retouch menu control options, 151–152 with wide-angle lenses, 277–278

FEV (flash exposure compensation)

with built-in flash, 315 shooting information display for, 65, 67 viewfinder information display for, 74–75

File information screen on reviewing images, 59-60

File Number Sequence options, Setup menu, 130–131

continuous light compared, 294-299

with Adobe Camera Raw, 343	cost of, 299
iPads/iPods/iPhones for, 260	evenness of illumination with, 296-297
selecting, 311	explanation of, 304–306
working with, 323	exposure, calculating, 296, 308-309
filter thread on lens, 70–71	flexibility with, 299
filters. See also neutral-density (ND)	freezing action with, 297–298
filters	guide numbers (GN) and, 309
center-weighted metering with, 172	metering modes, 310-311
low-cut filters, 229	multiple light sources, using, 324-327
Monochrome Picture Control, filter effects for, 93–95	multiple non-dedicated flash units, connecting, 326–327
Retouch menu options, 144	previewing with, 296
toning <i>vs.</i> , 94–95	red-eye reduction with, 141
final setup, 16-21	setups for, 325
Finelight Studios, 293	techniques with, 318–320
firmware	telephoto lenses, dark flash photos with,
batteries for updates, 349	284
bootstrap loaders for updating, 348	typical flash sequence, 314-315
card readers, updating from, 350–351	viewfinder information display for,
modules, 349-350	74–75
preparing for updates, 349-350	Flash button, 47
starting updates, 351–352	flash modes, 319-320
updating, 347–352	shooting information display for, 65, 67
USB cables, updating from, 351	Flash Off mode. See Auto (Flash Off)
Version information, Setup menu, 138	mode
first-curtain sync, 304–306	Flash WB (white balance), 101-102
in A (Aperture-priority) mode, 311	flat faces in portraits with telephoto
ghost images and, 305–306	lenses, 282
in M (Manual) mode, 313	flat lighting for movies, 236
in P (Program) mode, 311	flexibility
problems, avoiding, 307–308	with continuous light, 299
in S (Shutter-priority) mode, 313	with flash, 299
selecting, 311	Flexible Program
fisheye lenses, 274, 279	exposure and, 166
Fisheye options, Retouch menu, 150	viewfinder information display for,
flare with telephoto lenses, 284	74–75
flash. See also Auto (Flash Off) mode;	Flicker Reduction options, Setup menu,
built-in flash; external flash; FEV	122
(flash exposure compensation);	Flickr, 254
manual flash; studio flash; sync	Eye-Fi cards for uploading to, 255
speed	geotagging information in, 251–252
basics of, 303-313	transmitting images as taken to, 358
with continuous light, 299	

fill flash/fill light

focus ring on lens, 70-71

focus scale on lens, 70-71

focus stacking, 210-213

folders. See also Playback folder flip-up hoods for LCD, 354 changing currently active folder, fluorescent light, 302-303 136 - 137Flicker Reduction options, Setup menu, custom folders, creating, 137 Storage Folder options, Setup menu, Fluorescent WB (white balance), 135 - 137101-102 foregrounds Fn (Function) button, 47-48 with telephoto lenses, 282 Setup menu options for, 131-132 with wide-angle lenses, 277 foamboard reflectors, 324 foreign language options, Setup menu, focal lengths apps for calculating, 260 formatting memory cards. See memory DX/FX format mix-up, 264 movies and, 223-224 frame size/frame rate options, Shooting range of, 276 menu, 113 focal plane indicator, 68-69 freezing action focus. See also AF (autofocus); MF with continuous light, 297 (manual focus); rangefinder with flash, 297-298 circles of confusion, 196-199 Guide mode options, 42 contrast detection, 194-195 S (Shutter-priority) mode and, 176–177 explanation of, 191-199 with short exposures, 241-244 Live View, focusing in, 206–210 VR (vibration reduction) and, 291 locking in, 195–196 front-curtain sync. See first-curtain sync phase detection, 192-194 front view of camera, 44-50 with telephoto lenses, 280-281 full-frame cameras, crop factor and, 262 viewfinder information display for, full-time servo AF (AF-F) with Live 74 - 75View, 206, 217 focus limit switch on lens, 71-72 Function (Fn) button. See Fn (Function) focus modes, 33, 196, 200-204. See also button AF (autofocus); AF-A (auto-servo FX lenses, 271 AF); AF-C (continuous-servo AF); AF-S (single-servo AF); MF (manual focus) G with Live View, 206, 217 G-Series lenses, 271. See also specific selecting, 34–35 types shooting information display for, 65–66 GE color rendering index (CRI), 300, focus points, 33 303 AF-area and, 204 Gepe card safes, 356 cross-type focus points, 193–194 GGS glass shields for LCD, 353 shooting information display for, 65 ghost images viewfinder information display for, 74 first-curtain sync and, 305-306 focus priority, 201 second-curtain sync and, 305-306

ghoul lighting for movies, 236

Giottos Rocket. See blower bulbs

glossary, 373–384 Goddard, Jean-Luc, 232 Google's AVI Editor, 220 GPS camera setup for, 252–253 clock, setting, 15 connecting, 252 Eye-Fi cards and, 255 information display for, 253 reviewing images, GPS data screen for, 60 Setup menu options, 137–138 working with, 251–254 graphic information display, 24–26, 64 Setup menu option, 119 GraphicConverter for Macintosh, 131 gray cards, 167–170 iPads/iPhones/iPods as, 260 Green filter effects, 93–95, 144 Green toning effects, 93–95, 144 Green toning effects, 93–95 Guide mode Advanced operations, 42 Easy operation selections, 40–42 Setup options, 42 working with, 40–42 guide numbers (GN), 309 for Nikon SB-910 flash unit, 319 H halogen light, 301 Halsman, Philippe, 243 hand grip, 46–47 HDMI port, 49–50 HDR (High Dynamic Range), 162–163 Merge to HDR, 187–190 HDR (High Dynamic Range), 162–163 Merge to HDR, 187–190 HDR (High Dynamic Range), 162–163 Merge to HDR, 187–190 HDR (High Dynamic Range), 162–163 Merge to HDR, 187–190 HDR (High Dynamic Range), 162–163 Merge to HDR, 187–190 HDR (High Dynamic Range), 162–163 Merge to HDR, 187–190 HDR (High Dynamic Range), 162–163 Merge to HDR, 187–190 HDR (High Dynamic Range), 162–163 Merge to HDR, 187–190 Helicon Focus, 213 help, shooting information display for, 65, 67 Help button, 52–53 high ISO noise dealing with, 181–182 Shooting menu's reduction options, 109–111, 181 high-speed photography, 241–244 highlights. See also HDR (High Dynamic Range) werking vith, 251–254 Helicon Focus, 213 help, shooting information display for, 65, 67 Help button, 52–53 high ISO noise dealing with, 181–182 Shooting menu's reduction options, 109–111, 181 high-speed photography, 241–244 highlights. See also HDR (High Dynamic Range) with Active D-Lighting, 106 on reviewing images, 62, 64 histograms displaying, 182 for fixing exposure, 182–186 Hoodman magnifiers for LCD, 354 plastic overlays for LCD, 354 plastic overlays for LCD, 354 horizontal composition in movies, 231 hot pixel and the plant of th	glass shields for LCD, 353	HDMI format options, Setup menu,
Goddard, Jean-Luc, 232 Google's AVI Editor, 220 GPS camera setup for, 252–253 clock, setting, 15 connecting, 252 Eye-Fi cards and, 255 information display for, 253 reviewing images, GPS data screen for, 60 Setup menu options, 137–138 working with, 251–254 graphic information display, 24–26, 64 Setup menu option, 119 GraphicConverter for Macintosh, 131 gray cards, 167–170 iPads/iPhones/iPods as, 260 Green filter effects, 93–95, 144 Green toning effects, 93–95 Guide mode Advanced operations, 42 Easy operation selections, 40–42 Setup options, 40–41 view/delete options, 42 working with, 40–42 guide numbers (GN), 309 for Nikon SB-910 flash unit, 319 H halogen light, 301 Halsman, Philippe, 243 hand grip, 46–47 hand-held microphones, 229 Hand tool, Adobe Camera Raw, 341 hard light for movies, 235 hazy contrast with telephoto lenses, 284 HDMI-CEC remote control operations,	glasses, diopter correction for, 18–19	
Google's AVI Editor, 220 GPS camera setup for, 252–253 clock, setting, 15 connecting, 252 Eye-Fi cards and, 255 information display for, 253 reviewing images, GPS data screen for, 60 Setup menu options, 137–138 working with, 251–254 graphic information display, 24–26, 64 Setup menu option, 119 Graphic Converter for Macintosh, 131 gray cards, 167–170 iPads/iPhones/iPods as, 260 Green filter effects, 93–95, 144 Green toning options, 40–41 view/delete options, 42 Setup options, 42 guide numbers (GN), 309 for Nikon SB-910 flash unit, 319 H halogen light, 301 Halsman, Philippe, 243 hand grip, 46–47 hand-held microphones, 229 Hand tool, Adobe Camera Raw, 341 hard light for movies, 235 hazy contrast with telephoto lenses, 284 HDMI-CEC remote control operations,	glossary, 373-384	HDMI port, 49-50
Gogle's AVI Editor, 220 GPS camera setup for, 252–253 clock, setting, 15 connecting, 252 Eye-Fi cards and, 255 information display for, 253 reviewing images, GPS data screen for, 60 Setup menu options, 137–138 working with, 251–254 graphic information display, 24–26, 64 Setup menu option, 119 GraphicConverter for Macintosh, 131 gray cards, 167–170 iPads/iPhones/iPods as, 260 Green filter effects, 93–95, 144 Green toning options, 40–41 view/delete options, 42 shooting options, 40–42 guide numbers (GN), 309 for Nikon SB-910 flash unit, 319 H halogen light, 301 Halsman, Philippe, 243 hand grip, 46–47 hand-held microphones, 229 Hand tool, Adobe Camera Raw, 341 hard light for movies, 235 hazy contrast with telephoto lenses, 284 HDMI-CEC remote control operations,	Goddard, Jean-Luc, 232	HDR (High Dynamic Range), 162-163
camera setup for, 252–253 clock, setting, 15 connecting, 252 Eye-Fi cards and, 255 information display for, 253 reviewing images, GPS data screen for, 60 Setup menu options, 137–138 working with, 251–254 graphic information display, 24–26, 64 Setup menu option, 119 GraphicConverter for Macintosh, 131 gray cards, 167–170 iPads/iPhones/iPods as, 260 Green filter effects, 93–95, 144 Green toning effects, 93–95, 144 Green toning effects, 93–95 Guide mode Advanced operations, 42 Easy operation selections, 40–42 Setup options, 40–41 view/delete options, 42 working with, 40–42 guide numbers (GN), 309 for Nikon SB-910 flash unit, 319 H halogen light, 301 Halsman, Philippe, 243 hand grip, 46–47 hand-held microphones, 229 Hand tool, Adobe Camera Raw, 341 hard light for movies, 235 Hasselblad H3D-39 camera, 263 hazy contrast with telephoto lenses, 284 HDMI-CEC remote control operations,	Google's AVI Editor, 220	
clock, setting, 15 connecting, 252 Eye-Fi cards and, 255 information display for, 253 reviewing images, GPS data screen for, 60 Setup menu options, 137–138 working with, 251–254 graphic information display, 24–26, 64 Setup menu option, 119 GraphicConverter for Macintosh, 131 gray cards, 167–170 iPads/iPhones/iPods as, 260 Green filter effects, 93–95, 144 Green toning effects, 93–95 Guide mode Advanced operations, 42 Easy operation selections, 40–42 Setup options, 42 working with, 40–42 guide numbers (GN), 309 for Nikon SB-910 flash unit, 319 H halogen light, 301 Halsman, Philippe, 243 hand grip, 46–47 hand-held microphones, 229 Hand tool, Adobe Camera Raw, 341 hard light for movies, 235 hazy contrast with telephoto lenses, 284 HDMI-CEC remote control operations,	GPS	HDTV settings, 121-122
connecting, 252 Eye-Fi cards and, 255 information display for, 253 reviewing images, GPS data screen for, 60 Setup menu options, 137–138 working with, 251–254 graphic information display, 24–26, 64 Setup menu option, 119 Graphic Converter for Macintosh, 131 gray cards, 167–170 iPads/iPhones/iPods as, 260 Green filter effects, 93–95, 144 Green toning effects, 93–95 Guide mode Advanced operations, 42 Easy operation selections, 40–42 Setup options, 42 shooting options, 40–41 view/delete options, 42 guide numbers (GN), 309 for Nikon SB-910 flash unit, 319 H halogen light, 301 Halsman, Philippe, 243 hand grip, 46–47 hand-held microphones, 229 Hand tool, Adobe Camera Raw, 341 hard light for movies, 235 Hasselblad H3D-39 camera, 263 hazy contrast with telephoto lenses, 284 HDMI-CEC remote control operations,	camera setup for, 252-253	Helicon Focus, 213
connecting, 252 Eye-Fi cards and, 255 information display for, 253 reviewing images, GPS data screen for, 60 Setup menu options, 137–138 working with, 251–254 graphic information display, 24–26, 64 Setup menu option, 119 GraphicConverter for Macintosh, 131 gray cards, 167–170 iPads/iPhones/iPods as, 260 Green filter effects, 93–95, 144 Green toning effects, 93–95 Guide mode Advanced operations, 42 Easy operation selections, 40–42 Setup options, 42 shooting options, 40–41 view/delete options, 42 working with, 40–42 guide numbers (GN), 309 for Nikon SB-910 flash unit, 319 H halogen light, 301 Halsman, Philippe, 243 hand grip, 46–47 hand-held microphones, 229 Hand tool, Adobe Camera Raw, 341 hard light for movies, 235 Hasselblad H3D-39 camera, 263 hazy contrast with telephoto lenses, 284 HDMI-CEC remote control operations,	clock, setting, 15	help, shooting information display for,
information display for, 253 reviewing images, GPS data screen for, 60 Setup menu options, 137–138 working with, 251–254 graphic information display, 24–26, 64 Setup menu option, 119 GraphicConverter for Macintosh, 131 gray cards, 167–170 iPads/iPhones/iPods as, 260 Green filter effects, 93–95, 144 Green toning effects, 93–95 Guide mode Advanced operations, 42 Easy operation selections, 40–42 Setup options, 42 shooting options, 40–41 view/delete options, 42 working with, 40–42 guide numbers (GN), 309 for Nikon SB-910 flash unit, 319 H halogen light, 301 Halsman, Philippe, 243 hand grip, 46–47 hand-held microphones, 229 Hand tool, Adobe Camera Raw, 341 hard light for movies, 235 Hasselblad H3D-39 camera, 263 hazy contrast with telephoto lenses, 284 HDMI-CEC remote control operations,	connecting, 252	
dealing with, 181–182 Shooting menu's reduction options, 109–111, 181 bigh-speed photography, 241–244 bighlights. See also HDR (High Dynamic Range) with Active D-Lighting, 106 on reviewing images, 62, 64 bistograms, 182–186. See also RGB bistograms, 182–186. See also RGB bistograms, 182–186. See also RGB bistograms bistograms, 182–186. See also RGB bistograms	Eye-Fi cards and, 255	Help button, 52–53
Setup menu options, 137–138 working with, 251–254 graphic information display, 24–26, 64 Setup menu option, 119 GraphicConverter for Macintosh, 131 gray cards, 167–170 iPads/iPhones/iPods as, 260 Green filter effects, 93–95, 144 Green toning effects, 93–95 Guide mode Advanced operations, 42 Easy operation selections, 40–42 shooting options, 40–41 view/delete options, 42 working with, 40–42 guide numbers (GN), 309 for Nikon SB-910 flash unit, 319 H halogen light, 301 Halsman, Philippe, 243 hand grip, 46–47 hand-held microphones, 229 Hand tool, Adobe Camera Raw, 341 hard light for movies, 235 Hasselblad H3D-39 camera, 263 hazy contrast with telephoto lenses, 284 HDMI-CEC remote control operations,	information display for, 253	high ISO noise
Setup menu options, 137–138 working with, 251–254 graphic information display, 24–26, 64 Setup menu option, 119 GraphicConverter for Macintosh, 131 gray cards, 167–170 iPads/iPhones/iPods as, 260 Green filter effects, 93–95, 144 Green toning effects, 93–95 Guide mode Advanced operations, 42 Easy operation selections, 40–42 Setup options, 42 shooting options, 40–41 view/delete options, 42 working with, 40–42 guide numbers (GN), 309 for Nikon SB-910 flash unit, 319 H halogen light, 301 Halsman, Philippe, 243 hand grip, 46–47 hand-held microphones, 229 Hand tool, Adobe Camera Raw, 341 hard light for movies, 235 Hasselblad H3D-39 camera, 263 hazy contrast with telephoto lenses, 284 HDMI-CEC remote control operations,	reviewing images, GPS data screen for,	dealing with, 181–182
high-speed photography, 241–244 highlights. See also HDR (High Dynamic Range) with Active D-Lighting, 106 on reviewing images, 62, 64 histograms, 182–186. See also RGB histograms displaying, 182 for fixing exposure, 182–186 Hoodman magnifiers for LCD, 354 plastic overlays for LCD, 352 hoods. See also lens hoods for LCD, 354 horizontal composition in movies, 231 hot pixels, 361–362 hot shoe. See accessory/hot shoe How It's Made apps, 260 HSL/Grayscale control, Adobe Camera Raw, 343–344 hue Picture Controls, editing for, 92–96 high-speed photography, 241–244 highlights. See also HDR (High Dynamic Range) with Active D-Lighting, 106 on reviewing images, 62, 64 histograms, 182–186. See also RGB histograms displaying, 182 for fixing exposure, 182–186 Hoodman magnifiers for LCD, 354 plastic overlays for LCD, 352 hoods. See also lens hoods for LCD, 354 horizontal composition in movies, 231 hot pixels, 361–362 hot shoe. See accessory/hot shoe How It's Made apps, 260 HSL/Grayscale control, Adobe Camera Raw, 343–344 hue Picture Controls, editing for, 92–96 highlights. See also HDR (High Dynamic Range) with Active D-Lighting, 106 on reviewing images, 62, 64 histograms displaying, 182 for fixing exposure, 182–186 Hoodman magnifiers for LCD, 354 horizontal composition in movies, 231 hot pixels, 361–362 hot shoe. See accessory/hot shoe How It's Made apps, 260 HSL/Grayscale control, Adobe Camera Raw, 343–344 hue Picture Controls, editing for, 92–96 halanced fill-flash, 310 standard fill-flash, 310	60	Shooting menu's reduction options,
graphic information display, 24–26, 64 Setup menu option, 119 GraphicConverter for Macintosh, 131 gray cards, 167–170 iPads/iPhones/iPods as, 260 Green filter effects, 93–95, 144 Green toning effects, 93–95 Guide mode Advanced operations, 42 Easy operation selections, 40–42 Setup options, 42 working with, 40–42 guide numbers (GN), 309 for Nikon SB-910 flash unit, 319 H halogen light, 301 Halsman, Philippe, 243 hand grip, 46–47 hand-held microphones, 229 Hand tool, Adobe Camera Raw, 341 hard light for movies, 235 Hasselblad H3D-39 camera, 263 hazy contrast with telephoto lenses, 284 HDMI-CEC remote control operations,	Setup menu options, 137–138	109–111, 181
Setup menu option, 119 GraphicConverter for Macintosh, 131 gray cards, 167–170 iPads/iPhones/iPods as, 260 Green filter effects, 93–95, 144 Green toning effects, 93–95 Guide mode Advanced operations, 42 Easy operation selections, 40–42 Setup options, 42 working with, 40–42 guide numbers (GN), 309 for Nikon SB-910 flash unit, 319 H halogen light, 301 Halsman, Philippe, 243 hand grip, 46–47 hand-held microphones, 229 Hand tool, Adobe Camera Raw, 341 hard light for movies, 235 Hasselblad H3D-39 camera, 263 hazy contrast with telephoto lenses, 284 HDMI-CEC remote control operations,		high-speed photography, 241–244
GraphicConverter for Macintosh, 131 gray cards, 167–170 iPads/iPhones/iPods as, 260 Green filter effects, 93–95, 144 Green toning effects, 93–95 Guide mode Advanced operations, 42 Easy operation selections, 40–42 Setup options, 42 shooting options, 40–41 view/delete options, 42 working with, 40–42 guide numbers (GN), 309 for Nikon SB-910 flash unit, 319 H halogen light, 301 Halsman, Philippe, 243 hand grip, 46–47 hand-held microphones, 229 Hand tool, Adobe Camera Raw, 341 hard light for movies, 235 Hasselblad H3D-39 camera, 263 hazy contrast with telephoto lenses, 284 HDMI-CEC remote control operations,		
on reviewing images, 62, 64 histograms, 182–186. See also RGB histograms displaying, 182 for fixing exposure, 182–186 Hoodman magnifiers for LCD, 354 plastic overlays for LCD, 352 hoods. See also lens hoods for LCD, 354 horizontal composition in movies, 231 hot pixels, 361–362 hot shoe. See accessory/hot shoe How It's Made apps, 260 HSL/Grayscale control, Adobe Camera Raw, 343–344 hue Picture Controls, editing for, 92–96 Hasman, Philippe, 243 hand grip, 46–47 hand-held microphones, 229 Hand tool, Adobe Camera Raw, 341 hard light for movies, 235 Hasselblad H3D-39 camera, 263 hazy contrast with telephoto lenses, 284 HDMI-CEC remote control operations,		
iPads/iPhones/iPods as, 260 Green filter effects, 93–95, 144 Green toning effects, 93–95 Guide mode Advanced operations, 42 Easy operation selections, 40–42 Setup options, 42 shooting options, 42 working with, 40–42 guide numbers (GN), 309 for Nikon SB-910 flash unit, 319 H halogen light, 301 Halsman, Philippe, 243 hand grip, 46–47 hand-held microphones, 229 Hand tool, Adobe Camera Raw, 341 hard light for movies, 235 Hasselblad H3D-39 camera, 263 hazy contrast with telephoto lenses, 284 HDMI-CEC remote control operations,	GraphicConverter for Macintosh, 131	
Green filter effects, 93–95, 144 Green toning effects, 93–95 Guide mode Advanced operations, 42 Easy operation selections, 40–42 Setup options, 42 shooting options, 40–41 view/delete options, 42 working with, 40–42 guide numbers (GN), 309 for Nikon SB-910 flash unit, 319 H halogen light, 301 Halsman, Philippe, 243 hand grip, 46–47 hand-held microphones, 229 Hand tool, Adobe Camera Raw, 341 hard light for movies, 235 Hasselblad H3D-39 camera, 263 hazy contrast with telephoto lenses, 284 HDMI-CEC remote control operations,		
Green toning effects, 93–95 Guide mode Advanced operations, 42 Easy operation selections, 40–42 Setup options, 42 shooting options, 42 working with, 40–42 guide numbers (GN), 309 for Nikon SB-910 flash unit, 319 H halogen light, 301 Halsman, Philippe, 243 hand grip, 46–47 hand-held microphones, 229 Hand tool, Adobe Camera Raw, 341 hard light for movies, 235 Hasselblad H3D-39 camera, 263 hazy contrast with telephoto lenses, 284 HDMI-CEC remote control operations,		
Guide mode Advanced operations, 42 Easy operation selections, 40–42 Setup options, 42 shooting options, 40–41 view/delete options, 42 working with, 40–42 guide numbers (GN), 309 for Nikon SB-910 flash unit, 319 H halogen light, 301 Halsman, Philippe, 243 hand grip, 46–47 hand-held microphones, 229 Hand tool, Adobe Camera Raw, 341 hard light for movies, 235 Hasselblad H3D-39 camera, 263 hazy contrast with telephoto lenses, 284 HDMI-CEC remote control operations,		
Advanced operations, 42 Easy operation selections, 40–42 Setup options, 42 shooting options, 40–41 view/delete options, 42 working with, 40–42 guide numbers (GN), 309 for Nikon SB-910 flash unit, 319 H halogen light, 301 Halsman, Philippe, 243 hand grip, 46–47 hand-held microphones, 229 Hand tool, Adobe Camera Raw, 341 hard light for movies, 235 Hasselblad H3D-39 camera, 263 hazy contrast with telephoto lenses, 284 HDMI-CEC remote control operations,	Green toning effects, 93–95	
Easy operation selections, 40–42 Setup options, 42 shooting options, 40–41 view/delete options, 42 working with, 40–42 guide numbers (GN), 309 for Nikon SB-910 flash unit, 319 H halogen light, 301 Halsman, Philippe, 243 hand grip, 46–47 hand-held microphones, 229 Hand tool, Adobe Camera Raw, 341 hard light for movies, 235 Hasselblad H3D-39 camera, 263 hazy contrast with telephoto lenses, 284 HDMI-CEC remote control operations, magnifiers for LCD, 354 plastic overlays for LCD, 352 hoods. See also lens hoods for LCD, 354 horizontal composition in movies, 231 hot pixels, 361–362 hot shoe. See accessory/hot shoe How It's Made apps, 260 HSL/Grayscale control, Adobe Camera Raw, 343–344 hue Picture Controls, editing for, 92–96 i-TTL (intelligent through the lens), 309 balanced fill-flash, 310 standard fill-flash fee Photo options,	Guide mode	
Setup options, 42 shooting options, 40–41 view/delete options, 42 working with, 40–42 guide numbers (GN), 309 for Nikon SB-910 flash unit, 319 H halogen light, 301 Halsman, Philippe, 243 hand grip, 46–47 hand-held microphones, 229 Hand tool, Adobe Camera Raw, 341 hard light for movies, 235 Hasselblad H3D-39 camera, 263 hazy contrast with telephoto lenses, 284 HDMI-CEC remote control operations,	Advanced operations, 42	
shooting options, 40–41 view/delete options, 42 working with, 40–42 guide numbers (GN), 309 for Nikon SB-910 flash unit, 319 H halogen light, 301 Halsman, Philippe, 243 hand grip, 46–47 hand-held microphones, 229 Hand tool, Adobe Camera Raw, 341 hard light for movies, 235 Hasselblad H3D-39 camera, 263 hazy contrast with telephoto lenses, 284 HDMI-CEC remote control operations, hoods. See also lens hoods for LCD, 354 horizontal composition in movies, 231 hot pixels, 361–362 hot shoe. See accessory/hot shoe How It's Made apps, 260 HSL/Grayscale control, Adobe Camera Raw, 343–344 hue Picture Controls, editing for, 92–96 i-TTL (intelligent through the lens), 309 balanced fill-flash, 310 standard fill-flash, 310 standard fill-flash, 310–311 IF (internal focusing) lenses, 271 Image Dust Off Ref Photo options,	Easy operation selections, 40–42	-
view/delete options, 42 working with, 40–42 guide numbers (GN), 309 for Nikon SB-910 flash unit, 319 H halogen light, 301 Halsman, Philippe, 243 hand grip, 46–47 hand-held microphones, 229 Hand tool, Adobe Camera Raw, 341 hard light for movies, 235 Hasselblad H3D-39 camera, 263 hazy contrast with telephoto lenses, 284 HDMI-CEC remote control operations, for LCD, 354 horizontal composition in movies, 231 hot pixels, 361–362 hot shoe. See accessory/hot shoe How It's Made apps, 260 HSL/Grayscale control, Adobe Camera Raw, 343–344 hue Picture Controls, editing for, 92–96 i-TTL (intelligent through the lens), 309 balanced fill-flash, 310 standard fill-flash, 310 standard fill-flash, 310–311 IF (internal focusing) lenses, 271 Image Dust Off Ref Photo options,	Setup options, 42	-
working with, 40–42 guide numbers (GN), 309 for Nikon SB-910 flash unit, 319 H halogen light, 301 Halsman, Philippe, 243 hand grip, 46–47 hand-held microphones, 229 Hand tool, Adobe Camera Raw, 341 hard light for movies, 235 Hasselblad H3D-39 camera, 263 hazy contrast with telephoto lenses, 284 HDMI-CEC remote control operations, horizontal composition in movies, 231 hot pixels, 361–362 hot shoe. See accessory/hot shoe How It's Made apps, 260 HSL/Grayscale control, Adobe Camera Raw, 343–344 hue Picture Controls, editing for, 92–96 i-TTL (intelligent through the lens), 309 balanced fill-flash, 310 standard fill-flash, 310 standard fill-flash, 310–311 IF (internal focusing) lenses, 271 Image Dust Off Ref Photo options,	shooting options, 40–41	
guide numbers (GN), 309 for Nikon SB-910 flash unit, 319 H halogen light, 301 Halsman, Philippe, 243 hand grip, 46–47 hand-held microphones, 229 Hand tool, Adobe Camera Raw, 341 hard light for movies, 235 Hasselblad H3D-39 camera, 263 hazy contrast with telephoto lenses, 284 HDMI-CEC remote control operations, hot pixels, 361–362 hot shoe. See accessory/hot shoe How It's Made apps, 260 HSL/Grayscale control, Adobe Camera Raw, 343–344 hue Picture Controls, editing for, 92–96 i-TTL (intelligent through the lens), 309 balanced fill-flash, 310 standard fill-flash, 310 standard fill-flash, 310–311 IF (internal focusing) lenses, 271 Image Dust Off Ref Photo options,	view/delete options, 42	for LCD, 354
hot shoe. See accessory/hot shoe How It's Made apps, 260 HSL/Grayscale control, Adobe Camera Raw, 343–344 halogen light, 301 halsman, Philippe, 243 hand grip, 46–47 hand-held microphones, 229 Hand tool, Adobe Camera Raw, 341 hard light for movies, 235 Hasselblad H3D-39 camera, 263 hazy contrast with telephoto lenses, 284 HDMI-CEC remote control operations, hot shoe. See accessory/hot shoe How It's Made apps, 260 HSL/Grayscale control, Adobe Camera Raw, 343–344 hue Picture Controls, editing for, 92–96 i-TTL (intelligent through the lens), 309 balanced fill-flash, 310 standard fill-flash, 310 IF (internal focusing) lenses, 271 Image Dust Off Ref Photo options,	working with, 40-42	
How It's Made apps, 260 HSL/Grayscale control, Adobe Camera Raw, 343–344 hue Picture Controls, editing for, 92–96 Halsman, Philippe, 243 hand grip, 46–47 hand-held microphones, 229 Hand tool, Adobe Camera Raw, 341 hard light for movies, 235 Hasselblad H3D-39 camera, 263 hazy contrast with telephoto lenses, 284 HDMI-CEC remote control operations, How It's Made apps, 260 HSL/Grayscale control, Adobe Camera Raw, 343–344 hue Picture Controls, editing for, 92–96 i-TTL (intelligent through the lens), 309 balanced fill-flash, 310 standard fill-flash, 310–311 IF (internal focusing) lenses, 271 Image Dust Off Ref Photo options,	guide numbers (GN), 309	
HSL/Grayscale control, Adobe Camera Raw, 343–344 hue Picture Controls, editing for, 92–96 Halsman, Philippe, 243 hand grip, 46–47 hand-held microphones, 229 Hand tool, Adobe Camera Raw, 341 hard light for movies, 235 Hasselblad H3D-39 camera, 263 hazy contrast with telephoto lenses, 284 HDMI-CEC remote control operations, HSL/Grayscale control, Adobe Camera Raw, 343–344 hue Picture Controls, editing for, 92–96 i-TTL (intelligent through the lens), 309 balanced fill-flash, 310 standard fill-flash, 310–311 IF (internal focusing) lenses, 271 Image Dust Off Ref Photo options,	for Nikon SB-910 flash unit, 319	
Raw, 343–344 halogen light, 301 Halsman, Philippe, 243 hand grip, 46–47 hand-held microphones, 229 Hand tool, Adobe Camera Raw, 341 hard light for movies, 235 Hasselblad H3D-39 camera, 263 hazy contrast with telephoto lenses, 284 HDMI-CEC remote control operations, Raw, 343–344 hue Picture Controls, editing for, 92–96 i-TTL (intelligent through the lens), 309 balanced fill-flash, 310 standard fill-flash, 310 IF (internal focusing) lenses, 271 Image Dust Off Ref Photo options,		
Halsman, Philippe, 243 hand grip, 46–47 hand-held microphones, 229 Hand tool, Adobe Camera Raw, 341 hard light for movies, 235 Hasselblad H3D-39 camera, 263 hazy contrast with telephoto lenses, 284 HDMI-CEC remote control operations, I i-TTL (intelligent through the lens), 309 balanced fill-flash, 310 standard fill-flash, 310 IF (internal focusing) lenses, 271 Image Dust Off Ref Photo options,	Н	
Halsman, Philippe, 243 hand grip, 46–47 hand-held microphones, 229 Hand tool, Adobe Camera Raw, 341 hard light for movies, 235 Hasselblad H3D-39 camera, 263 hazy contrast with telephoto lenses, 284 HDMI-CEC remote control operations, Setter many 135	halogen light, 301	
hand-held microphones, 229 Hand tool, Adobe Camera Raw, 341 hard light for movies, 235 Hasselblad H3D-39 camera, 263 hazy contrast with telephoto lenses, 284 HDMI-CEC remote control operations, In the light through the lens, 309 balanced fill-flash, 310 standard fill-flash, 310–311 IF (internal focusing) lenses, 271 Image Dust Off Ref Photo options,	Halsman, Philippe, 243	3
Hand tool, Adobe Camera Raw, 341 hard light for movies, 235 Hasselblad H3D-39 camera, 263 hazy contrast with telephoto lenses, 284 HDMI-CEC remote control operations, ITTL (intelligent through the lens), 309 balanced fill-flash, 310 standard fill-flash, 310–311 IF (internal focusing) lenses, 271 Image Dust Off Ref Photo options,	hand grip, 46–47	ſ
hard light for movies, 235 Hasselblad H3D-39 camera, 263 hazy contrast with telephoto lenses, 284 HDMI-CEC remote control operations, balanced fill-flash, 310 standard fill-flash, 310–311 IF (internal focusing) lenses, 271 Image Dust Off Ref Photo options,	hand-held microphones, 229	
Hasselblad H3D-39 camera, 263 hazy contrast with telephoto lenses, 284 HDMI-CEC remote control operations, standard fill-flash, 310–311 IF (internal focusing) lenses, 271 Image Dust Off Ref Photo options,	Hand tool, Adobe Camera Raw, 341	
hazy contrast with telephoto lenses, 284 HDMI-CEC remote control operations, IF (internal focusing) lenses, 271 Image Dust Off Ref Photo options,	hard light for movies, 235	
hazy contrast with telephoto lenses, 284 HDMI-CEC remote control operations, IF (internal focusing) lenses, 271 Image Dust Off Ref Photo options,		
HDMI-CEC remote control operations, Image Dust Off Ref Photo options,		•
	HDMI-CEC remote control operations,	_

image editors. *See also* Adobe Photoshop/Photoshop Elements; Nikon Capture NX 2

cloning out dust spots, 365 DxO Optics Pro, 339 filtering out dust with, 365 video editors, 220

Image Overlay tool, Retouch menu, 145-146

image quality. See also JPEG formats; RAW formats; RAW+JPEG format

for continuous shooting, 241 first lens and, 265 Fn (Function) button and, 131–132 of prime lenses, 275 shooting information display for, 65–66 Shooting menu options, 96–99 of zoom lenses, 275

Image Recall, 358 image size

Fn (Function) button and, 131–132 shooting information display for, 65–66 Shooting menu options, 99–100

image stabilization. See VR (vibration reduction)

iMovie, 226

incandescent/tungsten light, 301 Incandescent WB (white balance), 101 Info button, 23–24, 68–69 information displays, 24–26

for GPS, 253 for reviewing images, 36, 59–64

saving power by turning off, 127 Setup menu

Auto Info Display options, 120 Display Format options, 118–119 shooting information display, 64–66

Information Edit button, 24–25, 52–53 information edit screen, 64–66 infrared remote. See IR remote infrared sensor, 46, 50–51 initial setup, 13–16 instruction manuals. See user manuals

intensity of light, 164 interleaving shots on memory cards, 359 inverse square law, 296–297 invisible people with long exposures, 247 iodine light, 301 iPads, 257–259

backing up images on, 359 for fill light, 260

iPhones, 257, 259

for fill light, 260

Wireless Mobile adapter for, 49

iPods, 257–259 for fill light, 260

IR remote

for Merge to HDR, 187 Nikon SU-800 commander unit using, 322

ISO sensitivity. See also Auto ISO; high ISO noise

adjusting, 35–36
adjusting exposure with, 180–181
Fn (Function) button and, 132
for focus stacking, 212
maximum sensitivity setting, 105
minimum shutter speed setting, 105
pixels and, 164
shooting information display for, 65
Shooting menu options, 104–105
viewfinder information display for,
74–75

IX lenses, 271

J

JPEG formats, 96-99. See also RAW+JPEG format

advantages of using, 97 Capture One Pro (C1 Pro) with, 340 for continuous shooting, 240–241 movie frame as still, saving, 221 Nikon Capture NX 2 with, 336 RAW formats compared, 98–99

jump cuts in movies, 231–232 jumping photos, 243

K	lenses, 261-292. See also rangefinder;
Kenko teleconverters, 287	VR (vibration reduction); specific
Kindkade, Thomas, 293	types
Kindle Fire, 257–259	accessory lenses, 274
Kodak Gray Cards, 170	AF/MF switch, 18
and stay salas, 1, 0	alphabetical list of lens terms, 270–272
L	apps for selecting, 259
L	capabilities of, 272–276
Landscape mode, 29, 180	categories of, 276
landscape photography, invisible people	cleaning, 364
in, 247	compatible lenses, 269–270
Landscape Picture Control, 90-96	components of, 70–73
Language options, Setup menu, 123	crop factor, 261–264
lapel microphones, 228-229	first lenses, 264–268
lavalieres, 228–229	light passed by, 164
LCD, 51-5251-52. See also Live View;	mounting, 17–18
reviewing images	for movies, 223–225
acrylic shields for, 353	older lenses, converting, 169
brightness	speed of, 274
saving power by reducing, 127	third-party lenses, 269
Setup menu options, 118–119	unpacking, 8
flip-up hoods for, 354	leveling camera, 260
glass shields for, 353	Li-ion batteries. See batteries
plastic overlays for, 353	library for WB (white balance), creating,
protecting, 352–354	104
LD/UD lenses, 271	light, 293-330. See also continuous
leaping photos, 243	light; exposure; fill flash/fill light;
LED video lights, 235	flash
lens bayonet mount, 72	diffusing light, 322–324
Lens Corrections control, Adobe Camera	duration of, 164
Raw, 343–344	emitted light, 164
lens hood bayonet, 70–71	lens, light passed by, 164
lens hoods, 286	movies, lighting for, 234–236
AF-assist lamp and, 112	multiple light sources, using, 324–327
shadows, eliminating, 279	reflected light, 164
lens indexing ring, 45	sensor, light captured by, 164
lens mount, 45	shutter, light passed through, 164
index mark, 47, 49	source, light at, 163–164
lens multiplier factor, 261–264	transmitted light, 164
Lens release button, 45–46	light stands, 328
	light streaks with long exposures, 245,
	248

light trails with long exposures,	macro lenses, 274, 288-289
248–249	adapters for, 288
linearity of lens and movies, 225 liquid cleaning sensors, 367, 369–370	macro photography and focus stacking, 210–213
Live View	magnifiers
activating, 216–217	for eyepiece, 12
AF-area in, 111–112, 207–210, 217	for LCD, 354
contrast detection in, 194–195	for sensor cleaning, 370-372
focus modes with, 206, 217	Mamiya 64ZD camera, 263
focusing in, 206–210	manual flash, 310
metering modes with, 217	Shooting menu options, 114
quick start guide for, 7	manual focus (MF). See MF (manual
steps for shooting in, 218	focus)
working with, 215–218	Manual mode (M). See M (Manual)
Live View button, 7, 53, 218	mode
Lock Mirror Up for Cleaning option,	manuals. See user manuals
Setup menu, 121	marking/unmarking images, 82
locking in focus, 195-196	matrix metering, 32
locking pin, 45-46	with Active D-Lighting, 106
long exposure noise	flash metering and, 310-311
dealing with, 181–182	with Live View, 217
Shooting menu's reduction options,	Shooting menu options, 112
109-111	working with, 170-172
long exposures, 245-250. See also long	maximum aperture
exposure noise	of first lens, 265
bulb exposures, 245–246	movies, lenses for shooting, 225
neutral-density (ND) filters with, 245,	of prime lenses, 275
248	rangefinder feature and, 129
time exposures, 245–246	of zoom lenses, 275
timed exposures, 245–246	maximum burst, viewfinder information
working with, 247–250	display for, 74–75
low-cut filters, 229	MediaRecover, 358
luminance histograms, 182-186	medium shots in movies, 233
	memory card access lamp, 53-54
M	memory cards, 11. See also Eye-Fi cards;
	folders; remaining shots;
M (Manual) mode, 31 built-in flash in, 38	transferring images to computer
	for continuous shooting, 240
first-curtain sync in, 313	door for, 46–47
red-eye reduction in, 313	DPOF (Digital Print Order Format) on,
second-curtain sync in, 313	87
sync speeds in, 313	eggs in one basket argument, 354–355
working with, 178–179	failure rate for, 355–356

formatting, 19–21	microphones, 47, 49
Setup menu options, 20, 118	adding external microphones, 222
inserting, 19	camera noise and, 226-227
interleaving shots on, 359	configurations for, 228-229
managing, 347	directionality of, 227–228
for movies, 218, 221–222	plug for, 49–50
preventive measures for, 359-360	Shooting menu options, 113
Slot Empty Release Lock option, Setup	tips for using, 226
menu, 19, 133, 357	wind noise reduction, 229
troubleshooting for, 354–360	Miniature Effect tool, Retouch menu,
MENU button, 13, 52, 78-79	151–154
menus. See also specific menus	mirror, 45
color-coding for, 80	dust on, 361
columns of information in, 79	Lock Mirror Up for Cleaning option,
description of, 78–80	Setup menu, 121
navigating among, 80	sensor cleaning, placement for, 367
selecting menu items, 80	mirror lenses, 284
mercury vapor light	mixers for audio, 228
color rendering index (CRI) of, 303	MobileMe, Eye-Fi cards for uploading
Flicker Reduction options, Setup menu,	to, 255
122	mode dial, 68-69
Merge to HDR, 187-190	monitor. See LCD
steps for, 187–190	monitor pre-flash, 309
metering modes. See also center-	Monochrome Picture Control, 90-96
weighted metering; matrix	editing, 93
metering; spot metering	monolights, 295, 325
defined, 169	motion. See also freezing action
flash metering modes, 310-311	AF (autofocus) and, 199-200
with Live View, 217	circles of confusion and, 197
selecting, 32, 170–174	motor drive. See continuous shooting
shooting information display for, 65-66	mounting lenses, 17–18
Shooting menu options, 112–113	Movie button, 68–69
MF (manual focus), 35	movies, 218-236. See also audio
activating, 196	batteries for, 222
for focus stacking, 212	composition for, 231–234
with Live View, 206–207, 217	DOF (depth-of-field) and, 223–224
for Nikon SB-910 flash unit, 320	editing, 220–221
rangefinder feature and, 129	Retouch menu options, 156
with self-timer, 28	transitions, 231–232
working with, 202–204	establishing shots in, 232–233
Mi-Fi for iPods, 257	frame in movie, saving, 221
Micro lenses, 271	frame size/frame rate options, Shooting
, -, -	menu, 113

111:-h-f 225	netbooks, backing up images to,
hard light for, 235	359–360
horizontal composition in, 231	neutral-density (ND) filters, 248
lenses for shooting, 223–225	center-weighted metering with, 172
lighting for, 234–236	with long exposures, 245, 248
with Live View, 216	Neutral Picture Control, 90–96
manual movie settings, 113	newborns, Date Counter for tracking,
memory cards for, 218, 221–222	135
overheating and, 222	Newton, Isaac, 296
quality options, 113	night/darkness
resolution for, 219	with long exposures, 249–250
reviewing, 219–220	Take Dark Photo options, 42
saving movies, 220–221	
sensors for, 223–224	Night Portrait mode, 30, 180
Shooting menu settings, 113	sync speeds in, 313
shooting script for, 229	Nikon BR 2-A ring, 288
shot types in, 232–234	Nikon Camera Control Pro, 332
side space in, 232	Nikon Capture, 332
soft light for, 235	Nikon Capture NX 2, 13, 98, 332
storyboards for, 230	Auto Image Rotation with, 124
storytelling in, 230–231	comments, entering, 123
styles of lighting for, 235–236	Lens Distortion Correction feature, 279
time dimension in, 232	working with, 336–338
time limits for, 219	Nikon Coolpix, 332
tips for shooting, 222-225	Nikon D3200
transitions in, 231-232	back view of, 50–54
tripods for shooting, 229	bottom view of, 73
Video Mode options, Setup menu, 121	front view of camera, 44–50
zoom lenses for, 225	top view of, 67–68
zooming in/out in, 222, 224-225	Nikon ME-1 microphone, 227
multi selector, 13-14, 53-54	low-cut filters, disabling, 229
My Picturetown	Nikon SB-R200 flash unit, 318
geotagging information in, 251	Nikon SB-400 flash unit, 317–318
transmitting images as taken to, 358	Nikon SB-700 flash unit, 317
Mylar reflectors, 324	zoom adjustment, 319
•	Nikon SB-910 flash unit, 316-317
N	diffusers with, 324
	flash modes for, 319-320
natural sounds in movies, 225-226	overheating with, 320
Neat Image, 339	telephoto lenses with, 284
neck/shoulder straps, 8-9	zoom adjustment, 319
eyelet for attaching, 47, 49	Nikon SU-800 commander unit,
NEF formats. See RAW formats	320-322

Nikon Transfer, 334-336

Nikon View NX 2, 332	P
Auto Image Rotation with, 124	-
geotagging information in, 251	P (Program) mode, 31
working with, 332–334	built-in flash in, 38
Nikonos camera bodies, 272	equivalent exposures and, 166
Nixon, Richard, 243	red-eye reduction in, 311
noise. See also high ISO noise; long	slow sync in, 312
exposure noise; microphones	sync speeds in, 311–312
dealing with, 181–182	working with, 177–178
pixel density and, 263	PAL video standard, 121
Quiet Shutter Release, 28	pausing Slide Show, 86
Shooting menu's Noise Reduction	PC (Perspective Control) lenses, 272
options, 109–111	PC Micro-Nikkor 85mm f/2.8D lens,
software for reducing, 338-339	289
Noise Ninja, 182, 339	Pec-Pad sensor cleaning swabs, 369–370
noon, color temperature at, 300	Pelican card safes, 356
normal-area AF, 112	people. See also faces; portraits
with Live View, 207, 209, 217	Free Motion (People) options, 42
normal lenses, 276	invisible people with long exposures,
NTSC video standard, 121	247
* *	Personal Storage Devices, backing up
0	images to, 359–360
~	perspectives. See also distortion
OK button, 53–54	crop factor and, 264
On/Off switch, 46, 68-69	with lenses, 272
OnTrack, 357–358	Retouch menu's Perspective Control
Opanda iExif for Windows, 131	options, 151–152
Orange filters, 93-95	with short exposures, 243–244
outdoor light. See Daylight	phase detection, 192–194
over-the-shoulder shots in movies,	Phase One's Capture One Pro (C1 Pro),
233–234	338-340
overexposure	Photo Rescue 2, 358
Active D-Lighting and, 106	PhotoAcute, 213
example of, 168	Photographic Solutions
for high-key look, 178	Eclipse solution, 369
histograms for, 183–186	sensor cleaning swabs, 369
overheating	Photoshop/Photoshop Elements. See
and movies, 222	Adobe Photoshop/Photoshop
with Nikon SB-910 flash unit, 320	Elements
overlaying images	PictBridge-compatible printers, 87
Retouch menu options, 145–146	Auto Off Timers option with, 126
WB (white balance) and, 147	

Overview data screen on reviewing

images, 60

Picture Controls. See also Monochrome portraits Picture Control backgrounds for, 329 center-weighted metering for, 172 editing, 90-96 flat faces with telephoto lenses, 282 shooting information display for, 65 short exposures for, 243 Shooting menu options for setting, 90-96 power. See also AC adapters; batteries PictureProject, 332 Auto Off Timers options, Setup menu, pincushion distortion, 106 126 - 127Retouch menu's control options, DC power port, 46–47 148 - 150Live View using, 216 with telephoto lenses, 283 for monolights, 325 Pinnacle Studio, 220 for studio flash, 324 pixel mapping, 361 power connector, 12 pixels. See also histograms; noise Preset Manual WB (white balance) density and noise, 263 overlaying images and, 147 ISO sensitivity and, 164 working with, 103-104 stuck/hot pixels, 361–362 Presets control, Adobe Camera Raw, plastic overlays for LCD, 353 343-344 Playback button, 36, 52 previewing Playback display options, Playback in calendar view, 58 menu, 83 continuous light for, 295 Playback folder, 54 flash for, 296 Playback menu options, 82–83 with Live View, 216 Playback menu, 81-88 prime and zoom lenses compared, Delete options, 81–82 274-275 Image Review options, 84 printers and printing. See also PictBridge-compatible printers Playback display options, 83 date, Setup menu option for printing, Playback folder options, 82–83 134-135 Rotate Tall options, 84–85 DPOF Print Order options, Playback Slide Show options, 85–87 menu, 87–88 playing back images. See reviewing product photography, backgrounds for, images 329 polarizing filters, center-weighted Program mode (P). See P (Program) metering with, 172 mode pop-up flash. See built-in flash Pronea cameras, 271 port cover, 47, 49 protecting Portrait mode, 29, 179. See also Night batteries, 346–347 Portrait mode lock for protecting images, 51 sync options in, 313

Portrait Picture Control, 90-96

Purple Blue toning effects, 93-95

on reviewing images, 36

thumbnail images, 57

Q	recovering images, software for, 358
quartz-halogen/quartz-iodine light, 301	rectilinear lenses, 279
Quick Guide, 10	red-eye reduction
Quick Response Remote mode, 28	with Adobe Camera Raw, 341
Quick Retouch options, Retouch menu,	in A (Aperture-priority) mode, 311
148	in M (Manual) mode, 313
quick start guide, 6-7	in P (Program) mode, 311
quickie guide apps, 260	Retouch menu options, 141–142
Quiet Shutter Release, 28	in S (Shutter-priority) mode, 313
	in Scene modes, 313
R	selecting, 311
	red-eye reduction lamp, 44–45
rangefinder	red-eye reduction with slow sync, 312
with MF (manual focus), 202-204	in A (Aperture-priority) mode, 312
phase detection and, 192–194	in Night Portrait mode, 313
Setup menu options, 128–130	in P (Program) mode, 312
steps for using, 130, 204	Red filter effects, 93-95, 144
RAW formats, 96–99. See also Adobe	Red Purple toning effects, 93–95
Camera Raw; RAW+JPEG format	Red toning effects, 93–95
for continuous shooting, 241	reflected light, 164
JPEG formats compared, 98–99	reflectors
Merge to HDR with, 190	for diffusing light, 324
Retouch menu's processing options,	for movies, 236
146–147	registration cards, 11
WB (white balance), specifying, 300	Release Mode button, 26-28, 53-54
RAW utilities. See also Adobe Camera	release modes. See shooting modes
Raw; Nikon Capture NX 2; Nikon View NX 2	release priority, 202
BreezeBrowser Pro, 340	remaining shots
noise reduction with, 182	actuations, counting, 131
Phase One's Capture One Pro (C1 Pro),	shooting information display for, 67
338–340	typical number of shots on memory
RAW+JPEG format, 96–99	cards, 20–21
advantages of using, 98–99	viewfinder information display for,
for focus stacking, 212	74–75
RCA jacks, 49	Rembrandt, 293
rear-curtain sync. See second-curtain	remote control. See also IR remote
sync	external flash, Commander mode for,
rear lens cap, 9–10	320–322
removing, 17	for focus stacking, 212
Recent Settings menu, 156–157	HDMI-CEC operations, 122
Recover My Photos, 358	infrared sensor for, 46
recovering details with Adobe Camera	for Merge to HDR, 187
Raw, 343	remote cord, 11–12
	remote triggers, 295

deleting on, 36, 55

RescuePRO, SanDisk, 358 Reset Setup options, Setup menu, 117–118	File information scene for, 59–60 GPS data screen, 60 highlights on, 62, 64
Reset Shooting options, Shooting menu,	information displays for, 36, 59–64
90 resizing image options, Retouch menu, 148	movies, 219–220 Overview data screen, 60 retouching on, 55
resolution HDMI format options, 121–122 for movies, 219 Retouch menu, 138–156 Color Balance options, 144–145 Color Outline options, 150–151 Color Sketch options, 150 D-Lighting options, 140 Distortion Control options, 148–150	RGB histograms on, 62–63 saving power with, 127 Shooting Data screens, 60–63 as thumbnails, 54, 56–57 zooming in/out on, 36, 54–56 RGB histograms, 182–186 on reviewing images, 62–63 right-angle viewer, 12 Ritchie, Guy, 232
Edit Movie options, 156 Filter Effect options, 144 Fisheye options, 150	Rolls MX124 mixer, 228 rotating images with Adobe Camera Raw, 341
Image Overlay tool, 145–146 Miniature Effect tool, 151–154 Monochrome options, 144 NEF (RAW) Processing options,	Auto Image Rotation options, Setup menu, 124 Playback menu's Rotate Tall options, 84–85
146–147 Perspective Control options, 151–152	RPT (repeating flash) for Nikon SB-910 flash unit, 320
Quick Retouch options, 148 Red-Eye Correction options, 141–142 Resize options, 148 Selective Color options, 155–156 Side-by-Side Comparison options, 154–155 Straighten options, 148	S S (Shutter-priority) mode, 31 built-in flash in, 38 equivalent exposures and, 166
Trim options, 141–143	first-curtain sync in, 313 red-eye reduction in, 313
retouching images. See also Retouch menu	second-curtain sync in, 313
with Adobe Camera Raw, 341 creating retouched image, 139 on reviewing images, 55	sync speeds in, 313 working with, 176–177 SanDisk's RescuePRO, 358
revealing images with short exposures, 243	saturation Adobe Camera Raw, adjusting with,
reviewing images, 36–37, 54–64. See also Playback menu calendar view, working with, 58–59 deleting on, 36, 55	343 Picture Controls, editing for, 92–96 saving movies, 220–221 saving power. <i>See</i> power

SC-29 TTL coiled remote cords, 321	Sepia toning effects, 93–95
Scene modes	setup
selecting, 29–30	final setup, 16–21
working with, 179–180	initial setup, 13–16
Scotch Brand Magic Tape cleaning	Setup menu, 115-138. See also
sensors, 367, 370	information displays
SDHC memory cards. See also Eye-Fi	AE-L/AF-L lock options, 132-133
cards	Auto Image Rotation options, 124
for movies, 221	Auto Off Timers options, 126–127
SDXC memory cards for movies, 221	Beep options, 127–128
second-curtain sync, 304–306	Buttons options, 131–133
in A (Aperture-priority) mode, 311	Eye-Fi Upload options, 138, 256
ghost images and, 305-306	File Number Sequence options,
in M (Manual) mode, 313	130–131
in P (Program) mode, 311	Firmware Version options, 138
problems, avoiding, 307–308	Flicker Reduction options, 122
in S (Shutter-priority) mode, 313	Fn (Function) button options, 131–132
Secure Digital cards. See memory cards	Format Memory Card entry, 20
Selective Color options, Retouch menu,	Format Memory Card options, 118
155–156	GPS options, 137–138
self-timer, 27	HDMI Format options, 121-122
Setup menu options, 127	Image Comment options, 123–124
self-timer lamp, 44–45	Image Dust Off Ref Photo options, 125
Sensor Brush, 368–369	Language options, 123
sensor cleaning, 360–361, 365–372	Lock Mirror Up for Cleaning option,
air cleaning, 366–368	121
brush cleaning, 366, 368–369	Monitor Brightness options, 118-119
liquid cleaning, 367, 369–370	Print Date options, 134–135
Lock Mirror Up for Cleaning option,	Rangefinder options, 128-130
Setup menu, 121	Reset Setup options, 117–118
magnifiers for, 370–372	Self-Timer options, 127
mirror placement for, 367	Slot Empty Release Lock option, 19,
Setup menu options, 120–121	133, 357
tape cleaning, 367, 370	Storage Folder options, 135-137
sensor cleaning swabs, 369–370	Time Zone and Date options, 123
SensorKlear loupe/wand, 371–372	Video Mode options, 121
sensors. See also sensor cleaning	Shade WB (white balance), 101-102
CCD sensors, 182	shadows
CMOS sensors, 182	Merge to HDR and, 187–190
crop factor and, 261-264	with wide-angle lenses, 279
cross-type sensors, 193–194	sharpness
infrared sensor, 46, 50-51	lenses and, 274
light captured by, 164	Picture Controls and, 92-96

movies and, 223-224

shooting information display for, 65, 67 shiny objects, soft boxes for short exposures, 241-244 photographing, 328 viewfinder information display for, Shooting Data screens on reviewing images, 60-63 VR (vibration reduction) and, 291 shooting information display, 64-66 Shutterfly reactivating, 66 Eye-Fi cards for uploading to, 255 Shooting menu, 88-114 transmitting images as taken to, 358 Active D-Lighting options, 106-107 Side-by-Side Comparison options, AF-Area mode options, 111-112 Retouch menu, 154-155 AF-assist lamp options, 112 side space in movies, 232 Auto Distortion Control, 106 Sigma, 265, 269 Color Space options, 107-109 macro lenses, 289 Flash Cntrl for Built-in Flash, 113-114 teleconverters, 287 Image Quality options, 96–99 Silent Wave motor, 265 Image Size options, 99-100 silhouette effect, 161, 178 ISO sensitivity options, 104-105 M (Manual) mode and, 178 Metering options, 112-113 single frame shooting mode, 26 Movie settings, 113 single-point AF, 34, 111 Noise Reduction options, 109-111, 181 working with, 205 Reset Shooting options, 90 single-servo AF (AF-S). See AF-S (single-Set Picture Control options, 90-96 servo AF) WB (white balance) options, 99-104 size. See also image size shooting modes, 26-28 of first lens, 265 shooting information display for, 65-66 movie frame size/frame rate options, shooting script for movies, 229 Shooting menu, 113 short exposures, 241-244 resizing image options, Retouch menu, short telephoto lenses, 276 148 shotgun microphones, 228 Skylight filter effect, 144 shots remaining. See remaining shots slave triggers with external flash, 327 shoulder straps. See neck/shoulder straps Sleep (Warhol), 219 Show Water Flowing options, 42 slide shows Shure microphones, 228 pausing, 86 shutter. See also shutter speed Playback menu options, 85-87 light passed through, 164 Slot Empty Release Lock option, Setup Quiet Shutter Release, 28 menu, 19, 133, 357 Shutter-priority mode (S). See S slow sync, 312. See also red-eye (Shutter-priority) mode reduction with slow sync Shutter release button, 46, 68-69 in A (Aperture-priority) mode, 312 AE-L/AF-L lock with, 133 in P (Program) mode, 312 shutter speed, 165. See also ISO smart phones, 257. See also Android sensitivity; sync speed phones; iPhones apps for estimating, 259-260 GPS data and, 251 DOF (depth-of-field) and, 166

equivalent exposures, 166

Wireless Mobile adapter for, 49

Smugmug, Eye-Fi cards for uploading	sports photography
to, 255	Auto Off Timers option and, 126
Snapshots control, Adobe Camera Raw,	continuous shooting for, 239–241
343-344	JPEG formats for, 98
snoots, 329	memory cards for, 355
sodium-vapor light, 303	short exposures and, 241–244
soft boxes, 324, 327-328	telephoto lenses for, 282
Soft filter effect, 144	spot metering, 32
soft light	flash metering and, 310–311
for movies, 235	gray cards and, 169
working with, 322-324	with Live View, 217
Soften Backgrounds option, 42	Shooting menu options, 113
software, 331-344. See also Adobe	working with, 173–174
Camera Raw; Adobe Photoshop/	sRGB, 107–109
Photoshop Elements; image	Standard Picture Control, 90-96
editors; Nikon Capture NX 2;	Stegmeyer, Al, 9
Nikon View NX 2	stills
BreezeBrowser Pro, 340	with Live View, 216
bugs in, 347	movies and stills, shooting, 218
CD-ROM with, 11	Sto-Fen diffusers, 324
data recovery software, 358	stopping action. See freezing action
DxO Optics Pro, 339	stops, 166. See also f/stops
focus stacking programs, 212–213	Storage Folder options, Setup menu,
for GPS data, 254	135–137
Nikon Transfer, 334–335	storyboards for movies, 230
recovering images, software for, 358	storytelling in movies, 230–231
spare batteries, 11, 15	straightening images
speaker, 68-69	with Adobe Camera Raw, 341
speed. See also shutter speed	Retouch menu options, 148
of first lens, 265	streaks with long exposures, 245, 248
focus speed, 196	stuck pixels, 361–362
of lenses, 274	studio flash
of prime lenses, 275	sync speed problems with, 308
of zoom lenses, 275	working with, 325
speedlights. See external flash	subject-tracking AF, 112
spherical aberration	with Live View, 207, 209–210, 217
bokeh and, 284-285	working with, 209–210, 217
with telephoto lenses, 283	sunlight. See Daylight
Spiderlite lighting fixtures, 303	
split-color filters, center-weighted	Sunsets, Capture Reds in, 42
metering with, 172	super-sized subjects with wide-angle lenses, 277
Split Toning control, Adobe Camera	
Raw, 343-344	super-telephoto lenses, 276 Sylvania color rendering index (CRI),
Sports mode, 30, 180	300, 303

sync speed, 304–306. See also first-	Live View, previewing with, 216
curtain sync; second-curtain sync; slow sync	RCA jacks for, 49
in A (Aperture-priority) mode, 311–312	tethering iPods, 257 text entry, 124–125
with built-in flash, 315	three-point lighting for movies,
in M (Manual) mode, 313	235–236
in Night Portrait mode, 313	three-shots in movies, 233
in P (Program) mode, 311–312	3D Color Matrix metering II, 171
problems, avoiding, 307–308	3D-tracking mode, 34, 111
in S (Shutter-priority) mode, 313	working with, 206
in Scene modes, 313	thumb drives for reference manuals, 10
selecting, 311–313	Thumbnail button, 52
short exposures and, 242–243	thumbnails
	deleting, 57, 81
Т	reviewing images as, 54, 56–57
	TIFF format
tablet computers, 257–259	Capture One Pro (C1 Pro) with, 340
Wireless Mobile adapter for, 49	Nikon Capture NX 2 with, 336
WU-la Wi-Fi adapter, 254	Nikon View NX 2 with, 332
Take Bright Photos option, 42	tilt/shift capabilities of lenses, 274
Take Dark Photo options, 42	time exposures, 245–246
taking aperture, 73 Tamron, 265, 269	time zones, 14
macro lenses, 289	Setup menu options, 123
teleconverters, 287	timed exposures, 245–246
tape cleaning sensors, 367, 370	times. See dates and times
tele-zoom lenses. See telephoto lenses	Tokina, 265, 269
teleconverters, 286–288	macro lenses, 289
computability with lenses, 287	Tone Curve control, Adobe Camera Raw,
crop factor and, 263	343–344
disadvantages of, 287–288	toning
telephones. See smart phones	filters <i>vs.</i> , 94–95
telephoto converters. See teleconverters	Monochrome Picture Control, toning
telephoto lenses, 276, 280–286	effects for, 93–95
bokeh and, 284–286	transferring images to computer, 38–39
example of use, 272–273	with card readers, 38–39
problems, avoiding, 282–284	for focus stacking, 212–213
selective focus with, 280–281	formatting memory cards by, 20
speed of, 274	Nikon Transfer for, 334–336
television	with USB cables, 38–39
HDMI format options, Setup menu,	Wireless Mobile Transmitter for, 13 Transition Effects, 83
121–122	-
HDTV settings, 121–122	as Slide Show option, 85–86

transitions in movies, 231-232

transmitted light, 164 Use Photo option for WB (white trimming images. See cropping/ balance), 103-104 trimming images user manuals, 10 tripods apps, 259-260 for focus stacking, 212 quickie guide apps, 260 for Live View, 216 UV lenses, 272 for Merge to HDR, 187 UW lenses, 272 for movies, 229 for self-timer, 27 V socket for, 73 Vehicles (Freeze Motion) options, 42 TTL (through the lens), 310. See also vestibule, cleaning, 364-365 i-TTL (intelligent through the vibrance adjustments with Adobe lens) Camera Raw, 343 for Nikon SB-910, 319-320 vibration reduction (VR). See VR Shooting menu options, 113 (vibration reduction) TTL coiled remote cords, 321 video. See movies TTL flash cords, 12-13 video cables, 9 tungsten light, 301 port for, 49-50 12-18% gray cards, 167-170 video editors, 220 two-shots in movies, 233-234 viewfinder. See also eyecup/eyepiece diopter correction, adjusting, 18-19 U information display in, 74-75 ultrawide-angle lenses, 276 vignetting with wide-angle lenses, 279 umbrellas for diffusing light, 324 visible light, 163 underexposure Vivid Picture Control, 90-96 with Active D-Lighting, 106 VR (vibration reduction), 290-292 EV (exposure compensation) changes in camera or lens, 291 and, 178 lenses, 272 example of, 168-169 minimum shutter speed and, 105 histograms for, 183-186 saving power by canceling, 127 for silhouette effect, 161, 178 VR (vibration reduction) switch, 47, 49, unpacking box, 7-11 71 - 72unreal images with short exposures, 243-244 W UPstraps, 9 Walmart Digital Photo Center USB cables, 9 Eye-Fi cards for uploading to, 255 comments, entering, 123 transmitting images as taken to, 358 firmware updates with, 351 Warhol, Andy, 219 port for, 49-50 Warm filter effect, 144 transferring images to computer with, warning indicator in viewfinder 38 - 39information display, 74–75 USB port, 49-50 warranty cards, 11

water

blurring waterfalls/cascades, 249–250 Show Water Flowing options, 42

WB (white balance). See also Preset Manual WB (white balance)

adjusting, 35–36, 303
Adobe Camera Raw, adjusting with, 341, 343
of continuous light, 299–303
continuous light, adjusting for, 303
Fn (Function) button and, 132
for focus stacking, 212
library, creating, 104
overlaying images and, 147
shooting information display for, 65–66
Shooting menu options, 99–104
Use Photo option for, 103–104
viewfinder information display for,

74–75 wedding photography

memory cards, protecting, 357 recovering images on memory cards, 357

Wein Safe Sync, 327 White, John, 169 white balance (WB). See WB (white balance)

Wi-Fi, 254–256. See also Eye-Fi cards; GPS

free connections, 257

Wi-Fi Positioning System (WPS), 255 wide-angle lenses, 276

crop factor and, 264 example of use, 272–273 problems, avoiding, 279–280 working with, 277–278

wide-area AF, 111

with Live View, 207-208, 217

wide-zoom lenses. *See* wide-angle lenses wildlife photography

with telephoto lenses, 282 VR (vibration reduction) and, 290 wind noise reduction, 229 window light, working with, 322 Windows Movie Maker, 226 wipes in movies, 231 wireless flash, 320–322

Nikon SB-R200 flash unit, 318 wireless microphones, 229 Wireless Mobile Transmitter, 13, 49 wireless remote control, 11–12 WU-la Wi-Fi adapter, 254–255

Y

Yellow filters, 93–95 Yellow toning effects, 93–95 YouTube, Eye-Fi cards for uploading to, 255

Z

zoom head, adjusting, 319 Zoom In button, 66 zoom lenses

> crop factor and, 264 lens hoods for, 286 for movies, 225 prime lenses compared, 274–275

Zoom Out button, 52

zoom range

of first lens, 265 movies, lenses for shooting, 225

zoom ring on lens, 70–71 zoom setting on lens, 70–71 zooming in/out

with Adobe Camera Raw, 341 in Live View, 7, 218 in movies, 222, 224–225 on reviewing images, 36, 54–56 as Slide Show option, 85–86